T0236652

Refinery Feedstocks

Petroleum Refining Technology Series

Series Editor:
James G. Speight

This series of books is designed to address the current processes used by the refining industry and take the reader through the various steps that are necessary for crude oil evaluation and refining. Technological advancements and processing innovations are highlighted in each of the volumes.

Refinery Feedstocks
James G. Speight

Refinery Feedstocks

James G. Speight

CRC Press
Taylor & Francis Group
Boca Raton London New York

CRC Press is an imprint of the
Taylor & Francis Group, an **informa** business

First edition published 2021
by CRC Press
6000 Broken Sound Parkway NW, Suite 300, Boca Raton, FL 33487-2742

and by CRC Press
2 Park Square, Milton Park, Abingdon, Oxon, OX14 4RN

© 2021 Taylor & Francis Group, LLC

CRC Press is an imprint of Taylor & Francis Group, LLC

Library of Congress Cataloging-in-Publication Data
Names: Speight, James G., author.
Title: Refinery feedstocks / James G. Speight.
Description: 1. | Boca Raton : Taylor and Francis, 2020. |
Series: Petroleum refining technology series | Includes bibliographical
references and index.
Identifiers: LCCN 2020024663 (print) | LCCN 2020024664 (ebook) |
ISBN 9780367027100 (hardback) | ISBN 9780429398285 (ebook)
Subjects: LCSH: Petroleum—Refining. | Heavy oil. | Oil sands.
Classification: LCC TP690 .S7443 2020 (print) | LCC TP690 (ebook) |
DDC 665.5—dc23
LC record available at https://lccn.loc.gov/2020024663
LC ebook record available at https://lccn.loc.gov/2020024664

ISBN: 978-0-367-02710-0 (hbk)
ISBN: 978-0-429-39828-5 (ebk)

Typeset in Times
by codeMantra

Contents

PART 2 *Feedstocks in the Future Refinery*

Preface

Over the last decades, the energy industry has experienced significant changes in resource availability, petro-politics, and technological advancements dictated by the changing quality of refinery feedstocks. However, the dependence on fossil fuels as the primary energy sources has remained unchanged. Advancements made in exploration, production, and refining technologies allow utilization of resources that might have been considered unsuitable in the middle decades of the 20th century.

In this supply-and-demand scenario, it is expected that the existing peak in conventional oil production will decline within the next two to three decades, and the production of products from conventional crude oil (including crude oil from tight – low-to-no-permeability – formations) will decline leading the way for the increased use of heavy crude oil, extra-heavy crude oil, and tar sand bitumen as significant refinery feedstocks. For the purposes of this book, residua (resids), heavy oil, extra-heavy oil, and tar sand bitumen are (for convenience) included in the term *viscous feedstocks*.

Thus, just as there was a surge in upgrading technologies during the 1940s and 1950s to produce marketable products from residua, an equal surge in technologies that are related to producing marketable products will occur over the next two decades. And so the need for the development of upgrading processes continues in order to fulfill the product market demand as well as to satisfy environmental regulations. One area in particular, the need for residuum conversion technology, has emerged as a result of a declining residual fuel oil market and the necessity to upgrade crude oil residua beyond the capabilities of the visbreaking, coking, and low-severity hydrodesulfurization processes.

As the 21st century opened, the refining industry entered a significant transition period and the continued reassessment by various governments, and the various levels of government, of oil-importing and oil-exporting policies. Therefore, it is not surprising that refinery operations have evolved to include a range of *next-generation processes* as the demand for transportation fuels and fuel oil has shown a steady growth. These processes are different from one another in terms of the method and product slates and will find employment in refineries according to their respective features. The primary goal of these processes is to convert heavy feedstocks, such as residua, to lower-boiling products. Thus, these processes are given some consideration in this book.

But there are challenges when refining viscous feedstocks. A major challenge is the feedstock composition because of the high content of heteroatoms (sulfur, nitrogen, oxygen) and heavy metals (particularly nickel and vanadium). Although the concentration of these elements may be quite small, their impact is significant. For example, the presence of heteroatoms may also be responsible for objectionable characteristics in finished products causing environmental concerns, so the levels of heteroatoms in finished products have to be reduced following more and more stringent environmental regulations. Also, the deposition of trace heavy metals (vanadium and nickel) and/or chemisorption of nitrogen-containing compounds on the catalysts are the main reasons for catalyst passivation and/or poisoning in catalytic operations, and thus necessitate frequent regeneration of the catalyst or its replacement.

Another challenge related to composition is the presence of asphaltene constituents that can lead to the deposition of solids (phase separation) during processing and which is a consequence of (i) the high asphaltene content of the feedstocks, (ii) the formation of poorly soluble products during the refining process, (iii) the formation of alkane-type products that will cause phase separation of asphaltene constituents and reacted asphaltene constituents, and (iv) any inorganic solids. One of the most notorious effects of asphaltene constituents is the pronounced tendency to form aggregates in oil media and also under unfavorable solvent conditions leading to separation from the liquid medium. Inorganic fine solids are generally associated with asphaltene constituents and, as a result, the separated asphaltene constituents often contain a high concentration of inorganic fine solids.

The separation of organic and/or inorganic solids during processing poses severe problems leading to coking in the reactor and in the refinery lines as well as catalyst deactivation.

This book is designed to address the problems of solid deposition during heavy feedstock refining and is, accordingly, divided into two sections: (i) feedstock availability and properties and (ii) refining. Each section will take the reader through the various steps that are necessary for crude oil evaluation and refining, including the potential for the use of coal liquids, shale oil, and non-fossil fuel materials (biomass) as refinery feedstocks.

In addition, the evolution of refinery processing to the use of alternate (non-fossil fuel) feedstocks is also presented in anticipation of domestic and industrial waste into the refinery for blending into conventional (fossil fuel) feedstocks or for separate processing. Many refineries may have already begun such planning by incorporating a gasifier on the refinery site. This will lead to the production of gaseous products, especially synthesis gas – a mixture of carbon monoxide and hydrogen – that can, through the Fisher–Tropsch process, give rise to a variety of products.

Thus, by understanding the evolutionary changes that have occurred to date, coupled with a presentation of possible future scenarios, this book will satisfy the needs of engineers and scientists at all levels from academia to the refinery and help them understand the refining process and prepare for the new changes and evolution of the industry.

The target audience includes engineers, scientists, and students who want an update on crude oil refining and the direction the industry must take to assure the refinability of various feedstocks and the efficiency of the refining processes in the next 50 years. Non-technical readers, with help from the extensive Glossary, will also benefit from reading this book.

Dr. James G. Speight,
Laramie, Wyoming, USA
April 2020

Author

Dr. James G. Speight has a BSc and PhD in Chemistry; he also holds a DSc in Geological Sciences and a PhD in Petroleum Engineering. He has more than 50 years of experience in areas associated with (i) the properties, recovery, and refining of conventional petroleum, heavy oil, and tar sand bitumen, (ii) the properties and refining of natural gas, and (iii) the properties and refining of biomass, biofuels, biogas, and the generation of bioenergy. His work has also focused on environmental effects, environmental remediation, and safety issues associated with the production and use of fuels and biofuels. He is the author (and co-author) of more than 85 books in petroleum science, petroleum engineering, biomass and biofuels, and environmental sciences.

Although he has always worked in private industry which focused on contract-based work, Dr. Speight has served as a Visiting Professor in the College of Science, University of Mosul (Iraq), and as a Visiting Professor in Chemical Engineering at the Technical University of Denmark, and the University of Trinidad and Tobago as well as adjunct appointments at various universities. He has also served as a thesis examiner for more than 25 theses.

As a result of his work, Dr. Speight has been honored as the recipient of the following awards:

- Diploma of Honor, United States National Petroleum Engineering Society. *For Outstanding Contributions to the Petroleum Industry*, 1995.
- Gold Medal of the Russian Academy of Sciences. *For Outstanding Work in the Area of Petroleum Science*, 1996.
- Einstein Medal of the Russian Academy of Sciences. *In Recognition of Outstanding Contributions and Service in the Field of Geologic Sciences*, 2001.
- Gold Medal – Scientists without Frontiers, Russian Academy of Sciences. *In Recognition of His Continuous Encouragement of Scientists to Work Together across International Borders*, 2005.
- Gold Medal – Giants of Science and Engineering, Russian Academy of Sciences. *In Recognition of Continued Excellence in Science and Engineering*, 2006.
- Methanex Distinguished Professor, University of Trinidad and Tobago. *In Recognition of Excellence in Research*, 2007.
- In 2018, he received the American Excellence Award for Excellence in Client Solutions from the United States Institute of Trade and Commerce, Washington, DC.

Part 1

Feedstocks – Evaluation and Properties

1 Natural Gas, Crude Oil, Heavy Crude Oil, Extra-Heavy Crude Oil, and Tar Sand Bitumen

1.1 INTRODUCTION

For the purposes of this book, a refinery feedstock is defined as a native (naturally occurring) fossil fuel such as natural gas, crude oil, heavy crude oil, extra-heavy crude oil, and tar sand bitumen as well as any carbonaceous material that is destined for further processing. With further processing, the product will be transformed into one or more components and/or finished (saleable) products. In some cases, but excluded from this book, the feedstock is a refinery product (such as a residuum) that is destined for further processing (such as vacuum gas oil) excluding blending.

In the modern refinery, the feedstock is no longer (or very rarely) a single crude oil instead but is typically a blend of two or more crude oils (including heavy crude oil, extra-heavy crude oil, and tar sand bitumen). The refinery process units and the combination of units built and in service at a given refinery location are part of a plan to accommodate a certain slate of crudes based on their properties. The more consistent the supply of crude oil to a specific refinery, the more that refinery can tailor its operation to that specific crude supply. Necessity forces refiners to have to retain some flexibility in the refinery process to handle a wider range of crude types than that preferred. Crude blending works hand in hand with refinery process flexibility in crude types by enabling the ability to mix crudes that may not, as individual feeds, satisfy the operating range of the refinery, but as components of a mixed feed will meet the refinery operating requirements.

For those refineries which have to deal with a varied feedstock slate, pre-refinery blending is an attractive option to obtain either a better (average) quality feedstock or a stable quality feedstock. The blending operation typically takes place in the field where the properties of the blend are matched to meet the pipeline specifications. Because heavy crude oil and extra-heavy crude oil or tar sand bitumen cannot flow from the field to the refinery in their original state and at normal surface temperatures, they are blended with lighter (lower density) crude oils primarily to reduce the viscosity, thereby enabling transportation to a refinery. A secondary objective may be to produce a blend that has significantly higher economic value than the more viscous feedstocks. The blend is usually constructed so that the value of the overall blended volume is greater than the summed value of the initial volumes of individual viscous feedstocks and the light crude oil.

In terms of crude oils, such as opportunity crude oils and their blends, the risks may be high because these members of the crude oil family are usually laden with contaminants such as destabilized asphaltene constituents and high metals content. These contaminants can cause stable oil–water emulsion problems, heat exchanger fouling, and catastrophic coking in the furnace tubes, leading to high maintenance costs and equipment losses. Furthermore, incompatible crude oil blends can result in the flocculation and deposition of asphaltenes.

Thus, caution is advised in producing the blend because of the potential for blend instability though instability and/or incompatibility of the constituents and the potential, phase separation of one or more constituents of the blend or the deposition of asphaltene constituents, often referred to as fouling (Table 1.1) (Chapters 2 and 5) (Mushrush and Speight, 1995; Del Carmen García and Urbina, 2003; Bai et al., 2010; Speight, 2014a, 2015d; Ben Mahmoud and Aboujadeed, 2017; Speight, 2017; Kumar et al., 2018).

TABLE 1.1
The Constituents of Feedstocks That Can Cause Fouling (Sediment Formation) in the Refinery

Property	Comments
Asphaltene constituents	Separates from oil when gases are dissolved
	Thermal alteration can cause phase separation
Heteroatom constituents	Provide polar character to the oil
	Preferential reaction with oxygen
	Preferential thermal decomposition and molecular alteration
Aromatic constituents	May be incompatible with paraffin medium
	Phase separation of paraffins
Non-asphaltene constituents	Thermal alteration causes changes in polarity

More specifically, fouling as it pertains to refinery feedstocks is deposit formation, encrustation, deposition, scaling, scale formation, slagging, and sludge formation, which has an adverse effect on refinery operations. It is the accumulation of unwanted material within a processing unit or on the solid surfaces of the unit to the detriment of unit functionality. For example, when it does occur during refinery operations, the major effects include (i) loss of heat transfer as indicated by charge outlet temperature decrease and pressure drop increase, (ii) blocked process pipes, (iii) under-deposit corrosion and pollution, and (iv) localized hot spots in reactors, all of which culminate in production losses and increased maintenance costs. Typically, the fouling material consists of organic and/or inorganic materials deposited by the feedstock that is deposited by the occurrence of instability or incompatibility of the feedstock (one crude oil) with another during and shortly after a blending operation (Speight, 2014a). Thus, the complexity of the feedstock introduced into a refinery requires careful monitoring and the ability of the refiner to predict the behavior of the blend during the refining processes.

Predictability of the behavior of the feedstock during refining can be assessed by the development of models, but it must be remembered that models are paper calculations and may not always reflect the true behavior of the feedstock under the temperature and pressure conditions to which the feedstock is subjected during refining. For example, a model may predict excellent feedstock refinability in a particular process but in reality, fouling occurs thereby reducing the efficiency of the refining process.

In order to reduce fouling – while paper studies may solve only a part of the problems of identifying the presence and behavior of the foulants – it is necessary to perform a thorough assessment of the feedstock. This can only be achieved by knowing the feedstock and its behavior in a series of prescribed test methods that enable to refiner to predict the behavior of the feedstock during the refining process (Chapters 2–5). It is also necessary to be able to assess the behavior of the products in the same mix as unreacted and reacted feedstock, i.e., feedstock constituents that are intermediate between the original feedstock constituents and the final products (Mushrush and Speight, 1995).

Finally, an important aspect of designing a refinery for any carbonaceous feedstock (or two or more carbonaceous feedstocks) is the composition of the feedstocks. For example, a heavy oil refinery would differ somewhat from a conventional refinery, and a refinery for tar sand bitumen would be significantly different from both (Speight, 2014a, 2017, 2020). Furthermore, the composition of biomass is variable which is reflected the range of heat value (heat content, calorific value) of biomass, which is somewhat lesser than for coal and much lower than the heat value for crude oil, generally falling in the range 6,000–8,500 Btu/lb (Speight, 2020). Moisture content is probably the most important determinant of heating value. Air-dried biomass typically has about 15%–20% moisture, whereas the moisture content for oven-dried biomass is around 0%. Moisture content is

also an important characteristic of coals, varying in the range of 2%–30%. However, the bulk density (and hence energy density) of most biomass feedstocks is generally low, even after densification, about 10% and 40% of the bulk density of most fossil fuels.

It is the purpose of this chapter to present the feedstocks that are currently sent to refineries, and these are (i) members of the natural gas family, (ii) members of the crude oil family, (iii) extra-heavy crude oil, and (iv) tar sand bitumen as well as other feedstocks such as coal liquids, shale oil, and biomass which, while not in popular use at this time, could be well refinery feedstocks of the future.

1.2 THE NATURAL GAS FAMILY

For the purposes of this text, the natural gas family (sometimes referred to as fossil gases) is a naturally occurring gas mixture consisting primarily of hydrocarbon derivatives (predominantly methane) methane, but commonly including varying amounts of other higher-molecular-weight alkane derivatives, and sometimes a small percentage of carbon dioxide, hydrogen sulfide, or helium. The gas is typically formed over millions of years when layers of decomposing plant and animal matter are exposed to heat and pressure under the surface of the Earth.

1.2.1 NATURAL GAS

Natural gas is the gaseous mixture that is predominantly methane but does contain other combustible hydrocarbon compounds as well as non-hydrocarbon compounds (Figure 1.1) (Mokhatab et al., 2006; Speight, 2014a, 2019a). Natural gas is colorless, odorless, tasteless, and shapeless. In the natural state, it is not possible to see or smell natural gas. In addition to composition and thermal content (Btu/scf, Btu/ft^3), natural gas can also be characterized on the basis of the mode of the natural gas found in reservoirs where there is no or, at best only minimal amounts of, crude oil.

Other constituents are paraffinic hydrocarbon derivatives such as ethane (CH_3CH_3), propane ($CH_3CH_2CH_3$), and the butanes (C_4H_{10}). Many natural gases contain nitrogen (N_2) as well as carbon dioxide (CO_2) and hydrogen sulfide (H_2S). Trace quantities of argon, hydrogen, and helium may also be present. Generally, the hydrocarbon derivatives having a higher molecular weight than methane, carbon dioxide, and hydrogen sulfide are removed from natural gas prior to its use as a fuel. However, since the composition of natural gas and refinery gas is never constant, there are standard test methods that can be used to determine the suitability of natural gas (and refinery gas)

Category	Component	Amount (%)
Paraffinic	Methane (CH_4)	70–98
	Ethane (C_2H_6)	1–10
	Propane (C_3H_6)	Trace–5
	Butane (C_4H_{10})	Trace–2
	Pentane (C_5H_{12})	Trace–1
	Hexane (C_6H_{14})	Trace–0.5
	Heptane and higher (C_{7+})	None–trace
Cyclic	Cyclopropane (C_3H_6)	Traces
	Cyclohexane (C_6H_{12})	Traces
Aromatic	Benzene (C_6H_6), others	Traces
Nonhydrocarbon	Nitrogen (N_2)	Trace–15
	Carbon dioxide (CO_2)	Trace–1
	Hydrogen sulfide (H_2S)	Trace occasionally
	Helium (He)	Trace–5
	Other sulfur and nitrogen compounds	Trace occasionally
	Water (H_2O)	Trace–5

FIGURE 1.1 Range of composition of natural gas. (Please use tear sheet from: Speight, J.G., and Ozum, B. 2002. *Petroleum Refining Processes*. Marcel Dekker Inc., New York, Table 2.2, Page 34.)

for further use and indicate the processes by which the composition of natural gas can be prepared for use (Mokhatab et al., 2006; Speight, 2014a, 2015b, 2019a).

1.2.2 Crude Oil-Related Gas

The generic term *natural gas* applies to gas commonly associated with petroliferous (crude oil-producing, crude oil-containing) geologic formations. Natural gas generally contains high proportions of methane (CH_4), and some of the higher-molecular-weight paraffins (C_nH_{2n+2}) generally containing up to six carbon atoms may also be present in small quantities. The hydrocarbon constituents of natural gas are combustible, but non-flammable non-hydrocarbon components such as carbon dioxide, nitrogen, and helium are often present in minor proportion and are regarded as contaminants. In addition to the gas found associated with crude oil in reservoirs, there are also reservoirs in which natural gas may be the sole occupant. And, just as crude oil can vary in composition, natural gas from different reservoirs also varies in composition.

Natural gas is often located in the same reservoir as with crude oil, but it can also be found trapped in gas reservoirs and within coal deposits. The occurrence of methane in coal seams is not a new discovery, and methane (called *firedamp* by the miners because of its explosive nature) was known to coal miners for at least 150 years (or more) before it was *rediscovered* and developed as coalbed methane (Speight, 2013a). The natural gas can originate by thermogenic alteration of coal or by biogenic action of indigenous microbes on the coal. There are some horizontally drilled coalbed methane wells, and some coalbed methane wells that receive hydraulic fracturing treatments. However, some coalbed methane reservoirs are also underground sources of drinking water, and as such, there are restrictions on hydraulic fracturing operations. The coalbed methane wells are mostly shallow, as the coal matrix does not have the strength to maintain porosity under the pressure of significant overburden thickness.

In addition to defining natural gas as *associated* and *non-associated*, the types of natural gas vary according to composition. There is *dry gas* or *lean gas*, which is mostly methane, and *wet gas*, which contains considerable amounts of higher-molecular-weight and higher-boiling hydrocarbon derivatives (Figure 1.2). *Sour gas* contains high proportions of much hydrogen sulfide, whereas *sweet gas* contains little or no hydrogen sulfide. *Residue gas* is the gas remaining (mostly methane) after the higher-molecular-weight paraffins have been extracted. *Casinghead gas* is the gas derived from an oil well by extraction at the surface. Natural gas has no distinct odor, and the main use is for fuel, but it can also be used to make chemicals and liquefied crude oil gas.

Some natural gas wells also produce helium, which can occur in commercial quantities; nitrogen and carbon dioxide are also found in some natural gases. Gas is usually separated at as high a pressure as possible, reducing compression costs when the gas is to be used for gas lift or delivered to a pipeline. After gas removal, lower-boiling hydrocarbon derivatives and hydrogen sulfide are removed as necessary to obtain a crude oil of suitable vapor pressure for transport yet retaining most of the natural gasoline constituents.

The non-hydrocarbon constituents of natural gas can be classified as two types of materials: (i) diluents, such as nitrogen, carbon dioxide, and water vapor, and (ii) contaminants, such as hydrogen sulfide and/or other sulfur compounds. The diluents are non-combustible gases that reduce the heating value of the gas and are on occasion used as *fillers* when it is necessary to reduce the heat content of the gas. On the other hand, the contaminants are detrimental to production and transportation equipment in addition to being obnoxious pollutants.

Thus, the primary reason for gas processing is to remove the unwanted constituents of natural gas such as (i) acid gas, which is predominantly hydrogen sulfide although carbon dioxide does occur to a lesser extent, (ii) water, which includes all entrained free water or water in condensed forms, (iii) liquids in the gas, such as higher-boiling hydrocarbon derivatives as well as pump lubricating oil, scrubber oil, and, on occasion, methanol, and (iv) any solid matter that may be present, such as fine silica (sand) and scaling from the pipe. As with crude oil, natural gas from different

Constituents	Composition (vol%)		
	Wet	Dry	Range
Hydrocarbons			
Methane	84.6	96.0	
Ethane	6.4	2.0	
Propane	5.3	0.6	
Isobutane	1.2	0.18	
n-Butane	1.4	0.12	
Isopentane	0.4	0.14	
n-Pentane	0.2	0.06	
Hexanes	0.4	0.10	
Heptanes	0.1	0.80	
Nonhydrocarbons			
Carbon dioxide			0–5
Helium			0–0.5
Hydrogen sulfide			0–5
Nitrogen			0–10
Argon			0–0.05
Radon, krypton, xenon			Traces

FIGURE 1.2 Range of composition for *wet* and *dry* natural gas. (Please use tear sheet from: Speight, J.G., and Ozum, B. 2002. *Petroleum Refining Processes*. Marcel Dekker Inc., New York, Table 2.3, Page 35.)

wells varies widely in composition and analyses (Mokhatab et al., 2006; Speight, 2014a, 2019a), and the proportion of non-hydrocarbon constituents can vary over a very wide range. Thus, a particular natural gas field could require production, processing, and handling protocols different from those used for gas from another field.

Just as crude oil was used in antiquity, natural gas was also known in antiquity, although the use of crude oil was relatively better documented because of its use as a mastic for walls and roads as well as for its use in warfare (Abraham, 1945; Pfeiffer, 1950; Van Nes and van Westen, 1951; Forbes, 1958a,b, 1959, 1964; Hoiberg, 1964; Cobb and Goldwhite, 1995; Anderton, 2012; Speight, 2014a). The use of natural gas in antiquity is somewhat less well documented, although historical records indicate that the use of natural gas (for other than religious purposes) dates back to approximately 250 AD when it was used as a fuel in China. The gas was obtained from shallow wells and was distributed through a piping system constructed from hollow bamboo stems. There is other fragmentary evidence for the use of natural gas in certain old texts, but the use is usually inferred since the gas is not named specifically. However, it is known that natural gas was used on a small scale for heating and lighting in northern Italy during the early 17th century. From this, it might be conjectured that natural gas found some use from the 17th century to the present day; recognizing that gas from coal would be a strong competitor.

Differences in natural gas composition occur between different reservoirs, and two wells in the same field may also yield gaseous products that are different in composition. Indeed, there is no single composition of components which might be termed *typical* natural gas. Methane and ethane constitute the bulk of the combustible components; carbon dioxide (CO_2) and nitrogen (N_2) are the major non-combustible (inert) components. Other constituents such as hydrogen sulfide (H_2S), mercaptan derivatives (thiols; R–SH) as well as trace amounts of other sulfur-containing constituents may also be present.

Before the discovery of natural gas, the principal gaseous fuel source was the gas produced by the surface gasification of coal (Speight, 2013a). In fact, each town of any size had a plant for the gasification of coal (hence the use of the term *town gas*). Most of the natural gas produced at the crude oil fields was vented to the air or burned in a flare stack; only a small amount of the natural

gas from the crude oil fields was pipelined to industrial areas for commercial use. It was only in the years after World War II that natural gas became a popular fuel commodity, leading to the recognition that it has at the present time.

There are several general definitions that have been applied to natural gas. Thus, *lean* gas is gas in which methane is the major constituent. *Wet* gas contains considerable amounts of the higher-molecular-weight hydrocarbon derivatives. *Sour* gas contains hydrogen sulfide, whereas *sweet* gas contains very little, if any, hydrogen sulfide. *Residue gas* is natural gas from which the higher-molecular-weight hydrocarbon derivatives have been extracted, and *casinghead gas* is derived from crude oil but is separated at the separation facility at the wellhead.

To further define the terms *dry* and *wet* in quantitative measures, the term *dry* natural gas indicates that there is less than 0.1 gallon of gasoline vapor (higher-molecular-weight paraffins) per 1,000 ft³ (1 ft³=0.028 m³). The term *wet natural gas* indicates that there are such paraffins present in the gas, in fact more than 0.1 gal/1,000 ft³. *Associated* or *dissolved* natural gas occurs either as free gas or as gas in solution in the crude oil. Gas that occurs as a solution in the crude oil is *dissolved* gas whereas the gas that exists in contact with the crude oil (*gas cap*) is *associated* gas.

1.2.3 Gas Hydrates

Methane hydrates, which consist of methane molecules trapped in a cage of water molecules, occur as crystalline solids in sediments in arctic regions and below the floor of the deep ocean. Although taking on the appearance of ice, methane hydrates will burn if ignited. Methane hydrates are the most abundant unconventional natural gas source and the most difficult to extract. Methane hydrates are conservatively estimated to hold twice the amount of energy found in all conventional fossil fuels, but the technical challenges of economically retrieving the resource are significant. There is also a significant risk that rising temperatures from global warming could destabilize the deposits, releasing the methane – a potent greenhouse gas – into the atmosphere, and further exacerbating the problem.

Another product is *gas condensate*, which contains relatively high amounts of the higher-molecular-weight liquid hydrocarbon derivatives (up to and including octane, C_8H_{18}). These hydrocarbon derivatives may occur in the gas phase in the reservoir. On the other hand, natural gasoline (like refinery gasoline) consists mostly of pentane (C_5H_{12}) and higher-molecular-weight hydrocarbon derivatives. The term *natural gasoline* has also on occasion in the gas industry been applied to mixtures of liquefied crude oil gas, pentanes, and higher-molecular-weight hydrocarbon derivatives. Caution should be taken not to confuse *natural gasoline* with the term *straight-run gasoline* (often also incorrectly referred to as natural gasoline), which is the gasoline distilled unchanged from crude oil.

Liquefied petroleum gas (LPG) is composed of propane (C_3H_8), butanes (C_4H_{10}), and/or mixtures thereof, small amounts of ethane and pentane may also be present as impurities.

1.2.4 Coalbed Methane

In coalbeds (coal seams), methane (the primary component of natural gas) is generally adsorbed to the coal rather than contained in the pore space or structurally trapped in the formation. Pumping the injected and native water out of the coalbeds after fracturing serves to depressurize the coal, thereby allowing the methane to desorb and flow into the well and to the surface. Methane has traditionally posed a hazard to underground coal miners, as the highly flammable gas is released during mining activities. Otherwise inaccessible coal seams can also be tapped to collect this gas, known as coalbed methane, by employing similar well-drilling and hydraulic fracturing techniques as are used in shale gas extraction.

Coalbed methane is a gas formed as part of the geological process of coal generation and is contained in varying quantities within all coal. Coalbed methane is exceptionally pure compared

to conventional natural gas, containing only very small proportions of higher-molecular-weight hydrocarbon derivatives such as ethane and butane and other gases (such as hydrogen sulfide and carbon dioxide). Coalbed gas is over 90% methane and, subject to gas composition, may be suitable for introduction into a commercial pipeline with little or no treatment (Rice, 1993; Levine, 1993; Mokhatab et al., 2006; Speight, 2013a). Methane within coalbeds is not structurally trapped by overlying geologic strata, as in the geologic environments typical of conventional gas deposits (Speight, 2013a, 2014a). Only a small amount (on the order of 5% v/v–10% v/v) of the coalbed methane is present as free gas within the joints and cleats of coalbeds. Most of the coalbed methane is contained within the coal itself (adsorbed to the sides of the small pores in the coal).

The primary (or natural) permeability of coal is very low, typically ranging from 0.1 to 30 milliDarcys (mD) and, because coal is a very weak (low modulus) material and cannot take much stress without fracturing, coal is almost always highly fractured and cleated. The resulting network of fractures commonly gives coalbeds a high secondary permeability (despite coal's typically low primary permeability). Groundwater, hydraulic fracturing fluids, and methane gas can more easily flow through the network of fractures. Because hydraulic fracturing generally enlarges pre-existing fractures in addition to creating new fractures, this network of natural fractures is very important to the extraction of methane from the coal.

1.2.5 BIOGENIC GAS

Biogenic gas (sometimes referred to as biogas and often predominantly methane) is produced by certain types of bacteria (methanogens) during the process of breaking down organic matter in an oxygen-free environment (Speight, 2011b). Thus, biogenic gas is created by methanogenic organisms in marshes, bogs, landfills, and shallow sediments. On the other hand, as a point of differentiation, thermogenic gas is created from buried organic material deeper in the earth, at greater temperature and pressure. Livestock manure, food waste, and sewage are all potential sources of biogenic gas, or biogas, which is usually considered a form of renewable energy. Small-scale biogas production is a well-established technology in parts of the developing world, particularly Asia, where farmers collect animal manure in vats and capture the methane given off while it decays.

Landfills offer another under-utilized source of biogas (Speight, 2011b). When municipal waste is buried in a landfill, bacteria break down the organic material contained in garbage such as newspapers, cardboard, and food waste, producing gases such as carbon dioxide and methane. Rather than allowing these gases to go into the atmosphere, where they contribute to global warming, landfill gas facilities can capture them, separate the methane, and combust it to generate electricity, heat, or both.

1.3 THE CRUDE OIL FAMILY

The crude oil family is a collection of naturally occurring, unrefined type of crude oil composed of hydrocarbon derivatives and other organic materials. Members of the family can be refined to produce usable products such as gasoline, diesel, and various other forms of petrochemicals (Speight, 2014a, 2017, 2019b). The family members are non-renewable resources that cannot be replaced naturally.

Chemically, the term crude oil covers a wide assortment of materials consisting of mixtures of hydrocarbon derivatives and other compounds containing variable amounts of sulfur, nitrogen, and oxygen, which may vary widely in volatility, specific gravity, and viscosity. Metal-containing constituents, notably those compounds that contain vanadium and nickel, usually occur in the more viscous crude oils in amounts up to several thousand parts per million and can have serious consequences during processing of these feedstocks (Speight, 1984). Because crude oil is a mixture of widely varying constituents and proportions, its physical properties also vary widely and the color from colorless to black.

Historically, crude oil (also referred to as petroleum) and its derivatives have been known and used for millennia. Ancient workers recognized that certain derivatives of crude oil (such as asphalt) could be used for civic and decorative purposes, while others (naphtha) could provide certain advantages in warfare (Abraham, 1945; Pfeiffer, 1950; Van Nes and van Westen, 1951; Forbes, 1958a,b, 1959, 1964; Hoiberg, 1964; Speight, 1978; Cobb and Goldwhite, 1995; Speight, 2014a). Scientifically, crude oil is a carbon-based resource and is an extremely complex mixture of hydrocarbon compounds, usually with minor amounts of nitrogen-, oxygen-, and sulfur-containing compounds as well as trace amounts of metal-containing compounds. Heavy oil is a sub-category of crude oil that contains a greater proportion of the higher-boiling constituents and heteroatom compounds. Tar sand bitumen is different from crude oil and heavy oil insofar as it cannot be recovered by any of the conventional (including enhanced recovery) methods (Speight, 2014a, 2015c). For the purposes of this book, residua (resids), heavy oil, extra-heavy oil, and tar sand bitumen are (for convenience) included in the term *heavy feedstocks*.

In the crude state crude oil, heavy crude oil, extra-heavy crude oil, and tar sand bitumen have minimal value, but when refined they provide high-value liquid fuels, solvents, lubricants, and many other products. The fuels derived from crude oil contribute approximately one-third to one-half of the total world energy supply and are used not only for transportation fuels (i.e., gasoline, diesel fuel, and aviation fuel, among others) but also to heat buildings. Crude oil products have a wide variety of uses that vary from gaseous and liquid fuels to near-solid machinery lubricants. In addition, asphalt (a once-maligned by-product and the residue of many refinery processes) is now a premium value product for highway surfaces, roofing materials, and miscellaneous waterproofing uses (Speight, 2014a, 2015c).

The *definition* of crude oil has been varied, unsystematic, diverse, and often archaic. Furthermore, the terminology of crude oil is a product of many years of growth. Thus, the long-established use of an expression, however inadequate it may be, is altered with difficulty, and a new term, however precise, is at best adopted only slowly.

If there is to be a thorough understanding of crude oil and the associated technologies, it is essential that the definitions and the terminology of crude oil science and technology be given prime consideration (Meyer and De Witt, 1990; Speight, 2014a). This will aid in a better understanding of crude oil, its constituents, and its various fractions. Of the many forms of terminology that have been used not all have survived, but the more commonly used are illustrated here. Particularly troublesome, and more confusing, are those terms that are applied to the more viscous materials, for example, the use of the terms *bitumen* and *asphalt*. This part of the text attempts to alleviate much of the confusion that exists, but it must be remembered that the terminology of crude oil is still open to personal choice and historical usage.

1.3.1 CONVENTIONAL CRUDE OIL

Conventional crude oil (often referred to simply as *crude oil*) is a mixture of gaseous, liquid, and solid hydrocarbon compounds that occur in sedimentary rock deposits throughout the world and also contains small quantities of nitrogen-, oxygen-, and sulfur-containing compounds as well as trace amounts of metallic constituents (Speight, 2012a, 2014a).

Crude oil is a naturally occurring mixture of hydrocarbon derivatives, generally in a liquid state, which may also include compounds of sulfur, nitrogen, oxygen, and metals and other elements. Crude oil has also been defined as (i) any naturally occurring hydrocarbon, whether in a liquid, gaseous, or solid state, (ii) any naturally occurring mixture of hydrocarbon derivatives, whether in a liquid, gaseous, or solid state, or (iii) any naturally occurring mixture of one or more hydrocarbon derivatives, whether in a liquid, gaseous, or solid state and one or more of the following, that is to say, hydrogen sulfide, helium, and carbon dioxide. The definition also includes any crude oil as defined by the above three categories that has been returned to a natural reservoir (ASTM D4175).

Furthermore, there is a wide variation in the properties of crude oil because the proportions in which the different constituents occur vary with origin. Thus, some crude oils have higher

proportions of the lower-boiling components and others (such as heavy oil and bitumen) have higher proportions of higher-boiling components (asphaltic components and residuum).

The molecular boundaries of crude oil cover a wide range of boiling points and carbon numbers of hydrocarbon compounds and other compounds containing nitrogen, oxygen, and sulfur, as well as metallic (porphyrin) constituents which dictate the options to be used in a refinery (Long and Speight, 1998; Parkash, 2003; Gary et al., 2007; Speight, 2014a; Hsu and Robinson, 2017; Speight, 2017). However, the actual boundaries of such a *crude oil map* can only be arbitrarily defined in terms of boiling point and carbon number. In fact, crude oil is so diverse that materials from different sources exhibit different boundary limits, and for this reason alone, it is not surprising that crude oil has been difficult to *map* in a precise manner.

The term crude oil and the equivalent term petroleum cover a wide assortment of materials consisting of mixtures of hydrocarbon derivatives and other compounds containing variable amounts of sulfur, nitrogen, and oxygen, which may vary widely in American Petroleum Institute (API) gravity and sulfur content (Speight, 2014a, 2017) as well as viscosity and the amount of residuum (the portion of crude oil boiling above 510°C, 950°F). Metal-containing constituents, notably those compounds that contain vanadium and nickel, usually occur in the more viscous crude oils in amounts up to several thousand parts per million and can have serious consequences during processing of these feedstocks (Speight, 1984, 2014a). Because crude oil is a mixture of widely varying constituents and proportions, its physical properties also vary widely and the color from colorless to black. The terms *heavy oil* and *bitumen* add further complexity to the nature of refinery feedstocks.

Crude oil occurs underground, at various pressures depending on the depth. Because of the pressure, it contains considerable natural gas in solution. The oil underground is much more fluid than it is on the surface and is generally mobile under reservoir conditions because the elevated temperatures in subterranean formations (on the average, the temperature rises 1°C (1.8°F) for every 100 feet of depth) decrease the viscosity.

Crude oil is derived from aquatic plants and animals that lived and died hundreds of millions of years ago. Their remains mixed with mud and sand in layered deposits that, over the millennia, were geologically transformed into sedimentary rock. Gradually, the organic matter decomposed and eventually formed crude oil (or a related precursor), which migrated from the original source beds to more porous and permeable rocks, such as *sandstone* and *siltstone*, where it finally became entrapped. Such entrapped accumulations of crude oil are called *reservoirs*. A series of reservoirs within a common rock structure or a series of reservoirs in separate but neighboring formations is commonly referred to as an *oil field*. A group of fields is often found in a single geologic environment known as a *sedimentary basin* or *province*.

Crude oil reservoirs are generally classified according to their geologic structure and their production (drive) mechanism. Crude oil reservoirs exist in many different sizes and shapes of geologic structures. It is usually convenient to classify the reservoirs according to the conditions of their formation. For example, *dome-shaped* and *anticline reservoirs* are formed by the folding of the rock. Typically, the dome is circular in outline, and the anticline is long and narrow. Oil or gas moved or migrated upward through the porous strata where it was trapped by the sealing cap rock and the shape of the structure. On the other hand, *faulted reservoirs* are formed by shearing and offsetting of the strata (faulting). The movement of the nonporous rock opposite the porous formation containing the oil/gas creates the sealing. The tilt of the crude oil-bearing rock and the faulting trap the oil/gas in the reservoir. *Salt-dome reservoirs* take the shape of a dome, was formed due to the upward movement of a large, impermeable salt dome that deformed and lifted the overlying layers of rock.

Unconformities are formed as a result of an unconformity where the impermeable cap rock was laid down across the cutoff surfaces of the lower beds. In the *lens-type reservoir*, the crude oil-bearing porous formation is sealed by the surrounding, nonporous formation. Irregular deposition of sediments and shale at the time the formation was laid down is the probable cause for the change in the porosity of the formation. Finally, a *combination reservoir* is, as the name implies,

a combination of folding, faulting, abrupt changes in porosity, or other conditions create the trap which exists as this type of crude oil reservoir.

The major components of crude oil are *hydrocarbon derivatives*, compounds of hydrogen and carbon that display great variation in their molecular structure. The simplest hydrocarbon derivatives are a large group of chain-shaped molecules known as the *paraffins*. This broad series extends from methane, which forms natural gas, through liquids that are refined into gasoline, to crystalline waxes. A series of saturated hydrocarbon derivatives containing a (usually six-membered) ring, known as the *naphthenes*, ranges from volatile liquids such as *naphtha* to high-molecular-weight substances isolated as the *asphaltene* fraction. Another group of hydrocarbon derivatives containing a single or condensed aromatic ring system is known as the *aromatics*; the chief compound in this series is benzene, a popular raw material for making petrochemicals. *Non-hydrocarbon constituents* of crude oil include organic derivatives of nitrogen, oxygen, sulfur, and the metals nickel and vanadium. Most of these impurities are removed during refining.

Other members of the crude oil family that may invoke the need for enhanced recovery methods, including the application of hydraulic fracturing techniques (Speight, 2015a) and which are worthy of mention here include (i) crude oil from tight formations, (ii) opportunity crude oil, (iii) high acid crude oil, and (iv) foamy oil.

1.3.2 Crude Oil from Tight Formations

Generally, unconventional tight oil resources are found at considerable depths in sedimentary rock formations that are characterized by very low permeability. While some of the tight oil plays produce oil directly from shales, tight oil resources are also produced from low-permeability siltstone formations, sandstone formations, and carbonate formations that occur in close association with a shale source rock. Tight formations scattered throughout North America have the potential to produce crude oil (*tight oil*) (US EIA, 2011, 2013; Mayes, 2015). Such formations might be composted of shale sediments or sandstone sediments. In a conventional sandstone reservoir, the pores are interconnected so gas and oil can flow easily from the rock to a wellbore. In tight sandstones, the pores are smaller and are poorly connected by very narrow capillaries which results in low permeability. Tight oil occurs in sandstone sediments that have an effective permeability of less than 1 milliDarcy (<1 mD). A shale play is a defined geographic area containing an organic-rich fine-grained sedimentary rock that underwent physical and chemical compaction during diagenesis to produce the following characteristics: (i) clay to silt-sized particles, (ii) high proportions of silica, and sometimes carbonate minerals, (iii) thermally mature, (iv) hydrocarbon-filled porosity – on the order of 6%–14%, (v) low permeability – on the order of <0.1 mD, (vi) large areal distribution, and (vii) fracture stimulation required for economic production.

The most notable tight oil plays in North America include the Bakken shale, the Niobrara formation, the Barnett shale, the Eagle Ford shale, and the Miocene Monterey play of California's San Joaquin Basin (California) and the Cardium play (Alberta, Canada). In many of these tight formations, the existence of large quantities of crude oil has been known for decades and efforts to commercially produce those resources have occurred sporadically with typically disappointing results. However, starting in the mid-2000s, advancements in well drilling and stimulation technologies combined with high oil prices have turned tight oil resources into one of the most actively explored and produced targets in North America.

Other known tight formations (on a worldwide basis) include the R'Mah Formation (Syria), the Sargelu Formation (northern Persian Gulf region), the Athel Formation (Oman), the Bazhenov formation and Achimov Formation (West Siberia, Russia), the Coober Pedy formation (Australia), the Chicontepex Formation (Mexico), and the Vaca Muerta field (Argentina) (US EIA, 2011, 2013). However, tight oil formations are heterogeneous and vary widely over relatively short distances. Thus, even in a single horizontal production well, the amount of oil recovered may vary as may recovery within a field or even between adjacent wells. This makes evaluation of *shale plays* and

decisions regarding the profitability of wells on a particular lease difficult. In addition, tight reservoirs which contain only crude oil (without natural gas as the pressurizing agent) cannot be economically produced (US EIA, 2011, 2013).

Typical of the crude oil from tight formations (*tight oil, tight light oil, and tight shale oil* have been suggested as alternate terms) is the Bakken crude oil which is a light highly volatile crude oil. Briefly, Bakken crude oil is a light sweet (low-sulfur) crude oil that has a relatively high proportion of volatile constituents. The production of the oil also yields a significant amount of volatile gases (including propane and butane) and low-boiling liquids (such as pentane and natural gasoline), which are often referred to collectively as (low-boiling or light) naphtha. By definition, natural gasoline (sometime also referred to as *gas condensate*) is a mixture of low-boiling liquid hydrocarbon derivatives isolate from crude oil and natural gas wells suitable for blending with light naphtha and/or refinery gasoline (Mokhatab et al., 2006; Speight, 2014a, 2019a). Because of the presence of low-boiling hydrocarbon derivatives, low-boiling naphtha (*light naphtha*) can become extremely explosive, even at relatively low ambient temperatures. Some of these gases may be burned off (flared) at the field well-head, but others remain in the liquid products extracted from the well (Speight, 2014a).

Oil from tight shale formation is characterized by low-asphaltene content, low-sulfur content, and a significant molecular weight distribution of the paraffinic wax content (Speight, 2014a, 2015b). Paraffin carbon chains of C_{10}–C_{60} have been found, with some shale oils containing carbon chains up to C_{72}. To control deposition and plugging in formations due to paraffins, the dispersants are commonly used. In upstream applications, these paraffin dispersants are applied as part of multifunctional additive packages where asphaltene stability and corrosion control are also addressed simultaneously (Speight, 2014a–c, 2015b,c). In addition, scale deposits of calcite ($CaCO_3$), other carbonate minerals (minerals containing the carbonate ion, CO_3^{2-}), and silicate minerals (minerals classified on the basis of the structure of the silicate group, which contains different ratios of silicon and oxygen) must be controlled during production or plugging problems arise. A wide range of scale additives is available which can be highly effective when selected appropriately. Depending on the nature of the well and the operational conditions, a specific chemistry is recommended or blends of products are used to address scale deposition.

While the basic approach toward developing a tight oil resource are expected to be similar from area to area, the application of specific strategies, especially with respect to well completion and stimulation techniques, will almost certainly differ from play to play, and often even within a given play. The differences depend on the geology (which can be very heterogeneous, even within a play) and reflect the evolution of technologies over time with increased experience and availability.

Finally, the properties of crude oils from tight formations are highly variable. Density and other properties can show wide variation, even within the same field. The Bakken crude is light and sweet with an API of 42° and a sulfur content of 0.19% w/w. Similarly, Eagle Ford is a light sweet feed, with a sulfur content of approximately 0.1% w/w and with published API gravity between 40° API and 62° API.

1.3.3 OPPORTUNITY CRUDE OIL

There is also the need for a refinery to be configured to accommodate *opportunity crude oils* and/or *high acid crude oils* which, for many purposes are often included with heavy feedstocks (Speight, 2014a,b; Yeung, 2014). *Opportunity crude oils* are either new crude oils with unknown or poorly understood properties relating to processing issues or are existing crude oils with well-known properties and processing concerns (Ohmes, 2014). Opportunity crude oils are often, but not always, heavy crude oils but in either case are more difficult to process due to high levels of solids (and other contaminants) produced with the oil, high levels of acidity, and high viscosity. These crude oils may also be incompatible with other oils in the refinery feedstock blend and cause excessive equipment fouling when processed either in a blend or separately (Speight, 2015b). There is also the need for a refinery to be configured to accommodate *opportunity crude oils* and/or *high acid crude oils* which, for many purposes are often included with heavy feedstocks.

In addition to taking preventative measure for the refinery to process, these feedstocks without serious deleterious effects on the equipment, refiners need to develop programs for detailed and immediate feedstock evaluation so that they can understand the qualities of a crude oil very quickly and it can be valued appropriately and management of the crude processing can be planned meticulously (Babich and Moulijn, 2003; Speight, 2014a). For example, the compatibility of opportunity crudes with other opportunity crudes and with conventional crude oil and heavy oil is a very important property to consider when making decisions regarding which crude to purchase. Blending crudes that are incompatible can lead to extensive fouling and processing difficulties due to unstable asphaltene constituents (Speight, 2014a, 2015b). These problems can quickly reduce the benefits of purchasing the opportunity crude in the first place. For example, extensive fouling in the crude preheat train may occur resulting in decreased energy efficiency, increased emissions of carbon dioxide, and increased frequency at which heat exchangers need to be cleaned. In a worst-case scenario, crude throughput may be reduced leading to significant financial losses.

Opportunity crude oils, while offering initial pricing advantages, may have composition problems which can cause severe problems at the refinery, harming infrastructure, yield, and profitability. Before refining, there is the need for comprehensive evaluations of opportunity crudes, giving the potential buyer and seller the needed data to make informed decisions regarding fair pricing and the suitability of a particular opportunity crude oil for a refinery. This will assist the refiner to manage the ever-changing crude oil quality input to a refinery – including quality and quantity requirements and situations, crude oil variations, contractual specifications, and risks associated with such opportunity crudes.

1.3.4 HIGH ACID CRUDE OIL

High acid crude oils are crude oils that contain considerable proportions of naphthenic acids which, as commonly used in the crude oil industry, refers collectively to all of the organic acids present in the crude oil (Shalaby, 2005; Speight, 2014b). In many instances, the high acid crude oils are actually the higher boiling more viscous crude oils (Speight, 2014a,b). The total acid matrix is therefore complex and it is unlikely that a simple titration, such as the traditional methods for measurement of the total acid number, can give meaningful results to use in predictions of problems. An alternative way of defining the relative organic acid fraction of crude oils is therefore a real need in the oil industry, both upstream and downstream.

By the original definition, a naphthenic acid is a monobasic carboxyl group attached to a saturated cycloaliphatic structure. However, it has been a convention accepted in the oil industry that all organic acids in crude oil are called naphthenic acids. Naphthenic acids in crude oils are now known to be mixtures of low- to high-molecular-weight acids, and the naphthenic acid fraction also contains other acidic species. Naphthenic acids, which are not *user friendly* in terms of refining (Kane and Cayard, 2002; Ghoshal and Sainik, 2013), can be either (or both) water-soluble to oil-soluble depending on their molecular weight, process temperatures, salinity of waters, and fluid pressures. In the water phase, naphthenic acids can cause stable reverse emulsions (oil droplets in a continuous water phase). In the oil phase with residual water, these acids have the potential to react with a host of minerals, which are capable of neutralizing the acids. The main reaction product found in practice is the calcium naphthenate soap (the calcium salt of naphthenic acids). The total acid matrix is therefore complex and it is unlikely that a simple titration, such as the traditional methods for measurement of the total acid number, can give meaningful results to use in predictions of problems. An alternative way of defining the relative organic acid fraction of crude oils is therefore a real need in the oil industry, both upstream and downstream.

Normally, the end result of formation of low-molecular-weight acidic species is treated in the overheads in refineries. A combined approach to front-end treating at crude inlet to heaters and preheat exchangers should be considered. It is commonly assumed that acidity in crude oils is related to carboxylic acid species, i.e., components containing a –COOH functional group. While it is clear

that carboxylic acid functionality is an important feature (60% of the ions have two or more oxygen atoms), a major portion (40%) of the acid types are not carboxylic acids. In fact, naphthenic acids are a mixture of different compounds which may be polycyclic and may have unsaturated bonds, aromatic rings, and hydroxyl groups. Even the carboxylic acids are more diverse than expected, with approximately 85% containing more heteroatoms than the two oxygen atoms needed to account for the carboxylic acid groups. Examining the distribution of component types in the acid fraction reveals that there is a broad distribution of species.

High acid crude oils cause corrosion in the refinery – corrosion is predominant at temperatures in excess of 180°C (355°F) (Kane and Cayard, 2002; Ghoshal and Sainik, 2013; Speight, 2014c) – and occurs particularly in the atmospheric distillation unit (the first point of entry of the high acid crude oil) and also in the vacuum distillation units. In addition, overhead corrosion is caused by the mineral salts, magnesium, calcium, and sodium chloride which are hydrolyzed to produce volatile hydrochloric acid, causing a highly corrosive condition in the overhead exchangers. Therefore, these salts present a significant contamination in opportunity crude oils. Other contaminants in opportunity crude oils which are shown to accelerate the hydrolysis reactions are inorganic clays and organic acids.

Corrosion by naphthenic acids typically has a localized pattern, particularly at areas of high velocity and, in some cases, where condensation of concentrated acid vapors can occur in crude distillation units. The attack also is described as lacking corrosion products. Damage is in the form of unexpected high corrosion rates on alloys that would normally be expected to resist sulfidic corrosion (particularly steels with more than 9% Cr). In some cases, even very highly alloyed materials (i.e., 12% Cr, type 316 stainless steel (SS) and type 317 SS, and in severe cases even 6% Mo stainless steel has been found to exhibit sensitivity to corrosion under these conditions.

The corrosion reaction processes involve the formation of iron naphthenates:

$$Fe + 2RCOOH = Fe(RCOO)_2 + H_2$$

$$Fe(RCOO)_2 + H_2S = FeS + 2RCOOH$$

The iron naphthenates are soluble in oil and the surface is relatively film free. In the presence of hydrogen sulfide, a sulfide film is formed which can offer some protection depending on the acid concentration. If the sulfur-containing compounds are reduced to is hydrogen sulfide, the formation of a potentially protective layer of iron sulfide occurs on the unit walls and corrosion is reduced (Kane and Cayard, 2002). When the reduction product is water, coming from the reduction of sulfoxides, the naphthenic acid corrosion is enhanced (Yépez, 2005).

Thermal decarboxylation can occur during the distillation process (during which the temperature of the crude oil in the distillation column can be as high as 400°C (750°F):

$$R - CO_2H \rightarrow R - H + CO_2$$

However, not all acidic species in crude oil are derivatives of carboxylic acids (–COOH), and some of the acidic species are resistant to high temperatures. For example, acidic species appear in the vacuum residue after having been subjected to the inlet temperatures of an atmospheric distillation tower and a vacuum distillation tower (Speight and Francisco, 1990). In addition, for the acid species that are volatile, naphthenic acids are most active at their boiling point and the most severe corrosion generally occurs on condensation from the vapor phase back to the liquid phase.

1.3.5 FOAMY OIL

Foamy oil is oil-continuous foam that contains dispersed gas bubbles produced at the wellhead from heavy oil reservoirs under solution gas drive. The nature of the gas dispersions in oil distinguishes

foamy oil behavior from conventional heavy oil. The gas that comes out of solution in the reservoir does not coalesce into large gas bubbles nor into a continuous flowing gas phase. Instead it remains as small bubbles entrained in the crude oil, keeping the effective oil viscosity low while providing expansive energy that helps drive the oil toward the producing. Foamy oil accounts for unusually high production in heavy oil reservoirs under solution gas drive.

During primary production of heavy oil from solution gas drive reservoirs, the oil is pushed into the production wells by energy supplied by the dissolved gas. As fluid is withdrawn from the production wells, the pressure in the reservoir declines and the gas that was dissolved in the oil at high pressure starts to come out of solution (*foamy oil*). As pressure declines further with continued removal of fluids from the production wells, more gas is released from solution and the gas already released expands in volume. The expanding gas, which at this point is in the form of isolated bubbles, pushes the oil out of the pores and provides energy for the flow of oil into the production well. This process is very efficient until the isolated gas bubbles link up and the gas itself starts flowing into the production well. Once the gas flow starts, the oil has to compete with the gas for available flow energy. Thus, in some heavy oil reservoirs, due to the properties of the oil and the sand and also due to the production methods, the released gas forms foam with the oil and remains subdivided in the form of dispersed bubbles much longer.

Thus, foamy oil is formed in solution gas drive reservoirs when gas is released from solution with a decline in reservoir pressure. It has been noted that the oil at the wellhead of these heavy-oil reservoirs resembles the form of foam, hence the term *foamy oil*. The gas initially exists in the form of small bubbles within individual pores in the rock. As time passes and pressure continues to decline, the bubbles grow to fill the pores. With further declines in pressure, the bubbles created in different locations become large enough to coalesce into a continuous gas phase. Once the gas phase becomes continuous (i.e., when gas saturation exceeds the critical level – the minimum saturation at which a continuous gas phase exists in porous media – traditional two-phase (oil and gas) flow with classical relative permeability occurs. As a result, the production gas–oil ratio (GOR) increases rapidly after the critical gas saturation has been exceeded.

However, it has been observed that many heavy oil reservoirs in Alberta and Saskatchewan exhibit foamy oil behavior which is accompanied by sand production, leading to anomalously high oil recovery and lower GOR (Chugh et al., 2000). These observations suggest that the foamy oil flow might be physically linked to sand production. It is apparent that some additional factors, which remain to be discovered, are involved in making the foamy solution gas possible at field rates of decline. One possible mechanism is the synergistic influence of sand influx into the production wells. Allowing 1% w/w–3% w/w sand to enter the wellbore with the fluids can result in propagation of a front of sharp pressure gradients away from the wellbore. These sharp pressure gradients occur at the advancing edge of solution gas drive. It is still unknown how far from the wellbore the dilated zone can propagate.

However, the actual structure of foamy oil flow and its mathematical description are still not well understood. Much of the earlier discussion of such flows was based on the concept of microbubbles (i.e., bubbles that are much smaller than the average pore-throat size and are thus free to move with the oil during flow (Sheng et al., 1999). Dispersion of this type can be produced only by nucleation of a very large number of bubbles (explosive nucleation) and by the availability of a mechanism that prevents these bubbles from growing into larger bubbles with decline in pressure. Another hypothesis for the structure of foamy oil flow is that much larger bubbles migrating with the oil, with the dispersion created by breakup of bubbles during migration. The major difference between conventional solution gas drive and foamy solution gas drive is that the pressure gradient in the latter is strong enough to mobilize gas clusters once they have grown to a certain size (Maini, 1999).

Reservoirs that exhibit foamy oil behavior are typically characterized by the appearance of an oil-continuous foam at the wellhead. When oil is produced as this non-equilibrium mixture, reservoirs can perform with higher than expected rates of production: up to 30 times that predicted by Darcy's Law, and lower than expected production GORs (Poon and Kisman, 1992). Moreover,

foamy oil flow is often accompanied by sand production along with the oil and gas – the presence of sand at the wellhead leads to sand dilation and the presence of high porosity, high permeability zones (wormholes) in the reservoir (Maini, 1999, 2001). It is generally believed that in the field, the high rates and recoveries observed are the combination of the foamy oil mechanism and the presence of these wormholes.

1.3.6 HEAVY CRUDE OIL

There are also other *types* of crude oil that are different from the conventional crude oil insofar as they are much more difficult to recover from the subsurface reservoir (Speight, 2014a). These materials have a higher viscosity (and lower API gravity) than conventional crude oil, and recovery of these crude oil types usually requires thermal stimulation of the reservoir leading to application of various thermal methods (such as coking) in the refinery for suitable conversion to low-boiling distillates.

For example, crude oil and heavy oil have been arbitrarily defined in terms of physical properties. For example, heavy oil was considered to be the type of crude oil that had an API gravity less than 20°. For example, an API gravity equal to 12° signifies a heavy oil, while extra-heavy oil and tar sand bitumen usually have an API gravity less than 10° (e.g., Athabasca bitumen=8° API). Residua would vary depending upon the temperature at which distillation was terminated but usually vacuum residua are in the range 2° API–8° API. The term *heavy oil* has also been used collectively to describe both the heavy oils that require thermal stimulation of recovery from the reservoir and the bitumen in bituminous sand formations from which the viscous bituminous material is recovered by a mining operation (Speight, 2013b,c, 2014a). Convenient as this may be, it is scientifically and technically incorrect.

Heavy oil is a *type* of crude oil that is different from conventional crude oil insofar as they are much more difficult to recover from the subsurface reservoir. Heavy oil, particularly heavy oil formed by biodegradation of organic deposits, is found in shallow reservoirs, formed by unconsolidated sands. This characteristic, which causes difficulties during well drilling and completion operations, may become a production advantage due to higher permeability. In simple terms, heavy oil is a type of crude oil which is very viscous and does not flow easily. The common characteristic properties (relative to conventional crude oil) are high specific gravity, low hydrogen-to-carbon ratios, high carbon residues, and high contents of asphaltenes, heavy metal, sulfur, and nitrogen. Specialized refining processes are required to produce more useful fractions, such as naphtha, kerosene, and gas oil.

Thus, when crude oil occurs in a reservoir that allows the crude material to be recovered by pumping operations as a free-flowing dark- to light-colored liquid, it is often referred to as *conventional crude oil*. The definition of heavy oil is usually based on the API gravity or viscosity, and the definition is quite arbitrary although there have been attempts to rationalize the definition based upon viscosity, API gravity, and density.

There are large resources of *heavy oil* in Canada, Venezuela, Russia, the United States, and many other countries. The resources in North America alone provide a small percentage of current oil production (approximately 2%), existing commercial technologies could allow for significantly increased production. Under current economic conditions, heavy oil can be profitably produced, but at a smaller profit margin than for conventional oil, due to higher production costs and upgrading costs in conjunction with the lower market price for the higher boiling more viscous crude oils. In fact, heavy oil accounts for more than double the resources of conventional oil in the world, and heavy oil offers the potential to satisfy current and future oil demand. Not surprisingly, heavy oil has become an important theme in the crude oil industry with an increasing number of operators getting involved or expanding their plans in this market around the world.

However, heavy oil is more difficult to recover from the subsurface reservoir than conventional or light oil. A very general definition of heavy oils has been and remains based on the API gravity

or viscosity, and the definition is quite arbitrary although there have been attempts to rationalize the definition based upon viscosity, API gravity, and density. For example, heavy oils were considered to be those crude oils that had gravity somewhat less than 20° API with the heavy oils falling into the API gravity range 10°–15°. For example, Cold Lake heavy crude oil has an API gravity equal to 12° and tar sand bitumen usually have an API gravity in the range 5°–10° (Athabasca bitumen=8° API). Residua would vary depending upon the temperature at which distillation was terminated but usually vacuum residua are in the range 2° API–8° API (Speight, 2000; Parkash, 2003; Gary et al., 2007; Speight, 2014a; Hsu and Robinson, 2017; Speight, 2017).

The term *heavy oil* has also been arbitrarily (incorrectly) used to describe both the heavy oils that require thermal stimulation of recovery from the reservoir and the bitumen in bituminous sand (tar sand) formations from which the heavy bituminous material is recovered by a mining operation. *Extra-heavy oil* is a non-descript term that is related to viscosity but has little scientific meaning. This type of viscous feedstock is usually compared (righty so) to tar sand bitumen, which is generally incapable of free flow under reservoir conditions. The general difference is that extra-heavy oil, which may have properties similar to tar sand bitumen in the laboratory but, unlike tar sand bitumen in the deposit, has some degree of mobility in the reservoir or deposit because of the relatively high temperature of the deposit (Table 1.2) (Delbianco and Montanari, 2009; Speight, 2014a). Extra-heavy oils can flow at reservoir temperature and can be produced economically, without additional viscosity-reduction techniques, through variants of conventional processes such as long horizontal wells, or multilaterals. This is the case, for instance, in the Orinoco basin (Venezuela) or in offshore reservoirs of the coast of Brazil but, once outside of the influence of the high reservoir temperature, these oils are too viscous at surface to be transported through conventional pipelines and require heated pipelines for transportation. Alternatively, the oil must be partially upgraded or fully upgraded or diluted with a light hydrocarbon (such as aromatic naphtha) to create a mix that is suitable for transportation (Speight, 2014a).

The methods outlined in this book for heavy oil refining focus on heavy oil with an API gravity of less than 20 with a variable sulfur content (Speight, 2000, 2014a, 2017). However, it must be recognized that some of the heavy oil sufficiently liquid to be recovered by pumping operations and are already being recovered by this method. Refining depends on the characteristics (properties) since these heavy oils fall into a range of high viscosity, and the viscosity is subject to temperature effects (Speight, 2014a, 2017), which is the reason for the application of thermal conditions or dilution with a suitable solvent (such as aromatic naphtha) to enable heavy oil to flow in pipeline or within the refinery system.

1.4 EXTRA-HEAVY CRUDE OIL AND TAR SAND BITUMEN

In addition to conventional crude oil and heavy crude oil, there are even more viscous material that offers some relief to the potential shortfalls in supply (Meyer and De Witt, 1990). These resources are often referred to as (i) extra-heavy crude oil and (ii) tar sand bitumen.

1.4.1 EXTRA-HEAVY CRUDE OIL

The term *extra-heavy oil* is a recent addition to the fossil fuel lexicon and is used to describe materials that occur in the solid or near-solid state in the deposit or reservoir and are generally incapable of free flow under ambient conditions. Whether or not such a material exists in the near-solid or solid state in the reservoir can be determined from the pour point and the reservoir temperature. Extra-heavy oil is a non-descript term (related to viscosity) of little scientific meaning that is usually applied to tar sand bitumen-like material. The general difference is that extra-heavy oil, which may have properties similar to tar sand bitumen in the laboratory but, unlike immobile tar sand bitumen in the deposit, has some degree of mobility in the reservoir or deposit such as the Zuata material (Venezuela) (Tables 1.2–1.4) (Delbianco and Montanari, 2009; Speight, 2013d, 2014a).

TABLE 1.2

Simplified Differentiation between Conventional Crude Oil, Tight Oil, Heavy Crude Oil, Extra-Heavy Crude Oil, and Tar Sand Bitumen

Conventional Crude Oil

Mobile in the reservoir; API gravity: >25°
High-permeability reservoir
Primary recovery
Secondary recovery

Tight Oil

Similar properties to the properties of conventional crude oil; API gravity: >25°
Immobile in the reservoir
Low-permeability reservoir
Horizontal drilling into reservoir
Fracturing (typically multi-fracturing) to release fluids/gases

Heavy Crude Oil

More viscous than conventional crude oil; API gravity: 10°–20°
Mobile in the reservoir
High-permeability reservoir
Secondary recovery
Tertiary recovery (enhanced oil recovery – EOR, e.g., steam stimulation)

Extra-Heavy Crude Oil

Similar properties to the properties of tar sand bitumen; API gravity: <10°
Mobile in the reservoir
High-permeability reservoir
Secondary recovery
Tertiary recovery (enhanced oil recovery – EOR, e.g., steam stimulation)

Tar Sand Bitumen

Immobile in the deposit; API gravity: <10°
High-permeability reservoir
Mining (often preceded by explosive fracturing)
Steam-assisted gravity drainage (SAGD)
Solvent methods (VAPEX)
Extreme heating methods
Innovative methods[a]

This list is not intended for use as a means of classification.

[a] Innovative methods excludes tertiary recovery methods and methods such as steam assisted gravity drainage (SAGD) and vapor-assisted extraction (VAPEX) methods but does include variants or hybrids thereof (Speight, 2016).

Another example is the extra-heavy oil of the Zaca-Sisquoc material (sometimes referred to as the Zaca-Sisquoc bitumen) that has an API gravity on the order of 4.0°–6.0°. The reservoir has average depth 3,500 feet, average thickness 1,700 feet, average temperature 51°C–71°C (125°F–160°F), and sulfur in the range 6.8% w/w–8% w/w. The deposit temperature is certainly equal to or above the pour point of the oil (Isaacs, 1992). This renders the oil capable of being pumped as a liquid from the deposit because of the high deposit temperature (which is higher than the pour point of the oil). The same rationale applied to the extra-heavy oil found in the Orinoco deposits.

Thus, extra-heavy oil is a material that occurs in the solid or near-solid state and generally has mobility under reservoir conditions. While this type of oil resembles tar sand bitumen and does not

TABLE 1.3
Comparison of Selected Properties of Athabasca Tar Sand Bitumen (Alberta, Canada) and Zuata Extra-Heavy Oil (Orinoco, Venezuela)

		Athabasca Bitumen	Zuata Extra-Heavy Oil
Whole oil	API gravity	8	8
	Sulfur, % w/w	4.8	4.2
Resid (>650°F)	% v/v	85	86
	Sulfur, % w/w	5.4	4.6
	Ni+V, ppm	420	600
	CCR[a], % w/w	14	15

[a] Conradson carbon residue.

TABLE 1.4
Comparison of the Properties of Conventional Crude Oil with Tar Sand (Athabasca) Bitumen

Property	Athabasca Bitumen	Conventional Crude Oil
Specific gravity	1.03	0.85–0.90
Viscosity (cp)		
38°C/100°F	750,000	<200
100°C/212°F	11,300	
Pour point, °F	>50	ca. −20
Elemental Analysis (% w/w)		
Carbon	83.0	86.0
Hydrogen	10.6	13.5
Nitrogen	0.5	0.2
Oxygen	0.9	<0.5
Sulfur	4.9	<2.0
Ash	0.8	0.0
Nickel (ppm)	250	<10.0
Vanadium (ppm)	100	<10.0
Fractional Composition (% w/w)		
Asphaltenes (pentane)	17.0	<10.0
Resins	34.0	<20.0
Aromatics	34.0	>30.0
Saturates	15.0	>30.0
Carbon Residue (% w/w)		
Conradson	14.0	<10.0

Extra-heavy oil (e.g., Zuata extra-heavy oil) has a similar analysis to tar sand bitumen (Table 1.5) but some mobility in the deposit because of the relatively high temperature of the deposit.

flow easily, extra-heavy oil is generally recognized as having mobility in the reservoir compared to tar sand bitumen, which is typically incapable of mobility (free flow) under reservoir conditions. It is likely that the mobility of extra-heavy oil is due to a high reservoir temperature (that is higher than the pour point of the extra-heavy oil) or due to other factors is variable and subject to localized conditions in the reservoir.

However, the term *extra-heavy oil* is a recently evolved term (related to viscosity) of little scientific meaning. While this type of oil may resemble tar sand bitumen and does not flow easily, extra-heavy oil is generally recognized as having mobility in the reservoir compared to tar sand bitumen, which is typically incapable of mobility (free flow) under reservoir conditions. For example, the tar sand bitumen located in Alberta Canada is not mobile in the deposit and requires extreme methods of recovery to recover the bitumen. On the other hand, much of the extra-heavy oil located in the Orinoco basin of Venezuela requires recovery methods that are less extreme because of the mobility of the material in the reservoir. Whether the mobility of extra-heavy oil is due to a high reservoir temperature (that is higher than the pour point of the extra-heavy oil) or due to other factors is variable and subject to localized conditions in the reservoir. This may also be reflected in the choice of suitable extra-heavy oil or bitumen conversion processes in the refinery.

In order to utilize the extra-heavy oil produced in Venezuela, the government-run oil company (PDVSA) has developed Orimulsion fuel, which is a dispersion of extra-heavy oil and approximately 30% water which is targeted for use as a boiler fuel in applications such as power generation and industrial use. However, concerns about the environmental impact of the use of Orimulsion have been raised owing to the relatively high levels of sulfur, nickel, and vanadium compared with other fuel oils. Technologies such as *selective catalytic reduction*, *flue gas desulfurization*, and *electrostatic precipitation* are suitable for cleanup of the exhaust emissions (Mokhatab et al., 2006; Speight, 2019a).

Finally, because of the potential relevance to refining in the future (Chapter 17) (Speight, 2011a), there is the need to define *oil shale*, which is the term applied to a class of bituminous rocks that has achieved some importance. Oil shale does not contain oil (Scouten, 1990; Lee, 1991; Speight, 2012b). It is an argillaceous, laminated sediment of generally high organic content (*kerogen*) that can be thermally decomposed to yield appreciable amounts of a hydrocarbon-based oil that is commonly referred to as *shale oil*. Oil shale does not yield shale oil without the application of high temperatures and the ensuing thermal decomposition that is necessary to decompose the organic material (*kerogen*) in the shale.

1.4.2 TAR SAND BITUMEN

Tar sand bitumen is the *bitumen* found in *tar sand* (*oil sand*) deposits. However, many of these reserves are only available with some difficulty and optional refinery scenarios will be necessary for conversion of these materials to liquid products (Speight, 2000, 2014a) because of the substantial differences in character between conventional crude oil and tar sand bitumen (Table 1.2). *Tar sands*, also variously called *oil sands* or *bituminous sands*, are a loose-to-consolidated sandstone or a porous carbonate rock, impregnated with bitumen, a heavy asphaltic crude oil with an extremely high viscosity under reservoir conditions.

The term *tar sand bitumen* (also, on occasion referred to as *extra-heavy oil* and *native asphalt*, although the latter term is incorrect) includes a wide variety of reddish-brown to black materials of near-solid to solid character that exist in nature either with no mineral impurity or with mineral matter contents that exceed 50% by weight. Bitumen is frequently found filling pores and crevices of sandstone, limestone, or argillaceous sediments, in which case the organic and associated mineral matrix is known as *rock asphalt*.

Bitumen is also a naturally occurring material that is found in deposits that are incorrectly referred to as *tar sand* since tar is a product of the thermal processing of coal (Speight, 2013a). The permeability of a tar sand deposit low and passage of fluids through the deposit can only be achieved by prior application of fracturing techniques. Alternatively, bitumen recovery can be achieved by conversion of the

bitumen to a product in situ (in situ upgrading) followed by product recovery from the deposit (Speight, 2013b,c, 2014a, 2016). Tar sand bitumen is a high-boiling material with little, if any, material boiling below 350°C (660°F) and the boiling range approximates the boiling range of an atmospheric residuum.

There have been many attempts to define tar sand deposits and the bitumen contained therein. In order to define conventional crude oil, heavy oil, and bitumen, the use of a single physical parameter such as viscosity is not sufficient. Other properties such as API gravity, elemental analysis, composition, and, most of all, the properties of the bulk deposit must also be included in any definition of these materials. Only then will it be possible to classify crude oil and its derivatives.

In fact, the most appropriate definition of *tar sands* is found in the writings of the United States government, viz.:

> Tar sands are the several rock types that contain an extremely viscous hydrocarbon which is not recoverable in its natural state by conventional oil well production methods including currently used enhanced recovery techniques. The hydrocarbon-bearing rocks are variously known as bitumen-rocks oil, impregnated rocks, oil sands, and rock asphalt.

This definition speaks to the character of the bitumen through the method of recovery. Thus, the bitumen found in tar sand deposits is an extremely viscous material that is *immobile under reservoir conditions* and cannot be recovered through a well by the application of secondary or enhanced recovery techniques. Mining methods match the requirements of this definition (since mining is not one of the specified recovery methods) and the bitumen can be recovered by alteration of its natural state such as thermal conversion to a product that is then recovered. In this sense, changing the natural state (the chemical composition) as occurs during several thermal processes (such as some in situ combustion processes) also matches the requirements of the definition.

By inference and by omission, conventional crude oil and heavy oil are also included in this definition. Crude oil is the material that can be recovered by conventional oil well production methods whereas heavy oil is the material that can be recovered by enhanced recovery methods. Tar sand currently recovered by a mining process followed by separation of the bitumen by the hot water process. The bitumen is then used to produce hydrocarbon derivatives by a conversion process.

The only commercial operations for the recovery of bitumen from tar sand and its subsequent conversion to liquid fuels exist in the Canadian Province of Alberta where Suncor (initially as Great Canadian Oil Sands before the name change) went on-stream in 1967 and Syncrude (a consortium of several companies) went on-steam in 1977. Thus, throughout this text, frequent reference is made to tar sand bitumen, but because commercial operations have been in place for approximately 50 years, it is not surprising that more is known about the Alberta (Canada) tar sand reserves than any other reserves in the world. Therefore, when discussion is made of tar sand deposits, reference is made to the relevant deposit, but when the information is not available, the Alberta material is used for the purposes of the discussion.

Refining tar sand bitumen depends to a large degree on the composition of the bitumen and the structure of the bitumen (Speight, 2014a, 2017). Generally, the bitumen found in tar sand deposits is an extremely viscous material that is *immobile* and cannot be refined by the application of conventional refinery. On the other hand, extra-heavy oil, which is often likened to tar sand bitumen because of similarities in the properties of the two, has a degree of mobility under reservoir or deposit conditions but typically suffers from the same drawbacks as the immobile bitumen in refinery operations.

It is incorrect to refer to native bituminous materials as *tar* or *pitch*. Although the word tar is descriptive of the black, heavy bituminous material, it is best to avoid its use with respect to natural materials and to restrict the meaning to the volatile or near-volatile products produced in the destructive distillation of such organic substances as coal (Speight, 2013a). In the simplest sense, pitch is the distillation residue of the various types of tar.

Thus, alternative names, such as *bituminous sand* or *oil sand*, are gradually finding usage, with the former name (bituminous sands) more technically correct. The term *oil sand* is also used in the same way as the term *tar sand*, and these terms are used interchangeably throughout this text.

Bituminous rock and *bituminous sand* are those formations in which the bituminous material is found as a filling in veins and fissures in fractured rocks or impregnating relatively shallow sand, sandstone, and limestone strata. The deposits contain as much as 20% bituminous material, and if the organic material in the rock matrix is bitumen, it is usual (although chemically incorrect) to refer to the deposit as *rock asphalt* to distinguish it from bitumen that is relatively mineral free. A standard test (ASTM D4) is available for determining the bitumen content of various mixtures with inorganic materials, although the use of word *bitumen* as applied in this test might be questioned and it might be more appropriate to use the term *organic residues* to include *tar* and *pitch*. If the material is the asphaltite-type or asphaltoid-type, the corresponding terms should be used: *rock asphaltite* or *rock asphaltoid*.

Bituminous rocks generally have a coarse, porous structure, with the bituminous material in the voids. A much more common situation is that in which the organic material is present as an inherent part of the rock composition insofar as it is a diagenetic residue of the organic material detritus that was deposited with the sediment. The organic components of such rocks are usually refractory and are only slightly affected by most organic solvents.

Tar sand deposits occur throughout the world, and the largest deposits occur in Alberta, Canada (the Athabasca, Wabasca, Cold Lake, and Peace River areas), and in Venezuela. Smaller deposits occur in the United States, with the larger individual deposits in Utah, California, New Mexico, and Kentucky. The term *tar sand*, also known as *oil sand* (in Canada), or bituminous sand, commonly describes sandstones or friable sand (quartz) impregnated with a viscous organic material known as *bitumen* (a hydrocarbonaceous material that is soluble in carbon disulfide). Significant amounts of fine material, usually largely or completely clay, are also present. The degree of porosity in tar sand varies from deposit to deposit and is an important characteristic in terms of recovery processes. The bitumen makes up the desirable fraction of the tar sands from which liquid fuels can be derived. However, the bitumen is usually not recoverable by conventional crude oil production techniques (Speight, 2013b,c, 2014a, 2016).

The properties and composition of the tar sands and the bitumen significantly influence the selection of recovery, and the bitumen conversion processes vary among the bitumen from different deposits. In the so-called wet sands or water-wet sands of the Athabasca deposit, a layer of water surrounds the sand grain, and the bitumen partially fills the voids between the wet grains. Utah tar sands lack the water layer; the bitumen is directly in contact with the sand grains without any intervening water; such tar sands are sometimes referred to as oil-wet sands. Typically, more than 99% w/w of mineral matter is composed of quartz and clays – the latter is detrimental to most refining processes. The general composition of typical deposits at the P.R. Spring Special Tar Sand Area showed a porosity of 8.4 volume percent with the solid/liquid fraction being 90.5% w/w sand, 1.5% w/w fines, 7.5% w/w bitumen, and 0.5% w/w water. Utah deposits range from largely consolidated sands with low porosity and permeability to, in some cases, unconsolidated sand. High concentrations of heteroatoms (nitrogen, oxygen, sulfur, and metals) tend to increase viscosity, increase the bonding of bitumen with minerals, reduce yields, and make processing more difficult.

1.5 OTHER FEEDSTOCKS

In addition to the so-called conventional fossil fuel feedstocks such as conventional crude oil, heavy crude oil, extra-heavy crude oil, and tar sand bitumen, there is a variety of other carbonaceous feedstocks that could well see use as refinery feedstocks in the future. These feedstocks include (i) coal liquids, (ii) shale oil, and (iii) non-fossil fuel materials such as biomass. In each case, there are relevant issues that can interfere with the refinability of such feedstock in a conventional crude oil refinery, but as the 21st century evolves, there is no doubt that refineries will become adaptable to the use of these feedstocks. In addition, as with all refinery feedstocks, the environmental consequences of the use of such non-conventional feedstocks will also be an issue that needs to be addressed.

As a result, and the adaptation of the refining industry to the various environmental regulation that affect use of non-conventional feedstocks will continue to play a key role in the energy mix of various countries, with demand in certain regions set to grow rapidly especially in those countries where the demand for liquid fuel is on an ever-increasing curve (Speight, 2011c; Speight and Islam, 2016).

1.5.1 COAL LIQUIDS

Coal liquids are produced from coal which is a combustible dark-brown-to-black organic sedimentary rock that occurs in *coalbeds* or *coal seams*. Coal is composed primarily of carbon with variable amounts of hydrogen, nitrogen, oxygen, and sulfur and may also contain mineral matter and gases as part of the coal matrix.

The rush to produce liquid fuels (or liquid fuel precursors) from coal almost reached a fever pitch during the 1970s and the early 1980s. The rush to coal was spurred by the two energy crises of the 1970s when crude oil imports into energy-consuming countries were severely reduced and high prices for crude oil were initiated (Speight, 2011c; Speight and Islam, 2016).

For the past two centuries, coal played this important role – providing coal gas for lighting and heating and then electricity generation with the accompanying importance of coal as an essential fuel for steel and cement production, as well as a variety of other industrial activities (Speight, 2013a,b,e). In fact, coal remains an important source of energy in many countries and is used to provide approximately 40% of electricity worldwide but this does not give the true picture of the use of coal for electricity production. Coal, which is currently considered the bad boy of fossil fuels due to environmental issues – some of which are real and some of which are emotional – may become more important both as an energy source and as the source of organic chemical feedstock in the 21st century. However, as the 20th century evolved into the 21st century, the coal industry has been responded to the environmental aspects of coal use and has responded with a variety of on-stream coal-cleaning and gas-cleaning technologies (Speight, 2013a,e).

As a result, and the adaptation of the industry to the various environmental regulation that affect coal use, coal will continue to play a key role in the world's energy mix, with demand in certain regions set to grow rapidly. Growth in both the steam and coking coal markets will be strongest in developing Asian countries, where demand for electricity and the need for steel in construction, car production, and demands for household appliances will increase as incomes rise. In fact, the production of liquid fuels from coal is not new and has received considerable attention. In fact, the concept is often cited as a viable option for alleviating projected shortages of liquid fuels as well as offering some measure of energy independence for those countries with vast resources of coal who are also net importers of crude oil.

Coal liquids are produced by a series of processes that fall under the gernal banner of *coal liquefaction* (Speight, 2013a). These processes are used to convert coal, a solid fuel, into a substitute for liquid fuels such as diesel and gasoline. Coal liquefaction has historically been used in countries without a secure supply of crude oil, such as Germany (during World War II) and South Africa (since the early 1970s). The technology used in coal liquefaction is quite old and was first implemented during the 19th century to provide gas for indoor lighting. Coal liquefaction may be used in the future to produce oil for transportation and heating, in case crude oil supplies are ever disrupted.

The thermal decomposition of coal on a commercial scale is an old art and is often more commonly referred to as carbonization (Table 1.5). Coal decomposition to a mix of solid, liquid, and gaseous products is usually achieved by the use of temperatures up to 1,500°C (2,730°F). However, the carbonization was designed as a process for the production of a carbonaceous residue (coke) by the thermal decomposition (with simultaneous removal of distillate) of organic substances. The process, which is also referred to as destructive distillation, has been applied to a whole range of organic (carbon-containing) materials particularly natural products such as wood, sugar, and vegetable matter to produce charcoal. In this present context, the carbonaceous residue from the thermal decomposition of coal is usually referred to as "coke" (which is physically dissimilar from charcoal)

TABLE 1.5
Bulk Products (% w/w) from Coal Carbonization

Product (% w/w)	Low Temperature (Carbonization)	High Temperature (Carbonization)
Gas	5	20
Liquids	15	2
Tar	10	3
Coke	70	75

and has the more familiar honeycomb-type structure. But, coal carbonization is not a process which has been designed for the production of liquids as the major products.

In terms of refinery feedstocks, liquid products from coal are generally different from those feedstock accepted by a refinery because the coal liquids contain substantial amounts of phenol derivatives. Therefore, there will always be some question about the place of coal liquids in refining operations. Current concepts for refining the products of liquids from coal have relied, for the most part, on the already existing crude oil refineries, although it must be recognized that the acidity (due to the content of the phenol derivatives) of the coal liquids and their potential incompatibility with conventional crude oil (including heavy crude oil, extra-heavy crude oil, and tar sand bitumen) may pose new issues within the refinery system (Speight, 2013a, 2014a, 2017).

The coal-to-liquid technology would complement the expanding extra-heavy oil and tar sand bitumen technology allowing the long-predicted decline in crude oil production to be delayed for decades and the geopolitics of energy would be rewritten.

In fact, coal has several positive attributes when considered as a feedstock for aromatic chemicals, specialty chemicals, and carbon-based materials (Speight, 2013a). Substantial progress in advanced polymer materials, incorporating aromatic and polyaromatic units in their main chains, has created new opportunities for developing value-added or specialty organic chemicals from coal and tars from coal carbonization for coke making. The decline of the coal tar industry has diminished the traditional sources of these chemicals. A new coal chemistry for chemicals and materials from coal may involve direct and indirect coal conversion strategies as well as the co-production approach. In addition, the needs for environmental-protection applications have also expanded market demand for carbon materials and carbon-based adsorbents.

1.5.2 SHALE OIL

Oil shale is the term applied to a class of bituminous rocks that contain a complex heteroatomic molecule known as *kerogen* and oil shale does not contain oil. *Shale oil* is produced when *kerogen* is thermally decomposed to yield appreciable amounts of a hydrocarbon-based oil; it is this product that is commonly referred to as *shale oil*. Oil shale does not yield shale oil without the application of high temperatures and the ensuing thermal decomposition that is necessary to decompose the organic material (*kerogen*) in the shale.

In fact, the term *oil shale* is a misnomer since the mineral does not contain oil nor is it always composed of shale minerals. Like tar sand (*oil sand* in Canada) and coal, oil shale is considered unconventional because oil cannot be produced directly from the resource by sinking a well and pumping. Oil has to be produced by thermal decomposition of the organic matter (kerogen) in the shale. The organic material contained in the shale is called *kerogen*, a solid material intimately bound within the mineral matrix. However, oil shale does not contain any oil – this must be produced by a process in which the kerogen is thermally decomposed (cracked) to produce the liquid product (shale oil) (Scouten, 1990; Lee, 1991; Lee et al., 2007; Speight, 2020). Compared to crude oil, shale oil obtained by retorting of oil shale is characterized by wide boiling range and by large concentrations of heteroelements and also by high content of oxygen-, nitrogen-, or sulfur-containing compounds.

The organic material is chiefly *kerogen* and the *shale* is usually a relatively hard rock, called marl. *Oil shale* is a complex and intimate mixture of organic and inorganic materials that vary widely in composition and properties. In general terms, oil shale is a fine-grained sedimentary rock that is rich inorganic matter and yields oil when heated. Some oil shale is genuine shale but others have been mis-classified and are actually siltstones, impure limestone, or even impure coal. Oil shale does not contain oil and only produces oil when it is heated to approximately 500°C (approximately 930°F), when some of the organic material is transformed into a distillate similar to crude oil (Scouten, 1990; Speight, 2012b, 2020).

Kerogen is, for the most part, insoluble in the common organic solvents and produces distillable hydrocarbon derivatives when subjected to heat (Scouten, 1990; Lee, 1991; Speight, 2012b). When the kerogen occurs in shale, the whole material is often referred to as *oil shale*. Kerogen is not the same as the bitumen that occurs in tar sand deposits (Scouten, 1990; Lee, 1991; Speight, 2012b, 2014a). A *synthetic crude oil* can be produced from oil shale kerogen by thermal decomposition, typically at temperatures above 500°C (930°F) at which the kerogen is thermally decomposed (cracked) to produce the lower-molecular-weight distillable products (Scouten, 1990; Lee, 1991; Speight, 2012b). Kerogen is also reputed to be a precursor of crude oil but this concept and the actual maturation pathway of the kerogen to crude oil is still the subject of considerable speculation and debate (Speight, 2014a).

Thus, when properly processed, kerogen can be converted into a product somewhat similar to crude oil which is often better than the lowest grade of oil produced from conventional oil reservoirs but of lower quality than conventional light oil. *Shale oil* (*retort oil*) is the liquid oil condensed from the effluent in oil shale retorting and typically contains appreciable amounts of water and solids, as well as having an irrepressible tendency to form sediments. Oil shale is an inorganic, nonporous sedimentary marlstone rock containing various amounts of solid organic material (known as *kerogen*) that yields hydrocarbons, along with non-hydrocarbons, and a variety of solid products, when subjected to pyrolysis (a treatment that consists of heating the rock at high temperature) (Lee, 1990; Scouten, 1990; Speight, 2012b, 2020).

In fact, shale oil is a synthetic crude oil produced by retorting oil shale and is the pyrolysis product of the organic matter (kerogen) contained in oil shale. The raw shale oil produced from retorting oil shale can vary in properties and composition (Table 1.6) (Scouten, 1990; Lee, 1991; Lee et al., 2007; Speight, 2020). Compared with crude oil, shale oil is high in nitrogen and oxygen compounds and a higher specific gravity – on the order of 0.9–1.0 owing to the presence of high-boiling nitrogen-, sulfur-, and oxygen-containing compounds. Shale oil also has a relatively high pour point and small quantities of arsenic and iron are present.

TABLE 1.6

Major Compound Types in Shale Oil

Saturate	Heteroatom systems
Paraffin	Benzothiophene
Cycloparaffin	Dibenzothiophene
Olefin	Phenol
Aromatic	Carbazole
Benzene	Pyridine
Indan	Quinoline
Tetralin	Nitrile
Naphthalene	Ketone
Biphenyl	Pyrrole
Phenanthrene	
Chrysene	

Oil production potential from oil shale is measured by a laboratory pyrolysis method, commonly referred to as the Fischer Assay (Speight, 2012, 2020) and is reported in barrels per ton (42 US gallons per barrel, approximately 35 Imperial gallons per barrel). Rich oil shale zones can yield more than 40 US gallons per ton, while most shale zones produce 10–25 US gallons per ton. Yields of shale oil in excess of 25 US gallons per ton are generally viewed as the most economically attractive, and hence, the most favorable for initial development. Thus, oil shale has, though, a definite potential for meeting energy demand in an environmentally acceptable manner (Lee, 1990; Scouten, 1990; Speight, 2012, 2020).

For comparison with tar sand, *oil shale* is any fine-grained sedimentary rock containing solid organic matter (*kerogen*) that yields a hydrocarbon oil when heated. Oil shale varies in mineral composition. For example, clay minerals predominate in true shale, while other minerals (e.g., dolomite and calcite) occur in appreciable but subordinate amounts in the carbonates. In all shale types, layers of the constituent mineral alternate with layers of kerogen.

Shale oil is produced from a special class of bituminous rocks that has achieved some importance is the so-called *oil shale* (Scouten, 1990; Lee, 1991; Speight, 2012b). These are argillaceous, laminated sediments of generally high organic content that can be thermally decomposed to yield appreciable amounts of oil, commonly referred to as *shale oil*. Oil shale does not yield shale oil without the application of high temperatures and the ensuing thermal decomposition that is necessary to decompose the organic material (*kerogen*) in the shale. The kerogen produces a liquid product (shale oil) by thermal decomposition at high temperature (>500°C, >930°F). The raw oil shale can even be used directly as a fuel akin to a low-quality coal. Indeed, oil shale deposits have been exploited as such for several centuries and shale oil has been produced from oil shale since the 19th century.

Shale retorting processes produce oil with almost no high-boiling residual fraction. With upgrading, shale oil is a light boiling premium product more valuable than most crude oils. However, the properties of shale oil vary as a function of the production (retorting) process. Fine mineral matter carried over from the retorting process and the high viscosity, and instability of shale oil produced by present retorting processes have necessitated upgrading of the shale oil before transport to a refinery.

After fines removal, the shale oil is hydrotreated to reduce nitrogen, sulfur, and arsenic content and improve stability; the cetane index of the diesel and heater oil portion is also improved. The hydrotreating step is generally accomplished in fixed catalyst bed processes under high hydrogen pressures, and hydrotreating conditions are slightly more severe than for comparable boiling range crude oil stocks, because of the higher nitrogen content of shale oil.

Shale oil (produced from the kerogen-containing shale rock) is a complex mixture of hydrocarbon derivatives, and it is characterized using bulk properties of the oil. Shale oil usually contains large quantities of olefin derivatives and aromatic hydrocarbon derivatives as well as significant quantities of heteroatom atom compounds (nitrogen-, oxygen-, and sulfur-containing compounds). A typical shale oil composition includes nitrogen 1.5% w/w–2% w/w, oxygen 0.5% w/w–1% w/w, and sulfur 0.15% w/w–1% w/w as well as mineral particles and metal-containing compounds (Scouten, 1990; Lee, 1991; Lee et al., 2007; Speight, 2020). Generally, the oil is less fluid than crude oil, becoming and which is reflected in the pour point that is on the order of 24°C–27°C (75°F–81°F), while conventional crude oil is has a pout point on the order of −60°C to +30°C (−76°F to +86°F) which affects the ability of shale oil to be transported using unheated pipelines. Shale oil also contains polycyclic aromatic hydrocarbon derivatives.

Nitrogen compounds in shale oil render technological difficulties in the downstream processing of shale oil, in particular, poisoning of the refining catalysts. Such nitrogen compounds are all originated from the oil shale, and the amount and types depend heavily on the geochemistry of oil shale deposits. Since direct analysis and determination of molecular forms of nitrogen-containing compounds in oil shale rock is very difficult, the analysis of shale oil that is extracted by retorting processes provides valuable information regarding the organo-nitrogen species in the oil shale.

The oxygen content of shale oil is much higher than in natural crude oil. Low-molecular-weight oxygen compounds in shale oil are mainly phenol derivatives – carboxylic acid derivatives and

non-acidic oxygen compounds such as ketone derivatives are also present. Low-molecular-weight phenol derivatives are the main acidic oxygen-containing compounds in the low-boiling fraction of the shale oil and are usually derivatives of phenol, such as cresol and poly-methylated phenol derivatives. The oxygen content of crude oil is typically on the order of 0.1% w/w–1.0% w/w whereas the oxygen contents in shale oils are much higher and vary with different shale oil (Scouten, 1990; Lee, 1991; Lee et al., 2007). In addition, the oxygen content varies in different boiling point fractions of the shale oil. In general, it increases as the boiling point increases, and most of the oxygen atoms are concentrated in the high boiling point fraction.

Other oxygen-containing constituents of shale oil include small amounts of carboxylic acids and non-acidic oxygen-containing compounds with a carbonyl functional group such as ketone derivatives, aldehyde derivatives (RCH=O), ester derivatives RCO_2R'), and amide derivatives ($RCONH_2$) are also present in the <350°C (<660°F) fraction of shale oil. Ketones in the shale oil mainly exist as 2-alkanone and 3-alkanone derivatives in which the ketone functional groups is at the second or third carbon atom in the chain, respectively.

By way of further explanation, alkanone derivatives in shale oil are constituents that contain carbon (C), hydrogen (H), and oxygen (O) only and which belong to the ketone group in which the constituents of the group contain a carbonyl (C=O) functional group. A straight-chain alkanone consists of a chain of three or more carbon atoms joined to each other by single covalent bonds, with the carbonyl functional group attached to a non-terminal carbon atom in the chain of carbon atoms.

An alkanone where R and R′ are ethyl groups or longer chains

Based on large quantity of oxygen-containing compounds in the high-boiling fraction, asphalt blending material, road asphalt, construction mastics, anti-corrosion oils, and rubber softeners, benzene and toluene for production of benzoic acid as well as solvent mixtures on pyrolysis of lower-boiling fractions of shale oil are produced. Higher-boiling (mid-distillate) shale oil fractions having antiseptic properties are used to produce effective oil for the impregnation of wood as a major shale oil derived specialty product. Water-soluble phenol derivatives are selectively extracted from shale oil, fractionated and crystallized for production of pure 5-methyl resorcinol and other alkyl resorcinol derivatives and high value intermediates to produce tanning agents, epoxy resins and adhesives, diphenyl ketone and phenol–formaldehyde adhesive resins, rubber modifiers, chemicals, and pesticides. Some conventional products such as coke and various distillate fuels are produced from shale oil as by-products.

Resorcinol (1,3-dimethylbenzene)

The presence of the polar constituents (containing nitrogen and oxygen functions, sulfur compounds are also an issues worthy of consideration) and cause shale oil to be incompatible with conventional crude oil feedstocks and with crude oil products (Speight, 2014a). As a result, particular care must be taken to ensure that all of the functions that cause such incompatibility are removed from the shale oil before it is blended with a conventional crude oil liquid.

Sulfur compounds in shale oil include thiol derivatives, sulfide derivatives, thiophene derivatives, and other miscellaneous sulfur compounds. Elemental sulfur is found in some crude shale oil but is absent in others. Generally, the sulfur content of oil-shale distillates is comparable in weight percentage to crude oil (Scouten, 1990; Lee, 1991; Lee et al., 2007; Speight, 2020). The remaining sulfur that is bound in multi-ring thiophene derivatives is difficult to remove by hydrotreating because the molecular ring structure attaches the sulfur on two sides, and if alkyl groups are present, they provide steric protection for the sulfur atom. Although these compounds occur throughout the range of crude oil distillates, they are more concentrated in the residuum.

2,4-Dimethylthiophene

Upgrading, or partial refining, to improve the properties of a crude shale oil may be carried out using different options. Hydrotreating is the option of choice to produce a stable product that is comparable to conventional crude oil. In terms of refining and catalyst activity, the nitrogen content of shale oil is a disadvantage. But, in terms of the use of shale oil residua as a modifier for asphalt, where nitrogen species can enhance binding with the inorganic aggregate, the nitrogen content is beneficial. If not removed, the arsenic and iron in shale oil would poison and foul the supported catalysts used in hydrotreating.

Blending shale oil products with corresponding crude oil products, using shale oil fractions obtained from a very mildly hydrogen-treated shale oil, yields kerosene and diesel fuel of satisfactory properties. Hydroprocessing shale oil products, either alone or in a blend with the corresponding crude oil fractions, is therefore necessary. The severity of the hydroprocessing has to be adjusted according to the particular properties of the feed and the required level of the stability of the product. The refined (hydrotreated) shale oil, in which the heteroatom content has been reduced to acceptable levels, may also be referred to as *synthetic crude oil* that is sent to a refinery for further processing into various products.

Thus, shale oil is different to conventional crude oils, and several refining technologies have been developed to deal with this. The primary problems identified in the past were arsenic, nitrogen, and the waxy nature of the crude. Issues arising from the presence of nitrogen-containing constituents and wax constituents (long-chain alkane derivatives that are solid at room temperature and incompatible with some crude oil liquids) can be reduced using hydroprocessing approaches, essentially classical hydrocracking and the production of making high-quality lube stocks, which require that waxy materials be removed or isomerized. However, the arsenic problem remains.

In general, oil-shale distillates have a much higher concentration of high boiling point compounds that would favor production of middle distillates (such as diesel and jet fuels) rather than naphtha. Oil-shale distillates also had a higher content of olefins, oxygen, and nitrogen than crude oil, as well as higher pour points and viscosities. Above-ground retorting processes tended to yield a lower API gravity oil than the in situ processes (a 25° API gravity was the highest produced). Additional processing equivalent to hydrocracking would be required to convert oil-shale distillates to a lighter range hydrocarbon (gasoline). Removal of sulfur and nitrogen would, however, require hydrotreating.

1.5.3 Biomass

Biomass is carbon based and is composed of a mixture of organic molecules containing hydrogen, usually including atoms of oxygen, often nitrogen and also small quantities of other atoms, including

TABLE 1.7

Methods for the Conversion of Biomass to Petrochemical Feedstocks

Feedstock	Conversion Type	Primary Method	Product	Secondary Method
Biomass	Biological conversion	Fermentation	Methane	
			Sugar	
			Protein	
	Thermochemical conversion	Pyrolysis	Gas	
			Oil	Gasification
			Char	Gasification
		Hydrocarbonization	Gas	Gasification
			Oil coke	Gasification

alkali metals, alkaline earth metals, and heavy metals. These metals are often found in functional molecules such as the porphyrin molecules which include chlorophyll which contains magnesium. Unlike crude oil, heavy oil, and tar sand bitumen, biomass is a *renewable* energy source and, as a result, biomass has a high potential to play role in the production of liquid fuels in the future and could, more than likely, be an additional feedstock to a refinery, especially as a feedstock for the production of petrochemicals (Table 1.7) (Speight, 2019b).

Biomass is a term used to describe any material of recent biological origin, including plant materials such as trees, grasses, agricultural crops, and even animal manure. Other biomass components, which are generally present in minor amounts, include triglyceride derivatives, sterol derivatives, alkaloid derivatives, terpene derivatives, terpenoid derivatives, and waxes. This includes everything from *primary sources* of crops and residues harvested/collected directly from the land, to *secondary sources* such as sawmill residuals, to *tertiary sources* of post-consumer residuals that often end up in landfills. A *fourth source*, although not usually categorized as such, includes the gases that result from anaerobic digestion of animal manures or organic materials in landfills (Wright et al., 2006). Generally, there are four distinct sources of biomass that can be converted to energy: (i) agricultural crops, (ii) wood, and (iii) carbon-based municipal and industrial wastes, and (iv) carbon-based landfill waste which produced landfill gas (Speight, 2011b, 2020).

Primary biomass is produced directly by photosynthesis and includes all terrestrial plants now used for food, feed, fiber, and fuel wood. All plants in natural and conservation areas (as well as algae and other aquatic plants growing in ponds, lakes, oceans, or artificial ponds and bioreactors) are also considered primary biomass. However, only a small portion of the primary biomass produced will ever be harvested as feedstock material for the production of bioenergy and by-products.

Secondary biomass feedstocks differ from primary biomass feedstocks in that the secondary feedstocks are a by-product of processing of the primary feedstocks. By *processing*, it is meant that there is substantial physical or chemical breakdown of the primary biomass and production of by-products; *processors* may be factories or animals. Field processes such as harvesting, bundling, chipping, or pressing do not cause a biomass resource that was produced by photosynthesis (e.g., tree tops and limbs) to be classified as secondary biomass. Specific examples of secondary biomass include sawdust from sawmills, black liquor (which is a by-product of paper making), and cheese whey (which is a by-product of cheese-making processes). Manures from concentrated animal feeding operations are collectable secondary biomass resources. Vegetable oils used for biodiesel that are derived directly from the processing of oilseeds for various uses are also a secondary biomass resource.

Tertiary biomass feedstock includes post-consumer residues and wastes, such as fats, greases, oils, construction and demolition wood debris, other waste wood from the urban environments, as well as packaging wastes, municipal solid wastes, and landfill gases. A category *other wood waste*

from the urban environment includes trimmings from urban trees, which technically fits the definition of primary biomass. However, because this material is normally handled as a waste stream along with other post-consumer wastes from urban environments (and included in those statistics), it makes the most sense to consider it to be part of the tertiary biomass stream.

As expected from the above descriptions, biomass feedstocks exhibit a wide range of physical, chemical, and agricultural/process engineering properties. Despite their wide range of possible sources, biomass feedstocks are remarkably uniform in many of their fuel properties, compared with competing feedstocks such as coal or crude oil. Approximately 6% of contiguous United States land area put into cultivation for biomass could supply all current demands for oil and gas. And this production would not add any net carbon dioxide to the atmosphere.

Dried biomass has a heating value of 5,000–8,000 Btu/lb. with virtually no ash or sulfur produced during combustion. However, nearly all kinds of biomass feedstocks destined for combustion fall in the range 6,450–8,200 Btu/lb. For most agricultural residues, the heating values are even more uniform – approximately 6,450–7,300 Btu/lb; the values for woody materials are on the order of 7,750–8,200 Btu/lb. Moisture content is probably the most important determinant of heating value. Air-dried biomass typically has approximately 15%–20% moisture, whereas the moisture content for oven-dried biomass is around 0%. The bulk density (and hence energy density) of most biomass feedstocks is generally low, even after densification, approximately 10% and 40% of the bulk density of most fossil fuels. Liquid biofuels have comparable bulk densities to fossil fuels. Finally, many types of biomass do contain high amounts of mineral matter (translated as mineral ash during analysis) and the amount can vary from a fraction of 1% w/w to as much as 30% w/w. As is well known in the crude oil refining industry, mineral matter can be a *catalyst killer* in catalyst-based processes.

Biofuel is any fuel derived from biomass (Speight, 2011b, 2020) and has the potential to produce fuels that are more environmentally benign than crude oil-based fuels (Speight, 2020). Biofuel is a renewable energy source, unlike other natural resources, such as crude oil, and like crude oil, biomass is a form of stored energy. The production of biofuels to replace oil and natural gas is in active development, focusing on the use of cheap organic matter (usually cellulose, agricultural and sewage waste) in the efficient production of liquid and gas biofuels which yield high net energy gain. One advantage of biofuel over most other fuel types is that it is biodegradable, and so relatively harmless to the environment if spilled.

Direct biofuels are biofuels that can be used in existing unmodified crude oil engines. Because engine technology changes all the time, direct biofuel can be hard to define; a fuel that works well in one unmodified engine may not work in another. In general, newer engines are more sensitive to fuel than older engines, but new engines are also likely to be designed with some amount of biofuel in mind. Straight vegetable oil can be used in many older diesel engines (equipped with indirect injection system), but only in the warmest climates. In reality, small amounts of biofuel (such as bio-ethanol) are often blended with traditional fuels. The biofuel portion of these fuels is a direct replacement for the fuel they offset, but the total offset is small. For biodiesel, 5% v/v or 20% v/v are commonly approved by various engine manufacturers.

The reserves of biomass are unlimited insofar as biomass resources are renewable and available each year unlike non-renewable resources (such as the fossil fuels) which are eventually depleted (Speight, 2011b, 2020). While forests and grasslands, say, could be depleted, if managed properly they do represent a continuous supply of energy – compared to the fossil fuels which, once they have been exhausted, are no longer available.

The specific components of plants such as carbohydrates, vegetable oils, plant fiber, and complex organic molecules known as primary and secondary metabolites can be utilized to produce a range of valuable monomers, chemical intermediates, pharmaceuticals, and materials.

Chemically, plants capture solar energy as fixed carbon during which carbon dioxide is converted to water and sugars $(CH_2O)_x$:

$$CO_2 + H_2O \rightarrow (CH_2O)_x + O_2$$

The sugars produced are stored in three types of polymeric macromolecules: (i) starch, (ii) cellulose, and (iii) hemicellulose.

In general, sugar polymers such as cellulose and starch can be readily broken down to their constituent monomers by hydrolysis, preparatory to conversion to ethanol, or other chemicals (Speight, 2019b, 2020). In contrast, lignin is an unknown complex structure containing aromatic groups that is totally hypothetical and is less readily degraded than starch or cellulose. Although lignocellulose is one of the cheapest and the most abundant forms of biomass, it is difficult to convert this relatively unreactive material into sugars. Among other factors, the walls of lignocellulose are composed of lignin, which must be broken down in order to render the cellulose and hemicellulose accessible to acid hydrolysis. For this reason, many efforts focused on ethanol production from biomass are based almost entirely on the fermentation of sugars derived from the starch in corn grain.

Carbohydrates (starch, cellulose, sugars): starch readily obtained from wheat and potato, while cellulose is obtained from wood pulp. The structures of these polysaccharides can be readily manipulated to produce a range of biodegradable polymers with properties similar to those of conventional plastics such as polystyrene foams and polyethylene film. In addition, these polysaccharides can be hydrolyzed, catalytically or enzymatically to produce sugars, a valuable fermentation feedstock for the production of ethanol, citric acid, lactic acid, and dibasic acids such as succinic acid.

Vegetable oil is obtained from seed oil plants such as palm, sunflower, and soy. The predominant source of vegetable oils in many countries is rapeseed oil. Vegetable oils are a major feedstock for the oleo-chemicals industry (surfactants, dispersants, and personal care products) and are now successfully entering new markets such as diesel fuel, lubricants, polyurethane monomers, functional polymer additives, and solvents.

In many cases, it has been advocated that vegetable oil, and similar feedstocks, be used as feedstocks for a catalytic cracking unit. The properties of the product(s) can be controlled by controlling the process variables including the cracking temperature as well as the type of catalyst used.

Lignocellulosic fibers extracted from plants such as hemp and flax can replace cotton and polyester fibers in textile materials and glass fibers in insulation products. Lignin is a complex chemical that is most commonly derived from wood and is an integral part of the cell wall of plants. The chemical structure of lignin is unknown and, at best, can only be represented by hypothetical formulas.

Lignin is one of the most abundant organic chemicals on earth after cellulose and chitin. By way of clarification, chitin $[(C_8H_{13}O_5N)_n]$ is a long-chain polymeric polysaccharide of β-glucose that forms a hard, semitransparent material found throughout the natural world. Chitin is the main component of the cell walls of fungi and is also a major component of the exoskeletons of arthropods, such as the crustaceans (e.g., crab, lobster, and shrimp), insects (e.g., ants, beetles, and butterflies), and the beaks of cephalopods (e.g., squids and octopuses).

Lignin makes up about one-quarter to one-third of the dry mass of wood and is generally considered to be a large, cross-linked hydrophobic, aromatic macromolecules with a molecular mass that is estimated to be in excess of 10,000. Lignin fills the spaces in the cell wall between cellulose, hemicellulose, and pectin components and is covalently linked (bonded) to hemicellulose. Lignin also forms covalent bonds with polysaccharides which enables cross-linking to different plant polysaccharides. Lignin confers mechanical strength to the cell wall (stabilizing the mature cell wall) and therefore the entire plant.

The published data that are used to illustrate the amount of available biomass are, at best, estimates and do not give any indications of the true (almost inexhaustible) amounts of material available. However, the production of biomass and biofuels brings up the food crops vs. fuel crops concept, and there must be plans to ensure that local, regional, and national food needs will be met prior to shifting crop acreage into bioenergy feedstocks. This can place limitations on the amount of land available to produce energy crops but does leave the door open to use as much waste as possible for energy production.

REFERENCES

Abraham, H. 1945. *Asphalts and Allied Substances*. Van Nostrand Scientific Publishers, New York.

ASTM D4. 2015. *Test Method for Bitumen Content*. Annual Book of Standards. ASTM International, West Conshohocken, PA.

ASTM D4175. 2015. *Standard Terminology Relating to Crude Oil, Petroleum Products, and Lubricants*. Annual Book of Standards. ASTM International, Philadelphia, PA.

Babich, I.V., and Moulijn, J.A. 2003. Science and Technology of Novel Processes for Deep Desulfurization of Oil Refinery Streams: A Review. *Fuel* 82: 607–631.

Bai, L., Jiang, Y., Huang, D., and Liu, X. 2010. A Novel Scheduling Strategy for Crude Oil Blending. *Chin. J. Chem. Eng.* 18(5): 777–778.

Ben Mahmoud, M.A.M., and Aboujadeed, A. 2017. Compatibility Assessment of Crude Oil Blends Using Different Methods. *Chem. Eng. Trans.* 57: 1705–1710.

Chugh, S., Baker, R., Telesford, A., and Zhang, E. 2000. Mainstream Options for Heavy Oil: Part I – Cold Production. *J. Can. Pet. Technol.* 39(4): 31–39.

Cobb, C., and Goldwhite, H. 1995. *Creations of Fire: Chemistry's Lively History from Alchemy to the Atomic Age*. Plenum Press, New York.

Delbianco, A., and Montanari, R. 2009. *Encyclopedia of Hydrocarbons, Volume III/New Developments: Energy, Transport, Sustainability*. Eni S.p.A., Rome, Italy.

Del Carmen García, M., and Urbina, A. 2003. Effect of Crude Oil Composition and Blending on Flowing Properties. *Pet. Sci. Technol.* 21(5–6): 863–878.

Forbes, R.J. 1958a. *A History of Technology*. Oxford University Press, Oxford, United Kingdom.

Forbes, R.J. 1958b. *Studies in Early Petroleum Chemistry*. E.J. Brill Publishers, Leiden, Netherlands.

Forbes, R.J. 1959. *More Studies in Early Petroleum Chemistry*. E.J. Brill Publishers, Leiden, Netherlands.

Forbes, R.J. 1964. *Studies in Ancient Technology*. E.J. Brill Publishers, Leiden, Netherlands.

Gary, J.G., Handwerk, G.E., and Kaiser, M.J. 2007. *Petroleum Refining: Technology and Economics*, 5th Edition. CRC Press, Taylor & Francis Group, Boca Raton, FL.

Ghoshal, S., and Sainik, V. 2013. Monitor and Minimize Corrosion in High-TAN Crude Processing. *Hydrocarbon Process.* 92(3): 35–38.

Hoiberg, A.J. 1964. *Bituminous Materials: Asphalts, Tars, and Pitches*. John Wiley & Sons Inc., New York.

Hsu, C.S., and Robinson, P.R. (Editors). 2017. *Handbook of Petroleum Technology*. Springer International Publishing AG, Cham, Switzerland.

Kane, R.D., and Cayard, M.S. 2002. *A Comprehensive Study on Naphthenic Acid Corrosion. Corrosion 2002*. NACE International, Houston, TX.

Kumar, R., Voolapalli, R.V., and Upadhyayula, S. 2018. Prediction of Crude Oil Blends Compatibility and Blend Optimization for Increasing Heavy Oil Processing. *Fuel Process. Technol.* 177: 309–327.

Lee, S. 1991. *Oil Shale Technology*. CRC Press, Taylor & Francis Group, Boca Raton, FL.

Lee, S., Speight, J.G., and Loyalka, S.K. 2007. *Handbook of Alternative Fuel Technologies*. CRC Press, Taylor & Francis Group, Boca Raton, FL.

Levine, J.R. 1993. Coalification: The Evolution of Coal as a Source Rock and Reservoir Rock for Oil and Gas. *Am. Assoc. Pet. Geol., Stud. Geol.* 38: 39–77.

Long, R.B., and Speight, J.G. 1998. The Composition of Petroleum. *Petroleum Chemistry and Refining*. J.G. Speight (Editor). Taylor & Francis, Washington, DC, Chapter 2.

Maini, B.B. 1999. Foamy Oil Flow in Primary Production of Heavy Oil under Solution Gas Drive. Paper No. SPE 56541. Proceedings. *Annual Technical Conference and Exhibition*, Houston, TX, October 3–6. Society of Petroleum Engineers, Richardson, TX.

Maini, B.B. 2001. Foamy Oil Flow. Paper No. SPE 68885. SPE J. Pet. Tech., Distinguished Authors Series. Pages 54–64, October. Society of Petroleum Engineers, Richardson, TX.

Mayes, J.M. 2015. What are the Possible Impacts on US Refineries Processing Shale Oils? *Hydrocarbon Process.* 94(2): 67–70.

Meyer, R.F., and De Witt, W. Jr. 1990. *Definition and World Resources of Natural*. United States Geological Survey, Washington, DC.

Mokhatab, S., Poe, W.A., and Speight, J.G. 2006. *Handbook of Natural Gas Transmission and Processing*. Elsevier, Amsterdam, Netherlands.

Mushrush, G.W., and Speight, J.G. 1995. *Petroleum Products: Instability and Incompatibility*. Taylor & Francis, Philadelphia, PA.

Ohmes, R. 2014. Characterizing and Tracking Contaminants in Opportunity Crudes. Digital Refining. http://www.digitalrefining.com/article/1000893,Characterising_and_tracking_contaminants_in_opportunity_crudes_.html#.VJhFjV4AA; accessed November 1, 2014.

Parkash, S. 2003. *Refining Processes Handbook*. Gulf Professional Publishing, Elsevier, Amsterdam, Netherlands.

Pfeiffer, J.H. 1950. *The Properties of Asphaltic Bitumen*. Elsevier, Amsterdam, Netherlands.

Poon, D., and Kisman, K. 1992. Non-Newtonian Effects on the Primary Production of Heavy Oil Reservoirs. *J. Can. Pet. Technol.* 31(7): 1–6.

Rice, D.D. 1993. Composition and Origins of Coalbed Gas. *Am. Assoc. Pet. Geol., Stud. Geol.* 38: 159–184.

Scouten, C.S. 1990. Oil Shale. *Fuel Science and Technology Handbook*. J.G. Speight (Editor). Marcel Dekker Inc., New York, Chapters 25–31.

Shalaby, H.M. 2005. Refining of Kuwait's Heavy Crude Oil: Materials Challenges. Proceedings. *Workshop on Corrosion and Protection of Metals*. Arab School for Science and Technology. December 3–7, Kuwait.

Sheng, J.J., Maini, B.B., Hayes, R.E., and Tortike, W.S. 1999. Critical Review of Foamy Oil Flow. *Trans. Porous Media* 35: 157–187.

Speight, J. G. 1984. *Characterization of Heavy Crude Oils and Petroleum Residues*. S. Kaliaguine and A. Mahay (Editors). Elsevier, Amsterdam, Netherlands, Page 515.

Speight, J.G. 2000. *The Desulfurization of Heavy Oils and Residua*, 2nd Edition. Marcel Dekker Inc., New York.

Speight, J.G. 2011a. *The Refinery of the Future*. Gulf Professional Publishing, Elsevier, Oxford, United Kingdom.

Speight, J.G. (Editor). 2011b. *The Biofuels Handbook*. Royal Society of Chemistry, London, United Kingdom.

Speight, J.G. 2011c. *An Introduction to Petroleum Technology, Economics, and Politics*. Scrivener Publishing, Beverly, MA.

Speight, J.G. 2012a. *Crude Oil Assay Database*. Knovel, Elsevier, New York. Online version available at: http://www.knovel.com/web/portal/browse/display?_EXT_KNOVEL_DISPLAY_bookid=5485&VerticalID=0.

Speight, J.G. 2012b. *Shale Oil Production Processes*. Gulf Professional Publishing, Elsevier, Oxford, United Kingdom.

Speight, J. G. 2013a. *The Chemistry and Technology of Coal*, 3rd Edition. CRC-Taylor & Francis Group, Boca Raton, FL.

Speight, J.G. 2013b. *Heavy Oil Production Processes*. Gulf Professional Publishing, Elsevier, Oxford, United Kingdom.

Speight, J.G. 2013c. *Oil Sand Production Processes*. Gulf Professional Publishing, Elsevier, Oxford, United Kingdom.

Speight, J.G. 2013d. *Heavy and Extra Heavy Oil Upgrading Technologies*. Gulf Professional Publishing, Elsevier, Oxford, United Kingdom.

Speight, J.G. 2013e. *Coal-Fired Power Generation Handbook*. Scrivener Publishing, Beverly, MA.

Speight, J.G. 2014a. *The Chemistry and Technology of Petroleum*, 5th Edition. CRC Press, Taylor & Francis Group, Boca Raton, FL.

Speight, J.G. 2014b. *High Acid Crudes*. Gulf Professional Publishing, Elsevier, Oxford, United Kingdom.

Speight, J.G. 2014c. *Oil and Gas Corrosion Prevention*. Gulf Professional Publishing, Elsevier, Oxford, United Kingdom.

Speight, J.G. 2015a. *Handbook of Hydraulic Fracturing*. John Wiley & Sons Inc., Hoboken, NJ.

Speight, J.G. 2015b. *Handbook of Petroleum Product Analysis*, 2nd Edition. John Wiley & Sons Inc., Hoboken, NJ.

Speight, J.G. 2015c. *Asphalt Materials Science and Technology*. Butterworth-Heinemann, Elsevier, Oxford, United Kingdom.

Speight, J.G. 2015d. *Fouling in Refineries*. Gulf Professional Publishing Company, Elsevier, Oxford, United Kingdom.

Speight, J.G. 2016. *Introduction to Enhanced Recovery Methods for Heavy Oil and Tar Sands*, 2nd Edition. Gulf Professional Publishing, Elsevier, Oxford, United Kingdom.

Speight, J.G. 2017. *Handbook of Petroleum Refining*. CRC Press, Taylor & Francis Group, Boca Raton, FL.

Speight, J.G. 2019a. *Natural Gas: A Basic Handbook*, 2nd Edition. Gulf Publishing Company, Elsevier, Cambridge, MA.

Speight, J.G. 2019b. *Handbook of Petrochemical Processes*. CRC Press, Taylor & Francis Group, Boca Raton, FL.

Speight, J.G. 2020. *Synthetic Fuels Handbook: Properties, Processes, and Performance*, 2nd Edition. McGraw-Hill, New York.

Speight, J.G., and Francisco, M.A. 1990. Studies in Petroleum Composition IV: Changes in the Nature of Chemical Constituents during Crude Oil Distillation. *Rev. Inst. Fr. Pét.* 45: 733.

Speight, J.G., and Islam, M.R. 2016. *Peak Energy – Myth or Reality*. Scrivener Publishing, Beverly, MA.

US EIA. 2011. *Review of Emerging Resources. US Shale Gas and Shale Oil Plays.* Energy Information Administration, United States Department of Energy, Washington, DC.

US EIA. 2013. *Technically Recoverable Shale Oil and Shale Gas Resources: An Assessment of 137 Shale Formations in 41 Countries outside the United States.* Energy Information Administration, United States Department of Energy, Washington, DC.

Van Nes, K., and van Westen, H. A. 1951. *Aspects of the Constitution of Mineral Oils.* Elsevier, Amsterdam, Netherlands.

Wright, L., Boundy, R., Perlack, R., Davis, S., and Saulsbury, B. 2006. Biomass Energy Data Book: Edition 1. Office of Planning, Budget and Analysis, Energy Efficiency and Renewable Energy, United States Department of Energy. Contract No. DE-AC05-00OR22725. Oak Ridge National Laboratory, Oak Ridge, TN.

Yeung, T.W. 2014. Evaluating Opportunity Crude Processing. Digital Refining. http://www.digitalrefining.com/article/1000644; accessed October 25, 2014.

2 Feedstock Evaluation

2.1 INTRODUCTION

In any refinery, the starting is a description of the products as well as the range of products that are produced by the various refining processes. This must also include a description of each of the individual crude oils that are members of the blend that is fed to the distillation unit. Moreover, current refineries no longer accept a single crude oil as the feedstock but accept several crude oils which are fed to the refinery as a blend. Evaluation of the individual crude oils in a blended feedstock typically involves an examination of one or more of the physical properties of the material. By this means, a set of basic characteristics can be obtained that can be correlated with utility (Speight, 2014a, 2015, 2017).

Evaluation, in this context, is the determination of the physical and chemical characteristics of crude oil, heavy crude oil, extra-heavy crude oil, and tar sand bitumen since the yields and properties of products or fractions produced from these feedstocks vary considerably and are dependent on the concentration of the various types of hydrocarbon derivatives as well as the amounts of the heteroatom compounds (i.e., molecular constituents contacting nitrogen and/or oxygen and/or sulfur and/or metals). Some types of feedstocks have economic advantages as sources of fuels and lubricants with highly restrictive characteristics because they require less specialized processing than that needed for production of the same products from many types of feedstocks. Others may contain unusually low concentrations of components that are desirable fuel or lubricant constituents, and the production of these products from certain types of feedstocks (such as extra-heavy crude oil and tar sand bitumen) may not be economically feasible.

In the early days of petroleum processing, because of the character and easy-to-refine nature of petroleum, there was no need to understand the character and behavior of refinery feedstocks in detail that is currently required. Refining was relatively simple and involved distillation of the valuable kerosene fraction that was then sold as an illuminant. However, with the acceptance of several crude oils and the resulting crude oil blend by refineries, feedstock evaluation is an important aspect of the pre-refining examination of a refinery feedstock.

In the modern refinery, strategies for upgrading petroleum emphasize differences in properties that, in turn, influence the choice of methods or combinations thereof for conversion of petroleum to various products (Parkash, 2003; Gary et al., 2007; Speight, 2014a; Hsu and Robinson, 2017; Speight, 2017). Naturally, similar principles are applied to heavy feedstocks (such as heavy oil, extra-heavy oil, tar sand bitumen, and residua), and the availability of processes that can be employed to convert these feedstocks to usable products has increased significantly in recent years (Parkash, 2003; Gary et al., 2007; Speight, 2014a; Hsu and Robinson, 2017; Speight, 2017).

Since feedstocks exhibit a wide range of physical properties that may be mixed into a blend before introduction to the refining processes, it is not surprising the behavior of the various feedstocks in refinery operations is not simple. The atomic ratios from ultimate analysis can give an indication of the nature of a feedstock and the generic hydrogen requirements to satisfy the refining chemistry, but it is not possible to predict with any degree of certainty how the feedstock will behave during refining.

In addition, the chemical composition of a feedstock is also an indicator of refining behavior (Parkash, 2003; Gary et al., 2007; Speight, 2014a, 2015; Hsu and Robinson, 2017; Speight, 2017). Whether the composition is represented in terms of the chemical nature of the constituents or in terms of generic compound classes, chemical composition can play a large part in determining the nature of the products that arise from the refining operations. It can also play a major role in

determining the means by which a particular feedstock should be processed (Parkash, 2003; Gary et al., 2007; Speight, 2014a; Hsu and Robinson, 2017; Speight, 2017).

Although it is possible to classify refinery operations using the three general terms: (i) separation, (ii) conversion, and (iii) finishing, the chemical composition of a feedstock is a much truer indicator of refining behavior. Whether the composition is represented in terms of compound types or in terms of generic compound classes, it can enable the refiner to determine the nature of the reactions. Hence, chemical composition can play a large part in determining the nature of the products that arise from the refining operations. It can also play a role in determining the means by which a particular feedstock should be processed (Wallace, 1988; Wallace et al., 1988; Parkash, 2003; Gary et al., 2007; Speight, 2014a; Hsu and Robinson, 2017; Speight, 2017).

To satisfy specific needs with regard to the type of feedstock to be processed, as well as to the nature of the product, most refiners have, through time, developed their own methods of feedstock analysis and evaluation. However, such methods are considered proprietary and are not normally available. Consequently, various standard organizations, such as the ASTM International (formerly the American Society for Testing and Materials) in North America have devoted considerable time and effort to the correlation and standardization of methods for the inspection and evaluation of refinery feedstocks and the products. A complete discussion of the large number of routine tests available for feedstocks fills an entire book (Speight, 2015; ASTM, 2019). However, it seems appropriate that in any discussion of the physical properties of the feedstock and the related products, reference should be made to the corresponding standard test method and, accordingly, the various test numbers have been included in the text.

Whatever the test method employed to evaluate refinery feedstocks, the test methods should be standardized (within a company or by a standards organization) to produce a series of consistent and standardized characterization procedures (Speight, 2015). A further requirement is that the standard procedures can be used with a wide variety of feedstocks to develop a general approach to predict processability. The ability to predict the outcome of feedstock processing offers (i) the choice of processing sequences, (ii) the potential to mitigate coke lay-down on the catalyst by mitigating the chemical reactions that produce coke, (iii) determining the catalyst tolerance to different feedstocks, (iv) the ability to predict product distribution and product quality, and (v) the ability to predict the potential for incompatibility in the blended refinery feedstock, and (vi) the ability to predict the potential for incompatibility during processing as well as the potential for incompatibility between the newly formed product with unreacted and reacted feedstock constituents.

In respect of the issues of incompatibility during refinery operations, as already noted (Chapter 1) the predictability of the behavior of the feedstock during refining can be assessed by the development of models to estimate when incompatibility will occur. However, it must be remembered that models are paper calculations and may not always reflect the true behavior of the feedstock under the temperature and pressure conditions to which the feedstock is subjected during refining. For example, a model may predict excellent feedstock refinability in a particular process but in reality fouling (a form of incompatibility of a product with the feedstock constituents in a reactor or after the products have been pumped from the reactor.

In order to reduce fouling, it is necessary to perform a thorough assessment of the feedstock. This can only be achieved by knowing the feedstock and its behavior in a series of prescribed test methods that enable to refiner to predict the behavior of the feedstock during the refining process (Chapters 3–5). It is also necessary to be able to assess the behavior of the products in the same mix as unreacted and reacted feedstock (i.e., feedstock constituents that are intermediate between the original feedstock constituents and the final products. Fortunately, a number of experimental methods are available for estimation of the factors that influence instability/incompatibility (Chapter 4).

It is the purpose of this chapter to present an outline of the tests that may be applied to crude oil, heavy crude oil, extra-heavy crude oil, and tar sand bitumen as well as to their respective products as well as the resulting chemical properties and physical properties from which a feedstock or product can be evaluated (Speight, 2014a, 2015, 2017). For this purpose, data relating to various

chemical physical properties have been included as illustrative examples, but theoretical discussions of the physical properties of hydrocarbon derivatives were deemed irrelevant and are omitted.

2.2 FEEDSTOCK ASSAY

The general condition or properties of a refinery feedstock is determined by a feedstock assay which is derived from a series of test data that give an accurate description of feedstock quality and allow an indication of its behavior during refining. The first step is, of course, to assure adequate (correct) sampling by use of the prescribed protocols (ASTM D4057). In the assay, analyses are performed to determine whether each batch of feedstock received at the refinery is suitable for refining purposes. However, in order to obtain the necessary information, two different analytical schemes are commonly used, and these are (i) an inspection assay and (ii) a comprehensive assay (Table 2.1) (Speight, 2014a, 2015, 2017).

Inspection assays usually involve determination of several key bulk properties of the feedstock (e.g., API (American Petroleum Institute) gravity, sulfur content, pour point, and distillation range) as a means of determining if *major* changes in characteristics have occurred since the last comprehensive assay was performed. For example, a more detailed inspection assay might consist of the following tests: API gravity (or density or relative density), sulfur content, pour point, viscosity, salt content, water and sediment content, trace metals (or organic halides). The results from these tests with the archived data from a comprehensive assay provide an estimate of any changes that have

TABLE 2.1

Recommended Inspection Data Required for Crude Oil and Heavy Feedstocks (Heavy Crude Oil, Extra-Heavy Crude Oil, and Tar Sand Bitumen)

Crude Oil[a]	Heavy Feedstocks[b]
Density, specific gravity	Density, specific gravity
API gravity	API gravity
Carbon, % w/w	Carbon, % w/w
Hydrogen, % w/w	Hydrogen, % w/w
Nitrogen, % w/w	Nitrogen, % w/w
Sulfur, % w/w	Sulfur, % w/w
	Nickel, ppm
	Vanadium, ppm
	Iron, ppm
Pour point	Pour point
Wax content	
Wax appearance temperature	
Viscosity (various temperatures)	Viscosity (various temperatures)
Carbon residue of residuum	Carbon residue, % w/w
	Ash, % w/w
Distillation profile:	Fractional composition:
All fractions plus vacuum residue	Asphaltenes, % w/w
	Resin constituents, % w/w
	Aromatics, % w/w
	Saturates, % w/w

[a] Preliminary assay.
[b] Full assay.

occurred in the feedstock that may be critical to refinery operations. Inspection assays are routinely performed on all feedstocks received at a refinery.

On the other hand, the comprehensive (or full) assay is more complex (as well as time-consuming and costly) and is usually only performed only when a new field comes on stream, or when the inspection assay indicates that significant changes in the composition of the feedstock have occurred. Except for these circumstances, a comprehensive assay of a particular feedstock stream may not (unfortunately) be updated for several years. A full feedstock assay may involve at least determinations of (i) carbon residue yield, (ii) density or specific gravity, (iii) sulfur content, (iv) distillation profile or volatility, (v) metallic constituents, (vi) viscosity, and (vii) pour point as well as any tests designated necessary to understand properties and behavior of the feedstock under examination.

The inspection assay tests discussed above are not exhaustive but are the ones most commonly used and provide data on the impurities present as well as a general idea of the products that may be recoverable. Other properties that are determined on an as needed basis include, but are not limited to, the following: (i) vapor pressure by the Reid method, ASTM D323, (ii) total acid number, ASTM D664, and the aniline point or mixed aniline point, ASTM D611.

Using the data derived from the test assay, it is possible to assess feedstock quality acquire a degree of predictability of performance during refining. However, knowledge of the basic concepts of refining will help the analyst understand the production and, to a large extent, the anticipated properties of the product, which, in turn, is related to storage, sampling, and handling the products.

2.3 PHYSICAL PROPERTIES

For the purposes of this text, a *physical property* is any property that is measurable and the value of which describes the physical state of the feedstock that does not change the chemical nature of the feedstock. The changes in the physical properties of a system can be used to describe its transformations (or evolutions between its momentary states). Physical properties are contrasted with chemical properties, which determine the way a material behaves in a chemical reaction.

Several relationships can be made between various physical properties (Speight, 2001, 2014a, 2015, 2017). Whereas the properties such as viscosity, density, boiling point, and color of the feedstock may vary widely, the ultimate or elemental analysis varies, as already noted, over a narrow range for a large number of feedstock samples. The carbon content is relatively constant, while the hydrogen and heteroatom contents are responsible for the major differences between the various feedstocks. Coupled with the changes brought about to the feedstock constituents by refinery operations, it is not surprising that feedstock characterization is a monumental task.

Thus, the standard test methods described below in the various sections (presented in alphabetical order rather than order of preference, which is feedstock dependent) are based on the assumption that water has been reduced to an acceptable level, is usually defined by each standard test.

2.3.1 ACID NUMBER

A characteristic of the feedstock is the *total acid number* (TAN), which represents a composite of acids present in the feedstock (ASTM D664) and is often also expressed as the *neutralization number*. High-acid feedstocks are considered to be those with an acid content >1.0 mg KOH/gm sample (many refiners consider TAN number greater than 0.5 mg KOH/gm to be high) and refiners looking for discounted crude supplies will import and use greater volumes of high total acid number (TAN) feedstocks. Caution is advised since these feedstocks are also a cause of corrosion during their passage through the refinery processes.

Current methods for the determination of the acid content are well established (ASTM D664) which includes potentiometric titration in non-aqueous conditions to clearly defined end points as detected by changes in millivolts readings versus volume of titrant used. A color indicator method (ASTM D974) is also available.

TABLE 2.2
Standard Test Methods Designated for Elemental Analysis

Analysis	Test Methods
Carbon and hydrogen	ASTM D1018, ASTM D3178, ASTM D3343, ASTM D3701, ASTM D5291, ASTM E777
Nitrogen	ASTM D3179, ASTM D3228, ASTM E258, ASTM D5291, ASTM E778
Oxygen	ASTM E385
Sulfur	ASTM D129, ASTM D139, ASTM D1266, ASTM D1552, ASTM D1757, ASTM D2622, ASTM D3120, ASTM D3177, ASTM D4045, ASTM D4294
Metals content	ASTM C1109, ASTM C1111, ASTM D482, ASTM D1318, ASTM D3340, ASTM D3341, ASTM D3605

2.3.2 ELEMENTAL ANALYSIS

The elemental analysis (ultimate analysis) of a feedstock for the percentages of carbon, hydrogen, nitrogen, oxygen, and sulfur is perhaps the first method used to examine the general nature, and perform an evaluation, of a feedstock. The atomic ratios of the various elements to carbon (i.e., H/C, N/C, O/C, and S/C) are frequently used for indications of the overall character of the feedstock. It is also of value to determine the amounts of trace elements, such as vanadium, nickel, and other metals, in a feedstock since these materials can have serious deleterious effects on catalyst performance during refining by catalytic processes.

However, it has become apparent, with the introduction of the more viscous feedstocks into refinery operations, that these ratios are not the only requirement for predicting feedstock character before refining. The use of more complex feedstocks (in terms of chemical composition) has added a new dimension to refining operations. Thus, although atomic ratios, as determined by elemental analyses, may be used on a comparative basis between feedstocks, there is now no guarantee that a particular feedstock will behave as predicted from these data. Product slates cannot be predicted accurately, if at all, from these ratios.

The ultimate analysis (elemental composition) of a refinery feedstock is not reported to the same extent as for coal (Speight, 1994). Nevertheless, there are ASTM procedures (ASTM, for the ultimate analysis of the feedstock and products but many such methods may have been designed for other materials (Speight, 2015). For example, *carbon content* can be determined by the method designated for coal and coke (ASTM D3178) or by the method designated for municipal solid waste (ASTM E777) (Table 2.2).

Of the data that are available, the proportions of the elements in crude oil vary only slightly over narrow limits (Speight, 2014a, 2015, 2017):

Carbon	83.0%–87.0%
Hydrogen	10.0%–14.0%
Nitrogen	0.1%–2.0%
Oxygen	0.05%–1.5%
Sulfur	0.05%–6.0%
Metals (Ni and V)	<1,000 ppm

And yet, there is a wide variation in physical properties from the lighter (low density) more mobile crude oil at one extreme to the heavier (high density) asphaltic crude oils at the other extreme. The majority of the more aromatic species and the heteroatoms occur in the higher-boiling fractions of feedstocks and the viscous feedstocks are relatively rich in these higher-boiling fractions (Speight, 2014a, 2015).

Of the ultimate analytical data, more has been made of the sulfur content than any other property. For example, the sulfur content (ASTM D1552, ASTM D4294) and the API gravity represent the two properties that have, in the past, had the greatest influence on determining the value of a refinery feedstock. The sulfur content varies from approximately 0.1% w/w to approximately 3% w/w for the more conventional crude oils to as much as 5%–6% for extra-heavy crude oil and tar sand bitumen. Residua, depending on the sulfur content of the feedstock, may be of the same order or even have higher sulfur content. Indeed, the very nature of the distillation process by which residua are produced, that is, removal of distillate without thermal decomposition, dictates that the majority of the sulfur, which is located predominantly in the higher-molecular-weight fractions, be concentrated in the non-volatile residuum.

2.3.3 DENSITY AND SPECIFIC GRAVITY

The *density* and *specific gravity* (ASTM D70, ASTM D71, ASTM D287, ASTM D1217, ASTM D1298, ASTM D1480, ASTM D1481, ASTM D1555, ASTM D1657, ASTM D4052) are two properties that have found wide use in the industry for preliminary assessment of the character and quality of the feedstock.

Density is the mass of a unit volume of material at a specified temperature and has the dimensions of grams per cubic centimeter (a close approximation to grams per milliliter). *Specific gravity* is the ratio of the mass of a volume of the substance to the mass of the same volume of water and is dependent on two temperatures, those at which the masses of the sample and the water are measured. When the water temperature is 4°C (39°F), the specific gravity is equal to the density in the centimeter-gram-second (cgs) system, since the volume of 1 g of water at that temperature is, by definition, 1 ml. Thus the density of water, for example, varies with temperature, and its specific gravity at equal temperatures is always unity.

In the early years of the crude oil industry, density was the principal specification for a refinery feedstock and was used to give an estimation of the naphtha (the precursor to gasoline) and, more particularly, the kerosene present in the feedstock. However, the derived relationships between the density of the feedstock and the fractional composition of the feedstock (Chapter 3) were valid only if they were applied to a certain type of feedstock and lost some of their significance when applied to different types of refinery feedstocks. Nevertheless, density is still used to give a rough estimation of the nature of the feedstock. Although density and specific gravity are used extensively, the API gravity is the preferred property:

$$\text{Degrees API} = (141.5 / \text{sp gr @ } 60 / 60°F) - 131.5$$

Specific gravity is influenced by the chemical composition of a feedstock, but quantitative correlation is difficult to establish. Nevertheless, it is generally recognized that increased amounts of aromatic compounds result in an increase in density, whereas an increase in saturated compounds results in a decrease in density. Indeed, it is also possible to recognize certain preferred trends between the density of a feedstock and one or another of the physical properties. For example, an approximate correlation exists between the density (API gravity) and sulfur content, Conradson carbon residue, viscosity, and nitrogen content (Speight, 2000).

The density or specific gravity of crude oil, heavy crude oil, extra-heavy crude oil, and tar sand bitumen may be measured by means of a hydrometer (ASTM D287, ASTM D1298, ASTM D1657) or by means of a pycnometer (ASTM D70, ASTM D1217, ASTM D1480, and ASTM D1481), or by means of a digital density meter (ASTM D4052) and a digital density analyzer (ASTM D5002). Not all of these methods are suitable for measuring the density (or specific gravity of heavy oil and bitumen although some methods lend themselves to adaptation. The API gravity of a feedstock (ASTM D287) is calculated directly from the specific gravity.

The density of a feedstock usually ranges from approximately 0.8 (45.3° API) for the lighter (less viscous) feedstocks to more than 1.0 (less than 10° API) for extra-heavy crude oil, tar sand

bitumen – the density of heavy crude oil feedstocks is often borderline between these two numbers but does range considerably. The variation of density with temperature (Speight, 2015), effectively the coefficient of expansion, is a property of great technical importance in the refinery.

The API gravity of a feedstock (ASTM D287) is calculated directly from the specific gravity. The specific gravity of bitumen shows a fairly wide range of variation. The largest degree of variation is usually due to local conditions that affect material close to the faces, or exposures, occurring in surface oil sand beds. There are also variations in the specific gravity of the bitumen found in beds that have not been exposed to weathering or other external factors. The range of specific gravity usually varies over the range of the order of 0.995–1.04.

2.3.4 METALS CONTENT

Metal-containing constituents cause problems during refining because they poison catalysts used for sulfur and nitrogen removal. The heavier more viscous feedstocks (heavy crude oil, extra-heavy crude oil, and tar sand bitumen) contain relatively high proportions of metals either in the form of salts or as organometallic constituents (such as the metallo-porphyrins), which are extremely difficult to remove from the feedstock. Indeed, the nature of the process by which residua are produced virtually dictates that all the metals in the original feedstock are concentrated in the residuum (Speight, 2000, 2014a, 2015, 2017). Those metallic constituents that may actually *volatilize* under the distillation conditions and appear in the higher=boiling distillates are the exceptions here. The deleterious effect of metallic constituents on the catalyst is known, and serious attempts have been made to develop catalysts that can tolerate a high concentration of metals without serious loss of catalyst activity or catalyst life.

The viscous feedstocks (heavy crude oil, extra-heavy crude oil, and tar sand bitumen) contain relatively high proportions of metals either in the form of salts or as organometallic constituents (such as the metallo-porphyrins), which are extremely difficult to remove from the feedstock. Indeed, the nature of the process by which residua are produced virtually dictates that all the metals in the original feedstock are concentrated in the residuum (Speight, 2000, 2014a, 2017). Those metallic constituents that may actually *volatilize* under the distillation conditions and appear in the higher-boiling distillates are the exceptions here. The deleterious effect of metallic constituents on the catalyst is known, and serious attempts have been made to develop catalysts that can tolerate a high concentration of metals without serious loss of catalyst activity or catalyst life.

2.3.5 SURFACE AND INTERFACIAL TENSION

Surface tension is a measure of the force acting at a boundary between two phases. If the boundary is between a liquid and a solid or between a liquid and a gas (air), the attractive forces are referred to as surface tension, but the attractive forces between two immiscible liquids are referred to as *interfacial tension*.

Temperature and molecular weight have a significant effect on surface tension (Speight, 2014a, 2015). For example, in the normal hydrocarbon series, a rise in temperature leads to a decrease in the surface tension, but an increase in molecular weight increases the surface tension. A similar trend, that is, an increase in molecular weight causing an increase in surface tension, also occurs in the acrylic series and, to a lesser extent, in the alkylbenzene series.

A high proportion of the complex phenomena shown by emulsions and foams can be traced to these induced surface tension effects. Dissolved gases, even hydrocarbon gases, lower the surface tension of oils, but the effects are less dramatic and the changes probably result from dilution. The matter is presumably of some importance in production engineering in which the viscosity and surface tension of the reservoir fluid may govern the amount of oil recovered under certain conditions.

2.3.6 Viscosity

Viscosity is the force in dynes required to move a plane of $1 \, cm^2$ area at a distance of $1 \, cm$ from another plane of $1 \, cm^2$ area through a distance of $1 \, cm$ in 1 second. In the centimeter-gram-second (cgs) system, the unit of viscosity is the poise or centipoise (0.01 P). Two other terms in common use are *kinematic viscosity* and *fluidity*. The kinematic viscosity is the viscosity in centipoises divided by the specific gravity, and the unit is the stoke (cm^2/s), although centistokes (0.01 cSt) is in more common usage; fluidity is simply the reciprocal of viscosity. The viscosity (ASTM D445, ASTM D88, ASTM D2161, ASTM D341, ASTM D2270) of refinery feedstocks varies markedly over a very wide range. Values vary from less than 10 cP at room temperature to many thousands of centipoises at the same temperature.

In the early days of the crude oil industry, viscosity was regarded as the *body* of the feedstock, a significant number for lubricants or for any liquid pumped or handled in quantity. The changes in viscosity with temperature, pressure, and rate of shear are pertinent not only in lubrication but also for such engineering concepts as heat transfer. The viscosity and relative viscosity of different phases, such as gas, liquid oil, and water, are determining influences in producing the flow of reservoir fluids through porous oil-bearing formations. The rate and amount of oil production from a reservoir are often governed by these properties.

Many types of instruments have been proposed for the determination of viscosity. The simplest and most widely used are capillary types (ASTM D445), and the viscosity is derived from the equation:

$$\mu = \pi r^4 P / 8nl$$

Where r is the tube radius, l the tube length, P the pressure difference between the ends of a capillary, n the *coefficient of viscosity*, and the quantity discharged in unit time. Not only are such capillary instruments the most simple, but when designed in accordance with known principle and used with known necessary correction factors, they are probably the most accurate viscometers available. It is usually more convenient, however, to use relative measurements, and for this purpose the instrument is calibrated with an appropriate standard liquid of known viscosity.

As a result of the various methods for viscosity determination, it is not surprising that much effort has been spent on interconversion of the several scales, especially converting Saybolt to kinematic viscosity (ASTM D2161). Each table or chart is constructed in such a way that for any given feedstock the viscosity-temperature points result in a straight line over the applicable temperature range. Thus, only two viscosity measurements need be made at temperatures far enough apart to determine a line on the appropriate chart from which the approximate viscosity at any other temperature can be read. The charts can be applicable only to measurements made in the temperature range in which a given feedstock is a Newtonian liquid. The oil may cease to be a simple liquid near the cloud point because of the formation of wax particles or, near the boiling point, because of vaporization. However, the charts do not give accurate results when either the cloud point or boiling point is approached but they are useful over the Newtonian range for estimating the temperature at which oil attains a desired viscosity.

2.4 THERMAL PROPERTIES

The thermal properties of feedstock are those properties (or characteristics) that determine how feedstock will behave (or react) when it is subjected to excessive heat or heat fluctuations over time.

As with all properties of feedstocks, a collection of standard test methods is instrumental in the evaluation and assessment of the thermal properties (Speight, 2015). These standards allow refineries to appropriately examine and process the feedstock in a safe and efficient manner.

2.4.1 ANILINE POINT

The *aniline point* of a liquid was originally defined as the *consolute* or *critical solution temperature* of the two liquids, that is, the minimum temperature at which they are miscible in all proportions. The term is now most generally applied to the temperature at which exactly equal parts of the two are miscible. This value is more conveniently measured than the original value and is only a few tenths of a degree lower for most substances.

Although it is an arbitrary index (ASTM D611), the aniline point is of considerable value in the characterization of refinery products, it does have some value when applied to refinery feedstocks. For example, when considering feedstocks of a particular type the aniline point increases slightly with molecular weight while for feedstocks having a similar molecular weight the aniline point it increases rapidly with increasing paraffinic character. The simplicity of the determination makes it attractive for an estimation of the aromatic content of a feedstock when that value is important for functional requirements.

2.4.2 CARBON RESIDUE

Refinery feedstocks are mixtures of many compounds that differ widely in their physical and chemical properties. Some of the feedstock constituents may be vaporized in the absence of air at atmospheric pressure without leaving an appreciable residue. Other nonvolatile constituents leave a carbonaceous residue when destructively distilled under such conditions. This residue is known as carbon residue when determined in accordance with prescribed procedure.

The carbon residue of any feedstocks is a property that can be correlated with several other properties of the feedstock (Speight, 2000, 2014a, 2015, 2017) and, hence, the value of the carbon residue also presents indications of the volatility of the crude oil and the coke-forming (or distillate-producing) propensity. In addition, the standard test methods for determining the carbon residue are often used to evaluate the carbonaceous depositing characteristics of feedstocks in certain types of catalytic units.

There are two older methods for determining the carbon residue of a crude oil or crude oil product: the *Conradson method* (ASTM D189) and the *Ramsbottom method* (ASTM D524). Both are applicable to the relatively nonvolatile portion of a feedstock, which partially decompose when distilled at a pressure of 1 atmosphere. However, a feedstock that contains mineral (i.e., ash-forming) constituents will have an erroneously high carbon residue – the degree of error is proportional to the amount of mineral matter in the feedstock – by either method unless the mineral matter is first removed from the feedstock.

A third method, involving micropyrolysis of the sample, is also available as a standard test method (ASTM D4530). The method requires smaller sample amounts and was originally developed as a *thermogravimetric method*. The carbon residue produced by this method is often referred to as the *microcarbon residue* (*MCR*). Agreements between the data from the three methods are good, making it possible to interrelate all of the data from carbon residue tests (Long and Speight, 1989).

Even though the three methods have their relative merits, there is a tendency to advocate use of the more expedient microcarbon method to the exclusion of the Conradson and Ramsbottom methods because of the lesser amounts required in the *microcarbon* method, which is somewhat less precise in practical technique.

The carbon residue is a property that can be correlated with several other properties of a feedstock. Hence it also presents indications of the volatility of the feedstock and the coke-forming (or distillate-producing) propensity of the feedstock (Speight, 2014a, 2015, 2017).

Recent work has focused on the carbon residue of the different fractions of a feedstocks, especially the asphaltene constituents (Chapter 4) (Speight, 1994, 2014a, 2015). A more precise

relationship between carbon residue and hydrogen content, H/C atomic ratio, nitrogen content, and sulfur content has been shown to exist. These data can provide more precise information about the anticipated behavior of a variety of feedstocks in thermal processes. Thus, there is a fairly universal linear correlation between the carbon residue (Conradson) and the H/C ratio:

$$H/C = 171 - 0.0115 \text{ CR (Conradson)}.$$

This equation holds within two limits; at H/C values = 171, where the carbon residue is zero (no coke formation) and H/C = 0.5, where the carbon residue is 100 (all the material converts to coke under test conditions). There is a relationship between the carbon residue (Conradson) and the nitrogen content.

2.4.3 CRITICAL PROPERTIES

A study of the pressure, volume, and temperature relationships of a pure component reveals a particular unique state where the properties of a liquid and vapor become indistinguishable from each other. At that state the latent heat of vaporization becomes zero and no volume change occurs when the liquid is vaporized. This state is called the critical state and the appropriate parameters of state are termed the critical pressure (P_C), critical volume (V_C), and critical temperature (T_C). It is an important characteristic of the critical state for a pure component that with values of P or T greater than either P_C or T_C the vapor and liquid states cannot coexist at equilibrium, and thus P_C and T_C represent the maximum values of P and T at which phase separation can occur.

Since the critical state of a component is unique, it is perhaps not surprising that knowledge of P_C, T_C, and V_C allows many predictions to be made concerning the physical properties of substances. These predictions are based on the Law of Corresponding States that states that substances behave in the same way when they are in the same state with reference to the critical state. The particular corresponding state is characterized by its reduced properties, i.e., $T_r = T/T_C$, $P_r = P/P_C$, $V_r = V/V_C$.

The temperature, pressure, and volume at the critical state are of considerable interest in feedstock physics, particularly in connection with modern high-pressure, high-temperature refinery operations and in correlating pressure–temperature–volume relationships for other states. Critical data are known for most of the lower-molecular-weight pure hydrocarbon derivatives, and standard methods are generally used for such determinations. The temperature, pressure, and volume at the critical state are of considerable interest in feedstock physics, particularly in connection with modern high-pressure, high-temperature refinery operations and in correlating pressure–temperature–volume relationships for other states. Critical data are known for most of the lower-molecular-weight pure hydrocarbon derivatives, and standard methods are generally used for such determinations.

The *critical point* of a pure compound is the equilibrium state in which its gaseous and liquid phases are indistinguishable and coexistent; they have the same intensive properties. However, localized variations in these phase properties may be evident experimentally. The definition of the critical point of a mixture is the same. However, mixtures generally have a maximum temperature or pressure at other than the true critical point; *maximum* here denotes the greatest value at which two phases can coexist in equilibrium.

2.4.4 ENTHALPY

Enthalpy (heat content) is the heat energy necessary to bring a system from a reference state to a given state. Enthalpy is a function only of the end states and is the integral of the specific heats with respect to temperature between the limit states, plus any latent heats of transition that occur within the interval. The usual reference temperature is 0°C (32°F). Enthalpy data are easily obtained from

specific heat data by graphic integration, or, if the empirical equation given for specific heat is sufficiently accurate, from the equation:

$$H = 1 / d \; (0.388 + 0.000225t^2 - 12.65)$$

Generally, only differences in enthalpy are required in engineering design, that is, the quantity of heat necessary to heat (or cool) a unit amount of material from one temperature to another. Such calculations are very simple since the quantities are arithmetically additive, and the enthalpy for such a change of state is merely the difference between the enthalpies of the end states.

2.4.5 Heat of Combustion

The heat of combustion (ASTM D240) is a direct measure of fuel energy content and is determined as the quantity of heat liberated by the combustion of a quantity of fuel with oxygen in a standard bomb calorimeter.

Chemically, the heat of combustion is the energy (heat) released when an organic compound is burned to produce water (H_2O_{liquid},) carbon dioxide (CO_{2gas}), sulfuric acid ($H_2SO_{4liquid}$), and nitric acid ($HNO_{3liquid}$). The value can be calculated using a theoretical equation based upon the elemental composition of the feedstock:

$$H_g / 4.187 = 8,400C + 27,765H + 1,500N + 2,500S - 2,650O$$

H_g is given in kilo joules per kilogram (1.0 kJ/kg=0.43 Btu/lb), C, H, N, S, and O are the normalized weight fractions for these elements in the sample.

The gross heats of combustion of a feedstocks is given with fair accuracy by the equation:

$$Q = 12,400 - 2,100d^2$$

Where d is the 60/60°F specific gravity. Deviation is generally less than 1% although many highly aromatic feedstocks show considerably higher values; the range for a variety of feedstocks is on the order of 10,000–11,600 calories/gm and the heat of combustion of heavy crude oil, extra-heavy crude oil, and tar sand bitumen is considerably higher (Speight, 2014a, 2015).

An alternative criterion of energy content is the aniline gravity product (AGP) (ASTM D1405) that is in reasonable agreement with the calorific value. It is the product of the API gravity and the aniline point (ASTM D611) of the sample.

2.4.6 Latent Heat

The *latent heat of vaporization* is the amount of heat required to vaporize a unit weight of a liquid at its atmospheric boiling point, is perhaps the most important property of the two and has received considerably more attention because of its connection with equipment design. The latent heat of vaporization at the atmospheric boiling point generally increases with increasing molecular weight and, for the normal paraffins, generally decreases with increasing temperature and pressure.

2.4.7 Liquefaction and Solidification

Many refinery feedstocks, especially the conventional crude oil and some of the less dense heavy crude oils, are liquids at ambient temperature, and problems that may arise from solidification during normal use are not common. Nevertheless, there are feedstocks and products that are semi-solid to solid due to the wax content.

Although the melting points of feedstocks are of limited usefulness, except to estimate the purity or perhaps the composition of waxes, the reverse process, *solidification*, has received attention in crude oil chemistry. In fact, solidification of a feedstock has been differentiated into four categories, namely (i) the freezing point, (ii) the congealing point, (iii) the cloud point, and (iv) the pour point.

Crude oil becomes more or less a plastic solid when cooled to sufficiently low temperatures. This is due to the congealing of the various hydrocarbon derivatives that constitute the oil. The cloud point of a crude oil is the temperature at which paraffin wax or other solidifiable compounds present in the oil appear as a haze when the oil is chilled under definitely prescribed conditions (ASTM D2500, ASTM D3117). As cooling is continued, all crude oils become more and more viscous and flow becomes slower and slower. The pour point of a crude oil is the lowest temperature at which the oil pours or flows under definitely prescribed conditions when it is chilled without disturbance at a standard rate (ASTM D97).

The solidification characteristics of a crude oil product depend on its grade or kind. For grease, the temperature of interest is that at which fluidity occurs, commonly known as the *dropping point*. The dropping point of grease is the temperature at which the grease passes from a plastic solid to a liquid state and begins to flow under the conditions of the test (ASTM D566, ASTM D2265). For another type of plastic solid, including petrolatum and microcrystalline wax, both *melting point* and *congealing point* are of interest.

In general, cloud, melting, and freezing points are of more limited value and each is of narrower range of application than the pour point. The *cloud point* of a feedstock is the temperature at which paraffin wax or other solidifiable compounds present in the oil appear as a haze when the sample is chilled under definitely prescribed conditions (ASTM D2500, ASTM D3117). The *pour point* of crude oil or a crude oil product is determined using this same technique (ASTM D97) and it is the lowest temperature at which the oil pours or flows. It is actually 2°C (3°F) above the temperature at which the oil ceases to flow under these definitely prescribed conditions when it is chilled without disturbance at a standard rate.

2.4.8 Pressure–Volume–Temperature Relationships

Hydrocarbon vapors, like other gases, follow the ideal gas law (i.e., PV=RT) only at relatively low pressures and high temperatures, that is, far from the critical state. Several more empirical equations have been proposed to represent the gas laws more accurately, such as the well-known van der Waals equation, but they are either inconvenient for calculation or require the experimental determination of several constants. A more useful device is to use the simple gas law and to induce a correction, termed the *compressibility factor*, μ, so that the equation takes the form:

$$PV = \mu RT$$

For hydrocarbon derivatives, the compressibility factor is very nearly a function only of the reduced variables of state, that is, a function of the pressure and temperature divided by the respective critical values. The compressibility factor method functions excellently for pure compounds but may become ambiguous for mixtures because the critical constants have a slightly different significance. However, the use of pseudocritical temperature and pressure values generally lower than the true values, permitting the compressibility factor to be employed in such cases.

2.4.9 Specific Heat

Specific heat is defined as the quantity of heat required to raise a unit mass of material through one degree of temperature (ASTM D2766). Specific heats are extremely important engineering quantities in refinery practice because they are used in all calculations on heating and cooling feedstocks.

Many measurements have been made on various hydrocarbon materials, but the data for most purposes may be summarized by the general equation:

$$C = 1 / d \ (0.388 + 0.00045t)$$

C is the specific heat at a specified temperature (°F) of an oil whose specific gravity 60/60°F is d; thus, specific heat increases with temperature and decreases with specific gravity.

2.4.10 THERMAL CONDUCTIVITY

The thermal conductivity K of hydrocarbon derivatives (in cgs units) is given by the equation:

$$K = 0.28 / d \ (1 - 0.00054) \times 10^{-3}$$

Where d is the specific gravity. The value for solid paraffin wax is approximately 0.00056, nearly independent of temperature and wax type; the oil equation holds satisfactorily for waxes above the melting point.

2.4.11 VOLATILITY

The volatility of a feedstock is the tendency of constituents of the feedstock to vaporize, that is, to change from the liquid to the vapor or gaseous state. However, before any volatility tests (or, for that matter, any physical tests) are carried out, it must be recognized that the presence of more than 0.5% water in test samples of crude can cause several problems during various test procedures and produce erroneous results. For example, during various thermal tests, water (which has a high heat of vaporization) requires the application of additional thermal energy to the distillation flask. In addition, water is relatively easily superheated and therefore, excessive *bumping* can occur, leading to erroneous readings and the potential for destruction of the glass equipment is real. Steam formed during distillation can act as a carrier gas and high boiling point components may end up in the distillate (often referred to as *steam distillation*).

Removal of water (and sediment) can be achieved by centrifugation if the sample is not a tight emulsion. Other methods that are used to remove water include (i) heating in a pressure vessel to control loss of light ends, (ii) addition of calcium chloride as recommended in ASTM D1160, (iii) addition of an azeotroping agent such as *iso*-propanol or n-butanol, (iv) removal of water in a preliminary low-efficiency or flash distillation followed by re-blending the hydrocarbon which co-distills with the water into the sample, and (v) separation of the water from the hydrocarbon distillate by freezing.

The vaporizing tendencies of a feedstock are the basis for the general characterization of liquid fuels (ASTM D2715). A test method (ASTM D6) also exists for determining the loss of material when a feedstock is heated. Another test (ASTM D20) is a method for the distillation of viscous feedstocks and asphalt products might also be applied to estimating the volatility of high-molecular-weight residues.

For some purposes, it is necessary to have information on the initial stage of vaporization. To supply this need, flash and fire, vapor pressure, and evaporation methods are available. The data from the early stages of the several distillation methods are also useful. For other uses, it is important to know the tendency of a product to partially vaporize or to completely vaporize, and in some cases, to know if small quantities of high-boiling components are present. For such purposes, chief reliance is placed on the distillation methods.

The *flash point* of a feedstock is the temperature to which the material must be heated under specified conditions to give of sufficient vapor to form a mixture with air that can be ignited

momentarily by a specified flame (ASTM D56, ASTM D92, ASTM D93). The *fire point* is the temperature to which the product must be heated under the prescribed conditions of the method to burn continuously when the mixture of vapor and air is ignited by a specified flame (ASTM D92).

From the viewpoint of safety, information about the flash point is of most significance at or slightly above the maximum temperatures (30°C–60°C, 86°F–140°F) that may be encountered in storage, transportation, and use of liquid materials in either closed or open containers. In this temperature range, the relative fire and explosion hazard can be estimated from the flash point. For products with flash point below 40°C (104°F), special precautions are necessary for safe handling. Flash points above 60°C (140°F) gradually lose their safety significance until they become indirect measures of some other quality. The flash point is also used to detect contamination. For example, a substantially lower flash point than expected is a reliable indicator that a feedstock has become contaminated with a more volatile material.

A further aspect of volatility that receives considerable attention is the vapor pressure of a feedstock and its constituent fractions. The *vapor pressure* is the force exerted on the walls of a closed container by the vaporized portion of a liquid. Conversely, it is the force that must be exerted on the liquid to prevent it from vaporizing further (ASTM D323). The vapor pressure increases with temperature for any given gasoline, liquefied petroleum gas, or other product. The temperature at which the vapor pressure of a liquid, either a pure compound of a mixture of many compounds, equals 1 atmosphere (14.7 psi, absolute) is designated as the boiling point of the liquid.

In each homologous series of hydrocarbon derivatives, the boiling points increase with molecular weight and structure also has a marked influence since it is a general rule that branched paraffin isomers have lower-boiling points than the corresponding n-alkane. In any given series, steric effects notwithstanding, there is an increase in boiling point with an increase in carbon number of the alkyl side chain. This particularly applies to alkyl aromatic compounds where alkyl-substituted aromatic compounds can have higher-boiling points than polycondensed aromatic systems. And this fact is very meaningful when attempts are made to develop hypothetical structures for asphaltene constituents (Speight, 1994, 2014a).

The boiling points of feedstock fractions are rarely, if ever, distinct temperatures; it is, in fact, more correct to refer to the boiling ranges of the various fractions. To determine these ranges, the feedstock is tested in various methods of distillation, either at atmospheric pressure or at reduced pressure. In general, the limiting molecular weight range for distillation at atmospheric pressure without thermal degradation is 200–250, whereas the limiting molecular weight range for conventional vacuum distillation is 500–600.

Distillation involves the general procedure of vaporizing the feedstock liquid in a suitable flask either at *atmospheric pressure* (ASTM D86, ASTM D2892) or at *reduced pressure* (ASTM D1160), and the data are reported in terms of one or more of the following seven items: (i) the initial boiling point is the thermometer reading in the neck of the distillation flask when the first drop of distillate leaves the tip of the condenser tube. This reading is materially affected by a number of test conditions, namely room temperature, rate of heating, and condenser temperature, (ii) the distillation temperatures, which are usually observed when the level of the distillate reaches each 10% mark on the graduated receiver, with the temperatures for the 5% and 95% marks often included, (iii) the end-point or maximum temperature, which is the highest thermometer reading observed during distillation. In most cases, it is reached when the entire sample has been vaporized, (iv) the dry point, which is the thermometer reading at the instant the flask becomes dry and is for special purposes, such as for solvents and for relatively pure hydrocarbon derivatives, (v) the recovery, which is the total volume of distillate recovered in the graduated receiver and residue is the liquid material, mostly condensed vapors, left in the flask after it has been allowed to cool at the end of distillation, (vi) the total recovery is the sum of the liquid recovery and residue; *distillation loss* is determined by subtracting the total recovery from 100%, and (vii) the percentage evaporated, which is the percentage recovered at a specific thermometer reading or other distillation temperatures, or the converse.

For a more detailed distillation analysis of feedstocks and products, a low-resolution, temperature-programmed gas chromatographic analysis has been developed to simulate the time-consuming true boiling point distillation. The method relies on the general observation that hydrocarbon derivatives are eluted from a non-polar adsorbent in the order of their boiling points. The regularity of the elution order of the hydrocarbon components allows the retention times to be equated to distillation temperatures and the term *simulated distillation by gas chromatography* (or *simdis*) is used throughout the industry to refer to this technique.

Simulated distillation by gas chromatography is often applied in the crude oil industry to obtain true boiling point data for feedstocks (Speight, 2014a, 2015). Two standardized methods (ASTM D2887 and ASTM D3710) are available for the boiling point determination of feedstock fractions and gasoline, respectively.

2.5 ELECTRICAL PROPERTIES

Understanding of how a feedstock behaves and why different feedstocks differ in properties is also possible with an atomistic understanding allowed by quantum mechanics. The combination of physics, chemistry, and the focus on the relationship between the properties of a material and its electrical properties allows uses to be designed and also provides a knowledge base for a variety of chemical and engineering applications.

2.5.1 CONDUCTIVITY

From the fragmentary evidence available, the electrical conductivity of feedstock fractions is small but measurable (Penzes and Speight, 1974; Fotland et al., 1993; Fotland and Anfindsen, 1996). For example, the normal hydrocarbon derivatives (from hexane up) have an electrical conductivity smaller than 10^{-16} Ω/cm; benzene itself has an electrical conductivity of 4.4×10^{-17} Ω/cm, and cyclohexane has an electrical conductivity of 7×10^{-18} Ω/cm. It is generally recognized that hydrocarbon derivatives do not usually have an electrical conductivity larger than 10^{-18} Ω/cm. Thus, it is not surprising that the electrical conductivity of hydrocarbon oils is also exceedingly small – on the order of 10^{-19} to 10^{-12} Ω/cm.

Available data indicate that the observed conductivity is frequently more dependent on the method of measurement and the presence of trace impurities than on the chemical type of the oil. Conduction through oils is not ohmic insofar as the current is not proportional to field strength: in some regions, it is observed to increase exponentially with the latter. Time effects are also observed, the current being at first relatively large and decreasing to a smaller steady value. This is partly because of electrode polarization and partly because of ions removed from the solution. Most oils increase in conductivity with rising temperatures.

2.5.2 DIELECTRIC CONSTANT

The *dielectric constant* (ε) of a substance may be defined as the ratio of the capacity of a condenser with the material between the condenser plates C to that with the condenser empty and under vacuum C_0:

$$\varepsilon = C / C_0$$

The dielectric constant of a feedstock products may be used to indicate the presence of various constituents, such as asphaltene constituents, resin constituents, or oxidized materials.

The dielectric constant of hydrocarbon derivatives and hence most feedstocks and their products is usually low and decreases with an increase in temperature. It is also noteworthy that for hydrocarbon derivatives, hydrocarbon derivatives fractions, and products, the dielectric constant is

approximately equal to the square of the refractive index. Polar materials have dielectric constants greater than the square of the refractive index.

2.5.3 DIELECTRIC STRENGTH

The dielectric strength, or breakdown voltage (ASTM D877), is the greatest potential gradient or potential that an insulator can withstand without permitting an electric discharge. The property is, in the case of oils as well as other dielectric materials, somewhat dependent on the method of measurement, that is, on the length of path through which the breakdown occurs, the composition, shape, and condition of the electrode surfaces, and the duration of the applied potential difference.

The standard test used in North America is applied to oils of crude oil origin for use in cables, transformers, oil circuit breakers, and similar apparatus. Oils of high purity and cleanliness show nearly the same value under standard conditions, generally ranging from 30 to 35 kV. For alkane derivatives, the dielectric strength has been shown to increase linearly with liquid density, and the value for a mineral oil fits the data well. For n-heptane, a correlation was found between the dielectric strength and the density changes with temperature. There are many reasons that the dielectric strength of an insulator may fail. The most important appears to be the presence of some type of impurity, produced by corrosion, oxidation, thermal or electrical cracking, or gaseous discharge; invasion by water is a common trouble.

2.5.4 DIELECTRIC LOSS AND POWER FACTOR

A condenser insulated with an ideal dielectric shows no dissipation of energy when an alternating potential is applied. The charging current, technically termed the *circulating current*, lags exactly 90° in phase angle behind the applied potential, and the energy stored in the condenser during each half-cycle is completely recovered in the next. No real dielectric material exhibits this ideal behavior; that is, some energy is dissipated under alternating stress and appears as heat. Such a lack of efficiency is broadly termed *dielectric loss*.

Ordinary conduction comprises one component of dielectric loss. Here the capacitance-held charge is partly lost by short circuit through the medium. Other effects in the presence of an alternating field occur, and a dielectric of zero conductivity may still exhibit losses. Suspended droplets of another phase undergo spheroidal oscillation by electrostatic induction effects and dissipate energy as heat as a consequence of the viscosity of the medium. Polar molecules oscillate as electrets and dissipate energy on collision with others. All such losses are of practical importance when insulation is used in connection with alternating current equipment.

The measure of the dielectric loss is the power factor. This is defined as the factor k in the relation:

$$k = W/EI$$

W is the power in watts dissipated by a circuit portion under voltage E and passing current, I.

From alternating current theory, the power factor is recognized as the cosine of the phase angle between the voltage and current where a pure sine wave form exists for both; it increases with a use in temperature. When an insulating material serves as the dielectric of a condenser, the power factor is an intrinsic property of the dielectric. For practical electrical equipment, low-power factors for the insulation are of course always desirable; feedstock oils are generally excellent in this respect, having values of the order of 0.0005, comparable with fused quartz and polystyrene resin constituents. The power factor of pure hydrocarbon derivatives is extremely small. Traces of polar impurities, however, cause a striking increase. All electrical oils, therefore, are drastically refined and handled with care to avoid contamination; insoluble oxidation products are particularly undesirable.

2.5.5 STATIC ELECTRIFICATION

Dielectric liquids, particularly light naphtha, may acquire high static charges on flowing through or being sprayed from metal pipes. The effect seems to be associated with colloidally dispersed contaminants, such as oxidation products, which can be removed by drastic filtration or adsorption. Since a considerable fire hazard is involved that a variety of methods have been studied for minimizing the danger.

For large-scale storage, avoidance of surface agitation and the use of floating metal roofs on tanks are beneficial. High humidity in the surrounding atmosphere is helpful in lowering the static charge, and radioactive materials have been used to try to induce discharge to ground. A variety of additives have been found that increase the conductivity of feedstock liquids, thus lowering the degree of electrification; chromium salts of alkylated salicylic acids and other salts of alkylated sulfo-succinic acids are employed in low concentrations, say 0.005%.

2.6 OPTICAL PROPERTIES

By *optical property* is meant the response of a feedstock to exposure to electromagnetic radiation and, in particular, to visible light. Such properties, while not often used in the past are not finding use in environmental cases.

Among their many impacts, oil pollutants modify light fields above and below the water surface. These modifications are manifested by the attenuation of the light passing through an oiled water surface by changes in light absorption in the seawater column due to the formation of an emulsion, and by the scattering of light by particles of such an emulsion. The optical properties of an emulsion can be described by the attenuation specific cross-section and the absorption specific cross-section, which depend on the optical characteristics of the oil and the seawater, on the size distribution of oil droplets and on their concentration.

In the case of pollution with fresh crude, the oil undergoes weathering, which alters its properties and, hence, changes in the optical properties of a feedstock-seawater emulsion due to weathering and oxidation.

2.6.1 OPTICAL ACTIVITY

The occurrence of optical activity in crude oil is universal and is a general phenomenon not restricted to a particular type of feedstock, such as the paraffinic or naphthenic feedstocks. Crude oil is usually *dextrorotatory*, that is, the plane of polarized light is rotated to the right, but there are known *laevorotatory* crude oils, that is, the plane of polarized light is rotated to the left, and some crude oils have been reported to be optically inactive.

Examination of the individual fractions of optically active crude oils shows that the rotatory power increases with molecular weight (or boiling point) to pronounced maxima and then decreases again. The rotatory power appears to be concentrated in certain fractions, the maximum lying at a molecular weight of approximately 350–400; this maximum is approximately the same for all crude oils. The occurrence of optically active compounds in unaltered natural crude oil has been a strong argument in favor of a rather low temperature origin of crude oil from organic raw materials.

A magnetic field causes all liquids to exhibit optical rotation, usually in the same direction as that of the magnetizing current; this phenomenon is known as the Faraday effect (θ) and it may be expressed by the relation:

$$\theta = pth$$

θ is the total angle of rotation, t is the thickness of substance through which the light passes, and h is the magnetic field; the constant p is an intrinsic property of the substance, usually termed the

Verdet constant (minutes of arc/cm per G); there have been some attempts to use the Verdet constant in studying the constitution of hydrocarbon derivatives by physical property correlation.

2.6.2 REFRACTIVE INDEX

The *refractive index* is the ratio of the velocity of light in a vacuum to the velocity of light in the substance. The measurement of the refractive index is very simple (ASTM D1218) that requires small quantities of material, and, consequently, has found wide use in the characterization of hydrocarbon derivatives and feedstock samples.

For closely separated fractions of similar molecular weight, the values increase in the order paraffin, naphthene, and aromatic. For polycyclic naphthenes and polycyclic aromatics, the refractive index is usually higher than that of the corresponding monocyclic compounds. For a series of hydrocarbon derivatives of essentially the same type, the refractive index increases with molecular weight, especially in the paraffin series. Thus, the refractive index can be used to provide valuable information about the composition of hydrocarbon (feedstock) mixtures; as with density, low values indicate paraffinic materials and higher values indicate the presence of aromatic compounds. However, the combination of refractive index and density may be used to provide even more definite information about the nature of a hydrocarbon mixture and, hence, the use of the refractivity intercept $(n - d/2)$.

The refractive and specific dispersion as well as the molecular and specific refraction have all been advocated for use in the characterization of a refinery feedstock.

The *refractive dispersion* of a substance is defined as the difference between its refractive indices at two specified wavelengths of light. Two lines commonly used to calculate dispersions are the C (6563 D, red) and F (4861 D, blue) lines of the hydrogen spectrum. The *specific dispersion* is the refractive dispersion divided by the density at the same temperature:

$$\text{Specific dispersion} = n_F - n_C \,/\, d$$

This equation is of particular significance in feedstock chemistry because all the saturated hydrocarbon derivatives, naphthene and paraffin, have nearly the same value irrespective of molecular weight, whereas aromatics are much higher and unsaturated aliphatic hydrocarbon derivatives are intermediate.

Specific refraction is the term applied to the quantity defined by the expression:

$$n - 1 \,/\, (n^2 + 2)d = C$$

Where n is the refractive index, d is the density, and C is a constant independent of temperature.

Molecular refraction is the specific refraction multiplied by molecular weight; its particular usefulness lies in the fact that it is very nearly additive for the components of a molecule; that is, numerical values can be assigned to atoms and structural features, such as double bonds and rings. The value for any pure compound is then approximately the sum of such component constants for the molecule.

2.7 SPECTROSCOPIC PROPERTIES

Spectroscopic studies have played an important role in the evaluation of feedstocks for the last six decades (from the 1960s to the present), and many of the methods are now used as standard methods of analysis for refinery feedstocks and products. Application of these methods to feedstocks and products is a natural consequence for the refiner.

The methods include the use of *mass spectrometry* to determine the (i) hydrocarbon types in middle distillates, ASTM D2425, (ii) hydrocarbon types of gas oil saturate fractions, ASTM D2786,

(iii) hydrocarbon types in low-olefin gasoline, ASTM D2789, and (iv) aromatic types in gas oil aromatic fractions, ASTM D3239. *Nuclear magnetic resonance spectroscopy* has been developed as a standard method for the determination of hydrogen types in aviation turbine fuels (ASTM D3701). *X-ray fluorescence spectrometry* has been applied to the determination of sulfur in various feedstock and their respective products (ASTM D2622, ASTM D4294).

Infrared spectroscopy is used for the determination of benzene in motor and/or aviation gasoline (ASTM D4053) while ultraviolet spectroscopy is employed for the evaluation of mineral oils (ASTM D2269) and for determining the naphthalene content of aviation turbine fuels (ASTM D1840).

Other techniques include the use of *flame emission spectroscopy* for determining trace metals in gas turbine fuels (ASTM D3605) and the use of *absorption spectrophotometry* for the determination of the alkyl nitrate content of diesel fuel (ASTM D4046). *Atomic absorption* has been employed as a means of measuring the lead content of gasoline (ASTM D3237) and also for the manganese content of gasoline (ASTM D3831) as well as for determining the barium, calcium, magnesium, and zinc contents of lubricating oils (ASTM D4628). *Flame photometry* has been employed as a means of measuring the lithium/sodium content of lubricating greases (ASTM D3340) and the sodium content of residual fuel oil (ASTM D1318).

Nowhere is the contribution of spectroscopic studies more emphatic than in application to the delineation of structural types in the heavier feedstocks. This has been necessary because of the unknown nature of these feedstocks by refiners. One particular example is the *ndM. method* (ASTM D3238) which is designed for the carbon distribution and structural group analysis of feedstocks. Later investigators have taken structural group analysis several steps further than the ndM. method (Speight, 2014a, 2015). It is also appropriate at this point to give a brief description of other methods that are used for the identification of the constituents of refinery feedstocks.

However, it is not intended to convey here that any one of these methods can be used for identification purposes. Although these methods may fall short of complete acceptability as methods for the characterization of individual constituents of feedstocks, they can be used as methods by which an overall evaluation of the feedstock may be obtained in terms of various molecular types in the feedstock.

2.7.1 INFRARED SPECTROSCOPY

Conventional infrared spectroscopy yields information about the functional features of various feedstock constituents. For example, infrared spectroscopy will aid in the identification of N–H and O–H functions, the nature of polymethylene chains, the C–H out-of-place bending frequencies, and the nature of any polynuclear aromatic systems.

With the recent progress of *Fourier transform infrared (FTIR) spectroscopy*, quantitative estimates of the various functional groups can also be made. This is particularly important for application to the higher-molecular-weight solid constituents of a feedstock (i.e., the asphaltene fraction). It is also possible to derive structural parameters from infrared spectroscopic data, and these are (i) saturated hydrogen to saturated carbon ratio, (ii) paraffinic character, (iii) naphthenic character, (iv) methyl group content, and (v) paraffin chain length.

In conjunction with proton magnetic resonance (see next section), structural parameters such as the fraction of paraffinic methyl groups to aromatic methyl groups can be obtained.

2.7.2 MASS SPECTROMETRY

Mass spectrometry can play a key role in the identification of the constituents of feedstocks and products. The principal advantages of mass spectrometric methods are (i) high reproducibility of quantitative analyses, (ii) the potential for obtaining detailed data on the individual components and/ or carbon number homologues in complex mixtures, and (iii) a minimal sample size is required for

analysis. The ability of mass spectrometry to identify individual components in complex mixtures is unmatched by any modern analytical technique. Perhaps the exception is gas chromatography.

However, there are disadvantages arising from the use of mass spectrometry, and these are (i) the limitation of the method to organic materials that are volatile and stable at temperatures up to 300°C (570°F) and (ii) the difficulty of separating isomers for absolute identification. The sample is usually destroyed, but this is seldom a disadvantage.

Nevertheless, in spite of these limitations, mass spectrometry does furnish useful information about the composition of feedstocks and products even if this information is not as exhaustive as might be required. There are structural similarities that might hinder identification of individual components. Consequently, identification by type or by homologue will be more meaningful since similar structural types may be presumed to behave similarly in processing situations. Knowledge of the individual isomeric distribution may add only a little to an understanding of the relationships between composition and processing parameters.

Mass spectrometry should be used discriminately where a maximum amount of information can be expected. The heavier nonvolatile feedstocks are for practical purposes, beyond the useful range of routine mass spectrometry. At the elevated temperatures necessary to encourage volatility, thermal decomposition will occur in the inlet, and any subsequent analysis would be biased to the low-molecular-weight end and to the lower molecular products produced by the thermal decomposition.

2.7.3 NUCLEAR MAGNETIC RESONANCE SPECTROSCOPY

Nuclear magnetic resonance spectroscopy has frequently been employed for general studies and for the structural studies of feedstock constituents (Bouquet and Bailleul, 1982; Hasan et al., 1989). In fact, *proton magnetic resonance* (PMR) studies (along with infrared spectroscopic studies) were, perhaps, the first studies of the modern era that allowed structural inferences to be made about the polynuclear aromatic systems that occur in the high-molecular-weight constituents of a feedstock.

In general, the proton (hydrogen) types in feedstock fractions can be subdivided into five types which subdivides the hydrogen distribution into (i) aromatic hydrogen, (ii) substituted hydrogen next to an aromatic ring, (iii) naphthenic hydrogen, (iv) methylene hydrogen, and (v) terminal methyl hydrogen remote from an aromatic ring. Other ratios are also derived from which a series of structural parameters can be calculated. However, it must be remembered that the structural details of structural entities obtained by use of physical techniques are, in many cases, derived by inference and it must be recognized that some signals can be obscured by intermolecular interactions. This, of course, can cause errors in deduction reasoning which that can have a substantial influence on the outcome of the calculations (Ebert et al., 1984; Ebert et al., 1987; Ebert, 1990; Speight, 1994, 2014a, 2015).

It is in this regard that *carbon-13 magnetic resonance* (CMR) can play a useful role. Since carbon magnetic resonance deals with analyzing the carbon distribution types, the obvious structural parameter to be determined is the aromaticity, f_a. A direct determination from the various carbon type environments is one of the better methods for the determination of aromaticity (Snape et al., 1979). Thus, through a combination of proton and carbon magnetic resonance techniques, refinements can be made on the structural parameters, and for the solid-state high-resolution CMR technique, additional structural parameters can be obtained (Weinberg et al., 1981).

2.8 CHROMATOGRAPHIC PROPERTIES

Chromatography is the collective term for a set of laboratory techniques for the separation of mixtures. Typically, the mixture is dissolved in a fluid (*mobile phase*) which carries it through a structure holding another material (*stationary phase*). The various constituents of the mixture travel at different speeds, causing them to separate. The separation is based on differential partitioning between the mobile and stationary phases. Subtle differences in the partition coefficient of different compounds result in differential retention on the stationary phase and thus changing the separation.

A chromatographic technique may be preparative or analytical. The purpose of preparative chromatography is to separate the components of a mixture for more advanced use (and is thus a form of purification). Analytical chromatography generally requires smaller amounts of material and is for measuring the relative proportions of analytes in a mixture. The two are not mutually exclusive.

2.8.1 ADSORPTION CHROMATOGRAPHY

Adsorption chromatography has helped to characterize the group composition of refinery feedstocks crude oils and hydrocarbon products for many decades. The type and relative amount of certain hydrocarbon classes in the matrix can have a profound effect on the quality and performance of the hydrocarbon product, and two standard test methods have been used predominantly over the years (ASTM D2007, ASTM D4124). The fluorescent indicator adsorption (FIA) method (ASTM D1319) has served for over 30 years as the official method of the crude oil industry for measuring the amount of paraffin derivatives, olefin derivatives, and aromatic derivatives. The technique consists of displacing a sample under *iso*-propanol pressure through a column packed with silica gel in the presence of fluorescent indicators specific to each hydrocarbon family. Despite its widespread use, FIA has numerous limitations (Suatoni and Garber, 1975; Miller et al., 1983; Norris and Rawdon, 1984).

The segregation of individual components from a mixture can be achieved by application of adsorption chromatography in which the adsorbent is either packed in an open tube (column chromatography) or shaped in the form of a sheet (thin-layer chromatography, TLC). A suitable solvent is used to elute from the bed of the adsorbent. Chromatographic separations are usually performed for the purpose of determining the composition of a sample. Even with such complex samples as feedstock blends as well as extra-heavy oil and tar sand bitumen, some information about the chemical structure of a fraction can be gained from the separation data.

In the present context, the challenge is the nature of the heteroatomic species in the heavier feedstocks. It is these constituents that are largely responsible for coke formation and catalyst deactivation during refining operations. Therefore, it is these constituents that are the focus of much of the study. An ideal integrated separation scheme for the analysis of the heteroatomic constituents should therefore meet several criteria:

1. The various compound types should be concentrated into a reasonable number of discrete fractions, and each fraction should contain specific types of the heteroatomic compounds. It is also necessary that most of the hetero-compounds be separated from the hydrocarbon derivatives and sulfur compounds that may constitute the bulk of the sample.
2. Perhaps most important, the separation should be reproducible insofar as the yields of the various fractions and the distribution of the compound types among the fractions should be constant within the limits of experimental error.
3. The separation scheme should be applicable to high-boiling distillates and heavy feedstocks such as residua since heteroatomic compounds often predominate in these feedstocks.
4. The separation procedures should be relatively simple to perform and free of complexity.
5. Finally, the overall separation procedure should yield quantitative or, at worst, near quantitative recovery of the various heteroatomic species present in the feedstock. There should be no significant loss of these species to the adsorbent or, perhaps more important, any chemical alteration of these compounds. Should chemical alteration occur, it will give misleading data that could have serious effects on refining predictions or on geochemical observations.

Group-type analysis by means of chromatography has been applied to a wide variety of feedstock types and products (Speight, 2014a, 2015). These types of analysis are often abbreviated by the names PONA (paraffins, olefins, naphthenes, and aromatics), PIONA (paraffins, *iso*-paraffins,

olefins, naphthenes, and aromatics), PNA (paraffins, naphthenes, and aromatics), PINA (paraffins, *iso*-paraffins, naphthenes, and aromatics), or SARA (saturates, aromatics, resin constituents, and asphaltene constituents).

2.8.2 GAS CHROMATOGRAPHY

Gas-liquid chromatography (GLC) is a method for separating the volatile components of various mixtures. It is, in fact, a highly efficient fractionating technique, and it is ideally suited to the quantitative analysis of mixtures when the possible components are known and the interest lies only in determining the amounts of each present. In this type of application, gas chromatography has taken over much of the work previously done by the other techniques; it is now the preferred technique for the analysis of hydrocarbon gases, and gas chromatographic in-line monitors are having increasing application in refinery plant control.

Thus, it is not surprising that gas chromatography has been used extensively for individual component identification, as well as percentage composition, in the gaseous boiling ranges (ASTM D2163, ASTM D2504, ASTM D2505, ASTM D2593, ASTM D2597, ASTM D2712, ASTM D4424, ASTM D4864, ASTM D5303, ASTM D6159), in the gasoline boiling range (ASTM D2427, ASTM D3525, ASTM D3606, ASTM D3710, ASTM D4815, ASTM D5134, ASTM D5441, ASTM D5443, ASTM D5501, ASTM D5580, ASTM D5599, ASTM D5623, ASTM D5845, ASTM D5986), in higher-boiling ranges such as diesel fuel (ASTM D3524), aviation gasoline (ASTM D3606), engine oil, motor oil, and wax (ASTM D5442), as well as for the boiling range distribution of feedstock fractions (ASTM D2887, ASTM D5307) or the purity of solvents using capillary gas chromatography (ASTM D2268).

The evolution of GLC has been a major factor in the successful identification of feedstock constituents. It is, however, almost impossible to apply this technique to the higher-boiling feedstock constituents because of the comparatively low volatility. It is this comparative lack of volatility in the higher-molecular-weight asphaltic constituents of the feedstock that brought about another type of identification procedure, namely carbon-type analysis.

GLC also provides a simple and convenient method for determining n-paraffin distribution throughout the feedstock distillate range. In this method, the n-paraffins are first separated by activated chemical destruction of the sieve with hydrofluoric acid, and the identity of the individual paraffins is determined chromatographically. This allows n-paraffin distribution throughout the boiling range 170°C–500°C (340°F–930°F) to be determined.

Pyrolysis gas chromatography can be used for information on the gross composition of the viscous feedstocks. In this technique, the sample under investigation is pyrolyzed, and the products are introduced into a gas chromatography system for analysis. There has also been extensive use of pyrolysis gas chromatography by geochemists to correlate crude oil with source rock and to derive geochemical characterization parameters from oil-bearing strata.

2.8.3 GEL PERMEATION CHROMATOGRAPHY

There are two additional techniques that have evolved from the more recent development of chromatographic methods. The first technique, *gel filtration chromatography (GFC)*, has been successfully employed for application to aqueous systems by biochemists for more than five decades. The technique was developed using soft, cross-linked dextran beads. The second technique, *gel permeation chromatography (GPC)*, employs semi-rigid, cross-linked polystyrene beads. In either technique, the packing particles swell in the chromatographic solvent forming a porous gel structure. The distinction between the methods is based on the degree of swelling of the packing; the dextran swells to a much greater extent than the polystyrene. Subsequent developments of rigid porous packings of glass, silica, and silica gel have led to their use and classification as packings for GPC.

GPC, also called *size exclusion chromatography (SEC)*, which in its simplest representation, consists of employing column(s) packed with gels of varying pore sizes in a liquid chromatograph (Carbognani, 1997). Under conditions of constant flow, the solutes are injected onto the top of the column, whereupon they appear at the detector in order of decreasing molecular weight. The separation is based on the fact that the larger solute molecules cannot be accommodated within the pore systems of the gel beads and thus are eluted first. On the other hand, the smaller solute molecules have increasing volume within the beads, depending upon their relative size, and require more time to elute.

2.8.4 High-Performance Liquid Chromatography

High-performance liquid chromatography (HPLC), particularly in the normal phase mode, has found great utility in separating different hydrocarbon group types and identifying specific constituent types (Colin and Vion, 1983; Miller et al., 1983). However, a severe shortcoming of most high-performance liquid chromatographic approaches to a hydrocarbon group type of analysis is the difficulty in obtaining accurate response factors applicable to different distillate products. Unfortunately, accuracy can be compromised when these response factors are used to analyze hydrotreated and hydrocracked materials having the same boiling range. In fact, significant changes in the hydrocarbon distribution within a certain group type cause the analytic results to be misleading for such samples because of the variation in response with carbon number exhibited by most routinely used HPLC detectors.

Of particular interest is the application of the HPLC technique to the identification of the molecular types in highly viscous feedstocks, such as heavy crude oil, extra-heavy crude oil, and tar sand bitumen. The molecular species in the asphaltene fraction have been of particular interest leading to identification of the size of polynuclear aromatic systems in the asphaltene constituents (Colin and Vion, 1983; Felix et al., 1985; Speight, 1986, 1994, 2014a).

The general advantages of HPLC method are (i) each sample is analyzed *as received,* (ii) the boiling range of the sample is generally immaterial, (iii) the total time per analysis is usually of the order of minutes, and (iv) the method can be adapted for on-stream analysis.

2.8.5 Ion-Exchange Chromatography

Ion-exchange chromatography is widely used in the analyses of feedstock fractions for the isolation and preliminary separation of acid and basic components (Speight, 2014a, 2015). This technique has the advantage of greatly improving the quality of a complex operation, but it can be a very time-consuming separation.

Cation-exchange chromatography has been used primarily to isolate the nitrogen constituents in a feedstock fraction. The relative importance of these compounds in feedstocks has arisen because of their deleterious effects in many refining processes. They reduce the activity of cracking and hydrocracking catalysts and contribute to gum formation, color, odor, and poor storage properties of the fuel. However, not all basic compounds isolated by cation-exchange chromatography are nitrogen compounds. Anion-exchange chromatography is used to isolate the acid components (such as carboxylic acids and phenols) from feedstock fractions.

2.8.6 Simulated Distillation

Distillation is the most widely used separation process in the crude oil industry (Parkash, 2003; Gary et al., 2007; Speight, 2014a; Hsu and Robinson, 2017; Speight, 2017). In fact, knowledge of the boiling range of crude feedstocks and finished products has been an essential part of the determination of feedstock quality since the start of the refining industry. The technique has been used for control of plant and refinery processes as well as for predicting product slates. Thus, it is not surprising that routine laboratory scale distillation tests have been widely used for determining the boiling ranges of crude feedstocks and a whole slate of refinery products (Speight, 2015).

There are some limitations to the routine distillation tests. For example, although many heavy crude oils contain volatile constituents, it is not always advisable to use distillation for identification of these volatile constituents. Thermal decomposition of the constituents of feedstocks is known to occur at approximately 350°C (660°F). Thermal decomposition of the constituents of the heavier, but immature, crude oil has been known to commence at temperatures as low as 200°C (390°F), however. Thus, thermal alteration of the constituents and erroneous identification of the decomposition products as *natural* constituents is always a possibility.

On the other hand, the limitations to the use of distillation as an identification technique may be economic, and detailed fractionation of the sample may also be of secondary importance. There have been attempts to combat these limitations, but it must be recognized that the general shape of a one-plate distillation curve is often adequate for making engineering calculations, correlating with other physical properties, and predicting the product slate.

2.8.7 SUPERCRITICAL FLUID CHROMATOGRAPHY

A supercritical fluid is defined as a substance above its critical temperature that has properties not usually found at ambient temperatures and pressures. Use of a fluid under supercritical conditions conveys upon the fluid extraction capabilities that allows the opportunity to improve recovery of a solute.

In a chromatographic column, the supercritical fluid usually has a density approximately one-third to one-fourth of that of the corresponding liquid when used as the mobile phase; the diffusivity is approximately 1/100 that of a gas and approximately 200 times that of the liquid. The viscosity is of the same order of magnitude as that of the gas. Thus, for chromatographic purposes, such a fluid has more desirable transport properties than a liquid. In addition, the high density of the fluid results in a 1,000-fold better solvency than that of a gas. This is especially valuable for analyzing high-molecular-weight compounds.

A primary advantage of chromatography using supercritical mobile phases results from the mass transfer characteristics of the solute. The increased diffusion coefficients of supercritical fluids compared with liquids can lead to greater speed in separations or greater resolution in complex mixture analyses. Another advantage of supercritical fluids compared with gases is that they can dissolve thermally labile and non-volatile solutes and, upon expansion (decompression) of this solution, introduce the solute into the vapor phase for detection. Although supercritical fluids are sometimes considered to have superior solvating power, they usually do not provide any advantages in solvating power over liquids given a similar temperature constraint. In fact, many unique capabilities of supercritical fluids can be attributed to the poor solvent properties obtained at lower fluid densities. This dissolution phenomenon is increased by the variability of the solvent power of the fluid with density as the pressure or temperature changes.

The solvent properties that are most relevant for supercritical fluid chromatography are the critical temperature, polarity, and any specific solute–solvent intermolecular interactions (such as hydrogen bonding) that can enhance solubility and selectivity in a separation. Non-polar or low-polarity solvents with moderate critical temperatures (e.g., nitrous oxide, carbon dioxide, ethane, propane, pentane, xenon, sulfur hexafluoride, and various Freon derivatives) have been well explored for use in supercritical fluid chromatography. Carbon dioxide has been the fluid of choice in many supercritical fluid chromatography applications because of its low critical temperature (31°C, 88°F), non-toxic nature, and lack of interference with most detection methods (Smith et al., 1988).

2.9 MOLECULAR WEIGHT

Refinery feedstocks being complex mixtures of (at least) several thousand constituents requires qualification of the molecular weight as either (i) number average molecular weight or (ii) weight average molecular weight. The *number average molecular weight* is the ordinary arithmetic mean or average of the molecular weights of the individual constituents. It is determined by measuring

the molecular weight of n molecules, summing the weights, and dividing by n. The *weight average molecular weight* is a way of describing the molecular weight of a complex mixture such as a feedstock blend even if the molecular constituents are not of the same type and exist in different sizes. For those original constituents and products, e.g., resin constituents and asphaltene constituents, that have little or no volatility, *vapor pressure osmometry* (*VPO*) has been proven to be of considerable value (Blondel-Telouk et al., 1995).

A particularly appropriate method involves the use of different solvents (at least two), and the data are then extrapolated to infinite dilution. There has also been the use of different temperatures for a particular solvent after which the data are extrapolated to room temperature (Speight et al., 1985; Speight, 1987). In this manner, different solvents are employed, and the molecular weight of a feedstock fraction (particularly the asphaltene constituents) can be determined for which it can be assumed that there is little or no influence from any intermolecular forces. In summary, the molecular weight may be as close to the real value as possible.

In fact, it is strongly recommended that to negate concentration effects and temperature effects the molecular weight determination be carried out at three different concentrations at three different temperatures. The data for each temperature are then extrapolated to zero concentration, and the zero concentration data at each temperature are then extrapolated to room temperature (Speight, 1987).

2.10 USE OF THE DATA

The data derived from the evaluation techniques described here can be employed to give the refiner an indication of the means by which the crude feedstock should be processed as well as for the prediction of product properties (Dolbear et al., 1987; Wallace and Carrigy, 1988; Speight, 2014a, 2015). Other properties (Table 2.1) may also be required for further feedstock evaluation, or, more likely, for comparison between feedstocks even though they may not play any role in dictating which refinery operations are necessary. An example of such an application is the calculation of product yields for delayed coking operations by using the carbon residue and the API gravity (Speight, 2014a, 2015, 2017).

Nevertheless, it must be emphasized that to proceed from the raw evaluation data to full-scale production is not the preferred step; further evaluation of the processability of the feedstock is usually necessary through the use of a pilot-scale operation. To take the evaluation of a feedstock one step further, it may then be possible to develop correlations between the data obtained from the actual plant operations (as well as the pilot plant data) with one or more of the physical properties determined as part of the initial feedstock evaluation.

However, it is essential that when such data are derived, the parameters employed should be carefully specified. For example, the data presented in the tables were derived on the basis of straight-run residua having API gravity less than 18°. The gas oil end point was of the order of 470°C–495°C (875°F–925°F), the gasoline end point was 205°C (400°F), and the pressure in the coke drum was standardized at 35–45 psi. Obviously, there are benefits to the derivation of such specific data, but the numerical values, although representing only an approximation, may vary substantially when applied to different feedstocks (Speight, 1987).

Evaluation of feedstocks from known physical properties may also be achieved by use of the refractivity intercept. Thus, if refractive indices of hydrocarbon derivatives are plotted against the respective densities, straight lines of constant slope are obtained, one for each homologous series; the intercepts of these lines with the ordinate of the plot are characteristic, and the refractivity intercept is derived from the formula:

$$\text{Refractivity intercept} = n - d / 2$$

The intercept cannot differentiate accurately among all series, which restricts the number of different types of compounds that can be recognized in a sample. The technique has been applied to

non-aromatic olefin-free materials in the gasoline range by assuming additivity of the constant on a volume basis.

Following from this, an equation has been devised that is applicable to straight-run lubricating distillates if the material contains between 25% and 75% of the carbon present in naphthenic rings:

$$\text{Refractivity intercept} = 1.0502 - 0.00020\%C_N$$

Although not specifically addressed in this chapter, the fractionation of feedstocks (Speight, 2014a, 2015) also plays a role, along with the physical testing methods, of evaluating a crude oil as a refinery feedstock. For example, by careful selection of an appropriate technique, it is possible to obtain a detailed overview of feedstock or product composition that can be used for process predictions. Using the adsorbent separation as an example, it becomes possible to develop one or more compositional maps and determine how a feedstock might behave under specified process conditions.

This concept has been developed to the point where various physical parameters as the ordinates and abscissa. However, it must be recognized that such *maps* do not give any indication of the complex interactions that occur between, for example, such fractions as the asphaltene constituents and resin constituents (Koots and Speight, 1975; Speight, 1994), but it does allow predictions of feedstock behavior. It must also be recognized that such a representation varies for different feedstocks.

In summary, evaluation of feedstock behavior from test data is not only possible but has been practiced for decades. And such evaluations will continue for decades to come. However, it is essential to recognize that the derivation of an equation for predictability of behavior will not suffice (with a reasonable degree of accuracy) for all feedstocks. Many of the data are feedstock dependent because they incorporate the complex reactions of the feedstock constituents with each other. Careful testing and evaluation of the behavior of each feedstock and blend of feedstocks is recommended. If this is not done, incompatibility or instability (Speight, 2014a, 2015) can result leading to higher-then-predicted yields of thermal or catalytic coke.

REFERENCES

ASTM. 2019. Annual Book of Standards. ASTM International, West Conshohocken, PA.
ASTM C1109. 2019. *Standard Practice for Analysis of Aqueous Leachates from Nuclear Waste Materials Using Inductively Coupled Plasma-Atomic Emission Spectroscopy.* Annual Book of Standards. ASTM International, West Conshohocken, PA.
ASTM C1111. 2019. *Standard Test Method for Determining Elements in Waste Streams by Inductively Coupled Plasma-Atomic Emission Spectroscopy.* Annual Book of Standards. ASTM International, West Conshohocken, PA.
ASTM D6. 2019. *Standard Test Method for Loss on Heating of Oil and Asphaltic Compounds.* Annual Book of Standards. ASTM International, West Conshohocken, PA.
ASTM D20. 2019. *Standard Test Method for Distillation of Road Tars.* Annual Book of Standards. ASTM International, West Conshohocken, PA.
ASTM D56. 2019. *Standard Test Method for Flash Point by Tag Closed Cup Tester.* Annual Book of Standards. ASTM International, West Conshohocken, PA.
ASTM D70. 2019. *Standard Test Method for Density of Semi-Solid Bituminous Materials (Pycnometer Method).* Annual Book of Standards. ASTM International, West Conshohocken, PA.
ASTM D71. 2019. *Standard Test Method for Relative Density of Solid Pitch and Asphalt (Displacement Method).* Annual Book of Standards. ASTM International, West Conshohocken, PA.
ASTM D86. 2019. *Standard Test Method for Distillation of Petroleum Products at Atmospheric Pressure.* Annual Book of Standards. ASTM International, West Conshohocken, PA.
ASTM D88. 2019. *Standard Test Method for Saybolt Viscosity.* Annual Book of Standards. ASTM International, West Conshohocken, PA.
ASTM D92. 2019. *Standard Test Method for Flash and Fire Points by Cleveland Open Cup Tester.* Annual Book of Standards. ASTM International, West Conshohocken, PA.

ASTM D93. 2019. *Standard Test Methods for Flash Point by Pensky-Martens Closed Cup Tester.* Annual Book of Standards. ASTM International, West Conshohocken, PA.

ASTM D97. 2019. *Standard Test Method for Pour Point of Petroleum Products.* Annual Book of Standards. ASTM International, West Conshohocken, PA.

ASTM D129. 2019. *Standard Test Method for Sulfur in Petroleum Products (General High Pressure Decomposition Device Method).* Annual Book of Standards. ASTM International, West Conshohocken, PA.

ASTM D139. 2019. *Standard Test Method for Float Test for Bituminous Materials.* Annual Book of Standards. ASTM International, West Conshohocken, PA.

ASTM D189. 2019. *Standard Test Method for Conradson Carbon Residue of Petroleum Products.* Annual Book of Standards. ASTM International, West Conshohocken, PA.

ASTM D240. 2019. *Standard Test Method for Heat of Combustion of Liquid Hydrocarbon Fuels by Bomb Calorimeter.* Annual Book of Standards. ASTM International, West Conshohocken, PA.

ASTM D287. 2019. *Standard Test Method for API Gravity of Crude Petroleum and Petroleum Products (Hydrometer Method).* Annual Book of Standards. ASTM International, West Conshohocken, PA.

ASTM D323. 2019. *Standard Test Method for Vapor Pressure of Petroleum Products (Reid Method).* Annual Book of Standards. ASTM International, West Conshohocken, PA.

ASTM D341. 2019. *Standard Practice for Viscosity-Temperature Charts for Liquid Petroleum Products.* Annual Book of Standards. ASTM International, West Conshohocken, PA.

ASTM D445. 2019. *Standard Test Method for Kinematic Viscosity of Transparent and Opaque Liquids (and Calculation of Dynamic Viscosity).* Annual Book of Standards. ASTM International, West Conshohocken, PA.

ASTM D482. 2019. *Standard Test Method for Ash from Petroleum Products.* Annual Book of Standards. ASTM International, West Conshohocken, PA.

ASTM D524. 2019. *Standard Test Method for Ramsbottom Carbon Residue of Petroleum Products.* Annual Book of Standards. ASTM International, West Conshohocken, PA.

ASTM D566. 2019. *Standard Test Method for Dropping Point of Lubricating Grease.* Annual Book of Standards. ASTM International, West Conshohocken, PA.

ASTM D611. 2019. *Standard Test Methods for Aniline Point and Mixed Aniline Point of Petroleum Products and Hydrocarbon Solvents.* Annual Book of Standards. ASTM International, West Conshohocken, PA.

ASTM D664. 2019. *Standard Test Method for Acid Number of Petroleum Products by Potentiometric Titration.* Annual Book of Standards. ASTM International, West Conshohocken, PA.

ASTM D877. 2019. *Standard Test Method for Dielectric Breakdown Voltage of Insulating Liquids Using Disk Electrodes.* Annual Book of Standards. ASTM International, West Conshohocken, PA.

ASTM D974. 2019. *Standard Test Method for Acid and Base Number by Color-Indicator Titration.* Annual Book of Standards. ASTM International, West Conshohocken, PA.

ASTM D1018. 2019. *Standard Test Method for Hydrogen in Petroleum Fractions.* Annual Book of Standards. ASTM International, West Conshohocken, PA.

ASTM D1160. 2019. *Standard Test Method for Distillation of Petroleum Products at Reduced Pressure.* Annual Book of Standards. ASTM International, West Conshohocken, PA.

ASTM D1217. 2019. *Standard Test Method for Density and Relative Density (Specific Gravity) of Liquids by Bingham Pycnometer.* Annual Book of Standards. ASTM International, West Conshohocken, PA.

ASTM D1218. 2019. *Standard Test Method for Refractive Index and Refractive Dispersion of Hydrocarbon Liquids.* Annual Book of Standards. ASTM International, West Conshohocken, PA.

ASTM D1266. 2019. *Standard Test Method for Sulfur in Petroleum Products (Lamp Method).* Annual Book of Standards. ASTM International, West Conshohocken, PA.

ASTM D1298. 2019. *Standard Test Method for Density, Relative Density, or API Gravity of Crude Petroleum and Liquid Petroleum Products by Hydrometer Method.* Annual Book of Standards. ASTM International, West Conshohocken, PA.

ASTM D1318. 2019. *Standard Test Method for Sodium in Residual Fuel Oil (Flame Photometric Method).* Annual Book of Standards. ASTM International, West Conshohocken, PA.

ASTM D1319. 2019. *Standard Test Method for Hydrocarbon Types in Liquid Petroleum Products by Fluorescent Indicator Adsorption.* Annual Book of Standards. ASTM International, West Conshohocken, PA.

ASTM D1405. 2019. *Standard Test Method for Estimation of Net Heat of Combustion of Aviation Fuels.* Annual Book of Standards. ASTM International, West Conshohocken, PA.

ASTM D1480. 2019. *Standard Test Method for Density and Relative Density (Specific Gravity) of Viscous Materials by Bingham Pycnometer.* Annual Book of Standards. ASTM International, West Conshohocken, PA.

ASTM D1481. 2019. *Standard Test Method for Density and Relative Density (Specific Gravity) of Viscous Materials by Lipkin Bicapillary Pycnometer.* Annual Book of Standards. ASTM International, West Conshohocken, PA.

ASTM D1552. 2019. *Standard Test Method for Sulfur in Petroleum Products (High-Temperature Method).* Annual Book of Standards. ASTM International, West Conshohocken, PA.

ASTM D1555. 2019. *Standard Test Method for Calculation of Volume and Weight of Industrial Aromatic Hydrocarbons and Cyclohexane.* Annual Book of Standards. ASTM International, West Conshohocken, PA.

ASTM D1657. 2019. *Standard Test Method for Density or Relative Density of Light Hydrocarbons by Pressure Hydrometer.* Annual Book of Standards. ASTM International, West Conshohocken, PA.

ASTM D1757. 2019. *Standard Test Method for Sulfur in Ash from Coal and Coke.* Annual Book of Standards. ASTM International, West Conshohocken, PA.

ASTM D1840. 2019. *Standard Test Method for Naphthalene Hydrocarbons in Aviation Turbine Fuels by Ultraviolet Spectrophotometry.* Annual Book of Standards. ASTM International, West Conshohocken, PA.

ASTM D2007. 2019. *Standard Test Method for Characteristic Groups in Rubber Extender and Processing Oils and Other Petroleum-Derived Oils by the Clay-Gel Absorption Chromatographic Method.* Annual Book of Standards. ASTM International, West Conshohocken, PA.

ASTM D2161. 2019. *Standard Practice for Conversion of Kinematic Viscosity to Saybolt Universal Viscosity or to Saybolt Furol Viscosity.* Annual Book of Standards. ASTM International, West Conshohocken, PA.

ASTM D2163. 2019. *Standard Test Method for Determination of Hydrocarbons in Liquefied Petroleum (LP) Gases and Propane/Propene Mixtures by Gas Chromatography.* Annual Book of Standards. ASTM International, West Conshohocken, PA.

ASTM D2265. 2019. *Standard Test Method for Dropping Point of Lubricating Grease Over Wide Temperature Range.* Annual Book of Standards. ASTM International, West Conshohocken, PA.

ASTM D2268. 2019. *Standard Test Method for Analysis of High-Purity n-Heptane and Isooctane by Capillary Gas Chromatography.* Annual Book of Standards. ASTM International, West Conshohocken, PA.

ASTM D2269. 2019. *Standard Test Method for Evaluation of White Mineral Oils by Ultraviolet Absorption.* Annual Book of Standards. ASTM International, West Conshohocken, PA.

ASTM D2270. 2019. *Standard Practice for Calculating Viscosity Index from Kinematic Viscosity at 40 and 100°C.* Annual Book of Standards. ASTM International, West Conshohocken, PA.

ASTM D2425. 2019. *Standard Test Method for Hydrocarbon Types in Middle Distillates by Mass Spectrometry.* Annual Book of Standards. ASTM International, West Conshohocken, PA

ASTM D2427. 2019. *Standard Test Method for Determination of C_2 through C_5 Hydrocarbons in Gasolines by Gas Chromatography.* Annual Book of Standards. ASTM International, West Conshohocken, PA.

ASTM D2500. 2019. *Standard Test Method for Cloud Point of Petroleum Products.* Annual Book of Standards. ASTM International, West Conshohocken, PA.

ASTM D2504. 2019. *Standard Test Method for Non-Condensable Gases in C2 and Lighter Hydrocarbon Products by Gas Chromatography.* Annual Book of Standards. ASTM International, West Conshohocken, PA.

ASTM D2505. 2019. *Standard Test Method for Ethylene, Other Hydrocarbons, and Carbon Dioxide in High-Purity Ethylene by Gas Chromatography.* Annual Book of Standards. ASTM International, West Conshohocken, PA.

ASTM D2593. 2019. *Standard Test Method for Butadiene Purity and Hydrocarbon Impurities by Gas Chromatography.* Annual Book of Standards. ASTM International, West Conshohocken, PA.

ASTM D2597. 2019. *Standard Test Method for Analysis of Demethanized Hydrocarbon Liquid Mixtures Containing Nitrogen and Carbon Dioxide by Gas Chromatography.* Annual Book of Standards. ASTM International, West Conshohocken, PA.

ASTM D2622. 2019. *Standard Test Method for Sulfur in Petroleum Products by Wavelength Dispersive X-ray Fluorescence Spectrometry.* Annual Book of Standards. ASTM International, West Conshohocken, PA.

ASTM D2712. 2019. *Standard Test Method for Hydrocarbon Traces in Propylene Concentrates by Gas Chromatography.* Annual Book of Standards. ASTM International, West Conshohocken, PA.

ASTM D2715. 2019. *Standard Test Method for Volatilization Rates of Lubricants in Vacuum.* Annual Book of Standards. ASTM International, West Conshohocken, PA.

ASTM D2766. 2019. *Standard Test Method for Specific Heat of Liquids and Solids.* Annual Book of Standards. ASTM International, West Conshohocken, PA.

ASTM D2786. 2019. *Standard Test Method for Hydrocarbon Types Analysis of Gas-Oil Saturates Fractions by High Ionizing Voltage Mass Spectrometry.* Annual Book of Standards. ASTM International, West Conshohocken, PA.

ASTM D2887. 2019. *Standard Test Method for Boiling Range Distribution of Petroleum Fractions by Gas Chromatography*. Annual Book of Standards. ASTM International, West Conshohocken, PA.

ASTM D2892. 2019. *Standard Test Method for Distillation of Crude Petroleum (15-Theoretical Plate Column)*. Annual Book of Standards. ASTM International, West Conshohocken, PA.

ASTM D3117. 2019. *Standard Test Method for Wax Appearance Point of Distillate Fuels*. Annual Book of Standards. ASTM International, West Conshohocken, PA.

ASTM D3120. 2019. *Standard Test Method for Trace Quantities of Sulfur in Light Liquid Petroleum Hydrocarbons by Oxidative Microcoulometry*. Annual Book of Standards. ASTM International, West Conshohocken, PA.

ASTM D3177. 2019. *Standard Test Methods for Total Sulfur in the Analysis Sample of Coal and Coke*. Annual Book of Standards. ASTM International, West Conshohocken, PA.

ASTM D3178. 2019. *Standard Test Methods for Carbon and Hydrogen in the Analysis Sample of Coal and Coke*. Annual Book of Standards. ASTM International, West Conshohocken, PA.

ASTM D3179. 2019. *Standard Test Methods for Nitrogen in the Analysis Sample of Coal and Coke*. Annual Book of Standards. ASTM International, West Conshohocken, PA.

ASTM D3228. 2019. *Standard Test Method for Total Nitrogen in Lubricating Oils and Fuel Oils by Modified Kjeldahl Method*. Annual Book of Standards. ASTM International, West Conshohocken, PA.

ASTM D3237. 2019. *Standard Test Method for Lead in Gasoline by Atomic Absorption Spectroscopy*. Annual Book of Standards. ASTM International, West Conshohocken, PA.

ASTM D3238. 2019. *Standard Test Method for Calculation of Carbon Distribution and Structural Group Analysis of Petroleum Oils by the n-d-M Method*. Annual Book of Standards. ASTM International, West Conshohocken, PA.

ASTM D3239. 2019. *Standard Test Method for Aromatic Types Analysis of Gas-Oil Aromatic Fractions by High Ionizing Voltage Mass Spectrometry*. Annual Book of Standards. ASTM International, West Conshohocken, PA.

ASTM D3340. 2019. *Standard Test Method for Lithium and Sodium in Lubricating Greases by Flame Photometer*. Annual Book of Standards. ASTM International, West Conshohocken, PA.

ASTM D3341. 2019. *Standard Test Method for Lead in Gasoline—Iodine Monochloride Method*. Annual Book of Standards. ASTM International, West Conshohocken, PA.

ASTM D3343. 2019. *Standard Test Method for Estimation of Hydrogen Content of Aviation Fuels*. Annual Book of Standards. ASTM International, West Conshohocken, PA.

ASTM D3525. 2019. *Standard Test Method for Gasoline Diluent in Used Gasoline Engine Oils by Gas Chromatography*. Annual Book of Standards. ASTM International, West Conshohocken, PA.

ASTM D3605. 2019. *Standard Test Method for Trace Metals in Gas Turbine Fuels by Atomic Absorption and Flame Emission Spectroscopy*. Annual Book of Standards. ASTM International, West Conshohocken, PA.

ASTM D3606. 2019. *Standard Test Method for Determination of Benzene and Toluene in Finished Motor and Aviation Gasoline by Gas Chromatography*. Annual Book of Standards. ASTM International, West Conshohocken, PA.

ASTM D3701. 2019. *Standard Test Method for Hydrogen Content of Aviation Turbine Fuels by Low Resolution Nuclear Magnetic Resonance Spectrometry*. Annual Book of Standards. ASTM International, West Conshohocken, PA.

ASTM D3710. 2019. *Standard Test Method for Boiling Range Distribution of Gasoline and Gasoline Fractions by Gas Chromatography*. Annual Book of Standards. ASTM International, West Conshohocken, PA.

ASTM D3831. 2019. *Standard Test Method for Manganese in Gasoline by Atomic Absorption Spectroscopy*. Annual Book of Standards. ASTM International, West Conshohocken, PA.

ASTM D4045. 2019. *Standard Test Method for Sulfur in Petroleum Products by Hydrogenolysis and Rateometric Colorimetry*. Annual Book of Standards. ASTM International, West Conshohocken, PA.

ASTM D4046. 2019. *Standard Test Method for Alkyl Nitrate in Diesel Fuels by Spectrophotometry*. Annual Book of Standards. ASTM International, West Conshohocken, PA.

ASTM D4052. 2019. *Standard Test Method for Density, Relative Density, and API Gravity of Liquids by Digital Density Meter*. Annual Book of Standards. ASTM International, West Conshohocken, PA.

ASTM D4053. 2019. *Standard Test Method for Benzene in Motor and Aviation Gasoline by Infrared Spectroscopy*. Annual Book of Standards. ASTM International, West Conshohocken, PA.

ASTM D4057. 2019. *Standard Practice for Manual Sampling of Petroleum and Petroleum Products*. Annual Book of Standards. ASTM International, West Conshohocken, PA.

ASTM D4124. 2019. *Standard Test Method for Separation of Asphalt into Four Fractions*. Annual Book of Standards. ASTM International, West Conshohocken, PA.

ASTM D4294. 2019. *Standard Test Method for Sulfur in Petroleum and Petroleum Products by Energy Dispersive X-ray Fluorescence Spectrometry*. Annual Book of Standards. ASTM International, West Conshohocken, PA.

ASTM D4424. 2019. *Standard Test Method for Butylene Analysis by Gas Chromatography*. Annual Book of Standards. ASTM International, West Conshohocken, PA.

ASTM D4530. 2019. *Standard Test Method for Determination of Carbon Residue (Micro Method)*. Annual Book of Standards. ASTM International, West Conshohocken, PA.

ASTM D4628. 2019. *Standard Test Method for Analysis of Barium, Calcium, Magnesium, and Zinc in Unused Lubricating Oils by Atomic Absorption Spectrometry*. Annual Book of Standards. ASTM International, West Conshohocken, PA.

ASTM D4815. 2019. *Standard Test Method for Determination of MTBE, ETBE, TAME, DIPE, tertiary-Amyl Alcohol and C1 to C4 Alcohols in Gasoline by Gas Chromatography*. Annual Book of Standards. ASTM International, West Conshohocken, PA.

ASTM D4864. 2019. *Standard Test Method for Determination of Traces of Methanol in Propylene Concentrates by Gas Chromatography*. Annual Book of Standards. ASTM International, West Conshohocken, PA.

ASTM D5002. 2019. *Standard Test Method for Density and Relative Density of Crude Oils by Digital Density Analyzer*. Annual Book of Standards. ASTM International, West Conshohocken, PA.

ASTM D5134. 2019. *Standard Test Method for Detailed Analysis of Petroleum Naphtha through n-Nonane by Capillary Gas Chromatography*. Annual Book of Standards. ASTM International, West Conshohocken, PA.

ASTM D5291. 2019. *Standard Test Methods for Instrumental Determination of Carbon, Hydrogen, and Nitrogen in Petroleum Products and Lubricants*. Annual Book of Standards. ASTM International, West Conshohocken, PA.

ASTM D5303. 2019. *Standard Test Method for Trace Carbonyl Sulfide in Propylene by Gas Chromatography*. Annual Book of Standards. ASTM International, West Conshohocken, PA.

ASTM D5307. 2019. *Standard Test Method for Determination of Boiling Range Distribution of Crude Petroleum by Gas Chromatography*. Annual Book of Standards. ASTM International, West Conshohocken, PA.

ASTM D5441. 2019. *Standard Test Method for Analysis of Methyl Tert-Butyl Ether (MTBE) by Gas Chromatography*. Annual Book of Standards. ASTM International, West Conshohocken, PA.

ASTM D5442. 2019. *Standard Test Method for Analysis of Petroleum Waxes by Gas Chromatography*. Annual Book of Standards. ASTM International, West Conshohocken, PA.

ASTM D5443. 2019. *Standard Test Method for Paraffin, Naphthene, and Aromatic Hydrocarbon Type Analysis in Petroleum Distillates through 200°C by Multi-Dimensional Gas Chromatography*. Annual Book of Standards. ASTM International, West Conshohocken, PA.

ASTM D5501. 2019. *Standard Test Method for Determination of Ethanol and Methanol Content in Fuels Containing Greater than 20% Ethanol by Gas Chromatography*. Annual Book of Standards. ASTM International, West Conshohocken, PA.

ASTM D5580. 2019. *Standard Test Method for Determination of Benzene, Toluene, Ethylbenzene, p/m-Xylene, o-Xylene, C9 and Heavier Aromatics, and Total Aromatics in Finished Gasoline by Gas Chromatography*. Annual Book of Standards. ASTM International, West Conshohocken, PA.

ASTM D5599. 2019. *Standard Test Method for Determination of Oxygenates in Gasoline by Gas Chromatography and Oxygen Selective Flame Ionization Detection*. Annual Book of Standards. ASTM International, West Conshohocken, PA.

ASTM D5623. 2019. *Standard Test Method for Sulfur Compounds in Light Petroleum Liquids by Gas Chromatography and Sulfur Selective Detection*. Annual Book of Standards. ASTM International, West Conshohocken, PA.

ASTM D5845. 2019. *Standard Test Method for Determination of MTBE, ETBE, TAME, DIPE, Methanol, Ethanol and t-Butanol in Gasoline by Infrared Spectroscopy*. Annual Book of Standards. ASTM International, West Conshohocken, PA.

ASTM D5986. 2019. *Standard Test Method for Determination of Oxygenates, Benzene, Toluene, C8–C12 Aromatics and Total Aromatics in Finished Gasoline by Gas Chromatography/Fourier Transform Infrared Spectroscopy*. Annual Book of Standards. ASTM International, West Conshohocken, PA.

ASTM D6159. 2019. *Standard Test Method for Determination of Hydrocarbon Impurities in Ethylene by Gas Chromatography*. Annual Book of Standards. ASTM International, West Conshohocken, PA.

ASTM E258. 2019. *Standard Test Method for Total Nitrogen in Organic Materials by Modified Kjeldahl Method*. Annual Book of Standards. ASTM International, West Conshohocken, PA.

ASTM E385. 2019. *Standard Test Method for Oxygen Content Using a 14-MeV Neutron Activation and Direct-Counting Technique*. Annual Book of Standards. ASTM International, West Conshohocken, PA.

ASTM E777. 2019. *Standard Test Method for Carbon and Hydrogen in the Analysis Sample of Refuse-Derived Fuel*. Annual Book of Standards. ASTM International, West Conshohocken, PA.

Blondel-Telouk, A., Loiseleur, H., Barreau, A., Béhar, E., 1995. Determination of the Average Molecular Weight of Petroleum Cuts by Vapor Pressure Depression. *Fluid Phase Equilib.* 110: 315–339.

Bouquet, M., and Bailleul, A. 1982. Nuclear Magnetic Resonance in the Petroleum Industry. *Petroananlysis '81. Advances in Analytical Chemistry in the Petroleum Industry 1975–1982*. G.B. Crump (Editor). John Wiley & Sons, Chichester, United Kingdom.

Carbognani, L. 1997. Fast Monitoring of C_{20}-C_{160} Crude Oil Alkanes by Size-Exclusion Chromatography-Evaporative Light Scattering Detection Performed with Silica Columns. *J. Chromatogr. A* 788: 63–73.

Colin, J.M., and Vion, G. 1983. Routine Hydrocarbon Group-Type Analysis in Refinery Laboratories by High-Performance Liquid Chromatography. *J. Chromatogr.* 280: 152–158.

Dolbear, G.E., Tang, A., and Moorehead, E.L. 1987. Upgrading Studies with California, Mexican, and Middle Eastern Heavy Oils. *Metal Complexes in Fossil Fuels*. R.H. Filby and J.F. Branthaver (Editors). Symposium Series No. 344. American Chemical Society, Washington, DC, Page 220.

Ebert, L.B. 1990. Comment on the Study of Asphaltenes by X-Ray Diffraction. *Fuel Sci. Technol. Int.* 8: 563–569.

Ebert, L.B., Mills, D.R., and Scanlon, J.C. 1987. Preprints, *Div. Pet. Chem. Am. Chem. Soc.* 32(2): 419.

Ebert, L.B., Scanlon, J.C., and Mills, D.R. 1984. X-Ray Diffraction of n-Paraffins and Stacked Aromatic Molecules: Insights into the Structure of Petroleum Asphaltenes. *Liq. Fuels Technol.* 2(3): 257–286.

Felix, G., Bertrand, C., and Van Gastel, F. 1985. Hydroprocessing of Heavy Oils and Residua. *Chromatographia* 20(3): 155–160.

Fotland, P., and Anfindsen, H. 1996. Electrical Conductivity of Asphaltenes in Organic Solvents. *Fuel Sci. Technol. Int.* 14: 101–115.

Fotland, P., Anfindsen, H., and Fadnes, F.H. 1993. Detection of Asphaltene Precipitation and Amounts Precipitated by Measurement of Electrical Conductivity. *Fluid Phase Equilib.* 82: 157–164.

Gary, J.G., Handwerk, G.E., and Kaiser, M.J. 2007. *Petroleum Refining: Technology and Economics*, 5th Edition. CRC Press, Taylor & Francis Group, Boca Raton, FL.

Hasan, M., Ali, M.F., and Arab, M. 1989. Structural Characterization of Saudi Arabian Extra Light and Light Crudes by 1-H and 13-C NMR Spectroscopy. *Fuel* 68: 801–803.

Hsu, C.S., and Robinson, P.R. (Editors). 2017. *Handbook of Petroleum Technology*. Springer International Publishing AG, Cham, Switzerland.

Koots, J.A., and Speight, J.G. 1975. The Relation of Petroleum Resins to Asphaltenes. *Fuel* 54: 179.

Long, R.B., and Speight, J.G. 1989. Studies in Petroleum Composition. I: Development of a Compositional Map for Various Feedstocks. *Rev. Inst. Fr. Pét.* 44: 205.

Miller, R.L., Ettre, L.S., and Johansen, N.G. 1983. Quantitative Analysis of Hydrocarbons by Structural Group Type in Gasoline and Distillates. *Part II. J. Chromatogr.* 259: 393.

Norris, T.A., and Rawdon, M.G. 1984. Determination of Hydrocarbon Types in Petroleum Liquids by Supercritical Fluid Chromatography with Flame Ionization Detection. *Anal. Chem.* 56: 1767–1769.

Parkash, S. 2003. *Refining Processes Handbook*. Gulf Professional Publishing, Elsevier, Amsterdam, Netherlands.

Penzes, S., and Speight, J.G. 1974. Electrical Conductivities of Bitumen Fractions in Non-Aqueous Solvents. *Fuel* 53: 192.

Snape, C.E., Ladner, W.R., and Bartle, K.D. 1979. Survey of Carbon-13 Chemical Shifts – Application to Coal-Derived Materials. *Anal. Chem.* 51: 2189–2198.

Speight, J.G. 1986. Polynuclear Aromatic Systems in Petroleum. Preprints, *Am. Chem. Soc., Div. Pet. Chem.* 31(4): 818.

Speight, J.G. 1987. Initial Reactions in the Coking of Residua. Preprints, *Am. Chem. Soc., Div. Pet. Chem.* 32(2): 413.

Speight, J.G. 1994. Chemical and Physical Studies of Petroleum Asphaltenes. Volume 40. *Asphaltenes and Asphalts, I. Developments in Petroleum Science*. T.F. Yen and G.V. Chilingarian (Editors). Elsevier, Amsterdam, Netherlands, Chapter 2.

Speight, J.G. 2000. *The Desulfurization of Heavy Oils and Residua*, 2nd Edition. Marcel Dekker Inc., New York.Speight, J.G. 2014a. *The Chemistry and Technology of Petroleum*, 5th Edition. CRC Press, Taylor & Francis Group, Boca Raton, FL.

Speight, J.G. 2015. *Handbook of Petroleum Product Analysis*, 2nd Edition. John Wiley & Sons Inc., Hoboken, NJ.

Speight, J.G. 2017. *Handbook of Petroleum Refining*. CRC Press, Taylor & Francis Group, Boca Raton, FL.

Speight, J.G., Wernick, D.L., Gould, K.A., Overfield, R.E., Rao, B.M.L., and Savage, D.W. 1985. Molecular Weights and Association of Asphaltenes: A Critical Review. *Rev. Inst. Fr. Pét.* 40: 27.

Suatoni, J.C., and Garber, H.R. 1975. HPLC Preparative Group-Type Separation of Olefins from Synfuels. *J. Chromatographic Sci.* 13: 367.

Wallace, D. (Editor). 1988. *A Review of Analytical Methods for Bitumens and Heavy Oils.* Alberta Oil Sands Technology and Research Authority, Edmonton, Alberta, Canada.

Wallace, D., and Carrigy, M.A. 1988. New Analytical Results on Oil Sands from Deposits throughout the World. Proceedings. *3rd UNITAR/UNDP International Conference on Heavy Crude and Tar Sands.* R.F. Meyer (Editor). Alberta Oil Sands Technology and Research Authority, Edmonton, Alberta, Canada.

Wallace, D., Starr, J., Thomas, K.P., and Dorrence, S.M. 1988. *Characterization of Oil Sand Resources.* Alberta Oil Sands Technology and Research Authority, Edmonton, Alberta, Canada.

Weinberg, V.L., Yen, T.F., Gerstein, B.C., and Murphy, P.D. 1981. Characterization of Pyrolyzed Asphaltenes by Diffuse Reflectance-Fourier Transform Infrared and Dipolar Dephasing-Solid State[13]C Nuclear Magnetic Resonance Spectroscopy. Preprints, *Div. Pet. Chem. Am. Chem. Soc.* 26(4): 816–824.

3 Feedstock Composition

3.1 INTRODUCTION

As part of the evaluation of refinery feedstocks (Chapter 2), data related to the chemical composition of the feedstock are also produced, if not every effort should be made to acquire such data. In fact, the production of these types of data is an important aspect of refining since the product distribution is dependent on (i) the chemical composition of feedstock, (ii) the primary reactions of the feedstock constituents, (iii) the secondary reactions of the feedstock constituents, and (iv) the interactions of the feedstock constituents with each other, and (v) the secondary reactions of the primary products (Parkash, 2003; Gary et al., 2007; Speight, 2014; Hsu and Robinson, 2017; Speight, 2017).

In the natural state crude oil, heavy crude oil, extra-heavy crude oil, and tar sand bitumen are not homogeneous materials, and the physical characteristics differ depending on where the material was produced. This is due to the fact that any of these feedstocks from different geographical locations will naturally have unique properties. In its natural, unrefined state, crude oil, heavy crude oil, extra-heavy crude oil, and tar sand bitumen range in density and consistency from very thin, lightweight, and volatile fluidity to an extremely thick, semi-solid (Speight, 2014). There is also a tremendous gradation in the color that ranges from a light, golden yellow (conventional crude oil) to black tar sand bitumen.

Thus, crude oil, heavy crude oil, extra-heavy crude oil, and tar sand bitumen are not (within the individual categories) uniform materials, and the chemical and physical (fractional) composition of each of these refinery feedstocks can vary not only with the location and age of the reservoir or deposit but also with the depth of the individual well within the reservoir or deposit. On a molecular basis, the three feedstocks are complex mixtures containing (depending upon the feedstock) hydrocarbon derivatives with varying amounts of hydrocarbonaceous constituents that contain sulfur, oxygen, and nitrogen as well as constituents containing metallic constituents, particularly those containing vanadium nickel, iron, and copper. The hydrocarbon content may be as high as 97% w/w, for example, in a light crude oil or less than 50% w/w in heavy crude oil and bitumen (Speight, 2014).

Thus, regardless of their origins, in the natural state, all crude oils are predominantly constituted of hydrocarbons mixed with variable amounts of sulfur, nitrogen, and oxygen compounds. Metals in the forms of inorganic salts or organometallic compounds are present in the crude mixture in trace amounts. Thus, the mount of heteroatom constituents of these feedstocks typically shows an increase as the equation below moves to the right. Thus:

crude oil → heavy crude oil → extra heavy crude oil ↔ tar sand bitumen

Furthermore, the ratio of the different constituents in these feedstocks vary appreciably from one reservoir (or deposit) to another and in the series. In fact, because of the lack of mobility of tar sand bitumen in the deposit, the amount of the constituents can vary horizontally and vertically within the deposit.

Heavy crude oil, heavy crude oil, and tar sand bitumen (and residua – as a result of the concentration effect of distillation) contain more heteroatomic species and less hydrocarbon constituents than conventional crude oil. Thus, to obtain more naphtha and other distillate products, there have been different approaches to refining the heavier feedstocks as well as the recognition that knowledge of the constituents of these higher-boiling feedstocks is also of some importance. The problems encountered in processing the heavier feedstocks can be equated to the *chemical character* and

the *amount* of complex, higher-boiling constituents in the feedstock. Refining these materials is not just a matter of applying know-how derived from refining *conventional* crude oils but requires knowledge of the *chemical structure* and *chemical behavior* of these more complex constituents.

It is the purpose of this a chapter to present brief overview of the types of constituents that are found in crude oil, petroleum, heavy crude oil, extra-heavy crude oil, oil, and tar sand bitumen and also to present brief descriptions of the chemistry and physics of thermal decomposition.

3.2 ELEMENTAL COMPOSITION

The analysis of feedstocks for the percentages by weight of carbon, hydrogen, nitrogen, oxygen, and sulfur (elemental composition, ultimate composition) is perhaps the first method used to examine the general nature, and perform an evaluation, of a feedstock. The atomic ratios of the various elements to carbon (i.e., H/C, N/C, O/C, and S/C) are frequently used for indications of the overall character of the feedstock. It is also of value to determine the amounts of trace elements, such as vanadium and nickel, in a feedstock since these materials can have serious deleterious effects on catalyst performance during refining by catalytic processes.

As part of the determination of the composition of refinery feedstocks, the first step is the determination of the elemental composition, such as carbon content, which can also be determined by the method designated for coal and coke (ASTM D3178) or by the method designated for municipal solid waste (ASTM E777), as well as hydrogen content, nitrogen content, oxygen content, and metals content (Table 3.1). For all feedstocks, the higher the atomic hydrogen–carbon ratio, the higher is its value as refinery feedstock because of the lower hydrogen requirements for upgrading. Similarly, the lower the heteroatom content, the lower the hydrogen requirements for upgrading. Thus, inspection of the elemental composition of feedstocks is an initial indication of the quality of the feedstock and, with the molecular weight, indicates the molar hydrogen requirements for upgrading (Speight, 2014, 2017).

However, it has become apparent, with the introduction of the heavier feedstocks (such as heavy crude oil, extra-heavy crude oil, and tar sand bitumen) into refinery operations, that these ratios are not the only requirement for predicting feedstock character before refining. The use of more complex feedstocks (in terms of chemical composition) has added a new dimension to refining operations. Thus, although atomic ratios, as determined by elemental analyses, may be used on a comparative basis between feedstocks, there is now no guarantee that a particular feedstock will behave as predicted from these data. In many cases, the product slates cannot be predicted accurately, if at all, from these ratios. Additional knowledge such as defining the various chemical reactions of the constituents as well as the reactions of these constituents with each other also play a role in determining the processability of a feedstock.

In summary, crude oil contains carbon, hydrogen, nitrogen, oxygen, sulfur, and metals (particularly nickel and vanadium) and the amounts of these elements in a whole series of crude oils vary

TABLE 3.1

Standard Test Methods Designated for Elemental Analysis

Analysis	Test Methods
Carbon and hydrogen	ASTM D1018, ASTM D3178, ASTM D3343, ASTM D3701, ASTM D5291, ASTM E777
Nitrogen	ASTM D3179, ASTM D3228, ASTM E258, ASTM D5291, ASTM E778
Oxygen	ASTM E385
Sulfur	ASTM D129, ASTM D139, ASTM D1266, ASTM D1552, ASTM D1757, ASTM D2622, ASTM D3120, ASTM D3177, ASTM D4045, ASTM D4294
Metals content	ASTM C1109, ASTM C1111, ASTM D482, ASTM D1318, ASTM D3340, ASTM D3341, ASTM D3605

TABLE 3.2

Approximate Range of the Elemental Composition of Conventional Crude Oil and Tar Sand Bitumen

Element (% w/w)	Crude Oil	Bitumen
Carbon	83.0–87.0	83.0–84.0
Hydrogen	10.0–14.0	10.0–10.5
Nitrogen	0.1–2.0	0.2–1.0
Oxygen	0.05–1.5	0.5–1.5
Sulfur	0.05–6.0	4.5–5.5
Metals (Ni and V), ppm	<1,000 ppm	>1,000 ppm

over fairly narrow limits (Table 3.2). This narrow range is contradictory to the wide variation in physical properties from the lighter, more mobile crude oils at one extreme to the heavier asphaltic crude oils at the other extreme (see also Charbonnier et al., 1969; Draper et al., 1977). And, because of the narrow range of carbon and hydrogen content, it is not possible to classify crude oil on the basis of carbon content as coal is classified; carbon contents of coal can vary from as low as 75% w/w in lignite to 95% w/w in anthracite (Speight, 2013). Of course, other subdivisions are possible within the various carbon ranges of the coals, but crude oil is restricted to a much narrower range of elemental composition.

The elemental analysis of tar sand bitumen has also been widely reported (Speight, 1990), but the data suffer from the disadvantage that identification of the source is too general (i.e., Athabasca bitumen which covers several deposits) and is often not site specific. In addition, the analysis is quoted for separated bitumen, which may have been obtained by any one of several procedures and may therefore not be representative of the total bitumen on the sand. However, recent efforts have focused on a program to produce sound, reproducible data from samples for which the origin is carefully identified (Wallace et al., 1988). As for conventional crude oil, of the data that are available the elemental composition of tar sand bitumen is generally constant and, like the data for crude oil also falls into a narrow range (Table 3.2). The major exception to these narrow limits is the oxygen content that can vary from as little as 0.2% to as high as 4.5%. This is not surprising, since when oxygen is estimated by difference the analysis is subject to the accumulation of all of the errors in the other elemental data. In addition, bitumen is susceptible to aerial oxygen, and the oxygen content is very dependent on sample history (Speight, 2014, 2015).

The viscosity of tar sand bitumen is related to its hydrogen-to-carbon atomic ratio and hence the required supplementary heat energy for thermal extraction processes. It also affects the bitumen's distillation curve or thermodynamic characteristics, its gravity, and its pour point. Atomic hydrogen-to-carbon ratios as low as 1.3 have been observed for tar sand bitumen although an atomic hydrogen-to-carbon ratio of 1.5 is more typical. The higher the hydrogen–carbon ratio of bitumen, the higher is its value as refinery feedstock because of the lower hydrogen requirements. Elements related to the hydrogen–carbon ratio are distillation curve, bitumen gravity, pour point, and bitumen viscosity.

The occurrence of sulfur in bitumen as organic or elemental sulfur or in produced gas as compounds of oxygen and hydrogen is an expensive nuisance. It must be removed from the bitumen at some point in the upgrading and refining process. Sulfur contents of some tar sand bitumen can exceed 10% w/w. Elements related to sulfur content are hydrogen content, hydrogen–carbon ratio, nitrogen content, distillation curve, and viscosity.

The nitrogen content of tar sand bitumen can be as high as 1.3% by weight and nitrogen-containing constituents complicate the refining process by poisoning the catalysts employed in the refining process. Elements related to nitrogen content are sulfur content, hydrogen content, hydrogen–carbon ratio, bitumen viscosity, distillation profile, and viscosity.

Furthermore, heteroatoms (i.e., nitrogen, oxygen, sulfur, and metals) in feedstocks affect every aspect of refining. The occurrence of *sulfur* in feedstocks as organic or elemental sulfur or in produced gas as compounds of oxygen (SO_x) and hydrogen (H_2S) is an expensive aspect of refining. It must be removed at some point in the upgrading and refining process. Sulfur contents of many crude oil are on the order of 1% by weight whereas the sulfur content of tar sand bitumen can exceed 5% or even 10% by weight. Of all of the heteroelements, sulfur is usually the easiest to remove and many commercial catalysts are available that routinely remove 90% of the sulfur from a feedstock (Speight, 2000).

The *nitrogen* content of crude oil is usually less than 1% by weight but the nitrogen content of tar sand bitumen can be as high as 1.5% by weight. The presence of nitrogen complicates refining by poisoning the catalysts employed in the various processes. Nitrogen is more difficult to remove than sulfur, and there are fewer catalysts that are specific for nitrogen. If the nitrogen is not removed, the potential for the production of nitrogen oxides (NO_x) during processing and use become real.

Metals (particularly *vanadium* and *nickel*) are found in every most crude oils. Heavy oils and residua contain relatively high proportions of metals either in the form of salts or as organometallic constituents (such as the metallo-porphyrins), which are extremely difficult to remove from the feedstock. Indeed, the nature of the process by which residua are produced virtually dictates that all the metals in the original crude oil are concentrated in the residuum (Speight, 2000). The metallic constituents that may actually *volatilize* under the distillation conditions and appear in the higher-boiling distillates are the exceptions here. Metal constituents of feedstocks cause problems by poisoning the catalysts used for sulfur and nitrogen removal as well as the catalysts used in other processes such as catalytic cracking. Thus, serious attempts are being made to develop catalysts that can tolerate a high concentration of metals without serious loss of catalyst activity or catalyst life.

A variety of tests have been designated for the determination of metals in crude oil products (ASTM D1318, ASTM D3340, ASTM D3341, ASTM D3605). Determination of metals in whole feeds can be accomplished by combustion of the sample so that only inorganic ash remains. The ash can then be digested with an acid and the solution examined for metal species by atomic absorption (AA) spectroscopy or by inductively coupled argon plasma (ICP) spectrometry.

3.3 CHEMICAL COMPOSITION

Processability is not only a matter of knowing the elemental composition of a feedstock, but it is also a matter of understanding the bulk properties as they relate to the chemical or physical composition of the material. Understanding of the chemical types (or composition) of any feedstock can lead to a better understanding of the chemical aspects of processing. The viscous feedstock that are a major part of the subject of this are the most complex feedstocks. Few of the molecular constituents are free of heteroatoms (nitrogen, oxygen, sulfur, and metals) and the molecular weight of the constituents extends from 400 to >2,000. In spite of claims to the contrary, at the upper end of this molecular weight range, characterization of individual species is virtually impossible and the concept of an average structure to represent the chemical and physical behavior of a bulk fraction (such as the asphaltene fraction) is nothing short of being inaccurate and totally inadequate (Chapter 4). Separations by group type become blurred by the shear frequency of substitution and by the presence of multiple functionality in single molecules.

In fact, crude oil, heavy crude oil, extra-heavy crude oil, and tar sand bitumen contain an extreme range of organic functionality and molecular size. The variety is so great that it is unlikely that a complete compound-by-compound description for even a single crude oil would not be possible. As already noted, the composition of crude oil can vary with the location and age of the field in addition to any variations that occur with the depth of the individual well. Two adjacent wells are more than likely to produce crude oil with very different characteristics.

In very general terms (and as observed from elemental analyses), crude oil, heavy oil, bitumen, and residua are a complex composition of (i) hydrocarbon derivatives; (ii) nitrogen compounds;

(iii) oxygen compounds; (iv) sulfur compounds; and (v) metallic constituents. However, this general definition is not adequate to describe the composition of crude oil *et al.* as it relates to the behavior of these feedstocks. Indeed, the consideration of hydrogen-to-carbon atomic ratio, sulfur content, and American Petroleum Institute (API) gravity are no longer adequate to the task of determining refining behavior.

Furthermore, the molecular composition of crude oil can be described in terms of three classes of compounds: saturates, aromatics, and compounds bearing heteroatoms (sulfur, oxygen, or nitrogen). Within each class, there are several families of related compounds: (i) saturated constituents include normal alkanes, branched alkanes, and cycloalkanes (paraffin derivatives, iso-paraffin derivatives, and naphthene derivatives, in crude oil terms), (ii) alkene constituents (olefins) are rare to the extent of being considered an oddity, (iii) monoaromatic constituents range from benzene to multiple fused ring analogs (naphthalene, phenanthrene, etc.), (iv) thiol constituents – mercaptan; constituents – contain sulfur as do thioether derivatives and thiophene derivatives, (v) nitrogen-containing and oxygen-containing constituents are more likely to be found in polar forms (pyridines, pyrroles, phenols, carboxylic acids, amides, etc.) than in non-polar forms (such as ethers). The distribution and characteristics of these molecular species account for the rich variety of crude oils.

Feedstock behavior during refining is better addressed through consideration of the molecular make-up of the feedstock (perhaps, by analogy, just as genetic make-up dictates human behavior). The occurrence of amphoteric species (i.e., compounds having a mixed acid/base nature) is rarely addressed nor is the phenomenon of molecular size or the occurrence of specific functional types which can play a major role in the interactions between the constituents of a feedstock (Chapter 4). All of these items are important in determining feedstock behavior during refining operations.

An understanding of the chemical types (or composition) of any feedstock can lead to an understanding of the chemical aspects of processing the feedstock. For example, it is difficult to understand, *a priori*, the process chemistry of various feedstocks from the elemental composition alone. From such data, it might be surmised that the major difference between a heavy crude oil and a more conventional material is the H/C atomic ratio alone. This property indicates that a heavy crude oil (having a lower H/C atomic ratio and being more aromatic in character) would require more hydrogen for upgrading to liquid fuels. This is, indeed, true but much more information is necessary to understand the *processability* of the feedstock.

With the necessity of processing crude oil residua, heavy oil, and tar sand bitumen, to obtain more gasoline and other liquid fuels, there has been the recognition that knowledge of the constituents of these higher-boiling feedstocks is also of some importance. Refining these materials is not just a matter of applying know-how derived from refining *conventional* crude oils but requires knowledge of the *chemical structure* and *chemical behavior* of these more complex constituents.

However, heavy crude oil and bitumen are extremely complex and very little direct information can be obtained by distillation. It is not possible to isolate and identify the constituents of the heavier feedstocks (using analytical techniques that rely upon volatility). Other methods of identifying the chemical constituents must be employed. Such techniques include a myriad of fractionation procedures as well as methods designed to draw inferences related to the hydrocarbon skeletal structures and the nature of the heteroatomic functions.

The hydrocarbon content of crude oil may be as high as 97% by weight (for example, in the lighter paraffinic crude oils) or as low as 50% by weight or less as illustrated by the heavy asphaltic crude oils. Nevertheless, crude oils with as little as 50% hydrocarbon components are still assumed to retain most of the essential characteristics of the hydrocarbon derivatives. It is, nevertheless, the non-hydrocarbon (sulfur, oxygen, nitrogen, and metal) constituents that play a large part in determining the processability of the crude oil and will determine the processability of crude oil, heavy crude oil, extra-heavy crude oil, and tar sand bitumen in the future (Speight, 2011). But there is more to the composition of crude oil than the hydrocarbon content. The inclusion of organic compounds of sulfur, nitrogen, and oxygen serves only to present crude oils as even more complex mixtures, and the appearance of appreciable amounts of these non-hydrocarbon compounds causes

some concern in the refining of crude oils. Even though the concentration of non-hydrocarbon constituents (i.e., those organic compounds containing one or more sulfur, oxygen, or nitrogen atoms) in certain fractions may be quite small, they tend to concentrate in the higher-boiling fractions of crude oil. Indeed, their influence on the processability of the crude oil is important irrespective of their molecular size and the fraction in which they occur. It is, nevertheless, the non-hydrocarbon (sulfur, oxygen, nitrogen, and metal) constituents that play a large part in determining the processability of the crude oil and their influence on the processability of the crude oil is important irrespective of their molecular size (Green et al., 1989; Speight, 2000, 2014, 2015). The occurrence of organic compounds of sulfur, nitrogen, and oxygen serves only to present crude oil as even more complex mixture, and the appearance of appreciable amounts of these non-hydrocarbon compounds causes some concern in crude oil refining. The non-hydrocarbon constituents (i.e., those organic compounds containing one or more sulfur, oxygen, or nitrogen atoms) tend to concentrate in the higher-boiling fractions of crude oil (Speight, 2000). In addition, as the feedstock series progresses to higher-molecular-weight feedstocks from crude oil to heavy crude oil to tar sand bitumen, not only does the number of the constituents increase but the molecular complexity of the constituents also increases (Speight, 2014, 2017).

The presence of traces of non-hydrocarbon compounds can impart objectionable characteristics to finished products, leading to discoloration and/or lack of stability during storage. On the other hand, catalyst poisoning and corrosion are the most noticeable effects during refining sequences when these compounds are present. It is therefore not surprising that considerable attention must be given to the non-hydrocarbon constituents of crude oil as the trend in the refining industry, of late, has been to process more heavy crude oil as well as residua that contain substantial proportions of these non-hydrocarbon materials.

3.3.1 HYDROCARBON CONSTITUENTS

The isolation of pure compounds from crude oil is an exceedingly difficult task, and the overwhelming complexity of the hydrocarbon constituents of the higher-molecular-weight fractions as well as the presence of compounds of sulfur, oxygen, and nitrogen, are the main causes for the difficulties encountered. It is difficult on the basis of the data obtained from synthesized hydrocarbon derivatives to determine the identity or even the similarity of the synthetic hydrocarbon derivatives to those that constitute many of the higher-boiling fractions of crude oil. Nevertheless, it has been well established that the hydrocarbon components of crude oil are composed of paraffinic, naphthenic, and aromatic groups (Table 3.3). Olefin groups are not usually found in crude oils, and acetylene-type hydrocarbon derivatives are very rare indeed. It is therefore convenient to divide the hydrocarbon components of crude oil into the following three classes: (i) paraffin derivatives, (ii) naphthene derivatives, and (iii) aromatic derivatives (Table 3.4).

3.3.1.1 Paraffin Hydrocarbon Derivatives

The proportion of paraffins in crude oil varies with the type of crude, but within any one crude oil, the proportion of paraffinic hydrocarbon derivatives usually decreases with increasing molecular weight and there is a concomitant increase in aromaticity and the relative proportions of the nitrogen-, oxygen-, and sulfur-containing species) (Speight, 2014, 2017).

The abundance of the different members of the same homologous series varies considerably in absolute and relative values. However, in any particular crude oil or crude oil fraction, there may be a small number of constituents forming the greater part of the fraction, and these have been referred to as the *predominant constituents* (Bestougeff, 1961). This generality may also apply to other constituents and is very dependent upon the nature of the source material as well as the relative amounts of the individual source materials prevailing during maturation conditions (Speight, 2014).

Normal paraffin hydrocarbon derivatives (*n-paraffins, straight-chain paraffins*) occur in varying proportions in most crude oils. In fact, paraffinic crude oil may contain up to 20%–50% by

TABLE 3.3
Hydrocarbon and Heteroatom Types in Crude Oil, Heavy Crude Oil, Extra-Heavy Crude Oil, and Tar Sand Bitumen

Class	Compound Types
Saturated hydrocarbons	n-Paraffins
	iso-Paraffins and other branched paraffins
	Cycloparaffins (naphthenes)
	Condensed cycloparaffins (including steranes, hopanes)
	Alkyl side chains on ring systems
Unsaturated hydrocarbons	Olefins: non-indigenous
	Present in products of thermal reactions
Aromatic hydrocarbons	Benzene systems
	Condensed aromatic systems
	Condensed naphthene-aromatic systems
	Alkyl side chains on ring systems
Saturated heteroatomic systems	Alkyl sulfides
	Cycloalkyl sulfides
Sulfides	Alkyl side chains on ring systems
Aromatic heteroatomic systems	Furans (single-ring and multi-ring systems)
	Thiophenes (single-ring and multi-ring systems)
	Pyrroles (single-ring and multi-ring systems)
	Pyridines (single-ring and multi-ring systems)
	Mixed heteroatomic systems
	Amphoteric (acid-base systems)
	Alkyl side chains on ring systems

TABLE 3.4
Hydrocarbon Derivatives Present in Feedstocks

Hydrocarbon	Description
Paraffin derivatives	Saturated hydrocarbon derivatives
	Straight (linear) or branched chains
	No ring structure
Naphthene derivatives	Saturated hydrocarbon derivatives
	Containing one or more rings
	Each ring may have one or more paraffinic side chains)
	More correctly known as alicyclic hydrocarbon derivatives
	If linked up with aromatic ring systems – such as occurs in tetralin – known as naphthene-aromatics; tetralin can be easily converted to naphthalene (see below)
Aromatic derivatives	Hydrocarbon derivatives containing one or more aromatic nuclei, such as benzene, naphthalene, and phenanthrene ring systems
	May be linked up with (substituted) naphthene rings and/or paraffin side chains

Tetralin

Naphthalene

weight *n*-paraffins in the gas oil fraction. However, naphthenic or asphaltic crude oils sometimes contain only very small amounts of normal paraffins.

Considerable quantities of *iso-paraffins* have been noted to be present in the straight-run gasoline fraction of crude oil. The 2-methyl and 3-methyl derivatives are the most abundant, and the 4-methyl derivative is present in small amounts. If at all, and it is generally accepted that the slightly branched paraffins predominate over the highly branched materials. It seems that the *iso*-paraffins occur throughout the boiling range of crude oil fractions. The proportion tends to decrease with increasing boiling point; it appears that if the *iso*-paraffins are present in lubricating oils, their amount is too small to have any significant influence on the physical properties of the lubricating oils.

As the molecular weight (or boiling point) of the crude oil fraction increases, there is a concomitant decrease in the amount of free paraffins in the fraction. In certain types of crude oil, there may be no paraffins at all in the vacuum gas oil (VGO) fraction. For example, in the paraffinic crude oils, free paraffins will separate as a part of the asphaltene fraction but in the naphthenic crude oils, free paraffins are not expected in the gas oil and asphaltene fractions. The vestiges of paraffins in the asphaltene constituents occur as alkyl side chains on aromatic and naphthenic systems. And, these alkyl chains can contain 20 or more carbon atoms (Speight, 1994, 2014).

3.3.1.2　Cycloparaffin Hydrocarbon Derivatives

Although only a small number of representatives have been isolated so far, cyclohexane derivatives, cyclopentane derivatives, and decahydronaphthalene (decalin) derivatives (naphthenes) are largely represented in oil fractions. Crude oil also contains polycyclic naphthenes, such as terpenes, and such molecules (often designated bridge-ring hydrocarbon derivatives) occur even in the heavy gasoline fractions (boiling point 150°C–200°C, 300°F–390°F). Naphthene rings may be built up of a varying number of carbon atoms, and among the synthesized hydrocarbon derivatives, there are individual constituents with rings of the three-, four-, five-, six-, seven-, and eight-carbon atoms. It is now generally believed that crude oil fractions contain chiefly five- and six-carbon rings. Only naphthenes with five- and six-membered rings have been isolated from the lower-boiling fractions. Thermodynamic studies show that naphthene rings with five and six carbon atoms are the most stable. The naphthenic acids contain chiefly cycle pentane as well as cyclohexane rings.

Cycloparaffin derivatives (naphthene derivatives) are represented in all fractions in which the constituent molecules contain more than five carbon atoms. Several series of cycloparaffin derivatives, usually containing five- or six-membered rings or their combinations, occur as polycyclic structures. The content of cycloparaffin derivatives in crude oil varies up to 60% v/v of the total hydrocarbon derivatives. However, the cycloparaffin content of different boiling range fractions of a crude oil may not vary considerably and generally remains within rather close limits. Nevertheless, the structure of these constituents may change within the same crude oil, as a function of the molecular weight or boiling range of the individual fractions as well as from one crude oil to another.

The principal structural variation of naphthenes is the number of rings present in the molecule. The mono- and bicyclic naphthenes are generally the major types of cycloparaffin derivatives in the lower-boiling fractions of crude oil, with boiling point or molecular weight increased by the presence of alkyl chains. The higher boiling point fractions, such as the lubricating oils, may contain two to six rings per molecule. As the molecular weight (or boiling point) of the crude oil fraction increases, there is a concomitant increase in the amount of cycloparaffin (naphthene) species in the fraction. In the asphaltic (naphthenic) crude oils, the gas oil fraction can contain considerable amounts of naphthenic ring systems that increase even more in consideration of the molecular types in the asphaltene constituents. However, as the molecular weight of the fraction increases, the occurrence of condensed naphthene ring systems and alkyl-substituted naphthene ring systems increases.

There is also the premise that the naphthene ring systems carry alkyl chains that are generally shorter than the alkyl substituents carried by aromatic systems. There are indications from spectroscopic studies that the short chains (methyl and ethyl) appear to be characteristic substituents

of the aromatic portion of the molecule, whereas a limited number (one or two) of longer chains may be attached to the cycloparaffin rings. The total number of chains, which is in general four to six, as well as their length, increases according to the molecular weight of the naphthene-aromatic compounds.

In the asphaltene constituent, free condensed naphthenic ring systems may occur but general observations favor the occurrence of combined aromatic-naphthenic systems that are variously substituted by alkyl systems. There is also general evidence that the aromatic systems are responsible for the polarity of the asphaltene constituents. The heteroatoms are favored to occur on or within the aromatic (pseudo-aromatic) systems (Speight, 1994, 2014).

3.3.1.3 Aromatic Hydrocarbon Derivatives

The concept of the occurrence of identifiable aromatic systems in nature is a reality and the occurrence of monocyclic and polycyclic aromatic systems in natural product chemicals is well documented (Sakarnen and Ludwig, 1971; Durand, 1980; Weiss and Edwards, 1980). However, one source of aromatic systems that is often ignored is crude oil (Eglinton and Murphy, 1969; Tissot and Welte, 1978; Brooks and Welte, 1984). Therefore, attempts to identify such systems in the nonvolatile constituents of crude oil should be an integral part of the repertoire of the crude oil chemist as well as the domain of the natural product chemist.

Crude oil is a mixture of compounds, and aromatic compounds are common to all crude oil, and it is the difference in extent that becomes evident upon examination of a series of crude oil. By far, the majority of these aromatics contain paraffinic chains, naphthene rings, and aromatic rings side by side.

There is a general increase in the proportion of aromatic hydrocarbon derivatives with increasing molecular weight. However, aromatic hydrocarbon derivatives without the accompanying naphthene rings or alkyl-substituted derivatives seem to be present in appreciable amounts only in the lower crude oil fractions. Thus, the limitation of instrumentation notwithstanding, it is not surprising that spectrographic identification of such compounds has been concerned with these low-boiling aromatics.

All known aromatics are present in gasoline fractions but the benzene content is usually low compared to the benzene homologues, such as toluene and the xylene isomer. In addition to the 1- and 2-methylnaphthalenes, other simple alkyl naphthalene derivatives have also been isolated from crude oil. Aromatics without naphthene rings appear to be relatively rare in the heavier fractions of crude oil (e.g., lubricating oils). In the higher-molecular-weight fractions, the rings are usually condensed together. Thus, components with two aromatic rings are presumed to be naphthalene derivatives and those with three aromatic rings may be phenanthrene derivatives. Currently, and because of the consideration of the natural product origins of crude oil, phenanthrene derivatives are favored over anthracene derivatives.

In summation, all hydrocarbon compounds that have aromatic rings, in addition to the presence of alkyl chains and naphthenic rings within the same molecule, are classified as aromatic compounds. Many separation procedures that have been applied to crude oil (Speight, 2001, 2014, 2015) result in the isolation of a compound as an *aromatic* even if there is only one such ring (i.e., six carbon atoms) that is substituted by many more than six non-aromatic carbon atoms.

It should also be emphasized that in the higher boiling point crude oil fractions, many polycyclic structures occur in naphthene-aromatic systems. The naphthene-aromatic hydrocarbon derivatives, together with the naphthenic hydrocarbon series, form the major content of higher boiling point crude oil fractions. Usually the different naphthene-aromatic components are classified according to the number of aromatic rings in their molecules. The first to be distinguished is the series with an equal number of aromatic and naphthenic rings. The first members of the bicyclic series $C_9–C_{11}$ are the simplest, such as the 1-methyl-, 2-methyl-, and 4-methylindanes and 2-methyl- and 7-methyltetralin. Tetralin and methyl-, dimethyl-, methyl ethyl-, and tetramethyl tetralin have been found in several crude oils, particularly in the heavier, naphthenic, crude oils, and there are valid

reasons to believe that this increase in the number of rings and side-chain complexity continues into the heavy oil and bitumen feedstocks.

Of special interest in the present context are the aromatic systems that occur in the nonvolatile asphaltene fraction (Speight, 1994). These polycyclic aromatic systems are complex molecules that fall into a molecular weight and boiling range where very little is known about model compounds (Speight, 1994, 2014). There has not been much success in determining the nature of such systems in the higher-boiling constituents of crude oil, i.e., the residua or nonvolatile constituents. In fact, it has been generally assumed that as the boiling point of a crude oil fraction increases, so does the number of condensed rings in a polycyclic aromatic system. To an extent, this is true but the simplicities of such assumptions cause an omission of other important structural constituents of the crude oil matrix, the alkyl substituents, the heteroatoms, and any polycyclic systems that are linked by alkyl chains or by heteroatoms.

The active principle is that crude oil is a continuum (Chapters 12 and 13) and has natural product origins (Long, 1979; Long, 1981; Speight, 1981, 1994, 2014). As such, it might be anticipated that there is a continuum of aromatic systems throughout crude oil that might differ from volatile to non-volatile fractions but which, in fact, are based on natural product systems. It might also be argued that substitution patterns of the aromatic nucleus that are identified in the volatile fractions, or in any natural product counterparts, also applies to the nonvolatile fractions.

The application of thermal techniques to study the nature of the volatile thermal fragments from asphaltene constituents has produced some interesting data relating to the nature of the aromatic systems and the alkyl side chains in crude oil, heavy oil, and bitumen (Speight, 1971; Schucker and Keweshan, 1980; Gallegos, 1981). These thermal techniques have produced strong evidence for the presence of small (one to four ring) aromatic systems (Speight and Pancirov, 1984; Speight, 1987). There was a preponderance of single ring (cycloparaffin and alkylbenzene) species as well as the domination of saturated material over aromatic material.

Further studies using pyrolysis/gas chromatography/mass spectrometry (py/gc/ms) showed that different constituents of the asphaltene fraction produce the same type of polycyclic aromatic systems in the volatile matter but the distribution was not constant (Speight and Pancirov, 1984). It was also possible to compute the hydrocarbon distribution from which a noteworthy point here is preponderance of single ring (cycloparaffin and alkylbenzene) species as well as the domination of saturated material over aromatic material. The emphasis on low-molecular-weight material in the volatile products is to be anticipated on the basis that more complex systems remain as nonvolatile material and, in fact, are converted to coke.

One other point worthy of note is that the py/gc/ms program does not accommodate nitrogen and oxygen species whether or not they be associated with aromatic systems. This matter is resolved, in part, not only by the concentration of nitrogen and oxygen in the nonvolatile material (coke) but also by the overall low proportions of these heteroatoms originally present in the asphaltene constituents (Speight and Pancirov, 1984). The major drawback to the use of the py/gc/ms technique to study of the aromatic systems in the asphaltene constituents is the amount of material that remains as a nonvolatile residue.

Of all of the methods applied to determining the types of aromatic systems in asphaltene constituents, one with considerable potential, but given the least attention, is ultraviolet spectroscopy (Lee et al., 1981; Bjorseth, 1983). Typically, the ultraviolet spectrum of an asphaltene shows two major regions with very little fine structure. Interpretation of such a spectrum can only be made in general terms. However, the technique can add valuable information about the degree of condensation of polycyclic aromatic ring systems through the auspices of high-performance liquid chromatography (hplc) (Lee et al., 1981; Bjorseth, 1983; Monin and Pelet, 1983; Felix et al., 1985; Killops and Readman, 1985; Speight, 1986). Indeed, when this approach is taken, the technique not only confirms the complex nature of the asphaltene fraction but also allows further detailed identifications to be made of the individual functional constituents of asphaltene fraction. The constituents of the fraction produce a multi-component chromatogram but subfractions produce a less complex

and much narrower chromatograph that may even approximate a single peak which may prove much more difficult to separate by a detector.

These data provide strong indications of the ring-size distribution of the polycyclic aromatic systems in the asphaltene constituents. For example, from an examination of various functional subfractions (Chapter 4), it was shown that amphoteric species and basic nitrogen species contain polycyclic aromatic systems having two-to-six rings per system. On the other hand, acid subfractions (phenolic/carboxylic functions) and neutral polar subfractions (amides/imino functions) contain few if any polycyclic aromatic systems having more than three rings per system. Moreover, the differences in the functionality of the subfractions result in substantial differences in thermal and catalytic reactivity that can lead to unanticipated phase separation and, subsequently, coke formation in a thermal reactor as well as structural orientation on, and blocking of, the active sites on a catalyst. This is especially the case when the behavior of the functional types that occur in the various high-boiling fractions of heavy crude oil, extra-heavy crude oil, and tar sand bitumen are considered (Speight, 2014).

In all cases, the evidence favored the preponderance of the smaller (one-to-four) ring systems (Speight, 1986). But, perhaps what is more important about these investigations is that the data show that the asphaltene fraction is a complex mixture of compound types which confirms fractionation studies and *cannot be adequately represented* by any particular formula that is construed to be *average*. Therefore, the concept of a large polycyclic aromatic ring system as the central feature of the asphaltene fraction must be abandoned for lack of evidence.

In summary, the premise is that crude oil is a natural product and that the aromatic systems are based on identifiable structural systems that are derived from natural product precursors.

3.3.1.4 Unsaturated Hydrocarbon Derivatives

The presence of olefins ($RCH=CHR^1$) in crude oil has been under dispute for many years because there are investigators who claim that olefins are actually present. In fact, these claims usually refer to distilled fractions, and it is very difficult to entirely avoid cracking during the distillation process. Nevertheless, evidence for the presence of considerable proportions of olefins in Pennsylvanian crude oils has been obtained; spectroscopic and chemical methods showed that the crude oils, as well as all distillate fractions, contained up to 3% w/w olefins. Hence, although the opinion that crude oil does not contain olefins requires some revision, it is perhaps reasonable to assume that the Pennsylvania crude oils may hold an exceptional position and that olefins are present in crude oil in only a few special cases. The presence of diene derivatives ($RCH=CH=CHR'$) and acetylene derivatives ($RC=CR'$) is considered to be extremely unlikely.

In summary, a variety of hydrocarbon compounds occur throughout crude oil. Although the amount of any particular hydrocarbon varies from one crude oil to another, the family from which that hydrocarbon arises is well represented.

3.3.2 Non-Hydrocarbon Constituents

The previous sections present some indication of the types and nomenclature of the organic hydrocarbon derivatives that occur in various crude oils. Thus, it is not surprising that crude oil which contains only hydrocarbon derivatives is, in fact, an extremely complex mixture. The phenomenal increase in the number of possible isomers for the higher hydrocarbon derivatives makes it very difficult, if not impossible in most cases, to isolate individual members of any one series having more than, say, 12 carbon atoms.

Inclusion of organic compounds of nitrogen, oxygen, and sulfur serves only to present crude oil as an even more complex mixture than was originally conceived. Nevertheless, considerable progress has been made in the isolation and/or identification of the lower-molecular-weight hydrocarbon derivatives, as well as accurate estimations of the overall proportions of the hydrocarbon types present in crude oil. Indeed, it has been established that, as the boiling point of the crude oil fraction

increases, not only the number of the constituents but the molecular complexity of the constituents also increases (Speight, 2000, 2014).

Crude oils contain appreciable amounts of organic non-hydrocarbon constituents, mainly sulfur-, nitrogen-, and oxygen-containing compounds and, in smaller amounts, organometallic compounds in solution and inorganic salts in colloidal suspension. These constituents appear throughout the entire boiling range of the crude oil but tend to concentrate mainly on the heavier fractions and the nonvolatile residues.

Although their concentration in certain fractions may be quite small, their influence is important. For example, the decomposition of inorganic salts suspended in the crude can cause serious breakdowns in refinery operations; the thermal decomposition of deposited inorganic chlorides with evolution of free hydrochloric acid can give rise to serious corrosion problems in the distillation equipment. The presence of organic acid components, such as mercaptan derivatives and acid derivatives, can also promote metallic corrosion. In catalytic operations, passivation and/or poisoning of the catalyst can be caused by deposition of traces of metals (vanadium and nickel) or by chemisorption of nitrogen-containing compounds on the catalyst, thus necessitating the frequent regeneration of the catalyst or its expensive replacement.

The presence of traces of non-hydrocarbon derivatives may impart objectionable characteristics in finished products, such as discoloration, lack of stability on storage, or a reduction in the effectiveness of organic lead antiknock additives. It is thus obvious that more extensive knowledge of these compounds and of their characteristics could result in improved refining methods and even in finished products of better quality. The non-hydrocarbon compounds, particularly the porphyrins and related compounds, are also of fundamental interest in the elucidation of the origin and nature of crude oils.

Although sulfur is the most important (certainly the most abundant) heteroatom (i.e., non-hydrocarbon) present in crude oil with respect to the current context, other non-hydrocarbon atoms can exert a substantial influence not only on the nature and properties of the products but also on the nature and efficiency of the process. Such atoms are nitrogen, oxygen, and metals, and because of their influence on the process, some discussion of each is warranted here. Furthermore, a knowledge of their surface-active characteristics is of help in understanding problems related to the migration of oil from the source rocks to the actual reservoirs.

3.3.2.1 Sulfur Compounds

Although the concentration of heteroatom constituents in certain fractions may be quite small, their influence is important. For example, the decomposition of inorganic salts suspended in the crude can cause serious breakdowns in refinery operations; the thermal decomposition of deposited inorganic chlorides with evolution of free hydrochloric acid can give rise to serious corrosion problems in the distillation equipment. The presence of organic acid components, such as mercaptan derivatives and acid derivatives, can also promote metallic corrosion. In catalytic operations, passivation and/or poisoning of the catalyst can be caused by deposition of traces of metals (vanadium and nickel) or by chemisorption of nitrogen-containing compounds on the catalyst, thus necessitating the frequent regeneration of the catalyst or its expensive replacement.

Sulfur compounds are among the most important heteroatomic constituents of crude oil, and although there are many varieties of sulfur compounds (Speight, 2000, 2014, 2017), the prevailing conditions during the formation, maturation, and even in situ alteration may dictate that only preferred types exist in any particular crude oil. Nevertheless, sulfur compounds of one type or another are present in all crude oils (Thompson et al., 1976). In general, the higher the density of the crude oil for the lower the API gravity of the crude oil) the higher the sulfur content and the total sulfur in the crude oil can vary from approximately 0.04% w/w for light crude oil to approximately 5.0% for heavy crude oil and tar sand bitumen. However, the sulfur content of crude oils produced from broad geographic regions varies with time, depending on the composition of newly discovered fields, particularly those in different geological environments.

The presence of sulfur compounds in finished crude oil products often produces harmful effects. For example, in gasoline, sulfur compounds are believed to promote corrosion of engine parts, especially under winter conditions, when water containing sulfur dioxide from the combustion may accumulate in the crankcase. In addition, mercaptan derivatives in hydrocarbon solution cause the corrosion of copper and brass in the presence of air and also affect lead susceptibility and color stability. Free sulfur is also corrosive, as are sulfide derivatives, disulfide derivatives, and thiophene derivatives, which are detrimental to the octane number response to tetraethyllead. However, gasoline with a sulfur content between 0.2% and 0.5% has been used without obvious harmful effects. In diesel fuels, sulfur compounds increase wear and can contribute to the formation of engine deposits. Although a high sulfur content can sometimes be tolerated in industrial fuel oils, the situation for lubricating oils is that a high content of sulfur compounds in lubricating oils seems to lower resistance to oxidation and increases the deposition of solids.

Although it is generally true that the proportion of sulfur increases with the boiling point during distillation (Speight, 2000, 2014), the middle fractions may actually contain more sulfur than higher-boiling fractions as a result of decomposition of the higher-molecular-weight compounds during the distillation. High-sulfur content is generally considered harmful in most crude oil products, and the removal of sulfur compounds or their conversion to less deleterious types is an important part of refinery practice. The distribution of the various types of sulfur compounds varies markedly among crude oils of diverse origin as well as between the various heavy feedstocks, but fortunately, some of the sulfur compounds in crude oil undergo thermal reactions at relatively low temperatures. If elemental sulfur is present in the oil, a reaction, with the evolution of hydrogen sulfide, begins at approximately 150°C (300°F) and is very rapid at 220°C (430°F), but organically bound sulfur compounds do not yield hydrogen sulfide until higher temperatures are reached. Hydrogen sulfide is, however, a common constituent of many crude oils, and some crude oils with >1% w/w sulfur are often accompanied by a gas having substantial properties of hydrogen sulfide.

Various thiophene derivatives have also been isolated from a variety of crude oils; benzothiophene derivatives are usually present in the higher-boiling crude oil fractions. On the other hand, disulfides are not regarded as true constituents of crude oil but are generally formed by oxidation of thiols during processing:

$$2R - SH + [O] \rightarrow RS - S - R + H_2O$$

3.3.2.2 Nitrogen Compounds

Nitrogen in crude oil may be classified arbitrarily as basic and non-basic. The basic nitrogen compounds Speight, 2014, 2017), which are composed mainly of pyridine homologues and occur throughout the boiling ranges, have a decided tendency to exist in the higher-boiling fractions and residua. The non-basic nitrogen compounds, which are usually of the pyrrole, indole, and carbazole types, also occur in the higher-boiling fractions and residua.

In general, the nitrogen content of crude oil is low and generally falls within the range 0.1% w/w–0.9% w/w, although early work indicates that some crude oil may contain up to 2% nitrogen. However, crude oils with no detectable nitrogen or even trace amounts are not uncommon, but in general the more asphaltic the oil, the higher its nitrogen content. Insofar as an approximate correlation exists between the sulfur content and API gravity of crude oils (Speight, 2000, 2014), there also exists a correlation between nitrogen content and the API gravity of crude oil. It also follows that there is an approximate correlation between the nitrogen content and the carbon residue: the higher the nitrogen content, the higher the carbon residue. The presence of nitrogen in crude oil is of much greater significance in refinery operations than might be expected from the small amounts present. Nitrogen compounds can be responsible for the poisoning of cracking catalysts, and they also contribute to gum formation in such products as domestic fuel oil. The trend in recent years toward cutting deeper into the crude to obtain stocks for catalytic cracking

has accentuated the harmful effects of the nitrogen compounds, which are concentrated largely in the higher-boiling portions.

Basic nitrogen compounds with a relatively low molecular weight can be extracted with dilute mineral acids; equally strong bases of higher molecular weight remain unextracted because of unfavorable partitioning between the oil and aqueous phases. A method has been developed in which the nitrogen compounds are classified as basic or non-basic, depending on whether they can be titrated with perchloric acid in a 50:50 solution of glacial acetic acid and benzene. Application of this method has shown that the ratio of basic to total nitrogen is approximately constant (0 to 30 ± 0.05) irrespective of the source of the crude. Indeed, the ratio of basic to total nitrogen was found to be approximately constant throughout the entire range of distillate and residual fractions. Nitrogen compounds extractable with dilute mineral acids from crude oil distillates were found to consist of alkyl pyridine derivatives, alkyl quinoline derivatives, and alkyl iso-quinoline derivatives carrying alkyl substituents, as well as pyridine derivatives in which the substituent was a cyclopentyl or cyclohexyl group. The compounds that cannot be extracted with dilute mineral acids contain the greater part of the nitrogen in crude oil and are generally of the carbazole, indole, and pyrrole types.

3.3.2.3 Oxygen Compounds

Oxygen in organic compounds can occur in a variety of forms (ROH, ArOH, ROR′, RCO_2H, $ArCO_2H$, RCO_2R, $ArCO_2R$, $R_2C=O$ as well as the cyclic furan derivatives, where R and R′ are alkyl groups and Ar is an aromatic group) in nature so it is not surprising that the more common oxygen-containing compounds occur in crude oil (Speight, 2014). The total oxygen content of crude oil is usually less than 2% w/w, although larger amounts have been reported, when the oxygen content is phenomenally high it may be that the oil has suffered prolonged exposure to the atmosphere either during or after production. However, the oxygen content of crude oil increases with the boiling point of the fractions examined; in fact, the nonvolatile residua may have oxygen contents up to 8% w/w. Although these high-molecular-weight compounds contain most of the oxygen in crude oil, little is known concerning their structure, but those of lower molecular weight have been investigated with considerably more success and have been shown to contain carboxylic acids and phenols.

It has generally been concluded that the carboxylic acids in crude oil with fewer than eight carbon atoms per molecule are almost entirely aliphatic in nature; monocyclic acids begin at C_6 and predominate above C_{14}. This indicates that the structures of the carboxylic acids correspond with those of the hydrocarbon derivatives with which they are associated with the crude oil. In the range in which paraffins are the prevailing type of hydrocarbon, the aliphatic acids may be expected to predominate. Similarly, in the ranges in which mono-cycloparaffin derivatives and di-cycloparaffin derivatives prevail, one may expect to find principally monocyclic and di-cyclic acid derivatives, respectively.

In addition to the carboxylic acids and phenolic compounds, the presence of ketones, esters, ethers, and anhydrides has been claimed for a variety of crude oils. However, the precise identification of these compounds is difficult because most of them occur in the higher-molecular-weight nonvolatile residua. They are claimed to be products of the air blowing of the residua, and their existence in virgin crude oil may yet need to be substantiated.

Although comparisons are frequently made between the sulfur and nitrogen contents, and such physical properties as the API gravity, it is not the same with the oxygen contents of crude oils. It is possible to postulate, and show, that such relationships exist. However, the ease with which some of the crude oil constituents can react with oxygen (aerial or dissolved) to incorporate oxygen functions into their molecular structure often renders the exercise somewhat futile if meaningful deductions are to be made.

Carboxylic acid derivatives (RCO_2H) may be less detrimental than other heteroatom constituents because there is the high potential for decarboxylation to a hydrocarbon and carbon

dioxide at the temperatures (>340°C, >645°F) used during distillation of flashing (Speight and Francisco, 1990):

$$RCO_2H \rightarrow RH + CO_2$$

3.3.2.4 Metallic Constituents

Metallic constituents are found in every crude oil, and the concentrations have to be reduced to convert the oil to transportation fuel. Metals affect many upgrading processes and cause particular problems because they poison catalysts used for sulfur and nitrogen removal as well as other processes such as catalytic cracking. The trace metals Ni and V are generally orders of magnitude higher than other metals in crude oil, except when contaminated with co-produced brine salts (Na, Mg, Ca, Cl) or corrosion products gathered in transportation (Fe).

The occurrence of metallic constituents in crude oil is of considerably greater interest to the crude oil industry than might be expected from the very small amounts present. Even minute amounts of iron, copper, and particularly nickel and vanadium in the charging stocks for catalytic cracking affect the activity of the catalyst and result in increased gas and coke formation and reduced yields of gasoline. In high-temperature power generators, such as oil-fired gas turbines, the presence of metallic constituents, particularly vanadium in the fuel, may lead to ash deposits on the turbine rotors, thus reducing clearances and disturbing their balance. More particularly, damage by corrosion may be very severe. The ash resulting from the combustion of fuels containing sodium and especially vanadium reacts with refractory furnace linings to lower their fusion points and so cause their deterioration.

Thus, the ash residue left after burning of crude oil is due to the presence of these metallic constituents, part of which occur as inorganic water-soluble salts (mainly chlorides and sulfates of sodium, potassium, magnesium, and calcium) in the water phase of crude oil emulsions (Abdel-Aal et al., 2016). These are removed in the desalting operations, either by evaporation of the water and subsequent water washing or by breaking the emulsion, thereby causing the original mineral content of the crude to be substantially reduced. Other metals are present in the form of oil-soluble organometallic compounds as complexes, metallic soaps, or in the form of colloidal suspensions, and the total ash from desalted crude oils is of the order of 0.1–100 mg/l. Metals are generally found only in the nonvolatile portion of crude oil (Reynolds, 1998).

Two groups of elements appear in significant concentrations in the original crude oil associated with well-defined types of compounds. Zinc, titanium, calcium, and magnesium appear in the form of organometallic soaps with surface-active properties adsorbed in the water/oil interfaces and act as emulsion stabilizers. However, vanadium, copper, nickel, and part of the iron found in crude oils seem to be in a different class and are present as oil-soluble compounds. These metals are capable of complexing with pyrrole pigment compounds derived from chlorophyll and hemoglobin and are almost certain to have been present in plant and animal source materials. It is easy to surmise that the metals in question are present in such form, ending in the ash content. Evidence for the presence of several other metals in oil-soluble form has been produced, and thus zinc, titanium, calcium, and magnesium compounds have been identified in addition to vanadium, nickel, iron, and copper. Examination of the analyses of a number of crude oil for iron, nickel, vanadium, and copper indicates a relatively high vanadium content, which usually exceeds that of nickel, although the reverse can also occur.

Distillation concentrates the metallic constituents in the residues (Reynolds, 1998), although some can appear in the higher-boiling distillates, the latter may be due in part to entrainment. Nevertheless, there is evidence that a portion of the metallic constituents may occur in the distillates by volatilization of the organometallic compounds present in the crude oil. In fact, as the percentage of overhead obtained by vacuum distillation of a reduced crude is increased, the amount of metallic constituents in the overhead oil is also increased. The majority of the vanadium, nickel, iron, and copper in residual stocks may be precipitated along with the asphaltene constituents by hydrocarbon solvents. Thus, removal of the asphaltene constituents with n-pentane reduces the vanadium content of the oil by up to 95% with substantial reductions in the amounts of iron and nickel.

3.3.2.5 Porphyrins

Porphyrins are a naturally occurring chemical species that exist in crude oil and usually occur in the non-basic portion of the nitrogen-containing concentrate (Bonnett, 1978; Reynolds, 1998). They are not usually considered among the usual nitrogen-containing constituents of crude oil, nor are they considered a metallo-containing organic material that also occurs in some crude oils. As a result of these early investigations there arose the concept of porphyrins as biomarkers that could establish a link between compounds found in the geosphere and their corresponding biological precursors.

Porphyrins are derivatives of porphine that consists of four pyrrole molecules joined by methine (–CH=) bridges (Figure 3.1). The methine bridges establish conjugated linkages between the component pyrrole nuclei, forming a more extended resonance system. Although the resulting structure retains much of the inherent character of the pyrrole components, the larger conjugated system gives increased aromatic character to the porphine molecule. Furthermore, the imine functions (–NH–) in the porphine system allow metals such as nickel to be included in the molecule through chelation.

A large number of different porphyrin compounds exist in nature or have been synthesized. Most of these compounds have substituents other than hydrogen on many of the ring carbons. The nature of the substituents on porphyrin rings determines the classification of a specific porphyrin compound into one of various types according to one common system of nomenclature (Bonnett, 1978). Porphyrins also have well-known trivial names or acronyms that are often in more common usage than the formal system of nomenclature. When one or two double bonds of a porphyrin are hydrogenated, a chlorin or a phlorin is the result. Chlorin derivatives are components of chlorophyll and possess an iso-cyclic ring formed by two methylene groups bridging a pyrrole-type carbon to a methine carbon. Geological porphyrins that contain this structural feature are assumed to be derived from chlorophylls. Etioporphyrin derivatives are also commonly found in geological materials and have no substituents (other than hydrogen) on the methine carbons. Benzoporphyrin derivatives and tetrahydrobenzoporphyrin derivatives also have been identified in geological materials. These compounds have either a benzene ring or a hydrogenated benzene ring fused onto a pyrrole unit.

Almost all crude oil, heavy oil, and bitumen contain detectable amounts of vanadium and nickel porphyrin derivatives. More mature, lighter crude oils usually contain only small amounts of these compounds. Heavy oils may contain large amounts of vanadium and nickel porphyrin derivatives. Vanadium concentrations of over 1,000 ppm are known for some crude oil, and a substantial amount of the vanadium in these crude oils is chelated with porphyrins. In high-sulfur crude oil of marine origin, vanadium porphyrin derivatives are more abundant than nickel porphyrin derivatives. Low-sulfur crude oils of lacustrine origin usually contain more nickel porphyrin derivatives than vanadium porphyrin derivatives.

FIGURE 3.1 Porphine – the basic structure of porphyrins.

Of all the metals in the periodic table, only vanadium and nickel have been proven definitely to exist as chelates in significant amounts in a large number of crude oils and tar sand bitumen. Geochemical reasons for the absence of substantial quantities of porphyrins chelated with metals other than nickel and vanadium in crude oils, heavy oils, and tar sand bitumen have been advanced (Hodgson et al., 1967; Baker, 1969; Baker and Palmer, 1978; Baker and Louda, 1986; Filby and Van Berkel, 1987; Quirke, 1987).

If the vanadium and nickel contents of crude oils are measured and compared with porphyrin concentrations, it is usually found that not all the metal content can be accounted for as porphyrin constituents (Reynolds, 1998). In some crude oils, as little as 10% w/w of total metals appears to be chelated with porphyrins. Only rarely can all measured nickel and vanadium in a crude oil be accounted for as porphyrin-type. Currently, some investigators believe that part of the vanadium and nickel in crude oils is chelated with ligands that are not porphyrins. These metal chelates are referred to as non-porphyrin metal chelates or complexes (Reynolds et al., 1987).

Finally, during the fractionation of crude oil, the metallic constituents (metalloporphyrins and non-porphyrin metal chelates) are concentrated in the asphaltene fraction. The deasphaltened oil contains smaller concentrations of porphyrins than the parent materials and usually very small concentrations of non-porphyrin metals.

3.4 CHEMICAL COMPOSITION BY DISTILLATION

Although distillation is presented in more detail elsewhere (Chapter 7), it is appropriate to mention distillation here insofar as it is a method by which the constituents of crude oil can be separated and identified. Distillation is a means of separating chemical compounds (usually liquids) through differences in the respective vapor pressures. In the mixture, the components evaporate, such that the vapor has a composition determined by the chemical properties of the mixture. Distillation of a given component is possible, if the vapor has a higher proportion of the given component than the mixture. This is caused by the given component having a higher vapor pressure and a lower boiling point than the other components.

By the nature of the process, it is theoretically impossible to completely separate and purify the individual components of a feedstock when the possible number of isomers are considered for the individual carbon numbers that occur within the paraffin family (Table 3.5). When other types of compounds are included, such as the aromatic derivatives and heteroatom derivatives, even though the maturation process might limit the possible number of isomeric permutations (Tissot and Welte, 1978), the potential number of compounds in crude oil is still (in a sense) astronomical.

However, crude oil can be separated into a variety of fractions on the basis of the boiling points of the crude oil constituents. Such fractions are primarily identified by their respective boiling

TABLE 3.5
Boiling Point of the n-Isomers of the Various Paraffins and the Number of Possible Isomers Associated with Each Carbon Number

Number of Carbon Atoms	Boiling Point (n-isomer °C)	Boiling Point (n-isomer °F)	Number of Isomers
5	36	97	3
10	174	345	75
15	271	519	4,347
20	344	651	366,319
25	402	755	36,797,588
30	450	841	4,111,846,763
40	525	977	62,491,178,805,831

ranges and, to a lesser extent, by chemical composition. However, it is often obvious that as the boiling ranges increase, the nature of the constituents remains closely similar and it is the number of the substituents that caused the increase in boiling point. It is through the recognition of such phenomena that molecular design of the higher-boiling constituents can be achieved (Speight, 2014, 2017). Invoking the existence of structurally different constituents in the nonvolatile fractions from those identifiable constituents in the lower-boiling fractions is unnecessary and (considering the nature of the precursors and maturation paths) is unnecessary and irrational (Speight, 1994, 2014). For example, the predominant types of condensed aromatic systems in crude oil are derivatives of phenanthrene and there it is to be anticipated that the higher peri-condensed homologues shall be present in resin constituents and asphaltene constituents rather than the derivatives of kata-condensed polynuclear aromatic system (Speight, 2014).

3.4.1 Gases and Naphtha

Methane is the main hydrocarbon component of crude oil gases with lesser amounts of ethane, propane, butane, isobutane, and some C_4^+ hydrocarbon derivatives. Other gases, such as hydrogen, carbon dioxide, hydrogen sulfide, and carbonyl sulfide, are also present.

Saturated constituents with lesser amounts of mono- and di-aromatics dominate the naphtha fraction. While naphtha covers the boiling range of gasoline, most of the raw crude oil naphtha molecules have low octane number. However, most raw naphtha is processed further and combined with other process naphtha and additives to formulate commercial gasoline.

Within the saturated constituents in crude oil gases and naphtha, every possible paraffin from methane (CH_4) hydrocarbon to n-decane (n-$C_{10}H_{22}$, normal decane) is present. Depending upon the source, one of these low-boiling paraffins may be the most abundant compound in a crude oil reaching several percent. The iso-paraffins begin at C4 with iso-butane as the only isomer of n-butane. The number of isomers grows rapidly with carbon number and there may be increased difficulty in dealing with multiple isomers during analysis.

In addition to aliphatic molecules, the saturated constituents consist of cycloalkanes (naphthenes) with predominantly five- or six-carbon rings. Methyl derivatives of cyclopentane and cyclohexane, which are commonly found at higher levels than the parent unsubstituted structures may be present (Tissot and Welte, 1978). Fused ring dicycloalkane derivatives such as cis-decahydronaphthalene (cis-decalin) and trans-decahydronaphthalene (trans-decalin) and hexahydro-indan are also common but bicyclic naphthene derivatives separated by a single bond, such as cyclohexyl cyclohexane, are not.

The numerous aromatic constituents in crude oil naphtha begin with benzene, but its C_1–C_3 alkylated derivatives are also present (Tissot and Welte, 1978). Each of the alkyl benzene homologues through the 20 isomeric C_4 alkyl benzenes has been isolated from crude oil along with various C_5-derivatives. Benzene derivatives having fused cycloparaffin rings (naphthene-aromatics) such as indane and tetralin have been isolated along with a number of their methyl derivatives. Naphthalene is included in this fraction while the 1- and 2-methyl naphthalene derivatives and higher homologues of fused two-ring aromatics appear in the mid-distillate fraction.

Sulfur-containing compounds are the only heteroatom compounds to be found in this fraction (Rall et al., 1972). Usually, the total amount of the sulfur in this fraction accounts for less than 1% of the total sulfur in the crude oil. In naphtha from high-sulfur (sour) crude oil, 50%–70% of the sulfur may be in the form of mercaptan derivatives (thiol derivatives). Over 40 individual thiols have been identified, including all the isomeric C_1 to ~6 compounds plus some C_7 and C_8 isomers plus thiophenol (Rall et al., 1972). In naphtha from low-sulfur (sweet) crude oil, the sulfur is distributed between sulfides (thioether derivatives) and thiophene derivatives. In these cases, the sulfides may be in the form of both linear (alkyl sulfides) and five- or six-ring cyclic (thiacyclane) structures. The sulfur structure distribution tends to follow the distribution of hydrocarbon derivatives, i.e., naphthenic oils with a high cycloalkane content tend to have a high thiacyclane content. Typical alkyl thiophene derivatives in naphtha have multiple short side chains or exist as naphthene-thiophene derivatives

(Rall et al., 1972). Methyl and ethyl disulfides have been confirmed to be present in some crude oils in analyses that minimized their possible formation by oxidative coupling of thiols (Aksenov and Kanayanov, 1980; Freidlina and Skorova, 1980).

3.4.2 MIDDLE DISTILLATES

Saturated species are the major component in the mid-distillate fraction of crude oil but aromatics, which now include simple compounds with up to three aromatic rings, and heterocyclic compounds are present and represent a larger portion of the total. Kerosene, jet fuel, and diesel fuel are all derived from raw middle distillate which can also be obtained from cracked and hydroprocessed refinery streams.

Within the saturated constituents, the concentration of n-paraffins decreases regularly from C_{11} to C_{20}. Two isoprenoid species (pristane=2,6,10,14-tetramethylpentadecane and phytane= 2,6,10,14-tetramethylhexadecane) are generally present in crude oils in sufficient concentration to be seen as irregular peaks alongside the n-C_{17} and n-C_{18} peaks in a gas chromatogram. These isoprene derivatives, believed to arise as fragments of ancient precursors, have relevance as simple biomarkers, to the genesis of crude oil. The distribution of pristane and phytane relative to their neighboring n-C_{17} and n-C_{18} peaks has been used to aid the identification of crude oils and to detect the onset of biodegradation. The ratio of pristane to phytane has also been used for the assessment of the oxidation and reduction environment in which ancient organisms were converted into crude oil.

Mono- and di-cycloparaffin derivatives with five or six carbons per ring constitute the bulk of the naphthenes in the middle distillate boiling range, decreasing in concentration as the carbon number increases (Tissot and Welte, 1978) and the alkylated naphthenes may have a single long side chain as well as one or more methyl or ethyl groups. Similarly substituted three-ring naphthenes have been detected by gas chromatography and adamantane has been found in crude oil (Lee et al., 1981).

The most abundant aromatics in the mid-distillate boiling fractions are di- and tri-methyl naphthalene derivatives. Other one and two ring aromatics are undoubtedly present in small quantities as either naphthene or alkyl homologues in the C_{11}–C_{20} range. In addition to these homologues of alkylbenzenes, tetralin, and naphthalene derivatives, the mid-distillate contains some fluorene derivatives and phenanthrene derivatives. The phenanthrene structure appears to be favored over that of anthracene structure (Tissot and Welte, 1978), and this appears to continue through the higher-boiling fractions of crude oil (Speight, 1994).

The five-membered heterocyclic constituents in the mid-distillate range are primarily the thiacyclane derivatives, benzothiophene derivatives, and dibenzothiophene derivatives with lesser amounts of dialkyl-, diaryl and aryl-alkyl sulfide derivatives (Aksenov and Kanayanov, 1980; Freidlina and Skorova, 1980). Alkylthiophenes are also present. As with the naphtha fractions, these sulfur species account for a minimal fraction of the total sulfur in the crude.

Although only trace amounts (usually ppm levels) of nitrogen are found in the middle distillate fractions, both neutral and basic nitrogen compounds have been isolated and identified in fractions boiling below 343°C (650°F) (Hirsch et al., 1974). Pyrrole derivatives and indole derivatives account for approximately two-thirds of the nitrogen while the remainder is found in the basic alkylated pyridine and alkylated quinoline compounds.

The saturate constituents contribute less to the VGO than the aromatic constituents but more than the polar constituents that are now present at percentage rather than trace levels. VGO is occasionally used as a heating oil but most commonly, it is processed by catalytic cracking to produce naphtha or extraction to yield lubricating oil.

Within the VGO, saturates, distribution of paraffins, iso-paraffins, and naphthenes are highly dependent upon the crude oil source. Generally, the naphthene constituents account for approximately two-thirds 60% of the saturate constituents but the overall range of variation is from <20% to >80%. In most samples, the n-paraffins from C_{20} to C_{44} are still present in sufficient quantity to be detected as distinct peaks in gas chromatographic analysis.

The bulk of the saturated constituents in VGO consists of iso-paraffins and especially naphthene species although isoprenoid compounds, such as squalane (C_{30}) and lycopane (C_{40}), have been detected. Analytical techniques show that the naphthenes contain from one to more than six fused rings accompanied by alkyl substitution. For mono- and di-aromatics, the alkyl substitution typically involves several methyl and ethyl substituents. Hopanes and steranes have also been identified and are also used as internal markers for estimating biodegradation of crude oils during bioremediation processes (Prince et al., 1994).

The aromatic constituents in VGO may contain one to six fused aromatic rings that may bear additional naphthene rings and alkyl substituents in keeping with their boiling range. Mono- and di-aromatics account for approximately 50% of the aromatics in crude oil VGO samples. Analytical data show the presence of up to four fused naphthenic rings on some aromatic compounds. This is consistent with the suggestion that these species originate from the aromatization of steroids. Although present at lower concentration, alkyl benzenes and naphthalene derivatives show one long side chain and multiple short side chains.

The fused ring aromatic compounds (having three or more rings) in crude oil include phenanthrene, chrysene, and picene as well as fluoranthene, pyrene, benzo(a)pyrene, and benzo(ghi) perylene. The most abundant reported individual phenanthrene compounds appear to be the three derivatives. In addition, phenanthrene derivatives outnumber anthracene derivatives by as much as 100:1. In addition, chrysene derivatives are favored over pyrene derivative.

Heterocyclic constituents are significant contributors to the VGO fraction. In terms of sulfur compounds, thiophene and thiacyclane sulfur predominate over sulfide sulfur. Some molecules even contain more than one sulfur atom. The benzothiophene derivatives and dibenzothiophene derivatives are the prevalent thiophene forms of sulfur. In the VGO range, the nitrogen-containing compounds include higher-molecular-weight pyridine derivatives, quinoline derivatives, benzoquinoline derivatives, amide derivatives, indole derivatives, carbazole derivative, and molecules with two nitrogen atoms (diaza compounds) with three and four aromatic rings are especially prevalent (Green et al., 1989). Typically, approximately one-third of the compounds are basic, i.e., pyridine and its benzo- derivatives while the remainder is present as neutral species (amide derivatives and carbazole derivatives). Although benzo- and dibenzo-quinoline derivatives found in crude oil are rich in sterically hindered structures, hindered and unhindered structures have been found to be present at equivalent concentrations in source rocks. This has been rationalized as geo-chromatography in which the less polar (hindered) structures moved more readily to the reservoir and are not adsorbed on any intervening rocks structures.

Oxygen levels in the VGO parallel the nitrogen content. Thus, the most commonly identified oxygen compounds are the carboxylic acids and phenols, collectively called naphthenic acids (Seifert and Teeter, 1970).

3.4.3 Vacuum Residua

The vacuum residuum (*vacuum bottoms*, typically 950°F+ or 1,050°F+) is the most complex of crude oil and, in many cases, may even resemble heavy oil or extra-heavy oil or tar sand bitumen in composition. Vacuum residua contain the majority of the heteroatoms originally in the crude oil and molecular weight of the constituents range up to several thousand (as near as can be determined but subject to method dependence). The fraction is so complex that the characterization of individual species is virtually impossible, no matter what claims have been made or will be made. Separation of vacuum residua by group type become difficult and confused because of the multi-substitution of aromatic and naphthenic species as well as by the presence of multiple functionalities in single molecules.

Classically, n-pentane or n-heptane precipitation is used as the initial step for the characterization of vacuum residuum. The insoluble fraction, the pentane- or heptane-asphaltene constituents, may be as much as 50% by weight of a vacuum residuum. The pentane- or heptane-soluble portion

(maltene) constituents of the residuum is then fractionated chromatographically into several solubility or adsorption classes for characterization. However, in spite of claims to the contrary, the method is not a separation by chemical type. Kit is a separation by solubility and adsorption. However, the separation of the asphaltene constituents does, however, provide a simple way to remove some of the highest molecular weight and most polar components but the asphaltene fraction is so complex that compositional detail based on average parameters is of questionable value.

For the $565°C^+$ ($1,050°F^+$) fractions of crude oil, the levels of nitrogen and oxygen may begin to approach the concentration of sulfur. These elements consistently concentrate in the most polar fractions to the extent that every molecule contains more than one heteroatom. At this point, structural identification is somewhat fruitless and characterization techniques are used to confirm the presence of the functionalities found in lower-boiling fractions such as, for example, acids, phenols, non-basic (carbazole-type) nitrogen, and basic (quinoline-type) nitrogen.

The nickel and vanadium that are concentrated into the vacuum residuum appear to occur in two forms: (i) porphyrin derivatives and (ii) non-porphyrin derivatives (Reynolds, 1998). Because the metalloporphyrins can provide insights into crude oil maturation processes, they have been studied extensively and several families of related structures have been identified. On the other hand, the non-porphyrin metals remain not clearly identified although some studies suggest that some of the metals in these compounds still exist in a tetra-pyrrole (porphyrin-type) environment (Pearson and Green, 1993).

It is more than likely that, in a specific residuum molecule, the heteroatoms are arranged in different functionalities, making an incredibly complex molecule. Considering how many different combinations are possible, the chances of determining every structure in a residuum are very low. Because of this seemingly insurmountable task, it may be better to determine ways of utilizing the residuum rather than attempting to determine (at best questionable) molecular structures.

3.5 FRACTIONAL COMPOSITION

Refining crude oil involves subjecting the feedstock to a series of integrated physical and chemical unit processes (Figure 3.2) (Parkash, 2003; Gary et al., 2007; Speight, 2014; Hsu and Robinson, 2017; Speight, 2017) as a result of which a variety of products are generated. In some of the processes, e.g., distillation, the constituents of the feedstock are isolated unchanged, whereas in other processes (such as cracking), considerable changes are occurred in the constituents.

Feedstocks can be defined (on a *relative* or *standard* basis) in terms of three or four general fractions: asphaltene constituents, resin constituents, saturates, and aromatics (Figure 3.3). Thus, it is possible to compare inter-laboratory investigations and thence to apply the concept of predictability to refining sequences and potential products. Recognition that refinery behavior is related to the composition of the feedstock has led to a multiplicity of attempts to establish crude oil and its fractions as compositions of matter. As a result, various analytical techniques have been developed for the identification and quantification of *every molecule* in the lower-boiling fractions of crude oil. It is now generally recognized that the name *crude oil* does not describe a composition of matter but rather a mixture of various organic compounds that includes a wide range of molecular weights and molecular types that exist in balance with each other (Speight, 1994; Long and Speight, 1998). There must also be some questions of the advisability (perhaps *futility* is a better word) of attempting to describe *every molecule* in crude oil. The true focus should be to what ends these molecules can be used.

The fractionation methods available to the crude oil industry allow a reasonably effective degree of separation of hydrocarbon mixtures (Speight, 2014, 2015). However, the problems are separating the crude oil constituents without alteration of their molecular structure and obtaining these constituents in a substantially pure state. Thus, the general procedure is to employ techniques that segregate the constituents according to molecular size and molecular type.

It is more generally true, however, that the success of any attempted fractionation procedure involves not only the application of one particular technique but also the utilization of several

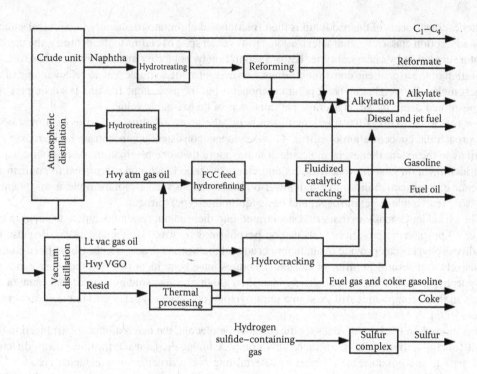

FIGURE 3.2 Representation of a refinery.

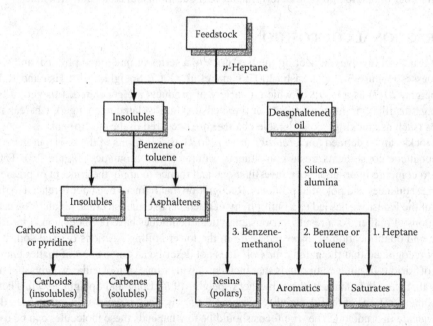

FIGURE 3.3 Separation scheme for various feedstocks.

integrated techniques, especially those techniques involving the use of chemical and physical prop-
erties to differentiate among the various constituents. For example, the standard processes of physi-
cal fractionation used in the crude oil industry are those of distillation and solvent treatment, as well
as adsorption by surface-active materials. Chemical procedures depend on specific reactions, such
as the interaction of olefins with sulfuric acid or the various classes of adduct formation. Chemical

fractionation is often but not always successful and, because of the complex nature of crude oil. This may result in unprovoked chemical reactions that have an adverse effect on the fractionation and the resulting data. Indeed, caution is advised when using methods that involve chemical separation of the constituents.

The order in which the several fractionation methods are used is determined not only by the nature and/or composition of the crude oil but also by the effectiveness of a particular process and its compatibility with the other separation procedures to be employed. Thus, although there are wide variations in the nature of refinery feedstocks, there have been many attempts to devise standard methods of crude oil fractionation. However, the various laboratories are inclined to adhere firmly to, and promote, their own particular methods. Recognition that no one particular method may satisfy all the requirements of crude oil fractionation is the first step in any fractionation study. This is due, in the main part, to the complexity of crude oil not only from the distribution of the hydrocarbon species but also from the distribution of the heteroatom (nitrogen, oxygen, and sulfur) species.

3.5.1 SOLVENT METHODS

Fractionation of crude oil by distillation is an excellent means by which the volatile constituents can be isolated and studied. However, the nonvolatile residuum, which may actually constitute from 1% to 60% of the crude oil, cannot be fractionated by distillation without the possibility of thermal decomposition, and as a result alternative methods of fractionation have been developed.

The distillation process separates *light* (lower molecular weight) and *heavy* (higher molecular weight) constituents by virtue of their volatility and involves the participation of a vapor phase and a liquid phase. These are, however, physical processes that involve the use of two liquid phases, usually a solvent phase and an oil phase.

Solvent methods have also been applied to crude oil fractionation on the basis of molecular weight. The major molecular weight separation process used in the laboratory as well as in the refinery is solvent precipitation. Solvent precipitation occurs in a refinery in a deasphalting unit (Speight, 2014, 2017) and is essentially an extension of the procedure for separation by molecular weight, although some separation by polarity might also be operative. The deasphalting process is usually applied to the higher-molecular-weight fractions of crude oil such as atmospheric and vacuum residua.

These fractionation techniques can also be applied to cracked residua, asphalt, bitumen, and even to virgin crude oil, but in the last case the possibility of losses of the lower-boiling constituents is apparent; hence the recommended procedure for virgin crude oil is, first, distillation followed by fractionation of the residua.

The simplest application of solvent extraction consists of mixing the feedstock with another liquid, which results in the formation of two phases. This causes the distribution of the crude oil constituents over the two phases (i) the dissolved portion, i.e., the extract and (ii) the non-dissolved portion, the raffinate which is the feedstock from which the non-desirable constituents have been removed by solvent extraction.

The ratio of the concentration of any particular component in the two phases is known as the distribution coefficient K:

$$K = C1 / C2$$

C_1 and C_2 are the concentrations of the components in the various phases. The distribution coefficient is usually constant and may vary only slightly, if at all, with the concentration of the other components. In fact, the distribution coefficients may differ for the various components of the mixture to such an extent that the ratio of the concentrations of the various components in the solvent phase differs from that in the original crude oil; this is the basis for solvent extraction procedures.

It is generally molecular type, not molecular size, which is responsible for the solubility of species in various solvents. Thus, solvent extraction separates crude oil fractions according to type, although

within any particular series, there is a separation according to molecular size. Lower-molecular-weight hydrocarbon derivatives of a series (the light fraction) may well be separated from their higher-molecular-weight homologues (the heavy fraction) by solvent extraction procedures.

In general, it is advisable that selective extraction be employed with fairly narrow boiling range fractions. However, the separation achieved after one treatment with the solvent is rarely complete and several repetitions of the treatment are required. Such repetitious treatments are normally carried out by movement of the liquids counter-currently through the extraction equipment (*counter-current extraction*), which affords better yields of the extractable materials.

The list of compounds that have been suggested as selective solvents for the preferential extraction fractionation of crude oil contains a large selection of different functional types (Speight, 2014). However, before any extraction process is attempted, it is necessary to consider the following criteria: (i) the differences in the solubility of the crude oil constituents in the solvent should be substantial, (ii) the solvent should be significantly less dense or denser than the crude oil (product) to be separated to allow easier countercurrent flow of the two phases, and (iii) separation of the solvent from the extracted material should be relatively easy.

It may also be advantageous to consider other properties, such as viscosity, surface tension, and the like, as well as the optimal temperature for the extraction process. Thus, aromatics can be separated from naphthene and paraffinic hydrocarbon derivatives by the use of selective solvents. Furthermore, aromatics with differing numbers of aromatic rings that may exist in various narrow boiling fractions can also be effectively separated by solvent treatment.

The separation of crude oil into two fractions – (i) the asphaltene fraction and (ii) the maltene fraction – is conveniently brought about by use of low-molecular-weight paraffin hydrocarbon derivatives, which were recognized to have selective solvency for hydrocarbon derivatives, and simple relatively low-molecular-weight hydrocarbon derivatives. The more complex, higher-molecular-weight compounds are precipitated particularly well by addition of 40 volumes of *n*-pentane or *n*-heptane in the methods generally preferred at present (Speight et al., 1984; Speight, 1994) although hexane is used on occasion (Yan et al., 1997). It is no doubt a separation of the chemical components with the most complex structures from the mixture, and this fraction, which should correctly be called the *n-pentane asphaltene fraction* or the *n-heptane asphaltene fraction* is qualitatively and quantitatively reproducible (Figure 3.3) (Speight, 2014, 2015).

Variation in the solvent type also causes significant changes in asphaltene yield. For example, in the ease of a Western Canadian bitumen and, indeed, for conventional crude oils, branched-chain paraffins or terminal olefins do not precipitate the same amount of asphaltene constituents as do the corresponding normal paraffins (Mitchell and Speight, 1973). Cycloparaffin derivatives (naphthene derivatives) have a remarkable effect on asphaltene yield and give results totally unrelated to those from any other non-aromatic solvent. For example, when cyclopentane, cyclohexane, or their methyl derivatives are employed as precipitating media, only approximately 1% w/w of the material remains insoluble.

To explain those differences, it was necessary to consider the solvent power of the precipitating liquid, which can be related to molecular properties (Hildebrand et al., 1970). The solvent power of non-polar solvents has been expressed as a solubility parameter (δ) and equated to the internal pressure of the solvent, that is, the ratio between the surface tension (γ) and the cubic root of the molar volume (V):

$$\delta_1 = \sqrt[3]{V}$$

Alternatively, the solubility parameter of non-polar solvents can be related to the energy or vaporization ΔR^v and the molar volume:

$$\delta_2 = \left(\Delta E^V / V\right)^{1/2_v}$$

Also:

$$\delta_2 = (\Delta H^V - RT/V)^{1/2}$$

In these equations, ΔH^v is the heat of vaporization, R is the gas constant, and T is the absolute temperature.

The introduction of a polar group (heteroatom function) into the molecule of the solvent has significant effects on the quantity of precipitate. For example, treatment of a residuum with a variety of ethers or treatment of asphaltene constituents with a variety of solvents illustrates this point (Speight, 1979). In the latter instance, it was not possible to obtain data from addition of the solvent to the whole feedstock *per se* since the majority of the non-hydrocarbon materials were not miscible with the feedstock. It is nevertheless interesting that, as with the hydrocarbon derivatives, the amount of precipitate, or asphaltene solubility, can be related to the solubility parameter.

The solubility parameter allows an explanation of certain apparent anomalies, for example, the insolubility of asphaltene constituents in pentane and the near complete solubility of the materials in cyclopentane. Moreover, the solvent power of various solvents is in agreement with the derivation of the solubility parameter; for any one series of solvents the relationship between amount of precipitate (or asphaltene solubility) and the solubility parameter δ is quite regular.

In any method used to isolate asphaltene constituents as a separate fraction, standardization of the technique is essential. For many years, the method of asphaltene constituents separation was not standardized, and even now it remains subject to the preferences of the standard organizations of different countries. The use of both *n*-pentane and *n*-heptane has been widely advocated, and although *n*-heptane is becoming the deasphalting liquid of choice, this is by no means a hard-and-fast rule. And it must be recognized that large volumes of solvent may be required to effect a reproducible separation, similar to amounts required for consistent asphaltene separation. It is also preferable that the solvents be of sufficiently low boiling point that complete removal of the solvent from the fraction can be effected and, most important, the solvent must not react with the feedstock. Hence, the preference for hydrocarbon liquids, although the several standard methods that have been used are not unanimous in the ratio of hydrocarbon liquid to feedstock.

Method	Deasphalting Liquid	Volume (ml/gm)
ASTM D893	*n*-pentane	10
ASTM D2007	*n*-pentane	10
ASTM D3279	*n*-heptane	100
ASTM D4124	*n*-heptane	100

However, it must be recognized that some of these methods were developed for use with feedstocks other than heavy oil and adjustments are necessary.

Although, *n*-pentane and *n*-heptane are the solvents of choice in the laboratory (other solvents can be used (Speight, 1979) and cause the separation of asphaltene constituents as brown-to-black powdery materials. In the refinery, supercritical low-molecular-weight hydrocarbon derivatives (e.g., liquid propane, liquid butane, or mixtures of both) are the solvents of choice and the product is a semisolid (tacky) to solid asphalt. The amount of asphalt that settles out of the paraffin/residuum mixture depends on the size of the paraffin, the temperature, and the paraffin-to-feedstock ratio (Corbett and Petrossi, 1978; Speight et al., 1984; Speight, 2014, 2015).

Insofar as industrial solvents are very rarely one compound, it was also of interest to note that the physical characteristics of two different solvent types, in this case benzene and *n*-pentane, are additive on a mole-fraction basis (Mitchell and Speight, 1973) and also explain the variation of solubility with temperature. The data also show the effects of blending a solvent with the bitumen itself and allowing the resulting solvent-heavy oil blend to control the degree of bitumen solubility. Varying

proportions of the hydrocarbon alter the physical characteristics of the oil to such an extent that the amount of precipitate (asphaltene constituents) can be varied accordingly within a certain range.

At constant temperature, the quantity of precipitate first increases with increasing ratio of solvent to feedstock and then reaches a maximum (Speight et al., 1984). In fact, there are indications that when the proportion of solvent in the mix is <35% little or no asphaltene constituents are precipitated. In addition, when pentane and the lower-molecular-weight hydrocarbon solvents are used in large excess, the quantity of precipitate and the composition of the precipitate change with increasing temperature (Mitchell and Speight, 1973).

Contact time between the hydrocarbon and the feedstock also plays an important role in asphaltene separation (Speight et al., 1984). Yields of the asphaltene constituents reach a maximum after approximately 8 hours, which may be ascribed to the time required for the asphaltene particles to agglomerate into particles of a *filterable size* as well as the diffusion-controlled nature of the process. Heavier feedstocks also need time for the hydrocarbon to penetrate their mass.

After removal of the asphaltene fraction, further fractionation of crude oil is also possible by variation of the hydrocarbon solvent. For example, liquefied gases, such as propane and butane, precipitate as much as 50% by weight of the residuum or bitumen. The precipitate is a black, tacky, semisolid material, in contrast to the pentane-precipitated asphaltene constituents, which are usually brown, amorphous solids. Treatment of the propane precipitate with pentane then yields the insoluble brown, amorphous asphaltene constituents and soluble, near-black, semisolid resin constituents, which are, as near as can be determined, equivalent to the resin constituents isolated by adsorption techniques (Speight, 2014, 2015).

3.5.2 ADSORPTION METHODS

Separation by adsorption chromatography essentially commences with the preparation of a porous bed of finely divided solid, the adsorbent. The adsorbent is usually contained in an open tube (column chromatography); the sample is introduced at one end of the adsorbent bed and induced to flow through the bed by means of a suitable solvent. As the sample moves through the bed the various components are held (adsorbed) to a greater or lesser extent depending on the chemical nature of the component. Thus, those molecules that are strongly adsorbed spend considerable time on the adsorbent surface rather than in the moving (solvent) phase, but components that are slightly adsorbed move through the bed comparatively rapidly.

It is essential that, before application of the adsorption technique to the crude oil, the asphaltene constituents first be completely removed, for example, by any of the methods outlined in the previous section. The prior removal of the asphaltene constituents is essential insofar as they are usually difficult to remove from the earth or clay and may actually be irreversibly adsorbed on the adsorbent.

By definition, the *saturate fraction* consists of paraffins and cycloparaffin derivatives (naphthene derivatives). The single-ring *naphthene derivatives*, or *cycloparaffin derivatives*, present in crude oil are primarily alkyl-substituted cyclopentane and cyclohexane rings. The alkyl groups are usually quite short, with methyl, ethyl, and isopropyl groups the predominant substituents. As the molecular weight of the naphthenes increases, the naphthene fraction contains more condensed rings with six-membered rings predominating. However, five-membered rings are still present in the complex higher-molecular-weight molecules.

The *aromatic fraction* consists of those compounds containing an aromatic ring and varies from *mono-aromatics* (containing one benzene ring in a molecule) to *di-aromatics* (substituted naphthalene) to *tri-aromatics* (substituted phenanthrene). Higher condensed ring systems (*tetra-aromatics*, *penta-aromatics*) are also known but are somewhat less prevalent than the lower ring systems, and each aromatic type will have increasing amounts of condensed ring naphthene attached to the aromatic ring as molecular weight is increased.

However, depending upon the adsorbent employed for the separation, a compound having an aromatic ring (i.e., six aromatic carbon atoms) carrying side chains consisting *in toto* of more than six carbon atoms (i.e., more than six non-aromatic carbon atoms) will appear in the aromatic fraction.

Careful monitoring of the experimental procedures and the nature of the adsorbent has been responsible for the successes achieved with this particular technique. Early procedures consisted of warming solutions of the crude oil fraction with the adsorbent and subsequent filtration. This procedure has continued to the present day, and separation by adsorption is used commercially in plant operations in the form of clay treatment of crude oil fractions and products. In addition, the proportions of each fraction are subject to the ratio of adsorbent to deasphaltened oil.

It is also advisable, once a procedure using a specific adsorbent has been established, that the same type of adsorbent be employed for future fractionation since the ratio of the product fractions varies from adsorbent to adsorbent. It is also very necessary that the procedure be used with caution and that the method not only be reproducible but quantitative recoveries be guaranteed; reproducibility with only, say, 85% of the material recoverable is not a criterion of success.

There are two procedures that have received considerable attention over the years and these are (i) the United States Bureau of Mines-American Petroleum Institute (USBM-API) method and (ii) the saturates-aromatics-resin constituents–asphaltene constituents (SARA) method. This latter method is often also called the saturates-aromatics-polar constituents–asphaltene constituents (SAPA) method. These two methods are used as representing the standard methods of crude oil fractionation. Other methods are also noted, especially when the method has added further meaningful knowledge to compositional studies (Speight, 2014, 2015).

However, there are precautions that must be taken when attempting to separate heavy feedstocks (heavy oil, tar sand bitumen) or polar feedstocks into constituent fractions. The disadvantages in using ill-defined adsorbents are that adsorbent performance differs with the same feed and, in certain instances, may cause chemical and physical modification of the feed constituents. The use of a chemical reactant like sulfuric acid should only be advocated with caution since feedstocks react differently and may even cause irreversible chemical changes and/or emulsion formation (Abdel-Aal et al., 2016). These advantages may be of little consequence when it is not, for various reasons, the intention to recover the various product fractions *in toto* or in the original state, but in terms of the compositional evaluation of different feedstocks, the disadvantages are very real.

In summary, the terminology used for the identification of the various methods might differ. However, in general terms, group-type analysis of crude oil is often identified by the acronyms for the names: PONA (paraffins, olefins, naphthenes, and aromatics), PIONA (paraffins, *iso*-paraffins, olefins, naphthenes, and aromatics), PNA (paraffins, naphthenes, and aromatics), PINA (paraffins, *iso*-paraffins, naphthenes, and aromatics), or SARA (saturates, aromatics, resin constituents, and asphaltene constituents). However, it must be recognized that the fractions produced by the use of different adsorbents will differ in content and will also be different from fractions produced by solvent separation techniques.

The variety of fractions isolated by these methods and the potential for the differences in composition of the fractions makes it even more essential that the method is described accurately and that it reproducible not only in any one laboratory but also between various laboratories.

3.5.3 CHEMICAL METHODS

Methods of fractionation using chemical reactants are entirely different in nature from the methods described in the preceding sections. Although several methods using chemical reactants have been applied to fractionation, method such as adsorption, solvent treatment, and treatment with alkali (Speight, 2014, 2015), these methods are often applied to product purification as well as separation.

The method of chemical separation commonly applied to separate crude oil into various fractions is treatment with sulfuric acid and, since this method has also been applied in the refinery

but with limited success in the fractionation of heavy oil and/or bitumen due to the formation of complex sulfates and difficult-to-break emulsions (Speight, 2014, 2015). Obviously, the success of this fractionation method is feedstock dependent and, in conclusion, it would appear that the test be left more as a method of product cleaning for which it was originally designed rather than a method of separation of the various fractions.

3.6 USE OF THE DATA

The use of composition data to model feedstock behavior during refining is becoming increasingly important in refinery operations (Speight, 2014, 2017). For example, molecular models have been used for some time with limited success, and the use of the analytical data requires somewhat more than reduction of the data to a mental paper exercise. The trend of the use of compositional data for process modeling has progressed beyond this stage and compositional models use (i) analytical data, (ii) representation of the molecular structure of a large number of components, and (iii) molecular structure property relationships.

Furthermore, the composition of crude oil, heavy crude oil, extra-heavy crude oil, and tar sand bitumen is reflected in the properties of these feedstocks. For example, whereas (conventional) crude oil flows readily at ambient conditions, heavy crude oil, extra-heavy crude oil, and tar sand bitumen are highly viscous at ambient conditions and cannot flow readily without some form of stimulation (typically thermal stimulation) under ambient conditions. This is a direct result of the lower content of lower-molecular-weight constituents and the higher content of higher-molecular-weight constituents in the heavy crude oil, extra-heavy crude oil, and tar sand bitumen.

Thus, by careful selection of an appropriate technique, it is possible to obtain an overview of feedstock composition that can be used for behavioral predictions. By taking the approach one step further and by assiduous collection of various subfractions, it becomes possible to develop the compositional map and add an extra dimension to compositional studies. Such a map does not give any indication of the complex interrelationships of the constituents of the various fractions (Koots and Speight, 1975; Speight, 1994, 2014). Although predictions of feedstock behavior is possible using such data, for more accurate predictions, it is necessary to take the composition studies one step further using subfractionation of the major fractions to obtain a more representative indication of feedstock composition.

In the simplest sense, each feedstock is a composite of four major fractions that are defined by the method of separation (Figure 3.3) (Long, 1979, 1981; Long and Speight, 1989; Speight, 2014, 2015) but, more important, the behavior and properties of any feedstock are dictated by composition (Speight, 2014, 2015). Although early studies were primarily focused on the composition and behavior of asphalt, the techniques developed for those investigations have provided an excellent means of studying heavy feedstocks (Tissot, 1984). Later studies have focused not only on the composition of crude oil and its major operational fractions but on further fractionation that allows the different feedstocks to be compared on a relative basis and to provide a very simple but convenient feedstock *map*.

Furthermore, crude oil can be viewed as consisting of two continuous distributions, one of molecular weight and the other of molecular type. Using data from molecular weight studies and elemental analyses, the number of nitrogen and sulfur atoms in the aromatic fraction and in the polar aromatic fraction can also be also exhibited. These data showed that not only can every molecule in the resin constituents and asphaltene constituents have more than one sulfur atom or more than one nitrogen atom but also some molecules probably contain both sulfur and nitrogen. As the molecular weight of the aromatic fraction decreases, the sulfur and nitrogen contents of the fractions also decrease. In contrast to the sulfur-containing molecules, which appear in both the naphthene aromatics and the polar aromatic fractions, the oxygen compounds present in the heavy fractions of crude oil are normally found in the polar aromatics fraction.

More recent work (Long and Speight, 1989) involved the development of a different type of compositional map using the molecular weight distribution and the molecular type distribution as

coordinates. The separation involved the use of an adsorbent such as clay, and the fractions were characterized by *solubility parameter* as a measure of the polarity of the molecular types. The molecular weight distribution can be determined by gel permeation chromatography. Using these two distributions, a map of composition can be prepared using molecular weight and solubility parameter as the coordinates for plotting the two distributions. Such a composition map can provide insights into many separation and conversion processes used in crude oil refining.

A composition map can be very useful for predicting the effectiveness of various types of separations or conversions of refinery feedstocks (Long and Speight, 1998). These processes are adsorption, distillation, solvent precipitation with relatively non-polar solvents, and solvent extraction with polar solvents. The vertical lines show the cut points between saturates aromatics and polar aromatics as determined by clay chromatography. The slanted lines show how distillation, extraction, and solvent precipitation can divide the composition map. The line for distillation divides the map into distillate, which lies below the dividing line, and bottoms, which lies above the line. As the boiling point of the distillate is raised, the line moves upward, including higher-molecular-weight materials and more of the polar species in the distillate and rejecting lower-molecular-weight materials from the bottoms. As more of the polar species are included in the distillate, the carbon residue of the distillate rises. In contrast to the cut lines generated by separation processes, conversion processes move materials in the composition from one molecular type to another (Long and Speight, 1998).

The ultimate decision in the choice of any particular fractionation technique must be influenced by the need for the data. For example, there are those needs that require only that the crude oil be separated into four bulk fractions. On the other hand, there may be the need to separate the crude oil into many subfractions in order to define specific compound types (Green et al., 1988; Vogh and Reynolds, 1988). Neither method is incorrect; each method is merely being used to answer the relevant questions about the character of the crude oil.

Thus, once the composition of the feedstock is known with a high degree of certainty, the processes can be selected and products manufactured to give a balanced operation in which the refinery feedstock oil is converted into a variety of products in amounts that are in accord with the demand for each. For example, the manufacture of products from the lower-boiling portion of a feedstock automatically produces a certain amount of higher-boiling components using distillation and various thermal processes (Speight, 2014, 2017). If the latter cannot be sold as, say, heavy fuel oil, these products will accumulate until refinery storage facilities are full. To prevent the occurrence of such a situation, the refinery must be flexible and be able to change operations as needed. This usually means more processes are required for refining the heavier feedstocks: (i) thermal processes to change an excess of heavy fuel oil into more naphtha (from which gasoline is produced) with coke as the residual product or (ii) a vacuum distillation process to separate the viscous feedstock into lubricating oil stocks and asphalt.

REFERENCES

Abdel-Aal, H.K., Aggour, M.A., and Fahim, M.A. 2016. *Petroleum and Gas Filed Processing.* CRC Press, Taylor & Francis Publishers, Boca Raton, FL.

Aksenov, V.S., and Kanayanov, V.F. 1980. Regularities in Composition and Structures of Native Sulfur Compounds from Petroleum. Proceedings. *9th International Symposium on Organic Sulfur Chemistry.* Riga, USSR, June 9–14.

ASTM D893. 2019. *Standard Test Method for Insolubles in Used Lubricating Oils.* Annual Book of Standards. ASTM International, West Conshohocken, PA.

ASTM D1018. 2019. *Standard Test Method for Hydrogen in Petroleum Fractions.* Annual Book of Standards. ASTM International, West Conshohocken, PA.

ASTM D1266. 2019. *Standard Test Method for Sulfur in Petroleum Products (Lamp Method).* Annual Book of Standards. ASTM International, West Conshohocken, PA.

ASTM D1318. 2019. *Standard Test Method for Sodium in Residual Fuel Oil (Flame Photometric Method).* Annual Book of Standards. ASTM International, West Conshohocken, PA.

ASTM D1552. 2019. *Standard Test Method for Sulfur in Petroleum Products (High-Temperature Method).* Annual Book of Standards. ASTM International, West Conshohocken, PA.

ASTM D1757. 2019. *Standard Test Method for Sulfur in Ash from Coal and Coke.* Annual Book of Standards. ASTM International, West Conshohocken, PA.

ASTM D2007. 2019. *Standard Test Method for Characteristic Groups in Rubber Extender and Processing Oils and Other Petroleum-Derived Oils by the Clay-Gel Absorption Chromatographic Method.* Annual Book of Standards. ASTM International, West Conshohocken, PA.

ASTM D2622. 2019. *Standard Test Method for Sulfur in Petroleum Products by Wavelength Dispersive X-ray Fluorescence Spectrometry.* Annual Book of Standards. ASTM International, West Conshohocken, PA.

ASTM D3177. 2019. *Standard Test Methods for Total Sulfur in the Analysis Sample of Coal and Coke.* Annual Book of Standards. ASTM International, West Conshohocken, PA.

ASTM D3178. 2019. *Standard Test Methods for Carbon and Hydrogen in the Analysis Sample of Coal and Coke.* Annual Book of Standards. ASTM International, West Conshohocken, PA.

ASTM D3179. 2019. *Standard Test Methods for Nitrogen in the Analysis Sample of Coal and Coke.* Annual Book of Standards. ASTM International, West Conshohocken, PA.

ASTM D3228. 2019. *Standard Test Method for Total Nitrogen in Lubricating Oils and Fuel Oils by Modified Kjeldahl Method.* Annual Book of Standards. ASTM International, West Conshohocken, PA.

ASTM D3279. 2019. *Standard Test Method for n-Heptane Insolubles.* Annual Book of Standards. ASTM International, West Conshohocken, PA.

ASTM D3340. 2019. *Standard Test Method for Lithium and Sodium in Lubricating Greases by Flame Photometer.* Annual Book of Standards. ASTM International, West Conshohocken, PA.

ASTM D3341. 2019. *Standard Test Method for Lead in Gasoline—Iodine Monochloride Method.* Annual Book of Standards. ASTM International, West Conshohocken, PA.

ASTM D3343. 2019. *Standard Test Method for Estimation of Hydrogen Content of Aviation Fuels.* Annual Book of Standards. ASTM International, West Conshohocken, PA.

ASTM D3605. 2019. *Standard Test Method for Trace Metals in Gas Turbine Fuels by Atomic Absorption and Flame Emission Spectroscopy.* Annual Book of Standards. ASTM International, West Conshohocken, PA.

ASTM D3701. 2019. *Standard Test Method for Hydrogen Content of Aviation Turbine Fuels by Low Resolution Nuclear Magnetic Resonance Spectrometry.* Annual Book of Standards. ASTM International, West Conshohocken, PA.

ASTM D4045. 2019. *Standard Test Method for Sulfur in Petroleum Products by Hydrogenolysis and Rateometric Colorimetry.* Annual Book of Standards. ASTM International, West Conshohocken, PA.

ASTM D4124. 2019. *Standard Test Method for Separation of Asphalt into Four Fractions.* Annual Book of Standards. ASTM International, West Conshohocken, PA.

ASTM D4294. 2019. *Standard Test Method for Sulfur in Petroleum and Petroleum Products by Energy Dispersive X-ray Fluorescence Spectrometry.* Annual Book of Standards. ASTM International, West Conshohocken, PA.

ASTM E258. 2019. *Standard Test Method for Total Nitrogen in Organic Materials by Modified Kjeldahl Method.* Annual Book of Standards. ASTM International, West Conshohocken, PA.

ASTM E385. 2019. *Standard Test Method for Oxygen Content Using a 14-MeV Neutron Activation and Direct-Counting Technique.* Annual Book of Standards. ASTM International, West Conshohocken, PA.

ASTM E777. 2019. *Standard Test Method for Carbon and Hydrogen in the Analysis Sample of Refuse-Derived Fuel.* Annual Book of Standards. ASTM International, West Conshohocken, PA.

ASTM E778. 2019. *Standard Test Methods for Nitrogen in Refuse-Derived Fuel Analysis Samples.* Annual Book of Standards. ASTM International, West Conshohocken, PA.

Baker, E.W. 1969. *Organic Geochemistry.* G. Eglinton and M.T.J. Murphy (Editors). Springer-Verlag, New York.

Baker, E.W., and Louda, J.W. 1986. *Biological Markers in the Sedimentary Record.* R.B. Johns (Editor). Elsevier, Amsterdam.

Baker, E.W., and Palmer, S.E. 1978. *The Porphyrins, Volume I: Structure and Synthesis, Part A.* D. Dolphin (Editor). Academic Press, New York.

Bestougeff, M.A. 1961. Études Methodes Separation Immediate. *Chromatogr. Comptes Réndus* 55.

Bjorseth, A. 1983. *Handbook of Polycyclic Aromatic Hydrocarbons.* Marcel Dekker Inc., New York.

Bonnett, R. 1978. *The Porphyrins, Volume I: Structure and Synthesis, Part A.* D. Dolphin (Editor). Academic Press, New York.

Brooks, J., and Welte, D.H. 1984. *Advances in Petroleum Geochemistry.* Academic Press Inc., New York.

Charbonnier, R.P., Draper, R.G., Harper, W.H., and Yates, A. 1969. Analyses and Characteristics of Oil Samples from Alberta. Information Circular IC 232. Department of Energy Mines and Resources, Mines Branch, Ottawa, Canada.

Corbett, L.W., and Petrossi, U. 1978. Differences in Distillation and Solvent Separated Asphalt Residua. *Ind. Eng. Chem. Prod. Res. Dev.* 17: 342.

Draper, R.G., Kowalchuk, E., and Noel, G. 1977. Analyses and Characteristics of Crude Oil Samples Performed Between 1969 and 1976. Report ERP/ERL 77-59 (TR). Energy, Mines, and Resources, Ottawa, Canada.

Durand, B. 1980. *Kerogen: Insoluble Organic Matter from Sedimentary Rocks.* Editions Technip, Paris, France.

Eglinton, G., and Murphy, B. 1969. *Organic Geochemistry: Methods and Results.* Springer-Verlag, New York.

Felix, G., Bertrand, C., and Van Gastel, F. 1985. Hydroprocessing of Heavy Oils and Residua. *Chromatographia* 20: 155–160.

Filby, R.H., and Van Berkel, G.J. 1987. *Metal Complexes in Fossil Fuels.* R.H. Filby and J.F. Branthaver (Editors). Symposium Series No. 344. American Chemical Society, Washington, DC, Page 2.

Freidlina, I.K., and Skorova, A.E. (Editors). 1980. *Organic Sulfur Chemistry.* Pergamon Press, New York.

Gallegos, E.J.J. 1981. Alkylbenzenes Derived from Carotenes in Coals by GC/MS. *Chromatogr. Sci.* 19: 177–182.

Gary, J.G., Handwerk, G.E., and Kaiser, M.J. 2007. *Petroleum Refining: Technology and Economics*, 5th Edition. CRC Press, Taylor & Francis Group, Boca Raton, FL.

Green, J.A., Green, J.B., Grigsby, R.D., Pearson, C.D., Reynolds, J.W., Sbay, I.Y., Sturm, O.P. Jr., Thomson, J.S., Vogh, J.W., Vrana, R.P., Yu, S.K.Y., Diem, B.H., Grizzle, P.L., Hirsch, D.E., Hornung, K.W., Tang, S.Y., Carbognani, L., Hazos, M., and Sanchez, V. 1989. Analysis of Heavy Oils: Method Development and Application to Cerro Negro Heavy Petroleum, NIPER-452 (DE90000200). Volumes I and II. Research Institute, National Institute for Petroleum and Energy Research (NIPER), Bartlesville, OK.

Green, J.B., Grizzle, P.L., Thomson, P.S., Shay, J.Y., Diehl, B.H., Hornung, K.W., and Sanchez, V. 1988. Report No. DE88 001235. Contract FC22–83F460149. United States Department of Energy, Washington, DC.

Hildebrand, J.H., Prausnitz, J.M., and Scott, R.L. 1970. *Regular Solutions.* Van Nostrand-Reinhold, New York.

Hirsch, D.E., Cooley, J.E., Coleman, H.J., and Thompson, C.J. 1974. Qualitative Characterization of Aromatic Concentrates of Crude Oils from GPC Analysis. Report 7974. Bureau of Mines, U.S. Department of the Interior, Washington, DC.

Hodgson, G.W., Baker, B.L., and Peake, E. 1967. *Fundamental Aspects of Petroleum Geochemistry.* B. Nagy and U. Columbo (Editors). Elsevier, Amsterdam, Chapter 5.

Hsu, C.S., and Robinson, P.R. (Editors). 2017. *Handbook of Petroleum Technology.* Springer International Publishing AG, Cham, Switzerland.

Killops, S.D., and Readman, J.W. 1985. HPLC Fractionation and GC-MS Determination of Aromatic Hydrocarbons for Oils and Sediments. *Org. Geochem.* 8: 247–257.

Koots, J.A., and Speight, J.G. 1975. The Relationship of Petroleum Resins to Asphaltenes. *Fuel* 54: 179.

Lee, M.L., Novotny, M.S., and Bartle, K.D. 1981. *Analytical Chemistry of Polycyclic Aromatic Compounds.* Academic Press Inc., New York.

Long, R.B. 1979. The Concept of Asphaltenes. Preprints, *Div. Pet. Chem. Am. Chem. Soc.* 24(4): 891.

Long, R.B. 1981. The Concept of Asphaltenes. *The Chemistry of Asphaltenes.* J.W. Bunger and N. Li (Editors). Advances in Chemistry Series No. 195. American Chemical Society, Washington, DC.

Long, R.B., and Speight, J.G. 1989. Studies in Petroleum Composition. I: Development of a Compositional Map for Various Feedstocks. *Rev. Inst. Fr. Pét.* 44: 205.

Long, R.B., and Speight, J.G. 1998. The Composition of Petroleum. *Petroleum Chemistry and Refining.* Taylor & Francis Publishers, Washington, DC, Chapter 1.

Mitchell, D.L., and Speight, J.G. 1973. The Solubility of Asphaltenes in Hydrocarbon Solvents. *Fuel* 52: 149.

Monin, J.C., and Pelet, R. 1983. *Advances in Organic Geochemistry.* M. Bjorev (Editor). John Wiley & Sons Inc., New York.

Parkash, S. 2003. *Refining Processes Handbook.* Gulf Professional Publishing, Elsevier, Amsterdam, Netherlands.

Pearson, C.D., and Green, J.B. 1993. Vanadium and Nickel Complexes in Petroleum Resid Acid, Base, and Neutral Fractions. *Energy Fuels* 7: 338–346.

Prince, R.O., Elmendoff, D.L., Lute, B.R., Hsu, C.S., Hath, C., Sunnis, B.P., Decherd, G., Douglas, D., and Butler, E. 1994. *Environ. Sci Technol.* 28: 142.

Quirke, J.M.E. 1987. *Metal Complexes in Fossil Fuels.* R.H. Filby and J.F. Branthaver (Editors). Symposium Series No. 344. American Chemical Society, Washington, DC, Page 74.

Rall, H.T., Thompson, C.J., Coleman, H.J., and Hopkins, R.L. 1972. *Sulfur Compounds in Crude Oil.* Bulletin 659. Bureau of Mines, U.S. Department of the Interior, Washington, DC.

Reynolds, J.G. 1998. Metals and Heteroatoms in Heavy Crude Oils. *Petroleum Chemistry and Refining.* J.G. Speight (Editor). Taylor & Francis Publishers, Washington, DC, Chapter 3.

Reynolds, J.G., Biggs, W.E., and Bezman, S.A. 1987. *Metal Complexes in Fossil Fuels*. R.H. Filby and J.F. Branthaver (Editors). Symposium Series No. 344. American Chemical Society, Washington, DC, Page 205.

Sakarnen, K.V., and Ludwig, C.H. 1971. *Lignins: Occurrence, Formation, Structure and Reactions*. John Wiley & Sons Inc., New York.

Schucker, R.C., and Keweshan, C.F. 1980. Reactivity of Cold Lake Asphaltenes. Preprints, *Div. Fuel Chem. Am. Chem. Soc.* 25: 155.

Seifert, W.K., and Teeter, R.M. 1970. Identification of Polycyclic Aromatic and Heterocyclic Crude Oil Carboxylic Acids. *Anal Chem.* 42: 750–758.

Speight, J.G. 1971. Thermal Cracking of Athabasca Bitumen, Athabasca Asphaltenes, and Athabasca Deasphalted Heavy Oil. *Fuel* 49: 134.

Speight, J.G. 1979. Studies on Bitumen Fractionation: (a) Fractionation by a Cryoscopic Method (b) Effect of Solvent Type on Asphaltene Solubility. Information Series No. 84. Alberta Research Council, Edmonton, Alberta, Canada.

Speight, J.G. 1981. Asphaltenes as an Organic Natural Product and Their Influence on Crude Oil Properties. Proceedings. *Division of Geochemistry. American Chemical Society*, New York Meeting.

Speight, J.G. 1986. Polynuclear Aromatic Systems in Petroleum. Preprints, *Div. Pet. Chem. Am. Chem. Soc.* 31(4): 818.

Speight, J.G. 1987. Initial Reactions in the Coking of Residua. Preprints, *Div. Pet. Chem. Am. Chem. Soc.* 32(2): 413.

Speight, J.G. 1990. Tar Sands. *Fuel Science and Technology Handbook*. Marcel Dekker Inc., New York, Chapter 12.

Speight, J.G. 1994. Chemical and Physical Studies of Petroleum Asphaltenes. Volume 40. *Asphaltenes and Asphalts. I. Developments in Petroleum Science*. T.F. Yen and G.V. Chilingarian (Editors). Elsevier, Amsterdam, Netherlands, Chapter 2.

Speight, J.G. 2000. *The Desulfurization of Heavy Oils and Residua*, 2nd Edition. Marcel Dekker, New York.

Speight, J.G. 2001. *Handbook of Petroleum Analysis*. John Wiley & Sons Inc., Hoboken, NJ.

Speight, J.G. 2011. *The Refinery of the Future*. Gulf Professional Publishing, Elsevier, Oxford, United Kingdom.

Speight, J.G. 2013. *The Chemistry and Technology of Coal*, 3rd Edition. CRC Press, Taylor & Francis Group, Boca Raton, FL.

Speight, J.G. 2014. *The Chemistry and Technology of Petroleum*, 5th Edition. CRC Press, Taylor & Francis Group, Boca Raton, FL.

Speight, J.G. 2015. *Handbook of Petroleum Product Analysis*, 2nd Edition. John Wiley & Sons Inc., Hoboken, NJ.

Speight, J.G. 2017. *Handbook of Petroleum Refining*. CRC Press, Taylor & Francis Group, Boca Raton, FL.

Speight, J.G., and Francisco, M.A. 1990. Studies in Petroleum Composition IV: Changes in the Nature of Chemical Constituents during Crude Oil Distillation. *Rev. Inst. Fr. Pét.* 45: 733.

Speight, J.G., Long, R.B., and Trowbridge, T.D. 1984. Factors Influencing the Separation of Asphaltenes from Heavy Petroleum Feedstocks. *Fuel* 63: 616.

Speight, J.G., and Pancirov, R.J. 1984. Structural Types in Asphaltenes as Deduced from Pyrolysis-Gas Chromatography-Mass Spectrometry. *Liq. Fuels Technol.* 2: 287.

Thompson, C.J., Ward, C.C., and Ball, J.S. 1976. Characteristics of World's Crude oils and Results of API Research Project 60. Report BERC/RI-76/8. Bartlesville Energy Technology Center, Bartlesville, OK.

Tissot, B.P. (Editor). 1984. *Characterization of Heavy Crude Oils and Petroleum Residues*. Editions Technip, Paris.

Tissot, B.P., and Welte, D.H. 1978. *Petroleum Formation and Occurrence*. Springer-Verlag, New York.

Vogh, J.W., and Reynolds, J.W. 1988. Report No. DE88 001242. Contract FC22–83FE60149. United States Department of Energy, Washington, DC.

Wallace, D., Starr, J., Thomas, K.P., and Dorrence, S.M. 1988. Characterization of Oil Sands Resources. Alberta Oil Sands Technology and Research Authority, Edmonton, Alberta, Canada.

Weiss, V., and Edwards, J.M. 1980. *The Biosynthesis of Aromatic Compounds*. John Wiley & Sons, Inc., New York.

Yan, J., Plancher, H., and Morrow, N.R. 1997. Wettability Changes Induced by Adsorption of Asphaltenes. Paper No. SPE 37232. Proceedings. *SPE International Symposium on Oilfield Chemistry*. Houston, TX. Society of Petroleum Engineers, Richardson, TX.

4 Asphaltene Constituents in Feedstocks

4.1 INTRODUCTION

The properties and processability of any feedstock are dictated by the chemical composition of the feedstock (Chapter 3), and once the chemical composition of a material has been established, it becomes possible to correlate composition and properties. In terms of bulk composition, a feedstock can be fractionated into four bulk fraction: (i) the saturates fraction, (ii) the aromatics fraction, (iii) the resins or resin constituents, and (iv) the asphaltenes or asphaltene constituents. However, the names of these fractions are not intended to be (and, indeed, are not) an accurate representation of the chemical compositions of the fractions but are used to indicate the method of separation of the fractions (Speight, 2014, 2015). In previous chapters (Chapters 2 and 3), there has been frequent reference to the asphaltene constituents of feedstocks and, because of the importance of this fraction during refining, further discussion is warranted here.

The asphaltene fraction of a feedstock is composed of a variety of constituents that are the highest molecular weight and the most polar constituents in the feedstock (Speight, 1994, 2014, 2015, 2019). Isolation of the asphaltene fraction is achieved from a feedstock by the addition of a hydrocarbon liquid (such as n-pentane or n-heptane) (Andersen and Speight, 1992; Speight, 1994; Andersen and Speight, 2001; Speight, 2014, 2019). The fraction is isolated a dark brown to black friable solids that have no definite melting point and usually foam and swell on heating to leave a carbonaceous residue.

The issues arising from the presence of problems with asphaltene constituents (Table 4.1) have increased due to the increased use of need to extract even the high viscosity feedstocks. Examples of the issues that arise due to asphaltene flocculation and/or sedimentation are (i) wellbore plugging and pipeline deposition during recovery and transportation operations, (ii) water contamination during wellhead storage and in pipelines can lead to the formation of emulsions because the asphaltene constituents highly polar and surface active, (iii) sedimentation and plugging during feedstock storage (and during product storage) can occur due to oxidation of the asphaltene constituents and the increased polarity of the oxidized products, and (iv) thermally degraded asphaltene constituents are more aromatic (loss of aliphatic chains) and less soluble and appear as sediment (the onset of coke formation) during the visbreaking process and during cracking processes.

For the purposes of this chapter, the resin constituents are regarded as those materials soluble in *n*-pentane or *n*-heptane (i.e., whichever hydrocarbon is used for the separation of asphaltene constituents) but insoluble in liquid propane. In addition, *resin constituents* are also those materials soluble in *n*-pentane or *n*-heptane but that cannot be extracted from an earth by *n*-pentane or *n*-heptane. The oils fraction is, therefore, that fraction of feedstock soluble in *n*-pentane or in *n*-heptane that is extractable from an earth by *n*-pentane or by *n*-heptane and the fraction is composed of saturates and aromatics fractions (Chapter 3).

Nevertheless, attempts have been made to collate the results of work carried out on the resin and oil factions, as it is now evident that a refinery feedstock is a delicately balanced physical system. Each fraction depends on the others for complete mobility and maintaining the stability of the feedstock.

Questions may also be raised regarding the usefulness of attempting to determine the exact structure of each complex material, such as asphaltene constituents, resin constituents, and nonvolatile

TABLE 4.1

Examples of Problems Arising from the Presence of Asphaltene Constituents in a Feedstock

Process	Problem
Oil recovery	Wellbore plugging and pipeline deposition
Blending	Blending conventional crude oil with viscous crude oils cause a change in the properties of the medium that can cause destabilization of the asphaltene constituents
Visbreaking	Degraded (partially reacted) asphaltene constituents are more aromatic (due to loss of aliphatic side chains) and less soluble
Cracking processes	Degraded (partially reacted) asphaltene constituents are more aromatic (due to loss of aliphatic side-chains) and less soluble
Blending fuel oils	The change of solvent properties of the medium during mixing may cause destabilization of the asphaltene constituents
Storage	Sedimentation and plugging can occur due to oxidation of the asphaltenes; the increased polarity may cause asphaltene aggregation; sludge formation can furthermore be accelerated if there is bacterial infestation in the fuel
Emulsion formation	A high degree of water contamination can result in the formation of emulsions; asphaltene constituents are highly polar and surface active and can be responsible for the undesired stabilization of emulsions, since asphaltenes
Preheating	Preheating of fuel oils prior to combustion encourages the precipitation of asphaltene constituents and coking
Combustion	A high content (>65 w/w) of asphaltene constituents in the fuel results in ignition delay and poor combustion; the result is boiler fouling, poor heat transfer, stack solid emission, and corrosion

oils (the saturates and aromatics fractions). Perhaps the answers lie not only in determining the locations of the heteroatoms (nitrogen, oxygen, and sulfur). It is the hope that this allows modifications to the various processes resulting in easy elimination of these atoms. It will also allow evaluation of the structural types present in the hydrocarbon portions of these molecules in the hope of deriving as much benefit as possible during processing of these complex materials.

4.2 SEPARATION

The asphaltene fraction is, by definition, a *solubility class* and is the fraction precipitated from feedstocks by the addition of 40 volumes of the liquid hydrocarbon to one volume of the feedstock (Table 4.2). For highly viscous feedstock which require addition of an equal volume of a solvent (such as toluene) to ensure diffusion of the precipitant into the feedstock mass, the ratio is 40 volumes of the precipitate to one volume of the feedstock plus the toluene or 80 volumes of the precipitant to the feedstock volume (Girdler, 1965; Mitchell and Speight, 1973; Speight et al., 1982, 1984; Andersen and Birdi, 1990; Andersen, 1994; Speight, 1994, 2014, 2015, 2019).

The asphaltene fraction is a dark brown to black friable solid that has no definite melting point and usually foams and swells on heating to leave a carbonaceous residue. The fraction is obtained from a feedstock by the addition of a non-polar solvent (such as a hydrocarbon) with a surface tension lower than that of 25 dyne/cm at 25°C (77°F) such as low-boiling naphtha, petroleum ether, *n*-pentane, *iso*-pentane, *n*-heptane, liquefied petroleum gases and the like (Mitchell and Speight, 1973; Speight, 1994, 2014, 2019) and, in fact, propane is used commercially in processing feedstock residua for asphalt production (Parkash, 2003; Gary et al., 2007; Speight, 2014; Hsu and Robinson, 2017; Speight, 2017). On the other hand, the asphaltene constituents are soluble in

TABLE 4.2

Standard Methods for Asphaltene Separation

Method	Precipitant	Volume Precipitant per Gram of Sample (ml)
ASTM D893	*n*-pentane	10
ASTM D2006	*n*-pentane	50
ASTM D2007	*n*-pentane	10
ASTM D3279	*n*-heptane	100
ASTM D4124	*n*-heptane	100

Source: Please use tear sheet from Speight, J.G. 2007. *The Chemistry and Technology of Petroleum*, 4th Edition.
CRC Press, Taylor & Francis Publishers, Boca Raton, FL, Table 11.1, Page 316.
ASTM Annual Book of Standards, 1980–2012.

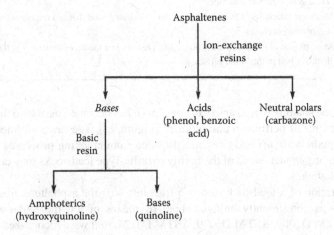

FIGURE 4.1 Separation of asphaltene constituents based on functionality (polarity).

liquids with a surface tension above 25 dyne/cm, such as pyridine, carbon disulfide, carbon tetrachloride, and benzene.

Thus, the *nomenclature* of feedstock fractions is an *operational aid* and is not usually based on chemical or structural features (Speight, 2014). However, the asphaltene fraction can be defined in terms of functional group composition (Figure 4.1) (Francisco and Speight, 1984) but it cannot be defined by the separation method and the solvent employed. In fact, there is no one parameter that is operational in the separation of asphaltene constituents; the relevant parameters for asphaltene separation are physical and chemical in nature (Table 4.3) (Girdler, 1965; Mitchell and Speight, 1973; Long, 1979, 1981; Hirschberg et al., 1984; Speight et al., 1984; Andersen and Birdi, 1990; Andersen and Speight, 1994; Speight, 1994, 2014, 2019).

4.2.1 INFLUENCE OF SOLVENT TYPE

The suggestion arose in 1914 that the systematic separation of petroleum be effected by treatment with solvents. If chosen carefully, solvents effect a separation between the constituents of residua, bituminous materials, and virgin petroleum according to differences in molecular weight and aromatic character. The nature and the quantity of the components separated depend on the conditions of the experiment, namely the degree of dilution temperature and the nature of the solvent (Mitchell and Speight, 1973; Speight et al., 1984, Speight, 2014).

TABLE 4.3
Operative Parameters in Asphaltene Separation

Parameter	Description
Polarity	The presence of functional groups derived from the presence of heteroatoms in the asphaltene constituents
Aromaticity	The presence of polynuclear aromatic systems in the asphaltene constituents
Molecular weight	Molecular size
3-D structure	The asphaltene constituents as they exist in relationship with the other constituents of the feedstock
Solvent power	The solvent strength of the precipitating/extracting liquid used for the separation
Ratio	The ratio of the precipitating/extracting liquid to feedstock that dictates the yield and character of the asphaltene product
Time	The time required to allow the precipitating/extracting liquid to penetrate the micelle which is dependent upon the ability of the hydrocarbon liquid to penetrate the micelle, indicating that the process is diffusion-controlled
Temperature	The temperature may have an effect on the induction period that is a requirement of diffusion-controlled processes
Pressure	As employed in several refinery processes, pressure is a means of maintaining the low-boiling liquid hydrocarbon in the liquid phase

On the basis of the solubility in a variety of solvents, it has become possible to distinguish among the various constituents of petroleum and bitumen (Figure 9.1). The raw unrefined feedstock generally does not contain *carboids* and *carbenes*. Residua from cracking processes may contain 2% w/w by weight or more. In fact, some of the highly paraffin-type feedstocks may contain only small proportions of asphaltenes.

Thus, the separation of a feedstock into two fractions – (i) the asphaltene fraction and (ii) the maltene fraction – is conveniently brought about by means of low-molecular-weight paraffinic hydrocarbons (ASTM D2007, ASTM D3279, ASTM D4124) that were recognized to have selective solvency for hydrocarbons, and simple relatively low-molecular-weight heteroatom derivatives. The more complex, higher molecular weight compounds are precipitated particularly well by addition of 40 volumes of *n*-pentane or *n*-heptane in the methods generally preferred at present (Speight et al., 1984; Speight, 1994, 2014, 2015) although hexane is used on occasion. It is no doubt a separation of the chemical components with the most complex structures from the mixture, and this fraction, which should correctly be called *n-pentane asphaltenes* or *n-heptane asphaltenes* is qualitatively and quantitatively reproducible (Figure 9.1).

If the precipitation method (deasphalting) involves the use of a solvent and a residuum or bitumen and is essentially a leaching of the deasphaltened from the insoluble residue, this process may be referred to as *extraction*. However, under the prevailing conditions now in laboratory use using conventional petroleum or heavy oil or a solution of the residuum or bitumen in toluene (or a similar solvent), the term *precipitation* is more correct and descriptive of the method.

Variation in the solvent type also causes significant changes in asphaltene yield. For example, branched-chain paraffins or terminal olefins do not precipitate the same amount of asphaltenes as the corresponding normal paraffins (Mitchell and Speight, 1973). The solvent power of the solvents (i.e., the ability of the solvent to dissolve asphaltenes) increases in the order

2-Methyl paraffin > *n*-paraffin > terminal olefin
(*iso*-paraffin)

Cycloparaffins (naphthenes) have a remarkable effect on asphaltene yield and give results totally unrelated to those from any other non-aromatic solvent. For example, when cyclopentane, cyclohexane, or

their methyl derivatives are employed as precipitating media, only about 1% of the material remains insoluble.

To explain those differences it was necessary to consider the solvent power of the precipitating liquid, which can be related to molecular properties.

Thus, the solvent power of non-polar solvents has been expressed as a solubility parameter, δ, and equated to the internal pressure of the solvent, that is, the ratio between the surface tension γ and the cubic root of the molar volume V:

$$\delta_1 = \sqrt[3]{V}$$

Alternatively, the solubility parameter of non-polar solvents can be related to the energy or vaporization ΔR^V and the molar volume,

$$\delta_2 = (\Delta E^V / V)^{1/2}$$

or

$$\delta_2 = (\Delta H^V - RT / V)^{1/2}$$

In this equation, ΔH^V is the heat of vaporization, R is the gas constant, and T is the absolute temperature.

Consideration of this approach shows that there is indeed a relationship between the solubility parameters for a variety of solvents and the amount of precipitate (Mitchell and Speight, 1973). The introduction of a polar group (heteroatom function) into the molecule of the solvent has significant effects on the quantity of precipitate. For example, treatment of a residuum with a variety of ethers or treatment of asphaltenes with a variety of solvents illustrates this point (Speight, 1979). In the latter instance, it was not possible to obtain data from addition of the solvent to the whole feedstock *per se* since the majority of the non-hydrocarbon materials were not miscible with the feedstock. It is nevertheless interesting that, as with the hydrocarbons, the amount of precipitate, or asphaltene solubility, can be related to the solubility parameter.

The solubility parameter allows an explanation of certain apparent anomalies, for example, the insolubility of asphaltenes in pentane and the near complete solubility of the materials in cyclo-pentane. Moreover, the solvent power of various solvents is in agreement with the derivation of the solubility parameter; for any one series of solvents the relationship between amount of precipitate (or asphaltene solubility) and the solubility parameter δ is quite regular.

In any method used to isolate asphaltenes as a separate fraction, standardization of the technique is essential. For many years, the method of asphaltenes separation was not standardized, and even now it remains subject to the preferences of the standard organizations of different countries. The use of both *n*-pentane and *n*-heptane has been widely advocated, and although *n*-heptane is becoming the deasphalting liquid of choice, this is by no means a hard-and-fast rule. And it must be recognized that large volumes of solvent may be required to effect a reproducible separation, similar to amounts required for consistent asphaltene separation. It is also preferable that the solvents be of sufficiently low boiling point that complete removal of the solvent from the fraction can be effected and, most important, the solvent must not react with the feedstock. Hence, the preference for hydrocarbon liquids, although the several standard methods that have been used are not unanimous in the ratio of hydrocarbon liquid to feedstock (Table 9.2).

Although, *n*-pentane and *n*-heptane are the solvents of choice in the laboratory (other solvents can be used; Speight, 1979) and cause the separation of asphaltenes as brown-to-black powdery materials. In the refinery, supercritical low-molecular-weight hydrocarbons (e.g., liquid propane, liquid butane, or mixtures of both) are the solvents of choice and the product is a semisolid (tacky) to solid asphalt. The amount of asphalt that settles out of the paraffin/residuum mixture depends on

the size of the paraffin, the temperature, and the paraffin-to-feedstock ratio (Figure 9.5) (Girdler, 1965; Speight et al., 1984).

Insofar as industrial solvents are very rarely one compound, it was also of interest to note that the physical characteristics of two different solvent types, in this case, benzene and *n*-pentane, are additive on a mole-fraction basis (Mitchell and Speight, 1973) and also explain the variation of solubility with temperature. The data also show the effects of blending a solvent with the bitumen itself and allowing the resulting solvent–heavy oil blend to control the degree of bitumen solubility. Varying proportions of the hydrocarbon alter the physical characteristics of the oil to such an extent that the amount of precipitate (asphaltenes) can be varied accordingly within a certain range.

4.2.2 Influence of the Degree of Dilution

One of the asphaltene separation methods (ASTM D893) was developed for a specific test to determine the amount of insoluble material in lubricating oil. Another (ASTM D2007) was designed for use with rubber extending and processing oils. Both tests recommend use of 10 ml of hydrocarbon liquid per gram of feedstock. This is not recommended in the tests that are now considered standard for asphaltenes separation (AST D3279, ASTM D4124) (Speight et al., 1984; Speight, 1994, 2014, 2015). However, it must be recognized that some of these methods were developed for use with feedstocks other than heavy oil and bitumen; thus, adjustments are necessary.

At constant temperature, the quantity of precipitate first increases with increasing ratio of solvent to feedstock and then reaches a maximum. Depending on the feedstock, there is a *solvent induction volume* in which little or no asphaltenes are precipitated. Very few data have been reported that relate to this aspect of asphaltene separation. There is evidence by the author to show that the most polar materials (not necessarily the highest molecular weight material) separate first from the feedstock. This is in keeping with the increased paraffin character of the feedstock as the hydrocarbon is added.

4.2.3 Influence of Temperature

When pentane and the lower-molecular-weight hydrocarbon solvents are used in large excess, the quantity of precipitate and the composition of the precipitate change with increasing temperature (Mitchell and Speight, 1973; Andersen, 1994; Speight, 1994, 2014, 2015). One particular example is the separation of asphaltenes from using *n*-pentane. At ambient temperatures (~21°C, 70°F), the yield of asphaltenes is 17% w/w but at 35°C (95°F), 22.5% by weight *asphaltenes* are produced using the same feedstock-pentane ratio. This latter precipitate is in fact asphaltenes plus resins; similar effects have been noted with other hydrocarbon solvents at temperatures up to 70°C (160°F). These results are self-explanatory when it is realized that the heat of vaporization ΔH^v and the surface tension γ, from which the solubility parameters are derived, both decrease with increasing temperature.

4.2.4 Influence of Contact Time

Contact time between the hydrocarbon and the feedstock also plays an important role in asphaltene separation (Speight et al., 1984; Speight, 1994, 2014). The yield of the asphaltene fraction reaches a maximum after approximately 8 hours, which may be ascribed to the time required for the asphaltene particles to agglomerate into particles of a *filterable size* as well as the diffusion-controlled nature of the process. Heavier feedstocks also need time for the hydrocarbon to penetrate their mass.

4.2.5 General Aspects

Other parameters may be defined as subsets of those enumerated above. It is also worthy of note that, in order to remove entrained resin material, precipitation of the asphaltene constituents from benzene or toluene is often necessary (Speight et al., 1984; Ali et al., 1985). But, none of these

TABLE 4.4
Parameters for the Separation of the Asphaltene Fraction

Parameter	Description
Volume ratio	An excess of the liquid hydrocarbon (40 ml hydrocarbon per ml of feedstock)
Liquid hydrocarbon	Volatility constraints and consistency of the of the asphaltene fraction favor the use of n-heptane over n-pentane
Contact time	8–10 hours is preferable
Purification	A dissolution–precipitation sequence to remove any non-asphaltene constituents that separate with the asphaltene constituents

parameters applied to the separation of a feedstock can be related to the separation of distinct chemical types. In fact, it is now accepted that to ensure *stable* asphaltene yields, it is necessary to employ specific parameters (Table 4.4). The precipitation sequence involves dissolution of the asphaltene constituents in benzene or toluene (10 ml/g asphaltene) followed by the addition of the hydrocarbon (50 ml precipitant per ml toluene or benzene) to the solution. This sequence should be repeated three times to remove adsorbed lower-molecular-weight resin material and to provide consistency of the asphaltene fraction.

Briefly, the precipitation of asphaltene constituents can be ascribed to changes in feedstock composition caused by the addition of lower-boiling components that the complex equilibrium keeping the asphaltene constituents in solution or in a *peptized state*. In the case of addition of low-boiling liquid hydrocarbon derivatives to the feedstock, the hydrocarbon causes a change in the solubility parameter of the oil medium that, in turn, changes the tolerance of the medium for the complex micelle structure. As this occurs, the lower-molecular-weight and less polar constituents of the micelle are extracted into the liquid, leaving the asphaltene constituents without any surrounding (dispersing) sheath. Separation then ensues. If the process is thermal (i.e., in excess of the thermal decomposition temperature) a different sequence of events ensues leading to the formation of an insoluble phase and ultimately to coke (Speight, 2014, 2017).

The focal point of the asphaltene separation method is the isolation of the asphaltene constituents as a discrete fraction. However, a question that often arises is related to whether or not the asphaltene constituents self-associate in the feedstock or whether the asphaltene constituents interact directly with the other feedstock constituents. In addition, there is also a question related to precipitation of the asphaltene constituents or extraction of the non-asphaltene constituents from the micelle that is responsible for the dispersion of the asphaltene constituents in the oil.

The term *resin* generally implies material that has been eluted from various solid adsorbents, whereas the term *maltenes* (or *petrolenes*) indicates a mixture of the resin constituents and oil constituents obtained in the filtrates from the asphaltene precipitation. Thus, after the asphaltene constituents are precipitated, adsorbents are added to the *n*-pentane solutions of the resin constituents and oils (the saturates and aromatics fractions), by which process the resin constituents are adsorbed and subsequently recovered by use of a more polar solvent and the oils (the saturates and aromatics fractions) remain in solution (Speight, 2014, 2015).

Resin constituents are soluble in the liquids that precipitate asphaltene constituents and are usually soluble in most organic liquids, except in the lower alcohols and acetone, but they are precipitated by liquid propane and liquid butanes. The resin constituents often coprecipitate with the asphaltene constituents in controlled propane deasphalting procedures, and the product, called *propane asphalt*, contains appreciable amounts of adsorbed resin constituents and has the properties of a low-melting-point asphalt. The resin constituents are dark, semisolid or solid, very adhesive materials of high molecular weight. Their composition can vary depending on the kind of precipitating liquid and on the temperature of the liquid system. They become quite fluid on heating but often show pronounced brittleness when cold.

The *oils fraction* (comprising the *saturates fraction* plus the *aromatics fraction*) comprises the lowest molecular weight fraction of a feedstock and is the dispersion medium for the peptized asphaltene constituents. Although the *oils fraction* is sometimes colored, fractions obtained by chromatography are colorless and are similar to white medicinal oils or lubricating oils of high purity. The oils fraction may be quite viscous because of the presence of paraffin waxes that vary over a wide range for the feedstock.

4.3 COMPOSITION

The asphaltene fraction isolated from different sources is remarkably constant in terms of ultimate composition, although there can be variations in terms of heteroatom content because of local and regional variations in the plant precursors and mineralogical composition of the nearby geological formations. Even though the nature of the source material and subtle regional variations in maturation conditions serve to differentiate one feedstock (and hence one asphaltene) from another, it might be suggested that the maturation process tends to be a *molecular equalizer* over the time periods involved. Thus, differences between the asphaltene constituents reflect differences in the relative amounts of the functional molecular types present and the way in which the structural types are combined in the various asphaltene constituents. This is reflected, in part, by changes in the functional group composition of asphaltene fractions from different feedstocks (see, for example, Koots and Speight, 1975; Huc et al., 1984; Andersen and Speight, 2001).

The elemental composition of asphaltene constituents isolated by use of excess (>40) volumes of *n*-pentane as the precipitating medium show that the amounts of carbon and hydrogen usually vary over only a narrow range (Speight, 1994). These values correspond to a hydrogen-to-carbon atomic ratio of 1.15%±0.5%, although values outside this range are sometimes found. The near constancy of the H/C ratio is surprising when the number of possible molecular permutations involving the hetero elements is considered. In fact, this property, more than any other, is the cause for the general belief that unaltered asphaltene constituents from a feedstock have a definite composition. Furthermore, it is still believed that asphaltene constituents are precipitated from a feedstock by hydrocarbon solvents because of this composition, not only because of solubility properties.

In contrast to the carbon and hydrogen contents of asphaltene constituents, notable variations occur in the proportions of the hetero elements, in particular in the proportions of oxygen and sulfur. Oxygen contents vary from 0.3% to 4.9% and sulfur contents vary from 0.3% to 10.3%. On the other hand, the nitrogen content of the asphaltene constituents has a somewhat lesser degree of variation (0.6%–3.3% at the extremes). However, exposing asphaltene constituents to atmosphere oxygen can substantially alter the oxygen content and exposing a feedstock to elemental sulfur or even to sulfur-containing minerals can result in excessive sulfur uptake. Perhaps oxygen and sulfur contents vary more markedly than do nitrogen contents because of these conditions.

The use of *n*-heptane as the precipitating medium yields a product that is substantially different from the *n*-pentane-insoluble material. For example, the hydrogen-to-carbon atomic ratio of the *n*-heptane precipitate is lower than that of the *n*-pentane precipitate (Speight, 1994, 2014, 2015). This indicates a higher degree of aromaticity in the *n*-heptane precipitate. Nitrogen-to-carbon, oxygen-to-carbon, and sulfur-to-carbon ratios are usually higher in the *n*-heptane precipitate, indicating higher proportions of the hetero elements in this material (Speight and Moschopedis, 1981a).

One aspect of asphaltene characterization that has provided strong evidence for the complexity of the fraction arises from composition studies using fractionation techniques (Bestougeff and Mouton, 1977; Speight, 1986a). Indeed, the asphaltene fraction can be subdivided by a variety of techniques (Bestougeff and Darmois, 1947, 1948; Bestougeff and Mouton, 1977; Francisco and Speight, 1984). Of specific interest is the observation that when asphaltene constituents are fractionated on the basis of aromaticity *and* polarity, it appears that the more aromatic species contain higher amounts of nitrogen (Speight, 1984), suggesting that the nitrogen species are located predominantly in aromatic systems (Speight, 1994, 2014, 2019). In fact, during recovery operations, a

distinct subfraction of the bulk asphaltene fraction plays a role in the recovery operations (Khulbe et al., 1996).

The fractionation of the asphaltene component of feedstocks shows that it is possible to obtain asphaltene fractions characterized by different degrees of aromaticity or heteroatom content by using benzene/pentane (toluene/pentane) or benzene/methanol (toluene/methanol) mixtures in variable ratios (Speight, 1979; Andersen et al., 1997; Miller et al., 1998). The use of mixtures of a polar and a non-polar solvent in order to fractionate an asphaltene sample will tend to direct the fractionation by introducing polar forces and hydrogen bonding, as well as dispersion forces, as factors determining which components of the asphaltene sample are soluble in the mixture.

In contrast, the exclusive use of saturated hydrocarbon derivatives whose solvent power derives entirely from the dispersion forces should, in principle, permit the fractionation to be carried out with variation of only a single component of the solubility parameter. It is known that the quantity of asphaltene constituents precipitated by linear paraffins decreases with increasing carbon number until a limiting value is reached above n-heptane (n-C_7H_{16}) to n-nonane (n-C_9H_{20}) (Girdler, 1965; Mitchell and Speight, 1973).

The cycloparaffins have better solvating power toward the asphaltene constituents and often fail to induce asphaltene separation from a feedstock. It is possible to fractionate asphaltene constituents using mixtures of solvents, such as cyclohexane and n-alkanes, and any differences in the precipitation threshold underscore the point that the solubility properties of the asphaltene fractions of different feedstocks can vary markedly (Speight, 1994, 2014, 2019).

It appears, therefore, that the tendency of asphaltene constituents to precipitate from a given feedstock because of a variation in the solubility parameter of the precipitating solvent mixture is more closely related to the aromaticity and polarity of the asphaltene constituents than to their dimensions. However, it is possible to conclude that molecular weight, aromaticity, and polarity combine to determine asphaltene solubility in hydrocarbon media.

The fractionation of asphaltene constituents into a variety of functional (and polar) types (Figure 4.1) (Francisco and Speight, 1984) has confirmed the complexity of the asphaltene fraction. Other studies (Schmitter et al., 1984) have brought to light the occurrence of four-ring aromatic nitrogen species in the feedstock. These findings are of particular interest since they correspond to the ring systems that have been tentatively identified by application of the high-performance liquid chromatography (HPLC) technique to the basic nitrogen fraction of asphaltene constituents (Speight, 1986b, 1994, 2014, 2019).

The molecular weight/polarity concept in which asphaltene fractions are defined on the basis of molecular weight and polarity (Figure 4.2), can be used to indicate the relative nature of carbenes and carboids (thermal decomposition products of asphaltene constituents), which are lower molecular weight and more polar than the asphaltene constituents from which they are formed (Speight, 1994, 2014, 2019). Furthermore, the slope of the line as illustrated is purely arbitrary and will vary with the source and composition of different fractions (Figure 4.3). However, it should not be construed that this two-dimensional diagram is truly representative of the nature of asphaltene constituents and a three-dimensional diagram involving functionality or molecular weight might be more appropriate for showing the chemical and physical differences between the various asphaltene constituents, carbenes, and carboids. Nevertheless, the concept does emphasize the lower molecular weight and increased polarity of the various asphaltene constituents.

Unfortunately, in many studies, too little emphasis has been placed on determining the nature and location of the nitrogen, oxygen, and sulfur atoms in the asphaltene structure.

Studies on the disposition of *nitrogen* in feedstock asphaltene constituents indicated the existence of nitrogen as various heterocyclic types (Clerc and O'Neal, 1961; Nicksic and Jeffries-Harris, 1968; Moschopedis and Speight, 1976b, 1979; Jacobson and Gray, 1987). The more conventional nitrogen species (from the viewpoint of organic chemistry), such as primary (–NH2), secondary (=NH), and tertiary aromatic amines (≡N) have not been established as present in asphaltene constituents of feedstocks. There are also reports in which the organic nitrogen in feedstock asphaltene

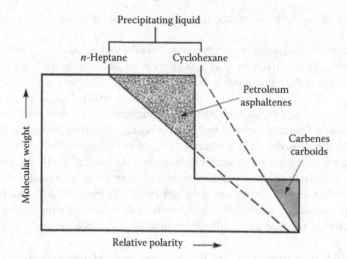

FIGURE 4.2 Representation of the asphaltene fraction using molecular weight and polarity.

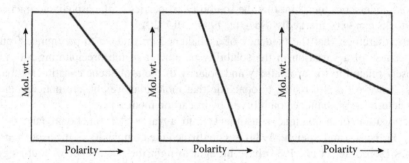

FIGURE 4.3 Representation of the molecular weight/polarity diagram for different asphaltene fractions.

constituents has been defined in terms of basic and non-basic types (Nicksic and Jeffries-Harris, 1968). Spectroscopic investigations indicate that carbazoles occur in asphaltene constituents that support earlier mass spectroscopic evidence for the occurrence of carbazole nitrogen in asphaltene constituents (Clerc and O'Neal, 1961; Moschopedis and Speight, 1979; Speight, 1994, 2014, 2019).

Thermal studies have shown that only 1% of the nitrogen is lost during the thermal treatment, but substantially more sulfur (23%) and almost all the oxygen (81%) is lost as a result of this treatment. The tendency for nitrogen and sulfur to remain in the nonvolatile residue produced during thermal decomposition, as opposed to the relatively facile elimination of oxygen, supports the concept that nitrogen and sulfur have stability because of their location in ring systems.

Oxygen has been identified in carboxylic, phenol, and ketone functions (Nicksic and Jeffries-Harris, 1968; Petersen et al., 1974; Moschopedis and Speight, 1976a,b; Ritchie et al., 1979; Speight and Moschopedis, 1981b; Rose and Francisco, 1987) locations but is not usually regarded as located primarily in heteroaromatic ring systems.

Some evidence for the location of oxygen within the asphaltene fraction has been obtained by infrared spectroscopy. Examination of dilute solutions of the asphaltene constituents in carbon tetrachloride shows that at low concentration (0.01% wt/wt) of asphaltene constituents a band occurs at 3,585 cm^{-1}, which is within the range anticipated for free non-hydrogen-bonded phenolic hydroxyl groups. In keeping with the concept of hydrogen bonding, this band becomes barely perceptible, and the appearance of the broad absorption in the range 3,200–3,450 cm^{-1} becomes evident at concentrations above 1% by weight.

Other evidence for the presence and nature of oxygen functions in asphaltene constituents has been derived from infrared spectroscopic examination of the products after interaction of the asphaltene constituents with acetic anhydride. Thus, when asphaltene constituents are heated with acetic anhydride in the presence of pyridine, the infrared spectrum of the product exhibits prominent absorptions at 1680, 1730, and 1760 cm^{-1}. These changes in the infrared spectrum of the asphaltene fraction as a result of treatment with refluxing acetic anhydride suggest acetylation of free and hydrogen-bonded phenolic hydroxyl groups present in the asphaltene constituents (Moschopedis and Speight, 1976a,b).

The absorption bands at 1,680 and 1,760 cm^{-1} are attributed to a non-hydrogen-bonded carbonyl of a ketone, for example, a diaryl ketone and/or a quinone, and to the carbonyl of a phenolic acetate, respectively. If the 1,680 cm^{-1} band is in fact the result of the presence of non-hydrogen-bonded ketones or quinones, the appearance of this band in the infrared spectra of the products could conceivably arise by acetylation of a nearby hydroxyl function. This hydroxyl function may have served as a hydrogen-bonding partner to the ketone (or quinone), thereby releasing this function and causing a shift from approximately 1,600 cm^{-1} to higher frequencies.

The 1,730 cm^{-1} band is the third prominent feature in the spectrum of the acetylated products. It is also ascribed to phenolic acetates and, as with the 1,760 cm^{-1} band, falls within the range 1,725–1,760 cm^{-1} assigned to esters of polyfunctional phenols. This suggests that a considerable portion of the hydroxyl groups present in the asphaltene constituents may occur as collections of two or more hydroxyl functions on the same aromatic ring. Alternate sites include adjacent peripheral sites on a condensed ring system or sites adjacent to a carbonyl function in a condensed ring system. In the context of polyhydroxyaromatic nuclei existing in asphaltene constituents, it is of interest to note that pyrolysis at 800°C (1,470°F) results in the formation of resorcinols (Ritchie et al., 1979), implying that such functions may indeed exist in the asphaltene constituents.

Sulfur occurs as benzothiophenes, dibenzothiophenes, and naphthene benzothiophenes (Clerc and O'Neal, 1961; Nicksic and Jeffries-Harris, 1968; Drushel, 1970; Yen, 1974; Speight and Pancirov 1984; Rose and Francisco, 1988; Keleman et al., 1990); more highly condensed thiophene types may also exist but are precluded from identification by low volatility. Other forms of sulfur that occur in asphaltene constituents include the alkyl-alkyl sulfides, alkyl-aryl sulfides, and aryl-aryl sulfides (Yen, 1974).

Metals (i.e., nickel and vanadium) are much more difficult to integrate into the asphaltene system. Nickel and vanadium occur as porphyrins but whether these are an integral part of the asphaltene structure is not known. Some of the porphyrins can be isolated as a separate stream from the feedstock (Branthaver, 1990; Reynolds, 1998).

In summary, the asphaltene fraction from different members of the crude oil family as well as from extra-heavy crude oil and tar sand bitumen contain similar functionalities but with some variation in degree (Speight, 1981a, 1994, 2014, 2019). For example, the asphaltene constituents from the more paraffinic feedstocks appeared (through this cursory examination) to contain less quinone and amide systems than those from the high viscosity feedstocks (such as extra-heavy oil and tar sand bitumen).

Thus, it is apparent that asphaltene fraction can be defined by the proportion of the functional groups present in the constituent functionality which casts severe doubt, and even negates, the concept of an average structure for the complete fraction which is, by the method of separation, a solubility class of mixed chemical types.

4.4 MOLECULAR WEIGHT

Perhaps the most confusing aspect of the character of the asphaltene fraction is measurement of the molecular weight. The asphaltene fraction is a complex composition of functional types, and molecular weight data represent an average number. Furthermore, there are those who will advocate (with some justification) in one breath that asphaltene fraction contains 20,000 constituents. In the

next breath, these same advocates will announce that they know the correct and precise molecular weight of the fraction. Such pronouncement border on the ludicrous and nothing can be further from the truth!

Determining the molecular weights of asphaltene constituents is a problem because they have a low solubility in the liquids often used for determination. Also, adsorbed resin constituents lead to discrepancies in molecular weight determination, and precipitated asphaltene constituents should be reprecipitated several times before the determination (Ali et al., 1985). Thus, careful precipitation and careful choice of the determination method are both very important for obtaining meaningful results (Speight et al., 1985). The molecular weights of asphaltene fractions span a wide range from a few hundred to several million leading to speculation in relation to self-association (Reerink, 1973; Koots and Speight, 1975; Speight et al., 1985; Speight, 1994; Galtsev et al., 1995; Andersen and Speight, 2001).

The tendency of the asphaltene constituents to form aggregates in hydrocarbon solution is one of their most characteristic features and complicates the determination of asphaltene molecular weight (Winniford, 1963; Speight and Moschopedis, 1977). The average molecular weights measured by means of vapor pressure osmometry (VPO) or size exclusion chromatography (SEC) are significantly influenced by the conditions of the analysis (temperature, asphaltene concentration, solvent polarity) (Moschopedis et al., 1976; Speight and Moschopedis, 1980; Speight, 1981b; Speight et al., 1985). For this reason, molecular weights are reported in the literature as relative values only and these values may be quite different from the molecular weights of unassociated molecules.

The influence of the asphaltene concentration on the values of molecular weight measured is significant, and it is important to use as high dilution as possible in order to measure a molecular weight that at least approaches that of the unassociated asphaltene molecules, remembering that the asphaltene fraction is a complex mixture of different species and that any molecular weight of unassociated species will be an average molecular weight of different chemical species.

The existence of asphaltene constituents aggregates in hydrocarbon solvents has been demonstrated by means of small-angle neutron scattering (SANS) studies. The physical dimensions and shape of the aggregates are functions of the solvent used and the temperature of the investigation (Ravey et al., 1988; Overfield et al. 1989; Thiyagarajan et al., 1995). In addition, surface tension measurements have been used to study the self-association of asphaltene constituents in pyridine and nitrobenzene (Sheu et al., 1992; Storm and Sheu, 1994). A discontinuous transition in the surface tension as a function of asphaltene concentration was interpreted as the critical asphaltene concentration above which self-association occurs.

The study of asphaltene molecular weights by VPO shows that the molecular weights of various asphaltene constituents are dependent not only on the nature of the solvent but also on the solution temperature at which the determinations were performed (Moschopedis et al., 1976). However, data from later work involving molecular weight determinations by the cryoscopic method (Speight and Moschopedis, 1977) indicate that the molecular nature of asphaltene constituents is not conducive to the determination of absolute molecular weights by any one method.

For any one method, the observed molecular weights suggest that asphaltene constituents form molecular aggregates, even in dilute solution, and this association is influenced by solvent polarity, asphaltene concentration, and the temperature at which the determination is made. The precise mechanism of the association has not been conclusively established, but hydrogen bonding and the formation of charge-transfer complexes have been cited as responsible for intermolecular association (Yen, 1974, 1994). In fact, intermolecular hydrogen bonding could be involved in asphaltene association and may have a significant effect on observed molecular weights (Moschopedis and Speight, 1976c; Speight et al., 1985).

It is also interesting to note that use of a solvent of low dielectric constant (benzene) does not cause any variation in the molecular weight when the concentration of the asphaltene constituents is varied over the range 2%–7% by weight. However, use of a solvent of higher dielectric constant (pyridine) caused significant variation in the observed molecular weights over this particular range.

Molecular weight determinations at lower (<2%) and higher (>8%) concentrations are subject to instrument sensitivity and solubility interference, respectively. Extrapolation of the pyridine data to infinite dilution, when asphaltene–asphaltene interaction may be assumed negligible, affords molecular weights of the same order (ca. 1,800) as those recorded using nitrobenzene as the solvent. On the other hand, extrapolation of the pyridine data to higher concentrations suggests that molecular weights of the order of those recorded in a solvent of lower dielectric constant (e.g., benzene) may be obtained.

The higher molecular weights recorded when solvents of low polarity are employed are undoubtedly the result of intermolecular association between the asphaltene nuclei, but solvents of high dielectric constant are able to cause dissociation of these asphaltene agglomerations to what, in fact, appear to be single asphaltene particles. Furthermore, this observation precludes asphaltene structures that invoke the concept of a polymer molecule to account for the high molecular weights observed in nonpolar solvents.

Determination of asphaltene molecular weight is subject to the presence of occluded resin constituents (Ali et al., 1985) and removal of the resin constituents gives rise to higher observed molecular weights of the *purified* asphaltene constituents. In addition, and as noted previously for the whole asphaltene constituents (Moschopedis et al., 1976), the molecular weights of the *purified* asphaltene constituents also varied with the solvent used for the determination; that is, solvents of high dielectric constant decrease the observed molecular weights. Furthermore, extraction of freshly precipitated asphaltene fractions using a Soxhlet extractor and different solvents followed by molecular weight determinations of the insoluble material show a decrease in the asphaltene molecular weight with the dielectric constant of the solvent.

Thus, the tendency of asphaltene constituents to undergo association and/or dissociation depending upon the nature of the solvent also appears true for the series of higher-molecular-weight fractions. However, it should be noted here that although the results with asphaltene constituents available from several feedstocks (Moschopedis et al., 1976) suggest that molecular weight varies with the dielectric constant of the solvent, there may be other factors which may in part also be responsible for this phenomenon. The final phenomenon that influences the molecular weight of the asphaltene is the relative polarity of the solvent used in the precipitation technique.

It is of interest to speculate at this point in relation to the means by which the resin material is retained by the asphaltene constituents. For example, asphaltene constituents may be analogous to coal insofar as it appears that asphaltene constituents have adsorption characteristics and may even exhibit a distinct physical structure or may even participate in clathrate systems. If this is the case, swelling by a solvent such as pyridine would undoubtedly free resin material from the asphaltene constituents. On the other hand, if the resin material is retained purely by a surface adsorption phenomenon, it may be expected to be removed from the asphaltene constituents by the repetitive precipitation. Both effects could play a part in the retention of resin (i.e., precipitant-soluble) material by the asphaltene constituents.

Obviously, many other facets of asphaltene precipitation need to be investigated, but it is obvious from these data that it is extremely difficult to obtain *clean* (resin-free) asphaltene constituents without a multiple precipitation technique. The amount of resin may have some influence on the asphaltene yield (and, therefore, on an estimation of feedstock composition). However, the resin occluded within (or adsorbed onto) the asphaltene during the separation procedure has a considerable effect on the observed molecular weight and, presumably, on the degree of association of the asphaltene constituents. Indeed, the speculative concept that asphaltene constituents release the final vestiges of this resin only upon swelling by a solvent such as pyridine is also worthy of consideration.

In summary, asphaltene molecular weights are variable (Yen, 1974; Speight et al., 1985; Speight, 1994, 2014, 2019). There is a tendency to associate even in dilute solution in non-polar solvents. However, data obtained using highly polar solvents indicate that the molecular weights, in solvents that prevent association, usually fall in the range 2,000±500.

4.5 REACTIONS

The relative reactivity of feedstock constituents can be assessed on the basis of bond energies and the asphaltene constituents are no exception to this generalization. While the use of bond energy data is a method for predicting the reactivity or the stability of specific bonds under designed conditions, it must be remembered that the reactivity of a particular bond is also subject to its environment. Thus, it is not only the reactivity of the constituents of feedstock that are important in processing behavior, but it is also the stereochemistry of the constituents as they relate to one another that is also of some importance (Speight, 2014).

The desirability of removing the asphaltene fraction from a feedstock has been advocated many times, the principal reasons being the production of a cracking stock low in metal impurities and heteroatom compounds and a low carbon residue. As a result of the structural studies just discussed, it is evident that feedstock asphaltene constituents are agglomerations of compounds of a particular type. Thus, it is not surprising that asphaltene constituents undergo a wide range of interactions of a chemical and physical nature based not only on their condensed aromatic structure but also on the attending alkyl and naphthenic moieties (Speight, 1984).

Asphaltenes can be *thermally decomposed* under conditions similar to those employed for visbreaking (viscosity breaking; ca. 470°C, 880°F) to afford, on the one hand, light (low viscosity) oils that contain higher (to $>C_{40}$) paraffins and, on the other hand, coke:

$$\text{Asphaltene fraction} \rightarrow H_2, CO, CO_2, H_2S, SO_2, H_2O + CH_2 = CH_2, CH_4, CH_3CH_2, CH_3(CH_2)_n CH_3$$

The thermal decomposition of asphaltene constituents provides an excellent example of inconsistencies in the derivation of structural types from spectroscopic materials (i.e., magnetic resonance) in which alkyl side chains are deduced to contain approximately four carbon atoms (Speight, 1970, 1971). Asphaltene pyrolysis (350°C–800°C, 660°F–1,470°F) produces substantial amounts of alkanes (having up to 40 carbon atoms in the molecule) in the distillate that can only be presumed to reflect the presence of such chains in the original asphaltene. Transalkylation studies (Farcasiu et al., 1983) also provide evidence for longer alkyl chains. Obviously, recognition of the inconsistencies of the spectroscopic method with respect to the paraffinic moieties must lead to the recognition of similar inconsistencies when considering the aromatic nucleus.

The application of thermal techniques to study the nature of the volatile thermal fragments from feedstock asphaltene constituents has produced some interesting data relating to the polynuclear aromatic systems (Speight, 1971; Ritchie et al., 1979; Schucker and Keweshan, 1980). These thermal techniques have produced strong evidence for the presence of small (one-ring to four-ring) polynuclear aromatic systems (Speight and Pancirov, 1984) and now, application of the technique to the various functional fractions confirmed the general but unequal distribution of these systems throughout asphaltene constituents.

Each asphaltene fraction produced the same type of polynuclear aromatic systems (i.e., alkyl derivatives of benzene, naphthalene, phenanthrene, chrysene, benzothiophene, and dibenzothiophene) in the volatile matter but the distribution was not constant. It was also possible to compute the hydrocarbon distribution; a noteworthy point here is the overall preponderance of single-ring (cycloparaffin and alkylbenzene) species as well as the domination of saturated material over aromatic material. The preponderance of the low-molecular-weight material in the volatile products is anticipated on the basis that more complex systems remain as nonvolatile material and, in fact, are converted to coke. One other point worthy of note is that the py/gc/ms program does not accommodate nitrogen and oxygen species. This matter is resolved, in part, by the concentration of nitrogen and oxygen in the nonvolatile material (coke) and the overall low proportions of these heteroatoms originally present in the asphaltene constituents.

The major drawback to the application of a pyrolysis-gas chromatography-mass spectrometry (py/gc/ms) technique to the study of the polynuclear aromatic systems in asphaltene constituents

is the amount of material that remains as a nonvolatile residue. Aside from speculation related to the polynuclear aromatic systems in the residue, it should be noted that the majority of the nitrogen (>90%), oxygen (>50%), and sulfur (>60%) in the natural asphaltene remains in the coke (Speight, 1971; Speight and Pancirov, 1984).

Paraffins are not the only hydrocarbon products of the thermal reactions of asphaltene constituents. The reaction paths are extremely complex; spectroscopic investigations indicate an overall dealkylation of the aromatics to methyl (predominantly) or ethyl (minority) groups. This is in keeping with a mass spectroscopic examination of asphaltene fractions (by direct introduction into the ionization chamber), which indicates a progressive increase with increasing temperature (50°C–350°C, 120°F–660°F) of ions attributable to low-molecular-weight hydrocarbon derivatives. Higher temperatures (500°C, 932°F) promote the formation of benzene and naphthalene nuclei as the predominant aromatics in the light oil, but unfortunately an increase in coke production is noted.

In conclusion, thermal decomposition of asphaltene constituents affords a light oil having a similar composition to that from the heavy oil and a hydrocarbon gas composed of the lower paraffins, which, after the removal of the by-products (water, ammonia, and hydrogen sulfide) has good burning properties. The formation of these paraffins can be ascribed to the generation of hydrogen within the system that occurs during the pyrolysis of condensed aromatic structures.

Oxidation of asphaltene constituents with common oxidizing agents, such as acid and alkaline peroxide, acid dichromate, and alkaline permanganate, is a slow process. The occurrence of a broadband centered at $3,420 \, cm^{-1}$ and a band at $1,710 \, cm^{-1}$ in the infrared spectra of the products indicates the formation of phenolic and carboxyl groups during the oxidation. Elemental analyses of the products indicate that there are two predominant oxidation routes, notably

1. The oxidation of naphthene moieties to aromatics as well as the oxidation of *active* methylene groups to ketones.
2. Severe oxidation of naphthene and aromatic functions resulting in degradation of these systems to carboxylic acid functions.

Oxidation of asphaltene constituents in solution, by air, and in either the presence or absence of a metal salt, is also possible (Moschopedis and Speight, 1978). There is some oxygen uptake, as can be seen from the increased O/C atomic ratios, but the most obvious effect is the increase in the amount of *n*-heptane-insoluble material. And analysis of the data shows that it is the higher heteroatom (more polar constituents) of the asphaltene constituents that are more susceptible to oxidation leaving the suggestion that the polarity of the constituents may be determined by the incorporation of the heteroatoms into ring systems.

Air-blowing of asphaltene constituents at various temperatures brings causes significant uptake of oxygen. This is accompanied by a marked decrease in the molecular weight (VPO, benzene solution) of the product. This indicates that intermolecular hydrogen bonding of oxygen functionality may play a part in the observed *high* molecular weights and physical structure of the feedstock (Moschopedis and Speight, 1978).

Asphaltene constituents may also be hydrogenated to produce resin constituents and oils at elevated temperatures (>250°C, 480°F). Chemical hydrogenation under much milder conditions, for example, with lithium-ethylenediamine or sodium-liquid ammonia, also produces lower-molecular-weight species together with marked reductions in the sulfur and oxygen contents.

It may appear at first sight that sulfur and oxygen exist as linkages among hydrocarbon segments of asphaltene molecules. Although this may be true, in part, it is also very likely, in view of what has been discussed previously, that the lower molecular weights reflect changes in molecular association that is caused by the elimination of oxygen and sulfur.

Aromatics undergo *condensation with formaldehyde* to afford a variety of products. This process can be extended to the introduction of various functions into the asphaltene molecules, such as

sulfomethylation, that is, introduction of the –CH$_2$SO$_3$H group. This latter process, however, usually proceeds more readily if functional groups are present within the asphaltene molecule.

Thus, oxidation of asphaltene constituents produces the necessary functional groups, and subsequently sulfomethylation can be conveniently achieved. Sulfomethylation of the oxidized asphaltene constituents occurs that can be confirmed from three sources: (i) overall increases in the sulfur contents of the products relative to those of the starting material, (ii) the appearance of a new infrared absorption band at 1,030 cm^{-1} attributable to the presence of sulfonic acid group(s) in the molecule(s), and (iii) the water solubility of the products, a characteristic of this type of material. These sulfomethylated oxidized asphaltene constituents even remain in solution after parent oxidized asphaltene constituents can be precipitated from alkaline solution by acidification to pH 6.5.

The facile sulfomethylation reaction indicates the presence in the starting materials of reactive sites ortho or para to a phenolic hydroxyl group. The related reaction, sulfonation, is also a feasible process for oxidized asphaltene constituents. The ease with which this reaction proceeds suggests the presence of quinoid structures in the oxidized materials. Alternatively, active methylene groups in the starting materials facilitate sulfonation since such groups have been known to remain intact after prolonged oxidation.

Halogenation of asphaltene constituents occurs readily to afford the corresponding halo-derivatives; the physical properties of the halogenated materials are markedly different from those of the parent asphaltene constituents. For example, the unreacted asphaltene constituents are dark brown, amorphous, and readily soluble in benzene, nitrobenzene, and carbon tetrachloride, but the products are black, shiny, and only sparingly soluble, if at all, in these solvents.

There are also several features that distinguish the individual halogen reactions from one another. For example, during *chlorination* of asphaltene constituents, there is a cessation of chlorine uptake by the asphaltene constituents after 4 hours. Analytical data indicate that more than 37% of the total chlorine in the final product is introduced during the first 0.5 hours, reaching the maximum after 4 hours. Furthermore, the H/C ratio of 1.22 in the parent asphaltene constituents [the (H+Cl)/C ratio] in the chlorinated materials remains constant during the first 2 hours of chlorination, by which time chlorination is 88% complete (Moschopedis and Speight, 1971). This is interpreted as substitution of hydrogen atoms by chlorine in the alkyl moieties of the asphaltene constituents; the condensed aromatic sheets remain unaltered since substitution of aryl hydrogen appears to occur readily only in the presence of a suitable catalyst, such as FeCl$_3$, or at elevated temperatures. It is only after more or less complete reaction of the alkyl chains that addition to the aromatic rings occurs, as evidenced by the increased atomic (H+Cl)/C ratios in the final stages of chlorination.

Bromine uptake by the asphaltene constituents is also complete in a comparatively short time (<8 hours). However, in contrast to the chlorinated products, the atomic (H+halogen)/C ratio remains fairly constant (1.23 and 1.21 in the bromo-asphaltene constituents or 1.22 in the unreacted asphaltene constituents) over the prolonged periods (up to 24 hours) of the bromination.

Iodination of asphaltene constituents is different insofar as a considerable portion of the iodine, recorded initially as iodine uptake, can be removed by extraction with ether or with ethanol, whereas very little weight loss is recorded after prolonged exposure of the material to a high vacuum. The net result is the formation of a product with an atomic (H+I)/C ratio of 1.24 after an 8 hours reaction; a more prolonged reaction period affords a product with a (H+I)/C ratio of 1.17. This latter may be the result of iodination of the alkyl or naphthenic moieties of the asphaltene constituents with subsequent elimination of hydrogen iodide. Alternatively, dehydrogenation of naphthene rings to aromatic systems or coupling of aromatic nuclei would also account for lower (H+I)/C ratios. In fact, this latter phenomenon could account, in part, for the insolubility of the products in solvents that are normally excellent for dissolving the unchanged asphaltene constituents. However, it will be appreciated that these aforementioned reactions are only a few of many possible reactions that can occur, and undoubtedly halogenation of the asphaltene constituents is much more complex than would appear from the product data.

Halogenation of the asphaltene constituents can also be achieved by use of sulfonyl chloride, iodine monochloride, and N-bromusuccinimide, or, indirectly, via the Gomberg reaction.

Attempts to introduce hydrophilic groups into asphaltene constituents by *hydrolysis* of the halo-derivatives with either aqueous sodium hydroxide or with aqueous sodium sulfite are not feasible. The products from the reaction of halogenated Athabasca asphaltene constituents with these aqueous solutions are insoluble in strong aqueous alkali. Partial reaction does occur and is evident from the decreased atomic (H+Cl)/C ratios and the increased oxygen-to-carbon atomic ratios of the products relative to those of the untreated halo-asphaltene constituents (Moschopedis and Speight, 1971). However, it was not possible to establish conclusively the presence of sulfonic acid group(s) in the product from the sodium sulfite reaction by assignment of infrared absorption bands to this particular group.

It is also conceivable that the decreased atomic (H+Cl)/C ratios may be due, in part, to eliminate the elements of hydrogen chloride during the reactions, not solely, as intended, to substitution of chlorine by –OH and by –SO$_3$H. Olefin formation by elimination of hydrogen halide from alkyl or aralkyl halides in strongly basic media is well known, and the elimination of hydrogen chloride from β-phenylethyl chloride in the presence of aqueous sodium sulfite to yield styrene has also been recorded. On the other hand, α-phenylpropyl and α-phenylbutylbromides react normally with aqueous sodium sulfite to afford the corresponding sulfonic acids:

Interactions of asphaltene constituents with *metal chlorides* yield products containing organically bound chlorine, but the analytic data indicate that dehydrogenation processes occur simultaneously. There is, of course, no clear way that the extent of the dehydrogenation can be estimated, but it is presumed to be a dehydrogenation condensation rather than olefin formation.

Inter- or intramolecular condensations are the preferred reaction route, insofar as the solubility and apparent complexity of the products vary markedly from those of the starting materials, and these differences cannot be attributed wholly to the incorporation of chlorine atoms into the constituents of the asphaltene constituents or heavy oil. Indeed, the data accumulated are indicative of a condensation dehydrogenation or, in part, loss of alkyl substituents, for example, lower-molecular-weight hydrocarbon derivatives, during the reactions. As an illustration of the former, the cokes produced during the thermal cracking (450°C, 840°F) of the asphaltene constituents or heavy oil have H/C ratios in the range of 0.59–0.77. The majority of the insoluble materials produced in the asphaltene-metal chloride reactions have only slightly higher (H+Cl)/C ratios (0.88–1.10).

The facile reactions of asphaltene constituents with metal chlorides have also been applied as a possible means of feedstock *deasphalting*. The results indicate that, without exception, the asphaltene constituents react more rapidly than the heavy oil to produce insoluble organic material. It is also worthy of note here that, in the case of the heavy oil, the soluble organic material contains only traces (<1%, usually of the order of 0.5%) of organically bound chlorine. This is in contrast to the results described when higher ratios of metal chloride to heavy oil are employed and the reaction is presumed to go to completion over 24 hours.

Thus, application of the process to a heavy feedstock shows that maximum yields of asphaltene materials are removed from the feedstock–solvent mix at low concentrations of metal chloride. The resulting deasphalted heavy oil contains only traces (<0.5% w/w) of organically bound chlorine and little or no (<0.1% wt/wt) mineral matter.

It is therefore apparent that asphaltene removal from a feedstock is greatly facilitated by addition of reactive metal salts, which remove the necessity of handling large volumes of solvents and the like as in the conventional deasphalting process. Although the precipitated asphaltene materials contain substantial amounts (10%–20% and even up to 30% wt/wt) of organically bound chlorine, this is nevertheless not a disadvantage, as other work has shown that these materials lend themselves to a variety of uses, especially thermal decomposition to good grade coke.

Reactions of asphaltene constituents with sulfur have also received some attention and have yielded interesting results. For example, treatment of the asphaltene constituents with oxygen or with sulfur at 150°C–250°C (300°F–480°F) yields a condensed aromatic product [H/C=0.97; H/C

(asphaltene constituents)=1.20] containing very little additional sulfur. The predominant reaction here appears to be condensation between the aromatic and aliphatic moieties of the asphaltene constituents caused by elemental sulfur, which are, in turn, converted to hydrogen sulfide. Condensation appears to proceed in preference to molecular degradation, and treatment of the condensed products at 200°C–300°C (390°F–570°F) for 1–5 hours again affords good grade cokes (H/C=0.54–0.56). In all instances, the final products contain only very low amounts of elements other than carbon and hydrogen (ΣNOS <5% wt/wt), a desirable property of good grade coke.

Attempts to *phosphorylate* asphaltene constituents with phosphoric acid, phosphorous trichloride, or phosphorous oxychloride have been partially successful insofar as it is possible to introduce up to 3% wt/wt phosphorus into the asphaltene constituents. However, application of these same reactions to oxidized asphaltene constituents increased the uptake of phosphorus quite markedly since there is up to 10% wt/wt in the product. Subsequent reaction of the phosphorus-containing products is necessary to counteract the acidity of the phosphorus functions.

Other reactions of asphaltene constituents have also been performed, but the emphasis has mainly been on the formation of more condensed materials to produce good grade cokes. For example, thermal treatment of the halogenated derivatives affords aromatic cokes [H/C=0.58; coke from the thermal conversion of asphaltene constituents at approximately 460°C (860°F) has H/C=0.77] containing less than 1% wt/wt halogen. Other investigations also show that treatment of the halo-asphaltene products with suitable metal catalysts -copper at 200°C–300°C (390°F–570°F) for 1–5 hours or sodium at 80°C–100°C (175°F–212°F for 1–5 hours yields aromatic (H/C=0.55–0.86, respectively) coke-like materials having 0.5% wt/wt–3% wt/wt halogen. Residual halogen may finally be removed by treatment at 300°C (570°F) for 5 hours.

Other chemical modifications include *metalation* of the asphaltene constituents or halo-asphaltenes using metal or metallo-organics, followed by *carboxylation* to yield acid functions in the product. Interaction of the asphaltenes with *m-dinitrobenzene* affords a product that, when treated with hydroxylamine (NH_2OH) or an amine (RNH_2), yields nitrogen-enriched products.

Reaction of asphaltenes with *maleic anhydride* and subsequent hydrolysis also yields a product bearing carboxylic acid functions. Asphaltenes react with diazo compounds and the procedure may be used to introduce functional groups into the asphaltene molecule to modify the properties of these materials.

4.6 SOLUBILITY PARAMETER

The solubility parameter is a measure of the ability of the compound to act as a solvent or non-solvent as well as a measure of the intermolecular and intramolecular forces between the solvent molecule and between the solvent and solute molecules (Barton, 1991). The solubility parameter is also a major parameter in certain products, especially in material such as residua (Redelius, 2000, 2004).

Any change in the physical and chemical properties of feedstock can be a key factor in the stability of the system. For example, as the degree of conversion *in a thermal process* increases, the solubility power of the medium toward the heavy and polar molecules decreases due to the formation of saturated products (Speight, 1994). This is reflected in a relative change in the solubility parameters of the dispersed and solvent phases leading to a phase separation (Speight, 1992, 1994, 2014, 2017).

The most prevalent thermodynamic approach to describing asphaltene solubility has been the application of the solubility parameter or the concept of cohesive energy density. The application of solubility parameter data to correlate asphaltene precipitation, and, hence, feedstock–solvent interaction, has been used on prior occasions (Mitchell and Speight, 1973; Speight, 1994). The solubility parameters of asphaltene constituents can be estimated from the properties of the solvent used for separation (Yen, 1984; Long and Speight, 1989) or be measured by the titration method (Andersen and Speight, 1992) or even from the atomic hydrogen–carbon ratio (Speight, 1994, 2014, 2015, 2019).

The solubility parameter difference that results in a phase separation of two materials, such as asphaltene constituents in a solvent, can be estimated using the Scatchard-Hildebrand equation:

$$\ln a_a = \ln x_a + M_a / \left\{ RT\rho_a \left[\Phi_s^2 (\delta_s - \delta_a)^2 \right] \right\}$$

Where a_a is the activity of the solute a, x_a is the mole fraction solubility of a, M_a is the molecular weight of a, ρ_a is the density of a, Φ_s is the volume fraction of solvent, and $(\delta_s - \delta_a)$ is the difference between the solubility parameters of the solute a and the solvent s. Assuming that the activity of the asphaltene constituents a_a is 1 (solid asphaltene constituents in equilibrium with dissolved asphaltene constituents) and the volume fraction of an excess of solvent is essentially 1, the equation can be rearranged into a form that can be used to gain insight into the solubility of asphaltene constituents:

$$\ln x_a = -M_a / RT \Delta_a \left[(\delta_s - \delta_a)^2 \right]$$

Assuming a density for asphaltene constituents of 1.28 g/cc and a molecular weight of 1,000 g/mole, the solubility of asphaltene constituents as a function of the differences between solubility parameters of the asphaltene constituents and precipitating solvent can be calculated. Thus, the solubility of asphaltene constituents can be shown to decrease as the difference between solubility parameters increases, with the limit of solubility attained at a difference of approximately 3. Thus, if the asphaltene constituents are part of a polarity and molecular weight continuum in a feedstock, their precipitation is not as straightforward as it would be for a single species with a particular solubility parameter.

Additional information can be gleaned by calculating the solubility parameter difference at several molecular weights ranging from 50 to 10,000 g/mole at which the solubility of asphaltenic or other material is a mole fraction of 0.001 (0.1% or 1,000 ppm). As a result, a phase diagram that is a function of molecular weight and solubility parameter difference can be defined. Both polarity and molecular weight of asphaltene constituents in a solvent define the solubility boundaries and explains conceptually how asphaltene constituents are precipitated from the mixture in feedstocks that can be considered a type of continuum of molecular weights and polarities. Furthermore, as the molecular weight of a particular solute decreases, there is an increased tolerance of polarity difference between solute and solvent under miscible conditions.

Incompatibility phenomena can be explained by the use of the solubility parameter for asphaltene constituents and other feedstock fractions (Speight, 1992, 1994, 2014). As an extension of this concept, there is sufficient data to draw an approximate correlation between hydrogen-to-carbon atomic ratio and the solubility parameter, δ, for hydrocarbon solvents and feedstock constituents (Speight, 1994, 2014). In general, hydrocarbon liquids can dissolve polynuclear aromatic hydrocarbon derivatives where there is, usually, less than a three-point difference between the lower solubility parameter of the solvent and the solubility parameter of the hydrocarbon.

By this means, the solubility parameter of asphaltene constituents can be estimated to be a range of values that is also in keeping with the asphaltene constituents being composed of a mixture of different compound types with the accompanying variation in polarity. Removal of alkyl side chains from the asphaltene constituents will decrease the H/C ratio and increase the solubility parameter thereby causing a concurrent decrease of the asphaltene product in the hydrocarbon solvent. In fact, on the molecular weight polarity diagram for asphaltene constituents, carbenes and carboids can be shown as lower-molecular-weight, highly polar entities in keeping with molecular fragmentation models.

4.7 STRUCTURAL ASPECTS

The molecular nature of the nonvolatile fractions of feedstock has been the subject of numerous investigations (Speight, 1972; Yen, 1974; Speight, 1994; Yen, 1994; Speight, 2014, 2019), but determining the actual structures of the constituents of the asphaltene fraction has proved to be difficult. It is the complexity of the asphaltene fraction that has hindered the formulation of the individual

molecular structures. Nevertheless, various investigations have brought to light some significant facts related to asphaltene structure. There are indications that asphaltene constituents consist of condensed aromatic nuclei that carry alkyl and alicyclic systems with hetero elements (i.e., nitrogen, oxygen, and sulfur) scattered throughout in various, including heterocyclic, locations.

Other basic generalizations have also been noted: with increasing molecular weight of the asphaltene fraction, both aromaticity and the proportion of hetero-elements increase (Koots and Speight, 1975). In addition, the proportion of asphaltene constituents in feedstock varies with source, depth of burial, the specific (or API) gravity of the feedstock, and the sulfur content of the feedstock as well as non-asphaltene sulfur (Koots and Speight, 1975). However, many facets of asphaltene structure remain unknown, and it is the purpose of this chapter to bring together the pertinent information on asphaltene structure as well as the part played by asphaltene constituents in the physical structure of feedstock.

In fact, it is this overall lack of structural detail that indicates current, and future, chemical research should focus on several items. These are (i) the skeletal structure, (ii) the size of the polynuclear aromatic systems, (iii) the internuclear bonds that need to be thermally or catalytically cleaved to produce more *identifiable* lower-molecular-weight fragments, (iv) the heteroatom types and subsequent ease or difficulty of removal, (v) the metallic constituents and their occurrence in porphyrin or non-porphyrin locations, and (vi) the physicochemical relationships that exist between the asphaltene constituents and the other constituents of the oil (Speight, 1994; Merdrignac and Espinat, 2007; Speight, 2014, 2019).

Despite numerous investigations, determination of the actual molecular structures, there are indications that the asphaltene constituents consist of condensed aromatic nuclei that carry alkyl and cylcoalkyl (naphthenic) substituents; heteroatoms (i.e., sulfur, nitrogen, and oxygen) are scattered throughout the hydrocarbon systems. In addition, it appears that with increasing molecular weight both aromaticity and the proportion of the heteroatoms increase. There is also fragmentary evidence that, with increasing molecular weight, the heteroatoms become incorporated into the more stable heterocyclic systems. This is especially true for sulfur constituents in which dibenzothiophene systems are believed to predominate in the higher-molecular-weight asphalts; it is presumed that similar arrangements occur for the nitrogen atoms, and oxygen may also occur in cyclic systems or in various functional groups.

If the residuum is produced by a process in which thermal decomposition has occurred, there may be traces of thiols (mercaptans, R–SH) in the mix that would, along with any hydrogen sulfide generated during the process, impart an objectionable odor to the residuum. The occurrence of thiol derivatives (also called mercaptan derivatives with the general formula RSH) in heavy crude oil, extra-heavy crude oil, and tar sand bitumen that have not been subjected to thermal treatment is also possible but is generally not considered likely.

The structural nature of the asphaltene constituents has been open to question for some time. Early postulates invoked the concept of simple aromatic structures while other postulates consider the possibility of polymers of aromatic and naphthenic ring systems (see, for example, Hillman and Barnett, 1937). A considerable amount of structural work has been carried out since that time on asphaltene constituents from various feedstocks. In fact, attempts to derive information related to the carbon skeleton of the asphaltene constituents have mainly been centered on the use of infrared and nuclear magnetic resonance spectroscopic techniques (Speight, 1994, 2014, 2019).

The data obtained by these methods seemingly supported the occurrence of condensed polynuclear aromatic ring systems bearing alkyl side chains. The condensed aromatic ring systems appear to vary from smaller systems composed of approximately six rings to the more ponderous, 15-ring to 20-ring systems. The high molecular weight of asphaltene constituents is accounted for by suggesting that the unit is repeated one or more times and is linked through saturated chains or rings.

However, it is somewhat difficult to visualize the existence of structures of this type as part of the asphaltene molecule, irrespective of their means of derivation. Indeed, all the methods employed for structural analysis involve, at some stage or another, assumptions that, although based upon

molecular types identified in the more volatile fractions of feedstock, must be of questionable validity, even though they may appear to serve the purpose and produce *acceptable* data.

Of all the methods applied to determine the types of polynuclear aromatic systems in asphaltene constituents (Speight and Long, 1981; Tissot, 1984), one with considerable potential, but given the least attention, is ultraviolet spectroscopy (Bjorseth, 1983). Typically, the ultraviolet spectrum of an asphaltene fraction shows two major regions with very little fine structure, and interpretation of such a spectrum can only be made in general terms. What is often not realized is that the technique can add valuable information related to the degree of condensation of polynuclear aromatic ring systems through the auspices of high-performance liquid chromatography (Lee et al., 1981; Bjorseth, 1983; Speight, 1986b).

For the whole asphaltene fraction, before fractionation into functional types, the *high-performance liquid chromatography–ultraviolet spectroscopy* chromatogram confirms the complexity of the asphaltene fraction (Figure 4.4). In addition, the technique offers the attractive option of investigating the nature of asphaltene constituents on a *before processing* and *after processing* basis. This allows researchers to make more detailed studies of asphaltene chemistry during processing. The distribution of chemical and molecular types in the asphaltene fraction is also emphasized by the different yields of thermal carbon (Conradson carbon residue test) produced by each fraction showing a variation in yield between approximately 40% w/w and 60% w/w (Figure 4.5).

For more detailed information on ring size distribution, fractionation of the asphaltene is advocated. A high-performance liquid chromatographic investigation of a mixture of standard polynuclear aromatic systems with the UV detector at fixed wavelengths from 240 to 360 nm confirmed the applicability of the technique to determine the presence of ring size distribution using the different selectivity of the polynuclear aromatic systems (Speight, 1986b). The one-ring and two-ring polynuclear aromatic systems were more prominent in the chromatogram at 240 mm but were not at all evident in the chromatogram at wavelengths above 300 nm. The converse was true for the three-ring to six-ring systems. This was confirmed examination of a standard solution of polynuclear aromatic (one-ring to seven-ring) systems, which confirmed that one-ring to three-ring systems gave prominent ultraviolet detector signals at <300 nm but gave no signals at >300 nm. On the other hand, compounds with four-ring to seven-ring systems still gave signals at >300 nm but gave no signals at 365 nm.

These data provide strong indications of the ring size distribution of the polynuclear aromatic systems in asphaltene constituents. For example, amphoteric species and basic nitrogen species contain polynuclear aromatic systems having two to six rings per system. On the other hand, the acid subfractions (phenolic or carboxylic functions) and the neutral polar subfractions (amides and imino functions) contain few if any polynuclear aromatic systems with more than three rings per system. In no case was there any strong or conclusive evidence for polynuclear aromatic ring systems

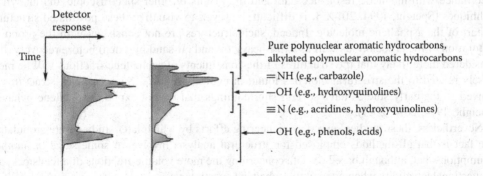

FIGURE 4.4 The complexity of the asphaltene fraction as shown by HPLC – the figure also refutes the concept of using an average structure to determine the behavior and properties of the asphaltene fraction.

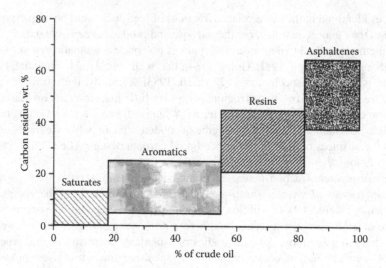

FIGURE 4.5 Subfractionation of the various fractions of crude oil yield subfractions with different carbon residues – particularly worthy of note in this instance is the spread of the yield of the carbon residue for the subfractions of the asphaltene fraction.

containing more than six condensed rings. In all cases, the evidence favored the preponderance of the smaller one-ring to four-ring systems (Speight, 1986b; Speight, 1994, 2014, 2019).

It must not be forgotten that the method is subject to the limitation of the sensitivity of poly-nuclear aromatic systems, and the fact that some of the asphaltene material (<2% wt/wt) was irreversibly adsorbed on the adsorbent. In this latter case, the *missing* material is polar material and any deviation from the ring size distribution just outlined is not believed to be significant enough to influence the general conclusions in relation to the nature of the polynuclear aromatic systems in asphaltene constituents.

These observations require some readjustment to the previous postulates of the asphaltene structure. Previously conceived hypotheses in which the polynuclear aromatic system is large (>10 rings) are considered unlikely despite their frequent and recent occurrence in the literature. The thermolysis products are indicative of a much more *open* structure than has previously been recognized. Indeed, the failure to detect (during the chromatographic examination) any strong evidence for the existence of large multi-ring polynuclear aromatic systems in the asphaltene fractions is evidence against structures invoking this concept.

Attempts have also been made to describe the total structures of asphaltene constituents in accordance with magnetic resonance data and the results of other spectroscopic and analytical techniques (Speight, 1994, 2014). It is difficult, however, to visualize these postulated structures as part of the asphaltene molecule. Indeed, such structures are not consistent with the proposed maturation of the crude oil (as well as extra-heavy oil and tar sand bitumen) before recovery. It is considered more likely that the structures of the constituents of asphaltene fractions will be more closely related to the structural moieties found in natural products. Such complex structures as derived in the early studies have several shortcomings that do not explain asphaltene behavior (Speight, 1994, 2014, 2019).

Nevertheless, these studies served as pioneering efforts by which later studies were stimulated. The fact is that all methods employed for structural analysis involve, at some stage or another, assumptions that, although based on data concerning the more volatile fractions of a feedstock, are of questionable validity when applied to asphaltene constituents.

The concept of asphaltene constituents as a sterane–sulfur polymer or even a regular hydrocarbon polymer has arisen because of the nature of the products obtained by reaction of an asphaltene

fraction with potassium naphthalide (Ignasiak et al., 1977). It was *erroneously assumed* that this particular organometallic reagent, one of several known to participate in rapid, complex reactions with organic substrates, cleaved only carbon–sulfur–carbon bonds but not carbon–carbon bonds. However, potassium naphthalide cleaves carbon–carbon bonds in various diphenylmethanes, and the cleavage of carbon–carbon bonds in 1,2-diarylethanes has been documented.

In each case, the isolation of well-defined organic reaction products confirms the nature of the reaction. Furthermore, the possibility of transmetallation from the arylnaphthalide to the aromatic centers of the asphaltene constituents complicates the situation and undoubtedly leads to more complex reactions and to reaction products of questionable composition. Formulating the structure of the unknown reactant (asphaltene constituents) under such conditions is extremely difficult. Indeed, it is evident that reacting asphaltene constituents with any particularly active reagents (e.g., the alkali aryls) leads to complex reactions, and it may be difficult if not impossible to predict accurately the course of these reactions.

In fact, the reaction of potassium naphthalide with tetrahydrofuran under conditions identical to those reported in which asphaltene constituents were also present, produces a light brown amorphous powder (Speight and Moschopedis, 1980). This product could erroneously be identified as a major degradation product of the asphaltene constituents had any asphaltene been present. Errors of this type have only added confusion to the already complex area of asphaltene structure!

There is now adequate evidence to show that asphaltene constituents contain smaller polynuclear aromatic systems than has previously been, or even continues to be acknowledged. In addition, spectroscopic studies (before and after derivative formation) have indicated that the presence of carbazole nitrogen and amide nitrogen. Non-aqueous potentiometric titration has confirmed the presence of these nitrogen types and has also provided evidence for the presence of pyridine nitrogen and indole nitrogen in asphaltene constituents. Oxygen fractions vary from the phenol oxygen and polyhydroxyphenols to quinone and amide oxygen.

These observations require some readjustments to the previous postulates of the asphaltene structure. Thus, previously conceived structures in which the sole aromatic system is a large polynuclear alkylated system are considered unlikely in view of these data. In fact, the current evidence is indicative of a much more *open* (rather than highly condensed) structure. From these investigations, a key structural feature of asphaltene constituents is the occurrence of small polynuclear aromatic systems, benzothiophenes, dibenzothiophenes, and n-paraffins within the asphaltene *molecule*.

The manner in which these moieties appear within the asphaltene molecule must for the present remain largely speculative, but above all, it must be remembered that asphaltene constituents are a solubility class and, as such, may be an accumulation of (literally) thousands of structural entities. Hence caution is advised against combining a range of identified products into one (albeit hypothetical) structure.

The danger in all of these studies is in attempts to link together fragmented molecules produced by thermal processes into a structure that is believed to be real. Functionality and polynuclear aromatic ring systems are real, but combination of these parameters into one or even several structures can be misleading. Molecular models can be an excellent aid to understanding process chemistry and physics. As long as the model allows predictability of process behavior, use of the model is warranted. Caution is advised, however. Because of the complexity of the asphaltene fraction, there is no one method that will guarantee the development of a suitable molecular model. The effort must be multidimensional, taking into account all the properties and characteristics of the material. Extreme caution is advised when average structures are used since averages can be meaningless and, worse case, misleading (Speight, 1994, 2014, 2019). Indeed, even when a multidimensional approach is employed for the derivation of a model there is no guarantee that the model is a true reflection of the molecular types in the asphaltene fraction. It must also be recognized that any model developed may not be the only, or final, answer to the problem. As techniques improve and knowledge evolves so must the model.

The constituents of the asphaltene fraction are *macromolecules* insofar as the molecular weights are generally accepted to be at least several hundred and more often approaching 2,000. In addition,

asphaltene constituents exist as complex mixtures of components that are separated from a feed-stock by treatment with a low-boiling liquid hydrocarbon (Mitchell and Speight, 1973; Speight et al., 1984).

A number of molecular models have been proposed for asphaltene constituents and are described in detail elsewhere (Speight, 1994, 2014), and repetition is not warranted here. It is sufficient to state that any molecular models derived for asphaltene constituents must be in keeping with behavioral characteristics. Efforts were made to describe the asphaltene fraction in terms of a single, representative asphaltene molecule or molecules incorporating, in the correct proportions, all of the chemical and elemental constituents known to be present in a given asphaltenic matrix (Speight, 1994, 2014, 2019).

Briefly, there are essentially three types of models: (i) those models that help to visualize the three-dimensional architecture and stereochemistry but are not to scale, (ii) framework-type models that indicate correct bond distances and bond angles and can be used to measure distances between non-bonded atoms in molecules but do not show the atoms as such, and (iii) space-filling models that provide a fairly realistic three-dimensional representation of what the molecule actually looks like. Attempts to model asphaltene constituents have usually employed pictographic representations of the first kind of models. Minor efforts have been made to represent asphaltene constituents using models of Types (ii) and (iii).

A serious shortcoming that is common to all molecular models is that the models have fixed bond angles and that rotation about single bonds is excessively facile, especially in the first two types of models. In contrast, in the real situation, there are relatively easily definable bond angles and substantial barriers to rotation about single bonds. Moreover, if it is desired to measure intramolecular and/or intermolecular bond distances, the model must first be fixed in its actual conformation. For molecules having a number of single bonds, this may be quite inconvenient (even though mechanical devices to stop bond rotation are available) and it may be difficult to set the actual torsion angles with any kind of precision.

As a result of all these difficulties, modeling of the macromolecules in the asphaltene fraction has proved to be speculative, although some success has been achieved in attempting to understand the nature of the constituents and their behavior in thermal processes (Speight, 1994, 2014, 2019). Success notwithstanding, the chemical dynamics are still speculative because of the speculative nature of the model!

The properties of macromolecules depend on both the chemical structure and physical structure. The term *primary structure* describes the chemical sequence of atoms in a macromolecule. The ordering of the atoms in space relative to each other is referred to as the *secondary structure*, and the three-dimensional structure of a molecule is called the *tertiary structure*.

By analogy, the *primary structure* of asphaltene constituents is the two-dimensional structure derived by a variety of analytical techniques and is often presented on paper as an *average structure*. The *secondary and tertiary structure*, and perhaps an often ignored but extremely important aspect of asphaltene chemistry and physics, is the micelle structure, which represents the means by which asphaltene constituents exist in feedstock.

A model that may be more in keeping with the amphoteric constituents of the asphaltene constituents would, on the basis of the preceding concept, have smaller polynuclear aromatic systems. Such a model would not only have to be compatible with the other constituents of the feedstock but also be able to represent the thermal chemistry and other process operations. It must also be recognized that such a model can have large size dimensions that have been proposed for asphaltene constituents. It can also be a *molecular chameleon* insofar as it can vary in these dimensions and shape depending upon the freedom of rotation about one or more of the bonds and whether or not it has been isolated from the feedstock. It is not possible to compose a model that represents all the properties of asphaltene constituents. The molecular size, as deduced from molecular weight measurements, prohibits this. It will be necessary to compose models that are representative of the various constituent fractions of an asphaltene. Then, perhaps, we will truly have representative models.

REFERENCES

Ali, L.H., Al-Ghannan, A., and Speight, J.G. 1985. Investigations on Asphaltenes in Heavy Crude Oils: Part II. Determination of Resins Occlusion through Swelling by Organic Solvents. *Iraqi J. Sci.* 26: 41.

Andersen, S.I., and Birdi, K.S. 1990. Influence of Temperature and Solvent on the Precipitation of Asphaltenes. *Fuel Sci. Technol. Int.* 8: 593–615.

Andersen, S.I. 1994. Dissolution of Solid Boscan Asphaltenes in Mixed Solvents. *Fuel Sci. Technol. Int.* 12: 1551–1577.

Andersen, S.I., Keul, A., and Stenby, E. 1997. Variation in Composition of the Sub-Fractions of Petroleum Asphaltenes. *Pet. Sci. Technol.* 15: 611–645.

Andersen, S.I., and Speight, J.G. 1992. Asphaltene Precipitation and Incipient Flocculation in Mixed Solvents. Preprints, *Div. Fuel Chem. Am. Chem. Soc.* 37(3): 1335.

Andersen, S.I., and Speight, J. 1994. Observations on the Critical Micelle Concentration of Asphaltenes. *Fuel* 72: 1343–1344.

Andersen, S.I., and Speight, J.G. 2001. Petroleum Reins: Separation, Character, and Role in Petroleum. *Pet. Sci. Technol.* 19: 1.

Barton, A.F.M. 1991. *CRC Handbook of Solubility Parameters and Other Cohesion Parameters*, 2nd Edition. CRC Press, Boca Raton, FL.

Bestougeff, M.A., and Darmois, R. 1947. *Comptes Rend.* 224: 1365.

Bestougeff, M.A., and Darmois, R. 1948. *Comptes Rend.* 227: 129.

Bestougeff, M.A., and Mouton, Y. 1977. *Bull. Liason Lab. Pont. Chaus.* Special Volume, p. 79.

Bjorseth, A. 1983. *Handbook of Polycyclic Aromatic Hydrocarbons*. Marcel Dekker Inc., New York.

Branthaver, J.F. 1990. Porphyrins. *Fuel Science and Technology Handbook*. J.G. Speight (Editor). Marcel Dekker Inc., New York.

Clerc, R.J., and O'Neal, M.J. 1961. *Anal. Chem.* 33: 380.

Drushel, H.V. 1970. Preprints, *Div. Pet. Chem. Am. Chem. Soc.* 15: C13.

Farcasiu, M., Forbus, T.R., and LaPierre, R.B. 1983. Preprints, *Div. Pet. Chem. Am. Chem. Soc.* 28: 279.

Francisco, M.A., and Speight, J.G. 1984. Asphaltene Characterization by a Non-spectroscopic Method. Preprints, *Div. Fuel. Chem. Am. Chem. Soc.* 29(1): 36.

Galtsev, V.E., Ametov, I.M., and Grinberg, O.Y. 1995. Asphaltene Association in Crude Oil as Studied by ENDOR. *Fuel* 74: 670.

Gary, J.G., Handwerk, G.E., and Kaiser, M.J. 2007. *Petroleum Refining: Technology and Economics*, 5th Edition. CRC Press, Taylor & Francis Group, Boca Raton, FL.

Girdler, R.B. 1965. Constitution of Asphaltenes and Related Studies. *Proc. Assoc. Asphalt Paving Technol.* 34: 45.

Hillman, E., and Barnett, B. 1937. *Proc. 4th Ann. Meet. ASTM.* 37(2): 558.

Hirschberg, A., deJong, L., Schipper, B., and Maijer, J. 1984. Influence of Temperature and Pressure on Asphaltene Flocculation. *SPE J.* June: 283–293.

Hsu, C.S., and Robinson, P.R. (Editors). 2017. *Handbook of Petroleum Technology*. Springer International Publishing AG, Cham, Switzerland.

Huc, A.Y., Behar, F., and Roussel, J.C. 1984. Geochemical Variety of Asphaltenes from Crude Oils. Proceedings. *Symposium on Characterization of Heavy Crude Oils and Petroleum Residues*. Editions Technip, Paris, France, Pages 99–103.

Ignasiak, T., Kemp-Jones, A.V., and Strausz, O.P. 1977. The Molecular Structure of Athabasca Asphaltenes. Cleavage of the Carbon Sulfur Bonds by Radical Ion Electron Transfer Reactions. *J. Org. Chem.* 42: 312–320.

Jacobson, J.M., and Gray, M.R. 1987. The Use of Infrared Spectroscopy and Nitrogen Titration Data in the Structural Group Analysis of Bitumen. *Fuel* 66: 749–752.

Keleman, S.R., George, G.N., and Gorbaty, M.L. 1990. *Fuel* 69: 939.

Khulbe, K.C., Manna, R.S., MacPhee, J.A. (1996) Separation of Acidic Fraction from the Cold Lake Bitumen Asphaltenes and its Relationship to Enhanced Oil Recovery. *Fuel Process. Technol.* 46: 63–69.

Koots, J.A., and Speight, J.G. 1975. The Relation of Petroleum Resins to Asphaltenes. *Fuel* 54: 179.

Lee, M.L., Novotny, M.S., and Bartle, K.D. 1981. *Analytical Chemistry of Polycyclic Aromatic Compounds*. Academic Press Inc., New York.

Long, R.B. 1979. The Concept of Asphaltenes. Preprints, *Div. Pet. Chem. Am. Chem. Soc.* 24(4): 891.

Long, R.B. 1981. The Concept of Asphaltenes. *The Chemistry of Asphaltenes*. J.W. Bunger and N. Li (Editors). Advances in Chemistry Series No. 195. American Chemical Society, Washington, DC.

Long, R.B., and Speight, J.G. 1989. Studies in Petroleum Composition. I: Development of a Compositional Map for Various Feedstocks. *Rev. Inst. Fr. Pétrol.* 44: 205.

Merdrignac, I., and Espinat, D. 2007. Physicochemical Characterization of Petroleum Fractions: The State of the Art. *Oil Gas Sci. Technol. – Rev. Inst. Fr. Pet.* 62(1): 7–32.

Miller, J.T., Fisher, R.B., Thiyagarajan, P., Winans, R.E., and Hunt, J.E. 1998. Sub-Fraction and Characterization of Mayan Asphaltenes. *Energy Fuels* 12(6): 1290–1298.

Mitchell, D.L., and Speight, J.G. 1973. The Solubility of Asphaltenes in Hydrocarbon Solvents. *Fuel* 52: 149.

Moschopedis, S.E., Fryer, J.F., and Speight, J.G. 1976. An Investigation of Asphaltene Molecular Weights. *Fuel* 55: 227.

Moschopedis, S.E., and Speight, J.G. 1971. Halogenation of Athabasca Asphaltenes with Elemental Halogen. *Fuel* 50: 58.

Moschopedis, S.E., and Speight, J.G. 1976a. An Investigation of Hydrogen Bonding by Oxygen Functions in Athabasca Bitumen. *Fuel* 55: 187.

Moschopedis, S.E., and Speight, J.G. 1976b. Oxygen Functions in Asphaltenes. *Fuel* 55: 334.

Moschopedis, S.E., and Speight, J.G. 1976c. An Investigation of Asphalt Preparation from Athabasca Bitumen. *Proc. Assoc. Asphalt Paving Technol.* 45: 78.

Moschopedis, S.E., and Speight, J.G. 1978. The Influence of Metal Salts on Bitumen Oxidation. *Fuel* 57: 235.

Moschopedis, S.E., and Speight, J.G. 1979. Investigation of Nitrogen Types in Athabasca Bitumen. Preprints, *Div. Pet. Chem. Am. Chem. Soc.* 24(4): 1007.

Nicksic, S.W., and Jeffries-Harris, M.J. 1968. *J. Inst. Petroleum.* 54: 107.

Overfield, R.E., Sheu, E.Y., Sinha, S.K., and Liang, K.S. 1989. SANS Study of Asphaltene Aggregation. *Fuel Sci. Technol. Int.* 7: 611–624.

Parkash, S. 2003. *Refining Processes Handbook.* Gulf Professional Publishing, Elsevier, Amsterdam, Netherlands.

Petersen, J.C., Barbour, F.A., and Dorrence, S.M. 1974. Oxygen Identification in Asphaltenes. *Proc. Assoc. Asphalt Paving Technol.* 43: 162–169.

Ravey, J.C., Decouret, G., and Espinat, D. 1988. Asphaltene Macrostructure by Small Angle Neutron Scattering. *Fuel* 67: 1560–1567.

Redelius, P.G. 2000. Solubility Parameters and Bitumen. *Fuel* 79: 27–35.

Redelius, P.G. 2004. Bitumen Solubility Model using Hansen Solubility Parameter. *Energy Fuels* 18: 1087–1092.

Reerink, H. 1973. Size and Shape of Asphaltene Particles in Relationship to High Temperature Viscosity. *Ind. Eng. Chem. Prod. Res. Dev.* 12: 82–88.

Reynolds, J.G. 1998. *Petroleum Chemistry and Refining.* Taylor & Francis Publishers, Washington, DC, Chapter 3: Metals and Heteroatoms in Heavy Crude Oils Editor: J.G. Speight.

Ritchie, R.G.S., Roche, R.S., and Steedman, W. 1979. *Fuel* 58: 523.

Rose, K.D., and Francisco, M.A. 1987. Characterization of Acidic Heteroatoms in Heavy Petroleum Fractions by Phase-Transfer Methylation and NMR Spectroscopy. *Energy Fuels* 1: 233.

Rose, K.D., and Francisco, M.A. 1988. A Two-Step Chemistry for Highlighting Heteroatom Species in Petroleum Material Using [13]C NMR Spectroscopy. *J. Am. Chem. Soc.* 110: 637.

Schmitter, J.M., Garrigues, P., Ignatiadis, I., De Vazelhes, R., Perin, F., Ewald, M., and Arpino, P. 1984. *Org. Geochem.* 6: 579.

Schucker, R.C., and Keweshan, C.F. 1980. Reactivity of Cold Lake Asphaltenes. Preprints, *Div. Fuel Chem. Am. Chem. Soc.* 25: 155.

Sheu, E.Y., DeTar, M.M., Storm, D.A., and DeCanio, S.J. 1992. Aggregation and Kinetics of Asphaltenes in Organic Solvents. *Fuel* 71: 299.

Speight, J.G. 1970. A Structural Investigation of the Constituents of Athabasca Bitumen by Proton Magnetic Resonance Spectroscopy. *Fuel* 49: 76.

Speight, J.G. 1971. Structural Analysis of Athabasca Asphaltenes by Proton Magnetic Resonance Spectroscopy. *Fuel* 50: 102.

Speight, J.G. 1972. The Application of Spectroscopic Techniques to the Structural Analysis of Coal and Petroleum. *Appl. Spectrosc. Rev.* 5: 211.

Speight, J.G. 1979. Studies on Bitumen Fractionation: (a) Fractionation by a Cryoscopic Method (b) Effect of Solvent Type on Asphaltene Solubility. Information Series No. 84. Alberta Research Council, Edmonton, Alberta, Canada.

Speight, J.G. 1981a. Asphaltenes as an Organic Natural Product and their Influence on Crude Oil Properties. Proceedings. *Division of Geochemistry. American Chemical Society.* New York, August 23–28.

Speight, J.G. 1981b. Solvent Effects in the Molecular Weights of Petroleum Asphaltenes. Preprints, *Div. Pet. Chem. Am. Chem. Soc.* 26: 825.

Speight, J.G. 1984. The Chemical Nature of Petroleum Asphaltenes. *Characterization of Heavy Crude Oils and Petroleum Residues*. B. Tissot (Editor). Editions Technip, Paris.

Speight, J.G. 1986a. Upgrading Heavy Feedstocks. *Annu. Rev. Energy*. 11: 253.

Speight, J.G. 1986b. Polynuclear Aromatic Systems in Petroleum. Preprints, *Div. Pet. Chem. Am. Chem. Soc.* 31(4): 818.

Speight, J.G. 1992. A Chemical and Physical Explanation of Incompatibility during Refining Operations. Proceedings. *4th International Conference on the Stability and Handling of Liquid Fuels*. U.S. Department of Energy (DOE/CONF-911102), Page 169.

Speight, J.G. 1994. Chemical and Physical Studies of Petroleum Asphaltenes. Volume 40. *Asphaltenes and Asphalts. I. Developments in Petroleum Science*. T.F. Yen and G.V. Chilingarian (Editors). Elsevier, Amsterdam, Netherlands, Chapter 2.

Speight, J.G. 2014. *The Chemistry and Technology of Petroleum*, 5th Edition. CRC Press, Taylor & Francis Group, Boca Raton, FL.

Speight, J.G. 2015. *Handbook of Petroleum Product Analysis*, 2nd Edition. John Wiley & Sons Inc., Hoboken, NJ.

Speight, J.G. 2017. *Handbook of Petroleum Refining*. CRC Press, Taylor & Francis Group, Boca Raton, FL.

Speight, J.G. 2019. The Asphaltene Fraction – Demystified. *Pet. Chem. Ind. Int.* 2(4). https://opastonline.com/wp-content/uploads/2019/10/the-asphaltene-fraction-demystified-pcii-19.pdf

Speight, J.G., and Long, R.B. 1981. Spectroscopy and Asphaltene Structure. *Atomic and Nuclear Methods in Fossil Energy Research*. R.H. Filby (Editor). Plenum Press, New York, Page 295.

Speight, J.G., Long, R.B., and Trowbridge, T.D. 1982. On the Definition of Asphaltenes. Preprints, *Div. Fuel Chem. Am. Chem.* Soc. 27(3/4): 268

Speight, J.G., Long, R.B., and Trowbridge, T.D. 1984. Factors Influencing the Separation of Asphaltenes from Heavy Petroleum Feedstocks. *Fuel* 63: 616.

Speight, J.G., and Moschopedis, S.E. 1977. Asphaltene Molecular Weights by a Cryoscopic Method. *Fuel* 56: 344.

Speight, J.G., and Moschopedis, S.E. 1980. On the "Polymeric Nature" of Petroleum Asphaltenes. *Fuel* 59: 440.

Speight, J.G., and Moschopedis, S.E. 1981a. On the Molecular Nature of Petroleum Asphaltenes. *Chemistry of Asphaltenes*. J.W. Bunger and N.C. Li (Editors). Advances in Chemistry Series No. 195. American Chemical Society, Washington. DC.

Speight, J.G., and Moschopedis, S.E. 1981b. Anomalous Effects in the Character of the Carbonyl Absorption in the Infrared Spectra of Petroleum Resins and Asphaltenes. Preprints, *Div. Pet. Chem. Am. Chem. Soc.* 26(4): 907.

Speight, J.G., and Pancirov, R.J. 1984. Structural Types in Asphaltenes as Deduced from Pyrolysis-Gas Chromatography-Mass Spectrometry. *Liq. Fuels Technol.* 2: 287.

Speight, J.G., Wernick, D.L., Gould, K.A., Overfield, R.E., Rao, B.M.L., and Savage, D.W. 1985. Molecular Weights and Association of Asphaltenes: A Critical Review. *Rev. Inst. Fr. Pét.* 40: 51.

Storm, D.A. and Sheu, E.Y. 1994. Colloidal Nature of Petroleum Asphaltenes. Volume 40. *Asphaltenes and Asphalt, 1. Developments in Petroleum Science*. T.F. Yen and G.V. Chilingarian (Editors). Elsevier, Amsterdam, Netherlands.

Thiyagarajan, P., Hunt, J.E., Winansa, R.E., Anderson, K.B., and Miller, J.T. 1995. Temperature Dependent Structural Changes of Asphaltenes in 1-Methylnaphthlene. *Energy Fuels* 9: 629.

Tissot, B. 1984. *Characterization of Heavy Crude Oils and Petroleum Residues*. Editions Technip, Paris, France.

Winniford, R.S. 1963. *Inst. Petroleum Rev.* 49: 215.

Yen, T.F. 1974. The Structure of Asphaltene and Its Significance. *Energy Sources* 1: 447.

Yen, T.F. 1984. *The Future of Heavy Crude Oil and Tar Sands*. R.F. Meyer, J.C. Wynn, and J.C. Olson (Editors). McGraw-Hill, New York, Page 412.

Yen, T.F. 1994. Multiple Structural Orders of Asphaltenes. Volume 40. *Asphaltenes and Asphalt, 1. Developments in Petroleum Science*. T.F. Yen and G.V. Chilingarian (Editors). Elsevier, Amsterdam, Netherlands.

5 Instability and Incompatibility

5.1 INTRODUCTION

The study of the properties of refinery feedstocks would not be complete without some attention to the phenomena of instability and incompatibility – sometimes referred to as *fouling*. Both result in formation of degradation products and other undesirable changes in the original properties of crude oil products. And it is the analytical methods that provide the data that point to the reason for problems in the refinery or for the failure of products to meet specifications and to perform as desired.

In some case, the terms instability and incompatibility are used separately. For example, the term instability might refer to a blend of two or more feedstocks that, after blending, appears to be stable but after the passage of a given time period (the induction period) forms two or more separate phases. Similarly, the term incompatibility might refer to a blend of two or more feedstocks that, after blending, forms two or more separate phases without an induction period. In this book, the terms are used interchangeably.

Briefly, and by way of explanation, an induction period in chemical (or physical) reactions is an initial stage of the reaction (or a slow stage of a reaction) in which the reaction does not appear to occur after which the reaction may accelerate, even leading to (in some reactions) an explosion. Typically, the end of the induction period marks the end of the period of low (or no) chemical or physical activity and the onset of the reaction. For example, in the coking process, there is an induction period during which coke is not formed but the chemistry of coke formation as already started and coke depletion is manifested after a period of time that is dependent upon the feedstock composition and the temperature of the process (Chapter 7) (Magaril and Akensova, 1967, 1968; Magaril and Ramazaeva, 1969; Magaril and Aksenova, 1970a,b; Magaril et al., 1970, 1971; Magaril and Aksenova, 1972; Wiehe, 1994; Speight, 2014a). In another case, in the deasphalting procedure, there is an induction volume during which time the amount of precipitant does not cause any asphaltene constituents to separate. Again, the appearance of the asphaltene phase is dependent upon the feedstock composition and the temperature of the process (Speight, 2014, 2015).

Moreover, instability and incompatibility through the disposition of sludge or sediment are real, and the challenge in mitigating instability and incompatibility is to eliminate or modify the prime chemical reactions in the formation of incompatible products during the processing of feedstocks containing resin constituents and asphaltene constituents, particularly those reactions in which the insoluble lower-molecular-weight products (*carbenes* and *carboids*) (Figure 5.1) are formed (Speight, 2014a,b, 2017). In fact, the asphaltene constituents of feedstocks have been a source of problems for decades.

Thus, the deposition of asphaltene constituents is the consequence of instability of the crude oil (i.e., in this context, a feedstock blend or a product from the feedstock, such as fuel oil). The asphaltene constituents are stabilized by resin constituents and maintained in the crude oil due to this stabilization. Asphaltene dispersants are substitutes for the natural resin constituents and are able to keep the asphaltene constituents dispersed to prevent flocculation/aggregation and phase separation (Speight, 1994). Dispersants will also clean up sludge in the fuel system, and they have the ability to adhere to surface of materials that are insoluble in the oil and convert them into stable colloidal suspensions.

Crude oil products have been in use for over 5,000 years (Abraham, 1945; Forbes, 1958a,b, 1959; James and Thorpe, 1994; Speight, 2014a). Certain derivatives of crude oil (the nonvolatile residua and asphalt) could be used for caulking and as an adhesive for jewelry or for construction purposes as well as the use of asphalt for medicinal purposes. Other derivatives (the volatile *naft* or naphtha) were sued as incendiary materials or as illuminants. Current refineries are a complex series of

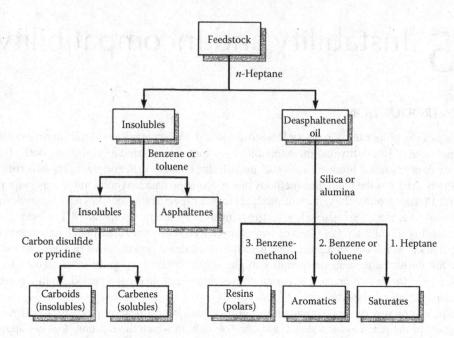

FIGURE 5.1 General fractionation scheme and nomenclature of petroleum fraction; carbenes and carboids are thermally generated product fractions.

manufacturing plants that can be subdivided into (i) separation processes, (ii) conversion processes, and (iii) finishing processes (Parkash, 2003; Gary et al., 2007; Speight, 2014a; Hsu and Robinson, 2017; Speight, 2017). Incompatibility can occur many of these processes, and the product can also exhibit incompatibility and instability.

Product complexity and the means by which the product is evaluated have made the industry unique among industries. But product complexity has also brought to the fore issues such as *instability* and *incompatibility*. Product complexity becomes even more disadvantageous when various fractions from different types of crude oil are blended or are allowed to remain under conditions of storage (prior to use) and a distinct phase separates from the bulk product. Typically, the individual components of a feedstock blend have a high, medium, or low fouling potential. The blends of those that are incompatible however showed increased instability and may be the cause of the fouling problems encountered during processing

The adverse implications of this for refining the fractions to salable products increase (Batts and Fathoni, 1991; Por, 1992; Mushrush and Speight, 1995; Speight, 2014a). Therefore, it is appropriate here to define some of the terms that are used in the liquid fuels field so that their use later in the text will be more apparent and will also alleviate some potential for misunderstanding.

Briefly, the term *incompatibility* refers to the formation of a *precipitate* (or *sediment*) or *separate phase* when two liquids are mixed. The term *instability* is often used in reference to the formation of color, sediment, or gum in the liquid over a period of time and is usually due to chemical reactions, such as oxidation, and is chemical rather than physical. This term may be used to contrast the formation of a precipitate in the near term (almost immediately). In addition, self-incompatible feedstocks are those containing insoluble asphaltenes that were not formed by mixing incompatible components. Examples of self-incompatible feedstocks are (i) thermally cracked feedstocks and (ii) feedstocks that have been hydrotreated with size selective catalysts that convert resin constituents to asphaltene constituents.

The phenomenon of *instability* is often referred to as *incompatibility*, and more commonly known as *sludge formation*, and *sediment formation*, or *deposit formation*. In crude oil and its products,

TABLE 5.1

Examples of Properties Related to Instability in Crude Oil and Crude Oil Products

Property	Comments
Asphaltene constituents	Influence oil–rock interactions
	Separates from oil when gases are dissolved
	Thermal alteration can cause phase separation
Heteroatom constituents	Provide polarity to oil
	Preferential reaction with oxygen
	Preferential thermal alteration
Aromatic constituents	May be incompatible with paraffinic medium
	Phase separation of paraffinic constituents
Non-asphaltene constituents	Thermal alteration causes changes in polarity
	Phase separation of polar species

TABLE 5.2

Examples of the Influence of Asphaltene Constituents in Feedstocks on Various Processes

Process	Issues
Oil recovery	Wellbore plugging and pipeline deposition
Visbreaking process	Degraded asphaltene constituents are more aromatic (loss of aliphatic chains) and less soluble and from deposits in the reactor
Cracking processes	Degraded asphaltene constituents are more aromatic (loss of aliphatic chains) and less soluble and deposit on the catalyst
Emulsion formation	Emulsions may be formed
	Asphaltene constituents highly polar and surface active and responsible for the undesired stabilization of emulsions
Preheating	Preheating of a feedstocks prior to entering a fraction combustion encourages reaction and precipitation of the reacted asphaltene constituents leading to premature coking
Combustion	A high content (>6% w/w) of asphaltene constituents in the feedstock can result in ignition delay and poor combustion further leading to boiler fouling, poor heat transfer, stack solid emission, and corrosion problems
Blending of feedstocks	Blending and the resulting change of the properties of the liquid medium during mixing can cause destabilization of asphaltene (and reacted asphaltene) constituents
Storage	In the case of visbroken products, sedimentation and plugging can occur due to oxidation of the asphaltene constituents

instability often manifests itself in various ways (Tables 5.1 and 5.2) (Stavinoha and Henry, 1981; Hardy and Wechter, 1990; Power and Mathys, 1992; Mushrush and Speight, 1995; Speight, 2014a). Hence, there are different ways of defining each of these terms but the terms are often used interchangeably.

Gum formation (ASTM D525, IP 40) alludes to the formation of soluble organic material whereas *sediment* is the insoluble organic material. *Storage stability* (or *storage instability*) (ASTM D381, ASTM D4625, IP 131, IP 378) is a term used to describe the ability of the liquid to remain in storage over extended periods of time without appreciable deterioration as measured by gum formation and/or the formation sediment. *Thermal stability* is also defined as the ability of the liquid to withstand relatively high temperatures for short periods of time without the formation of sediment (i.e., carbonaceous deposits and/or coke). *Thermal oxidative stability* is the ability of the liquid to withstand relatively high temperatures for short periods of time in the presence of oxidation and

without the formation of sediment or deterioration of properties (ASTM D3241), and there is standard equipment for various oxidation tests (ASTM D4871). *Stability* is also the ability of the liquid to withstand long periods at temperatures up to 100°C (212°F) without degradation. Determination of the *reaction threshold temperature* for various liquid and solid materials might be beneficial (ASTM D2883).

Existent-gum is the name given to the nonvolatile residue present in the fuel as received for test (ASTM D381, IP 131). In this test, the sample is evaporated from a beaker maintained at a temperature of 160°C–166°C (320°F–331°F) with the aid of a similarly heated jet of air. This material is distinguished from the *potential gum* that is obtained by aging the sample at an elevated temperature. Thus, *potential gum* is determined by the *accelerated gum test* (ASTM D873, IP 138) that is used as a safeguard of storage stability and can be used to predict the potential for gum formation during prolonged storage. In this test, the fuel is heated for 16 hours with oxygen under pressure in a bomb at 100°C (212°F). After this time, both the gum content and the solids precipitate are measured. A similar test, using an accelerated oxidation procedure is also in use for determining the oxidative stability of diesel fuel (ASTM D2274), steam turbine oil (ASTM D2272), distillate fuel oil (ASTM D2274), and lubricating grease (ASTM D942).

Dry sludge is defined as the material separated from crude oil and crude oil products by filtration and which is insoluble in heptane. *Existent dry sludge* is the dry sludge in the original sample as received and is distinguished from the accelerated dry sludge obtained after aging the sample by chemical addition or heat. The *existent dry sludge* is distinguished from the *potential dry sludge* that is obtained by aging the sample at an elevated temperature. The *existent dry sludge* is operationally defined as the material separated from the bulk of crude oil or crude oil product by filtration and which is insoluble in heptane. The test is used as an indicator of process operability and as a measure of potential downstream instability/incompatibility.

An analogous test, the *thin-film oven test* (*TFOT*) (ASTM D1754) is used to indicate the rate of change of various physical properties such as penetration (ASTM D5), viscosity (ASTM D2170), and ductility (ASTM D113) after a film of asphalt or bitumen has been heated in an oven for 5 hours at 163°C (325°F) on a rotating plate. A similar test is available for the stability of engine oil by thin-film oxygen uptake test (*TFOUT*) (ASTM D4742). This test establishes the effects of heat and air based on changes incurred in the above physical properties measured before and after the oven test. The allowed rate of changes in the relevant bitumen properties after the exposure of the tested sample to the oven test are specified in the relevant specifications (ASTM D3381).

Attractive as they seem to be, any tests that involve *accelerated oxidation* of the sample must be used with caution and consideration of the chemistry. Depending on the constituents of the sample, it is quite possible that the higher temperature and extreme conditions (oxygen under pressure) may not be truly representative of the deterioration of the sample under storage conditions. The higher temperature and the oxygen under pressure might change the chemistry of the system and produce products that would not be produced under ambient storage conditions. An assessment of the composition of the fuel prior to storage and application of the test will assist in this determination.

In general, *fuel instability* and *fuel incompatibility* can be related to the heteroatom-containing compounds (i.e., nitrogen-, oxygen-, and sulfur-containing compounds) that are present. The degree of unsaturation of the fuel (i.e., the level of olefinic species) also plays a role in determining instability/incompatibility. And, recent investigations have also implicated catalytic levels of various oxidized intermediates and acids as especially deleterious for middle distillate fuels.

Fuel *incompatibility* can have many meanings. The most obvious example of incompatibility (*non-miscible*) is the inability of hydrocarbon fuels and water to mix. In the present context, incompatibility usually refers to the presence of various polar functions (i.e., heteroatom function groups containing nitrogen, or oxygen, or sulfur, and even various combinations of the heteroatoms) in the crude oil.

Instability reactions are usually defined in terms of the formation of filterable and non-filterable sludge (sediments, deposits, and gums), an increased peroxide level, and the formation of color

bodies. Color bodies in and of themselves do not predict instability. However, the reactions that initiate color body formation can be closely linked to heteroatom-containing (i.e., nitrogen-, oxygen-, and sulfur-containing) functional group chemistry.

In the current context, the meaning of the term *incompatibility* is found when it is applied to crude oil recovery and crude oil refining. Incompatibility during refining can occur in a variety of processes, either by intent (such as in the deasphalting process) or inadvertently when the separation is detrimental to the process. Thus, separation of solids occurs whenever the solvent characteristics of the liquid phase are no longer adequate to maintain polar and/or high-molecular-weight material in solution. Examples of such occurrences are (i) asphaltene separation which occurs when the paraffinic nature of the liquid medium increases, (ii) wax separation which occurs when there is a drop in temperature or the aromaticity of the liquid medium increases, (iii) sludge/sediment formation in a reactor which occurs when the solvent characteristics of the liquid medium change so that asphaltic or wax materials separate, coke formation which occurs at high temperatures and commences when the solvent power of the liquid phase is not sufficient to maintain the coke precursors in solution, and (iv) sludge/sediment formation in fuel products which occurs because of the interplay of several chemical and physical factors (Mushrush and Speight, 1995).

Instability/incompatibility occurs when a product is formed in the formation or well pipe (recovery) or in a reactor (refining), and the product is incompatible with (immiscible with or insoluble in) the original crude oil or its products. Such an example is the formation and deposition of was and other solids during recovery or the formation of coke precursors and even of coke during many thermal and catalytic operations. Coke formation is considered to be an initial *phase separation* of an insoluble, solid, coke precursor prior to coke formation proper. In the case of crude oils, *sediments* and *deposits* are closely related to *sludge*, at least as far as compositions are concerned. The major difference appears to be in the character of the material.

There is also the suggestion (often, but not always, real) in that the sediments and deposits originate from the inorganic constituents of crude oil. They may be formed from the inherent components of the crude oil (i.e., the metalloporphyrin constituents) or from the ingestion of contaminants by the crude oil during the initial processing operations. For example, crude oil is known to *pick up* iron and other metal contaminants from contact with pipelines and pumps.

Sediments can also be formed from organic materials but the usual inference is that these materials are usually formed from inorganic materials. The inorganic materials can be salt, sand, rust, and other contaminants that are insoluble in the crude oil and which settle to the bottom of the storage vessel. For example, *gum* typically forms by way of a hydroperoxide intermediate that induces polymerization of olefins. The intermediates are usually soluble in the liquid medium. However, gum that has undergone extensive oxidation reactions tends to be higher in molecular weight and much less soluble. In fact, the high-molecular-weight sediments that form in fuels are usually the direct result of *autoxidation* reactions. Active oxygen species involved include both molecular oxygen and hydroperoxides. These reactions proceed by a free-radical mechanism and the solids produced tend to have increased incorporation of heteroatom and are thus also more polar so increasingly less soluble in the fuel.

The most significant and undesirable instability change in fuel liquids is the formation of solids, termed *filterable sediment*. Filterable sediments can plug nozzles, filters, coke heat exchanger surfaces and otherwise degrade engine performance. These solids are the result of free-radical autoxidation reactions. Although slight thermal degradation occurs in non-oxidizing atmospheres, the presence of oxygen or active oxygen species, such as hydroperoxides, will greatly accelerate oxidative degradation as well as significantly lower the temperature at which undesirable products are formed. Solid deposits that form as the result of short-term high-temperature reactions share many similar chemical characteristics with filterable sediment that form in storage.

The soluble sludge/sediment precursors that form during processing or use may have a molecular mass in the several hundred range. For this soluble precursor to reach a molecular weight sufficient to precipitate (or to phase-separate), one of two additional reactions must occur. Either

the molecular weight must increase drastically as a result of condensation reactions leading to the higher-molecular-weight species. Or the polarity of the precursor must increase (without necessarily increasing the molecular weight) by incorporation of additional oxygen, sulfur, or nitrogen functional groups. Additionally, the polarity may increase because of the removal of non-polar hydrocarbon moieties from the polar core, as occurs during cracking reactions. In all three cases, insoluble material will form and separate from the liquid medium.

Additives are chemical compounds intended to improve some specific properties of fuels or other crude oil products. Different additives, even when added for identical purposes, may be incompatible with each other, for example, react and form new compounds. Consequently, a blend of two or more fuels, containing different additives, may form a system in which the additives react with each other and so deprive the blend of their beneficial effect.

The chemistry and physics of incompatibility can, to some extent, be elucidated (Por, 1992; Power and Mathys, 1992; Mushrush and Speight, 1995) but many unknowns remain. In addition to the chemical aspects, there are also aspects such as the attractive force differences, such as (i) specific interactions between like/unlike molecules, such as hydrogen bonding and electron donor–acceptor phenomena, (ii) field interactions such as dispersion forces and dipole–dipole interactions, (iii) any effects imposed on the system by the size and shape of the interacting molecular species.

Such interactions are not always easy to define and, thus, the measurement of instability and incompatibility has involved visual observations, solubility tests, hot filtration sediment (HFS), and gum formation. However, such methods are often considered to be *after-the-fact methods* insofar as they did not offer much in the way of predictability. In refinery processes (Parkash, 2003; Gary et al., 2007; Speight, 2014a; Hsu and Robinson, 2017; Speight, 2017), predictability is not just a luxury, it is a necessity. The same principle must be applied to the measurement of instability and incompatibility. Therefore, methods are continually being sought to aid in achieving this goal.

In addition to the gravimetric methods, there have also been many attempts to use crude oil and/or product characteristics and their relation to the sludge and deposit formation tendencies. In some cases, a modicum of predictability is the outcome but, in many cases, the data appear as *preferred ranges* and are subject to personal interpretation. Therefore, caution is advised.

It is the purpose of this chapter to document some of the more prominent methods used for the analysis of refinery feedstocks and the methods used for determining the potential for instability and incompatibility by examining the potential for instability and incompatibility of petroleum feedstocks and petroleum products. The choice of the method is subject to the composition and properties of the feedstock and process parameters as well as desired product. No preference will be shown, and none will be given to any individual methods. Also, it is the choice of the individual experimentalist to choose the method on the basis of the type of feedstock, the immediate needs, and the projected utilization of the data.

5.2 INSTABILITY AND INCOMPATIBILITY

Instability/incompatibility in crude oil refineries affects the operation of crude oil pre-distillation heat exchanger trains. Although feedstock instability/incompatibility has been the subject of study for decades, there is a lack of fundamental understanding of the chemical transformations leading to instability/incompatibility. The premise (and reality) is that analysis of foulant deposits may provide a key to understanding organic and inorganic instability/incompatibility in these heat exchangers.

Instability/incompatibility is a complex phenomenon which follows different mechanisms involving factors such as crude oil character (type, composition), crude blending, temperature, fluid velocity, and deposit properties (Young et al., 2009). In order to understand crude oil behavior leading to instability/incompatibility, there is a need to investigate crude oil characterization as well as crude oil blending to determine compatibility or incompatibility of the constituents of the blends which will lead to a better understanding of the mechanism of instability/incompatibility as well as potential methods of instability/incompatibility mitigation.

It is worthy of note here, that opportunity crude oils (Chapter 1) and the blends with other crude oils play an important role in increasing the refinery but the risks are high because they are usually laden with contaminants such as destabilized asphaltene constituents and high metals content. These contaminants can cause stable oil–water emulsion problems, heat exchanger fouling and coking in furnace tubes, leading to high maintenance costs and equipment losses. Furthermore, incompatible crude oil blends can result in the flocculation and deposition of asphaltene constituents as a preliminary step in the formation of (unwanted) coke.

In fact, opportunity crude oils have attracted the attention of oil companies looking to increase their gross refinery margin and although blends of various crude oils are often used in refining processes, this practice has several constraints in terms of logistics, such as the non-availability of sufficient numbers of storage tanks and vessels. It also has some unwanted consequences in terms of fouling in the preheat trains and heat exchangers, and coking in the pipe still furnace tubes. These problems may be caused by the precipitation of asphaltene constituents, oxidative polymerization, and the components of coke formation in the oil. Salts, sediment, and corrosion products can arise from the impurities. The problems associated with the flocculation and deposition of asphaltene constituents can further increase the cost of oil recovery processes. Therefore, a detailed knowledge of the factors that affect the composition and physico-chemical structure of crude oils is necessary.

In general, instability/incompatibility mechanisms are classified into five categories: (i) reaction instability/incompatibility, which can occur in reactors during crude oil processing, (ii) particulate instability/incompatibility, which is caused by the presence of particulate matter such as inorganic materials in crude oil, (iii) corrosion instability/incompatibility, which is caused by the presence of corroded metal flakes in crude oil, (iv) crystallization instability/incompatibility, which is typical of the presence of wax constituents in crude oil, and (v) biological instability/incompatibility, which is caused by the accumulation of microorganisms, plants, and algae on surfaces. Furthermore, while instability/incompatibility can be conveniently divided into the above five categories, in practice instability/incompatibility may be much more complicated and caused by interaction of two or more of these mechanisms.

Feedstock composition (which is even more complex with the use of feedstock blends for transportation, storage, and in the refinery) is the most common option studied to determine the instability/incompatibility potential of a feedstock (Gary et al., 2007; Speight, 2014). Evaluation of crude oil and the means by which products are evaluated is the object of a series of standard test methods to determine feedstock complexity leading to an estimation of the potential for instability/incompatibility (Speight, 2015). Feedstock and product composition becomes even more important when feedstocks (particularly different types of crude oils) or products are blended or are allowed to remain in storage (prior to use) and a distinct phase separates from the bulk liquid (Batts and Fathoni, 1991; Por, 1992; Mushrush and Speight, 1995; Speight, 2014).

Thus, feedstock constituents cause instability/incompatibility when they are *incompatible* resulting in the formation of sludge or sediment. If the sludge or sediment is marginally soluble in a blended feedstock mix, there is the possibility that the sludge/sediment can be separated by filtration or by extraction (ASTM D4310) – in the refinery, *guard reactors* are commonly used to remove any such solid matter from the feedstock before entry into the *reactor proper* (Speight, 2014). In addition, the sludge/sediment constituents typically increase the viscosity of the feedstock (ASTM D2532). The viscosity change might be due to separation of paraffins (wax deposition) as might occur when paraffin-based feedstocks are allowed to cool or are in a low-temperature environment.

It is generally recognized and accepted that the crude oil and heavy oil systems (which have been extended to include extra-heavy oil and tar sand bitumen) are a colloid-type system comprising fractions of saturates, aromatics, resin constituents, and asphaltene constituents (Speight, 1994, 2014a). The asphaltene constituents are stabilized by the resin constituents but the asphaltene constituents can be naturally or artificially precipitated if the molecular association with the resin constituents is disturbed.

As a result, deposition of the asphaltene constituents can occur in different parts of the crude oil system including (i) the reservoir, (ii) the well tubing, and (iii) the surface flowlines. The deposition

depends on the changes in flow conditions, pressure, temperature, and oil composition. Such occurrences will decrease well productivity and reservoir productivity and correction requires frequent chemical treatments for the removal of the asphaltene constituents. Destabilization (i.e., flocculation) of the asphaltene constituents depends on breaking up the balance of attraction forces between the associated resin molecule constituents and the asphaltene constituents (Koots and Speight, 1975; Branco et al., 2001; Stark and Asomaning, 2003; Speight, 2014a).

Thus, feedstocks and feedstock constituents are *incompatible* when sludge, semi-solid, or solid particles (for convenience here, these are termed *secondary products* to distinguish them from the actual crude oil product) are formed during and after blending. This phenomenon usually occurs prior to use. If the secondary products are marginally soluble in the blended crude oil product, use might detract from solubility of the secondary products and they will appear as sludge or sediment that can be separated by filtration or by extraction (ASTM D4310). When the secondary products are truly insoluble, they separate and settle out as a semi-solid or solid phase floating in the fuel or are deposited on the walls and floors of containers. In addition, secondary products usually increase the viscosity of the crude oil product. Standing at low temperatures will also cause a viscosity change in certain fuels and lubricants (ASTM D2532). Usually, the viscosity change might be due to separation of paraffins as might occur when diesel fuel and similar, engines are allowed to cool and stand unused overnight in low-temperature climates.

In attempts to define and understand the nature of instability/incompatibility by asphaltene constituents, many models for asphaltene deposition but very few if any consider the complexity of the asphaltene fraction preferring instead to use *average parameters*; therefore, frequent reference to model needing *fine tuning*. Furthermore, the effect or resins in the feedstock have been largely ignored in such models and there has been a general failure of the model proponents to recognize that the resin constituents also play a major role in crude oil chemistry and physic insofar as the resin constituents stabilize (peptize, disperse) the asphaltene constituents (Koots and Speight, 1975; Hammami and Freworn, 1998; Carnahan et al., 1999; Hammami et al., 2000; Gawrys et al., 2003).

In fact, the complexity and variation in the properties of subfractions of the resin fraction and the asphaltene fraction (Chapter 4) detract from the concept of any form of meaningful average structure for these fractions. Thus, the mechanism of instability/incompatibility by these constituents is a multi-path approach where each constituent (chemical-type) must be considered on the basis of individual chemistry and chemical properties.

However, instability/incompatibility is not only a refinery phenomenon but it can be manifested at the wellhead when the crude oil is prepared for shipping along with the hydrocarbon gases. The presence of these gases, which are soluble in the crude oil, causes a disturbance of the crude oil system that can result in irreversible flocculation of asphaltene constituents which can severely reduce the permeability of the reservoir, cause formation damage, and can also plug up the wellbore and tubing. This phenomenon is largely ascribed to the different extents of compressibility of the low-boiling feedstock constituents and the higher-boiling constituents (resin and asphaltene constituents) of the under-saturated crude. In fact, the relative volume fraction of the lower-boiling constituents within the liquid phase increases as the pressure of the under-saturated reservoir fluid approaches its bubble point. Thus, any factor such as changes in pressure, temperature, or composition that disrupt this adsorption equilibrium and precipitation can cause asphaltene separation and deposition. Precipitation and deposition may occur during primary production, during the displacement of reservoir oil by carbon dioxide, hydrocarbon gas or water, and gas application (Khanifar et al., 2011).

In the modern refinery where the refinery feedstock slate often is composed of several crude oils that are introduced into the refinery as a blend, the instability/incompatibility of crude oil (and of crude oil products) is manifested in the formation of sludge, sediment, and general darkening in color of the liquid (ASTM D1500). Sludge (or sediment) formation takes one of the following forms: (i) material dissolved in the liquid, (ii) precipitated material, and (iii) material emulsified in the liquid. Under favorable conditions, sludge or sediment will dissolve in the crude oil or product with the potential of increasing the viscosity. Sludge or sediment, which is not soluble in the crude

oil (ASTM D96, ASTM D473, ASTM D1796, ASTM D2273, ASTM D4007, ASTM D4807, ASTM D4870), may either settle at the bottom of the storage tanks or remain in the crude oil as an emulsion. In most of the cases, the smaller part of the sludge/sediment will settle satisfactorily, the larger part will stay in the crude oil as emulsions. In any case, there is a need of breaking the emulsion, whether it is a water-in-oil emulsion or whether it is the sludge itself, which has to be separated into the oily phase and the aqueous phase. The oily phase can be then processed with the crude oil and the aqueous phase can be drained out of the system.

Phase separation can be accomplished by either the use of suitable surface active agents allowing for sufficient settling time, or by use of a high voltage electric field for breaking such emulsions after admixing water at a rate of about 5% and at a temperature of about 100°C (212°F).

Emulsion breaking, whether the emulsion is due to crude oil–sludge emulsions, crude oil–water emulsions, or breaking the sludge themselves into organic (oily) and inorganic components are of a major importance from operational as well as commercial aspects. With some heavy fuel oil products and heavy crude oils phase separation, difficulties often arise (Por, 1992; Mushrush and Speight, 1995). Also, some crude oil emulsions may be stabilized by naturally occurring substances in the crude oil. Many of these polar particles accumulate at the oil–water interface, with the polar groups directed toward the water and the hydrocarbon groups toward the oil. A stable interfacial skin may be so formed; particles of clay or similar impurities, as well as wax crystals present in the oil may be embedded in this skin and make the emulsion very difficult to break (Schramm, 1992).

Chemical and electrical methods for sludge removal and for water removal, often combined with chemical additives, have to be used for breaking such emulsions. Each emulsion has its own structure and characteristics: water-in-oil emulsions, where the oil is the major component, or oil-in-water emulsions, where the water is the major component. The chemical and physical nature of the components of the emulsion plays a major role in their susceptibility to the various surface-active agents used for breaking them.

Therefore, appropriate emulsion breaking agents have to be chosen very carefully, usually with the help of previous laboratory evaluations. Water- or oil-soluble demulsifiers, the latter being often non-ionic surface-active alkylene oxide adducts, are used for this purpose. But, as had been said in the foregoing, the most suitable demulsifier has to be chosen for each case from a large number of such substances in the market, by a prior laboratory evaluation.

5.3 FACTORS INFLUENCING INSTABILITY AND INCOMPATIBILITY

There have been a series of paper studies and attempts to predict incompatibility. While these studies may serve a limited purpose, they are not always accurate. It is a more productive and accurate route to use a series of test methods that can shed light on the following: (i) which crude in a blend are compatible/incompatible with the other crude oils in the blend? (ii) at what ratio of the crude oils in the blend does incompatibility manifest itself? (iii) is there an induction period before incompatibility occurs? and (iv) is there temperature range in which incompatibility occurs?

On the other hand, multiple methods exist for measuring the specific properties of refinery feedstocks – most refiners utilize standard methods according to internationally accepted measurement techniques. However, the refiner must decide on the method that is utilized in their facility or use methods that are dictated by crude oil properties and by product specifications.

The standard test methods (ASTM, 2019) applied to an investigation of the properties of and feedstock are presented in the form of a feedstock assay (*crude oil assay, crude assay*), which provides a summary of its properties for the various boiling point cuts that exist in the feedstock, in addition to the quantity of each boiling point fraction. The assay provides information that can be used to decide the crude slate and product slate for a refinery. The information can also be used to estimate the properties of blended feedstock based on the properties of each crude oil in the blend. However, this does not take into account any interactions between the components of blend, and the assay is a *snapshot in time* because of the potential for crude oil properties from a reservoir to vary

with the age of the reservoir. Thus, the validation of any feedstock assay and the actual properties compared to assumed or predicted properties are critical components of the feedstock selection process – the assumption that a specific company (i.e., crude oil) of a blend will have a fixed and reproducible set of properties is erroneous.

Furthermore, the ability of any analytical laboratory to accurately measure a property is strongly influenced by the following factors: (i) sampling and a thorough mixing of the feedstock to overcome any tendency to undergo stratification during storage, (ii) sample preparation and handling, (iii) availability and accuracy of the measurement equipment, and (iv) adherence to a necessary analytical procedure (Speight, 2014a, 2015).

Briefly, stratification can occur in a blend when the components of the blend vary considerable in density, with the higher density component tending to settle to the bottom of the storage tank.

Following these guidelines should allow refinery personnel to make critical decisions based on accurate measurements of properties of feedstocks. In addition, any given method will have a level of repeatability and reproducibility (Speight, 2015). Therefore, when the results of laboratory testing are reported for a specific property, it is preferable that the users of the data recognize that the property is reported within the context of the repeatability and reproducibility levels.

The methods presented below are the most common methods used for the analysis of feedstocks as a means of determining the potential for instability/incompatibility of a feedstock blend. However, one test method producing one set of data is unlikely to provide the compete answer to the suitability of the crude oil for refining. The data from several test methods must be used in conjunction to determine whether or not the crude oil is suitable for the proposed refining sequence.

5.3.1 ACIDITY

The acidity of crude oil or crude oil products is usually measured in terms of the *acid number* which is defined as the number of milli-equivalents per gram of alkali required to neutralize the acidity of the crude oil sample (ASTM D664, ASTM D974, ASTM D3242).

Acidity due to the presence of inorganic constituents is not expected to be present in crude oils, but organic acidity might be found. Acidic character is composed of contributions from strong organic acids and other organic acids. Typically, the total acidity of crude oils is in the range of 0.1–0.5 mg potassium hydroxide per gram, although higher values are not exceptional. Values above 0.15 mg potassium hydroxide per gram are considered to be significantly high. Crude oils of higher acidity may exhibit a tendency of instability. The acid imparting agents in crude oils are naphthenic acids and hydrosulfides (thiols, mercaptans, R–SH). Acidity can also form by bacterial action insofar as some species of aerobic bacteria can produce organic acids from organic nutrients. On the other hand, anaerobic sulfate-reducing bacteria can generate hydrogen sulfide, which, in turn, can be converted to sulfuric acid (by bacterial action).

The term naphthenic acid has roots in the somewhat archaic term "naphthene" (cycloaliphatic but non-aromatic) used to classify hydrocarbons. It was originally used to describe the complex mixture of crude oil-based acid derivatives when the analytical methods available in the early 1900s could identify only a few naphthene-type components with accuracy. Currently, the term naphthenic acid is used in a more generic sense to refer to all of the carboxylic acids present in petroleum, whether cyclic, acyclic, or aromatic compounds, and carboxylic acids containing heteroatoms such as N and S. The naphthenic acid fraction is a mixture of several cyclopentyl and cyclohexyl carboxylic acids with molecular weight of on the order of 120–700.

Example of a cyclopentyl component of the naphthenic acid fraction

The main constituents of the fraction are carboxylic acids with a carbon backbone of 9–20 carbons, although acids containing up to 50 carbon atoms have been identified in heavy crude oil (Qian and Robbins, 2001). Although commercial naphthenic acids often contain a majority of cycloaliphatic acids, multiple studies have shown they also contain straight chain and branched aliphatic acids and aromatic acids; some naphthenic acids contain >50% combined aliphatic and aromatic acids (Clemente and Fedorak, 2005; Qian and Robbins, 2001). Naphthenic acids are represented by a general formula $C_nH_{2n-z}O_2$, where n indicates the carbon number and z specifies a homologous series. The z is equal to 0 for saturated, acyclic acids and increases to 2 in monocyclic naphthenic acids, to 4 in bicyclic naphthenic acids, to 6 in tricyclic acids, and to 8 in tetracyclic acids.

Free hydrogen sulfide is often present in crude oils, a concentration of up to 10 ppm being acceptable in spite of its toxic nature. However, higher hydrogen sulfide concentrations are sometimes present, 20 ppm posing serious safety hazards. Additional amounts of hydrogen sulfide can form during the crude oil processing, when hydrogen reacts with some organic sulfur compounds converting them to hydrogen sulfide. In this case, it is referred to as potential hydrogen sulfide, contrary to free hydrogen sulfide.

Naphthenates are the salts of naphthenic acids, analogous to the corresponding acetates, which are better defined and have the formula M(naphthenate)$_2$ or are basic oxide derivatives with the formula M$_3$O(naphthenate)$_6$. The naphthenate derivatives are highly soluble in organic media. Industrially useful naphthenates include those of aluminum, magnesium, calcium, barium, cobalt, copper, lead, manganese, nickel, vanadium, and zinc (Clemente and Fedorak, 2005).

5.3.2 ASPHALTENE CONTENT

The asphaltene fraction (Figure 5.1) is a dark brown to black friable solids that have no definite melting point and usually intumesce on heating with decomposition to leave a carbonaceous residue. The fraction is obtained from crude oil by the addition of a non-polar solvent (such as a liquid hydrocarbon) (Chapter 4). Liquids used for this purpose are *n*-pentane and *n*-heptane (Table 5.3) (Speight, 2014a). Usually, the asphaltene fraction is removed by filtration through paper but more recently, a membrane method has come into use (ASTM D4055). Liquid propane is used commercially in processing crude oil residua (Parkash, 2003; Gary et al., 2007; Speight, 2014a; Hsu and Robinson, 2017; Speight, 2017) – the asphaltene constituents are soluble in liquids such as benzene, toluene, pyridine, carbon disulfide, and carbon tetrachloride.

Asphaltene constituents are best known for the problems they cause as solid deposits that obstruct flow in the petroleum production systems as well as the formation of coke during processing. A better understanding of the effect of asphaltene constituents and resin constituents is key to preventing the formation of deposits during production and refining and mitigating the deleterious effects of these feedstock constituents (Speight, 1994, 2014a,b, 2015, 2017). In addition, the resin constituents of petroleum will also be considered – for the purposes of this chapter, the resin constituents are

TABLE 5.3

Standard Methods for Asphaltene Precipitation

Method	Precipitant	Volume Precipitant per gram of Sample (ml)
ASTM D893	*n*-pentane	10
ASTM D2006	*n*-pentane	50
ASTM D2007	*n*-pentane	10
ASTM D3279	*n*-heptane	100
ASTM D4124	*n*-heptane	100

Source: ASTM Annual Book of Standards, 1980–2019.

regarded as those materials soluble in *n*-pentane or *n*-heptane (i.e., whichever hydrocarbon is used for the separation of asphaltene constituents) but insoluble in liquid propane.

In terms of composition, it is generally recognized that crude oil and heavy feedstocks are composed of four major fractions (saturate constituents, aromatic constituents, resin constituents, and asphaltene constituents) (Figure 5.1) that differ from one another sufficiently in solubility and adsorptive character that the separation can be achieved by application of relevant methods (Speight, 2014a, 2015). Indeed, although these four fractions are chemically complex, the methods of separation have undergone several modifications to such an extent that the evolution of the separation techniques is a study in itself (Speight, 2014a, 2015). And because the fractions are in a balanced relationship in crude oil, the chemical and physical character of these constituents needs reference in this chapter.

Thus, the asphaltene fraction is particularly important because as the proportion of this fraction increases, there is (i) concomitant increase in thermal coke yield and (ii) an increase in hydrogen demand as well as catalyst deactivation. The constituents of the asphaltene fraction to form coke quite readily which is of particular interest in terms of the compatibility/incompatibility of the coke precursors (Speight, 1994b).

The effect of the asphaltene constituents and the micelle structure, the state of dispersion also merit some attention. The degree of dispersion of asphaltene constituents is higher in the more naphthenic/aromatic crude oils because of the higher solvency of naphthene constituents and aromatic constituents over paraffin constituents. This phenomenon also acts in favor of the dissolution of any sludge that may form thereby tending to decrease sludge deposition. However, an increase in crude oil often accompanies sludge dissolution.

The higher the asphaltene content of a feedstock, the greater the tendency of the feedstock to form a separate phase, especially when blended with other non-compatible stocks.

The resin constituents are closely related to the asphaltene constituents and for the purposes of this text, the term *resin* generally implies material that has been eluted from various solid adsorbents (Koots and Speight, 1975; Speight, 2014, 2015). Thus, after the asphaltene constituents are precipitated, adsorbents are added to the *n*-pentane or *n*-heptane solutions of the resin constituents and oils, by which process the resin constituents are adsorbed and subsequently recovered by the use of a more polar solvent and the oils remain in solution. The term *maltenes* (sometimes called *petrolenes*) indicates a mixture of the resin constituents and oil constituents obtained in the filtrates from the asphaltene precipitation (Speight, 2014a,b, 2015, 2017).

5.3.3 Density/Specific Gravity

In the earlier years of the crude oil industry, density and specific gravity (with the American Petroleum Institute (API) gravity) were the principal specifications for feedstocks and refinery products. They were used to give an estimate of the most desirable product, i.e., kerosene, in crude oil. At the present time, a series of standard tests exist for determining density and specific gravity (Parkash, 2003; Gary et al., 2007; Speight, 2014a, 2015; Hsu and Robinson, 2017; Speight, 2017).

There is no direct relation between the density and specific gravity of crude oils to their sludge-forming tendencies, but crude oil having a higher density (thus, a lower API gravity) is generally more susceptible to sludge formation, presumably because of the higher content of the polar/asphaltic constituents.

5.3.4 Elemental Composition

The ultimate analysis (elemental composition) of crude oil and its products is not reported to the same extent as for coal (Speight, 2013). Nevertheless, there are ASTM procedures (ASTM, 2012) for the ultimate analysis of crude oil and crude oil products but many such methods may have been designed for other materials (Speight, 2015).

Of the data that are available, the proportions of the elements in crude oil vary only slightly over narrow limits: carbon 83.0% w/w–87.0% w/w, hydrogen 10.0% w/w–14.0% w/w, nitrogen 0.10% w/w–2.0% w/w, oxygen 0.05% w/w–1.5% w/w, sulfur 0.05% w/w–6.0% w/w (Speight, 2014a, 2015). And yet, there is a wide variation in physical properties from the lighter more mobile crude oils at one extreme to the extra-heavy crude oil and tar sand bitumen at the other extreme (Chapter 1). In terms of the instability and incompatibility of crude oil and crude oil products, the heteroatom content appears to represent the greatest influence. In fact, it is not only the sulfur and nitrogen content of crude oil are important parameters in respect of the processing methods which have to be used in order to produce fuels of specification sulfur concentrations but also the type of sulfur and nitrogen species in the oil. There could well be a relation between nitrogen and sulfur content and crude oil (or product) stability; higher nitrogen and sulfur crude oils are suspect of the higher sludge forming tendencies.

In general, the reaction sequence for sediment formation can be envisaged as being dependent upon the most reactive of the various heteroatomic species that are present in fuels. The worst-case scenario would consist of a high olefin fuel with both high indole concentration and a catalytic trace of sulfonic acid species. This reaction matrix would lead to rapid degradation. However, just as there is no *one* specific distillate product, there is also no *one* mechanism of degradation. In fact, the mechanism and the functional groups involved will give a general but not specific mode of incompatibility. The key reaction in many incompatibility processes is the generation of the hydroperoxide species from dissolved oxygen. Once the hydroperoxide concentration starts to increase, macromolecular incompatibility precursors form in the fuel. Acid or base catalyzed condensation reactions then rapidly increase both the polarity, incorporation of heteroatoms, and the molecular weight.

When various feedstocks are blended at the refinery, incompatibility can be explained by the onset of acid-base catalyzed condensation reactions of the various organo-nitrogen compounds in the individual blending stocks. These are usually very rapid reactions with practically no observed induction time period.

5.3.5 Metals Content

The majority of crude oils contain metallic constituents that are often determined as combustion ash (ASTM D482). This is particularly so for the heavier feedstocks. These constituents, of which nickel and vanadium are the principal metals, are very influential in regard to feedstock behavior in processing operations.

The metal (inorganic) constituents of crude oil or a liquid fuel arise from either the inorganic constituents present in the crude oil originally or those picked up by the crude oil during storage. The former are mostly metallic substances such as vanadium, nickel, sodium, iron, silica, etc.; the latter may be contaminants such as sand, dust, and corrosion products.

Incompatibility, leading to deposition of the metals (in any form) on to the catalyst leads to catalyst deactivation whether it is by physical blockage of the pores or destruction of reactive sites. In the present context, the metals must first be removed if erroneously high carbon residue data are to be avoided. Alternatively, they can be estimated as ash by complete burning of the coke after carbon residue determination.

Metals content above 200 ppm are considered to be significant, but the variations are very large. The higher the ash content the higher is the tendency of the crude oil to form sludge or sediment.

5.3.6 Pour Point

The *pour point* defines the cold properties of crude oils and crude oil products, i.e., the minimal temperature at which they still retain their fluidity (ASTM D97). Therefore, pour point also indicates the characteristics of crude oils: the higher the pour point, the more paraffinic is the oil and vice versa. Higher pour point crude oils are waxy, and therefore, they tend to form wax-like materials that enhance sludge formation.

To determine the *pour point* (ASTM D97, ASTM D5327, ASTM D5853, ASTM D5949, ASTM D5950, ASTM D5985, IP 15, IP 219, IP 441), the sample is contained in a glass test tube fitted with a thermometer and immersed in one of three baths containing coolants. The sample is dehydrated and filtered at a temperature 25°C (45°F) higher than the above the anticipated cloud point. It is then placed in a test tube and cooled progressively in coolants held at −1°C to +2°C (30°F to 35°F), −18°C to −20°C (−4°F to 0°F), and −32°C to −35°C (−26°F to −31°F), respectively. The sample is inspected for cloudiness at temperature intervals of 1°C (2°F). If conditions or oil properties are such that reduced temperatures are required to determine the pour point, alternate tests are available that accommodate the various types of samples.

5.3.7 VISCOSITY

The viscosity of a feedstock varies with the origin and type of the crude oil and also with the character of the chemical constituents, particularly the polar functions where intermolecular interactions can occur. For example, there is a gradation of viscosity between conventional crude oil, heavy oil, and bitumen (Speight, 2014a, 2015). Viscosity is a measure of fluidity properties and consistency at specific temperatures. Heavier crude oil, i.e., crude oil having lower API gravity, typically has higher viscosity. Increases of viscosity during storage indicate either an evaporation of volatile components or formation of degradation products dissolving in the crude oil.

5.3.8 VOLATILITY

Crude oil can be subdivided by distillation into a variety of fractions of different *boiling ranges* or *cut points* (Speight, 2014a, 2015). In fact distillation was, and still is, the method for feedstock evaluation for various refinery options. Indeed, volatility is one of the major tests for crude oil products, and it is inevitable that the majority of all products will, at some stage of their history, be tested for volatility characteristics (Speight, 2014a, 2015).

The very nature of the distillation process by which residua are produced (Parkash, 2003; Gary et al., 2007; Speight, 2014a; Hsu and Robinson, 2017; Speight, 2017), i.e., removal of distillate without thermal decomposition, dictates that the majority of the heteroatoms which are predominantly in the higher-molecular-weight fractions, will be concentrated in the higher-boiling products and the residuum. Thus, the inherent nature of the crude oil and the means by which it is refined can seriously influence the stability and incompatibility of the products (Mushrush and Speight, 1995; Speight, 2014a, 2017). In fact, whether in a blend or not, the more viscous feedstocks tend to form more sludge during storage compared to light crude oils.

5.3.9 WATER CONTENT, SALT CONTENT, AND BOTTOM SEDIMENT/WATER (BS&W)

Water content (ASTM D4006, ASTM D4007, ASTM D4377, ASTM D4928), salt content (ASTM D3230), and bottom sediment/water (ASTM D96, ASTM D1796, ASTM D4007) indicate the concentrations of aqueous contaminants, present in the crude either originally or picked up by the crude during handling and storage. Water and salt content of crude oils produced in the field can be very high, forming sometimes its major part. The salty water is usually separated at the field, usually by settling and draining, surface-active agents electrical emulsion breakers (desalters) are sometimes employed. The water and salt contents of crude oil supplied to the buyers is function of the production field. Water content below 0.5%, salt content up to 20 pounds per 1,000 barrels, and bottom sediment and water up to 0.5% are considered to be satisfactory.

Although the centrifuge methods are still employed (ASTM D96, ASTM D1796, ASTM D2709 and ASTM D4007), many laboratories prefer the Dean and Stark adaptor (ASTM D95). The apparatus consists of a round-bottom flask of capacity 50 ml connected to a Liebig condenser by a receiving tube of capacity 25 ml, graduated in 0.1 ml. A weighed amount, corresponding to approximately

100 ml of oil, is placed in the flask with 25 ml of dry toluene. The flask is heated gently until the 25 ml of toluene have distilled into the graduated tube. The water distilled with the toluene, separates to the bottom of the tube where the volume is recorded as ml, or the weight as mg, or per cent.

The Karl Fischer titration method (ASTM D1744), the Karl Fischer titration method (ASTM D377), and the colorimetric Karl Fischer titration method (ASTM D4298) still find wide application in many laboratories for the determination of water in liquid fuels, specifically the water content of aviation fuels.

The higher the bottom sediment and water content, the higher sludge and deposit formation rates can be expected in the stored crude oil.

In summary, the asphaltene constituents (and the resin constituents) can cause major problems in refineries through phase separation of insoluble products and through unanticipated coke formation. The thermal decomposition of these constituents has received some attention with the objective of examining the products and the potential of these products to form coke (Speight, 2014a,b, 2017). The data contradicted earlier theories that coke formation was predominantly polymerization reaction and, in fact, the initial stages of coke formation involved the separation of lower-molecular-weight insoluble products from which coke was produced by further reaction of these products. There is an induction period before coke begins to form that seems to be triggered by phase separation of reacted asphaltene. The phase separation is likely triggered by changes in the molecular structure of the resin constituents or changes in the molecular structure of the asphaltene constituents or both and the products are isolated as insoluble carbene or carboids (Figure 5.1). In addition, the organic nitrogen originally in the resin and asphaltene constituents invariably undergoes thermal reaction to concentrate in the nonvolatile coke and is considered likely that carbon–carbon bonds or carbon–hydrogen in a heterocyclic nitrogen ring system may be susceptible to thermal decomposition as initial events in the thermal decomposition process (Chapter 3). When denuded of the attendant hydrocarbon moieties, the nitrogen heterocyclic systems and various polynuclear aromatic systems are undoubtedly insoluble (or non-dispersible) in the surrounding hydrocarbon medium. The next step is gradual carbonization of these entities to form coke (thermal instability/incompatibility).

5.4 DETERMINING INSTABILITY AND INCOMPATIBILITY

Instability/incompatibility of feedstocks in crude oil refineries affects the operation of crude oil pre-distillation heat exchanger trains. Although feedstock instability and incompatibility have been the subject of study for decades, there is a lack of fundamental understanding of the chemical transformations leading to instability and incompatibility. The premise (and reality) is that analysis of deposits (sludge, sediment) arising from instability and incompatibility that will provide a key to understanding instability and incompatibility.

In summary (from the previous section), the instability/incompatibility of crude oil products is a precursor to either the formation of degradation products or the occurrence of undesirable changes in the properties of the fuel. Individually, the components of a product may be stable and in compliance with specifications, but their blend may exhibit poor stability properties, making them unfit for use.

Stability/instability and compatibility/incompatibility can be estimated using several tests (Table 5.4) (Schermer et al., 2004; Speight, 2014a,b; Mendoza de la Cruz et al., 2015; Ben Mahmoud and Aboujadeed, 2017). One test, or property, that is somewhat abstract in its application but which is becoming more meaningful popular is the *solubility parameter* (Speight, 2014a, 2015), which allows estimations to be made of the ability of liquids to become miscible on the basis of miscibility of model compound types where the solubility parameter can be measured or calculated. Although the solubility parameter is often difficult to define when complex mixtures are involved, there has been some progress. For example, crude oil fractions have been assigned a similar solubility parameter to that of the solvent used in the separation. Whichever method is the best estimate may be immaterial as long as the data are used to the most appropriate benefit and allow some measure of predictability.

TABLE 5.4
**Standard Test Methods Suitable for the Estimation of Stability/
Instability and Compatibility/Incompatibility in Feedstocks**

Type	Test Methods
Asphaltene content	ASTM D3729
Color	ASTM D1500
Compatibility spot tests	ASTM D2781, ASTM D4740
Optical detection	ASTM D7112
Sludge formation	ASTM D4870
Thermal stability	ASTM D873, ASTM D3241
Viscosity increase	ASTM D445

Bottle tests constitute the predominant test method and the test conditions have varied in volume, type of glass or metal, vented and unvented containers, type of bottle closure. Other procedures have involved stirred reactor vessels under both air pressure or under oxygen pressure, and small volumes of fuel employing a cover slip for solid deposition (ASTM D4625). All of these procedures are gravimetric in nature.

There are several *accelerated fuel stability tests* that can be represented as a time–temperature matrix (Goetzinger et al., 1983; Hazlett, 1992). A graphical representation shows that the majority of the stability tests depicted fall close to the solid line, which represents a doubling of test time for each 10°C (18°F) change in temperature. The line extrapolates to approximately 1 year of storage under ambient conditions. Temperatures at 100°C (212°F) or higher present special chemical problems.

The heteroatom content of the deposits formed in stability studies varied as the source or type of dopant and fuel liquid source varied. This would be an anticipated result. The color changes of both the fuel and the deposits formed are more difficult to interpret.

It is also worthy of note that *fractionation* of crude oil and its products may also give some indication of instability. There are many schemes by which crude oil and related materials might be fractionated (Speight, 2014a, 2015) and although it is not the intent to repeat the details of these in this chapter, a brief overview is necessary since fractional composition can play a role in stability and incompatibility phenomena.

Crude oil can be fractionated into four broad fractions by a variety of techniques although the most common procedure involves precipitation of the asphaltene fraction and the use of adsorbents to fractionate the deasphalted (deasphaltened) oil. The fractions are named for convenience and the assumption that fractionation occurs by specific compound type is not quite true.

In general terms, studies of the composition of the incompatible materials often involve determination of the distribution of the organic functional groups by *selective fractionation* that is analogous to the deasphalting procedure and subsequent fractionation of the maltene (non-asphaltene) constituents: (i) heptane-soluble materials: often called maltenes or petrolenes in crude oil work, (ii) heptane-insoluble material, benzene- (or toluene) soluble material, often referred to as the asphaltene fraction, (iii) toluene-insoluble material, often referred to as carbenes (pyridine soluble constituents) and carboids (pyridine insoluble constituents) when the material under investigation is a thermal product.

Carbon disulfide and tetrahydrofuran have been used in place of pyridine. The former (carbon disulfide), although having an obnoxious odor and therefore not much different from pyridine, is easier to remove because of the higher volatility. The latter (tetrahydrofuran) is not as well established in crude oil science as it is in the coal-liquid-related research. Thus, it is more than likely that the crude oil researcher will use carbon disulfide or, pyridine, or some suitable alternate solvent. It may also be necessary to substitute cyclohexane as an additional step for treatment of the heptane-insoluble

materials prior to treatment with benzene (or toluene). The use of quinoline has been suggested in place of pyridine but this solvent presents issues associated with its high boiling point.

Whichever solvent separation scheme is employed, there should be ample description of the procedure so that the work can be repeated not only in the same laboratory by a different researcher but also in different laboratories by various researchers. Thus, for any particular feedstock and solvent separation scheme, the work should repeatable and reproducible within the limits of experimental error.

Fractionation procedures allow a before-and-after inspection of any feedstock or product and can give an indication of the means by which refining or use changes the composition of the feedstock. In addition, fractionation also allows studies to be made of the interrelations between the various fractions. For example, the most interesting phenomenon (in the present context) to evolve from the fractionation studies is the relationship between the asphaltene constituents and the resin constituents.

In crude oil, the asphaltene constituents and the resin constituents have strong interactions to the extent that the asphaltene constituents are immiscible (insoluble/incompatible) with the remaining constituents in the absence of the resins (Koots and Speight, 1975; Speight, 1994, 2014a). And there appears to be points of structural similarity between the asphaltene constituents and the resin constituents of a feedstock, thereby setting the stage for *a more-than-is-generally-appreciated* complex relationship but confirming the hypothesis that crude oil is a continuum of chemical species, including the asphaltene constituents (Speight, 1994, 2014a).

This sets the stage for the incompatibility of the asphaltene constituents in any operation in which the asphaltene or resin constituents are physically or chemically altered. Disturbance of the asphaltene–resin relationships can be the stimulation by which, for example, some or all of the asphaltene constituents form a separate *insoluble* phase leading to such phenomena as coke formation (in thermal processes) or asphalt instability during use.

There is a series of characterization indices that also present indications of whether or not a crude oil product is stable or unstable. For example, the *characterization factor* indicates the chemical character of the crude oil and has been used to indicate whether crude oil was paraffinic in nature or whether it was a naphthenic/aromatic crude oil.

The *characterization factor* (sometimes referred to as the *Watson characterization factor*) is a relationship between boiling point and specific gravity:

$$K = T_b^{1/3} / d$$

T_b is the cubic average boiling point, degrees Rankine (°F+460) and d is the specific gravity at 15.6°C (60°F).

The characterization factor was originally devised to illustrate the characteristics of various feedstocks. Highly paraffinic oils have K = 12.5–13.0 while naphthenic oils have K = 10.5–12.5. In addition, if the characterization factor is above 12, the liquid fuel or product might, because of its paraffinic nature, be expected to form waxy deposits during storage.

The *viscosity–gravity constant* (*vgc*) was one of the early indices proposed to classify crude oil on the basis of composition. It is particularly valuable for indicating a predominantly paraffinic or naphthenic composition. The constant is based on the differences between the density and specific gravity for the various hydrocarbon species:

$$vgc = \left[10d - 1.0752\log(v - 380)\right] / \left[10 - \log(v - 38)\right]$$

Where d is the specific gravity and v is the Saybolt viscosity at 38°C (100°F). For viscous crude oils (and viscous products) where the viscosity is difficult to measure at low temperature, the viscosity at 991°C (2,101°F) can be used:

$$vgc = \left[d - 0.24 - 0.022\log(v - 35.5)\right] / 0.755$$

In both cases, the lower the index number is indicative of a more paraffinic sample. For example, a paraffinic sample may have a vgc on the order of 0.840 while the corresponding naphthenic sample may have an index on the order of 0.876.

The obvious disadvantage is the closeness of the indices, almost analogous to comparing crude oil character by specific gravity only where most crude oils fall into the range d=0.800–1.000. The API gravity expanded this scale from 5 to 60 thereby adding more meaning to the use of specific gravity data.

In a similar manner, the *correlation index* which is based on a plot of the specific gravity (d) versus the reciprocal of the boiling point (K) in °K (°K=degrees Kelvin=°C+273) for pure hydrocarbons adds another dimension to the numbers:

$$\text{Correlation Index (CI)} = 473.7d - 456.8 + 48640 / K$$

In the case of a crude oil fraction, K is the average boiling point determined by the standard distillation method.

The line described by the constants of the individual members of the normal paraffin series is given a value of CI=0 and a parallel line passing through the point for benzene is given a value of CI=100. Values between 0 and 15 indicate a predominance of paraffinic hydrocarbons in the sample and values from 15 to 20 indicate predominance either of naphthenes or of mixtures of paraffins/naphthenes/aromatics; an index value above 50 indicates a predominance of aromatics in the fraction.

REFERENCES

Abraham, H. 1945. *Asphalts and Allied Substances*, 5th Edition. Van Nostrand Inc., New York, Volume I, Page 1.

ASTM. 2019. *Annual Book of Standards*. ASTM International, West Conshohocken, PA.

Batts, B.D., and Fathoni, A.Z. 1991. A Literature Review on Fuel Stability Studies with Particular Emphasis on Diesel Oil. *Energy Fuels* 5: 2–21.

Ben Mahmoud, M.A.M., and Aboujadeed, A. 2017. Compatibility Assessment of Crude Oil Blends Using Different Methods. *Chem. Eng. Trans.* 57: 1705–1710.

Branco, V.A.M., Mansoori, G.A., De Almeida Xavier, L.C., Park, S.J., and Manafi, H. 2001. Asphaltene Flocculation and Collapse from Petroleum Fluids. *J. Pet. Sci. Eng.* 32: 217–230.

Carnahan, N.J., Salager, R., and Davila, A. 1999. Properties of Resins Extracted from Boscan Crude Oil and their Effect on the Stability of Asphaltene Constituents in Boscan and Hamaca Crude Oils. *Energy Fuels* 13: 309.

Clemente, J.S., and Fedorak, P.M. 2005. A Review of the Occurrence, Analyses, Toxicity, and Biodegradation of Naphthenic Acids. *Chemosphere* 60(5): 585–600.

Forbes, R.J. 1958a. *A History of Technology*. Oxford University Press, Oxford, United Kingdom, Volume V, Page 102.

Forbes, R.J. 1958b. *Studies in Early Petroleum Chemistry*. E. J. Brill, Leiden, Netherlands.

Forbes, R.J. 1959. *More Studies in Early Petroleum Chemistry*. E.J. Brill, Leiden, Netherlands.

Gary, J.G., Handwerk, G.E., and Kaiser, M.J. 2007. *Petroleum Refining: Technology and Economics*, 5th Edition. CRC Press, Taylor & Francis Group, Boca Raton, FL.

Gawrys, K., Spiecker, L., Matthew, P., and Kilpatrick, P.K. 2003. The Role of Asphaltene Solubility and Chemical Composition on Asphaltene Aggregation. *Pet. Sci. Technol.* 21(3,4): 461–489.

Goetzinger, J.W., Thompson, C.J., and Brinkman, D.W. 1983. A Review of Storage Stability Characteristics of Hydrocarbon Fuels. US Department of Energy, Report No. DOE/BETC/IC–83–3.

Hammami, A., and Freworn, K.A. 1998. Asphaltic Crude Oil Characterization: An Experimental Investigation of the Effect of Resins on the Stability of Asphaltene Constituents. *Pet. Sci. Technol.* 16(3,4): 227–249.

Hammami, A., Phelps, H., and Little, T.M. 2000. Asphaltene Precipitation from Live Oils: An Experimental Investigation of the Onset Conditions and Reversibility. *Energy Fuels* 14: 14–18.

Hardy, D.R., and Wechter, M.A. 1990. Insoluble Sediment Formation in Middle-Distillate Diesel Fuel: The Role of Soluble Macromolecular Oxidatively Reactive Species. *Energy Fuels* 4: 270–274.

Hazlett, R.N. 1992. *Thermal Oxidation Stability of Aviation Turbine Fuels. Monograph No. 1.* American Society for Testing and Materials, Philadelphia, PA.

Hsu, C.S., and Robinson, P.R. (Editors). 2017. *Handbook of Petroleum Technology.* Springer International Publishing AG, Cham, Switzerland.

James, P., and Thorpe, N. 1994. *Ancient Inventions.* Ballantine Books, New York.

Khanifar, A., Demiral, B., and Darman, N. 2011. Modeling of Asphaltene Precipitation and Deposition during WAG Application. Proceedings. *International Petroleum Technology Conference.* Bangkok, Thailand, November 15–17. *International Petroleum Technology Conference (IPTC),* Richardson, TX.

Koots, J.A., and Speight, J.G. 1975. The Relation of Petroleum Resins to Asphaltenes. *Fuel* 54: 179.

Magaril, R.Z., and Akensova, E.I. 1967. Mechanism of Coke Formation during the Cracking of Petroleum Tars. *Izvestia Vyssh. Ucheb. Zaved. Neft. Gaz.* 10(11): 134–136.

Magaril, R.Z., and Akensova, E.I. 1968. Study of the Mechanism of Coke Formation in the Cracking of Petroleum Resins. *Int. Chem. Eng.* 8(4): 727–729.

Magaril, R.Z., and Aksenova, E.I. 1970a. Mechanism of Coke Formation in the Thermal Decompositon of Asphaltenes. *Khim. Tekhnol. Topl. Masel.* 15(7): 22–24.

Magaril, R.Z., and Aksenova, E.I. 1970b. Kinetics and Mechanism of Coking Asphaltenes. *Khim. Izvestia Vyssh. Ucheb. Zaved. Neft. Gaz.* 13(5): 47–53.

Magaril, R.Z., and Aksenova, E.I. 1972. Coking Kinetics and Mechanism of Asphaltenes. *Khim. Kim Tekhnol. Tr. Tyumen Ind. Inst.* 169–172.

Magaril, R.Z., and Ramazaeva, L.F. 1969. Study of Carbon Formation in the Thermal Decomposition of Asphaltenes in Solution. *Izvestia Vyssh. Ucheb. Zaved. Neft. Gaz.* 12(1): 61–64.

Magaril, R.Z., Ramazaeva, L.F., and Aksenova, E.I. 1970. Kinetics of Coke Formation in the Thermal Processing of Petroleum. *Khim. Tekhnol. Topl. Masel.* 15(3): 15–16.

Magaril, R.Z., Ramazaeva, L.F., and Aksenova, E.I. 1971. Kinetics of the Formation of Coke in the Thermal Processing of Crude Oil. *Int. Chem. Eng.* 11(2): 250–251.

Mendoza de la Cruz, J.L., Cedillo-Ramirez, J.C., Aguirre-Gutiérrez, A. de J., Garcia-Sánchez, F., and Aquino-Olivos, M.A. 2015. Incompatibility Determination of Crude Oil Blends from Experimental Viscosity and Density Data. *Energy Fuels* 29(2): 480–487.

Mushrush, G.W., and Speight, J.G. 1995. *Petroleum Products: Instability and Incompatibility.* Taylor & Francis Publishers, Washington, DC.

Parkash, S. 2003. *Refining Processes Handbook.* Gulf Professional Publishing, Elsevier, Amsterdam, Netherlands.

Por, N. 1992. *Stability Properties of Petroleum Products.* Israel Institute of Petroleum and Energy, Tel Aviv, Israel.

Power, A.J., and Mathys, G.I. 1992. Characterization of Distillate Fuel Sediment Molecules: Functional Group Derivatization. *Fuel* 71: 903–908.

Qian, K., and Robbins, W.K. 2001. Resolution and Identification of Elemental Compositions for More Than 3000 Crude Acids in Heavy Petroleum by Negative-Ion Micro-Electrospray High-Field Fourier Transform Ion Cyclotron Resonance Mass Spectrometry. *Energy Fuels* 15: 1505–1511.

Schermer, W.E.M., Melein, P.M.J., and Van Den Berg, F.G.A. 2004. Simple Techniques for Evaluation of Crude Oil Compatibility. *Pet. Sci. Technol.* 22(7): 1045–1054.

Schramm, L.L. (Editor). 1992. *Emulsions: Fundamentals and Applications in the Petroleum Industry.* Advances in Chemistry Series No. 231. American Chemical Society, Washington, DC.

Speight, J.G. 1994. Chemical and Physical Studies of Petroleum Asphaltenes. Volume 40. *Asphaltenes and Asphalts. I. Developments in Petroleum Science.* T.F. Yen and G.V. Chilingarian (Editors). Elsevier, Amsterdam, Netherlands, Chapter 2.

Speight, J.G. 2013. *The Chemistry and Technology of Coal,* 3rd Edition. CRC Press, Taylor & Francis Group, Boca Raton, FL.

Speight, J.G. 2014a. *The Chemistry and Technology of Petroleum,* 5th Edition. CRC Press, Taylor & Francis Group, Boca Raton, FL.

Speight, J.G. 2014b. *Oil and Gas Corrosion Prevention.* Gulf Professional Publishing Company, Elsevier, Oxford, United Kingdom.

Speight, J.G. 2015. *Handbook of Petroleum Product Analysis,* 2nd Edition. John Wiley & Sons Inc., Hoboken, NJ.

Speight, J.G. 2017. *Handbook of Petroleum Refining.* CRC Press, Taylor & Francis Group, Boca Raton, FL.

Stark, J.L., and Asomaning, S. 2003. Crude Oil Blending Effects on Asphaltene Stability in Refinery Fouling. *Pet. Sci. Technol.* 21(3–4): 569–579.

Stavinoha, L.L., and Henry, C.P. (Editors). 1981. *Distillate Fuel Stability and Cleanliness.* Special Technical Publication No. 751. American Society for Testing and Materials, Philadelphia, PA.

6 Introduction to Refining Processes

6.1 INTRODUCTION

Refinery operations commence with investigating the feedstock blend – in terms of the individual components of the blend and potential of these components, or the individual constituents of the components – to interact with each other – as well as the range of products that will be produced by the various processes. In the unrefined states, each component of the feedstock blend (even the blend itself) has minimal value, but when refined, it provides high-value liquid fuels, solvents, lubricants, and many other products (Parkash, 2003; Gary et al., 2007; Speight, 2011a,b, 2014; Hsu and Robinson, 2017; Speight, 2017). The fuels derived from feedstocks contribute approximately one-third to one-half of the total world energy supply and are used not only for transportation fuels (i.e., gasoline, diesel fuel, and aviation fuel, among others) but also to heat buildings. The products have a wide variety of uses that vary from gaseous and liquid fuels to near-solid machinery lubricants. In addition, the residue of many refinery processes, asphalt – a once-maligned by-product – is now a premium value product for highway surfaces, roofing materials, and miscellaneous waterproofing uses.

Briefly, refining is the separation of the feedstock into fractions and the subsequent treating of these fractions to yield marketable products (Parkash, 2003; Gary et al., 2007; Speight, 2014; Hsu and Robinson, 2017; Speight, 2017). In fact, a refinery is essentially a group of manufacturing plants, which vary in number with the variety of products produced (Figure 6.1). Refinery processes must be selected and products manufactured to give a balanced operation in which the feedstock is converted into a variety of products in amounts that are in accord with the demand for each.

For example, the manufacture of products from the lower-boiling portion of the feedstock automatically produces a certain amount of higher-boiling components. If the latter cannot be sold as, say, heavy fuel oil, these products will accumulate until refinery storage facilities are full. To prevent the occurrence of such a situation, the refinery must be flexible and be able to change operations as needed. This usually means more processes: thermal processes to change an excess of heavy fuel oil into more gasoline with coke as the residual product, or a vacuum distillation process to separate the heavy oil into lubricating oil blend stocks and the residuum. However, refining as it is currently practiced is a very recent science and many innovations evolved during the 20th century when the mode of refining was selected on the basis of the feedstock properties.

As the basic elements of the feedstock, carbon and hydrogen form the main input into a refinery, combining into thousands of individual constituents and the economic recovery of these constituents varies with (i) the individual feedstock and its components, (ii) the particular qualities of each component of the blend, and (iii) the processing facilities of a particular refinery. In general refinery, the feedstock, once refined, yields three basic groupings of products that are produced when it is broken down into cuts or fractions (Parkash, 2003; Gary et al., 2007; Speight, 2011a,b, 2014; Hsu and Robinson, 2017; Speight, 2017). The gas and naphtha fractions form the lower-boiling products and are usually more valuable than the higher-boiling fractions and provide gas (liquefied petroleum gas), naphtha, aviation fuel, motor fuel as well as feedstocks for the petrochemical industry (Speight, 2019a). Naphtha, a precursor to gasoline and solvents, is produced from the light and middle range of distillate cuts (sometimes referred to collectively as light gas oil) and is also used as a feedstock for the petrochemical industry (Speight, 2014, 2019a).

The term *middle distillates* refers to products from the middle boiling range of the feedstock and include kerosene, diesel fuel, distillate fuel oil, and light (low-boiling) gas oil. Waxy distillate

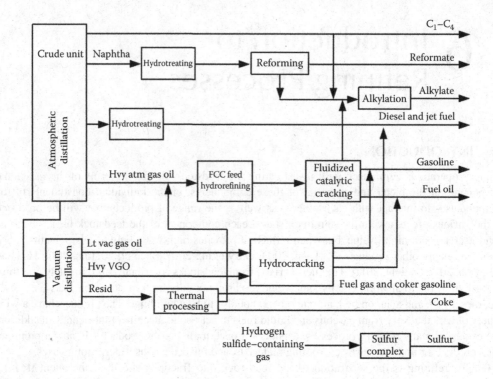

FIGURE 6.1 Schematic overview of a refinery.

and lower-boiling lubricating oils are sometimes included in the middle distillates. The remainder of the products includes the higher-boiling lubricating oils, gas oil, and residuum (the nonvolatile fraction of the feedstock). The residuum can also produce high-boiling lubricating oil and wax but is more often sued for asphalt production. The complexity of each refinery feedstock is emphasized insofar as the actual proportions of low-boiling, middle distillates, and high-boiling fractions vary significantly from one feedstock blend to another.

The refining industry has been the subject of the four major forces that affect most industries and which have hastened the development of new refining processes: (i) the demand for products such as gasoline, diesel, fuel oil, and jet fuel, (ii) feedstock supply, specifically the changing quality of the components of the feedstock and geopolitics between different countries and the emergence of alternate feed supplies such as bitumen from tar sand, natural gas, and coal, (iii) environmental regulations that include more stringent regulations in relation to sulfur in gasoline and diesel, and (iv) technology development such as new catalysts and processes.

In the early days of the 20th century, refining processes were developed to extract kerosene for lamps. Any other products were considered to be unusable and were usually discarded. Thus, first refining processes were developed to purify, stabilize, and improve the quality of kerosene. However, the invention of the internal combustion engine led (at approximately the time of World War I) to a demand for gasoline for use in increasing quantities as a motor fuel for cars and trucks. This demand on the lower-boiling products increased, particularly when the market for aviation fuel developed. Thereafter, refining methods had to be constantly adapted and improved to meet the quality requirements and needs of car and aircraft engines. Since then, the general trend throughout refining has been to produce more products from each barrel of feedstock oil and to process those products in different ways to meet the product specifications for use in modern engines. Overall, the demand for gasoline has rapidly expanded and demand has also developed for gas oils and fuels for domestic central heating, and fuel oil for power generation, as well as for light distillates and other inputs, derived from the refinery feedstock, for the petrochemical industries (Speight, 2019a).

As the need for the lower-boiling products developed, refinery feedstocks that were typically conventional crude oil which yield the desired quantities of the lower-boiling products became less available and refineries had to introduce conversion processes to produce greater quantities of lighter products from the higher-boiling fractions. The means by which a refinery operates in terms of producing the relevant products, depends not only on the nature of the feedstock but also on its configuration (i.e., the number and the types of the processes that are employed to produce the desired product slate) and the refinery configuration is, therefore, influenced by the specific demands of a market. Therefore, refineries need to be constantly adapted and upgraded to remain viable and responsive to ever-changing patterns of crude supply and product market demands. As a result, refineries have been introducing increasingly complex and expensive processes to gain higher yields of lower-boiling products from the higher-boiling fractions and residua.

With the evolution of the 21st century, and in spite of the availability of good quality crude oil from tight (low-to-no permeability) formations (Chapter 1), refining technology continued to experience great innovation driven by the increasing supply of viscous feedstocks of decreasing quality (such as heavy oil, extra-heavy oil, and tar sand bitumen) and the fast increases in demand for clean and ultraclean vehicle fuels and petrochemical raw materials. This is continuing the movement from conventional methods of refining viscous feedstocks using (typically) coking technologies to more innovative processes (including hydrogen management) that will produce optimal amounts of liquid fuels from the feedstock and maintain emissions within environmental compliance (Davis and Patel, 2004; Speight, 2011b).

In addition, the general trend throughout refining has been to produce more products from each barrel of the feedstock and to process those products in different ways to meet the product specifications required for sale to the domestic and industrial consumers. Overall, the demand for gasoline and diesel fuel has rapidly expanded and demand has also developed for gas oils and fuels for domestic central heating, and fuel oil for power generation, as well as for low-boiling distillates and other inputs, derived from refinery feedstocks, for the petrochemical industries.

Thus, upgrading the viscous feedstocks has become a major economic incentive and the feedstocks such as heavy oil, extra-heavy oil, and tar sand bitumen exist in large quantities throughout the world but are difficult to produce and transport because of their high viscosity (Hedrick et al., 2006; Castañeda et al., 2014; Villasana et al., 2015). Some refinery feedstocks contain compounds such as sulfur and/or heavy metals causing additional refining problems and costs. In situ upgrading could be a very beneficial process for leaving the unwanted elements in the reservoir and increasing API gravity.

As the need for the lower-boiling products developed, refinery feedstocks that could produce the desired quantities of the lower-boiling products became less available and refineries had to introduce conversion processes to produce greater quantities of lower-boiling products from the higher-boiling fractions. The means by which a refinery operates in terms of producing the relevant products depends not only on the nature of the refinery feedstock but also on its configuration (i.e., the number of types processes that are employed to produce the desired product slate), and the refinery configuration is, therefore, influenced by the specific demands of a market. Therefore, refineries need to be constantly adapted and upgraded to remain viable and responsive to ever-changing patterns of crude supply and product market demands. As a result, refineries have been introducing increasingly complex and expensive processes to gain higher yields of lower-boiling products from the viscous feedstocks.

Changes in the characteristics of the conventional refinery feedstock can be specified and will trigger changes in refinery configurations and corresponding investments. In the future, crude slate is expected to consist of higher proportions of both heavier (more viscous) feedstocks, sour (high-sulfur) feedstocks, and extra-light feedstocks such as natural gas liquids (NGLs). There will also be a shift toward viscous feedstocks such as Californian heavy oil, Venezuelan extra-heavy oil, and Athabasca tar sand bitumen. These changes will require investment in upgrading either at field level to process tar sand bitumen or oil shale into synthetic crude at the refinery level (Speight, 2011a).

In the not too distant past, end even now, the mature and well-established processes such as visbreaking, delayed coking, fluid coking, flexicoking, propane deasphalting, and butane deasphalting were deemed adequate for upgrading viscous feedstocks. Moreover, more options are now being sought in order to increase process efficiency in terms of the yields of the desired products. Currently, there are four ways of bringing viscous feedstocks to market (Hedrick et al., 2006).

Partial upgrading is, in the context of this book, any combination of processing steps applied to heavy oil, extra have oil, or tar sand bitumen that prepares the oil to meet the specifications for pipeline transport or the next steps in conversion of the oil to products (Hart, 2014). For example, the approaches used for reducing the viscosity of a heavy crude include heating, blending with a light crude and with kerosene, and forming oil-in-water emulsions. Heating has a dramatic effect on the heavy crude viscosity but does not always achieve a practical level; consequently, blending the heavy crude with either light crude or kerosene requires substantial amounts of the diluent and raises the potential for instability of the blend or incompatibility of the blend components (Chapter 5).

To convert a feedstock into the desired products in an economically feasible and environmentally acceptable manner. Refinery processes for a feedstock are generally divided into three categories: (i) separation processes, of which distillation is the prime example, (ii) conversion processes, of which coking and catalytic cracking are prime examples, and (iii) finishing processes, of which hydrotreating to remove sulfur is a prime example.

Since a refinery is a group of integrated manufacturing plants (Figure 6.1) which are selected to give a balanced production of saleable products in amounts that are in accord with the demand for each, it is necessary to prevent the accumulation of non-saleable products, the refinery must be flexible and be able to change operations as needed (Parkash, 2003; Gary et al., 2007; Speight, 2014; Hsu and Robinson, 2017; Speight, 2017). The complexity of each component of a feedstock blend is emphasized insofar as the actual amounts of the products vary significantly from one feedstock component to another (Speight, 2014, 2016, 2017). In addition, the configuration of refineries may vary from refinery to refinery. For example, some refineries may be more oriented toward the production of naphtha (large reforming and/or catalytic cracking) leading to the production of gasoline whereas the configuration of other refineries may be more oriented toward the production of middle distillates such as jet fuel and gas oil.

The previous chapters have focused on the properties of the refinery feedstock and the suitability of the feedstock for refining into various products. While the chemical constitution and physical properties of the feedstocks are important parameters that guide the section of the processing configurations, the refining processes must be selected according to the properties of the feedstock remembering that a blended feedstock will, more than likely contain not only one or more of the conventional crude oils but also one or more of the viscous oils.

This chapter presents an introduction to refinery processes in order for the reader to place each process in the correct context of the refinery when feedstock blends containing viscous feedstock components are the refinery feedstocks. However, not all possible refinery processes are included, and the chapter focuses on those processes that are applicable to viscous feedstocks such as (i) distillation, (ii) thermal processes, (iii) catalytic processes, and (iv) hydroprocesses. Other processes such as reforming processes, isomerization processes, alkylation processes, polymerization processes, and dewaxing processes are not included here since they fall under the general umbrella of finishing processes insofar as and are typically applied to the products from the initial stages of refinery operations (Parkash, 2003; Gary et al., 2007; Speight, 2014; Hsu and Robinson, 2017; Speight, 2017).

6.2 REFINERY CONFIGURATION

In the early-to-middle of the 20th century, refineries were originally designed and operated to operate within a narrow range of feedstock properties and to produce a relatively fixed slate of products. Since the 1970s, refiners had to increase their flexibility in order to adapt to a more volatile environment. Several possible paths may be used by refiners to increase their flexibility within existing

refineries. Examples of these paths are changed in the severity of operating rules of some process units by varying the range of inputs used, thus achieving a slight change in output. Alternatively refiners can install new processes, and this alternate scenario offers the greatest flexibility but is limited by the constraint of strict complementarily of the new units with the rest of the existing plant and involves a higher risk than the previous ones. It is not surprising that many refiners decide to modify existing processes.

As examples of refinery configuration, the following are presented here: (i) the topping refinery and hydroskimming refinery and (ii) the conversion refinery. Each type of refinery has its own distinctive character and process train.

6.2.1 Topping Refinery and Hydroskimming Refinery

The simplest refinery configuration is the *topping refinery* which is designed to prepare feedstocks for petrochemical manufacture or for production of industrial fuels in remote oil-production areas (Speight, 2014, 2017). The topping refinery consists of tankage, a distillation unit, recovery facilities for gases and low-boiling hydrocarbon derivatives, and the necessary utility systems (steam, power, and water-treatment plants) (Table 6.1).

A topping refinery (sometimes referred to as a modular mini refinery) is best utilized in emerging economies and in remote locations where naphtha and kerosene are needed. The local crude oil is typically the lowest cost feedstock because the transportation costs are minimized. A topping refinery with a viscous heavy crude and low API gravity will produce more fuel oil and less naphtha and kerosene. On the other hand, a crude oil with a high API gravity will produce more low-boiling distillates in the form of naphtha and kerosene and less fuel. Additionally, the sulfur content of the refinery feedstock determines refinery cost being as low sulfur crudes may not require hydrotreaters.

Thus, a topping refinery will produce substantial quantities of unfinished products and is highly dependent on local markets, but the addition of hydrotreating and reforming units to this basic configuration results in a more flexible hydroskimming refinery which can also produce desulfurized distillate fuels and high-octane gasoline. These refineries may produce up to half of their output as

TABLE 6.1
General Description of Refinery Types

Refinery Type	Processes	Other Name	Complexity	Complexity
Topping	Distillation	Skimming	Low	1
Hydroskimming	Distillation	Hydroskimming	Moderate	3
	Reforming			
	Hydrotreating			
Conversion	Distillation	Cracking	High	6
	Fluid catalytic cracking			
	Hydrocracking			
	Reforming			
	Alkylation			
	Hydrotreating			
Deep conversion	Distillation	Coking	Very high	10
	Coking			
	Fluid catalytic cracking			
	Hydrocracking			
	Reforming			
	Alkylation			
	Hydrotreating			

residual fuel oil, and they face increasing market loss as the demand for low-sulfur (even no-sulfur) high-sulfur fuel oil increases.

A hydroskimming refinery is a refinery equipped with an atmospheric distillation unit, a naphtha reforming unit, as well as the necessary treating processes. A hydroskimming refinery is therefore more complex than a *topping refinery*, which just separates the crude into its constituent petroleum products by atmospheric distillation and produces naphtha. However, a hydroskimming refinery produces a surplus of fuel with a relatively unattractive price and demand.

It is unlikely that a topping refinery would be used with feedstock blends that contain viscous feedstocks. The refinery would merely undo what the blending operation has achieved. However, the ability to switch between light feedstocks and viscous feedstocks means that one crude may require a larger naphtha hydrotreater, a larger naphtha reformer, and a larger kerosene hydrotreater whereas the other may not.

6.2.2 CONVERSION REFINERY

The most versatile refinery configuration is known as the *conversion refinery*, of which the refinery based on coking technology and the refinery based on catalytic cracking are examples (Speight, 2014, 2017). In this context, the term *conversion* is the difference in amount of unconverted oil between the feedstock and in the product(s) divided by the amount of unconverted oil in the feedstock.

Most refineries therefore add vacuum distillation and catalytic cracking, which adds one more level of complexity by reducing fuel oil by conversion to low-boiling distillates and middle distillates. A coking refinery adds further complexity to the cracking refinery by high conversion of fuel oil into distillates and petroleum coke. Thus, a conversion refinery incorporates all the basic units found in both the topping and hydroskimming refineries, but it also features gas oil conversion plants such as catalytic cracking and hydrocracking units, olefin conversion plants such as alkylation or polymerization units, and, frequently, coking units for sharply reducing or eliminating the production of residual fuels.

A modern conversion refinery may produce two-thirds of the product output as unleaded gasoline, with the balance distributed between liquefied petroleum gas, jet fuel, diesel fuel, and a small quantity of coke. Many such refineries also incorporate solvent extraction processes for manufacturing lubricants and petrochemical units with which to recover propylene, benzene, toluene, and xylenes for further processing into polymers.

Finally, the yields and quality of refined products produced by any particular refinery depend on the mixture of components used in the feedstock blend as well as the configuration of the refinery facilities. Light/sweet (low-sulfur) crude oil is generally more expensive and has inherent great yields of higher-value low-boiling products such naphtha, kerosene, and low-boiling gas oil. Viscous sour (high-sulfur) feedstocks are generally less expensive and produce higher yields of lower-value higher-boiling products (such as vacuum gas oil and residua) that must be converted into lower saleable boiling products (Speight, 2013a, 2014a).

6.3 DISTILLATION

In the early stages of refinery development, when illuminating and lubricating oils were the main products, distillation was the major, and often only, refinery process. At that time, gasoline was a minor product but, as the demand for gasoline increased, conversion processes were developed, because distillation could no longer supply the necessary quantities.

It is possible to obtain products ranging from gaseous materials taken off at the top of the distillation column to a nonvolatile residue or reduced crude (*bottoms*), with correspondingly lighter materials at intermediate points. The reduced crude may then be processed by vacuum, or steam, distillation in order to separate the high-boiling lubricating oil fractions without the danger of decomposition, which occurs at high (>350°C, >660°F) temperatures. Atmospheric distillation may

be terminated with a lower-boiling fraction (*cut*) if it is felt that vacuum or steam distillation will yield a better-quality product, or if the process appears to be economically more favorable. Not all crude oils yield the same distillation products – although there may be variations by several degrees in the boiling ranges of the fractions as specified by different companies) – and the nature of the crude oil dictates the processes that may be required for refining (Parkash, 2003; Gary et al., 2007; Speight, 2011a,b, 2014; Hsu and Robinson, 2017; Speight, 2017).

Distillation was the first method by which crude oil was refined. The original technique involved a batch operation in which the still was a cast-iron vessel mounted on brickwork over a fire and the volatile materials were passed through a pipe or gooseneck which led from the top of the still to a condenser. The latter was a coil of pipe (*worm*) immersed in a tank of running water.

Heating a batch of crude oil caused the more volatile, lower-boiling components to vaporize and then condense in the worm to form naphtha. As the distillation progressed, the higher-boiling components became vaporized and were condensed to produce kerosene: the major crude oil product of the time. When all of the possible kerosene had been obtained, the material remaining in the still was discarded. The still was then refilled with crude oil and the operation repeated.

The capacity of the stills at that time was usually several barrels of crude oil and if often required three or more days to distill (*run*) a batch of crude oil. The simple distillation as practiced in the 1860s and 1870s was notoriously inefficient. The kerosene was more often than not contaminated by naphtha, which distilled during the early stages, or by heavy oil, which distilled from the residue during the final stages of the process. The naphtha generally rendered the kerosene so flammable explosions accompanied that ignition. On the other hand, the presence of heavier oil adversely affected the excellent burning properties of the kerosene and created a great deal of smoke. This condition could be corrected by redistilling (*rerunning*) the kerosene, during which process the more volatile fraction (*front-end*) was recovered as additional naphtha, while the kerosene residue (*tail*) remaining in the still was discarded.

The 1880s saw the introduction of the continuous distillation of crude oil. The method employed a number of stills coupled together in a row, and each still was heated separately and was hotter than the preceding one. The stills were arranged so that oil flowed by gravity from the first to the last. Crude oil in the first still was heated so that a light naphtha fraction distilled from it before the crude oil flowed into the second still, where a higher temperature caused the distillation of a heavier naphtha fraction. The residue then flowed to the third still where an even higher temperature caused kerosene to distill. The oil thus progressed through the battery to the last still, where destructive distillation (thermal decomposition; cracking) was carried out to produce more kerosene. The residue from the last still was removed continuously for processing into lubricating oils or for use as fuel oil.

In the early 1900s, a method of partial (or selective) condensation was developed to allow a more exact separation of crude oil fractions. A partial condenser was inserted between the still and the conventional water-cooled condenser. The lower section of the tower was packed with stones and insulated with brick so that the heavier less volatile material entering the tower condensed and drained back into the still. Non-condensed material passed into another section where more of the less volatile material was condensed on air-cooled tubes and the condensate was withdrawn as a crude oil fraction. The non-condensable (overhead) material from the air-cooled section entered a second tower that also contained air-cooled tubes and often produced a second fraction. The volatile material remaining at this stage was then condensed in a water-cooled condenser to yield a third fraction. The van Dyke tower is essentially one of the first stages in a series of improvements which ultimately led to the distillation units found in modern refineries, which separate crude oil fractions by fractional distillation.

6.3.1 Distillation at Atmospheric Pressure

The present-day crude oil distillation unit is, like the battery of the 1800s, a collection of distillation units but, in contrast to the early battery units, a tower is used in the typical modern refinery and brings about a fairly efficient degree of fractionation (separation) (Parkash, 2003; Gary et al., 2007; Speight, 2014; Hsu and Robinson, 2017; Speight, 2017).

The feed to a distillation tower is heated by flow through pipes arranged within a large furnace. The heating unit is known as a pipe still heater or pipe still furnace, and the heating unit and the fractional distillation tower make up the essential parts of a distillation unit or pipe still. The pipe still furnace heats the feed to a predetermined temperature – usually a temperature at which a predetermined portion of the feed will change into vapor. The vapor is held under pressure in the pipe in the furnace until it discharges as a foaming stream into the fractional distillation tower. The unvaporized or liquid portion of the feed descends to the bottom of the tower to be pumped away as a bottom nonvolatile product, while the vaporized material passes up the tower to be fractionated into gas oils, kerosene, and naphtha.

Pipe still furnaces vary greatly and, in contrast to the early units where capacity was usually 200–500 bbl per day, can accommodate 25,000 bbl, or more of crude oil per day. The walls and ceiling are insulated with firebrick and the interior of the furnace is partially divided into two sections: a smaller convection section where the oil first enters the furnace and a larger section (fitted with heaters) where the oil reaches its highest temperature.

Another 20th-century innovation in distillation is the use of heat exchangers which are also used to preheat the feed to the furnace. These exchangers are bundles of tubes arranged within a shell so that a feedstock passes through the tubes in the opposite direction to a heated feedstock passing through the shell. By this means, cold crude oil is passed through a series of heat exchangers where hot products from the distillation tower are cooled, before entering the furnace and as a heated feedstock. This results in a saving of heater fuel and is a major factor in the economical operation of modern distillation units.

All of the primary fractions from a distillation unit are equilibrium mixtures and contain some of the lower-boiling constituents that are characteristic of a lower-boiling fraction. The primary fractions are *stripped* of these constituents (*stabilized*) before storage or further processing.

6.3.2 Distillation under Reduced Pressure

Distillation under reduced pressure (vacuum distillation) as applied to the crude oil refining industry is truly a technique of the 20th century and has since wide use in crude oil refining. Vacuum distillation evolved because of the need to separate the less volatile products, such as lubricating oils, from the crude oil without subjecting these high-boiling products to cracking conditions. The boiling point of the heaviest cut obtainable at atmospheric pressure is limited by the temperature (ca. 350°C; ca. 660°F) at which the residue starts to decompose (*crack*). When the feedstock is required for the manufacture of lubricating oils, further fractionation without cracking is desirable and this can be achieved by distillation under vacuum conditions.

Operating conditions for vacuum distillation are typically on the order of 50–100mm of mercury (atmospheric pressure=760mm of mercury) (Parkash, 2003; Gary et al., 2007; Speight, 2014; Hsu and Robinson, 2017; Speight, 2017). In order to minimize large fluctuations in pressure in the vacuum tower, the units are necessarily of a larger diameter than the atmospheric units. Some vacuum distillation units have diameters on the order of 45 feet (14m). By this means, a heavy gas oil may be obtained as an overhead product at temperatures of approximately 150°C (300°F), and lubricating oil cuts may be obtained at temperatures of 250°C–350°C (480°F–660°F), feed and residue temperatures being kept below the temperature of 350°C (660°F), above which cracking will occur. The partial pressure of the hydrocarbon derivatives is effectively reduced still further by the injection of steam. The steam added to the column, principally for the stripping of asphalt in the base of the column, is superheated in the convection section of the heater.

The fractions obtained by vacuum distillation of the reduced crude (atmospheric residuum) from an atmospheric distillation unit depend on whether or not the unit is designed to produce lubricating or vacuum gas oils. In the former case, the fractions include (i) heavy gas oil, which is an overhead product and is used as catalytic cracking stock or, after suitable treatment, a light lubricating oil, (ii) lubricating oil (usually three fractions – light, intermediate, and heavy), which is obtained as a side-stream

product, and (iii) asphalt (or residuum), which is the bottom product and may be used directly as, or to produce, asphalt and which may also be blended with gas oils to produce a heavy fuel oil.

In the early refineries, distillation was the prime means by which products were separated from crude oil. As the technologies for refining evolved into the 21st century, refineries became much more complex (Figure 6.1) but distillation remained the prime means by which crude oil is refined. Indeed, the distillation section of a modern refinery is the most flexible section in the refinery since conditions can be adjusted to process a wide range of refinery feedstocks from the lighter crude oils to the heavier more viscous crude oils (Parkash, 2003; Gary et al., 2007; Speight, 2014; Hsu and Robinson, 2017; Speight, 2017). However, the maximum permissible temperature (in the vaporizing furnace or heater) to which the feedstock can be subjected is 350°C (660°F). Thermal decomposition occurs above this temperature which, if it occurs within a distillation unit, can lead to coke deposition in the heater pipes or in the tower itself with the resulting failure of the unit. The contained use of atmospheric and vacuum distillation has been a major part of refinery operations during this century and no doubt will continue to be employed throughout the remainder of the century as the primary refining operation.

Difficult-to-refine feedstocks, such as heavy crude oil, extra-heavy crude oil, and tar sand bitumen are characterized by low API gravity (high density) and high viscosity, high initial boiling point, high carbon residue, high nitrogen content, high sulfur content, and high metals content (Parkash, 2003; Gary et al., 2007; Speight, 2014; Hsu and Robinson, 2017). In addition to these properties, the heavy feedstocks also have an increased molecular weight and reduced hydrogen content with a relatively low content of volatile saturated and aromatic constituents and a relatively high content of asphaltene and resin constituents that is accompanied by a high heteroatom (nitrogen, oxygen, sulfur, and metals) content. Thus, such feedstocks are not typically subject to distillation unless contained in the refinery feedstock as a blend with other crude oils.

Nevertheless, there has been a move of late to apply vacuum distillation to tar sand bitumen to isolate the vacuum gas oil fraction from the bitumen that can then be guided, through process judicious selection, to produce a good yield of the desirable naphtha and kerosene products.

6.4 THERMAL PROCESSES

Cracking was used commercially in the production of oils from coal and shales before the crude oil industry began, and the discovery that the heavier products could be decomposed to lighter oils was used to increase the production of kerosene and was called cracking distillation.

The precise origins of cracking distillation are unknown. It is rumored that, in 1861, the attending stillman had to leave his charge for a longer time than he intended (the reason is not known) during which time the still overheated. When he returned he noticed that the distillate in the collector was much more volatile than anticipated at that particular stage of the distillation. Further investigation leads to the development of cracking distillation (i.e., thermal degradation with the simultaneous production of distillate).

Cracking distillation (thermal decomposition with simultaneous removal of distillate) was recognized as a means of producing the valuable lighter product (kerosene) from heavier nonvolatile materials. In the early days of the process (1870–1900), the technique was very simple – a batch of crude oil was heated until most of the kerosene had been distilled from it and the overhead material had become dark in color. At this point, distillation was discontinued and the heavy oils were held in the hot zone, during which time some of the high-molecular-weight components were decomposed to produce lower-molecular-weight products. After a suitable time, distillation was continued to yield light oil (kerosene) instead of the heavy oil that would otherwise have been produced.

The yields of kerosene products were usually markedly increased by means of cracking distillation but the technique was not suitable for gasoline production. As the need for gasoline arose in the early 1900s, the necessity of prolonging the cracking process became apparent and a process known as pressure cracking evolved.

Pressure cracking was a batch operation in which, as an example, gas oil (200 bbl) was heated to approximately 425°C (800°F) in stills that had been reinforced to operate at pressures as high as 95 psi. The gas oil was held under maximum pressure for 24 hours, while fires maintained the temperature. Distillation was then started and during the next 48 hours to produce a lighter distillate (100 bbl) which contained the gasoline components. This distillate was treated with sulfuric acid to remove unstable gum-forming components and then redistilled to produce a cracked gasoline boiling range.

The large-scale production of cracked gasoline was first developed by Burton in 1912. The process employed batch distillation in horizontal shell stills and operated at approximately 400°C (ca. 750°F) and 75–95 psi. It was the first successful method of converting heavier oils into gasoline. Nevertheless, heating a bulk volume of oil was soon considered cumbersome, and during the years 1914–1922, a number of successful continuous cracking processes were developed. By these processes, gas oil was continuously pumped through a unit that heated the gas oil to the required temperature, held it for a time under pressure, and then discharged the cracked material into distillation equipment where it was separated into gases, gasoline, gas oil, and tar.

The tube-and-tank cracking process is not only typical of the early (post-1900) cracking units but also is one of the first units on record in which the concept of reactors (soakers) being on-stream/off-stream is realized. Such a concept departs from the true batch concept and allowed a greater degree of continuity. In fact, the tube-and-tank cracking unit may be looked upon as a forerunner of the delayed coking operation.

In the tube-and-tank process, a feedstock (at that time a gas oil) was preheated by exchange with the hot products from the unit pumped into the cracking coil, which consisted of several hundred feet of very strong pipe that lined the inner walls of a furnace where oil or gas burners raised the temperature of the gas oil to 425°C (800°F). The hot gas oil passed from the cracking coil into a large reaction chamber (soaker) where the gas oil was held under the temperature and pressure conditions long enough for the cracking reactions to be completed. The cracking reactions formed coke which, in the course of several days, filled the soaker. The gas oil stream was then switched to a second soaker, and the first soaker was cleaned out by drilling operations similar to those used in drilling an oil well.

The cracked material (other than coke) left the on-stream soaker to enter an evaporator (tar separator) maintained under a much lower pressure than the soaker where, because of the lower pressure, all of the cracked material, except the tar, became vaporized. The vapor left the top of the separator where it was distilled into separate fractions – gases, gasoline, and gas oil. The tar that was deposited in the separator was pumped out for use as asphalt or as a heavy fuel oil.

Early in the development of tube-and-tank thermal cracking, it was found that adequate yields of gasoline could not be obtained by one passage of the stock through the heating coil; attempts to increase the conversion in one pass brought about undesirable high yields of gas and coke. It was better to crack to a limited extent, remove the products, and recycle the rest of the oil (or a distilled fraction free of tar) for repeated partial conversion. The high-boiling constituents once exposed to cracking were so changed in composition as to be more refractory than the original feedstock.

With the onset of the development of the automobile the most important part of any refinery became the gasoline-manufacturing facilities. Among the processes that have evolved for gasoline production are thermal cracking, catalytic cracking, thermal reforming, catalytic reforming, polymerization, alkylation, coking, and distillation of fractions directly from crude oil.

When kerosene was the major product, gasoline was the portion of crude oil too volatile to be included in kerosene. The refiners of the 1890s and the early 1900s had no use for it and often dumped an accumulation of gasoline into the creek or river that was usually nearby. As the demand for gasoline increased with the onset of World War I and the ensuing 1920s, more crude oil had to be distilled not only to meet the demand for gasoline but also to reduce the overproduction of the heavier crude oil fractions, including kerosene.

The problem of how to produce more gasoline from less crude oil was solved in 1913 by the incorporation of cracking units into refinery operations in which fractions heavier than gasoline

were converted into gasoline by thermal decomposition. The early (pre-1940) processes employed for gasoline manufacture were processes in which the major variables involved were feedstock type, time, temperature, and pressure and which need to be considered to achieve the cracking of the feedstock to lighter products with minimal coke formation.

As refining technology evolved throughout this century, the feedstocks for cracking processes became the residuum or heavy distillate from a distillation unit. In addition, the residual oils produced as the end-products of distillation processes and even some of the heavier virgin oils, often contain substantial amounts of asphaltic materials, which preclude use of the residuum as fuel oils or lubricating stocks. However, subjecting these residua directly to thermal processes has become economically advantageous, since, on the one hand, the end result is the production of lower-boiling salable materials; on the other hand, the asphaltic materials in the residua are regarded as the unwanted coke-forming constituents.

As the thermal processes evolved and catalysts were employed with more frequency, poisoning of the catalyst with a concurrent reduction in the lifetime of the catalyst became a major issue for refiners. To avoid catalyst poisoning, it became essential that as much of the nitrogen and metals (such as vanadium and nickel) as possible should be removed from the feedstock. The majority of the heteroatoms (nitrogen, oxygen, and sulfur) and the metals are contained in, or associated with, the asphaltic fraction (residuum). It became necessary that this fraction be removed from cracking feedstocks.

With this as the goal, a number of thermal processes, such as tar separation (flash distillation), vacuum flashing, visbreaking, and coking, came into wide usage by refiners and were directed at upgrading feedstocks by removal of the asphaltic fraction. The method of deasphalting with liquid hydrocarbon, gases such as propane, butane, or iso-butane, became a widely used refinery operation in the 1950s and was very effective for the preparation of residua for cracking feedstocks. In this process, the desirable oil in the feedstock is dissolved in the liquid hydrocarbon and asphaltic materials remain insoluble.

Operating conditions in the deasphalting tower depend on the boiling range of the feedstock and the required properties of the product. Generally, extraction temperatures can range from 55°C to 120°C (130°F to 250°F) with a pressure of 400–600 psi. Hydrocarbon/oil ratios on the order of 6:1 to 10:1 by volume are typically used.

6.4.1 THERMAL CRACKING

One of the earliest conversion processes used in the crude oil industry is the thermal decomposition of higher-boiling materials into lower-boiling products. This process is known as thermal cracking, and the exact origins of the process are unknown. The process was developed in the early 1900s to produce gasoline from the "unwanted" higher-boiling products of the distillation process. However, it was soon learned that the thermal cracking process also produced a wide slate of products varying from highly volatile gases to nonvolatile coke.

The heavier oils produced by cracking are light and heavy gas oils as well as a residual oil which could also be used as heavy fuel oil. Gas oils from catalytic cracking were suitable for domestic and industrial fuel oils or as diesel fuels when blended with straight-run gas oils. The gas oils produced by cracking were also a further important source of gasoline. In a once-through cracking operation, all of the cracked material is separated into products and may be used as such. However, the gas oils produced by cracking (cracked gas oils) are more resistant to cracking (more refractory) than gas oils produced by distillation (straight-run gas oils) but could still be cracked to produce more gasoline. This was achieved using a later innovation (post-1940) involving a recycle operation in which the cracked gas oil was combined with fresh feed for another trip through the cracking unit. The extent to which recycling was carried out affected the yield of gasoline from the process.

The majority of the thermal cracking processes use temperatures of 455°C–540°C (850°F–1,005°F) and pressures of 100–1,000 psi; the Dubbs process may be taken as a typical application of an early thermal cracking operation. The feedstock (reduced crude) is preheated by direct exchange with the

cracking products in the fractionating columns. Cracked gasoline and heating oil are removed from the upper section of the column. Light and heavy distillate fractions are removed from the lower section and are pumped to separate heaters. Higher temperatures are used to crack the more refractory light distillate fraction. The streams from the heaters are combined and sent to a soaking chamber where additional time is provided to complete the cracking reactions. The cracked products are then separated in a low-pressure flash chamber where a heavy fuel oil is removed as bottoms. The remaining cracked products are sent to the fractionating columns.

Mild cracking conditions, with a low conversion per cycle, favor a high yield of gasoline components, with low gas and coke production, but the gasoline quality is not high, whereas more severe conditions give increased gas and coke production and reduced gasoline yield (but of higher quality). With limited conversion per cycle, the heavier residues must be recycled, but these recycle oils become increasingly refractory upon repeated cracking, and if they are not required as a fuel oil stock, they may be coked to increase gasoline yield or refined by means of a hydrogen process.

The thermal cracking of higher-boiling crude oil fractions to produce gasoline is now virtually obsolete. The antiknock requirements of modern automobile engines together with the different nature of crude oils (compared to those of 50 or more years ago) has reduced the ability of the thermal cracking process to produce gasoline on an economic basis. Very few new units have been installed since the 1960s and some refineries may still operate the older cracking units.

6.4.2 Visbreaking

Visbreaking (viscosity breaking) is essentially a process of the post-1940 era and was initially introduced as a mild thermal cracking operation that could be used to reduce the viscosity of residua to allow the products to meet fuel oil specifications. Alternatively, the visbroken residua could be blended with lighter product oils to produce fuel oils of acceptable viscosity. By reducing the viscosity of the residuum, visbreaking reduces the amount of light heating oil that is required for blending to meet the fuel oil specifications. In addition to the major product, fuel oil, material in the gas oil and gasoline boiling range is produced. The gas oil may be used as additional feed for catalytic cracking units, or as heating oil.

In a typical visbreaking operation, a crude oil residuum is passed through a furnace where it is heated to a temperature of 480°C (895°F) under an outlet pressure of approximately 100 psi (Parkash, 2003; Gary et al., 2007; Speight, 2014; Hsu and Robinson, 2017; Speight, 2017). The heating coils in the furnace are arranged to provide a soaking section of low heat density, where the charge remains until the visbreaking reactions are completed, and the cracked products are then passed into a flash-distillation chamber. The overhead material from this chamber is then fractionated to produce a low-quality gasoline as an overhead product and light gas oil as bottom. The liquid products from the flash chamber are cooled with a gas oil flux and then sent to a vacuum fractionator. This yields a heavy gas oil distillate and a residual tar of reduced viscosity.

6.4.3 Coking

Coking is a thermal process for the continuous conversion of heavy, low-grade oils into lighter products. Unlike visbreaking, coking involved complete thermal conversion of the feedstock into volatile products and coke (Table 6.2). The feedstock is typically a residuum and the products are gases, naphtha, fuel oil, gas oil, and coke. The gas oil may be the major product of a coking operation and serves primarily as a feedstock for catalytic cracking units. The coke obtained is usually used as fuel but specialty uses, such as electrode manufacture, production of chemicals and metallurgical coke are also possible and increases the value of the coke. For these uses, the coke may require treatment to remove sulfur and metal impurities.

After a gap of several years, the recovery of heavy oils either through secondary recovery techniques from oil sand formations caused a renewal of interest in these feedstocks in the 1960s and,

TABLE 6.2

Comparison of Visbreaking with Delayed Coking and Fluid Coking

Visbreaking

Purpose: to reduce viscosity of fuel oil to acceptable levels

Conversion is not a prime purpose

Mild (470°C–495°C; 880°F–920°F) heating at pressures of 50–200 psi

 Reactions quenched before going to completion

 Low conversion (10%) to products boiling less than 220°C (430°F)

Heated coil or drum (soaker)

Delayed Coking

Purpose: to produce maximum yields of distillate products

Moderate (480°C–515°C; 900°F–960°F) heating at pressures of 90 psi

 Reactions allowed to proceed to completion

 Complete conversion of the feedstock

Soak drums (845°F–900°F) used in pairs (one on stream and one off stream being de-coked)

Coked until drum solid

Coke removed hydraulically from off-stream drum

Coke yield: 20%–40% by weight (dependent upon feedstock)

Yield of distillate boiling below 220°C (430°F): ca. 30% (but feedstock dependent)

Fluid Coking

Purpose: to produce maximum yields of distillate products

Severe (480°C–565°C; 900°F–1,050°F) heating at pressures of 10 psi

 Reactions allowed to proceed to completion

 Complete conversion of the feedstock

Oil contacts refractory coke

Bed fluidized with steam; heat dissipated throughout the fluid bed

Higher yields of light ends (<C_5) than delayed coking

Less coke make than delayed coking (for one particular feedstock)

henceforth, for coking operations. Furthermore, the increasing attention paid to reducing atmospheric pollution has also served to direct some attention to coking, since the process not only concentrates pollutants such as feedstock sulfur in the coke but also can usually yield volatile products that can be conveniently desulfurized.

Investigations of technologies that result in the production of coke are almost as old as the refining industry itself but the development of the modern coking processes can be traced in the 1930s with many units being added to refineries in the 1940–1970 era. Coking processes generally utilize longer reaction times than the older thermal cracking processes and, in fact, may be considered to be descendants of the thermal cracking processes.

6.4.3.1 Delayed Coking

Delayed coking is a semi-continuous process in which the heated charge is transferred to large soaking (or coking) drums, which provide the long residence time needed to allow the cracking reactions to proceed to completion (Parkash, 2003; Gary et al., 2007; Speight, 2014; Hsu and Robinson, 2017; Speight, 2017). The feedstock to these units is normally an atmospheric residuum although cracked residua are also used.

The feedstock is introduced into the product fractionator where it is heated and lighter fractions are removed as side streams. The fractionator bottoms, including a recycle stream of heavy product, are then heated in a furnace whose outlet temperature varies from 480°C to 515°C (895°F to

960°F). The heated feedstock enters one of a pair of coking drums where the cracking reactions continue. The cracked products leave as overheads, and coke deposits form on the inner surface of the drum. To give continuous operation, two drums are used; while one is on stream, the other is being cleaned. The temperature in the coke drum ranges from 415°C to 450°C (780°F to 840°F) with pressures from 15 to 90 psi.

Overhead products go to the fractionator, where naphtha and heating oil fractions are recovered. The nonvolatile material is combined with preheated fresh feed and returned to the reactor. The coke drum is usually on stream for approximately 24 hours before becoming filled with porous coke after which the coke is removed hydraulically. Normally, 24 hours are required to complete the cleaning operation and to prepare the coke drum for subsequent use on stream.

6.4.3.2 Fluid Coking

Fluid coking is a continuous process which uses the fluidized-solids technique to convert atmospheric and vacuum residua to more valuable products (Parkash, 2003; Gary et al., 2007; Speight, 2014; Hsu and Robinson, 2017; Speight, 2017). The residuum is coked by being sprayed into a fluidized bed of hot, fine coke particles, which permits the coking reactions to be conducted at higher temperatures and shorter contact times than can be employed in delayed coking. Moreover, these conditions result in decreased yields of coke; greater quantities of more valuable liquid product are recovered in the fluid coking process.

Fluid coking uses two vessels, a reactor and a burner; coke particles are circulated between these to transfer heat (generated by burning a portion of the coke) to the reactor. The reactor holds a bed of fluidized coke particles, and steam is introduced at the bottom of the reactor to fluidize the bed.

Flexicoking is also a continuous process that is a direct descendent of fluid coking (Parkash, 2003; Gary et al., 2007; Speight, 2014; Hsu and Robinson, 2017; Speight, 2017). The unit uses the same configuration as the fluid coker but has a gasification section in which excess coke can be gasified to produce refinery fuel gas. The flexicoking process was designed during the late 1960s and the 1970s as a means by which excess coke-make could be reduced in view of the gradual incursion of the heavier feedstocks in refinery operations. Such feedstocks are notorious for producing high yields of coke (>15% by weight) in thermal and catalytic operations.

6.4.4 Comments on Viscous Feedstocks

The limitations of processing the more complex difficult-to-convert viscous feedstocks depend to a large extent on the amount of nonvolatile higher-molecular-weight constituents, which also contain the majority of the heteroatoms (i.e., nitrogen, oxygen, sulfur, and metals such as nickel and vanadium) (Chapter 3). The chemistry of the thermal reactions of some of these constituents dictates that certain reactions, once initiated, cannot be reversed and proceed to completion and coke is the eventual product (Parkash, 2003; Gary et al., 2007; Speight, 2014; Hsu and Robinson, 2017; Speight, 2017).

Upgrading viscous feedstocks, even in a blend, began with the introduction of desulfurization processes that were designed to reduce the sulfur content of the feedstock and products therefrom. In the early days of such upgrading, the goal was desulfurization but, in later years, the processes were adapted to a 10% w/w–30% w/w partial conversion operation, as intended to achieve desulfurization and obtain low-boiling fractions simultaneously, by increasing severity in operating conditions. Although new thermal cracking units are now under development for viscous feedstocks (Speight, 2011a, 2014, 2017), processes that can be regarded as having evolved from the original concept of thermal cracking are visbreaking and the various coking processes.

In summary, there is a need to improve conversion of viscous feedstocks and part of the future growth will be at or near recovery sites at heavy crude oil reservoirs, extra-heavy crude oil deposits, and tar sand bitumen deposits in order to improve the quality to ease transportation and open

markets for crudes of otherwise marginal value. Thus, refinery evolution has seen the introduction of a variety of viscous feedstock cracking processes. These processes are different from one another in cracking method, cracked product patterns, and product properties, and will be employed in refineries according to their respective features.

It is the purpose of this chapter to present these processes in relation to their use in modern refineries and the information that should be borne in mind when considering and deciding upon the potential utility of any process presented throughout this and subsequent chapters. In addition, the importance of solvents to mitigate coke formation has been recognized for many years, but their effects have often been ascribed to hydrogen-donor reactions rather than phase behavior. The separation of the phases depends on the solvent characteristics of the liquid. Addition of aromatic solvents will suppress phase separation, while paraffin-based solvents will enhance separation.

6.5 CATALYTIC PROCESSES

There are many processes in a refinery that employ a catalyst to improve process efficiency (Table 6.3) (Parkash, 2003; Gary et al., 2007; Speight, 2014; Hsu and Robinson, 2017; Speight, 2017). The original incentive arose from the need to increase gasoline supplies in the 1930s and 1940s. Since cracking could virtually double the volume of gasoline from a barrel of crude oil, cracking was justifiable on this basis alone.

In the 1930s, thermal cracking units produced approximately 50% of the total gasoline. The octane number of this gasoline was approximately 70 compared to approximately 60 for straight-run (distilled) gasoline. The thermal reforming and polymerization processes that were developed during the 1930s could be expected to further increase the octane number of gasoline to some extent but an additional innovation was needed to increase the octane number of gasoline to enhance the development of more powerful automobile engines.

TABLE 6.3
Summary of Catalytic Cracking Processes

Conditions

Solid acidic catalyst (such as silica–alumina and zeolite)
Temperature: 480°C–540°C (900°F–1,000°F) (solid/vapor contact)
Pressure: 10–20 psi
Provisions needed for continuous catalyst replacement with heavier feedstocks (residua)
Catalyst may be regenerated or replaced

Feedstocks

Gas oils and residua
Residua pretreated to remove salts (metals)
Residua pretreated to remove high molecular weight (asphaltic constituents)

Products

Lower molecular weight than feedstock
Some gases (feedstock and process parameters dependent)
Iso-paraffins in product
Coke deposited on catalyst

Variations

Fixed bed
Moving bed
Fluidized bed

6.5.1 CATALYTIC CRACKING

In 1936, a new cracking process opened the way to higher-octane gasoline – this process was catalytic cracking. This process is basically the same as thermal cracking but differs by the use of a catalyst, which is not (in theory) consumed in the process and directs the course of the cracking reactions to produce more of the desired higher-octane hydrocarbon products.

Catalytic cracking has a number of advantages over thermal cracking – (i) the gasoline produced has a higher octane number; (ii) the catalytically cracked gasoline consists largely of iso-paraffins and aromatics, which have high octane numbers and greater chemical stability than mono-olefins and di-olefins which are present in much greater quantities in thermally-cracked gasoline. Substantial quantities of olefinic gases suitable for polymer gasoline manufacture and smaller quantities of methane, ethane, and ethylene are produced by catalytic cracking. Sulfur compounds are changed in such a way that the sulfur content of catalytically cracked gasoline is lower than in thermally cracked gasoline. Catalytic cracking produces less heavy residual or tar and more of the useful gas oils than does thermal cracking. The process has considerable flexibility, permitting the manufacture of both motor and aviation gasoline and a variation in the gas oil yield to meet changes in the fuel oil market.

The last 40 years have seen substantial advances in the development of catalytic processes. This has involved not only rapid advances in the chemistry and physics of the catalysts themselves but also major engineering advances in reactor design. For example, the evolution of the design of the catalyst beds from fixed beds to moving beds to fluidized beds. Catalyst chemistry/physics and bed design have allowed major improvements in process efficiency and product yields.

Catalytic cracking is another innovation that truly belongs to the 20th century and is regarded as the modern method for converting high-boiling crude oil fractions, such as gas oil, into gasoline and other low-boiling fractions. Thus, catalytic cracking in the usual commercial process involves contacting a gas oil fraction with an active catalyst under suitable conditions of temperature, pressure, and residence time so that a substantial part (>50%) of the gas oil is converted into gasoline and lower-boiling products, usually in a single-pass operation. However, during the cracking reaction, carbonaceous material is deposited on the catalyst, which markedly reduces its activity, and removal of the deposit is very necessary. This is usually accomplished by burning the catalyst in the presence of air until catalyst activity is reestablished.

The several processes currently employed in catalytic cracking differ mainly in the method of catalyst handling, although there is overlap with regard to catalyst type and the nature of the products. The catalyst, which may be an activated natural or synthetic material, is employed in bead, pellet, or microspherical form and can be used as a fixed bed, moving bed, or fluid bed. The fixed-bed process was the first process to be used commercially and uses a static bed of catalyst in several reactors, which allows a continuous flow of feedstock to be maintained. Thus, the cycle of operations consists of (i) flow of feedstock through the catalyst bed, (ii) discontinuance of feedstock flow and removal of coke from the catalyst by burning, and (iii) insertion of the reactor on stream. The moving-bed process uses a reaction vessel (in which cracking takes place) and a kiln (in which the spent catalyst is regenerated) and catalyst movement between the vessels is provided by various means.

The *fluid-bed catalytic cracking process* differs from the fixed-bed and moving-bed processes, insofar as the powdered catalyst is circulated essentially as a fluid with the feedstock (Parkash, 2003; Gary et al., 2007; Speight, 2014; Hsu and Robinson, 2017; Speight, 2017). The several fluid catalytic cracking processes in use differ primarily in mechanical design. Side-by-side reactor-regenerator construction along with unitary vessel construction (the reactor either above or below the regenerator) is the two main mechanical variations.

6.5.2 CATALYSTS

Natural clays have long been known to exert a catalytic influence on the cracking of oils, but it was not until about 1936 that the process using silica–alumina catalysts was developed sufficiently for

commercial use. Since then, catalytic cracking has progressively supplanted thermal cracking as the most advantageous means of converting distillate oils into gasoline. The main reason for the wide adoption of catalytic cracking is the fact that a better yield of higher-octane gasoline can be obtained than by any known thermal operation. At the same time, the gas produced consists mostly of propane and butane with less methane and ethane. The production of heavy oils and tars, higher in molecular weight than the charge material, is also minimized, and both the gasoline and the uncracked cycle oil are more saturated than the products of thermal cracking.

The major innovations of the 20th century lie not only in reactor configuration and efficiency but also in catalyst development. There is probably not an oil company in the United States that does not have some research and development activity related to catalyst development. Much of the work is proprietary and, therefore, can only be addressed here in generalities.

The cracking of crude oil fractions occurs over many types of catalytic materials, but high yields of desirable products are obtained with hydrated aluminum silicates. These may be either activated (acid-treated) natural clays of the bentonite type of synthesized silica–alumina or silica–magnesia preparations. Their activity to yield essentially the same products may be enhanced to some extent by the incorporation of small amounts of other materials such as the oxides of zirconium, boron (which has a tendency to volatilize away on use), and thorium. Natural and synthetic catalysts can be used as pellets or beads and also in the form of powder; in either case, replacements are necessary because of attrition and gradual loss of efficiency. It is essential that they should be stable to withstand the physical impact of loading and thermal shocks, and that they withstand the action of carbon dioxide, air, nitrogen compounds, and steam. They also should be resistant to sulfur and nitrogen compounds and synthetic catalysts, or certain selected clays, appear to be better in this regard than average untreated natural catalysts.

The catalysts are porous and highly adsorptive and their performance is affected markedly by the method of preparation. Two chemically identical catalysts having pores of different size and distribution may have different activity, selectivity, temperature coefficients of reaction rates, and responses to poisons. The intrinsic chemistry and catalytic action of a surface may be independent of pore size but small pores produce different effects because of the manner in which hydrocarbon vapors are transported into and out of the pore systems.

6.5.3 COMMENTS ON VISCOUS FEEDSTOCKS

The fluid catalytic cracking process, using vacuum gas oil as the feedstock, was introduced into refineries in the 1930s. In recent years, because of a trend for low-boiling products, most refineries perform the operation by partially blending a viscous feedstock (such as a residuum) into vacuum gas oil. However, conventional fluid catalytic cracking processes have limits in residuum processing, so residuum fluid catalytic cracking processes have lately been employed one after another. Because the residuum fluid catalytic cracking process enables efficient gasoline production directly from residua, it will play the most important role as a residuum cracking process, along with a residuum hydrotreating process (Parkash, 2003; Gary et al., 2007; Speight, 2014; Hsu and Robinson, 2017; Speight, 2017).

The processes described below are the evolutionary offspring of the fluid catalytic cracking and the residuum catalytic cracking processes. Some of these newer processes use catalysts with different silica/alumina ratios as acid support of metals such as molybdenum(Mo), cobalt (Co), nickel (Ni), and tungsten (W). In general, the first catalyst used to remove metals from oils was the conventional hydrodesulfurization (HDS) catalyst. Diverse natural minerals are also used as raw material for elaborating catalysts addressed to the upgrading of viscous fractions. Among these minerals are clay minerals, manganese nodules, bauxite activated with vanadium (V), nickel (Ni), chromium (Cr), iron (Fe), and cobalt (Co), as well as and the high iron oxide content, iron laterites, sepiolite minerals, and mineral nickel and transition metal sulfides supported on silica and alumina. Other kinds of catalysts, such as vanadium sulfide, are generated in situ, possibly in colloidal states.

In the past decades, in spite of the difficulty of handling viscous feedstocks, residuum fluidized catalytic cracking, (RFCC), has evolved to become a well-established approach for converting a

significant portion of the heavier fractions of the crude barrel into a high-octane gasoline blending component. RFCC, which is an extension of conventional fluid catalytic cracking technology for applications involving the conversion of highly contaminated residua, has been commercially proven on feedstocks ranging from gas oil–residuum blends to atmospheric residua, as well as blends of atmospheric and vacuum residua blends. In addition to high naphtha yields, the RFCC unit also produces gaseous, distillate, and fuel oil-range products.

The product quality from the residuum fluidized catalytic cracker is directly affected by its feedstock quality. In particular, and unlike hydrotreating, the RFCC redistributes sulfur among the various products but does not remove sulfur from the products unless, of course, one discount the sulfur that is retained by any coke formed on the catalyst. Consequently, tightening product specifications have forced refiners to hydrotreat some, or all, of the products from the resid catalytic cracking unit. Similarly, in the future, the emissions of sulfur oxides (SO_x) from a resid catalytic cracker may become more of an obstacle for residue conversion projects. For these reasons, a point can be reached where the economic operability of the unit can be sufficient to justify hydrotreating the feedstock to the cat cracker.

As an integrated conversion block, residue hydrotreating and RFCC complement each other and can offset many of the inherent deficiencies related to viscous feedstock conversion.

6.6 HYDROPROCESSES

The use of hydrogen in thermal processes is perhaps the single most significant advance in refining technology during the 20th century. The process uses the principle that the presence of hydrogen during a thermal reaction of a crude oil feedstock will terminate many of the coke-forming reactions and enhance the yields of the lower-boiling components such as gasoline, kerosene, and jet fuel (Table 6.4) (Parkash, 2003; Gary et al., 2007; Speight, 2014; Hsu and Robinson, 2017; Speight, 2017).

Hydrogenation processes for the conversion of crude oil fractions and crude oil products may be classified as destructive and nondestructive. Destructive hydrogenation (hydrogenolysis or hydrocracking) is characterized by the conversion of the higher-molecular-weight constituents in a feedstock to lower-boiling products. Such treatment requires severe processing conditions and the use of high hydrogen pressures to minimize polymerization and condensation reactions that lead to coke formation.

Nondestructive or simple hydrogenation is generally used for the purpose of improving product quality without appreciable alteration of the boiling range. Mild processing conditions are employed so that only the more unstable materials are attacked. Nitrogen, sulfur, and oxygen compounds undergo reaction with the hydrogen to remove ammonia, hydrogen sulfide, and water, respectively. Unstable compounds which might lead to the formation of gums, or insoluble materials, are converted to more stable compounds.

6.6.1 HYDROTREATING

Distillate hydrotreating is carried out by charging the feed to the reactor, together with hydrogen in the presence of catalysts such as tungsten–nickel sulfide, cobalt–molybdenum–alumina, nickel oxide–silica–alumina, and platinum–alumina (Parkash, 2003; Gary et al., 2007; Speight, 2014; Hsu and Robinson, 2017; Speight, 2017). Most processes employ cobalt–molybdena catalysts which generally contain approximately 10% of molybdenum oxide and less than 1% of cobalt oxide supported on alumina. The temperatures employed are in the range of 260°C–345°C (500°F–655°F), while the hydrogen pressures are approximately 500–1,000 psi.

The reaction generally takes place in the vapor phase but, depending on the application, may be a mixed-phase reaction. Generally, it is more economical to hydrotreat high-sulfur feedstocks prior to catalytic cracking than to hydrotreat the products from catalytic cracking. The advantages are that (i) sulfur is removed from the catalytic cracking feedstock, and corrosion is reduced in the cracking

TABLE 6.4
Summary of Hydrocracking Processes

Conditions

Solid acid catalyst (silica–alumina with rare earth metals, various other options)

Temperature: 260°C–450°C (500°F–845°F) (solid/liquid contact)

Pressure: 1,000–6,000 psi hydrogen

Frequent catalysts renewal for heavier feedstocks

Gas oil: catalyst life up to 3 years

Heavy oil/tar sand bitumen: catalyst life less than 1 year

Feedstocks

Refractory (aromatic) streams

Coker oils

Cycle oils

Gas oils

Residua (as a full hydrocracking or hydrotreating option)

 In some cases, asphaltic constituents (S, N, and metals) removed by deasphalting

Products

Lower-molecular-weight paraffins

Some methane, ethane, propane, and butane

Hydrocarbon distillates (full range depending on the feedstock)

Residual tar (recycle)

Contaminants (asphaltic constituents) deposited on the catalyst as coke or metals

Variations

Fixed bed (suitable for liquid feedstocks)

Ebullating bed (suitable for viscous feedstocks)

unit, (ii) carbon formation during cracking is reduced so that higher conversions result, and (iii) the cracking quality of the gas oil fraction is improved.

6.6.2 HYDROFINING

Hydrofining is a process that first went on-stream in the 1950s and is one example of the many hydroprocesses available. It can be applied to lubricating oils, naphtha, and gas oils. The feedstock is heated in a furnace and passed with hydrogen through a reactor containing a suitable metal oxide catalyst, such as cobalt and molybdenum oxides on alumina. Reactor operating conditions range from 205°C to 425°C (400°F to 800°F) and from 50 to 800 psi and depend on the kind of feedstock and the degree of treating required. Higher-boiling feedstocks, high sulfur content, and maximum sulfur removal require higher temperatures and pressures.

After passing through the reactor, the treated oil is cooled and separated from the excess hydrogen which is recycled through the reactor. The treated oil is pumped to a stripper tower where hydrogen sulfide, formed by the hydrogenation reaction, is removed by steam, vacuum, or flue gas, and the finished product leaves the bottom of the stripper tower. The catalyst is not usually regenerated; it is replaced after use for approximately 1 year.

6.6.3 HYDROCRACKING

Hydrocracking is similar to catalytic cracking, with hydrogenation superimposed and with the reactions taking place either simultaneously or sequentially. Hydrocracking was initially used to

upgrade low-value distillate feedstocks, such as cycle oils (high aromatic products from a catalytic cracker which usually are not recycled to extinction for economic reasons), thermal and coker gas oils, and heavy-cracked and straight-run naphtha. These feedstocks are difficult to process by either catalytic cracking or reforming, since they are characterized usually by a high polycyclic aromatic content and/or by high concentrations of the two principal catalyst poisons – sulfur and nitrogen compounds.

The older hydrogenolysis type of hydrocracking practiced in Europe during, and after, World War II used tungsten or molybdenum sulfides as catalysts and required high reaction temperatures and operating pressures, sometimes in excess of approximately 3,000 psi for continuous operation. The modern hydrocracking processes were initially developed for converting refractory feedstocks (such as gas oils) to gasoline and jet fuel but process and catalyst improvements and modifications have made it possible to yield products from gases and naphtha to furnace oils and catalytic cracking feedstocks (Parkash, 2003; Gary et al., 2007; Speight, 2014; Hsu and Robinson, 2017; Speight, 2017).

A comparison of hydrocracking with hydrotreating is useful in assessing the parts played by these two processes in refinery operations. Hydrotreating of distillates may be defined simply as the removal of nitrogen–sulfur and oxygen-containing compounds by selective hydrogenation. The hydrotreating catalysts are usually cobalt plus molybdenum or nickel plus molybdenum (in the sulfide) form impregnated on an alumina base. The hydrotreated operating conditions are such that appreciable hydrogenation of aromatics will not occur, i.e., 1,000–2,000 psi hydrogen and 370°C (700°F). The desulfurization reactions are usually accompanied by small amounts of hydrogenation and hydrocracking.

Hydrocracking is an extremely versatile process that can be utilized in many different ways such as conversion of the high-boiling aromatic streams which are produced by catalytic cracking or by coking processes. To take full advantage of hydrocracking, the process must be integrated in the refinery with other process units.

The commercial processes for treating, or finishing, crude oil fractions with hydrogen all operate in essentially the same manner. The feedstock is heated and passed with hydrogen gas through a tower or reactor filled with catalyst pellets. The reactor is maintained at a temperature of 260°C–425°C (500°F–800°F) at pressures from 100 to 1,000 psi, depending on the particular process, the nature of the feedstock and the degree of hydrogenation required. After leaving the reactor, excess hydrogen is separated from the treated product and recycled through the reactor after removal of hydrogen sulfide. The liquid product is passed into a stripping tower where steam removes dissolved hydrogen and hydrogen sulfide and, after cooling, the product is taken to product storage or, in the case of feedstock preparation, pumped to the next processing unit.

The manufacture of base stocks for lubricating oil production is an essential part of modern refining. In the past four decades, the majority of the expansion of lubricating oil production is being achieved by production using catalytic hydroprocessing (hydrocracking and hydroisomerization) because of the demand for higher-quality lube base oils. Base oils are sub-divided into a number of categories: Groups I, II, III, and IV. Group I base oils are typically conventional solvent-refined products. Groups II and III were added to lubricant classifications in the early 1990s to represent low sulfur, low aromatic, and high viscosity index (VI) lubricants with good oxidative stability and soot handling. The reduction of wax content in the lubricants also improves the operating range and engine, low-temperature performance via improved pour and cloud point. The first catalytic based plants were introduced in the 1980s but at that time, the catalytic route only produced conventional base oil (Group I). In the 1990s, hydroisomerization was introduced to produce base oils with higher stability. Hydroisomerization has propagated such that a considerable amount of lube base oils is produced in this manner.

6.6.4 Comments on Viscous Feedstocks

Advances made in hydrotreating processes have made the utilization of heavier feedstocks almost a common practice for many refineries. Upgrading processes can be used for the upgrading of viscous

feedstocks (Parkash, 2003; Gary et al., 2007; Speight, 2011a,b, 2014; Hsu and Robinson, 2017; Speight, 2017). However, there is no hydroprocessing process that can universally be applicable to upgrade all viscous feedstocks. As a result, several hydroprocessing processes are developed for different commercial applications; many other processes are in their development stages.

Hydroprocessing units with fixed-bed reactors must be shut down to remove the spent catalyst when catalyst activity declines below an acceptable level (due to the accumulation of coke, metals, and other contaminants). There are a few types of hydroprocessing reactors with moving, or ebullating catalyst beds. In ebullated bed hydroprocessing, the catalyst within the reactor bed is not fixed. In such a process, the hydrocarbon feedstock stream enters the bottom of the reactor and flows upward through the catalyst. The catalyst is kept in suspension by the pressure of the fluid feed. Ebullating bed reactors are capable of converting the most problematic feeds, such as atmospheric resids, vacuum resids, and heavy oil, extra-heavy oil, and tar sand bitumen feedstocks (all of which have a high content of asphaltenes, metals, sulfur, and sediments) to lower-boiling, more valuable products while simultaneously removing contaminants. The function of the catalyst is to remove contaminants such as sulfur and nitrogen heteroatoms, which accelerate the deactivation of the catalyst, while cracking (converting) the feedstock to lower-boiling products. Because ebullating bed reactors perform both hydrotreating and hydrocracking functions (Chapter 14), they are also referred to as dual-purpose reactors (Parkash, 2003; Gary et al., 2007; Speight, 2014; Hsu and Robinson, 2017; Speight, 2017).

Both the fixed-bed processes and the ebullated-bed processes require a catalyst system with a pore size distribution to match the changing molecular structure of the feedstock constituents. The catalyst can be designed for high metal uptake capacity and moderate sulfur conversion to be applied in the front-end reactor when processing high metal-containing feedstocks (>70 ppm vanadium). On the other hand, the catalyst may be designed for moderate metals removal capacity but higher activity for sulfur and conversion of the coke precursors which is applied in front-end reactors when processing feedstocks with a lower metal content (<70 ppm vanadium) or in middle reactors when processing high metal-containing feedstocks. Catalysts with a high propensity for sulfur, removal of coke precursors, and removal of nitrogen are applied in the middle and/or tail-end reactors.

The goals of the hydroconversion of viscous feedstocks are to convert feedstocks to low-sulfur liquid product oils or, in some cases, to pretreat feedstocks for fluid catalytic cracking processes. However, when applied to viscous feedstocks (such as heavy oil, extra-heavy oil, and tar sand bitumen), the problems encountered can be directly equated to the amount of complex, higher-boiling constituents that may require pretreatment (Parkash, 2003; Gary et al., 2007; Speight, 2014; Hsu and Robinson, 2017; Speight, 2017). Furthermore, the majority of the higher-molecular-weight materials produce high yields (35% w/w–60% w/w) coke. It is this trend of coke formation that hydrocracking offers some relief. Thus, the major goal of *heavy feedstock hydroconversion* is cracking of viscous feedstocks with desulfurization, metal removal, denitrogenation, and asphaltene conversion. However, asphaltene constituents and metal-containing constituents exert a strong deactivating influence on the catalyst which markedly decreases the hydrogenolysis rate of sulfur compounds, practically without having an impact on coke formation. In addition, nitrogen-containing compounds are adsorbed on acid sites, blocking the sites and thereby lowering catalyst activity. Thus, during the hydrocracking of viscous feedstocks, preliminary feedstock HDS and demetallization over special catalyst is advantageous.

6.7 DEASPHALTING

Solvent deasphalting processes are a major part of refinery operations (Parkash, 2003; Gary et al., 2007; Speight, 2014; Hsu and Robinson, 2017; Speight, 2017) and are not often appreciated for the tasks for which they are used. In the solvent deasphalting processes, an alkane is injected into the feedstock to disrupt the dispersion of components and causes the polar constituents to precipitate. Propane (or sometimes propane/butane mixtures) is extensively used for deasphalting and produces

a deasphalted oil (DAO) and propane deasphalter asphalt (PDA or PD tar) (Dunning and Moore, 1957). Propane has unique solvent properties; at lower temperatures (38°C–60°C; 100°C–140°C), paraffins are very soluble in propane and at higher temperatures (approximately 93°C; 200°F) all hydrocarbon derivatives are almost insoluble in propane.

A *solvent deasphalting* unit processes the residuum from the vacuum distillation unit and produces DAO, used as feedstock for a fluid catalytic cracking unit, and the asphaltic residue (deasphalter tar, deasphalter bottoms) which, as a residual fraction, can only be used to produce asphalt or as a blend stock or visbreaker feedstock for low-grade fuel oil (Parkash, 2003; Gary et al., 2007; Speight, 2014; Hsu and Robinson, 2017; Speight, 2017). Solvent deasphalting processes have not realized their maximum potential. With on-going improvements in energy efficiency, such processes would display its effects in a combination with other processes. Solvent deasphalting allows removal of sulfur and nitrogen compounds as well as metallic constituents by balancing yield with the desired feedstock properties (Ditman, 1973).

The propane deasphalting process is similar to solvent extraction in that a packed or baffled extraction tower or rotating disc contactor is used to mix the feedstock with the solvent. In the tower method, four to eight volumes of propane are fed to the bottom of the tower for every volume of feed flowing down from the top of the tower. The oil which is more soluble in the propane dissolves and flows to the top. The asphaltene and resins flow to the bottom of the tower where they are removed in a propane mix. Propane is recovered from the two streams through two-stage flash systems followed by steam stripping in which propane is condensed and removed by cooling at high pressure in the first stage and at low pressure in the second stage. The asphalt recovered can be blended with other asphalts or heavy fuels, or can be used as feed to the coker.

The major process variables are temperature, pressure, solvent to oil ratio, and solvent type. Pressure and temperature are both variables because the solvent power of light hydrocarbon is approximately proportional to the density of the solvent. Higher temperature always results in a decreased yield of DAO. On the other hand, increasing solvent to oil ratio increases the recovery of DAO with an increase in viscosity. However, for the given product quality which can be maintained with change in temperature, solvent to oil ratio increases the yield of DAO. It has been shown that solvent power of paraffin solvent increases with an increase in solvent molecular weight.

The supercritical extraction process (ROSE process), as applied to a viscous feedstock, is a solvent deasphalting process with minimum energy consumption using supercritical solvent recovery system and the process is of value in obtaining oils for further processing (Parkash, 2003; Gary et al., 2007; Speight, 2011a,b, 2014; Hsu and Robinson, 2017; Speight, 2017). The process can be installed upstream of the desulfurizer to reduce a major portion of the heavy metals and coke precursors present in the feed. The ROSE process can also be installed between a vacuum flasher and a coking unit which reduces the carbon residue of the gas oil fraction for its catalytic cracking (Parkash, 2003; Gary et al., 2007; Speight, 2014; Hsu and Robinson, 2017; Speight, 2017).

The HSC-ROSE process – mild cracking solvent deasphalting – has been described for upgrading viscous feedstocks (Parkash, 2003; Gary et al., 2007; Speight, 2011a,b, 2014; Hsu and Robinson, 2017; Speight, 2017). The effects of cracking temperature and time on the yield, carbon residue, nickel content of DAO, and properties of raffinate asphalt were examined. The DAO obtained by the mild cracking solvent deasphalting was superior in yield and quality to that from solvent deasphalting alone. At the same yield of DAO, the softening point of the raffinate asphalt was lower and the penetration and the ductility were greater than those for the solvent deasphalting process.

The process used supercritical solvents and is a natural progression from propane deasphalting and allows the separation of viscous feedstocks into the base components (asphaltene constituents, resin constituents, and soluble constituents) for recombination to optimum properties. Propane, butane, and pentane may be used as the solvent depending on the feedstock and the desired compositions. A mixer is used to blend residue with liquefied solvent at elevated temperature and pressure. The blend is pumped into the first stage separator where, through counter current flow of solvent, the asphaltene constituents are precipitated, separated, and stripped of solvent by steam. The overhead

solution from the first tower is taken to a second stage where it is heated to a higher temperature. This causes the resin constituents to separate. The final material is taken to a third stage and heated to a supercritical temperature. This makes the oils insoluble and separation occurs. This process is very flexible and allows precise blending to required compositions.

The DAO from a ROSE unit is a suitable feedstock that can be processed in a fluid catalytic cracking unit or other conversion units. Since the contaminants (such as sulfur and metals) are rejected in the solid fuel to the cement industry, there is minimal impact on the auxiliary units (sulfur plant, amine regeneration) within the refinery. Options for use of the fraction (not necessarily in the order of importance) include (i) conversion as a coker feedstock, (ii) fuel oil blend stock, (iii) partial oxidation feedstock for synthesis gas or hydrogen production, and (iv) solid fuel with any necessary gas cleaning operations. The quality and definition of the product designated as the *asphaltene fraction* depend on the feedstock to the process and whether or not the feedstock is the result of a blend of crude different oil or part of a blend involving several oils (Speight, 2014, 2017). As the crude slate becomes heavier and higher sulfur content, the asphaltene fraction will also contain a higher quantity of sulfur.

6.8 VISCOUS FEEDSTOCKS IN THE REFINERY

The demand for petroleum and petroleum products has shown a sharp growth in recent years (Parkash, 2003; Gary et al., 2007; Speight, 2011a,b, 2014; Hsu and Robinson, 2017; Speight, 2017); this could well be the last century for petroleum refining, as we know it. The demand for transportation fuels and fuel oil is forecast to continue to show a steady growth in the future. The simplest means to cover the demand growth in low-boiling products is to increase the imports of light crude oils and low-boiling petroleum products, but these steps may be limited in the future.

Since the viscous feedstocks (heavy oil, extra-heavy oil, and tar sand bitumen), which can be constituents of refinery feedstock blends, exhibit a wide range of physical properties, it is not surprising the behavior of the viscous feedstocks in refinery operations is not simple. The atomic ratios from ultimate analysis (Speight, 2014) can give an indication of the nature of a feedstock and the generic hydrogen requirements to satisfy the refining chemistry (Chapter 7), but it is not possible to predict with any degree of certainty how the feedstock will behave during refining. Any deductions made from such data are pure speculation and are open to much doubt.

In addition, the chemical composition of a feedstock is also an indicator of refining behavior (Parkash, 2003; Gary et al., 2007; Hsu and Robinson, 2017; Speight, 2017). Whether the composition is represented in terms of compound types or in terms of generic compound classes, it can enable the refiner to determine the nature of the reactions. Hence, chemical composition can play a large part in determining the nature of the products that arise from the refining operations. It can also play a role in determining the means by which a particular feedstock should be processed (Parkash, 2003; Gary et al., 2007; Hsu and Robinson, 2017; Speight, 2017).

Therefore, the judicious choice of a refinery feedstock – as well as the judicious choice of a processing option – to produce any given product is just as important as the selection of the product for any given purpose. Thus, initial inspection of the nature of the feedstock will provide deductions related to the most logical means of refining. Indeed, careful evaluation of the feedstock from physical property data is a major part of the initial study of any viscous material that is destined to be a refinery feedstock or, at least in the present context, part of a feedstock blend. Proper interpretation of the data resulting from the inspection of crude oil requires an understanding of their significance.

The difficult-to-refine viscous feedstocks are characterized by low API gravity (high density) and high viscosity, high initial boiling point, high carbon residue, high nitrogen content, high sulfur content, and high metals content (Speight, 2013). In addition to these properties, the viscous feedstocks also have an increased molecular weight and reduced hydrogen content (Speight, 2014, 2017) with a relatively low content of volatile saturated and aromatic constituents and a relatively high content of asphaltene and resin constituents that is accompanied by a high heteroatom (nitrogen,

oxygen, sulfur, and metals) content (Speight, 2014, 2017). Thus, such feedstocks are not typically subject to distillation unless contained in the refinery feedstock as a blend with other crude oils.

The limitations of processing these viscous feedstocks depend to a large extent on the tendency for coke formation and the deposition of metals and coke on the catalyst due to the higher molecular weight (low volatility) and heteroatom content. However, the essential step required of refineries is the upgrading of viscous feedstocks. In fact, the increasing supply of viscous feedstocks is a matter of serious concern for the petroleum industry. In order to satisfy the changing pattern of product demand, significant investments in refining conversion processes will be necessary to profitably utilize these viscous feedstocks.

Upgrading viscous feedstock began with the introduction of desulfurization processes. In the early days, the goal was desulfurization but, in later years, the processes were adapted to a 10%–30% partial conversion operation, as intended to achieve desulfurization and obtain low-boiling fractions simultaneously, by increasing severity in operating conditions. Thus, refining viscous feedstocks have become a major issue in modern refinery practice and several process configurations have evolved to accommodate the viscous feedstocks (Table 1.1) (Parkash, 2003; Gary et al., 2007; Speight, 2014; Hsu and Robinson, 2017; Speight, 2017).

Technologies for upgrading viscous feedstocks can be broadly divided into *carbon rejection* and *hydrogen addition* processes. *Carbon rejection* redistributes hydrogen among the various components, resulting in fractions with increased H/C atomic ratios and fractions with lower H/C atomic ratios. On the other hand, *hydrogen addition* processes involve reaction the constituents of the viscous feedstocks with an external source of hydrogen and result in an overall increase in H/C ratio (Parkash, 2003; Gary et al., 2007; Speight, 2014; Hsu and Robinson, 2017; Speight, 2017). The criteria to select one of the routes as an upgrading option depend on several factors which must be analyzed in detail when it comes to considering the composition and properties of the feedstock. For example, the technology of *hydrogen addition* produces a high yield of products with a commercial value larger than that of the *carbon rejection* technology but requires a larger investment and more natural gas availability to produce the amounts of hydrogen and steam required for these processes.

New processes for the conversion of heavy oil feedstocks will probably be used in concert with visbreaking with some degree of hydroprocessing as a primary conversion step. Other processes may replace or augment the deasphalting units in many refineries. Depending on the properties, an option for heavy oil, like the early option for tar sand bitumen is to subject the feedstock to either delayed coking or fluid coking as the *primary upgrading* step with some prior distillation or topping (Parkash, 2003; Gary et al., 2007; Speight, 2014; Hsu and Robinson, 2017; Speight, 2017). After primary upgrading, the product streams are hydrotreated and combined to form a *synthetic crude oil* that is shipped to a conventional refinery for further processing to liquid fuels.

However, there is not one single heavy oil upgrading solution that will fit all refineries. Viscous feedstock properties, existing refinery configuration, and desired product slate all can have a significant effect on the final configuration. Furthermore, a proper evaluation however is not a simple undertaking for an existing refinery. The evaluation starts with an accurate understanding of the nature of the feedstock along with corresponding conversion chemistry need to be assessed. Once the options have been defined, development of the optimal configuration for refining the incoming feedstocks can be designed.

There is also recognition that in situ upgrading could be a very beneficial process for leaving the unwanted elements in the reservoir and increasing API gravity. While this is important in the context of this text insofar as upgrading during recovery will reduce surface refining costs, it is described in more detail elsewhere (Speight, 2014, 2019b) and will not be repeated here. However, the salient facts of the concept are certainly worthy of note.

There are two ways that are currently practiced in bringing viscous feedstocks to market (Speight, 2014, 2019b). The first method is to upgrade the material at, or close to, the recovery site and leave much of the material behind as coke, and then pipeline the upgraded material out as synthetic

crude. In this method, the crude is fractionated and the residue is coked. The products of the coking operation, and in some cases some of the residue, are hydrotreated. The hydrotreated materials are recombined with the fractionated light materials to form synthetic crude that is then transported to market in a pipeline.

The second method is to effect partial upgrading in situ as part of the recovery process (Speight, 2014, 2019b). Such an option, to produce an acceptable pipeline material would be an ideal solution but has a number of limitations (Parkash, 2003; Gary et al., 2007; Speight, 2014; Hsu and Robinson, 2017; Speight, 2017). For example, the amount of heavy oil production could be limited by the recovery process and the upgraded products must be compatible with the original or partially changed feedstock component. If the products and the original (partially changed) heavy oil have limited compatibility which that would the amount of dilution and again could limit the effectiveness of the refining process (Parkash, 2003; Gary et al., 2007; Speight, 2014; Hsu and Robinson, 2017; Speight, 2017).

However, the increased mobilization of heavy oil in the reservoir by partial upgrading is not a new idea and still has many hurdles to overcome before it can be considered close to commercial. The product will be less viscous than the heavy oil in place but some property changes such as high olefin content from cracking are not necessarily positive. In summary, there are three main approaches for heating the reservoir: (i) steam distillation, (ii) mild thermal cracking, such as visbreaking, and (iii) partial combustion (Parkash, 2003; Gary et al., 2007; Speight, 2013, 2014; Hsu and Robinson, 2017; Speight, 2017).

Nevertheless, there is (or will be) an obvious future need for partial upgrading during or immediately after recovery. On the other hand, hydrogen addition must be used during upgrading in order to stabilize the upgraded heavy oil – which could mean that the cost of partial upgrading is not much reduced as compared to full upgrading. Therefore, the only choice currently is no upgrading or full upgrading. Other goals could be to achieve breakthroughs in upgrading technologies – such as non-thermal coking methods that would use far less energy or such as gasification at 800°C (1,470°F) which is far less than current commercial temperatures. The technology where changes do occur involves combustion of the oil in situ. The concept of any combustion technology requires that the oil be partially combusted and that thermal decomposition occurs to other parts of the oil. This is sufficient to cause irreversible chemical and physical changes to the oil to the extent that the product is markedly different to the oil in place. Recognition of this phenomenon is essential before combustion technologies are applied to oil recovery.

Although this improvement in properties may not appear to be too drastic, nevertheless it usually is sufficient to have major advantages for refinery operators. Any incremental increase in the units of hydrogen/carbon ratio can save amounts of costly hydrogen during upgrading. The same principles are also operative for reductions in the nitrogen, sulfur, and oxygen contents. This latter occurrence also improves catalyst life and activity as well as reduces the metals content.

In short, in situ recovery processes (although less efficient in terms of bitumen recovery relative to mining operations) may have the added benefit of *leaving* some of the more obnoxious constituents (from the processing objective) in the ground. Processes that offer the potential for partial upgrading during recovery are varied but usually follow a surface process. Not that this be construed as an easy task, there are many disadvantages that arise from attempting in situ upgrading.

Finally, there is not a single in situ recovery process that will be applicable to all reservoirs and no single recovery process will be able to access all the heavy oil in a given reservoir. To achieve maximum recovery, it will be necessary to apply a combination of different processes. For example, a steam-based recovery process followed by in situ combustion, followed by in situ upgrading, followed by bioconversion of the residual hydrocarbons. This type of sequential recovery will require careful planning to ensure that the optimum sequence and timing are applied. Then to achieve partial upgrading during recovery requires a further sequential operation before a transportable produced. A multi-step system is required to achieve the necessary aims of heavy oil recovery with partial upgrading. What this might be is currently unknown but there are possibilities.

Thus, a major decision at the time of recovery of heavy oil, extra-heavy oil, and tar sand bitumen, is to acknowledge the practical (or impractical) aspects of upgrading during recovery, partial upgrading at the surface, or full upgrading in a conversion refinery. For the purposes of this text only, upgrading in a conversion refinery has been assumed as the means of upgrading one or all of the three viscous feedstocks. As the amount of viscous components in a feedstock blend increases, the refining industry will become increasingly flexible with improved technologies and improved catalysts for refining these feedstock components. The main technological progress will be directed to viscous feedstock upgrading, cleaner transportation fuel production, and the integration of refining and petrochemical operations in the refinery (Speight, 2011a, 2019a). In fact, because of the changing nature (specifically, the composition) of refinery feedstocks, even the *tried and true processes* will see changes as they evolve.

Thermal processes (Chapter 2) will also evolve and become more efficient. While the current processes may not see much change in terms of reactor vessel configuration, there will be changes to the reactor internals and to the nature of the catalysts. For example, the *tried and true coking processes* will remain the mainstay of refineries coping with an influx of viscous feedstocks, but other process options will be used.

For example, visbreaking (or even hydrovisbreaking – i.e., visbreaking in an atmosphere of hydrogen or in the presence of a hydrogen-donor material) (Chapter 2), the long ignored step-child of the refining industry may see a surge in use as a pretreatment process for viscous feedstock upgrading. Management of the process to produce a liquid product that has been freed of the high potential for coke deposition (by taking the process parameters into the region where sediment forms) either in the absence or presence of (for example) a metal oxide scavenger could be valuable addition to catalyst cracking or hydrocracking units.

In the integration of refining and petrochemical operations, new technologies based on the traditional fluid catalytic cracking process will be of increased interests to refiners because of their potential to meet the increasing demand for low-boiling olefin derivatives (Parkash, 2003; Gary et al., 2007; Speight, 2014; Hsu and Robinson, 2017; Speight, 2017). Meanwhile, hydrocracking, due to its flexibility, will take the central position in the integration of refining and petrochemical businesses in the 21st century. Alternately, operating the catalytic cracking unit solely as a slurry riser cracker (without the presence of the main reactor) followed by separation of coke (sediment) would save the capital outlay required for a new catalytic cracker and might even show high conversion to valuable liquids. The quality (i.e., boiling range) of the distillate would be dependent upon the residence time of the slurry in the pipe.

Scavenger additives such as metal oxides may also see a surge in use. As a simple example, a metal oxide (such as calcium oxide) has the ability to react with sulfur-containing feedstock to produce a hydrocarbon (and calcium sulfide):

$$\text{Viscous feedstock}\,[S] + CaO \rightarrow \text{hydrocarbon product} + CaS + H_2O$$

Propane has been used extensively in deasphalting viscous feedstocks (Chapter 6), especially in the preparation of high-quality lubricating oils and feedstocks for catalytic cracking units (Parkash, 2003; Gary et al., 2007; Speight, 2014; Hsu and Robinson, 2017; Speight, 2017). The use of propane has necessitated elaborate solvent cooling systems utilizing cooling water, which is a relatively expensive cooling agent. In order to circumvent such technology, future viscous feedstock processing units will use solvent systems that will allow operation at elevated temperatures relative to conventional propane deasphalting temperatures, thereby permitting easy heat exchange. This will require changes to the solvent composition and the inclusion of solvents not usually considered to be deasphalting solvents. Furthermore, as a means of energy reduction for the process, in future deasphalting units, the conventional solvent recovery scheme will be retrofitted with supercritical solvent recovery scheme to reap benefits of higher energy efficiency. Other improvements will include

variations in the extraction column internals (Parkash, 2003; Gary et al., 2007; Speight, 2014; Hsu and Robinson, 2017; Speight, 2017).

The increasing focus to reduce sulfur content in fuels will assure that the role of *desulfurization* in the refinery increases in importance. Currently, the process of choice is the hydrotreater, in which hydrogen is added to the fuel to remove the sulfur from the fuel. Some hydrogen may be lost to reduce the octane number of the fuel, which is undesirable.

Because of the increased attention for fuel desulfurization, various new process-concepts are being developed with various claims of efficiency and effectiveness. The major developments in desulfurization three main routes will be (i) advanced hydrotreating such as the development and introduction of new catalysts, catalytic distillation, as well as processing at relatively mild conditions, (ii) reactive adsorption, depending upon the type of adsorbent used and the process design, and (iii) oxidative desulfurization, which involves catalyst design and process design (Parkash, 2003; Gary et al., 2007; Speight, 2014; Hsu and Robinson, 2017; Speight, 2017).

Viscous feedstock hydrotreating processes require considerably different catalysts and process flows, depending on the specific operation so that efficient hydroconversion through uniform distribution of liquid, hydrogen-rich gas, and catalyst across the reactor is assured. In addition to an increase in *guard bed* use, the industry will see an increase in automated demetallization of fixed-bed systems as well as more units that operate as ebullating-bed hydrocrackers (Parkash, 2003; Gary et al., 2007; Speight, 2014; Hsu and Robinson, 2017; Speight, 2017).

For viscous feedstock upgrading, hydrotreating technology and hydrocracking technology will be the processes of choice. For cleaner transportation fuel production, the main task is the desulfurization of gasoline and diesel. With the advent of various techniques, such as adsorption and biodesulfurization, the future development will be still centralized on HDS techniques (Parkash, 2003; Gary et al., 2007; Speight, 2014; Hsu and Robinson, 2017; Speight, 2017).

In fact, hydrocracking will continue to be an indispensable processing technology to modern petroleum refining and petrochemical industry due to its flexibility to feedstocks and product scheme, and high-quality products. Particularly, high-quality naphtha, jet fuel, diesel, and lube base oil can be produced through this technology. The hydrocracker provides a better balance of gasoline and distillates, improves gasoline yield, octane quality, and can supplement the fluid catalytic cracker to upgrade viscous feedstocks. In the hydrocracker, light fuel oil is converted into lighter products under a high hydrogen pressure and over a hot catalyst bed – the main products are naphtha, jet fuel, and diesel oil.

For the viscous feedstocks (and even for bio-feedstocks), which will increase in amounts in terms of hydrocracking feedstocks, reactor designs will continue to focus on online catalyst addition and withdrawal. Fixed-bed designs have suffered from (i) mechanical inadequacy when used for the heavier feedstocks and (ii) short catalyst lives – 6 months or less – even though large catalyst volumes are used (liquid hourly space velocity (LHSV) typically of 0.5–1.5). Refiners will attempt to overcome these short-comings by innovative designs, allowing better feedstock flow and catalyst utilization or online catalyst removal. For example, the on-stream catalyst replacement process, in which a lead, moving bed reactor is used to demetallized heavy feed ahead of the fixed-bed hydrocracking reactors will find increased use, but whether this will be adequate for continuous hydrocracking viscous feedstocks remains a question.

Catalyst development for the various catalytic and hydrogen-related processes will be key in the modification of processes and the development of new ones to make environmentally acceptable fuels. Innovations have already occurred in catalyst materials which have allowed refiners to vastly improve environmental performance, product quality and volume, feedstock flexibility, and energy management without fundamentally changing fixed capital stocks. Advanced design and manufacturing techniques mean that catalysts can now be formulated and manufactured for specific processing units, feedstocks, operating environments, and finished product slates.

The *panacea* (rather than a *Pandora's Box*) for viscous feedstocks could well be the *gasification refinery* (Speight, 2011a). Furthermore, the integration of gasification technology into

a refinery offers alternate processing options for viscous feedstocks. The refinery of the future will have a gasification section devoted to the conversion of coal and biomass to Fischer–Tropsch hydrocarbons – perhaps even with rich oil shale added to the gasifier feedstock. Many refineries already have gasification capabilities but the trend will increase to the point (over the next two decades) nearly all refineries feel the need to construct a gasification section to handle viscous feedstocks.

The demand for high-value petroleum products will maximize production of transportation fuels. Hydroprocessing viscous feedstocks will be widespread rather than appearing on selected refineries. At the same time, hydrotreated viscous feedstocks will be the common feedstocks for fluid catalytic cracking units – additional conversion capacity will be necessary to process increasingly heavier feedstocks. Other challenges facing the refining industry include its capital-intensive nature and dealing with the disruptions to business operations that are inherent in industry. It is imperative for refiners to raise their operations to new levels of performance. Merely extending current performance incrementally will fail to meet most company's performance goals.

To circumvent these issues, there may be no way out of energy production than to consorting alternative energy sources with petroleum, and not of opposing them. This leads to the concept of *alternative energy systems*, which is wider-ranging and more meaningful than *alternative energy sources*, because it relate to the actual transformation process of the global energy system. Alternative energy systems integrate petroleum with other energy sources and pave the way for new systems where *refinery flexibility* will be a key target, especially when related to the increased use of renewable energy sources.

REFERENCES

Castañeda, L.C., Muñoz, J.A.D., and Ancheyta, J. 2014. Current Situation of Emerging Technologies for Upgrading of Heavy Oils. *Catal. Today* 220–222: 248–273.

Davis, R.A., and Patel, N.M. 2004. Refinery Hydrogen Management. *Pet. Technol. Q.* Spring: 29–35.

Ditman, J.G. 1973. Solvent Deasphalting. *Hydrocarbon Process.* 52(5): 110.

Dunning, H.N., and Moore, J.W. 1957. Propane Removes Asphalts from Crudes. *Pet. Refin.* 36(5): 247–250.

Gary, J.H., Handwerk, G.E., and Kaiser, M.J. 2007. *Petroleum Refining: Technology and Economics*, 5th Edition. CRC Press, Taylor & Francis Group, Boca Raton, FL.

Hart, A. 2014. A Review of Technologies for Transporting Heavy Crude Oil and Bitumen via Pipelines. *J. Pet. Explor. Prod. Technol.* 4: 327–336.

Hedrick, B.W., Seibert, K.D., and Crewe, C. 2006. A New Approach to Heavy Oil and Bitumen Upgrading. Report No. AM-06–29. UOP LLC, Des Plaines. IL.

Hsu, C.S., and Robinson, P.R. (Editors). 2017. *Handbook of Petroleum Technology.* Springer International Publishing AG, Cham, Switzerland.

Parkash, S. 2003. *Refining Processes Handbook.* Gulf Professional Publishing, Elsevier, Amsterdam, Netherlands.

Speight, J.G. 2011a. *An Introduction to Petroleum Technology, Economics, and Politics.* Scrivener Publishing, Salem, MA.

Speight, J.G. 2011b. *The Refinery of the Future.* Gulf Professional Publishing, Elsevier, Oxford, United Kingdom.

Speight, J.G. 2013. *Heavy and Extra Heavy Oil Upgrading Technologies.* Gulf Professional Publishing, Elsevier, Oxford, United Kingdom.

Speight, J.G. 2014. *The Chemistry and Technology of Petroleum*, 5th Edition. CRC Press, Taylor & Francis Publishers, Boca Raton, FL.

Speight, J.G. 2016. *Introduction to Enhanced Recovery Methods for Heavy Oil and Tar Sands*, 2nd Edition. Gulf Publishing Company, Elsevier, Waltham, MA.

Speight, J.G. 2017. *Handbook of Petroleum Refining.* CRC Press, Taylor & Francis Publishers, Boca Raton, FL.

Speight, J.G. 2019a. *Handbook of Petrochemical Processes.* CRC Press, Taylor & Francis Group, Boca Raton, FL.

Speight, J.G. 2019b. *Heavy Oil Recovery and Upgrading.* Gulf Publishing Company, Elsevier, Cambridge, MA.

Villasana, Y., Luis-Luis, M.A., Méndez, F.J., Labrador, H., and Brito, J.L. 2015. Upgrading and Hydrotreating Heavy Oils and Residua. *Energy Science and Technology. Volume 3: Oil and Natural Gas.* Sharma, U.C., Prasad, R., and Sivakumar, S. (Editors). Studium Press, Houston, TX, Chapter 9.

7 Feedstock Chemistry in the Refinery

7.1 INTRODUCTION

Crude oil is rarely used in its raw form but must instead be processed into its various products, generally as a means of forming products with hydrogen content different from that of the original feedstock. Thus, the chemistry of the refining process is concerned primarily with the production not only of better products but also of salable materials and is dictated by the type of reactor, the reactor parameters, and the properties of the feedstocks.

Crude oil and the viscous feedstocks (such as heavy crude oil, extra-heavy crude oil, tar sand bitumen, and crude oil residua) contain many thousands of different compounds that vary in molecular weight from methane (CH_4, molecular weight: 16) to more than 2,000 (Speight, 1994, 2014). This broad range in molecular weights results in boiling points that range from −160°C (−288°F) to temperatures on the order of nearly 1,100°C (2,000°F). Many of the constituents of crude oil are paraffins. Remembering that the word *paraffin* was derived from the Latin *parum affinis* meaning *little affinity* or *little reactivity*, it must have come as a great surprise that hydrocarbon derivatives, paraffins included can undergo a diversity of reactions thereby influencing the chemistry of refining depending upon the source of the crude oil (Smith, 1994; Laszlo, 1995; Yen, 1998).

Understanding refining chemistry not only allows an explanation of the means by which these products can be formed from crude oil but also offers a chance of predictability. This is very necessary when the different types of crude oil accepted by refineries are considered. And the major processes by which these products are produced from crude oil constituents involve thermal decomposition.

There are various theories relating to the thermal decomposition of organic molecules, and this area of crude oil technology has been the subject of study for several decades (Hurd, 1929; Fabuss et al., 1964; Fitzer et al., 1971). The relative reactivity of crude oil constituents can be assessed on the basis of bond energies but the thermal stability of an organic molecule is dependent upon the bond strength of the weakest bond. And even though the use of bond energy data is a method for predicting the reactivity or the stability of specific bonds under designed conditions, the reactivity of a particular bond is also subject to its environment. Thus, it is not only the reactivity of the constituents of crude oil that are important in processing behavior, but it is also the stereochemistry of the constituents as they relate to one another that is also of some importance (Speight, 2014). It must be appreciated that the stereochemistry of organic compounds is often a major factor in determining reactivity and properties.

In the present context, it is necessary to recognize that (*parum affinis* or not) most hydrocarbon derivatives decompose thermally at temperatures above approximately 650°F (340°C), so the high-boiling points of many crude oil constituents cannot be measured directly and must be estimated from other measurements. And in the present context, it is as well that hydrocarbon derivatives decompose at elevated temperatures. Thereby lies the route to many modern products. For example, in a crude oil refinery, the highest value products are transportation fuels: (i) gasoline – boiling range: 35°C–220°C, 95°F–425°F, (ii) jet fuel – boiling range 175°C–290°C, 350°F–550°F, and (iii) diesel fuel, boiling range 175°C–370°C, 350°F–700°F. These boiling ranges are not always precise to the degree and are subject to variation and depend upon the process used for their production. In winter, gasoline will typically (in cold regions) have butane added to the mix (to facilitate cold starting), thereby changing the boiling range to 0°C–220°C (32°F–425°F). The fuels are produced by thermal decomposition of a variety of hydrocarbon derivatives, high-molecular-weight

paraffins included. Less than one-third of a typical crude oil distills in these ranges and thus the goal of refining chemistry might be stated simply as the methods by which crude oil is converted to these fuels. It must be recognized that refining involves a wide variety of chemical reactions but the production of liquid fuels is the focus of a refinery.

Refining processes involve the use of various thermal and catalytic processes to higher-molecular-weight constituents to lower-boiling products (Parkash, 2003; Gary et al., 2007; Speight, 2014; Hsu and Robinson, 2017; Speight, 2017). This efficiency translates into a strong economic advantage, leading to widespread use of conversion processes in refineries today. However, in order to understand the principles of catalytic cracking, understanding the principles of adsorption and reaction on solid surfaces is valuable (Samorjai, 1994; Masel, 1995)

A refinery is a complex network of integrated unit processes for the purpose of producing a variety of products from crude oil (Chapter 4) (Parkash, 2003; Gary et al., 2007; Speight, 2014; Hsu and Robinson, 2017; Speight, 2017). Refined products establish the order in which the individual refining units will be introduced, and the choice from among several types of units and the size of these units is dependent upon economic factors. The trade-off among product types, quantity, and quality influences the choice of one kind of processing option over another.

Each refinery has its own range of preferred crude oil feedstock from which a desired distribution of products is obtained. Nevertheless, refinery processes can be divided into three major types:

1. *Separation*: division of crude oil into various streams (or fractions) depending on the nature of the crude material.
2. *Conversion*: production of salable materials from crude oil, usually by skeletal alteration, or even by alteration of the chemical type, of the crude oil constituents.
3. *Finishing*: purification of various product streams by a variety of processes that essentially remove impurities from the product; for convenience, processes that accomplish molecular alteration, such as *reforming*, are also included in this category.

The *separation* and *finishing* processes may involve distillation or even treatment with a *wash* solution, either to remove impurities or, in the case of distillation, to produce a material boiling over a narrower range and the chemistry of these processes can be represented by simple equations, even to the disadvantage of over-simplification of the process (Speight, 2014). The inclusion of reforming processes in this category is purely for descriptive purposes rather than being representative of the chemistry involved. Reforming processes produce streams that allow the product to be *finished* as the term applies to product behavior and utility.

Conversion processes are, in essence, processes that change the number of carbon atoms per molecule, alter the molecular hydrogen-to-carbon ratio, or change the molecular structure of the material without affecting the number of carbon atoms per molecule. These latter processes (*isomerization processes*) essentially change the shape of the molecule(s) and are used to improve the quality of the product (Speight, 2014).

Nevertheless, the chemistry of conversion process may be quite complex (King et al., 1973), and an understanding of the chemistry involved in the conversion of a crude oil to a variety of products is essential to an understanding of refinery operations. It is therefore the purpose of this chapter to serve as an introduction to the chemistry involved in these conversion processes so that the subsequent chapters dealing with refining are easier to visualize and understand. However, understanding refining chemistry from the behavior of model compounds – even under refining conditions – is not as straightforward as it may appear.

The complexity of the individual reactions occurring in an extremely complex mixture and the *interference* of the products with those from other components of the mixture is unpredictable. Or the *interference* of secondary and tertiary products with the course of a reaction and, hence, with the formation of primary products may also be cause for concern. Hence, caution is advised when

applying the data from model compound studies to the behavior of crude oil, especially the molecularly complex viscous feedstocks. These have few, if any, parallels in organic chemistry.

As a brief introduction to the subject, in the process of thermal cracking, catalytic cracking or hydrocracking, the high-molecular-weight constituents of the feedstock decomposed to produce (i) gases, such as methane (CH_4), ethane (CH_3CH_3), ethylene ($CH_2=CH_2$), propane ($CH_3CH_2CH_3$), propylene ($CH_3CH=CH_2$), butane ($CH_3CH_2CH_2CH_3$), and the butylene isomers ($CH_3CH_2CH=CH_2$, $CH_3CH=CHCH_3$), all of which can be used as feedstocks for petrochemicals production, (ii) lower molecular weight more volatile liquids of which naphtha (a precursor to gasoline) is an example, (iii) middle boiling-range liquids of which kerosene is an example and which is used in diesel fuel, (iv) low-boiling and high-boiling gas oils which are used to produce the various grades of fuel oil, and (v) coke, which is a solid carbonaceous product that can be used as a refinery fuel or in a gasification process to produce synthesis gas (Parkash, 2003; Gary et al., 2007; Speight, 2014; Hsu and Robinson, 2017; Speight, 2017, 2019, 2020).

The first thermal cracking process – the Burton Process – came into use in 1913. Various improvements to the process were introduced into the 1920s. In 1936, the first catalytic cracking process – the Houdry process – went on stream. The catalytic cracking process was improved in the 1940s with the use of fluidized or moving beds of powdered catalyst to produce high-octane liquids. During the 1950s, as demand for automobile and jet fuel increased, the hydrocracking process developed was applied to petroleum refining. The process employs hydrogen gas to improve the hydrogen–carbon ratio in the products and to arrive at a broader range of end products.

Understanding refining chemistry not only allows an explanation of the means by which products can be formed from various feedstocks but also offers a chance of process predictability. This is very necessary when the different types of feedstocks crude oil accepted by refineries are considered. However, the complexity of the individual reactions occurring in an extremely complex mixture and the *interference* of the products with those from other components of the mixture is unpredictable. Or the *interference* of secondary and tertiary products with the course of a reaction and, hence, with the formation of primary products may also be cause for concern. Hence, caution is advised when applying the data from model compound studies to the behavior of petroleum, especially the molecularly complex viscous feedstocks. These have few, if any, parallels in organic chemistry.

This chapter presents an introduction to refining chemistry in order for the reader to place each refinery process in the correct context of the refinery, especially when feedstock blends containing viscous feedstock components are the refinery feedstocks. However, not all possible refinery chemistry is included, and the chapter focuses on the chemistry of those processes that are applicable to viscous feedstocks such as (i) thermal processes, which involves the chemistry of thermal decomposition or cracking, (ii) catalytic processes, which involves the chemistry of thermal decomposition in the presence of or initiated by a catalyst, and (iii) hydroprocesses, which involves the chemistry of thermal decomposition in the presence of hydrogen or thermal decomposition in the presence of or initiated by a catalyst.

The chemistry of other processes such as reforming processes, isomerization processes, alkylation processes, polymerization processes, and dewaxing processes is not included here since the chemistry of these processes falls under the general umbrella of the chemistry involved in the so-called finishing processes insofar as the processes are typically applied to the products of the initial stages of refining and prepares the various products to meet the specifications for sale.

7.2 CRACKING CHEMISTRY

The term *cracking* applies to the decomposition of crude oil constituents that is induced by elevated temperatures (typically >350°C, >660°F, although thermal decomposition at lower temperatures does occur and is subject to the composition and properties of the feedstock) whereby the

higher-molecular-weight constituents of crude oil are converted to lower-molecular-weight products. Cracking reactions involve carbon–carbon bond rupture and are thermodynamically favored at high temperature.

7.2.1 THERMAL CRACKING

With the dramatic increases in the number of gasoline-powered vehicles, distillation processes (Chapters 4 and 7) were not able to completely fill the increased demand for gasoline. In 1913, the *thermal cracking process* was developed and is the phenomenon by which higher-boiling (higher-molecular-weight) constituents in crude oil are converted into lower-boiling (lower-molecular-weight) products at elevated temperatures (usually on the order of >350°C, >660°F).

Thermal cracking is the oldest and in principle the simplest refinery conversion process. The temperature and pressure depend on the type of feedstock and the product requirements as well as the residence time. Thermal cracking processes allow the production of lower-molecular-weight products such as the constituents of liquefied petroleum gas (LPG) and naphtha/gasoline constituents from higher-molecular-weight feedstocks such as the viscous feedstocks. The simplest thermal cracking process – the visbreaking process – is used to upgrade fractions such as viscous feedstocks to produce fuel oil that meets specifications or feedstocks for other refinery processes (Parkash, 2003; Gary et al., 2007; Speight, 2014; Hsu and Robinson, 2017; Speight, 2017).

, Thus, cracking is a phenomenon by which higher-boiling constituents (higher-molecular-weight constituents) in crude oil are converted into lower-boiling (lower-molecular-weight) products. However, certain products may interact with one another to yield products having higher molecular weights than the constituents of the original feedstock.

In thermal cracking processes, some of the lower-molecular-weight products are expelled from the system as gases, gasoline-range materials, kerosene-range materials, and the various intermediates that produce other products such as coke. Materials that have boiling ranges higher than gasoline and kerosene may (depending upon the refining options) be referred to as *recycle* stock, which is recycled in the cracking equipment until conversion is complete.

7.2.1.1 General Chemistry

Thermal cracking is a *free radical* chain reaction. A free radical (in which an atom or group of atoms possessing an unpaired electron) is very reactive (often difficult to control) and it is the mode of reaction of free radicals that determines the product distribution during thermal cracking (i.e., non-catalytic thermal decomposition). In addition, a significant feature of hydrocarbon free radicals is the resistance to isomerization during the existence of the radical. For example, thermal cracking does not produce any degree of branching in the products (by migration of an alkyl group) other than that already present in the feedstock. Nevertheless, the classical chemistry of free radical formation and behavior involves the following chemical reactions – it can only be presumed that the formation of free radicals during thermal (non-catalytic) cracking follows similar paths: (i) initiation, (ii) free radical reactions, and (iii) termination.

In the initiation stage, a single molecule breaks apart into two free radicals. Only a small fraction of the feedstock constituents may actually undergo initiation, which involves breaking the bond between two carbon atoms, rather than the thermodynamically stronger bond between a carbon atom and a hydrogen atom.

$$CH_3CH_3 \rightarrow 2CH_3{}^{\bullet}$$

In the free radical stage, several reactions can occur. For example, hydrogen abstraction in which the free radical abstracts a hydrogen atom from another molecule:

$$CH_3{}^{\bullet} + CH_3CH_3 \rightarrow CH_4 + CH_3CH_2{}^{\bullet}$$

This can be followed by a radical decomposition reaction in which a free radical decomposes into an alkene or by a radical addition reaction in which a radical reacts with an alkene to form a single, larger free radical:

$$CH_3CH_2^{\bullet} \rightarrow CH_2 = CH_2 + H^{\bullet}$$

$$CH_3CH_2^{\bullet} + CH_2 = CH_2 \rightarrow CH_3CH_2CH_2CH_2^{\bullet}$$

The final stage is the termination reaction in which two free radicals react with each other to produce the products – two common forms of termination reactions are *recombination reactions* (in which two radicals combine to form one molecule) and *disproportionation reactions* (in which one free radical transfers a hydrogen atom to the other to produce an alkene and an alkane):

$$CH_3^{\bullet} + CH_3CH_2^{\bullet} \rightarrow CH_3CH_2CH_3$$

$$CH_3CH_2^{\bullet} + CH_3CH_2^{\bullet} \rightarrow CH_2 = CH_2 + CH_3CH_3$$

The smaller free radicals, hydrogen, methyl, and ethyl are more stable than the larger radicals. They will tend to capture a hydrogen atom from another hydrocarbon, thereby forming a saturated hydrocarbon and a new radical. In addition, many thermal cracking processes and many different chemical reactions occur simultaneously. Thus, an accurate explanation of the mechanism of the thermal cracking reactions is difficult. The primary reactions are the decomposition of higher-molecular-weight species into lower-molecular-weight products.

As the molecular weight of the hydrocarbon feedstock increases, the reactions become much more complex leading to a wider variety of products. For example, using a more complex hydrocarbon (dodecane, $C_{12}H_{26}$) as the example, two general types of reactions occur during cracking: (i) primary reactions and (ii) secondary reactions.

In the primary reactions, the decomposition of high-molecular-weight constituents occurs with the production of lower-molecular-weight products:

$$CH_3 (CH_2)_{10} CH_3 \rightarrow CH_3 (CH_2)_8 CH_3 + CH_2 = CH_2$$

$$CH_3 (CH_2)_{10} CH_3 \rightarrow CH_3 (CH_2)_7 CH_3 + CH_2 = CHCH_3$$

$$CH_3 (CH_2)_{10} CH_3 \rightarrow CH_3 (CH_2)_6 CH_3 + CH_2 = CHCH_2CH_3$$

$$CH_3 (CH_2)_{10} CH_3 \rightarrow CH_3 (CH_2)_5 CH_3 + CH_2 = CH(CH_2)_2 CH_3$$

$$CH_3 (CH_2)_{10} CH_3 \rightarrow CH_3 (CH_2)_4 CH_3 + CH_2 = CH(CH_2)_3 CH_3$$

$$CH_3 (CH_2)_{10} CH_3 \rightarrow CH_3 (CH_2)_3 CH_3 + CH_2 = CH(CH_2)_4 CH_3$$

$$CH_3 (CH_2)_{10} CH_3 \rightarrow CH_3 (CH_2)_2 CH_3 + CH_2 = CH(CH_2)_5 CH_3$$

$$CH_3 (CH_2)_{10} CH_3 \rightarrow CH_3CH_2CH_3 + CH_2 = CH(CH_2)_6 CH_3$$

$$CH_3 (CH_2)_{10} CH_3 \rightarrow CH_3CH_3 + CH_2 = CH(CH_2)_7 CH_3$$

$$CH_3 (CH_2)_{10} CH_3 \rightarrow CH_4 + CH_2 = CH(CH_2)_8 CH_3$$

In the secondary reaction stage, there are reactions by which some of the primary products interact to form higher-molecular-weight materials (secondary reactions):

$$CH_2 = CH_2 + CH_2 = CH_2 \rightarrow CH_3CH_2CH=CH_2$$

$$RCH=CH_2 + R^1CH=CH_2 \rightarrow cracked\ residuum + coke + other\ products$$

Thus, from the chemistry of the thermal decomposition of pure compounds (and assuming little interference from other molecular species in the reaction mixture), it is difficult but not impossible

to predict the product types that arise from the thermal cracking of various feedstocks. However, during thermal cracking, all of the reactions illustrated above can and do occur simultaneously and to some extent are uncontrollable. However, one of the significant features of hydrocarbon free radicals is their resistance to isomerization, for example, migration of an alkyl group and, as a result, thermal cracking does not produce any degree of branching in the products other than that already present in the feedstock. The data do indicate certain decomposition characteristics that permit predictions to be made of the product types that arise from the thermal cracking of various feedstocks. For example, normal paraffins are believed to form, initially, higher-molecular-weight material, which subsequently decomposes as the reaction progresses. Other paraffinic materials and (terminal) olefins are produced. An increase in pressure inhibits the formation of low-molecular-weight gaseous products and therefore promotes the formation of higher-molecular-weight materials.

Furthermore, for saturated hydrocarbon derivatives, the connecting link between gas-phase pyrolysis and liquid-phase thermal degradation is the concentration of alkyl radicals. In the gas phase, alkyl radicals are present in low concentration and undergo unimolecular radical decomposition reactions to form α-olefins and smaller alkyl radicals. In the liquid phase, alkyl radicals are in much higher concentration and prefer hydrogen abstraction reactions to radical decomposition reactions. It is this preference for hydrogen abstraction reactions that gives liquid-phase thermal degradation a broad product distribution.

Branched paraffins react somewhat differently to the normal paraffins during cracking processes and produce substantially higher yields of olefins having one fewer carbon atom that the parent hydrocarbon. Cycloparaffins (naphthenes) react differently to their non-cyclic counterparts and are somewhat more stable. For example, cyclohexane produces hydrogen, ethylene, butadiene, and benzene: Alkyl-substituted cycloparaffins decompose by means of scission of the alkyl chain to produce an olefin and a methyl or ethyl cyclohexane.

The aromatic ring is considered fairly stable at moderate cracking temperatures ($350°C–500°C$, $660°F–930°F$). Alkylated aromatics, like the alkylated naphthenes, are more prone to dealkylation that to ring destruction. However, ring destruction of the benzene derivatives occurs above $500°C$ ($930°F$), but condensed aromatics may undergo ring destruction at somewhat lower temperatures ($450°C$, $840°F$).

Generally, the relative ease of cracking of the various types of hydrocarbon derivatives *of the same molecular weight* is given in the following descending order: (i) paraffins, (ii) olefins, (iii) naphthenes, (iv) aromatics. To remove any potential confusion, paraffins are the least stable and aromatics are the most stable.

Within any type of hydrocarbon, the higher-molecular-weight hydrocarbon derivatives tend to crack easier than the lighter ones. Paraffins are by far the easiest hydrocarbon derivatives to crack with the rupture most likely to occur between the first and second carbon bonds in the lighter paraffins. However, as the molecular weight of the paraffin molecule increases rupture tends to occur nearer the middle of the molecule. The main secondary reactions that occur in thermal cracking are polymerization and condensation.

Two extremes of the thermal cracking in terms of product range are represented by high-temperature processes: (i) steam cracking or (ii) pyrolysis. Steam cracking is a process in which feedstock is decomposed into lower-molecular-weight (often unsaturated) products and saturated hydrocarbon derivatives. In the process, a gaseous or liquid hydrocarbon feed like such as ethane or naphtha is diluted with steam and briefly heated in a furnace (at approximately $850°C$, $1,560°F$) in the absence of oxygen at a short residence time (often on the order of milliseconds). After the cracking temperature has been reached, the products are rapidly quenched in a heat exchanger. The products produced in the reaction depend on the composition of the feedstock, the feedstock/steam ratio, the cracking temperature, and the residence time. Pyrolysis processes require temperatures on the order of $750°C–900°C$ ($1,380°F–1,650°F$) to produce high yields of low-molecular-weight products, such as ethylene, for petrochemical use. Delayed coking, which uses temperature on the order of $500°C$

(930°F) is used to produce distillates from viscous feedstocks as well as coke for fuel and other uses – such as the production of electrodes for the steel and aluminum industries.

7.2.1.2 Asphaltene Chemistry

The viscous feedstocks contain substantial amounts of heptane-insoluble asphaltene constituents and resin constituents that, because of the content of polynuclear aromatic compounds and polar functionalities, provide hurdles to conversion. The high thermal stability of polynuclear aromatic systems prevents thermal decomposition to lower-boiling point products and usually results in the production of substantial yields of thermal coke. Furthermore, the high concentrations of heteroatom compounds (nitrogen, oxygen, sulfur) and metals (vanadium and nickel) in viscous feedstocks have an adverse effect on catalysts. Therefore, process choice often favors thermal process but catalytic processes can be used as long as catalyst replacement and catalyst regeneration is practiced.

Asphaltene constituents and, to a lesser extent, resin constituents can cause major problems in refineries through unanticipated coke formation and/or through excessive coke formation. Recognition of this is a step in the direction of mitigating the problem, and improvement in heavy feedstock conversion may be sought through the use of specific chemical additives. However, to improve the conversion of heavy feedstocks, it is necessary to understand the chemistry of conversion.

The thermal decomposition of the more complex asphaltene constituents has received some attention (Magaril and Akensova, 1967, 1968; Magaril and Ramazaeva, 1969; Magaril and Aksenova, 1970a,b; Magaril et al., 1970, 1971; Magaril and Aksenova, 1972; Schucker and Keweshan, 1980; Speight, 2014). The thermal reaction is believed to be first-order although there is the potential that it is, in fact, a multi-order reaction process but because of the multiplicity of the reactions that occur, it appears as a pseudo-first-order process. However, it is definite that there is an induction period before coke begins to form that seems to be triggered by phase separation of reacted asphaltene product (Magaril and Akensova, 1967, 1968; Magaril and Ramazaeva, 1969; Magaril and Aksenova, 1970a,b; Magaril et al., 1970, 1971; Magaril and Aksenova, 1972; Speight, 1987, 2014, 2015). It is during this induction that the key may be found for coke reduction or even a complete absence of coke formation. For example, if the chemistry is understood in detail, it may be possible to modify the chemistry that occurs during the induction period so that the coke precursors are converted to lower-molecular-weight species that appear in the product rather than undergo phase separation as the initial period of coke formation. The use of hydrogen is an obvious answer to a reduction in coke formation but there may be other ways through a detailed knowledge of the chemistry that occurs during the induction period.

In the scheme, the chemistry of asphaltene coking has been suggested to involve the thermolysis of thermally labile bonds to form reactive species that react with each other (*condensation*) to form coke. However, not all the original aromatic carbon in the asphaltene constituents forms coke. Volatile aromatic species are eliminated during thermal decomposition, and it must be assumed that some of the original aliphatic carbon plays a role in coke formation.

It is more likely that the initial reactions of asphaltene constituents involve thermolysis of pendant alkyl chains to form lower-molecular-weight higher polar species that are often referred to as carbenes and carboids (Chapters 2 and 3) which then react to form coke. The reactions involve unimolecular thermolysis of aromatic-alkyl systems of the asphaltene constituents to produce volatile species (paraffins and olefins) and nonvolatile species (aromatics) (Speight, 1987, 1994; Schabron and Speight, 1997).

It is also interesting to note that although the aromaticity of the resin and asphaltene constituents is approximately equivalent to the yield of thermal coke, not all the original aromatic carbon in the asphaltene constituents forms coke. Volatile aromatic species are eliminated during thermal decomposition, and it must be assumed that some of the original aliphatic carbon plays a role in coke formation. Its precise nature has yet to be determined, but the process can be represented as involving a multi-reaction process involving series and parallel reactions (Speight, 2014).

As examples of thermal cracking, in the delayed coking process, the feedstock is heated to high temperatures (480°C–500°C; 895°F–930°F) in a furnace and then the reaction is allowed to continue in a cylindrical, insulated drum. The volatile products pass overhead into a fractionator and coke accumulates in the drum. Any high-boiling liquid product from the fractionator is recycled to the coker furnace. When the drum fills up with coke, the reacting feedstock is directed to a second drum. The coke is removed from the first drum by hydraulic drilling and cutting after which the drum is ready for the next 16–24 hour reaction cycle. During this process, the asphaltene and resin constituents in the feedstock are converted to coke in accordance with their respective value from the carbon residue standard test method (approximately 45% w/w–50% w/w for the asphaltene fraction and approximately 33% w/w–38% w/w for resin constituents) (Speight, 2014, 2015, 2017).

Nitrogen species also appear to contribute to the pattern of the thermolysis insofar as the carbon-carbon bonds adjacent to ring nitrogen undergo thermolysis quite readily (Fitzer et al., 1971; Speight, 1998). Thus, the initial reactions of asphaltene decomposition involve thermolysis of aromatic–alkyl bonds that are enhanced by the presence of heterocyclic nitrogen (Speight, 1987). Thus, the molecular species within the asphaltene fraction, which contain nitrogen and other heteroatoms (and have lower volatility than the pure hydrocarbon derivatives), are the prime movers in the production of coke (Speight, 1987). Such species, containing various polynuclear aromatic systems, can be denuded of the attendant hydrocarbon moieties and are undoubtedly insoluble (Bjorseth, 1983; Dias, 1987, 1988) in the surrounding hydrocarbon medium. The next step is gradual carbonization of these heteroatom-rich entities to form coke.

Thus, coke formation is a complex thermal process involving both chemical reactions and thermodynamic behavior. The challenges that face process chemistry and physics are determining (i) the means by which crude oil constituents thermally decompose, (ii) the nature of the products of thermal decomposition, (iii) the subsequent decomposition of the *primary* thermal products, (iv) the interaction of the products with each other, (v) the interaction of the products with the original constituents, and (vi) the influence of the products on the composition of the liquids.

The goal is to mitigate coke formation by elimination or modification of the prime chemical reactions in the formation of incompatible products during the processing of feedstocks containing asphaltene constituents, particularly those reactions in which the insoluble lower-molecular-weight products (*carbenes* and *carboids*) (Chapter 3) are formed (Speight, 1987, 1992, 2014, 2017).

7.2.2 CATALYTIC CRACKING

Catalytic cracking is the thermal decomposition of crude oil constituents in the presence of a catalyst (Pines, 1981). Thermal cracking has been superseded by catalytic cracking as the process for gasoline manufacture. Indeed, gasoline produced by catalytic cracking is richer in branched paraffins, cycloparaffins, and aromatics, which all serve to increase the quality of the gasoline. Catalytic cracking also results in production of the maximum amount of butene derivatives and butane derivatives (C_4H_8 and C_4H_{10}) rather than production of ethylene and ethane (C_2H_4 and C_2H_6).

Catalytic cracking processes evolved in the 1930s from research on crude oil and coal liquids. The crude oil work came to fruition with the invention of acid cracking. The work to produce liquid fuels from coal, most notably in Germany, resulted in metal sulfide hydrogenation catalysts. In 1930, a catalytic cracking catalyst for crude oil that used solid acids as catalysts was developed using acid-treated clay minerals. Clay minerals are a family of crystalline aluminosilicate solids, and the acid treatment develops acidic sites by removing aluminum from the structure. The acid sites also catalyze the formation of coke, and Houdry developed a moving bed process that continuously removed the cooked beads from the reactor for regeneration by oxidation with air.

Although thermal cracking is a free radical (neutral) process, catalytic cracking is an ionic process involving carbonium ions, which are hydrocarbon ions having a positive charge on a carbon

atom. The formation of carbonium ions during catalytic cracking can occur by: (i) addition of a proton from an acid catalyst to an olefin and/or (ii) abstraction of a hydride ion (H⁻) from a hydrocarbon by the acid catalyst or by another carbonium ion. However, carbonium ions are not formed by cleavage of a carbon–carbon bond.

In essence, the use of a catalyst permits alternate routes for cracking reactions, usually by lowering the free energy of activation for the reaction. The acid catalysts first used in catalytic cracking were amorphous solids composed of approximately 87% silica (SiO_2) and 13% alumina (Al_2O_3) and were designated low-alumina catalysts. However, this type of catalyst is now being replaced by crystalline aluminosilicates (zeolites) or molecular sieves.

The first catalysts used for catalytic cracking were acid-treated clay minerals, formed into beads. In fact, clay minerals are still employed as a catalyst in some cracking processes (Speight, 2014). Clay minerals are a family of crystalline aluminosilicate solids, and the acid treatment develops acidic sites by removing aluminum from the structure. The acid sites also catalyze the formation of coke, and the development of a moving bed process that continuously removed the cooked beads from the reactor reduced the yield of coke; clay regeneration was achieved by oxidation with air.

Clays are natural compounds of silica and alumina, containing major amounts of the oxides of sodium, potassium, magnesium, calcium, and other alkali and alkaline earth metals. Iron and other transition metals are often found in natural clays, substituted for the aluminum cations. Oxides of virtually every metal are found as impurity deposits in clay minerals.

Clay minerals are layered crystalline materials. They contain large amounts of water within and between the layers (Keller, 1985). Heating the clays above 100°C can drive out some or all of this water; at higher temperatures, the clay structures themselves can undergo complex solid-state reactions. Such behavior makes the chemistry of clays a fascinating field of study in its own right. Typical clays include kaolinite, montmorillonite, and illite (Keller, 1985). They are found in most natural soils and in large, relatively pure deposits, from which they are mined for applications ranging from adsorbents to paper making.

Once the carbonium ions are formed, the modes of interaction constitute an important means by which product formation occurs during catalytic cracking. For example, isomerization either by hydride ion shift or by methyl group shift, both of which occur readily. The trend is for stabilization of the carbonium ion by *movement* of the charged carbon atom toward the center of the molecule, which accounts for the isomerization of α-olefins to internal olefins when carbonium ions are produced. Cyclization can occur by internal addition of a carbonium ion to a double bond which, by continuation of the sequence, can result in aromatization of the cyclic carbonium ion.

Like the paraffins, naphthenes do not appear to isomerize before cracking. However, the naphthenic hydrocarbon derivatives (from C_9 upward) produce considerable amounts of aromatic hydrocarbon derivatives during catalytic cracking. Reaction schemes similar to that outlined here provide possible routes for the conversion of naphthenes to aromatics. Alkylated benzenes undergo nearly quantitative dealkylation to benzene without apparent ring degradation below 500°C (930°F). However, polymethyl benzene derivatives undergo disproportionation and isomerization with very little benzene formation.

Catalytic cracking can be represented by simple reaction schemes. However, questions have arisen as to how the cracking of paraffins is initiated. Several hypotheses for the initiation step in catalytic cracking of paraffins have been proposed (Cumming and Wojciechowski, 1996). The Lewis site mechanism is the most obvious, as it proposes that a carbenium ion is formed by the abstraction of a hydride ion from a saturated hydrocarbon by a strong Lewis acid site: a tricoordinated aluminum species. On Brønsted sites, a carbenium ion may be readily formed from an olefin by the addition of a proton to the double bond or, more rarely, via the abstraction of a hydride ion from paraffin by a strong Brønsted proton. This latter process requires the formation of hydrogen as an initial product. This concept was, for various reasons that are of uncertain foundation, often neglected.

It is therefore not surprising that the earliest cracking mechanisms postulated that the initial carbenium ions are formed only by the protonation of olefins generated either by thermal cracking or present in the feed as an impurity. For a number of reasons, this proposal was not convincing, and in the continuing search for initiating reactions, it was even proposed that electrical fields associated with the cations in the zeolite are responsible for the polarization of reactant paraffins, thereby activating them for cracking. More recently, however, it has been convincingly shown that a penta-coordinated carbonium ion can be formed on the alkane itself by protonation, if a sufficiently strong Brønsted proton is available (Cumming and Wojciechowski, 1996).

Coke formation is considered, with just cause to a malignant side reaction of normal carbenium ions. However, while chain reactions dominate events occurring on the surface and produce the majority of products, certain less desirable bimolecular events have a finite chance of involving the same carbenium ions in a bimolecular interaction with one another. Of these reactions, most will produce a paraffin and leave carbene/carboid-type species on the surface. This carbene/carboid-type species can produce other products but the most damaging product will be one which remains on the catalyst surface and cannot be desorbed and results in the formation of coke, or remains in a non-coke form but effectively blocks the active sites of the catalyst.

A general reaction sequence for coke formation from paraffins involves oligomerization, cyclization, and dehydrogenation of small molecules at active sites within zeolite pores:

Alkanes → alkenes

Alkenes → oligomers

Oligomers → naphthenes

Naphthenes → aromatics

Aromatics → coke

Whether or not these are the true steps to coke formation can only be surmised. The problem with this reaction sequence is that it ignores sequential reactions in favor of consecutive reactions. And it must be accepted that the chemistry leading up to coke formation is a complex process, consisting of many sequential and parallel reactions.

There is a complex and little understood relationship between coke content, catalyst activity, and the chemical nature of the coke. For instance, the atomic hydrogen/carbon ratio of coke depends on how the coke was formed; its exact value will vary from system to system (Cumming and Wojciechowski, 1996). And it seems that catalyst decay is not related in any simple way to the hydrogen-to-carbon atomic ratio of the coke, or to the total coke content of the catalyst, or any simple measure of coke properties. Moreover, despite many and varied attempts, there is currently no consensus as to the detailed chemistry of coke formation. There is, however, much evidence and a good reason to believe that catalytic coke is formed from carbenium ions which undergo addition, dehydrogenation and cyclization, and elimination side reactions in addition to the main-line chain propagation processes (Cumming and Wojciechowski, 1996).

7.2.3 Dehydrogenation

Dehydrogenation is a class of chemical reactions by means of which less saturated and more reactive compounds can be produced. There are many important conversion processes in which hydrogen is directly or indirectly removed. In the current context, the largest-scale dehydrogenations are those of hydrocarbon derivatives such as the conversion of paraffin derivatives to olefin derivatives, olefin derivatives to diolefin derivatives:

$$-CH_2CH_2CH_2CH_3 \rightarrow -CH_2CH_2CH=CH_2$$
$$-CH_2CH_2CH=CH_2 \rightarrow -CH=CHCH=CH_2$$

Another example is the conversion of cycloparaffin derivatives to aromatic derivatives – the simplest example of which is the conversion of cyclohexane to benzene:

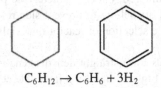

$$C_6H_{12} \rightarrow C_6H_6 + 3H_2$$

Dehydrogenation reactions of less specific character occur frequently in the refining and petrochemical industries, where many of the processes have names of their own. Some in which dehydrogenation plays a large part are pyrolysis, cracking, gasification by partial combustion, carbonization, and reforming.

The common primary reactions of pyrolysis are dehydrogenation and carbon bond scission. The extent of one or the other varies with the starting material and operating conditions, but because of its practical importance, methods have been found to increase the extent of dehydrogenation and, in some cases, to render it almost the only reaction.

Dehydrogenation is essentially the removal of hydrogen from the parent molecule. For example, at 550°C (1,025°F) n-butane loses hydrogen to produce butene-1 and butene-2. The development of selective catalysts, such as chromic oxide (chromia, Cr_2O_3) on alumina (Al_2O_3) has rendered the dehydrogenation of paraffins to olefins particularly effective, and the formation of higher-molecular-weight material is minimized. The extent of dehydrogenation (vis-à-vis carbon–carbon bond scission) during the thermal cracking of crude oil varies with the starting material and operating conditions, but because of its practical importance, methods have been found to increase the extent of dehydrogenation and, in some cases, to render it almost the only reaction.

Naphthenes are somewhat more difficult to dehydrogenate, and cyclopentane derivatives form only aromatics if a preliminary step to form the cyclohexane structure can occur. Alkyl derivatives of cyclohexane usually dehydrogenate at 480°C–500°C (895°F–930°F), and polycyclic naphthenes are also quite easy to dehydrogenate thermally. In the presence of catalysts, cyclohexane and its derivatives are readily converted into aromatics; reactions of this type are prevalent in catalytic cracking and reforming. Benzene and toluene are prepared by the catalytic dehydrogenation of cyclohexane and methyl cyclohexane, respectively.

Polycyclic naphthenes can also be converted to the corresponding aromatics by heating at 450°C (840°F) in the presence of a chromia–alumina (Cr_2O_3-Al_2O_3) catalyst. Alkyl aromatic derivatives also dehydrogenate to various products. For example, styrene is prepared by the catalytic dehydrogenation of ethylbenzene. Other alkylbenzenes can be dehydrogenated similarly; *iso*-propyl benzene yields α-methyl styrene.

In general, dehydrogenation reactions are difficult reactions that require high temperatures for favorable equilibria as well as for adequate reaction velocities. Dehydrogenation reactions – using reforming reactions as the example – are endothermic and, hence, have high heat requirements and active catalysts are usually necessary. Furthermore, since permissible hydrogen partial pressures are inadequate to prevent coke deposition, periodic regenerations are often necessary. Because of these problems with pure dehydrogenations, many efforts have been made to use oxidative dehydrogenations in which oxygen or another oxidizing agent combines with the hydrogen removed. This expedient has been successful with some reactions where it has served to overcome thermodynamic limitations and coke-formation problems.

The endothermic heat of pure dehydrogenation may be supplied through the walls of tubes (2–6 inches id), by preheating the feeds, by adding hot diluents, by reheaters between stages, or by heat stored in periodically regenerated fixed or fluidized solid catalyst beds. Usually, fairly large temperature gradients will have to be tolerated, either from wall to center of tube, from inlet to outlet of bed, or from start to finish of a processing cycle between regenerations. The ideal profile of a

constant temperature (or even a rising temperature) is seldom achieved in practice. In oxidative dehydrogenation reactions, the complementary problem of temperature rise because of exothermic nature of the reaction is encountered. Other characteristic problems met in dehydrogenations are the need for rapid heating and quenching to prevent side reactions, the need for low pressure drops through catalyst beds, and the selection of reactor materials that can withstand the operating conditions.

Selection of operating conditions for a straight dehydrogenation reaction often requires a compromise. The temperature must be high enough for a favorable equilibrium and for a good reaction rate, but not as high as to cause excessive cracking or catalyst deactivation. The rate of the dehydrogenation reaction diminishes as conversion increases, not only because equilibrium is approached more closely but also because in many cases reaction products act as inhibitors. The ideal temperature profile in a reactor would probably show an increase with distance, but practically attainable profiles normally are either flat or show a decline. Large adiabatic beds in which the decline is steep are often used. The reactor pressure should be as low as possible without excessive recycle costs or equipment size. Usually, the pressure is close to near atmospheric pressure but reduced pressures have been used in the Houdry butane dehydrogenation process. In any case, the catalyst bed must be designed for a low pressure drop.

Rapid preheating of the feed is desirable to minimize cracking. Usually, this is done by mixing pre-heated feedstock with superheated diluent just as the two streams enter the reactor. Rapid cooling or quenching at the exit of the reactor is usually necessary to prevent condensation reactions of the olefinic products. Materials of construction must be resistant to attack by hydrogen, capable of prolonged operation at high temperature, and not be unduly active for conversion of hydrocarbon derivatives to carbon. Alloy steels containing chromium are usually favored although steel alloys containing nickel are also used, but these latter alloys can cause problems arising from carbon formation. If steam is not present, traces of sulfur compounds may be needed to avoid carbonization. Both steam and sulfur compounds act to keep metal walls in a passive condition.

7.2.4 DEHYDROCYCLIZATION

Catalytic aromatization involving the loss of 1 mol of hydrogen followed by ring formation and further loss of hydrogen has been demonstrated for a variety of paraffins (typically *n*-hexane and *n*-heptane). Thus, n-hexane can be converted to benzene, heptane is converted to toluene, and octane is converted to ethylbenzene and o-xylene. Conversion takes place at low pressures, even atmospheric, and at temperatures above 300°C (570°F), although 450°C–550°C (840°F–1,020°F) is the preferred temperature range.

The catalysts are metals (or their oxides) of the titanium, vanadium, and tungsten groups and are generally supported on alumina; the mechanism is believed to be dehydrogenation of the paraffin to an olefin, which, in turn, is cyclized and dehydrogenated to the aromatic hydrocarbon. In support of this, olefins can be converted to aromatics much more easily that the corresponding paraffins.

7.3 HYDROGENATION

The purpose of hydrogenating crude oil constituents is (i) to improve existing crude oil products or develop new products or even new uses, (ii) to convert inferior or low-grade materials into valuable products, and (iii) to transform higher-molecular-weight constituents into liquid fuels. The distinguishing feature of the hydrogenating processes is that, although the composition of the feedstock is relatively unknown and a variety of reactions may occur simultaneously, the final product may actually meet all the required specifications for its particular use.

Hydrogenation processes for the conversion of crude oil and crude oil products may be classified as *nondestructive* and *destructive* (Parkash, 2003; Gary et al., 2007; Speight, 2014; Hsu and Robinson, 2017; Speight, 2017). Nondestructive, or simple, hydrogenation is generally used for the purpose of improving product (or even feedstock) quality without appreciable alteration of the boiling range. Treatment under such mild conditions is often referred to as *hydrotreating* or *hydrofining* and is essentially a means of eliminating nitrogen, oxygen, and sulfur as ammonia, water, and hydrogen sulfide, respectively. On the other hand, the latter process (*hydrogenolysis* or *hydrocracking*) is characterized by the rupture of carbon–carbon bonds and is accompanied by hydrogen saturation of the fragments to produce lower-boiling products. Such treatment requires rather high temperatures and high hydrogen pressures, the latter to minimize coke formation. Many other reactions, such as isomerization, dehydrogenation, and cyclization, can occur under these conditions (Dolbear et al., 1987). The chemistry of the hydroprocesses can be defined by the type of catalysis employed, either (i) metal catalysis or acid (ii) catalysis:

i. *Metal catalysis*:

ii. *Acid catalysis*:

One advantage of catalytic processing is the flexibility it offers in feedstock processing. Heavier feedstocks require more extensive processing which can be accomplished by higher conversion severity in the hydrocracking unit. This may result in lower yields of some products but the converted products from the hydrocracking unit are primarily higher-value transportation fuel such as high-quality diesel and jet fuel.

7.3.1 HYDROTREATING

It is generally recognized that the higher the hydrogen content of a crude oil product, especially the fuel products, the better is the quality of the product. This knowledge has stimulated the use of hydrogen-adding processes in the refinery.

7.3.1.1 General Chemistry

Hydrotreating (i.e., hydrogenation without simultaneous occurrence of thermal decomposition) (Chapters 4 and 10) is used for saturating olefins or for converting aromatics to naphthenes as well as for heteroatom removal. Under atmospheric pressure, olefins can be hydrogenated up to approximately 500°C (930°F), but beyond this temperature dehydrogenation commences. The presence of hydrogen changes the nature of the products (especially the decreasing coke yield) by preventing the buildup of precursors that are incompatible in the liquid medium and form coke (Magaril and Akensova, 1967, 1968; Magaril and Ramazaeva, 1969; Magaril and Aksenova, 1970a,b; Magaril et al., 1970, 1971; Magaril and Aksenova, 1972; Schucker and Keweshan, 1980; Speight and Moschopedis, 1979; Speight, 2014).

In contrast to the visbreaking process, in which the general principle is the production of products for use as fuel oil, the hydroprocessing is employed to produce a slate of products for use as liquid fuels. Nevertheless, the decomposition of asphaltene constituents is, again, an issue, and just as models consisting of large polynuclear aromatic systems are inadequate to explain the chemistry of visbreaking, they are also of little value for explaining the chemistry of hydrocracking.

7.3.1.2 Asphaltene Chemistry

The asphaltene constituents present complex modes of thermal cracking (Speight, 2014) and, in fact, it is at this point that the thermal chemistry of model compounds decreases in use in terms of understanding the thermal cracking of crude oil. As stated above, the thermal behavior of model compounds may not (does not) reflect the true thermal behavior of a complex mixture such as crude oil and the thermal cracking of viscous feedstocks cannot be described by a single activation energy model. The complexity of the individual reactions occurring in a viscous feedstock and the *interference* of the products with those from other components of the mixture is unpredictable. Or the *interference* of secondary and tertiary products with the course of a reaction and, hence, with the formation of primary products may also be cause for concern. Hence, caution is advised when applying the data from model compound studies to the behavior of crude oil, especially the molecularly complex viscous feedstocks. These have few, if any, parallels in organic chemistry.

Recognition that the thermal behavior of crude oil is related to composition has led to a multiplicity of attempts to establish crude oil and its fractions as compositions of matter. As a result, various analytical techniques have been developed for the identification and quantification of *every molecule* in the lower-boiling fractions of crude oil. However, the name *crude oil* does not describe a composition of matter but rather a mixture of various organic compounds that includes a wide range of molecular weights and molecular types that exist in balance with each other (Speight, 2014).

In a mixture as complex as crude oil, the reaction processes can only be generalized because of difficulties in analyzing not only the products but also the feedstock as well as the intricate and complex nature of the molecules that make up the feedstock. The formation of coke from the higher-molecular-weight and polar constituents (resin fraction and asphaltene fraction) of crude oil is detrimental to process efficiency and to catalyst performance. Although little has been acknowledged here of the role of low-molecular-weight polar species (resin constituents) in coke formation, the resin constituents are presumed to be lower-molecular-weight analogs of the asphaltene constituents. This being the case, similar reaction pathways may apply.

Deposition of solids or incompatibility is still possible when asphaltene constituents interact with catalysts, especially acidic support catalysts, through the functional groups, e.g., the basic nitrogen species just as they interact with adsorbents. And there is a possibility for interaction of the asphaltene with the catalyst through the agency of a single functional group in which the remainder of the asphaltene molecule remains in the liquid phase. There is also a less desirable option in which the asphaltene reacts with the catalyst at several points of contact, causing immediate incompatibility on the catalyst surface.

In addition, aromatization and dealkylation of the original asphaltene constituents yield asphaltene products that are of higher polarity and lower molecular weight than the original asphaltene constituents. Analogous to the thermal processes, this produces an overall asphaltene fraction that is more polar material and also of lower molecular weight. As the hydrotreating process proceeds, the amount of asphaltene constituents precipitated decreases due to conversion of the asphaltene constituents to products. At more prolonged on-stream times, there is a steady increase in the yield of the asphaltene constituents. This is accompanied by a general increase in the molecular weight of the precipitated material.

As the reaction progresses, the aromatic carbon atoms in the asphaltene constituents show a general increase and the degree of substitution of the aromatic rings decreases. Again this is in keeping with the formation of products from the original asphaltene constituents (carbenes, carboids, and eventually coke) that have increased aromaticity and decreased number of alkyl chains as well as a decrease in the alkyl chain length. Thus, as the reaction progresses with increased on-stream time, *new* asphaltene constituents are formed that, relative to the original asphaltene constituents, the *new* species have increased aromaticity coupled with a lesser number of alkyl chains that are shorter than the original alky chains.

7.3.1.3 Catalysts

A wide variety of metals are active hydrogenation catalysts; those of most interest are nickel, palladium, platinum, cobalt, iron, nickel-promoted copper, and copper chromite. Special preparations of the first three are active at room temperature and atmospheric pressure. The metallic catalysts are easily poisoned by sulfur-containing and arsenic-containing compounds, and even by other metals. To avoid such poisoning, less effective but more resistant metal oxides or sulfides are frequently employed, generally those of tungsten, cobalt, chromium, or molybdenum. Alternatively, catalysts poisoning can be minimized by mild hydrogenation to remove nitrogen, oxygen, and sulfur from feedstocks in the presence of more resistant catalysts, such as cobalt–molybdenum–alumina ($Co-Mo-Al_2O_3$). The reactions involved in nitrogen removal are somewhat analogous to those of the sulfur compounds and follow a stepwise mechanism to produce ammonia and the relevant substituted aromatic compound.

Hydrotreating catalysts consist of metals impregnated on a porous alumina support. Almost all of the surface area is found in the pores of the alumina ($200-300\,m^2/g$) and the metals are dispersed in a thin layer over the entire alumina surface within the pores. This type of catalyst does display a huge catalytic surface for a small weight of catalyst. Cobalt (Co), molybdenum (Mo), and nickel (Ni) are the most commonly used metals for desulfurization catalysts. The catalysts are manufactured with the metals in an oxide state. In the active form, they are in the sulfide state, which is obtained by sulfiding the catalyst either prior to use or with the feed during actual use. Any catalyst that exhibits hydrogenation activity will catalyze hydrodesulfurization to some extent. However, the Group VIB metals (chromium, molybdenum. and tungsten) are particularly active for desulfurization, especially when promoted with metals from the iron group (iron, cobalt, nickel).

Hydrodesulfurization and demetallization occur simultaneously on the active sites within the catalyst pore structure. Sulfur and nitrogen occurring in viscous feedstocks are converted to hydrogen sulfide (H_2S) and ammonia (NH_3) in the catalytic reactor and these gases are scrubbed out of the reactor effluent gas stream. The metals in the feedstock are deposited on the catalyst in the form of metal sulfides and cracking of the feedstock to distillate produces a laydown of carbonaceous material on the catalyst; both events poison the catalyst and activity or selectivity suffers. The deposition of carbonaceous material is a fast reaction that soon equilibrates to a particular carbon level and is controlled by hydrogen partial pressure within the reactors. On the other hand, metal deposition is a slow reaction that is directly proportional to the amount of feedstock passed over the catalyst.

Removal of sulfur from the feedstock results in a gradual increase in catalyst activity, returning almost to the original activity level. As with ammonia, the concentration of the hydrogen sulfide

can be used to control precisely the activity of the catalyst. Non-noble metal-loaded zeolite catalysts have an inherently different response to sulfur impurities since a minimum level of hydrogen sulfide is required to maintain the nickel-molybdenum and nickel-tungsten in the sulfide state.

Alternatively, catalysts poisoning can be minimized by mild hydrogenation to remove nitrogen, oxygen, and sulfur from feedstocks in the presence of more resistant catalysts, such as cobalt-molybdenum-alumina (Co-Mo-Al$_2$O$_3$). The reactions involved in nitrogen removal are somewhat analogous to those of the sulfur compounds and follow a stepwise mechanism to produce ammonia and the relevant substituted aromatic compound.

7.3.2 HYDROCRACKING

Hydrocracking (Chapters 4 and 11) is a thermal process (>350°C, >660°F) in which hydrogenation accompanies cracking. Relatively high pressure (100–2,000 psi) is employed, and the overall result is usually a change in the character or quality of the products. The wide range of products possible from hydrocracking is the result of combining catalytic cracking reactions with hydrogenation (Dolbear, 1998; Hajji et al., 2010). The reactions are catalyzed by dual-function catalysts in which the cracking function is provided by silica–alumina (or zeolite) catalysts, and platinum, tungsten oxide, or nickel provides the hydrogenation function.

7.3.2.1 General Chemistry

Essentially all the initial reactions of catalytic cracking occur, but some of the secondary reactions are inhibited or stopped by the presence of hydrogen. For example, the yields of olefins and the secondary reactions that result from the presence of these materials are substantially diminished and branched-chain paraffins undergo demethanation. The methyl groups attached to secondary carbons are more easily removed than those attached to tertiary carbon atoms, whereas methyl groups attached to quaternary carbons are the most resistant to hydrocracking.

The effect of hydrogen on naphthene hydrocarbon derivatives is mainly that of ring scission followed by immediate saturation of each end of the fragment produced. The ring is preferentially broken at favored positions, although generally all the carbon–carbon bond positions are attacked to some extent. For example, methyl-cyclopentane is converted (over a platinum–carbon catalyst) to 2-methylpentane, 3-methylpentane, and *n*-hexane.

Aromatic hydrocarbon derivatives are resistant to hydrogenation under mild conditions, but under more severe conditions, the main reactions are conversion of the aromatic to naphthenic rings and scissions within the alkyl side chains. The naphthenes may also be converted to paraffins. However, polynuclear aromatics are more readily attacked than the single-ring compounds, the reaction proceeding by a stepwise process in which one ring at a time is saturated and then opened. For example, naphthalene is hydrocracked over a molybdenum oxide-molecular catalyst to produce a variety of low-weight paraffins (≤C$_6$).

There have been many attempts to analyze the chemical kinetics of the hydrocracking reaction (Ancheyta et al., 2005; Bahmani et al., 2007). Lump models have been used for several years for kinetic modeling of complex reactions. Catalyst screening, process control, basic process studies, and dynamic modeling, among others, are areas in which lump kinetic models are extensively applied. The main disadvantages of lump models are their simplicity in predicting product yields, the dependency of kinetic parameters on feed properties, and the use of an invariant distillation range of products, which, if changed, necessitates further experiments and parameter estimation. Structure-oriented lumping models are more detailed approaches that express the chemical transformations in terms of typical molecule structures. These models describe reaction kinetics in terms of a relatively large number of pseudo-components, and hence they do not completely eliminate lumps. In addition, dependency of rate parameters on feedstock properties is present.

Models based on continuous mixtures (continuous theory of lumping) overcome some of these deficiencies by considering properties of the reaction mixture, the underlying pathways, and the

associated selectivity of the reactions. The common parameter of characterization is the true boiling point temperature, since during reaction it changes continuously inside the reactor as the residence time increases. However, dependency of model parameters on feedstock properties is still present. Distillation curves, either chromatographic or physical, also present some difficulties when analyzing viscous feedstocks since initial and final boiling points are not accurate during experimentation. In fact, for many purposes, 10% and 90% boiling point are commonly utilized instead of initial boiling point and final boiling point, respectively.

The single event concept uses elementary steps of cation chemistry, which consists of a limited number of types of steps involving a series of homologous species. The number of rate coefficients to be determined from experimental information can be reduced and are modeled based upon transition state theory and statistical thermodynamics. With this approach, parameter values are not dependent on feed properties. However, even though the number of parameters can be diminished, detailed and sufficient experimental data are necessary.

However, the complexity of the feedstocks – especially the heavy feedstocks such as heavy crude oil, extra-heavy crude oil, and tar sand bitumen – suggests (rightly or wrongly) that models based on lumping theory will continue to be used for the study of the reaction kinetics of the hydrocracking process. However, more accurate approaches are still required for a better understanding and representation of the kinetics involved in hydrocracking the viscous feedstocks. Because of the changing nature of heavy feedstocks and even refinery gas oils, whether or not the issues of reaction kinetics will ever be solved remains in question. In fact, dealing with one fraction of constituents – the asphaltene fraction – is itself a problem that can only be solved in general terms, being subject to the chemical and physical characteristics of the asphaltene constituents (recalling that the asphaltene fraction is not a homogenous chemical and physical fraction) as well as the react configuration and the process parameters. The same rationale can be applied with justification to the resin fraction which is also a heterogeneous chemical and physical fraction (Speight, 2014).

7.3.2.2 Asphaltene Chemistry

In terms of hydroprocessing, the means by which asphaltene constituents are desulfurized, as one step of a hydrocracking operation, is also suggested as part of the process. This concept can then be taken one step further to show the dealkylation of the aromatic systems as a definitive step in the hydrocracking process (Speight, 1987).

It may be that the chemistry of hydrocracking has to be given serious reconsideration insofar as the data show that the initial reactions of the asphaltene constituents appear to be the same as the reactions under thermal conditions where hydrogen is not present. Rethinking of the process conditions and the potential destruction of the catalyst by the deposition of carbenes and carboids require further investigation of the chemistry of asphaltene hydrocracking.

If these effects are prevalent during hydrocracking high-asphaltene feedstocks, the option may be to hydrotreat the feedstock first and then to hydrocrack the hydrotreated feedstock. There are indications that such hydrotreatment can (at some obvious cost) act beneficially in the overall conversion of the feedstocks to liquid products.

The resin fraction has received somewhat less attention than the asphaltene fractions, but the chemical and physical heterogeneity of the fraction remains unresolved and is believed to match the chemical and physical heterogeneity of the asphaltene fraction (Koots and Speight, 1975; Andersen and Speight, 2001).

7.3.2.3 Catalysts

The reactions of hydrocracking require a dual-function catalyst with high cracking and hydrogenation activities. The catalyst base, such as acid-treated clay, usually supplies the cracking function or alumina or silica–alumina that is used to support the hydrogenation function supplied by metals, such as nickel, tungsten, platinum, and palladium. These highly acid catalysts are very sensitive to

nitrogen compounds in the feed, which break down the conditions of reaction to give ammonia and neutralize the acid sites.

Hydrocracking catalysts typically contain separate hydrogenation and cracking functions. Palladium sulfide and promoted group VI sulfides (nickel molybdenum or nickel tungsten) provide the hydrogenation function. These active compositions saturate aromatics in the feed, saturate olefins formed in the cracking, and protect the catalysts from poisoning by coke. Zeolites or amorphous silica–alumina provide the cracking functions. The zeolites are usually type Y (faujasite), ion exchanged to replace sodium with hydrogen and make up 25%–50% of the catalysts. Pentasils (silicalite or ZSM-5) may be included in dewaxing catalysts.

Hydrocracking catalysts, such as nickel (5% by weight) on silica–alumina, work best on feedstocks that have been hydrotreated to low nitrogen and sulfur levels. The nickel catalyst then operates well at 350°C–370°C (660°F–700°F) and a pressure of approximately 1,500 psi to give good conversion of feed to lower-boiling liquid fractions with minimum saturation of single-ring aromatics and a high *iso*-paraffin to *n*-paraffin ratio in the lower-molecular-weight paraffins.

Catalysts containing platinum or palladium (approximately 0.5% wet) on a zeolite base appear to be somewhat less sensitive to nitrogen than are nickel catalysts, and successful operation has been achieved with feedstocks containing 40 ppm nitrogen. This catalyst is also more tolerant of sulfur in the feed, which acts as a temporary poison, the catalyst recovering its activity when the sulfur content of the feed is reduced. With catalysts of higher hydrogenation activity, such as platinum on silica–alumina, direct isomerization occurs. The product distribution is also different, and the ratio of low- to intermediate-molecular-weight paraffins in the breakdown product is reduced.

Catalyst poisoning can be minimized by mild hydrogenation to remove nitrogen, oxygen, and sulfur from feedstocks in the presence of more resistant catalysts, such as cobalt–molybdenum–alumina $(Co-Mo-Al_2O_3)$.

7.3.3 SOLVENT DEASPHALTING

Viscous feedstocks are mixtures of various hydrocarbon classes including saturates, aromatics, and asphaltenes as well as hydrocarbonaceous materials in which carbon and hydrogen have been replaced by heteroatoms (Speight, 2014). The chemistry of the deasphalting process does not, to the purist, involve not so much the organic chemistry of the system but is more related to the physical chemistry of the system insofar as the outcome of the process is dictated more by physical solvent-feedstock relationship rather than by organic chemical reactions.

It is postulated that the asphaltene constituents are effectively *peptized* by association with the resin constituents and exist as the center of a colloidal particle or micelle. The actual structure of the micelle is not known with any degree of certainty (Speight, 1994, 2014). When the entire micelle system contains sufficient constituents for the formation of the semi-continuous outer region, the asphaltenes are fully peptized by the outer ring that is more compatible (less prone to form a separate phase). Low-boiling liquid paraffin solvents partially or completely dissolve the peptizing agents and the asphaltene constituents, being incompatible with the liquid phase, separate and precipitate. As the molecular weight of the liquid paraffin solvent decreases, the solubility of the resins and of some of the heavier and more aromatic hydrocarbon in the paraffin solvent decreases (as evidenced by the propane deasphalting process). Thus, lower-molecular-weight paraffin solvents (such as propane) precipitate a tacky material consists of asphaltene constituents, resin constituents, other aromatic constituents (or naphthene-aromatic constituents with some long-chain paraffins derivative) as may be insoluble in the paraffin-dominated liquid phase.

7.3.3.1 Effect of Solvent Type

The yield and quality of the products, which are recovered in a solvent deasphalting unit, are directly related to the solvent composition low-boiling hydrocarbon derivatives such as propane, butane, and pentane can be used for the process. The solvent power (dissolving ability) of light hydrocarbon

derivatives increases with increased molecular weight, and when the lowest practical process temperature is reached with a particular solvent, it is necessary to use higher-molecular-weight solvents in order to recover the maximum yield of deasphalted oil. As the molecular weight of the solvent increases, the yield of deasphalted oil also increases but, concurrently, the quality of the deasphalted oil declines, which is reflected in higher viscosity, higher specific gravity, and higher propensity of coke formation as determined by the Conradson carbon residue text method (Speight, 2014, 2015, 2017). Since the deasphalted oil is usually processed in a conversion unit designed to utilize highly active, metals-sensitive catalysts which are incapable of economically processing feedstocks containing more than several ppm of organometallic derivatives, solvent selection must consider both the desired quantity and quality of the recovered products.

With the continually changing nature of refinery feedstocks, it is preferable that solvent deasphalting units have the flexibility to operate with different solvents. Factors such as market supply and technology of downstream processes can change during the operating life of a solvent deasphalting unit in a refinery. The continued development and improvement of catalyst performance (in catalytic processes) may allow feedstocks with higher metal content and a higher propensity of form coke (measure as the Conradson carbon residue) to produce even higher yields of distillate products (Chapters 9–11). In addition, the option for solvent flexibility in a solvent deasphalting unit needs to be a consideration during the design stage of a solvent process (Chapter 12).

7.3.3.2 Effect of Temperature and Pressure

As evidenced by the laboratory separation of asphaltene constituents and the fractionation of feedstocks (Speight, 1994, 2014, 2015), temperature and pressure are both variables because of the solvent power of low-boiling hydrocarbon is approximately proportional to the density of the solvent. That is, decreasing temperature or increasing pressure will increase the average molecular weight of hydrocarbon derivatives soluble in solvent-rich phase. For propane, at temperatures below 80°C (176°F) and a pressure above the vapor pressure of propane, temperature is the most important factor in determining solubility of the feedstock constituents. At temperatures near the critical region, pressure is also an important factor, as properties of the liquid propane approach those of gaseous propane. Thus, higher temperatures typically result in decreased yields of deasphalted oil, although the converse has also been observed (Speight, 1994, 2014). This is accompanied by the decrease in viscosity and molecular weight range of the deasphalted oil.

Thus, during normal operation, when both the solvent composition and the extraction pressure are fixed, the yields and qualities of the various products recovered in the solvent deasphalting unit are controlled by adjusting its operating temperature. Increasing the extraction temperature reduces the solubility of the heavier components of the feedstock, which results in improved deasphalted oil quality but reduced yield of deasphalted oil yield. Subsequent increases in the extractor temperature can further improve the quality of the deasphalted oil by causing further rejection of asphaltene constituents.

Generally, the control of the process may become difficult when rapid changes in temperature occur especially near the critical region because at conditions close to the critical point, the rate of change of solubility is very large. For practical applications, the lower operating temperature is set by the viscosity of the asphaltene phase. The upper limit is to stay below the critical temperature while maintaining the desired yield of deasphalted oil and stable operation. In some cases, a temperature gradient may be maintained along the length of the column with the higher temperature at the top of the column to generate an internal reflux by precipitation of dissolved heavier material – which improves the quality of the deasphalted oil – but a high rate of internal reflux can limit the capacity of the extraction column.

The operating pressure of the extractor is based on the composition of the solvent, which is being used. In the process, sufficient operating pressure must be maintained to ensure the solvent/feedstock mixture in the extractor is in the liquid state. Although the unit may be designed for a range of operating pressure, once it is in operation, the extractor pressure may not be typically considered a control variable.

7.3.3.3 Effect of the Solvent-to-Oil Ratio

In general, increasing solvent-to-oil ratio increases the recovery of deasphalted oil with an increase in viscosity. The yield of deasphalted oil can be further adjusted with other variables, such as solvent type or the temperature. At higher ratios of solvent-to-oil, the quality of the deasphalted can be improved by increasing the extraction temperature but with variable decreases in the yield of deasphalted oil. The solvent-to-oil ratio is important from the standpoint of solvent selectivity and the yield advantage at a given product quality at higher solvent ratio varies from feedstock to feedstock and needs to be estimated.

7.4 PROCESS CHEMISTRY

In a mixture as complex as crude oil, the reaction processes can only be generalized because of difficulties in analyzing not only the products but also the feedstock as well as the intricate and complex nature of the molecules that make up the feedstock. The formation of coke from the higher-molecular-weight and polar constituents of a given feedstock is detrimental to process efficiency and to catalyst performance (Speight, 1987; Dolbear, 1998).

Refining the constituents of viscous feedstocks has become a major issue in modern refinery practice. The limitations of processing the viscous feedstocks depend to a large extent on the amount of higher-molecular-weight constituents (i.e., asphaltene constituents) present in the feedstock (Speight, 1984; Schabron and Speight, 1997; Speight, 2000, 2004a) that are responsible for high yields of coke in thermal and catalytic processes (Chapters 8 and 9).

Thermal cracking processes are commonly used to convert viscous feedstocks into distillable liquid products, although thermal cracking processes as used in the early refineries are no longer in use. Examples of modern thermal cracking processes are *visbreaking* and *coking* (*delayed coking*, *fluid coking*, and *flexicoking*) (Chapter 8). In all of these processes, the simultaneous formation of sediment or coke limits the conversion to usable liquid products.

However, for the purposes of this section, the focus will be on the visbreaking and hydrocracking processes. The coking processes in which the reactions are taken to completion with the maximum yields of products are not a part of this discussion.

7.4.1 THERMAL CHEMISTRY

When crude oil is heated to temperatures in excess of 350°C (660°F), the rate of thermal decomposition of the constituents increases significantly. The higher the temperature, the shorter the time to achieve a given conversion and the *severity* of the process conditions is a combination of residence time of the crude oil constituents in the reactor and the temperature needed to achieve a given conversion.

Thermal conversion does not require the addition of a catalyst. This approach is the oldest technology available for conversion of viscous feedstocks and the severity of thermal processing determines the conversion and the product characteristics. As the temperature and residence time are increased, the primary products undergo further reaction to produce various secondary products, and so on, with the ultimate products (coke and methane) being formed at extreme temperatures of approximately 1,000°C (1,830°F).

The thermal decomposition of crude oil asphaltene constituents has received some attention (Magaril and Akensova, 1968; Magaril and Ramazaeva, 1969; Magaril and Aksenova, 1970a; Magaril et al., 1970, 1971; Schucker and Keweshan, 1980; Speight, 1990, 1994, 1998, 2014, 2017). Special attention has been given to the nature of the volatile products of asphaltene decomposition mainly because of the difficulty of characterizing the nonvolatile coke. One option suggests that the overall pathway by which hydrotreating and hydrocracking of viscous feedstocks occur involves a more complex multi-step mechanism is more likely:

Asphaltene constituents → resin-type products

Asphaltene constituents → reacted asphaltene products*

Asphaltene constituents → polar aromatic products*

Asphaltene constituents → aromatic products

Asphaltene constituents → saturate products

Asphaltene constituents → olefin products

Resin constituents → reacted resin products*

Resin constituents → polar aromatic products*

Resin constituents → aromatic products

Aromatic constituents → reacted aromatic products

Aromatic constituents → aromatic products

Aromatic constituents → saturate products

Aromatic constituents → olefin products

*Possibly incompatible with the oil medium

The organic nitrogen originally in the asphaltene constituents invariably undergoes thermal reaction to concentrate in the nonvolatile coke (Speight, 1970, 1989; Vercier, 1981; Speight, 2014). Thus although asphaltene constituents produce high yields of thermal coke, little is known of the actual chemistry of coke formation. In a more general scheme, the chemistry of asphaltene coking has been suggested to involve the thermolysis of thermally labile bonds to form reactive species that then react with each other to form coke. As part of the coke-forming process, the highly aromatic and highly polar (refractory) products separate from the surrounding oil medium as an insoluble phase and proceed to form coke.

It is also interesting to note that although the aromaticity of the asphaltene constituents is approximately equivalent to the yield of thermal coke (Speight, 1994, 2014), not all the original aromatic carbon in the asphaltene constituents forms coke. Volatile aromatic species are eliminated during thermal decomposition, and it must be assumed that some of the original aliphatic carbon plays a role in coke formation.

Various patterns of thermal behavior have been observed for the constituents of crude oil feedstocks (Speight, 2014). Since the chemistry of thermal and catalytic cracking has been studied and well resolved, there has been a tendency to focus on the refractory (nonvolatile) constituents. These constituents of crude oil generally produce coke in yields varying from almost zero to more than 60% w/w (Figure 7.1). However, the focus of thermal studies has been, for obvious reasons, on the asphaltene constituents that produce thermal coke in amounts varying from approximately 35% by weight to approximately 65% by weight. Crude oil mapping techniques often show the nonvolatile constituents, specifically the asphaltene constituents and the resin constituents, producing coke while the volatile constituents produce distillates. It is often ignored that the asphaltene constituents also produce high yields (35%–65% by weight) of volatile thermal products which vary from condensable liquids to gases.

It has been generally thought that the chemistry of coke formation involves immediate condensation reactions to produce higher-molecular-weight, condensed aromatic species. And there is the claim that coking is a bimolecular process. However, more recent approaches to the chemistry of coking render the bimolecular process debatable. The rate of decomposition will vary with the nature of the individual constituents, thereby giving rise to the perception of second-order or even multi-order kinetics. The initial reactions of asphaltene constituents involve thermolysis of pendant alkyl chains to form lower-molecular-weight higher-polar species (carbenes and carboids) which

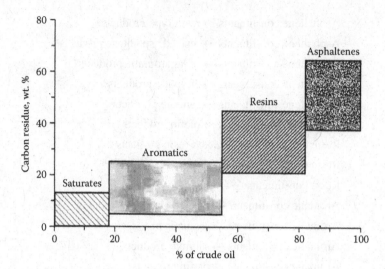

FIGURE 7.1 Illustration of the yields of thermal coke from fractions and subfractions of a feedstock as determined by the Conradson carbon residue test. (It should also be noted that the differences in thermal behavior of the different subfractions of the asphaltene fraction contradict claims that an average structure for the asphaltene fraction is representative of the behavior of the whole fraction (see also Chapter 4).)

then react to form coke. Indeed, as opposed to the bimolecular approach, the initial reactions in the coking of crude oil feedstocks that contain asphaltene constituents appear to involve unimolecular thermolysis of asphaltene aromatic–alkyl systems to produce volatile species (paraffins and olefins) and nonvolatile species (aromatics) (Speight, 1987; Schabron and Speight, 1997; Speight, 2014).

In support of the participation of asphaltene constituents in sediment or coke formation, it has been reported that the formation of a coke-like substance during viscous feedstock upgrading is dependent upon several factors (Storm et al., 1997): (i) the degree of polynuclear condensation in the feedstock, (ii) the average number of alkyl groups on the polynuclear aromatic systems, (iii) the ratio of heptane-insoluble material to the pentane-insoluble/heptane-soluble fraction, and (iv) the hydrogen-to-carbon atomic ratio of the pentane-insoluble/heptane-soluble fraction. These findings correlate quite well with the proposed chemistry of coke or sediment formation during the processing of heavy feedstocks and even offer some predictability since the characteristics of the whole feedstocks are evaluated.

For example, the hydrogen or carbon-carbon bonds to adjacent to ring nitrogen undergo thermolysis quite readily, as if promoted by the presence of the nitrogen atom (Fitzer et al., 1971; Speight, 1998). If it can be assumed that heterocyclic nitrogen plays a similar role in the thermolysis of asphaltene constituents, the initial reactions therefore involve thermolysis of aromatic–alkyl bonds that are enhanced by the presence of heterocyclic nitrogen. An ensuing series of secondary reactions, such as aromatization of naphthenic species and condensation of the aromatic ring systems, then leads to the production of coke. Thus, the initial step in the formation of coke from asphaltene constituents is the formation of volatile hydrocarbon fragments and nonvolatile heteroatom-containing systems.

It has been reported that as the temperature of a 1-methylnaphthalene is raised from 100°C (212°F) to 400°C (750°F), there is a progressive decrease in the particle size of the asphaltene constituents (Thiyagarajan et al., 1995). Furthermore, there is also the inference that the structural integrity of the asphaltene particle is compromised and that irreversible thermochemistry has occurred. Indeed, that is precisely what is predicted and expected from the thermal chemistry of asphaltene fraction and molecular weight studies of asphaltene fraction.

An additional corollary to this work is that conventional models of crude oil asphaltene constituents (which, despite evidence to the contrary, invoked the concept of a large polynuclear aromatic

system) offer little, if any, explanation of the intimate events involved in the chemistry of coking. Models that invoke the concept of the asphaltene fractions as a complex solubility class with molecular entities composed of smaller polynuclear aromatic systems are more in keeping with the present data. But the concept of an average structure is not in keeping with the complexity of the fraction and the chemical or thermal reactions of the constituents (Speight, 1994, 2014). Little has been acknowledged here of the role of low-molecular-weight polar species (resin constituents) in coke formation. However, it is worthy of note that the resin constituents are presumed to be lower-molecular-weight analogs of the asphaltene constituents. This being the case, similar reaction pathways may apply (Koots and Speight, 1975; Speight, 1994, 2014).

Thus, it is now considered more likely that molecular species within the asphaltene fraction, which contains nitrogen and other heteroatoms (and have lower volatility than the pure hydrocarbon derivatives), are the prime movers in the production of coke (Speight, 1987). Such species, containing various polynuclear aromatic systems, can be denuded of the attendant hydrocarbon moieties and are undoubtedly insoluble (Bjorseth, 1983; Dias, 1987, 1988) in the surrounding hydrocarbon medium. The next step is gradual carbonization of such entities to form coke (Magaril and Akensova, 1968; Magaril and Ramazaeva, 1969; Magaril et al., 1970; Cooper and Ballard, 1962).

Thermal processes (such as visbreaking and coking) are the oldest methods for crude oil conversion and are still used in modern refineries. The thermal chemistry of crude oil constituents has been investigated for more than five decades, and the precise chemistry of the lower-molecular-weight constituents has been well defined because of the bountiful supply of pure compounds. The major issue in determining the thermal chemistry of the nonvolatile constituents is, of course, their largely unknown chemical nature and, therefore the inability to define their thermal chemistry with any degree of accuracy. Indeed, it is only recently that some light has been cast on the thermal chemistry of the nonvolatile constituents.

When crude oil is heated to temperatures over approximately 410°C (770°F), the thermal or free radical reactions start to crack the mixture at significant rates. Thermal conversion does not require the addition of a catalyst; therefore, this approach is the oldest technology available for conversion of viscous feedstocks. The severity of thermal processing determines the conversion and the product characteristics.

Asphaltene constituents are substantial components of viscous feedstocks and their thermal decomposition has been the focus of much attention (Speight, 1994, 2014). The thermal decomposition not only produces high yields (40 wt. %) of coke but also, optimistically and realistically, produces equally high yields of volatile products (Speight, 1970). Thus, the challenge in studying the thermal decomposition of asphaltene constituents is to decrease the yields of coke and increase the yields of volatile products.

Several chemical models describe the thermal decomposition of asphaltene constituents (Speight, 1994, 2014). Using these available asphaltene models as a guide, the prevalent thinking is that the asphaltene nuclear fragments become progressively more polar as the paraffinic fragments are stripped from the ring systems by scission of the bonds (preferentially) between the carbon atoms alpha and beta to the aromatic rings.

The higher polarity polynuclear aromatic systems that have been denuded of the attendant hydrocarbon moieties are somewhat less soluble in the surrounding hydrocarbon medium than their *parent* systems (Bjorseth, 1983; Dias, 1987, 1988). Two factors are operative in determining the solubility of the polynuclear aromatic systems in the liquid product. The alkyl moieties that have a solubilizing effect have been removed and there is also enrichment of the liquid medium in paraffinic constituents. Again, there is an analogy with the deasphalting process (Chapter 12), except that the paraffinic material is a product of the thermal decomposition of the asphaltene molecules and is formed in situ rather than being added separately.

The coke has a lower hydrogen-to-carbon atomic ratio than the hydrogen-to-carbon ratio of any of the constituents present in the original crude oil. The hydrocarbon products *may* have a higher hydrogen-to-carbon atomic ratio than the hydrogen-to-carbon ratio of any of the constituents present

in the original crude oil or hydrogen-to-carbon atomic ratios at least equal to those of many of the original constituents. It must also be recognized that the production of coke and volatile hydrocarbon products is accompanied by a shift in the hydrogen distribution.

Mild-severity and high-severity processes are frequently used for processing of the fractions of viscous feedstocks, whereas conditions similar to those of *ultrapyrolysis* (high temperature and very short residence time) are used commercially only for cracking ethane, propane, butane, and light distillate feeds to produce ethylene and higher olefins.

The formation of solid sediments, or coke, during thermal processes is a major limitation on processing. Furthermore, the presence of different types of solids shows that solubility controls the formation of solids. And the tendency for solid formation changes in response to the relative amounts of the light ends, middle distillates, and residues and to their changing chemical composition during the process. In fact, the prime mover in the formation of incompatible products during the processing of feedstocks containing asphaltene constituents is the nature of the primary thermal decomposition products, particularly those fractions that are designated as *carbenes* and *carboids* (Chapters 2 and 3) (Speight, 2014, 2015).

Coke formation during the thermal treatment of viscous feedstocks is postulated to occur by a mechanism that involves the liquid–liquid phase separation of reacted asphaltene constituents (which may be *carbenes*) to form a phase that is of low hydrogen content that is substantially non-reactive. The unreacted asphaltene constituents were found to be the fraction with the highest rate of thermal reaction but with the least extent of reaction. This not only described the appearance and disappearance of asphaltene constituents but also quantitatively described the variation in molecular weight and hydrogen content of the asphaltene constituents with reaction time. Thus, the main features of coke formation are (i) an *induction period* prior to coke formation, first observed in the modern refining era and defined by Magaril and his co-workers, (ii) a maximum concentration of asphaltene constituents in the reacting liquid, (iii) a decrease in the asphaltene concentration that parallels the decrease in heptane-soluble material, and (iv) high reactivity of the unconverted asphaltene constituents.

The induction period has been observed experimentally by many previous investigators (Levinter et al., 1966, 1967; Magaril and Akensova, 1968; Magaril and Aksenova, 1970; Valyavin et al., 1979; Takatsuka et al., 1989) and makes visbreaking and the Eureka processes possible. The postulation that coke formation is triggered by the phase separation of asphaltene constituents (Magaril et al., 1971) led to the use of linear variations of the concentration of each fraction with reaction time, resulting in the assumption of zero-order kinetics rather than first-order kinetics. More recently (Yan, 1987), coke formation in visbreaking was described as resulting from a phase-separation step, but the phase-separation step was not included in the resulting kinetic model for coke formation.

This model represents the conversion of asphaltene constituents over the entire temperature range and of heptane-soluble materials in the coke induction period as first-order reactions. Also, the previous work showed that fractions of viscous feedstocks can be converted without completely changing solubility classes (Magaril et al., 1971) and that coke formation is triggered by the phase separation of converted (reacted) asphaltene constituents.

The maximum solubility of these product asphaltene constituents is proportional to the total heptane-soluble materials, as suggested by the observation that the decrease in asphaltene constituents parallels the decrease of heptane-soluble materials. Finally, the conversion of the insoluble product asphaltene constituents into toluene-insoluble coke is pictured as producing a heptane-soluble by-product, which provides a mechanism for the heptane-soluble conversion to deviate from the first-order behavior once coke begins to form. In support of this assumption, it is known (Langer et al., 1961) that partially hydrogenated refinery process streams provide reactive hydrogen and as a result, inhibit coke formation during thermal conversion of viscous feedstocks. Thus, the heptane-soluble fraction of a viscous feedstock which contains naturally occurring partially hydrogenated aromatics can provide reactive hydrogen during thermal reactions. As the conversion proceeds, the concentration of asphaltene cores continues to increase and the heptane-soluble fraction

continues to decrease until the solubility limit, S_L is reached. Beyond the solubility limit, the excess asphaltene cores, A^*_{ex}, phase separate to form a second liquid phase that contains little reactive hydrogen. In this new phase, asphaltene radical – asphaltene radical recombination is quite frequent, causing a rapid reaction to form solid coke and a by-product of a heptane-soluble core.

The asphaltene concentration varies little in the coke induction period but then decreases once coke begins to form. Observing this, it might be concluded that asphaltene constituents are unreactive, but it is the high reactivity of the asphaltene constituents down to the asphaltene core that offsets the generation of asphaltene cores from the heptane-soluble materials to keep the overall asphaltene concentration nearly constant.

Previously, it was demonstrated (Schucker and Keweshan, 1980; Savage et al., 1988) that the hydrogen-to-carbon atomic ratio of the asphaltene constituents decreases rapidly with reaction time for asphaltene thermolysis and then approaches an asymptotic limit at long reaction times, which provides qualitative evidence for asphaltene cracking down to a core.

The measurement of the molecular weight of crude oil asphaltene constituents is known to give different values depending on the technique, the solvent and the solvent-oil ratio (Moschopedis et al., 1976; Speight et al., 1985; Speight, 2014, 2015). As shown by small-angle X-ray (Kim and Long, 1979) and neutron (Overfield et al., 1989) scattering, this is because asphaltene constituents tend to self-associate and form aggregates.

Thus, coke formation is a complex process involving both chemical reactions and thermodynamic behavior. Reactions that contribute to this process are (i) cracking of side chains from aromatic groups, (ii) dehydrogenation of naphthenes to form aromatics, (iii) condensation of aliphatic structures to form aromatics, (iv) condensation of aromatics to form higher fused-ring aromatics, and (v) dimerization or oligomerization reactions. Loss of side chains always accompanies thermal cracking, and dehydrogenation and condensation reactions are favored by hydrogen-deficient conditions.

The importance of solvents in coking has been recognized for many years (e.g., Langer et al., 1961), but their effects have often been ascribed to hydrogen-donor reactions rather than phase behavior. The separation of the phases depends on the solvent characteristics of the liquid. Addition of aromatic solvents suppresses phase separation, whereas paraffins enhance separation. Microscopic examination of coke particles often shows evidence for the presence of mesophase, spherical domains that exhibit the anisotropic optical characteristics of liquid crystals.

This phenomenon is consistent with the formation of a second liquid phase; the mesophase liquid is denser than the rest of the hydrocarbon, has a higher surface tension, and probably wets metal surfaces better than the rest of the liquid phase. The mesophase characteristic of coke diminishes as the liquid phase becomes more compatible with the aromatic material.

The phase separation phenomenon that is the prelude to coke formation can also be explained by use of the solubility parameter, δ, for crude oil fractions and for the solvents (Yen, 1984; Speight, 1994, 2014). As an extension of this concept, there is sufficient data to draw a correlation between the atomic hydrogen/carbon ratio and the solubility parameter for hydrocarbon derivatives and the constituents of the lower-boiling fractions of crude oil (Speight, 1994). Recognition that hydrocarbon liquids can dissolve polynuclear hydrocarbon derivatives, a case in which there is usually less than a three-point difference between the lower solubility parameter of the solvent and the higher solubility parameter of the solute. Thus, a parallel, or near-parallel, line can be assumed that allows the solubility parameter of the asphaltene constituents and resin constituents to be estimated.

By this means, the solubility parameter of asphaltene constituents can be estimated to fall in the range 9–12, which is in keeping with the asphaltene fraction being composed of a mixture of different compound types with an accompanying variation in polarity. Removal of alkyl side chains from the asphaltene constituents decreases the hydrogen-to-carbon atomic ratio and increases the solubility parameter thereby causing a concurrent decrease of the asphaltene product in the hydrocarbon solvent.

In fact, on the molecular weight polarity diagram for asphaltene constituents, carbenes and carboids can be shown as lower molecular weight, highly polar entities in keeping with molecular

TABLE 7.1

Properties Related to Instability and Incompatibility

Property	Comments
Asphaltene constituents	Interact readily with catalyst
	Thermal alteration leading to phase separation
	Phase separation in paraffinic medium
Heteroatom constituents	Thermally labile
	React readily with oxygen
	Provide polarity to feedstock (or products)
Aromatic constituents	May be incompatible with paraffin medium
	Phase separation of paraffin constituents
Non-asphaltene constituents	Thermal alteration causes changes in polarity
	Phase separation of polar species in products

fragmentation models (Speight, 1994). If this increase in polarity and solubility parameter (Mitchell and Speight, 1973) is too drastic relative to the surrounding medium, phase separation will occur. Furthermore, the available evidence favors a multi-step mechanism rather than a stepwise mechanism as the means by which the thermal decomposition of crude oil constituents occurs (Speight, 1994, 2014).

Any chemical or physical interactions (especially thermal effects) that cause a change in the solubility parameter of the solute relative to that of the solvent will also cause *incompatibility* be it called *instability, phase separation, sediment formation,* or *sludge formation.*

Instability or *incompatibility* resulting in the separation of solids during refining can occur during a variety of process, either by intent (such as in the deasphalting process) or inadvertently when the separation is detrimental to the process (Table 7.1) (Chapter 5) (Mushrush and Speight, 1995; Speight, 2014). Thus, separation of solids occurs whenever the solvent characteristics of the liquid phase are no longer adequate to maintain polar and/or high-molecular-weight material in solution. Examples of such occurrences are: (i) asphaltene separation, which occurs when the paraffin content or character of the liquid medium increases, (ii) wax separation, which occurs when there is a drop in temperature or the aromatic content or character of the liquid medium increases, (iii) sludge or sediment formation in a reactor, which occurs when the solvent characteristics of the liquid medium change so that asphalt or wax materials separate, (iv) coke formation, which occurs at high temperatures and commences when the solvent power of the liquid phase is not sufficient to maintain the coke precursors in solution, and (v) sludge or sediment formation in fuel products and occurs because of the interplay of several chemical and physical factors.

This mechanism also appears to be operable during the hydroconversion of viscous feedstocks, which has included a phase-separation step (the formation of *dry sludge*) in a kinetic model but was not included as a preliminary step to coke formation in a thermal cracking model (Takatsuka et al., 1989; Takatuska et al. 1989; Andersen and Speight, 2001; Speight, 2004a–c; Ancheyta et al., 2005).

7.4.1.1 Visbreaking

To study the thermal chemistry of crude oil constituents, it is appropriate to select the visbreaking process (a *carbon rejection* process) (Chapters 4 and 8) and the hydrocracking process (a *hydrogen addition* process) (Chapters 4 and 11) as used in a modern refinery. The processes operate under different conditions and have different levels of conversion and, although they do offer different avenues for conversion, these processes are illustrative of the thermal chemistry that occurs in refineries (Parkash, 2003; Gary et al., 2007; Speight, 2014; Hsu and Robinson, 2017; Speight, 2017).

The visbreaking process (Chapters 4 and 8) is primarily a means of reducing the viscosity of heavy feedstocks by *controlled thermal decomposition* insofar as the hot products are quenched

before complete conversion can occur (Parkash, 2003; Gary et al., 2007; Speight, 2014; Hsu and Robinson, 2017; Speight, 2017). However, the process is often plagued by sediment formation in the products. This sediment, or sludge, must be removed if the products are to meet fuel oil specifications. The process uses the mild thermal cracking (*partial conversion*) as a relatively low-cost and low-severity approach to improving the viscosity characteristics of the viscous feedstock without attempting significant conversion to distillates. Low residence times are required to avoid coking reactions, although additives can help to suppress coke deposits on the tubes of the furnace (Allan et al., 1983).

A visbreaking unit consists of a reaction furnace, followed by quenching with a recycled oil, and fractionation of the product mixture. All of the reaction in this process occurs as the oil flows through the tubes of the reaction furnace. The severity is controlled by the flow rate through the furnace and the temperature; typical conditions are 475°C–500°C (885°F–930°F) at the furnace exit with a residence time of 1–3 minutes, with operation for 3–6 months on stream (continuous use) is possible before the furnace tubes must be cleaned and the coke removed (Parkash, 2003; Gary et al., 2007; Speight, 2014; Hsu and Robinson, 2017; Speight, 2017). The operating pressure in the furnace tubes varies over a considerable range depending on the degree of vaporization and the residence time desired. For a given furnace tube volume, a lower operating pressure will reduce the actual residence time of the liquid phase.

The reduction in viscosity of the unconverted feedstock tends to reach a limiting value with conversion, although the total product viscosity can continue to decrease. Conversion of a viscous feedstock in the visbreaking process follows first-order reaction kinetics (Henderson and Weber, 1965). The minimum viscosity of the unconverted feedstock can lie outside the range of allowable conversion if sediment begins to form. When pipelining of the visbreaker product is a process objective, a diluent such as gas condensate can be added to achieve a further reduction in viscosity.

The high viscosity of the viscous feedstocks is thought to be due to entanglement of the high-molecular-weight components of the oil and the formation of ordered structures in the liquid phase. Thermal cracking at low conversion can remove side chains from the asphaltene constituents and break bridging aliphatic linkages. A 5% w/w–10% w/w conversion of the viscous feedstock to naphtha is sufficient to reduce the entanglements and structures in the liquid phase and give at least a substantial (perhaps a five-fold) reduction in the viscosity.

The stability of visbroken products is also an issue that might be addressed at this time. Using this simplified model, visbroken products might contain polar species that have been denuded of some of the alkyl chains and which, on the basis of solubility, might be more rightly called *carbenes* and *carboids*, but an induction period is required for phase separation or agglomeration to occur. Such products might initially be *soluble* in the liquid phase but after the induction period, cooling, and/or diffusion of the products, incompatibility (phase separation, sludge formation, agglomeration) occurs.

On occasion, higher temperatures are employed in various reactors as it is often assumed that, if no side reactions occur, longer residence times at a lower temperature are equivalent to shorter residence times at a higher temperature. However, this assumption does not acknowledge the change in thermal chemistry that can occur at the higher temperatures, irrespective of the residence time. Thermal conditions can, indeed, induce a variety of different reactions in crude oil constituents, so that selectivity for a given product may change considerably with temperature. The onset of secondary, tertiary, and even quaternary reactions under the more extreme high-temperature conditions can convert higher-molecular-weight constituents of crude oil to low-boiling distillates, butane, propane, ethane, and (ultimately) methane. Caution is advised in the use of extreme temperatures.

Obviously, the temperature and residence time of the asphaltene constituents in the reactor are key to the successful operation of a visbreaker. A visbreaking unit must operate in temperature and residence time regimes that do not promote the formation of sediment (often referred to as coke). However, as already noted, there is a *break point* above which considering might be increased but the possibility of sediment deposition increases. At the temperatures and residence times outside of the most beneficial temperature and residence time regimes, thermal changes to the asphaltene

constituents cause phase separation of a solid product that then progresses to coke. Furthermore, it is in such operations that models derived from *average parameters* can be ineffective and misleading. For example, the amphoteric constituents of the asphaltene fraction are more reactive than the less polar constituents (Speight, 2014). The thermal products from the amphoteric constituents form first and will separate out from the reaction matrix before other products (Speight, 2014, 2017). Under such conditions, models based on average structural parameters or on average properties will not predict early phase separation to the detriment of the product and the process as a whole.

Knowing the actual nature of the sub-types of the asphaltene constituents is obviously beneficial and will allow steps to be taken to correct any such unpredictable occurrence. Indeed, the concept of hydrovisbreaking (visbreaking in the presence of hydrogen) could be of valuable assistance when high-asphaltene content feedstocks are used.

7.4.2 HYDROCONVERSION CHEMISTRY

There have also been many attempts to focus attention on the asphaltene constituents during hydrocracking studies. The focus has been on the macromolecular changes that occur by investigation of the changes to the generic fractions, that is, the asphaltene constituents, the resin constituents, and the other fractions that make up such a feedstock (Ancheyta and Speight, 2007).

When catalytic processes are employed, complex molecules (such as those that may be found in the original asphaltene fraction or those formed during the process) are not sufficiently mobile (or are too strongly adsorbed by the catalyst) to be saturated by the hydrogenation components. Hence, these molecular species continue to condense and eventually degrade to coke. These deposits deactivate the catalyst sites and eventually interfere with the process.

Several noteworthy attempts have been made to focus attention on the asphaltene constituents during hydroprocessing studies. The focus has been on the macromolecular changes that occur by investigation of the changes in the generic fractions, i.e., the asphaltene constituents, the resin constituents, and the other fractions that make up such a feedstock.

The means by which asphaltene constituents are desulfurized, as one step of a hydrocracking operation, is also suggested as part of this process. This concept can then be taken one step further to show the dealkylation of the aromatic systems as a definitive step in the hydrocracking process (Speight, 1987). It is also likely that molecular species (within the asphaltene fraction) that contain nitrogen and other heteroatoms, and have lower volatility than their hydrocarbon analogs, are the prime movers in the production of coke (Speight, 1987).

When catalytic processes are employed, complex molecules such as those that may be found in the original asphaltene fraction or those or formed during the process, are not sufficiently mobile (or are too strongly adsorbed by the catalyst) to be saturated by the hydrogenation components and, hence, continue to condense and eventually degrade to coke. These deposits deactivate the catalyst sites and eventually interfere with the hydroprocess.

A convenient means of understanding the influence of feedstock on the hydrocracking process is through a study of the hydrogen content (hydrogen-to-carbon atomic ratio) and molecular weight (carbon number) of the feedstocks and products. Such data show the extent to which the carbon number must be reduced and/or the relative amount of hydrogen that must be added to generate the desired lower-molecular-weight, hydrogenated products. In addition, it is possible to use data for hydrogen usage in processing viscous feedstocks, where the relative amount of hydrogen consumed in the process can be shown to be dependent upon the sulfur content of the feedstock.

Hydrotreating is the (relatively) low temperature removal of heteroatomic species by treatment of a feedstock or product in the presence of hydrogen (Chapters 4 and 10). On the other hand, *hydrocracking* is the thermal decomposition of a feedstock in which carbon–carbon bonds are cleaved in addition to the removal of heteroatomic species (Parkash, 2003; Gary et al., 2007; Speight, 2014; Hsu and Robinson, 2017; Speight, 2017). The presence of hydrogen changes the nature of the products (especially the decreasing coke yield) by preventing the buildup of precursors that are incompatible

in the liquid medium and form coke (Magaril and Akensova, 1968; Magaril and Ramazaeva, 1969; Magaril and Aksenova, 1970; Magaril et al., 1970; Speight and Moschopedis, 1979). In fact, the chemistry involved in the reduction of asphaltene constituents to liquids using models in which where the polynuclear aromatic system borders on graphitic is difficult to visualize, let alone justify. However, the *paper chemistry* derived from the use of a molecularly designed model composed of smaller polynuclear aromatic systems is much easier to visualize (Speight, 1994, 2014). But precisely how asphaltene constituents react with the catalysts is open to much more speculation.

In contrast to the visbreaking process, in which the general principle is the production of products for use as fuel oil, the hydroprocessing is employed to produce a slate of products for use as liquid fuels. Nevertheless, the decomposition of asphaltene constituents is, again, an issue, and just as models consisting of large polynuclear aromatic systems are inadequate to explain the chemistry of visbreaking, they are also of little value for explaining the chemistry of hydrocracking.

Deposition of solids or incompatibility is still possible when asphaltene constituents interact with catalysts, especially acidic support catalysts, through the functional groups, e.g., the basic nitrogen species just as they interact with adsorbents. And there is a possibility for interaction of the asphaltene with the catalyst through the agency of a single functional group in which the remainder of the asphaltene molecule remains in the liquid phase. There is also a less desirable option in which the asphaltene reacts with the catalyst at several points of contact, causing immediate incompatibility on the catalyst surface.

There is evidence to show that during the early stages of the hydrotreating process, the chemistry of the asphaltene constituents follows the same routes as the thermal chemistry (Ancheyta et al., 2005). Thus, initially, there is an increase in the amount of asphaltene constituents followed by a decrease indicating that, in the early stages of the process, resin constituents are being converted to asphaltene material by aromatization and by some dealkylation. In addition, aromatization and dealkylation of the original asphaltene constituents yield asphaltene products that are of higher polarity and lower molecular weight than the original asphaltene constituents.

These observations are in keeping with observations for the thermal reactions of asphaltene constituents in the absence in hydrogen where the initial events are a reduction in the molecular weight of the asphaltene constituents leading to lower molecular weight by more polar products that are derived from the asphaltene constituents but are often referred to as *carbenes* and *carboids*. As the reaction progresses, these derived products increase in molecular weight and eventually become insoluble in the reaction medium, deposit on the catalyst, and form coke.

As predicted from the chemistry of the thermal reactions of the asphaltene constituents, there is a steady increase in aromaticity (reflected as a decrease in the hydrogen/carbon atomic ratio) with on-stream time. This is due to (i) aromatization of naphthene ring system that are present in asphaltene constituents, (ii) cyclodehydrogenation of alkyl chains to form other naphthene ring systems (iii) dehydrogenation of the new naphthene ring systems to form more aromatic rings, and (iv) dealkylation of aromatic ring systems.

REFERENCES

Allan, D.E., Martinez, C. H., Eng, C.C., and Barton, W.J. 1983. Visbreaking Gains Renewed Interest. *Chem. Eng. Progr.* 79(1): 85–89.

Ancheyta, J., Sánchez, S., and Rodrıguez, M.A. 2005. Kinetic Modeling of Hydrocracking of Heavy Oil Fractions: A Review. *Catal. Today* 109: 76–92.

Ancheyta, J., and Speight, J.G. 2007. Feedstock Evaluation and Composition. *Hydroprocessing of Heavy Oils and Residua.* J. Ancheyta and J.G. Speight (Editors). CRC Press, Taylor & Francis Group, Boca Raton, FL, Chapter 2.

Andersen, S.I., and Speight, J.G. 2001. Petroleum Reins: Separation, Character, and Role in Petroleum. *Pet. Sci. Technol.* 19: 1.

Bahmani, M., Sadighi, S., Mashayekhi, M., Seif Mohaddecy, S.R., and Vakili, D. 2007. Maximizing Naphtha and Diesel Yields of an Industrial Hydrocracking Unit with Minimal Changes. *Pet. Coal* 49(1): 16–20.

Bjorseth, A. 1983. *Handbook of Polycyclic Aromatic Hydrocarbons*. Marcel Dekker Inc., New York.

Cooper, T.A., and Ballard, W.P. 1962. Volume 6. *Advances in Petroleum Chemistry and Refining*. K.A. Kobe and J.J. McKetta (Editors). Interscience, New York, Chapter 4.

Cumming, K.A., and Wojciechowski, B.W. 1996. *Catal. Rev. – Sci. Eng.* 38: 101–157.

Dias, J.R. 1987. *Handbook of Polycyclic Hydrocarbons. Part A. Benzenoid Hydrocarbons*. Elsevier, New York.

Dias, J.R. 1988. *Handbook of Polycyclic Hydrocarbons. Part B. Polycyclic Isomers and Heteroatom Analogs of Benzenoid Hydrocarbons*. Elsevier, New York.

Dolbear, G.E. 1998. Hydrocracking: Reactions, Catalysts, and Processes. *Petroleum Chemistry and Refining*. J.G. Speight (Editor). Taylor & Francis Publishers, Washington, DC, Chapter 7.

Dolbear, G.E., Tang, A., and Moorehead, E.L. 1987. Upgrading Studies with California, Mexican, and Middle Eastern Heavy Oils. *Metal Complexes in Fossil Fuels*. R.H. Filby and J.F. Branthaver (Editors). American Chemical Society, Washington, DC, Pages 220–232.

Fabuss, B.M., Smith, J.O., and Satterfield, C.N. 1964. Thermal Cracking of Pure Saturated Hydrocarbons. *Advances in Petroleum Chemistry and Refining 3*. J.J. McKetta (Editor). John Wiley and Sons, New York, Pages 156–201.

Fitzer, E., Mueller, K., and Schaefer, W. 1971. The Chemistry of the Pyrolytic Conversion of Organic Compounds to Carbon. *Chem. Phys. Carbon* 7: 237–383.

Gary, J.G., Handwerk, G.E., and Kaiser, M.J. 2007. *Petroleum Refining: Technology and Economics*, 5th Edition. CRC Press, Taylor & Francis Group, Boca Raton, FL.

Hajji, A.A., Muller, H., and Koseoglu, O.R. 2010. Molecular Details of Hydrocracking Feedstocks. *Saudi Aramco J. Technol.* Spring: 1–12.

Henderson, J.H., and Weber, L. 1965. Physical Upgrading of Heavy Oils by the Application of Heat. *J. Can. Pet. Tech.* 4: 206–212.

Hsu, C.S., and Robinson, P.R. (Editors). 2017. *Handbook of Petroleum Technology*. Springer International Publishing AG, Cham, Switzerland.

Hurd, C.D. 1929. *The Pyrolysis of Carbon Compounds*. The Chemical Catalog Company Inc., New York.

Keller, W.D. 1985. Clays. *Kirk Othmer Concise Encyclopedia of Chemical Technology*. M. Grayson (Editor). Wiley Interscience, New York, Page 283.

Kim, H., and Long, R.B. 1979. *J. Ind. Eng. Chem. Fundam.* 18: 60.

King, P.J., Morton, F., and Sagarra, A. 1973. *Modern Petroleum Technology*. G.D. Hobson and W. Pohl (Editors). Applied Science Publishers, Barking, Essex, United Kingdom.

Koots, J.A., and Speight, J.G. 1975. The Relation of Petroleum Resins to Asphaltenes. *Fuel* 54: 179–184.

Langer, A.W., Stewart, J., Thompson, C.E., White, H.T., and Hill, R.M. 1961. *Ind. Eng. Chem.* 53: 27.

Laszlo, P. 1995. *Organic Reactions: Logic and Simplicity*. John Wiley & Sons Inc., New York.

Levinter, M.E., Medvedeva, M.I., Panchenkov, G.M., Agapov, G.I., Galiakbarov, M.F., and Galikeev, R.K. 1967. *Khim. Tekhnol. Topl. Masel.* 4: 20.

Levinter, M.E., Medvedeva, M.I., Panchenkov, G.M., Aseev, Y.G., Nedoshivin, Y.N., Finkelshtein, G.B., and Galiakbarov, M.F. 1966. *Khim. Tekhnol. Topl. Masel.* 9: 31.

Magaril, R.Z., and Akensova, E.I. 1967. Mechanism of Coke Formation during the Cracking of Petroleum Tars. *Izvestia Vyssh. Ucheb. Zaved. Neft. Gaz.* 10(11): 134–136.

Magaril, R.Z., and Akensova, E.I. 1968. Study of the Mechanism of Coke Formation in the Cracking of Petroleum Resins. *Int. Chem. Eng.* 8(4): 727–729.

Magaril, R.Z., and Aksenova, E.I. 1970a. Mechanism of Coke Formation in the Thermal Decompositon of Asphaltenes. *Khim. Tekhnol. Topl. Masel.* 15(7): 22–24.

Magaril, R.Z., and Aksenova, E.I. 1970b. Kinetics and Mechanism of Coking Asphaltenes. *Khim. Izvestia Vyssh. Ucheb. Zaved. Neft. Gaz.* 13(5): 47–53.

Magaril, R.Z., and Aksenova, E.I. 1972. Coking Kinetics and Mechanism of Asphaltenes. *Khim. Kim Tekhnol. Tr. Tyumen Ind. Inst.* 169–172.

Magaril, R.Z., and Ramazaeva, L.F. 1969. Study of Carbon Formation in the Thermal Decomposition of Asphaltenes in Solution. *Izvestia Vyssh. Ucheb. Zaved. Neft. Gaz.* 12(1): 61–64.

Magaril, R.Z., Ramazaeva, L.F., and Aksenova, E.I. 1970. Kinetics of Coke Formation in the Thermal Processing of Petroleum. *Khim. Tekhnol. Topl. Masel.* 15(3): 15–16.

Magaril, R.Z., Ramazaeva, L.F., and Aksenova, E.I. 1971. Kinetics of the Formation of Coke in the Thermal Processing of Crude Oil. *Int. Chem. Eng.* 11(2): 250–251.

Masel, R.I. 1995. *Principles of Adsorption and Reaction on Solid Surfaces*. John Wiley & Sons Inc., New York.

Mitchell, D.L., and Speight, J.G. 1973. The Solubility of Asphaltenes in Hydrocarbon Solvents. *Fuel* 52: 149.

Moschopedis, S.E., Fryer, J.F., and Speight, J.G. 1976. An Investigation of Asphaltene Molecular Weights. *Fuel* 55: 227.

Mushrush, G.W., and Speight, J.G. 1995. *Petroleum Products: Instability and Incompatibility.* Taylor & Francis Publishers, Philadelphia, PA.

Overfield, R.E., Sheu, E.Y., Sinha, S.K., and Liang, K.S. 1989. SANS Study of Asphaltene Aggregation. *Fuel Sci. Technol. Int.* 7: 611.

Parkash, S. 2003. *Refining Processes Handbook.* Gulf Professional Publishing, Elsevier, Amsterdam, Netherlands.

Pines, H. 1981. *The Chemistry of Catalytic Hydrocarbon Conversions.* Academic Press, New York.

Samorjai, G.A. 1994. *Introduction to Surface Chemistry and Catalysis.* John Wiley & Sons Inc., New York.

Savage, P.E., Klein, M.T., and Kukes, S.G. 1988. Asphaltene Reaction Pathways 3. Effect of Reaction Environment. *Energy Fuels* 2: 619–628.

Schabron, J.F., and Speight, J.G. 1997. An Evaluation of the Delayed Coking Product Yield of Heavy Feedstocks Using Asphaltene Content and Carbon Residue. *Rev. Inst. Fr. Pét.* 52(1): 73–85.

Schucker, R.C., and Keweshan, C.F. 1980. Reactivity of Cold Lake Asphaltenes. Preprints, *Div. Fuel Chem. Am. Chem. Soc.* 25: 155.

Smith, M.B. 1994. *Organic Synthesis.* McGraw-Hill Inc., New York.

Speight, J.G. 1970. Thermal Cracking of Athabasca Bitumen, Athabasca Asphaltenes, and Athabasca Deasphalted Heavy Oil. *Fuel* 49: 134.

Speight, J.G. 1984. Upgrading Heavy Oils and Residua: The Nature of the Problem. *Catalysis on the Energy Scene.* S. Kaliaguine and A. Mahay (Editors). Elsevier, Amsterdam, Netherlands, Page 515.

Speight, J.G. 1987. Initial Reactions in the Coking of Residua. Preprints, *Div. Pet. Chem. Am. Chem. Soc.* 32(2): 413.

Speight, J.G. 1989. Thermal Decomposition of Asphaltenes. *Neftekhimiya* 29: 732.

Speight, J.G. 1990. The Chemistry of the Thermal Degradation of Petroleum Asphaltenes. *Acta Pet. Sin. (Pet. Process. Sect.)* 6(1): 29.

Speight, J.G. 1992. A Chemical and Physical Explanation of Incompatibility during Refining Operations. Proceedings. *4th International Conference on the Stability and Handling of Liquid Fuels.* US. Department of Energy (DOE/CONF-911102), Page 169.

Speight, J.G. 1994. Chemical and Physical Studies of Petroleum Asphaltenes. *Asphalts and Asphaltenes, 1.* T.F. Yen and G.V. Chilingarian (Editors). Elsevier, Amsterdam, Netherlands, Chapter 2.

Speight, J.G. 1998. Thermal Chemistry of Petroleum Constituents. *Petroleum Chemistry and Refining.* J.G. Speight (Editor). Taylor & Francis, Washington, DC, Chapter 5.

Speight, J.G. 2000. *The Desulfurization of Heavy Oils and Residua,* 2nd Edition. Marcel Dekker Inc., New York.

Speight, J.G. 2004a. New Approaches to Hydroprocessing. *Catal. Today* 98(1–2): 55–60.

Speight, J.G. 2004b. Petroleum Asphaltenes Part 1: Asphaltenes, Resins, and the Structure of Petroleum. *Rev. Inst. Fr. Pét.* 59: 467.

Speight, J.G. 2004c. Petroleum Asphaltenes Part 2: The Effect of Asphaltene and Resin Constituents on Recovery and Refining Processes. *Rev. Inst. Fr. Pét. – Oil Gas Sci. Technol.* 59(5): 479–488.

Speight, J.G. 2014. *The Chemistry and Technology of Petroleum,* 5th Edition. CRC Press, Taylor and Francis Group, Boca Raton, FL.

Speight, J.G. 2015. *Handbook of Petroleum Product Analysis,* 2nd Edition. John Wiley & Sons Inc., Hoboken, NJ.

Speight, J.G. 2017. *Handbook of Petroleum Refining.* CRC Press, Taylor and Francis Group, Boca Raton, FL.

Speight, J.G. 2019. *Handbook of Petrochemical Processes.* CRC Press, Taylor & Francis Group, Boca Raton, FL.

Speight, J.G. 2020. *Synthesis Gas: Production and Properties.* Scrivener Publishing, Beverly, MA.

Speight, J.G., and Moschopedis, S.E. 1979. The Production of Low-Sulfur Liquids and Coke from Athabasca Bitumen. *Fuel Process. Technol.* 2: 295.

Speight, J.G., Wernick, D.L., Gould, K.A., Overfield, R.E., Rao, B.M.L., and Savage, D.W. 1985. Molecular Weights and Association of Asphaltenes: A Critical Review. *Rev. Inst. Fr. Pét.* 40: 51.

Storm, D.A., Decanio, S.J., Edwards, J.C., and Sheu, E.Y. 1997. Sediment Formation during Heavy Oil Upgrading. *Pet. Sci. Technol.* 15: 77.

Takatsuka, T., Kajiyama, R., Hashimoto, H., Matsuo, I., and Miwa, S.A. 1989. *J. Chem. Eng. Jpn.* 22: 304.

Takatuska, T., Wada, Y., Hirohama, S., and Fukui, Y.A. 1989. *J. Chem. Eng. Jpn.* 22: 298.

Thiyagarajan, P., Hunt, J.E., Winans, R.E., Anderson, K.B., and Miller, J.T. 1995. Temperature Dependent Structural Changes of Asphaltenes in 1-Methylnaphthalene. *Energy Fuels* 9: 629.

Valyavin, G.G., Fryazinov, V.V., Gimaev, R.H., Syunyaev, Z.I., Vyatkin, Y.L., and Mulyukov, S.F. 1979. *Khim. Tekhol. Topl. Masel.* 8: 8.

Vercier, P. 1981. Programmed Pyrolysis, Programmed Combustion, and Specific Nitrogen and Sulfur Detection. *The Chemistry of Asphaltenes*. J.W. Bunger and N.C. Li (Editors). Advances in Chemistry Series No. 195. American Chemical Society, Washington, DC, Pages 203–217.

Yan, T.Y. 1987. Coker Formation in the Visbreaking Process. Preprints, *Div. Pet. Chem. Am. Chem. Soc.* 32: 490.

Yen, T.F. 1984. *The Future of Heavy Crude Oil and Tar Sands*. R.F. Meyer, J.C. Wynn, and J.C. Olson (Editors). McGraw-Hill, New York.

Yen, T.F. 1998. Correlation between Heavy Crude Sources and Types and Their Refining and Upgrading Methods. Proceedings. *7th UNITAR International Conference on Heavy Crude and Tar Sand*, Beijing, China, Volume 2, Pages 2137–2144.

8 Refinery Reactors

8.1 INTRODUCTION

Refining has evolved continuously in response to changing demand for better and different products. The original requirement was to produce kerosene as a cheaper and better source of light than whale oil. The development of the internal combustion engine led to the production of gasoline and diesel fuels. In addition, the evolution of the aeroplane created a need for high-octane aviation gasoline and then for jet fuel, which required further processing of the kerosene fraction. This, the modern refinery produces a variety of products including many required as feedstocks for the petrochemical industry and each product is the result of the application of one or more reactor configurations during the refining process.

The subject of chemical reaction engineering initiated as it applies to the refining industry evolved primarily to choose, size, and determine the optimal operating conditions for a reactor to produce a specific set of products (such as liquid fuels or the precursors to liquid fuels) and petrochemical application (Speight, 2019). This involves (i) the chemical reaction, (ii) the chemical changes to the feedstock that are expected to occur, (iii) the chemical nature of the products vis-à-vis the chemical nature of the feedstock, (iv) the physical nature of the products vis-à-vis the physical nature of the feedstock, and (v) the rate of the reaction. Thus, the initial task in approaching the description of a chemically reacting system is to understand the answers to these four criteria from which reactor design can eventually occur. Furthermore, each reaction is often represented by stoichiometrically simple equations that often are not truly representative of the refinery process (Parkash, 2003; Gary et al., 2007; Speight, 2014; Hsu and Robinson, 2017; Speight, 2017). Furthermore, the term *simple reaction* should be avoided since a stoichiometrically simple reaction does not occur in a simple manner. In fact, most refinery processes proceed through complicated sequences of *chemical steps* involving reactive intermediates that do not appear in the stoichiometric representations of the processes. The identification of these intermediates and the role that they play in the process is a necessity for the design of refinery reactors.

In discussions of the chemistry of refinery processes (Chapter 7), in studies of the process (or reaction) kinetics, the terms *mechanism* or *model* receive frequent use and are used to indicate a plausible, but *assumed* sequence of steps for a given reaction. However, the various levels of detail in investigating reaction mechanisms, sequences, and steps are so different that the terms *mechanism* and *model* (with the associated descriptors) are often associated with much speculation. An example is the ongoing attempts to assign molecular parameters to the higher molecular weight species in viscous feedstocks (such as heavy crude oil, extra-heavy crude oil, and tar sand bitumen as well as atmospheric residua and vacuum residua) (Speight, 2014) and thence basing process designs and reactors design on these assumptions. As worthy is such efforts may seem, the assumptions employed can lead to erroneous design and development of refinery processes. As any chemically reacting system proceeds from reactants to products, a number of species (*reactive intermediates*) are produced, reach a reaction-specific concentration, and then move to produce the products.

The complexity of the refinery-related chemistry and refinery-related processes dictates that reactor engineering and reactor design play an extremely important role in refining viscous feedstocks – the basis of economical and safe operation dictates that reactor selection and design must be suitable for the feedstock and for adapting to the changing nature of refinery feedstocks (Furimsky, 1998; Davis and Davis, 2003; Robinson, 2006; Salmi et al., 2011). Chemical reactions in viscous feedstock refining include a wide spectrum of unique properties and includes (i) composition of the feedstock, (ii) stability of the feedstock blend, (iii) contact between the reactants, (iv) the presence or absence

of a catalyst, (v) whether heat is evolved or absorbed, and (vi) the rate of the reaction. In addition, the reactors are used for the conversion of viscous feedstocks into products, which can be a batch-type reactor or a continuously operating reactor (Fogler, 2006; Salmi et al., 2011; Speight, 2014, 2017).

If the desired product purity cannot be achieved in the reactor – as is often the case – one or several separation units are installed after the actual reactor. Common separation units include distillation, absorption, extraction, or crystallization equipment (Versteeg et al., 1997). A chemical reactor coupled with a separation unit constitutes a unit process that is a part of the refinery system. The role of the reactor is crucial for the whole process: product quality from the chemical reactor determines the following process steps, such as type, structure, and operation principles of separation units.

Most processes that are relevant to refining viscous feedstocks are carried out in the presence of a catalyst. Homogeneous or homogeneously catalyzed reactions can be facilitated in a simple tube or tank reactors. For heterogeneous catalytic reactions (Jones and Pujado, 2006), the reactor typically has a solid catalyst phase, which is not consumed as the reaction takes place. The catalyst is placed in the reactor to enhance reaction velocity. Heterogeneous catalytic reactions are commonly carried out in packed-bed reactors, in which the reacting gas or liquid flows through a stagnant catalyst layer. If catalyst particles are very small, they can be set in motion and a fluidized bed can be considered. In case the catalytic reactor contains both a gas phase and a liquid phase, it is referred to as a three-phase reactor. If catalyst particles are immobile, the reactor is typically referred to as a *trickle-bed reactor*, which can operate under pressure (Ng and Chu, 1987; Haure et al., 1989; Gianetto and Specchia, 1992; Saroha and Nigam, 1996; Al-Dahhan et al., 1997).

In catalytic three-phase reactors, a gas phase, a liquid phase, and a solid catalyst phase coexist. Some of the reactants and/or products are in the gas phase under the prevailing conditions (temperature and pressure). The gas components diffuse through the gas-liquid interface, dissolve in the liquid, diffuse through the liquid film to the liquid bulk phase, and diffuse through the liquid film around the catalyst particle to the catalyst surface, where the chemical reaction takes place. If catalyst particles are porous, a chemical reaction and diffusion take place simultaneously in the catalyst pores. The product molecules are transported in the opposite direction.

The size of the catalyst particle is of considerable importance for catalytic three-phase reactors. Catalyst particles can be very small and are suspended in the liquid phase. Catalyst particles of a size similar to those used in two-phase packed-bed reactors can also be used in three-phase reactors. Small catalyst particles are mainly used in bubble columns, stirred-tank reactors, and fluidized beds. Slurry phase reactors – especially reactors used in hydrocracking processes – offer a thermal cracking process in the presence of hydrogen and dispersed catalyst (Parkash, 2003; Gary et al., 2007; Speight, 2014; Hsu and Robinson, 2017; Speight, 2017). The dispersed catalyst is typically in powder form and may be a natural ore (particularly iron ore, powdered coal) or an oil soluble salt which might contain metals such cobalt, molybdenum, nickel, tungsten, and manganese. On the other hand, packed-bed reactors typically contain large catalyst particles.

Catalytic three-phase processes are of enormous industrial importance. Catalytic three-phase processes exist in the refining industry and are used in hydrodesulfurization and hydrodemetallization processes for the removal of oxygen and nitrogen from oil fractions (hydrodeoxygenation and hydrodenitrogenation), and in the hydrogenation of aromatic compounds (dearomatization) (Parkash, 2003; Gary et al., 2007; Speight, 2014; Hsu and Robinson, 2017; Speight, 2017). The production of synthetic fuels (Fisher-Tropsch synthesis) is a three-phase system. For some catalytic two-phase processes, competing three-phase processes have been developed. Oxidation of sulfur dioxide (SO_2) to sulfur trioxide (SO_3) over an active carbon catalyst and methanol (CH_3OH) synthesis can be carried out in three-phase slurry reactors.

This type of reactor is considered to be the simplest reactor type for use in catalytic processes where gas and liquid (normally both reagents) are present in the reactor and accordingly it is extensively used in processing plants. Typical examples of the use of the trickle-bed reactor (downflow fixed-bed reactor) in refineries are (i) liquid-phase hydrogenation, (ii) hydrodesulfurization, and (iii) hydrodenitrogenation. Most commercial trickle-bed reactors operate adiabatically at high

temperatures and high pressures and generally involve hydrogen and organic liquids. Kinetics and/or thermodynamics of reactions conducted in trickle-bed reactors often necessitate high temperatures.

However, trickle-bed reactors (which contain a fixed bed of sulfided NiMo- or CoMo/Al$_2$O$_3$ catalyst particles) are sensitive to fouling though the deposition of solids and deactivation via metals, alkali, bio-heteroatoms (such as phosphorus) and may have challenges because of the heat gain across typical refinery hydrotreaters may exceed allowable temperature limits.

A variant of adown-flow fixed-bed reactor (Parkash, 2003; Gary et al., 2007; Speight, 2014; Hsu and Robinson, 2017; Speight, 2017) is the radial-flow fixed-bed reactor in which the feed enters the top of the reactor and flows through the bed in a radial direction and then passes out through the base of the reactor instead of flowing downward through the catalyst bed (Parkash, 2003; Gary et al., 2007; Speight, 2014; Hsu and Robinson, 2017; Speight, 2017).

Commercial hydrocracking processes mainly use two types of reactors: (i) the fixed trickle-bed reactor (TBR), and (ii) the ebullated-bed reactor (EBR), and, in both cases when processing heavy feedstocks, three phases are present (Ancheyta et al., 2005). The advantages of using fixed-bed reactors are the relative simplicity of scale-up and operation; the reactors operate in downflow mode, with liquid and gas (mainly hydrogen) flowing down over the catalytic bed, as in the distillate hydrotreating process (Parkash, 2003; Gary et al., 2007; Speight, 2014; Hsu and Robinson, 2017; Speight, 2017). The major issue that arises with this type of reactor is the accumulation of metals and coke in the mouth of the catalytic pores, blocking the access of reactants to the internal surface. The ebullated-bed reactors eliminate this difficulty by fluidizing the catalyst. Metals are deposited in the catalyst inventory allowing for uniform deactivation. The catalyst is continuously added and removed in order to keep the catalytic activity at a certain constant level. In general, ebullated-bed technology is most applicable for highly exothermic reactions and for feedstocks that are difficult to process in a fixed-bed reactor due to high levels of contaminants.

Ebullated-bed reactors are designed to hydroprocess heavy feedstocks that contain high amounts of metal constituents and asphaltene constituents (Parkash, 2003; Gary et al., 2007; Speight, 2014; Hsu and Robinson, 2017; Speight, 2017). The function of these reactors is to overcome some of the deficiencies present in the fixed-bed reactors. In the ebullated-bed reactor, the feedstock and hydrogen are fed in an up-flow mode through the catalyst bed, expanding and back-mixing the bed, minimizing bed plugging, and consequently reducing the effects of pressure drop. The mixture of the gas (make-up and recycle hydrogen) and feedstock (plus any recycled stream) enter the reactor where mixing through the gas/liquid mixer, spargers, and catalyst support grid plate occurs. The product quality is constantly maintained at a high level by intermittent catalyst addition and withdrawal, which is one of the features included to eliminate the need to shut down for catalyst replacement.

The hydroprocessing ebullated-bed reactor is a three-phase system (i.e. gas, liquid, and solid catalyst) in which oil is separated from the catalyst at the top of the reactor and recirculated to the bottom of the bed to mix with the new feed. The large liquid recycle causes the reactor to behave as a continuous stirred-tank reactor. The reactor is provided with an ebullating pump to maintain liquid circulation within the reactor and maintain the reactor at isothermal conditions so that there is no need for quenches within the reactor. Any unconverted feedstock is recirculated back to the reactor with a small amount of diluent to improve fluidity and thus overall conversion. Fresh catalyst is added to the top of the reactor and the spent catalyst is withdrawn from the bottom of the reactor. The inventory of catalyst in the reactor is maintained at the desired level by adjusting the catalyst addition rate equal to the withdrawal rate plus any losses. The catalyst replacement rate can be adjusted to suit feedstock properties, process parameters, product slate, and product quality requirements.

Homogeneous and homogeneously catalyzed gas-liquid reactions take place in the liquid phase in which gaseous reactants dissolve and react with other reactants that are primarily present in the liquid phase. Typical constructions to be used as gas-liquid reactors are column and tank reactors. Liquid-liquid reactors principally resemble gas-liquid reactors, but the gas phase is replaced by another liquid phase. The reactions can principally take place in either of, or even both, the liquid phases.

The most complicated systems are represented by reactors in which the solid phase is consumed – or solid particles are generated – while a reaction takes place. For this kind of reaction, similar types of reactors are utilized as for heterogeneous catalytic reactions: (i) packed-bed reactors and (ii) fluidized bed reactors (Parkash, 2003; Gary et al., 2007; Speight, 2014; Hsu and Robinson, 2017; Speight, 2017). However, it is not the configuration of the reactor itself but the chemistry involved in the industrial process that plays a central role in the production of new substances. The process chemistry decides, to a large extent, the choice of the reactor. Thus, reactor and reaction engineering play a vital role in the refinery.

Any errors (even small errors) in equipment sizing or yield translate to unnecessary expense and it is extremely important that the refinery engineer correctly size and specify the process parameters for a refinery reactor. The process chemist and the process engineer must have a clear understanding of a reactor at each of the three stages of development, which are (i) the laboratory reactor, which explores new reaction conditions, catalyst formulations, feedstock types, and reaction kinetics; (ii) development of the reactor to simulate the commercial operation by employing recycle streams to achieve a realistic assessment of the reactor behavior; and (iii) sizing of the reactor for operation at the commercial scale and adiabatic operation. In the second stage, isothermal conditions are usually maintained in the reactor, but if heat release is a concern, such as when hydrotreating viscous feedstocks, the reactor should be tested under adiabatic conditions to establish the adiabatic reaction temperature and to determine the amount of heat that must be removed in the final commercial design. At this stage, examining the potential for catalyst deactivation, product yield variations, and the manner in which changing feedstock quality can influence the process. Finally, as part of the third-stage investigations, the commercial-size reactor must be investigated for safe start-up and shut-down as well as operation under steady-state conditions.

By way of definition, an adiabatic process is a thermodynamic process during which no energy is transferred as heat across the boundaries of the system. This does not exclude energy transfer as work. The adiabatic process provides a rigorous conceptual basis for the theory used to expound the first law of thermodynamics, and as such, it is a key concept in thermodynamics. Some chemical and physical processes occur so rapidly that they may be conveniently described by the adiabatic approximation, meaning that there is not enough time for the transfer of energy as heat to take place to or from the system. An adiabatic reactor is designed to enhance and promote such reactions.

Thus, the purpose of this chapter is to present an introduction to design and selection and the characteristics of the chemical reaction of interest. The reactor types discussed focus on those in a refinery and whether the reaction occurs in the vapor, liquid, or mixed vapor-liquid phase. More specifically, a refinery must select reactors according to the process, such as (i) naphtha-processing reactors where reaction may be in the gaseous phase, (ii) reactors for processing kerosene and middle distillate fractions that react partially in the gas phase and the liquid phase, and (iii) reactors that are used for processing viscous feedstocks which react completely in the liquid phase. The chapter is especially to the activities of the modern refinery (Parkash, 2003; Gary et al., 2007; Speight, 2014; Hsu and Robinson, 2017; Speight, 2017) that may well evolve into a refinery that accepts other non-crude oil feedstocks for refining in the future. In such cases, reactor technology and the motivation of reactors for processing such feedstocks will become a major event in many refineries.

Thus, the chapter will serve as an introduction to reactor technology with emphasis on the types of reactors used in refineries and presents an introduction to the fundamentals of reactor technology as it applies to the various refinery processes.

8.2 REACTOR TYPES

A refinery reactor is an enclosed volume in which a chemical reaction takes place. The design of the reactor ensures that the reaction proceeds with the highest efficiency toward the desired output product, producing the highest yield of the product. Energy changes can be in the form of heating or cooling as well as increase or decrease in pressure. The reactor bed fouling can impact throughput,

process efficiency, and energy costs. As run lengths progress, organic solids and iron sulfide eventually build up on the top of the reactor bed and cause plugging. Plugging causes pressure drops across the reactor bed, limiting flow, and potentially impacting catalyst activity. The economic deficits associated with reactor bed fouling are significant.

The reactors used in a refinery are among the most complex and difficult to model and design. The composition and properties of the various feedstocks (varying from distillates such as naphtha to low-volatility viscous feedstocks) that are converted in refinery reactors have properties that are such that the reaction system can involve various phases, catalysts, reactor configuration, and continuous catalyst addition which serve to make the development and design of the reactor a serious challenge. In addition, the presence of an unknown (petrochemical processes being the general exception) number (but at least a number in the hundreds) of constituents undergoing different chemical reactions leading to a multitude of reaction paths and competing for the active sites of catalysts, contributes to increasing the complexity of the reactor design.

The choice of a suitable reactor type, and hence the design of the reactors, is dictated by the process parameters as well as the nature and boiling range (i.e. physical and chemical properties) of the feedstock (Fogler, 2006; Salmi et al., 2011). Typically, the higher the boiling point of the feed the higher the reaction severity, especially in the high-pressure hydroprocesses. Hence, the various reactors used in refining viscous feedstocks must be designed for non-catalytic processes and for catalytic processes that establish reactor size. However, one of the issues that often arise when defining reactor types is that the names of the various reactors are often arbitrary and difficult to define. However, as a word of caution, reactor definitions based on reactor use do not always signify the correct or standard name for the reactor – the name may be based on the reactor type, bed type, or process type and the names may be intermingled – and there may be more than one name for a particular reactor type. Where possible, simple names are used in this section and are often based on the use for which the reactor was designed and constructed.

In the design of a reactor for a refinery process, the first issue is whether the process should be operated in the batch mode (discontinuous mode) or continuous mode. In the refining industry the tendency is toward continuous operation, other than planned shut-downs for reactor maintenance. There is no general rule for the selection of the operation mode but economic balance, scale of production, long reaction times, the flexibility of production, and nature of the process and the product may dictate the selection of batch or semi-batch operation. However, batch reactors are therefore often used for small production rates such as fine chemicals and specialties where reaction conditions can be adjusted to product specification or quality.

In terms of production flexibility, the same reactor is often used not only for different products but also for different process operations such as heating, reacting, solvent evaporation, cooling, blending with additives, besides standard cyclic operations such as reactor initial conditioning, gas evacuation, reactants charge, product discharge, and reactor washing (Donati and Paludetto, 1999).

In summary, reactors can be divided into two broad categories: (i) batch reactors and (ii) continuous reactors (Butt, 2000; Fogler, 2006).

Batch reactors are stirred tanks sufficiently large to handle the full inventory of a complete batch cycle. In some cases, batch reactors may be operated in semi-batch mode where one chemical is charged to the vessel and a second chemical is added slowly. Continuous reactors are generally smaller than batch reactors and handle the product as a flowing stream. Continuous reactors may be designed as pipes with or without baffles or a series of interconnected stages.

8.2.1 Batch Reactor

The batch reactor is the simplest type of reactor (Figure 8.1) into which the feedstock is loaded into the reactor and the reaction proceeds with time. A batch reactor does not reach a steady state, and control of temperature, pressure, and volume is often necessary. Many batch reactors, therefore, have ports for sensors and material input and output. Batch reactors are typically used in small-scale

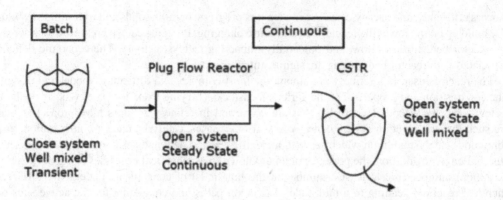

FIGURE 8.1 Simplified schematic of a batch reactor, a plug-flow reactor, and a continuous stirred-tank reactor (CSTR).

production and reactions with biological materials, such as in brewing, pulping, and production of enzymes.

The *batch reactor* is the generic term for a type of vessel widely used in the many process industries as well as in the refining industry – the analog is the laboratory-scale flask in which chemicals are mixed and reacted. Vessels of this type are used for a variety of process operations such as solids dissolution, product mixing, chemical reactions, batch distillation, crystallization, liquid/liquid extraction, and polymerization. In some cases, they are not referred to as reactors but have a name that reflects the role they perform such as a crystallizer (that might be used in the petrochemical industry) or a bioreactor (that might be used in the biomass-to-biofuels industry). To a point, the delayed coking drum can be considered to be a batch reactor or a semi-batch reactor insofar as the reactions that produce coke and distillate products are allowed to proceed to completion in the drum before the drum is taken off-stream and cleaned. The drums are used in pairs and when one of the pairs is off-stream the other is on-stream (Parkash, 2003; Gary et al., 2007; Speight, 2014; Hsu and Robinson, 2017; Speight, 2017).

In the process, the feedstock and any additional components of the reaction mixture, such as catalysts, are loaded into the reactor where they remain for a well-defined set of reaction parameters (under fixed conditions). In the course of this process, the composition of the content of the reactor changes continuously, i.e., the reactor operates in an *unsteady mode*. The advantages of the batch reactor lie with its versatility. A single vessel can carry out a sequence of different operations without the need to break containment. This is particularly useful when processing toxic or highly potent compounds.

The batch reactor may be as simple as a pipe that is operated batch-wise and then shut down for emptying/cleaning. The continuous stirred-tank reactor is typically used in kinetic studies because the reaction rate is derived directly from the inlet and outlet concentrations, and it may simulate operation in a larger commercial reactor such as an ebullated bed where the high recycle rate approximates complete mixing. For continuous processing, almost any feedstock may be fed over a fixed bed of catalyst in a plug-flow reactor, with vapor phase operation for naphtha and trickle phase for distillates and viscous feedstocks.

A micro-batch reactor, such as the tubing bomb reactor is a common, inexpensive device to develop data. The reactants and, optionally, the catalyst are changed in the small reactor, sealed, and then pressured. To start the reaction, the tubing bomb is typically immersed in a heated fluidized sand bath for a specified length of time with agitation. Shortly after immersion in the heated sand bath, the reactor pressure is increased to a final level, close to commercial conditions. To stop the reaction, the micro-reactor is pulled out of the heated bath and rapidly quenched in a cooling fluid.

The batch reactor has high flexibility and allows high conversion of reactants to products as the reaction time may be arbitrarily long. This flexibility of batch reactors allows to adjust the reaction

condition in various reaction phases and therefore to tailor the process variables to process specifications. This is an additional reason to prefer batch operation, in some cases even for large-scale productions, as in the plastic industry. Additional reasons, in favor of batch and semi-batch operations, belong more to the R&D practice and attitude. Many reactions are first investigated in batch lab equipment and scaling up by enlarging vessels, without kinetic experiments or other engineering evaluations may appear as the easiest way. This theorem is, however, far to be proven especially when transport phenomena and mixing effects are relevant to the examined process.

A typical batch reactor consists of a tank with an agitator and an integral heating/cooling system. These vessels may vary in size from less than 1 l to more than 15,000 l. They are usually fabricated in stainless steel, glass-lined steel, or suitable alloy. The liquids and/or solid feedstocks are usually charged via connections in the top cover of the reactor. Vapors and gases also discharge through connections in the top and liquids are usually discharged out of the bottom. The usual agitator arrangement is a centrally mounted driveshaft with an overhead drive unit. Impeller blades are mounted on the shaft. A wide variety of blade designs are used and typically the blades cover approximately two-thirds of the diameter of the reactor. Where viscous products are handled, anchor-shaped paddles are often used which have a close clearance between the blade and the vessel walls. Most batch reactors also use baffles. These are stationary blades that break up flow caused by the rotating agitator. These may be fixed to the vessel cover or mounted on the interior of the side walls.

Despite significant improvements in agitator blade and baffle design, mixing in large batch reactors is ultimately constrained by the amount of energy that can be applied. On large vessels, mixing energies of more than 5 W/l can put an unacceptable burden on the cooling system. High agitator loads can also create shaft stability problems. Where mixing is a critical parameter, the batch reactor is not the ideal solution. Much higher mixing rates can be achieved by using smaller flowing systems with high-speed agitators, ultrasonic mixing, or static mixers.

Products within batch reactors usually liberate or absorb heat during processing. Even the action of stirring stored liquids generates heat. In order to hold the reactor contents at the desired temperature, heat has to be added or removed by a cooling jacket or cooling pipe. Heating/cooling coils or external jackets are used for heating and cooling batch reactors. Heat transfer fluid passes through the jacket or coils to add or remove heat.

Temperature control is one of the key functions of a reactor. Poor temperature control can severely affect both yield and product quality. It can also lead to boiling or freezing within the reactor which may stop the reactor from working altogether. In extreme cases, poor temperature control can lead to severe overpressure which can be destructive on the equipment and potentially dangerous. Within the petrochemical and pharmaceutical industries, external cooling jackets are generally preferred as they make the vessel easier to clean. The performance of these jackets can be defined by three parameters: (i) response time to modify the jacket temperature, (ii) uniformity of jacket temperature, and (iii) stability of the jacket temperature. It can be argued that the heat transfer coefficient is also an important parameter. It has to be recognized however that large batch reactors with external cooling jackets have severe heat transfer constraints by virtue of design. It is difficult to achieve better than 100 W/l even with ideal heat transfer conditions. By contrast, continuous reactors can deliver cooling capacities in excess of 10,000 W/l. For processes with very high heat loads, there are better solutions than batch reactors.

Fast temperature control response and uniform jacket heating and cooling are particularly important for crystallization processes or operations where the product or process is very temperature sensitive. There are several types of batch reactor cooling jackets: (i) single external jacket, (ii) half coil jacket, and (iii) constant flux cooling jacket

The *single external jacket* design consists of an outer jacket which surrounds the vessel. Heat transfer fluid flows around the jacket and is injected at high *velocity* via nozzles. The temperature in the jacket is *regulated* to control heating or cooling. The single jacket is probably the oldest design of an external cooling jacket. Despite being a tried and tested solution, it has some limitations. On large vessels, it can take many minutes to adjust the temperature of the fluid in the cooling jacket. This results

in sluggish temperature control. The distribution of *heat transfer* fluid is also far from ideal and the heating or cooling tends to vary between the side walls and bottom dish. Another issue to consider is the inlet temperature of the heat transfer fluid which can oscillate (in response to the temperature control valve) over a wide temperature range to cause hot or cold spots at the jacket inlet points.

The *half coil jacket* is made by welding a half pipe around the outside of the vessel to create a semi-circular flow channel. The heat transfer fluid passes through the channel in a plug-flow fashion. A large reactor may use several coils to deliver the heat transfer fluid. Like the single jacket, the temperature in the jacket is regulated to control heating or cooling. The plug-flow characteristics of a half coil jacket permit faster displacement of the heat transfer fluid in the jacket (typically less than 60 seconds). This is desirable for good temperature control. It also provides a good distribution of heat transfer fluid which avoids the problems of non-uniform heating or cooling between the side walls and bottom dish. Like the single jacket design however the inlet heat transfer fluid is also vulnerable to large oscillations (in response to the temperature control valve) in temperature.

The *constant flux cooling jacket* (*coflux jacket*) is a relatively recent development. It is not a single jacket but has a series of 20 or more small jacket elements. The temperature control valve operates by opening and closing these channels as required. By varying the heat transfer area in this way, the process temperature can be regulated without altering the jacket temperature. The constant flux jacket has a very fast temperature control response (typically less than 5 seconds) due to the short length of the flow channels and the high velocity of the heat transfer fluid. Like the half coil jacket the heating/cooling *flux* is uniform. Because the jacket operates at substantially constant temperature the inlet temperature oscillations seen in other jackets are absent. An unusual feature of this type of jacket is that process heat can be measured very sensitively. This allows the user to perform tasks such as (i) monitor the rate of reaction for detecting endpoints, (ii) controlling addition rates, and (iii) controlling crystallization.

Batch reactors are often used in the process industry. Batch reactors also have many laboratory applications, such as small-scale production and inducing fermentation for beverage products. They also have many uses in medical production. Batch reactors are generally considered expensive to run, as well as variable product reliability. They are also used for experiments of reaction kinetics, volatiles, and thermodynamics. Batch reactors are also highly used in waste water treatment and are effective in reducing the biological oxygen demand (BODF) of influent untreated water.

Batch reactors are very versatile and are used for a variety of different unit operations (such as batch distillation, storage, crystallization, and liquid-liquid extraction) in addition to chemical reactions. Batch reactors represent an effective and economic solution for many types of slow reactions. In a batch reactor, good temperature control is achieved when the heat added or removed by the heat exchange surface is equal to the heat generated or absorbed by the process material. For flowing reactors made up of tubes or plates, satisfying the *heat added to the heat generated* relationship does not deliver good temperature control since the rate of process heat liberation/absorption varies at different points within the reactor. Controlling the outlet temperature does not prevent hot/cold spots within the reactor. Hot or cold spots caused by exothermic or endothermic activity can be eliminated by relocating the temperature sensor (T) to the point where the hot/cold spots exist. This however leads to overheating or overcooling downstream of the temperature sensor.

Hot/cold spots are created when the reactor is treated as a single stage for temperature control. Hot/cold spots can be eliminated by moving the temperature sensor. This, however, causes overcooling or overheating downstream of the temperature sensor. Many different types of plate or tube reactors use simple feedback control of the product temperature. However, this approach is only suitable for processes where the effects of hot/cold spots do not compromise safety, quality, or yield. The disadvantages of the batch reactor are that there are idle periods for loading, unloading, heating, and control and regulation of an unsteady process requires considerable instrumentation and efforts.

In the refining industry, the batch-type reactor is not commonly used, but in the petrochemical industry the reactor may be used when small quantities of a product are manufactured or if the reactor will be used for the production of a variety of different petrochemical products.

In summary, the batch operation mode involves loading the reaction vessel with the reactants, and the chemical reaction is allowed to proceed until the desired conversion of reactants into products has taken place. A more common approach is the semi-batch mode of operation or preferentially the continuous operation mode of operations of the reactor in which the reactants are fed continuously into the reaction vessel, and product flow is continuously removed from the vessel.

A semi-batch reactor (a semi-flow reactor) operates much like a batch reactor in that the reactor is a single tank with similar equipment to the batch reactor. However, the semi-batch reactor is modified to allow reactant addition and/or product removal during the process. A typical batch reactor is filled with reactants in a single stirred tank at the beginning of the process (time t=0) and the reaction is allowed to proceed. A semi-batch reactor, however, allows partial filling of reactants with the flexibility of adding more as time progresses.

Thus, semi-batch reactors lie between batch and continuous reactors in terms of operation. Semi-batch reactors occupy a middle ground between batch and continuous reactors. They are open systems (similar to the continuous stirred-tank reactors) and run on an unsteady state basis like the batch reactors. They usually consist of a single stirred tank, similar to a batch reactor. The *half-pipe coil jacketed* reactor shown below can be used in semi-batch operations. In a semi-batch process, an initial amount of reactants is charged into the reactor. The reactor is then started, and additional reactants are added continuously to the reaction mix in the vessel which is then allowed to run until the desired conversion is achieved. At this point, the products and remaining reactants are removed from the tank and the process can be started once more.

Semi-batch reactors are not used as often as other reactor types. However, they can be used for many two-phase (i.e. solid/liquid) reactions. Also, semi-batch reactors are used when a reaction has many unwanted side reactions or has a high heat of reaction and by limiting the introduction of fresh reactants, the potential problems can be mitigated.

8.2.2 Continuous Reactor

Continuous reactors (also referred to as *flow reactors*) carry material as a flowing stream. In use, reactants are continuously fed into the reactor and emerge as a continuous stream of product. Continuous reactors are used for a wide variety of processes within the refining industry. A survey of the continuous reactor market will throw up a daunting variety of shapes and types of machines. Beneath this variation however lies a relatively small number of key design features that determine the capabilities of the reactor. When classifying continuous reactors, it can be more helpful to look at these design features rather than the whole system.

In the semi-continuous mode of operation, individual reactants can be entered discontinuously while others are entered continuously – the products can be withdrawn continuously or discontinuously (batch-wise). The output from a continuous reactor can be altered by varying the run time. However, conditions within a continuous reactor change as the product passes along the flow channel. In an ideal reactor, the design of the flow channel is optimized to adapt to any changing conditions, and this is achieved by operating the reactor as a series of stages. Within each stage the ideal heat transfer conditions can be achieved by varying the surface-to-volume ratio or the cooling/heating flux. Thus stages where process heat output is very high either use extreme heat transfer fluid temperatures or have high surface-to-volume ratios (or both). By using a series of stages, extreme cooling/heating conditions can be employed at the hot/cold spots without suffering overheating or overcooling as the reactants and products pass through the various stages. Thus, larger flow channels can be used which permit (i) a higher flow rate, (ii) a lower pressure drop, and (iii) a reduced tendency for channel blockage.

Mixing is another important feature for continuous reactors since efficient mixing improves the efficiency of heat and mass transfer. In terms of flow through the reactor, the ideal condition for a continuous reactor is plug flow (since this delivers uniform residence time within the

reactor), but there is the potential (or reality) for flow conflict between efficient mixing and plug flow since mixing generates axial as well as the radial movement of the fluid. In the tube-type reactors (with or without static mixing), adequate mixing can be achieved without seriously compromising plug flow and, accordingly, these types of reactors are sometimes referred to as plug-flow reactors.

Continuous reactors can be classified in terms of the mixing mechanism as follows: (i) mixing by diffusion, (ii) mixing by pumping, and (iii) mixing by agitation. Diffusion mixing relies on concentration or temperature gradients within the product. This approach is common with micro reactors where the channel thicknesses are very small and heat can be transmitted to and from the heat transfer surface by conduction. In larger channels and for some types of the reaction mixture (especially immiscible fluids), mixing by diffusion is not always practical. However, if the product is continuously pumped through the reactor, the pump can be used to promote mixing – if the fluid velocity is sufficiently high, the induced turbulent flow conditions will promote mixing. The disadvantage with this approach is that it leads to long reactors with high-pressure drops and high minimum flow rates and is especially true where the reaction is slow or the product has high viscosity. This problem can be reduced with the use of static mixers which are typically represented as baffles in the flow channel which promote mixing. Static mixers can be effective but still tend to require relatively long flow channels and generate a relatively high-pressure drop. An oscillatory baffled reactor is a specialized form of the static mixer where the direction of process flow is cycled to allow static mixing of the reactants with a low net flow through the reactor which allows the reactor to be kept comparatively short.

On the other hand, some continuous reactors use mechanical agitation for mixing (rather than the product transfer pump). While this option adds complexity to the reactor design, it offers significant advantages insofar as (i) efficient mixing can be maintained irrespective of product throughput or product viscosity, and (ii) the method eliminates the need for long flow channels and high-pressure drops. However, the use of mechanical agitators does create strong axial mixing, but non-beneficial effects can be negated by sub-dividing the reactor into a series of mixed stages that are separated by small plug-flow channels.

The most familiar form of the continuous reactor of this type is the continuous stirred-tank reactor (CSTR) (Figure 8.1), which is essentially a batch reactor used in a continuous flow. In fact, the reactor is better described as a batch reactor equipped with an impeller or other mixing device to provide efficient mixing. In chemical engineering the name continuous stirred-tank reactor is often used to refer to an idealized agitated-tank reactor used to model operation variables required to attain a specified output. In flow chemistry, a continuous stirred-tank reactor equipped with features to continuously feed and exhaust reactants is an example of a mechanically mixed flow reactor. A continuous stirred-tank reactor often refers to a model used to estimate the key unit operation variables when using a continuous agitated-tank reactor to reach a specified output. The behavior of a continuous agitated-tank reactor is often approximated or modeled by that of a continuous stirred-tank reactor. All calculations performed with continuous ideally stirred-tank reactors assume perfect mixing. The disadvantage with a single-stage continuous stirred-tank reactor is that it can be relatively wasteful on products during start-up and shut-down. The reactants are also added to a mixture that is rich in product. For some types of processes, this can have an impact on quality and yield. These problems are managed by using multistage continuous stirred-tank reactors. At the large scale, conventional batch reactors can be used for the continuous stirred-tank reactor stages.

In a perfectly mixed reactor, the output composition is identical to the composition of the material inside the reactor, which is a function of residence time and rate of reaction. If the residence time is five-to-ten times the mixing time, this approximation is valid for engineering purposes. The continuous ideally stirred-tank reactor model is often used to simplify engineering calculations and can be used to describe research reactors. In practice it can only be approached, in particular, in industrial size reactors.

8.2.3 Demetallization Reactor

The demetallization reactor (*guard reactor, guard bed reactor*) is a reactor that is placed in front of hydrocracking reactors to remove contaminants, particularly metals, prior to hydrocracking. Such reactors may employ an inexpensive catalyst to remove metals from expanded-bed feed. Spent demetallization catalyst can be loaded to more than 30% vanadium. A catalyst support having large pores preferentially demetallized with a low degree of desulfurization.

Feedstocks that have relatively high metal contents (>300 ppm) substantially increase catalyst consumption because the metals poison the catalyst, thereby requiring frequent catalyst replacement. The usual desulfurization catalysts are relatively expensive for these consumption rates, but there are catalysts that are relatively inexpensive and can be used in the first reactor to remove a large percentage of the metals. Subsequent reactors downstream of the first reactor would use normal hydrodesulfurization catalysts. Since the catalyst materials are proprietary, it is not possible to identify them here. However, it is understood that such catalysts contain little or no metal promoters, i.e., nickel, cobalt, molybdenum. Metals removal on the order of 90% has been observed with these materials.

Thus, one method of controlling demetallization is to employ separate smaller *guard reactors* just ahead of the fixed-bed hydrodesulfurization reactor section. The preheated feed and hydrogen pass through the guard reactors that are filled with an appropriate catalyst for demetallization that is often the same as the catalyst used in the hydrodesulfurization section. The advantage of this system is that it enables the replacement of the most contaminated catalyst (*guard bed*), where pressure drop is highest, without having to replace the entire inventory or shut down the unit. The feedstock is alternated between guard reactors while catalyst in the idle guard reactor is being replaced.

When the expanded-bed design is used, the first reactor could employ a low-cost catalyst (5% of the cost of Co/Mo catalyst) to remove the metals and subsequent reactors can use the more selective hydrodesulfurization catalyst. The demetallization catalyst can be added continuously without taking the reactor out of service and the spent demetallization catalyst can be loaded to more than 30% vanadium, which makes it a valuable source of vanadium.

8.2.4 Ebullating Bed Reactor

An ebullated-bed reactor is a type of fluidized bed reactor that utilizes ebullition, or bubbling, to achieve appropriate distribution of the feedstock and the catalyst (Kressmann et al., 2000). The first application of this reactor technology was for vacuum residue hydroprocessing, using the H-Oil process. The improvement of this process and technology are an important challenge for the treatment of viscous feedstocks.

The ebullated-bed technology utilizes a three-phase reactor (liquid, vapor, and catalyst), and is most applicable for exothermic reactions and for feedstocks which are difficult to process in a fixed-bed reactor or a plug-flow reactor due to high levels of contaminants. Ebullated-bed reactors offer high-quality, continuous mixing of liquid and catalyst particles. The advantages of a good back-mixed bed include excellent temperature control, and by reducing bed plugging and channeling, low and constant pressure drop. Therefore, ebullated-bed reactors have the characteristics of stirred reactor type operation with a fluidized catalyst.

The catalyst used for the ebullated bed is typically a 0.8-mm diameter extrudate and is held in a fluidized state through the upward lift of liquid reactants and gas. The liquid and gas enter the reactor plenum and are distributed across the bed through a distributor and grid plate. The height of the ebullated catalyst bed can be controlled by the rate of liquid recycle flow and the rate of the liquid recycle is adjusted by varying the speed of the ebullating pump, a canned centrifugal pump which controls the flow of ebullating liquid obtained from the internal vapor/liquid separator inside the reactor. Fresh catalyst can be added, and spent catalyst withdrawn, to control the level of catalyst activity within the reactor. The capability of the regular addition of a small quantity of catalyst is

instrumental to ebullated-bed reactors' consistent product quality over long time periods. To adjust the operation and/or different feedstocks, the type of catalyst used can also be changed without shutting down the reactor.

In fixed-bed hydrocracking reactors, such as those used to process vacuum gas oil, viscous feedstocks (heavy crude oil, extra-heavy crude oil, and tar sand bitumen as well as crude oil residua) will reduce the catalyst cycle life because of the content of asphaltene constituents (and resin constituents), trace metals (nickel, vanadium, and iron), or particulate matter. Recalling that fixed-bed units designed to process residue remove metals and other contaminants with upstream guard beds or on-stream catalyst replacement technology, ebullated-bed units in which the catalyst within the reactor bed is not fixed, can and do process significant amounts of heavy feedstocks (Speight, 2013, 2014). In the ebullated-bed unit, a fresh catalyst is added, and the spent catalyst is removed continuously. Consequently, catalyst life does not impose limitations on feed selection or conversion.

In such a process, the hydrocarbon feed stream enters the bottom of the reactor and flows upward through the catalyst – the catalyst is kept in suspension by the pressure of the fluid feed. Ebullating bed reactors are capable of converting the most problematic viscous feedstocks (including atmospheric residua and vacuum residua), all of which have a high content of asphaltene constituents as well as metal constituents, sulfur constituents, and constituents ready to form sediment) to lower-boiling, more valuable products while simultaneously removing the contaminants.

In the unit, the hydrogen-rich recycle gas is bubbled up through a mixture of oil and catalyst particles which provides three-phase turbulent mixing, which is needed to ensure a uniform temperature distribution. At the top of the reactor, the catalyst is disengaged from the process fluids, which are separated in downstream flash drums. Some of the catalyst is withdrawn and replaced with fresh catalyst while the majority of the catalyst is returned to the reactor.

The function of the catalyst is to remove contaminants, such as sulfur and nitrogen heteroatoms, which accelerate the deactivation of the catalyst, while cracking (converting) the feed to lighter products. Because ebullating bed reactors perform both hydrotreating and hydrocracking functions, they are considered to be dual-purpose reactors. Ebullating bed catalysts are made of pellets that are less than 1 mm in size to facilitate suspension by the liquid phase in the reactor.

In contrast to fixed-bed hydrocracking units for vacuum gas oil, ebullating bed units are suitable for processing residua and other heavy feedstocks, such as tar sand bitumen. The main advantages are: (i) high conversion of atmospheric residue, up to 90% v/v, (ii) better product quality than many other residue conversion processes, especially delayed coking, and (iii) long run length – catalyst life does not limit these units since fresh catalyst is added and spent catalyst is removed continuously and (subject only to mechanical issues) the units can typically run for a much longer time than fixed-bed units for the same heavy feedstock.

Examples of processes that use ebullated-bed reactors are (i) the H-Oil process, (ii) the LC-Fining process, and (iii) the T-Star process.

8.2.5 FIXED-BED REACTOR

In fixed-bed reactors, the liquid hydrocarbon trickles down through the fixed catalyst bed from top to bottom of the reactor. Hydrogen gas passes co-currently through the bed. A single tailor-made optimum catalyst having high hydrodesulfurization activity and low metal tolerance can handle feedstocks having less than 25 ppm w/w of metal for cycle length of 1 year. For feedstocks containing metals in the range of 25–50 ppm w/w, a dual catalyst system is more effective. In such a system, one catalyst having a higher metal tolerance is placed in the front of the reactor, whereas the second catalyst located in the tail end of the reactor is generally of higher desulfurization activity (Scheffer et al., 1998; Kressmann et al., 1998; Liu et al., 2009). A triple catalyst system consisting of a hydrodemetallization catalyst, a hydrodemetallization/ hydrodesulfurization catalyst, and a refining catalyst is generally used for feedstocks where the metals content is in the range of 100–150 ppm w/w for a typical cycle length of 1 year. For feeds with metals content higher than this range, the

on-stream life of the hydrodemetallization catalyst is short (usually a matter of months) and for achieving a cycle length of 1 year, a swing reactor fixed-bed concept has been introduced. In the swing reactor fixed-bed system, the two reactors operate in a switchable mode and the catalyst can be unloaded/reloaded without disturbing the continuous operation of the system. The swing reactors are generally followed by various fixed-bed reactors in series containing hydrodesulfurization and other hydrofining catalysts.

However, when the feedstock contains a high amount of metals and other impurities, e.g., asphaltene constituents, the use of trickle-bed reactors has to be carefully examined according to the catalyst cycle life. Alternatively, moving-bed reactors and ebullated-bed reactors have demonstrated reliable operation with the heavy feedstocks. Depending on the feedstock, the catalyst life may vary in the order of months or a year. It is then clear that the time scale of deactivation influences the choice of the reactor (Moulijn et al., 2001).

8.2.6 Fluidized Bed Reactor

A fluidized bed is a type of reactor bed that can be used to carry out a variety of multiphase reactions. In this type of reactor, a fluid (gas or liquid) is passed through a granular solid material (usually a catalyst possibly configured as small spheres) at a sufficiently high velocity to suspend the solid and cause it to behave as though it were a fluid (Figure 8.2). This process (fluidization) imparts many advantages to the fluidized bed reactor and, as a result, the fluidized bed reactor is now used in many industrial applications.

In the reactor, the solid substrate (the catalytic material upon which chemical species react) material in the fluidized bed reactor is typically supported by a *porous* plate, known as a distributor. The fluid is then forced through the distributor up through the solid material. At lower fluid velocities, the solids remain in place as the fluid passes through the voids in the material. As the fluid velocity is increased, the reactor will reach a stage where the force of the fluid on the solids is enough to balance the weight of the solid material. This stage is known as incipient fluidization and occurs at this minimum fluidization velocity. Once this minimum velocity is surpassed, the contents of the reactor bed begin to expand and swirl around and the reactor is, at that point, a fluidized bed reactor. Depending on the operating conditions and properties of solid phase various flow regimes can be observed in this reactor.

Due to the intrinsic fluid-like behavior of the solid material, fluidized beds do not experience poor mixing as in packed beds. This complete mixing allows for a uniform product that can often be hard to achieve in other reactor designs. The elimination of radial and axial concentration gradients allows for better fluid-solid contact, which is essential for reaction efficiency and quality. Also, many chemical reactions require the addition or removal of heat. Local hot or cold spots within the reaction bed, often a problem in packed beds, are avoided in a fluidized situation such as a fluidized bed reactor. In other reactor types, these local temperature differences, especially hotspots, can result in product degradation. Thus, fluidized bed reactors are well suited to exothermic reactions. Moreover, the fluidized bed nature of these reactors allows for the ability to continuously withdraw products and introduce new reactants into the reaction vessel. Operating at a continuous process state allows refiners to produce the products more efficiently due to the removal of startup conditions in batch processes.

However, as in any design, the fluidized bed reactor does have its drawbacks, which any reactor designer must take into consideration. Because of the expansion of the bed materials in the reactor, a larger vessel is often required than that for a packed-bed reactor. This larger vessel means that more must be spent on initial capital costs. Also, the requirement for the fluid to suspend the solid material necessitates that higher fluid velocity is attained in the reactor. In order to achieve this, more pumping power and thus higher energy costs are needed. In addition, the pressure drop associated with deep beds also requires additional pumping power. Furthermore, the high gas velocities present in this style of reactor often result in fine particles becoming entrained in the fluid. These

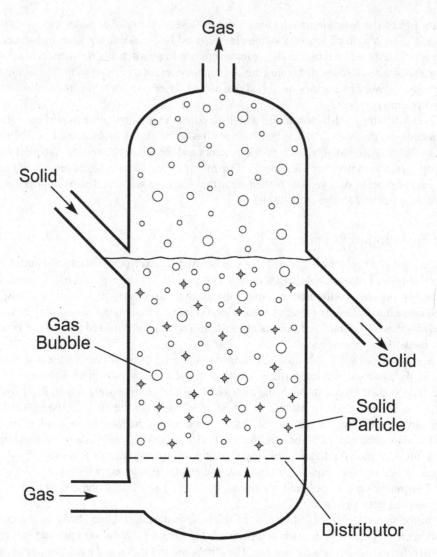

FIGURE 8.2 Schematic of a fluidized bed reactor.

captured particles are then carried out of the reactor with the fluid, where they must be separated. This can be a very difficult and expensive problem to address depending on the design and function of the reactor. This may often continue to be a problem even with other entrainment reducing technologies. In addition, the fluid-like behavior of the fine solid particles within the bed eventually results in the wear of the reactor vessel which can require expensive maintenance and upkeep for the reaction vessel and pipes.

In a fluidized bed, the finely crushed catalyst particles are fluidized because of the movement of the liquid. Three-phase fluidized beds usually operate in a concurrent mode with gas and liquid flowing upward. However, bubbles fill the cross-section of the channels. This flow type is called a *slug flow*. At higher gas flow rates, the smaller bubbles in a *slug flow* merge, and the resulting flow is called a *Taylor flow* or a *churn flow*. At even higher gas flow rates, the gas phase becomes continuous, and a gas-liquid dispersion develops. The flow is called an *annular flow*, and it is very inefficient and undesirable in three-phase systems. A monolith catalyst must always work under *bubble flow* or *slug flow* conditions; a *slug flow* gives the best mass transfer rates. Monolith catalysts are used in, for example, hydrogenation and dehydrogenation reactions.

Three different flow patterns can be observed in a fluidized bed reactor. For *bubble flow*, the solid particles are evenly distributed in the reactor. This flow pattern resembles fluidized beds where only a liquid phase and a solid catalyst phase exist. At high gas velocities, a flow pattern called *aggregative fluidization* develops. In aggregative fluidization, the solid particles are unevenly distributed, and the conditions resemble those of a fluidized bed with a gas phase and a solid catalyst phase. Between these extreme flow areas, there exists a *slug flow* domain, which has the characteristics typical of both extreme cases. Uneven distribution of gas bubbles is characteristic of a *slug flow*. The flow pattern in a three-phase fluidized bed is usually much closer to complete back-mixing than to a plug flow. Because of the higher liquid flow velocities, larger particles can be used than in bubble columns.

The fixed-bed design is commonly used in hydrodesulfurization of distillates in which the feedstock enters at the top of the reactor and the product leaves at the bottom of the reactor (Figure 8.3). The catalyst remains in a stationary position (fixed bed) with hydrogen and the feedstock passing in a downflow direction through the catalyst bed. The hydrodesulfurization reaction is exothermic and the temperature rises from the inlet to the outlet of each catalyst bed. With a high hydrogen consumption and subsequent large temperature rise, the reaction mixture can be quenched with cold recycled gas at intermediate points in the reactor system. This is achieved by dividing the catalyst charge into a series of catalyst beds and the effluent from each catalyst bed is quenched to the inlet temperature of the next catalyst bed.

In a fixed-bed reactor the flow pattern is much closer to plug flow, and the ratio of liquid-to-solid catalyst is small. If there are highly exothermic reactions such as those occurring in hydrotreating of unsaturated feeds (light cycle oil from fluid catalytic cracking units) (Sadeghbeigi, 2000), the reactions can be controlled by recycling of the liquid product stream, although this may not be practical if the product is not relatively stable under reaction conditions or if a very high conversion is desired, as in hydrodesulfurization, since recycling causes the system to approach the behavior of a

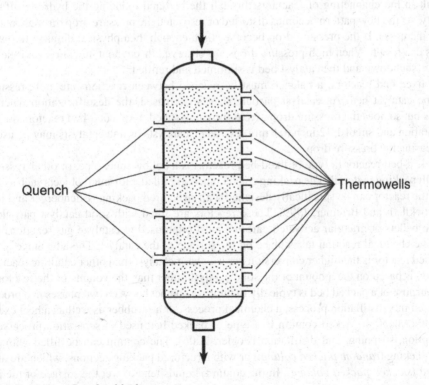

FIGURE 8.3 A downflow fixed-bed reactor.

continuous stirred-tank reactor (CSTR). For such high-temperature increases, the preferred solution is quenching with hydrogen.

The extent of desulfurization is controlled by raising the inlet temperature to each catalyst bed to maintain constant catalyst activity over the course of the process. Fixed-bed reactors are mathematically modeled as plug-flow reactors with very little back mixing in the catalyst beds. The first catalyst bed is poisoned with vanadium and nickel at the inlet to the bed and may be a cheaper catalyst (*guard bed*). As the catalyst is poisoned in the front of the bed, the temperature exotherm moves down the bed and the activity of the entire catalyst charge declines thus requiring a raise in the reactor temperature over the course of the process sequence. After catalyst regeneration, the reactors are opened and inspected, and the high metal content catalyst layer at the inlet to the first bed may be discarded and replaced with fresh catalyst. The catalyst loses activity after a series of regenerations and, consequently, after a series of regenerations, it is necessary to replace the complete catalyst charge. In the case of very high metal content feedstocks (such as the viscous feedstocks), it is often necessary to replace the entire catalyst charge rather than to regenerate it. This is due to the fact that the metal contaminants cannot be removed by economical means during rapid regeneration and the metals have been reported to interfere with the combustion of carbon and sulfur, catalyzing the conversion of sulfur dioxide (SO_2) to sulfate (SO_4^{2-}) that has a permanent poisoning effect on the catalyst.

Fixed-bed hydrodesulfurization units are generally used for distillate hydrodesulfurization and may also be used for the hydrodesulfurization of viscous feedstocks but require special precautions in processing. The feedstock must undergo two-stage electrostatic desalting so that salt deposits do not plug the inlet to the first catalyst bed and the feedstock must be low in vanadium and nickel content to avoid plugging the beds with metal deposits. Hence the need for a guard bed in hydrodesulfurization reactors that are employed for viscous feedstocks.

During the operation of a fixed-bed reactor, contaminants entering with fresh feed are filtered out and fill the voids between catalyst particles in the bed. The buildup of contaminants in the bed can result in the channeling of reactants through the bed and reducing the hydrodesulfurization efficiency. As the flow pattern becomes distorted or restricted the pressure drop throughout the catalyst bed increases. If the pressure drop becomes high enough then physical damage to the reactor internals can result. When high-pressure drops are observed throughout any portion of the reactor, the unit is shut down and the catalyst bed is skimmed and refilled.

With fixed-bed reactors, a balance must be reached between reaction rate and pressure drop across the catalyst bed. As catalyst particle size is decreased, the desulfurization reaction rate increases but so does the pressure drop across the catalyst bed. Expanded-bed reactors do not have this limitation and small 1/32 inch (0.8 mm) extrudate catalysts or fine catalysts may be used without increasing the pressure drop.

A packed-bed reactor (a type of fixed-bed reactor) is a hollow tube, pipe, or other vessel that is filled with packing material. The packing can be randomly filled with small objects such as Raschig rings or the reactor can be specifically designed with structured packing (Ellenberger and Krishna, 1999; Stockfleth and Brunner, 1999). These reactors are filled with solid catalyst particles (such as zeolite pellets or granular activated carbon), most often used to catalyze gas reactions (Fogler, 2006). The chemical reaction takes place on the surface of the catalyst. The advantage of using a packed-bed reactor is the higher conversion per weight of catalyst than other catalytic reactors. The conversion is based on the amount of the solid catalyst rather than the volume of the reactor.

The purpose of a packed bed is typically to improve contact between two phases in a process and can be used in a distillation process, a chemical process, or a scrubber as well as a heat exchanger. On the other hand, a packed column is a type of packed bed used in separation processes, such as absorption, stripping, and distillation (Fogler, 2006). The column can be filled with random dumped packing (*random packed column*) or with structured packing sections, which are arranged or stacked (*stacked packed column*). In the column, liquids tend to wet the surface of the packing and the vapors pass across this wetted surface, where mass transfer takes place. Packing material

can be used instead of trays to improve separation in distillation columns. Packing offers the advantage of a lower pressure drop across the column (when compared to plates or trays), which is beneficial while operating under vacuum. Differently shaped packing materials have different surface areas and void space between the packing. Both of these factors affect packing performance.

Another factor in performance, in addition to the packing shape and surface area, is the liquid and vapor distribution that enters the packed bed. The number of theoretical stages required to make a given separation is calculated using a specific vapor to liquid ratio. If the liquid and vapor are not evenly distributed across the superficial tower area as it enters the packed bed, the liquid-to-vapor ratio will not be correct and the required separation will not be achieved. The packing will appear to not be working properly. The *height equivalent to a theoretical plate* (HETP) will be greater than expected. The problem is not the packing itself but the mal-distribution of the fluids entering the packed bed. These columns can contain liquid distributors and redistributors which help to distribute the liquid evenly over a section of packing, increasing the efficiency of the mass transfer. The design of the liquid distributors used to introduce the feed and reflux to a packed bed is critical to making the packing perform at maximum efficiency.

Packed columns have a continuous vapor-equilibrium curve, unlike conventional tray distillation in which every tray represents a separate point of vapor-liquid equilibrium. However, when modeling packed columns it is useful to compute a number of theoretical plates to denote the separation efficiency of the packed column with respect to more traditional trays. In design, the number of necessary theoretical equilibrium stages is first determined, and then the packing height equivalent to a theoretical equilibrium stage (the *height equivalent to a theoretical plate*, (HETP)) is also determined. The total packing height required is the number of theoretical stages multiplied by the height equivalent to a theoretical plate.

Processes based upon multiphase reactions occur in a broad range of application areas and form the basis for the manufacture of a large variety of intermediate and consumer end-products (Salmi et al., 2011). Some examples of multiphase reactor technology use include: (i) the upgrading and conversion of viscous feedstocks and intermediates; (ii) the conversion of coal-derived chemicals or synthesis gas into fuels, hydrocarbon derivatives, and oxygenates: (iii) the manufacture of bulk commodity chemicals that serve as monomers and other basic building blocks for higher chemicals and polymers; (iv) the manufacture of pharmaceuticals or chemicals; and (v) the conversion of undesired chemical or crude oil processing by-products into environmentally acceptable or recyclable products (Duduković et al., 1999; Speight, 2014, 2019).

Multiphase catalytic packed-bed reactors (PBRs) operate in two modes: (i) trickle operation, with a continuous gas phase and a distributed liquid phase, and the main mass transfer resistance located in the gas; and (ii) bubble operation, with a distributed gas and a continuous liquid phase, and the main mass transfer resistance located in the liquid phase (Krishna and Sie, 1994; Duduković et al., 1999; Carbonell, 2000). For three-phase reactions (gas and liquid phases in contact with a solid catalyst), the common modes of operation are trickle- or packed-bed reactors, in which the catalyst is stationary, and slurry reactors, in which the catalyst is suspended in the liquid phase. In these reactors, gas and liquid move co-currently downflow or gas is fed counter-currently upflow. Commercially, the former is the most used reactor, in which the liquid phase flows mainly through the catalyst particles in the form of films, rivulets, and droplets.

A trickle-bed reactor (TBR) is a reactor that uses the downward movement of a liquid and gas over a packed bed of catalyst particles. Trickle-bed reactors are the most widely used type of three-phase reactors. The gas and liquid co-currently flow downward over a fixed bed of catalyst particles. Concurrent down-flow of gas and liquid over a fixed bed of catalyst. Liquid trickles down, while the gas phase is continuous. In a trickle bed, various flow regimes are distinguished, depending on gas and liquid flow rates, fluid properties, and packing characteristics. Approximate dimensions of commercial trickle-bed reactors vary but can be on the order of 30 feet high and 7 feet in diameter (Boelhouwer, 2001). In the earlier decades of the refining industry, fixed-bed hydrotreating reactors (trickle-bed reactors) were used predominantly for processing of the lower-boiling feedstocks (such

as naphtha and middle distillates), but at present, they are also used for hydroprocessing viscous feedstocks, including the residua from the distillation units.

Trickle-bed reactors are multifunctional reactive systems that allow a unique way of achieving reaction goals in the refining industry (Nigam and Larachi, 2005) and are extensively used in the refining industry for hydrotreatment of distillates, removal of impurities, such as sulfur and nitrogen, and hydrocracking. These reactors are also being used for hydrotreating viscous feedstocks, where hydrodesulfurization (HDS) and hydrodemetallization (HDM) are the key reactions. On the other hand, in place of the trickle-bed concept, the catalyst may be suspended in the liquid feedstock in which case the reactor is a slurry reactor. Furthermore, these types of reactors are essential to meet the ultra-low specification of transportation fuel. Process intensification by operating at elevated pressure and temperature, and a better understanding of flow behavior (which also helps for better design and scale-up), inducing pulse and operating in countercurrent (Nigam and Larachi, 2005).

Although the physical aspects of the trickle-bed reactor are relatively simple, the hydrodynamics in the reactor are extremely complex. It is for this reason that trickle-bed reactors have been extensively studied over the past several decades, but the understanding of the hydrodynamics still leaves much to be desired. In the trickle-bed reactor, the reactions take place in the liquid phase, since much of the viscous feedstock and product constituents do not vaporize at reactor pressure and temperature. The feedstock in the reactor is saturated with hydrogen gas because the partial pressure of hydrogen is very high and hydrogen is available in great excess. The oil and hydrogen reactant molecules diffuse through the liquid oil filling the catalyst pores and adsorb on to the catalyst surface where the hydrotreating reactions take place. Large molecular constituents tend to adsorb more strongly on to the catalyst surface than smaller molecules and, thus, the high molecular weight constituents tend to dominate the reactions on the catalyst when they can successfully diffuse into the catalyst pores. The product molecules must then desorb from the catalyst surface and diffuse out through the liquid that fills the catalyst pores.

Based on the direction of the fluid flow, packed-bed reactors can then be classified as trickle-bed reactors with co-current gas-liquid downflow, trickle-bed reactors with countercurrent gas-liquid flow, and packed-bubble reactors, where gas and liquid are contacted in co-current upflow. To carry out the catalyst and reactor selection and process design properly, knowledge of what each reactor type can and cannot do is very important. When a fixed-bed reactor is chosen, the issue is whether to use an upflow mode of operations or a downflow mode of operation.

Bubble column reactors are often operated in a semi-batch mode with the gas phase as the continuous phase and the liquid with the suspended catalyst particles in batch. This is a typical way of producing chemicals in smaller amounts. Good mixing of the gas-solid-liquid mixture is important in bubble columns. Mixing can be enhanced by the use of a gas lift or a circulation pump with an ejector. The back-mixing of the suspension of liquid and catalyst particles is more intensive than that of the gas phase. Because of back-mixing, bubble columns are mostly rather isothermal. The flow profile in a bubble column is determined by the gas flow velocity and the cross-sectional area of the column. At low gas velocities, all gas bubbles are assumed to have the same size. In this regime, we have a *homogeneous bubble flow*. If the gas velocity is increased in a narrow column, a *slug flow* is developed. In a slug flow, the bubbles fill the entire cross-section of the reactor. Small bubbles exist in the liquid between the slugs, but the main part of the gas is in the form of large bubbles. In wider bubble column vessels, a bubble size distribution is developed; this is called *a heterogeneous flow*. The flow properties in a bubble column are of considerable importance for the performance of three-phase reactors. The flow properties determine the gas volume fraction and the size of the interfacial area in the column. The flow profiles have a crucial impact on reactor performance.

In the case of catalytic packed beds with the two-phase flow (Trambouze, 1990), such as those used for straight-run naphtha hydrodesulfurization, from a reaction engineering perspective, a large catalyst-to-liquid volume ratio and plug flow of both phases are preferred, and catalyst deactivation is very slow or negligible, which facilitates reactor modeling and design. However, for three-phase catalytic reactors such as those employed for hydrotreating of middle distillates and gas oil fractions,

the reaction occurs between the dissolved gas and the liquid-phase reactant at the surface of the catalyst, and the choice of upflow versus downflow operation can be based on rational considerations regarding the limiting reactant at the operating conditions of interest (Topsøe et al., 1996; Duduković et al., 2002).

The flow properties are of utmost importance for packed beds used in three-phase reactions. The most common operation policy is to allow the liquid to flow downward in the reactor. The gas phase can flow upwards or downwards, in a concurrent or countercurrent flow. The name of this reactor – the *trickle-bed* reactor – is indicative of flow conditions in the reactor, as the liquid flows downward in a laminar flow wetting the catalyst particles efficiently *(trickling flow)*. It is also possible to allow both the gas and the liquid to flow upward in the reactor. In this case, no trickling flow can develop, and the reactor is called a *packed-bed* reactor or a *fixed-bed* reactor.

At low gas flow and low liquid flow, a *trickle flow* dominates; if the flow rates are higher, a *pulsed flow* develops in the reactor. At low gas and high liquid flows, the liquid phase is continuous and gas bubbles flow through the liquid phase. At high gas velocities, the gas phase is continuous and the liquid droplets are dispersed in the gas flow *(spray flow)*. Trickle-bed reactors are usually gas upflow fixed bed, operated under *trickle* or *pulse* flow conditions. Both the gas and liquid phases approach plug-flow conditions in a *trickle-bed* reactor. Different flow patterns also develop in these reactors, depending on the gas and the liquid flow rates. At low gas and high liquid flow rates, a bubble flow prevails, the bubbles flowing through the continuous liquid phase. At higher gas and low liquid velocities, the liquid is dispersed in the gas, and the flow type is called a *spray flow*. At higher gas and low liquid flow rates, a *slug flow* develops in the reactor, and the bubble size distribution becomes very uneven. In this kind of packed-bed reactor, the gas phase is close to a plug flow, but the liquid phase is partially back-mixed.

The main advantage of packed beds is the flow pattern. Conditions approaching a plug flow are advantageous for most reaction kinetics. Diffusion resistance in catalyst particles may sometimes reduce the reaction rates, but for strongly exothermic reactions, effectiveness factors higher than unity can be obtained. Hot spots appear in highly exothermic reactions and these can have negative effects on the chemical stability and physical sustainability of the catalyst. If the catalyst in a packed bed is poisoned, it must be replaced, which is a cumbersome procedure. A packed bed is sometimes favorable because the catalyst poison is accumulated in the first part of the bed and deactivation can be predicted in advance. In the hydrogenation of sulfur-containing aromatic compounds over nickel catalysts in a packed bed, the sulfur is adsorbed as a multimolecular layer on the catalyst at the inlet of the reactor. However, this layer works as a catalyst poison trap. For *bubble flow,* the solid particles are evenly distributed in the reactor. This flow pattern resembles fluidized beds where only a liquid phase and a solid catalyst phase exist. At high gas velocities, a flow pattern called *aggregative fluidization* develops. In aggregative fluidization, the solid particles are unevenly distributed, and the conditions resemble those of a fluidized bed with a gas phase and a solid catalyst phase. Between these extreme flow areas, there exists a *slug flow* domain, which has the characteristics typical of both extreme cases. An uneven distribution of gas bubbles is characteristic of a *slug flow*.

Recently, a novel technology for three-phase processes has been developed: the monolith catalyst, sometimes also called the *frozen slurry reactor*. Similar to catalytic gas-phase processes (Section 4.1), the active catalyst material and the catalyst carrier are fixed to the monolith structure. The gas and liquid flow through fluidized beds working in a countercurrent mode also exist. Because of gravity, the particles rise only to a certain level in the reactor. The liquid and gas phases are transported out of the reactor and can be separated by decanting.

8.2.7 Plug-Flow Reactor

The plug-flow reactor (also referred to as a tubular reactor) consists of a hollow pipe or tube through which reactants flow (Figure 8.1). These reactors are usually operated at steady-state and the reactants are continually consumed as they flow down the length of the reactor.

The plug-flow reactor may be configured as one long tube or a number of shorter tubes. They range in diameter from a few centimeters to several meters. The choice of diameter is based on construction cost, pumping cost, the desired residence time, and heat transfer needs. Typically, long small diameter tubes are used with high reaction rates, and larger diameter tubes are used with slow reaction rates. Plug-flow reactors have a wide variety of applications in either gas or liquid phase systems. Common industrial uses of tubular reactors are in gasoline production, oil cracking, synthesis of ammonia from its elements, and the oxidation of sulfur dioxide to sulfur trioxide.

The plug-flow reactor is probably the most commonly used reactor in catalyst evaluation because it is simply a tube filled with a catalyst (Figure 8.1) and the feedstock is fed into the tube. However, for catalyst evaluation, it is difficult to measure the reaction rate because concentration changes along the axis, and there are frequent temperature gradients, too. Furthermore, because the fluid velocity next to the catalyst is low, the chance for mass transfer limitations through the film around the catalyst is high.

The design of larger commercial reactors provides a significant challenge because heat effects are typically substantial and vary with the endothermic cat-cracking or reforming reactions to the highly exothermic hydrotreating and hydrocracking reactions; the flow regime deviates from the ideals of plug flow and perfect mixing.

8.2.8 FLASH REACTOR

The flash reactor is an extension of the fluidized bed family of separation processes; the flash reactor (FR) (or transport reactor) employs turbulent fluid introduced at high velocities to encourage chemical reaction with feedstocks and subsequently achieve separation through the chemical conversion of desired substances to different phases and streams. A flash reactor consists of the main reaction chamber and an outlet for separated products to enter downstream processes. Flash reactor vessels facilitate a low gas and solid retention (and hence reactant contact time) for industrial applications which give rise to high throughput, pure product, and less than ideal thermal distribution when compared to other fluidized bed reactors. Due to these properties as well as its relative simplicity, flash reactors have the potential for use for pre-treatment and post-treatment processes where these strengths of the flash reactor are prioritized the most. Whilst a variety of applications are available for a flash reactor, a general set of operating parameters are used and the important parameters to consider when designing a flash reactor are: (i) fluid velocity and flow configuration, (ii) solid retention time, (iii) refractory lining material, and (iv) feed and fluid type.

In the flash reactor, gas is introduced from the bottom at an elevated temperature and high velocity, with a slight drop in velocity experienced at the central part of the vessel. The design of the vessel can vary in shapes and sizes (i.e. from pipeline to an egg-like shape) to promote the vertical circulation of the gases and particulate matter. Whatever the choice of shape, the configuration should be designed to increase the velocity of the fluid at the bottom of the chamber thereby allowing for higher molecular weight (denser) feedstock constituents to be in a continuous circulation that promotes a reaction site for separation processes. The method of feed delivery varies depending on the phase – solid feedstocks may be delivered using a conveyor while fluid feedstocks are vaporized and sprayed directly into the flash reactor. The feedstock is then contacted with a continuously circulating hot gas that interacts throughout the chamber with the incoming feed. The product mixture is sent to a separator where an exhaust vent emits gaseous products.

A relatively fast fluid velocity is usually required in flash reactor operations to encourage a continuous particle distribution throughout the reactor's vessel. This minimizes the slip velocity (average velocity difference of different fluids in a pipe) of the column and provides a positive impact on heat and mass transfer rates thereby allowing for the use of smaller diameter vessels which can lower operating costs. Also, the use of a vertical fluid flow configuration results in inefficient mixing in the horizontal and vertical direction and can cause low product quality. The use of a fast fluid velocity also ensures a short solid feed retention time which is beneficial for reactions that require a

purer product and higher throughput. However, if the operating conditions for a reaction require an extended reaction time, this can be implemented by introducing a recycle mode in which the fluid in the flash reactor can be recirculated with the feedstock to allow for additional contact time. Due to the high-temperature requirements for flash reactor operations, a refractory lining is required to reinforce and maintain vessel integrity and operability and such a lining also serves to isolate the high temperature of the flash chamber from the ambient temperature.

In the *centrifugal flash reactor*, unlike other flash reactor designs, the powdered feed is contacted on a solid heat carrier rather than a gaseous carrier. The design involves the use of a heated rotating plate that disperses the feed powder particles for a short duration which is achieved by the use of centrifugal forces that compress the powder onto the surface of the plate thereby allowing for direct contact between the particles and hot metal and which enables a higher heat transfer rate. In the *pipeline flash reactor* which, as the name implies, is in the form of a pipe. The shape of the pipeline flash reactor allows it to be easily integrated into new process systems and, due to the shape, modifications and extensions can be easily added to the pipeline flash reactor to accommodate the requirements of certain processes. In the reactor, the reactants come into contact with each other in the pipe rather than a mixing vessel and this eliminates the need for extra mixing tanks. Due to the nature of the device, the reactants processed in a pipeline flash reactor will have short retention times although adding backflow options into the system can be used to increase retention time if required.

The versatility of flash/transport reactors makes them suitable for a wide range of quality-sensitive separation processes. In addition, flash reactor applications do not typically require any post-treatment or pre-treatment systems due to a lack of waste generated. For example, in some aspects of gas processing, especially in the glycol dehydration of gas streams, a flash tank separator (which consists of a device that reduces the pressure of the glycol solution stream) is employed to enable methane and other hydrocarbon derivatives to vaporize (*flash*) and separate from the glycol (Parkash, 2003; Gary et al., 2007; Speight, 2014; Hsu and Robinson, 2017; Speight, 2017).

8.2.9 SLURRY REACTOR

The slurry reactor is a three-phase reactor (gas/liquid/solid) that can be used to react solids, liquids, and gases simultaneously. They usually consist of a catalyst (solid) suspended in a liquid, through which a gas is bubbled and can operate in either semi-batch or continuous mode. The slurry phase Fischer–Tropsch reactor is an example of such a reactor that is used in a gas-to-liquid (GTL) process plant to convert natural gas into diesel fuel (Chadeesingh, 2011).

Inside the reactor are catalyst pellets suspended in a liquid. The gas reactant is bubbled into the reactor and the gas is absorbed into the liquid from the bubble surface. The absorbed gas then diffuses through the liquid to the catalyst surface, at which point it diffuses into the catalyst pellet and the reaction takes place. Thus, using the production of diesel fuel as an example, synthesis gas (syngas) enters at the bottom of the reactor into heated feedstock. The gas then reacts with the assistance of a suspended catalyst to form the methanol (methyl alcohol) product. Unreacted gas and methanol vapor exit through the top of the reactor. Once out of the reactor, the methanol is condensed to a liquid.

The advantage of a slurry reactor with small and finely dispersed catalyst particles is that the diffusion resistance inside the catalyst particles seldom limits the reaction, whereas the diffusion resistance can be a limiting factor in packed-bed reactors. The temperature in the slurry reactor is rather constant, and no hot spot phenomena occur. In slurry reactors, it is also possible to regenerate the catalyst (fluidized bed). However, the separation of small catalyst particles from the suspension may introduce problems. The high degree of back-mixing is usually less efficient for the reaction kinetics, which results in a lower conversion of the reactants than under plug-flow conditions. For autocatalytic reactions, there is the opposite effect since some degree of back-mixing can enhance the reaction rate. The flow pattern in a three-phase fluidized bed is usually much closer to complete back-mixing than to a plug flow. Because of the higher liquid flow velocities, larger particles can be used than in bubble columns.

Slurry reactors are most frequently used when a liquid reactant must be contacted with a solid catalyst, and when a reaction has a high heat of reaction.

8.2.10 Upflow Expanded-Bed Reactor

Expanded-bed reactors are applicable to distillates but are commercially used for very high metal viscous feedstocks or the so-called dirty feedstocks having extraneous fine solids material. They operate in such a way that the catalyst is in an expanded state so that the extraneous solids pass through the catalyst bed without plugging. They are isothermal, which conveniently handles the high-temperature exotherms associated with high hydrogen consumptions. Since the catalyst is in an expanded state of motion, it is possible to treat the catalyst as a fluid and to withdraw and add catalysts during operation.

Expanded beds of catalyst are referred to as particulate fluidized insofar as the feedstock and hydrogen flow upward through an expanded bed of catalyst with each catalyst particle in independent motion. Thus, the catalyst migrates throughout the entire reactor bed. Expanded-bed reactors are mathematically modeled as back-mix reactors with the entire catalyst bed at one uniform temperature. Spent catalyst may be withdrawn and replaced with fresh catalyst on a daily basis. Daily catalyst addition and withdrawal eliminate the need for costly shut-downs to change out catalysts and also result in a constant equilibrium catalyst activity and product quality. The catalyst is withdrawn daily and has a vanadium, nickel, and carbon content that is a representative on a macro-scale of what is found throughout the entire reactor. On a micro-scale, individual catalyst particles have ages from that of fresh catalyst to as old as the initial catalyst charge to the unit, but the catalyst particles of each age group are so well dispersed in the reactor that the reactor contents appear uniform.

In the unit, the feedstock and hydrogen recycle gas enters the bottom of the reactor, pass up through the expanded catalyst bed, and leave from the top of the reactor. Commercial expanded-bed reactors normally operate with 1/32 inch (0.8 mm) extrudate catalysts that provide a higher rate of desulfurization than the larger catalyst particles used in fixed-bed reactors. With extrudate catalysts of this size, the upward liquid velocity based on fresh feedstock is not sufficient to keep the catalyst particles in an expanded state. Therefore, for each part of the fresh feed, several parts of product oil are taken from the top of the reactor, recycled internally through a large vertical pipe to the bottom of the reactor, and pumped back up through the expanded catalyst bed. The amount of catalyst bed expansion is controlled by the recycling of product oil back up through the catalyst bed.

The expansion and turbulence of gas and oil passing upward through the expanded catalyst bed are sufficient to cause almost complete random motion in the bed (particulate fluidized). This effect produces the isothermal operation. It also causes almost complete back-mixing. Consequently, in order to affect near-complete sulfur removal (over 75%), it is necessary to operate with two or more reactors in series. The ability to operate at a single temperature throughout the reactor or reactors, and to operate at a selected optimum temperature rather than an increased temperature from the start to the end of the run, results in the more effective use of the reactor and catalyst contents. When all these factors are put together, i.e., use of a smaller catalyst particle size, isothermal, fixed temperature throughout the run, back-mixing, daily catalyst addition, and constant product quality, the reactor size required for an expanded bed is often smaller than that required for a fixed bed to achieve the same product goals. This is generally true when the feeds have high initial boiling points and/or the hydrogen consumption is very high.

8.3 PROCESS PARAMETERS

Reactor configurations within the hydroprocessing units may include catalysts beds that are fixed or moving (Kundu et al., 2003; Ancheyta and Speight, 2007). Most hydroprocessing reactors are fixed-bed reactors and units with fixed-bed reactors must be shut down to remove the spent catalyst when catalyst activity declines below an acceptable level (due to the accumulation of coke, metals,

and other contaminants) – there are also hydroprocessing reactors with moving, or ebullating catalyst beds. A further example of a fixed-bed reactor is in catalytic reforming of naphtha to produce branched-chain alkanes, cycloalkanes, and aromatic hydrocarbon derivatives using usually platinum or a platinum-rhenium alloy on an alumina support.

Using the hydrodesulfurization process as an example, all hydrodesulfurization processes react a feedstock with hydrogen to produce hydrogen sulfide and a desulfurized hydrocarbon product (Parkash, 2003; Gary et al., 2007; Speight, 2014; Hsu and Robinson, 2017; Speight, 2017). The feedstock is preheated and mixed with hot recycle gas containing hydrogen and the mixture is passed over the catalyst in the reactor section at temperatures between 290°C and 445°C (550°F and 850°F) and pressures between 150 and 3,000 psi (Parkash, 2003; Gary et al., 2007; Speight, 2014; Hsu and Robinson, 2017; Speight, 2017). The reactor effluent is then cooked by heat exchange, and desulfurized liquid hydrocarbon products and recycle gas are separated at essentially the same pressure as used in the reactor. The recycle gas is then scrubbed and/or purged of the hydrogen sulfide and light hydrocarbon gases, mixed with fresh hydrogen makeup, and preheated prior to mixing with hot hydrocarbon feedstock.

The recycle gas scheme is used in the hydrodesulfurization process to minimize the physical losses of expensive hydrogen. Hydrodesulfurization reactions require a high hydrogen partial pressure in the gas phase to maintain high desulfurization reaction rates and to suppress carbon laydown (catalyst deactivation). The high hydrogen partial pressure is maintained by supplying hydrogen to the reactors at several times the chemical hydrogen consumption rate. The majority of the unreacted hydrogen is cooled to remove hydrocarbon derivatives, recovered in the separator, and recycled for further utilization. Hydrogen is physically lost in the process by solubility in the desulfurized liquid hydrocarbon product, and from losses during the scrubbing or purging of hydrogen sulfide and light hydrocarbon gases from the recycle gas.

The operating conditions in distillate hydrodesulfurization are dependent upon the feedstock as well as the desired degree of desulfurization or quality improvement. Kerosene and light gas oils are generally processed at mild severity and high throughput whereas light catalytic cycle oils and thermal distillates require slightly more severe conditions. Higher boiling distillates, such as vacuum gas oils and lube oil extracts, require the most severe conditions. The principal variables affecting the required severity in distillate desulfurization are: (i) hydrogen partial pressure, (ii) space velocity, (iii) reaction temperature, and (iv) feedstock properties.

8.3.1 PARTIAL PRESSURE

The important effect of *hydrogen partial pressure* is the minimization of coking reactions. If the hydrogen pressure is too low for the required duty at any position within the reaction system, premature aging of the remaining portion of catalyst will be encountered. In addition, the effect of hydrogen pressure on desulfurization varies with the feed boiling range. For a given feed there exists a threshold level above which hydrogen pressure is beneficial to the desired desulfurization reaction. Below this level, desulfurization drops off rapidly as hydrogen pressure is reduced.

8.3.2 SPACE VELOCITY

As the *space velocity* is increased, desulfurization is decreased but increasing the hydrogen partial pressure and/or the reactor temperature can offset the detrimental effect of increasing space velocity.

Reactors for *endothermic processes* (catalytic cracking, reforming, coking) require heat input to maintain the reaction temperature in the cracking zone and is shown on the far right in the endothermic region. Burning coke off the catalyst in the regenerator provides this heat and the recirculating catalyst transfers that energy to the cracking reaction in the riser of the fluid catalytic cracking unit. In the reforming reactor, the dehydrogenation reaction is highly endothermic and requires

a reactor system of three to four reactors in series, with inter-stage heating between the reactors because the reaction temperature drop in each stage must be increased so that the reaction rate does not slow down too much. Reactors for *thermally neutral processes* (such as isomerization processes which involve skeletal rearrangement of the molecular constituents of the feedstock, but no change in the molecular weight) do not cause any cooling or heating of the feed stream. *Exothermic processes* include hydrotreating, hydrocracking, and alkylation processes. Hydrocracking is highly exothermic owing to aromatic saturation reactions. Although the molecular weight is reduced by the cracking reaction, this is preceded by hydrogenation reactions, for example, aromatic ring saturation, which is necessary before the ring opening can occur. The alkylation process is also quite exothermic because higher molecular weight compounds are formed from isobutane and olefins. Distillate and naphtha hydrotreating also release heat when organo-sulfur and nitrogen compounds (i.e., dibenzothiophene and pyridine) are converted to hydrogen sulfide and ammonia, respectively.

8.3.3 Temperature

A higher *reaction temperature* increases the rate of desulfurization at constant feed rate and the start-of-run temperature is set by the design desulfurization level, space velocity, and hydrogen partial pressure. The capability to increase the temperature as the catalyst deactivates is built into the most process or unit designs. Temperatures of 415°C (780°F) and above result in excessive coking reactions and higher than normal catalyst aging rates. Therefore, units are designed to avoid the use of such temperatures for any significant part of the cycle life.

8.3.4 Catalyst Life

Catalyst life depends on the charge stock properties and the degree of desulfurization desired. The only permanent poisons to the catalyst are metals in the feedstock that deposit on the catalyst, usually quantitatively, causing permanent deactivation as they accumulate. However, this is usually of little concern except when deasphalted oils are used as feedstocks since most distillate feedstocks contain low amounts of metals. Nitrogen compounds are a temporary poison to the catalyst, but there is essentially no effect on catalyst aging except that caused by a higher temperature requirement to achieve the desired desulfurization. Hydrogen sulfide can be a temporary poison in the reactor gas and recycle gas scrubbing is employed to counteract this condition.

Providing that pressure drop buildup is avoided, cycles of 1 year or more and the ultimate catalyst life of 3 years or more can be expected. The catalyst employed can be regenerated by normal steam-air or recycle combustion gas-air procedures. The catalyst is restored to near fresh activity by regeneration during the early part of its ultimate life. However, permanent deactivation of the catalyst occurs slowly during usage and repeated regenerations, so replacement becomes necessary.

8.3.5 Feedstock

The different types of feedstocks that can undergo hydroprocessing range from heavy feedstocks of resid and vacuum gas oil to lighter feedstocks of naphtha and distillate. Naphtha, or gasoline, is hydroprocessed to remove contaminants such as sulfur, which is harmful to downstream operations (such as precious metal reforming catalyst). Diesel hydroprocessing removes the sulfur to meet fuel requirements and saturates aromatics. The purpose of resid and vacuum gas oil hydroprocessing is to remove metals, sulfur, and nitrogen (*e.g.*, *hydrotreating*), as well as to convert high molecular weight hydrocarbon derivatives into lower molecular weight hydrocarbon derivatives (*e.g.*, *hydrocracking*). Thus it is not surprising that the character of the *feedstock properties*, especially the feed boiling range, has a definite effect on the ultimate design of the desulfurization unit and process flow. In addition, there is a definite relationship between the percent by weight sulfur in the feedstock and the hydrogen requirements. Also, the reaction rate constant in the kinetic relationships decreases

rapidly with an increasing average boiling point in the kerosene and light gas oil range but much more slowly in the heavy gas oil range. This is attributed to the difficulty in removing sulfur from ring structures present in the entire heavy gas oil boding range.

The hydrodesulfurization of light (low-boiling) distillate (naphtha or kerosene) is one of the more common catalytic hydrodesulfurization processes since it is usually used as a pretreatment of such feedstocks prior to deep hydrodesulfurization or prior to catalytic reforming. Hydrodesulfurization of such feedstocks is required because sulfur compounds poison the precious-metal catalysts used in reforming and desulfurization can be achieved under relatively mild conditions and is near quantitative (Parkash, 2003; Gary et al., 2007; Speight, 2014; Hsu and Robinson, 2017; Speight, 2017). If the feedstock arises from a cracking operation, hydrodesulfurization will be accompanied by some degree of saturation resulting in increased hydrogen consumption. The hydrodesulfurization of low boiling (naphtha) feedstocks is usually a gas-phase reaction and may employ the catalyst in fixed beds and (with all of the reactants in the gaseous phase) only minimal diffusion problems are encountered within the catalyst pore system. It is, however, important that the feedstock be completely volatile before entering the reactor as there may be the possibility of pressure variations (leading to less satisfactory results) if some of the feedstock enters the reactor in the liquid phase and is vaporized within the reactor.

In applications of this type, the sulfur content of the feedstock may vary from 100 ppm to 1% and the necessary degree of desulfurization to be affected by the treatment may vary from as little as 50% to more than 99%. If the sulfur content of the feedstock is particularly low, it will be necessary to pre-sulfide the catalyst. For example, if the feedstock only has 100–200 ppm sulfur, several days may be required to sulfide the catalyst as an integral part of the desulfurization process even with complete reaction of all of the feedstock sulfur to, say, cobalt and molybdenum (catalyst) sulfides. In such a case, pre-sulfiding can be conveniently achieved by the addition of sulfur compounds to the feedstock or by the addition of hydrogen sulfide to hydrogen.

Generally, hydrodesulfurization of naphtha feedstocks to produce catalytic reforming feedstocks is carried to the point where the desulfurized feedstock contains less than 20 ppm sulfur. The net hydrogen produced by the reforming operation may actually be sufficient to provide the hydrogen consumed in the desulfurization process. The hydrodesulfurization of middle distillates is also an efficient process and applications include predominantly the desulfurization of kerosene, diesel fuel, jet fuel, and heating oils that boil over the general range 250°C–400°C (480°F–750°F). However, with this type of feedstock, hydrogenation of the higher-boiling catalytic cracking feedstocks has become increasingly important where hydrodesulfurization is accomplished alongside the saturation of condensed-ring aromatic compounds as an aid to subsequent processing.

Under the relatively mild processing conditions used for the hydrodesulfurization of these particular feedstocks, it is difficult to achieve complete vaporization of the feed. Process conditions may dictate that only part of the feedstock is actually in the vapor phase and that sufficient liquid phase is maintained in the catalyst bed to carry the larger molecular constituents of the feedstock through the bed. If the amount of liquid phase is insufficient for this purpose, molecular stagnation (leading to carbon deposition on the catalyst) will occur.

Hydrodesulfurization of middle distillates causes a more marked change in the specific gravity of the feedstock, and the amount of low-boiling material is much more significant when compared with the naphtha-type feedstock. In addition, the somewhat more severe reaction conditions (leading to a designated degree of hydrocracking) also cause an overall increase in hydrogen consumption when middle distillates are employed as feedstocks in place of the naphtha.

High-boiling distillates, such as the atmospheric and vacuum gas oils, are not usually produced as a refinery product but merely serve as feedstocks to other processes for conversion to lower-boiling materials. For example, gas oils can be desulfurized to remove more than 80% of the sulfur originally in the gas oil with some conversion of the gas oil to lower-boiling materials. The treated gas oil (which has a reduced carbon residue as well as lower sulfur and nitrogen contents relative to the untreated material) can then be converted to lower-boiling products in, say, a catalytic

cracker where an improved catalyst life and volumetric yield may be noted. The conditions used for the hydrodesulfurization of gas oil may be somewhat more severe than the conditions employed for the hydrodesulfurization of middle distillates with, of course, the feedstock in the liquid phase.

In summary, the hydrodesulfurization of the low-, middle-, and high-boiling distillates can be achieved quite conveniently using a variety of processes. One major advantage of this type of feedstock is that the catalyst does not become poisoned by metal contaminants in the feedstock since only negligible amounts of these contaminants will be present. Thus, the catalyst may be regenerated several times, and on-stream times between catalyst regeneration (while varying with the process conditions and application) may be on the order of 3–4 years.

Hydroconversion of the viscous feedstocks requires a substantially different catalyst to the catalyst used for hydroconversion of distillates. The catalyst used is frequently a low metal loading with molybdenum (Mo) with a special pore size distribution that is less subject to pore plugging by coke – more specifically, a bimodal pore size distribution is frequently used. Because viscous feedstocks frequently have high levels of vanadium and nickel in them, the catalyst activity may actually increase initially and then slowly decrease as the promotional effects of the metals adsorbed on the hydrocracking catalyst are counterbalanced by deactivation because of coking. The hydroconversion reactors may be either fluid bed, or (more likely) ebullated bed. Because of the high rates of catalyst coking, most moving-bed conversion reactors have a capability for fresh catalyst addition and spent catalyst withdrawal while the reactor is operating.

Processes that employ the ebullated-bed concept are the H-Oil process and the LC-Fining process (Speight, 2013, 2014). In the H-Oil reactor, a recycle pump, located either internally or externally, circulates the reactor fluids down through a central downcomer and then upward through a distributor plate and into the ebullated-catalyst bed. The reactor is usually well insulated and operated adiabatically. Although the H-Oil reactor is loaded with catalyst, not all of the reactions are catalyzed; some are thermal reactions, like thermal cracking, which depend on liquid holdup and not on how much catalyst is present.

In the LC-Fining reactor, hydrogen reacts within an expanded catalyst bed that is maintained in turbulence by liquid upflow so as to achieve efficient isothermal operation. Product quality is constantly maintained at a high level by intermittent catalyst addition and withdrawal. Reactor products flow to the high-pressure separator, low-pressure separator, and then to product fractionation; recycled hydrogen is separated and purified. Process features include on-stream catalyst addition and withdrawal, thereby eliminating the need to shut down for catalyst replacement. The expanded-bed reactors operate at near isothermal conditions without the need for quenches within the reactor.

8.4 CHALLENGES

The first challenge relates to flow assurance through the reactor. The viscosity of viscous feedstocks is extremely high and variable. As the viscosity increases, flow characteristics of viscous feedstocks change considerably to very low mobility. The mobility of viscous feedstock reduces to such an extent that conventional pumping techniques fail to achieve any flow. In addition, the deposition of asphaltene constituents during transport and even into the refinery system also hinders the flow through the refinery pipelines. Such depositions can lead to multiphase flow, clogging of pipelines, high-pressure drops, and occasional pipeline stoppages. Flow assurance is a technique through which a fluid (specifically the refinery feedstock) feedstock is transported from not only from the wellbore but also in the refinery facilities while mitigating all the risks and guaranteeing a manageable and profitable flow. The flow assurance techniques are generally classified into three approaches, namely, (i) viscosity reduction, (ii) drag minimization, and (iii) in situ upgrading of the viscous feedstock.

In terms of viscosity reduction, there are several methods in practice to reduce the viscosity of the viscous feedstocks in an effort to increase their mobility. These methods include (i) heating, (ii)

dilution with low-boiling liquid hydrocarbon derivatives, (iii) oil-in-water emulsion formation, and (iv) depression of pour point.

Heating is one of the common methods employed for pipeline transportation of heavy oils. The viscosity of heavy oils is highly dependent on temperature, and an increase in temperature produces a significant drop in viscosity. The pipelines are generally well insulated, and the temperature is maintained by providing external heating. Thermal management of production and transportation pipelines is very important, and there are several approaches to provide external heat in the pipelines, e.g., bundled pipelines in which a heating fluid is circulated through a pipeline within a carrier pipe and electrically heated subsea pipelines.

Dilution is another method of reducing the viscosity of heavy oil. It involves the addition of lighter liquid hydrocarbons such as condensates from natural gas production, conventional lighter (low viscosity) feedstocks, and product streams such as naphtha and kerosene from the refinery. In some cases, up to 30% w/w of kerosene is required to sufficiently reduce the viscosity. The disadvantage is that this uses up large quantities of valuable commercial products, and, moreover, the added product is to be processed again through the refinery system along with the viscous feedstock. This, in turn, reduces the plant production capacity and at the same time reduces the plant energy efficiency. The addition of lighter liquid hydrocarbons may also affect the stability of wax and asphaltenes leading to pipeline clogging. Sometimes, the dilution is also necessary to meet the API requirements of the existing refineries.

Emulsion of oil-in-water is an alternative to the method of dilution to reduce the viscosity of heavy oils. When the heavy oil is dispersed in water, the flow characteristics improve tremendously. However, additional substances such as surfactants or stabilizing agents are added to ensure the stability of the emulsions.

Pour point depressants, also known as wax crystal modifiers, are the chemical additives that prevent nucleation and crystallization of paraffin. They reduce the viscosity and yield stress of the feedstock appreciably enabling the transportation of viscous feedstocks. Drag reduction techniques involve developing a core annular flow of viscous feedstocks with a thin film of water or an aqueous solution between the core and the wall of the pipe reduces the pressure drop due to friction in the pipeline. This is analogous to lubricating the inner core of the heavy oils and thus reducing the pressure drops.

Physicochemical upgrading of viscous feedstock produces a synthetic oil or syncrude with higher API gravity and low viscosity. Feedstock upgrading involves in situ production of a solvent through separation, distillation, and thermal cracking, a part of the heavy oil to produce lighter fractions. The lighter fractions can be used to dilute the heavier fractions to upgrade their mobility.

Once the feedstock is in the refinery system, other factors come into play. For example, heterogeneous manufacturing processes based on chemical reactions such as those used in the refining industry which may involve both a solid and a liquid phase are associated with several technical challenges. One of the most difficult issues is achieving contact between the reagents in the two phases – a phenomenon known as mass transfer limitation. The reagents in the liquid phase must be brought to an active site on the solid phase through the transport of the liquid medium relative to the solid particle. In the absence of any stirring to create convective flow, this transport only takes the form of diffusion, which can be a slow process. The mass transport is therefore increased in laboratories and production facilities by means of a suitably designed reactor.

The traditional and perhaps most common way to deal with mass transport limitations is the stirred-tank reactor in which a two-phase slurry of particles in suspension is stirred using an agitator. This generates a convective flow in the reactor which increases the relative transport of the liquid phase and solid particles, bringing reactants together at a higher rate than if left only to diffusion. The agitator also improves the mixing time of the reactor, being the time taken to disperse any concentration gradients in the liquid bulk that arise due to the local generation or removal of chemical species at the reaction sites. However, the stirred-tank reactor may cause physical damage to the solid phase as the particles collide with the agitator and each other. These collisions often lead

to grinding of the particles, producing fines that are hard to remove and limit the ability to reuse the solid material. For most applications, the stirred-tank reactor introduces a need for filtration after the reaction is completed.

A gentler treatment takes place in a packed column, also known as a fixed-bed reactor (FBR). Here the solid phase is packed in a stationary bed through which the liquid phase is then pumped. Grinding is then eliminated as there is no relative motion between any solid bodies. Still, associated with the fixed-bed reactor is a back pressure that increases with liquid viscosity and flow rate among other parameters. To avoid slow percolation of viscous feedstocks through the packed bed, powerful pumps and strong particles that can withstand immense pressures are required for the operation of the fixed-bed reactor.

REFERENCES

Al-Dahhan, M.H., Larachi, F., Duduković, M.P., and Laurent, A. 1997. High Pressure Trickle-Bed Reactors: A Review. *Ind. Eng. Chem. Res.* 36: 3292.

Ancheyta, J., Sánchez, S., and Rodríguez, M.A. 2005. Kinetic Modeling of Hydrocracking of Heavy Oil Fractions: A Review. *Catal. Today* 109: 76–92.

Ancheyta, J., and Speight, J.G. 2007. Feedstock Evaluation and Composition. *Hydroprocessing of Heavy Oils and Residua.* J. Ancheyta and J.G. Speight (Editors). CRC Press, Taylor & Francis Group, Boca Raton, FL, Chapter 2.

Boelhouwer, J.G. 2001. Non-steady Operation of Trickle-Bed Reactors: Hydrodynamics, Mass and Heat Transfer. PhD Thesis, Technische Universiteit Eindhoven, Netherlands.

Butt, J.B. 2000. *Reaction Kinetics and Reactor Design*, 2nd Edition. Marcel Dekker Inc., New York.

Carbonell, R.G. 2000. Multiphase Flow Models in Packed Beds. *Rev. Inst. Fr. Pét., Oil Gas Sci. Technol.* 55(4): 417.

Chadeesingh, R. 2011. The Fischer-Tropsch Process. *The Biofuels Handbook.* J.G. Speight (Editor). The Royal Society of Chemistry, London, United Kingdom, Part 3, Chapter 5, Pages 476–517.

Davis, M.E., and Davis, R.J. 2003. *Fundamentals of Chemical Reaction Engineering.* McGraw-Hill, New York.

Donati, G., and Paludetto, R. 1999. Batch and Semi-Batch Catalytic Reactors (From Theory to Practice). *Catal. Today* 52: 183–195.

Duduković, M.P., Larachi, F., and Mills, P.L. 1999. Multiphase Reactors – Revisited. *Chem. Eng. Sci.* 54: 1975–1995.

Duduković, M.P., Larachi, F., and Mills, P.L. 2002. Multiphase Catalytic Reactors: A Perspective on Current Knowledge and Future Trends. *Catal. Rev. Sci. Eng.* 44: 123.

Ellenberger, J., and Krishna, R. 1999. Counter-Current Operation of Structured Catalytically Packed Distillation Columns: Pressure Drop, Holdup and Mixing. *Chem. Eng. Sci.* 54: 1339.

Fogler, S.H. 2006. *Elements of Chemical Reaction Engineering*, 4th Edition. Prentice-Hall, Englewood Cliffs, NJ.

Furimsky, E. 1998. Selection of Catalysts and Reactors for Hydroprocessing. *Appl. Catal. A* 171: 177–206.

Gary, J.H., Handwerk, G.E., and Kaiser, M.J. 2007. *Petroleum Refining: Technology and Economics.* CRC Press, Taylor & Francis Group, Boca Raton, FL.

Gianetto, A., and Specchia, V. 1992. Trickle-Bed Reactors: State of the Art and Perspectives. *Chem. Eng. Sci.* 47: 3197.

Haure, P.M., Hudgins, R.R., and Silveston, P.L. 1989. Periodic Operation of a Trickle-Bed Reactor. *AIChE J.* 35: 1437.

Hsu, C.S., and Robinson, P.R. (Editors). 2017. *Handbook of Petroleum Technology.* Springer International Publishing, Cham, Switzerland.

Jones, D.S.J., and Pujado, P.P. (Editors). 2006. *Handbook of Petroleum Processing.* Springer Science, Heidelberg, Germany.

Kressmann, S., Boyer, C., Colyar, J.J., Schweitzer, J.M., and Viguié, J.C. 2000. Improvements of Ebullated-Bed Technology for Upgrading Heavy Oils. *Oil Gas Sci. Technol. – Rev. IFP* 55(4): 397–406.

Kressmann, S., Morel, F., Harlé, V., and Kasztelan, S. 1998. Recent Developments in Fixed-Bed Catalytic Residue Upgrading. *Catal. Today* 43: 203–215.

Krishna, R., and Sie, S.T. 1994. Strategies for Multiphase Reactor Selection. *Chem. Eng. Sci.* 49: 4029.

Kundu, A., Nigam, K.D.P., Duquenne, A.M., and Delmas, H. 2003. Recent Developments on Hydroprocessing Reactors. *Rev. Chem. Eng.* 19: 531–605.

Liu, Y., Gao, L., Wen, L., and Zong, B. 2009. Recent Advances in Heavy Oil Hydroprocessing Technologies. *Recent Pat. Chem. Eng.* 2: 22–36.

Moulijn, J.A., van Diepen, A.E., and Kapteijn, F. 2001. Catalyst Deactivation: Is It Predictable? What to Do? *Appl. Catal. A* 212: 3–16.

Ng, K.M., and Chu, C.F. 1987. Trickle-Bed Reactors. *Chem. Eng. Prog.* 83: 55.

Nigam, K.D.P., and Larachi, F. 2005. Process Intensification in Trickle-Bed Reactors. *Chem. Eng. Sci.* 60: 5880–5894.

Parkash, S. 2003. *Refining Process Handbook.* Gulf Professional Publishing, Elsevier, Amsterdam, Netherlands.

Robinson, K.K. 2006. *Reactor Engineering. Encyclopedia of Chemical Processing.* CRC Press, Taylor & Francis Group, Boca Raton, FL.

Sadeghbeigi, R. 2000. *Fluid Catalytic Cracking Handbook,* 2nd Edition. Gulf Professional Publishing, Elsevier, Oxford, United Kingdom.

Salmi, T.O., Mikkola, J.P., and Wärnå, J.P. 2011. *Chemical Reaction Engineering and Reactor Technology.* CRC Press, Taylor & Francs Group, Boca Raton, FL.

Saroha, A.K., and Nigam, K.D.P. 1996. Trickle Bed Reactors. *Rev. Chem. Eng.* 12: 207.

Scheffer, B., van Koten, M.A., Robschlager, K.W., and de Boks, F.C. 1998. The Shell Residue Hydroconversion Process: Development and Achievements. *Catal. Today* 43: 217–224.

Speight, J.G. 2013. *Heavy and Extra Heavy Oil Upgrading Technologies.* Gulf Professional Publishing, Elsevier, Oxford, United Kingdom.

Speight, J.G. 2014. *The Chemistry and Technology of Petroleum,* 5th Edition. CRC Press, Taylor & Francis Publishers, Boca Raton, FL.

Speight, J.G. 2017. *Handbook of Petroleum Refining.* CRC Press, Taylor & Francis Publishers, Boca Raton, FL.

Speight, J.G. 2019. *Handbook of Petrochemical Processes.* CRC Press, Taylor & Francis Publishers, Boca Raton, FL.

Stockfleth, R., and Brunner, G. 1999. Hydrodynamics of a Packed Countercurrent Column for Gas Extraction. *Ind. Eng. Chem. Res.* 38: 4000.

Topsøe, H., Clausen, B.S., and Massoth, F.E. 1996. *Hydrotreating Catalysis: Science and Technology.* Springer-Verlag, Berlin, Germany.

Trambouze, P. 1990. Countercurrent Two-Phase Flow Fixed Bed Catalytic Reactors. *Chem. Eng. Sci.* 45: 2269.

Versteeg, G.F., Visser, J.B.M., van Dierendonck, L.L., and Kuipers, J.A.M. 1997. Absorption Accompanied with Chemical Reaction in Trickle-Bed Reactors. *Chem. Eng. Sci.* 52: 4057.

Part 2

Feedstocks in the Future Refinery

9 Alternate Feedstocks

9.1 INTRODUCTION

The end of the widespread production of liquid fuels and other products within the current refinery infrastructure is considered by some observers to occur during the present century, even as early as the next five decades but, as with all projections, is very dependent upon the remaining reserves and petro-politics (Speight, 2011a; Islam and Speight, 2016). During this time, fossil fuels (including natural gas and crude oil from tight formations) will be the mainstay of the energy scenarios of many counties.

In addition, rightly or wrongly and without much justification but with much speculation, the combustion of fossil fuels is considered as the largest source of anthropogenic emissions of carbon dioxide (CO_2), which is largely blamed for global warming and climate change (Speight, 2020a) although other sources are evident but are often ignored (Speight, 2020). Nevertheless, having been identified as one of the causative agents of climate change, it is necessary to attempt to mitigate the emissions of carbon dioxide from fossil fuel combustion and to offset the depletion of fossil fuels such as the commonly used natural gas, and crude oil, and coal (Ragland et al., 1991). Coal is the current bad boy of the fossil fuel world but still offers many options for energy production, provided the process gases are cleaned rather than vented to the atmosphere (Speight, 2013). On the other hand, oil shale has been of lesser importance, having received on-again and off-again popularity as a source of fuels but has never really been recognized as a major source of fuels (Scouten, 1990; Lee, 1991, 1996; US DOE, 2004a–c).

The most popular energy resources (natural gas and the various members of the crude oil family) are currently on a depletion curve with estimates of the longevity of these resources varying up to 50 years (Speight and Islam, 2016). However, seeking alternate sources of energy is of critical importance for long-term security and continued economic growth. Supplementing crude oil consumption with renewable biomass resources is the first step toward this goal. The realignment of the chemical industry from one of crude oil refining to a refinery solely devoted to providing fuels and chemicals from biomass (frequently referred to as a biorefinery), given time, is feasible and has, in fact, become a national goal of many countries that currently rely on imports of crude oil to sustain their energy needs. However, clearly defined goals are necessary for increasing the use of biomass-derived feedstocks for fuel production and for the production of chemicals and it is important to keep the goal in perspective. In this context, the increased use of feedstocks and the production of fuels therefrom should be viewed as one of a range of possible measures for achieving self-sufficiency in energy, rather than a panacea (Demirbaş, 2008, 2009; Speight, 2019).

As the refining industry evolves even further and, in many cases away from natural gas and crude oil as the major feedstocks, a variety of biomass and waste-derived feedstocks will be used as feedstocks fuel production and this may be no more evident than the use of biofeedstocks for gasifier units. Moreover, gasification is (i) a well-established technology, (ii) has broad flexibility of feedstocks and operation, and (iii) the most environmentally friendly route for handling these feedstocks for power production. A wide variety of biofeedstocks such as wood pellets, wood chips, waste wood, plastics, municipal solid waste (MSW), refuse-derived fuel (RDF), agricultural and industrial wastes, sewage sludge, switch grass, discarded seed corn, corn stover, and other crop residues will all be used as gasifier feedstocks. In fact, wood is the oldest known biofuel. Burning wood rather than fossil fuels can reduce the carbon dioxide emissions responsible for global climate change. Wood fuel is carbon dioxide (CO_2) neutral. It gives off only as much carbon dioxide when burned as it stores during its lifetime. In addition, wood fuel has very low levels of sulfur, a chemical that contributes to acid rain.

This chapter presents an overview of the production of the potential of fuel production and chemical production from alternate sources (non-fossil fuel sources) for the reader to understand the chemical and physical parameters that are involved in the production of alternate fuels. For the purpose of this chapter, the alternate sources of energy are presented and these are (i) biomass, which includes agricultural crops and wood, and (ii) waste, which includes waste from domestic and industrial sources.

9.2 BIOMASS

Biomass is a term used to describe any material of recent biological origin, including plant materials such as trees, grasses, agricultural crops, and even animal manure. Thus, biomass (also referred to as bio-feedstock) refers to living and recently dead biological material which can be used as fuel or for industrial production of chemicals (Lee, 1996; Wright et al., 2006; Lorenzini et al., 2010; Nersesian, 2010; Speight, 2020).

In terms of the chemical composition, biomass is a mixture of complex organic compounds that contain, for the most part, carbon, hydrogen, and oxygen, with small amounts of nitrogen and sulfur, as well as with traces of other elements including metals. In most cases the biomass composition is approximately carbon 47% w/w–53% w/w, hydrogen 5.9% w/w–6.1% w/w, and oxygen 41% w/w–45% w/w. The presence of a large amount of oxygen in biomass makes a significant difference with fossil-derived hydrocarbon derivatives. When used as fuel this is less efficient but more suited for getting higher-value chemicals and bio-products containing functional entities within the constituent molecules.

The biomass used as industrial feedstock can be supplied by agriculture, forestry, and aquaculture, as well as resulting from various waste materials. The biomass can be classified as follows: (i) agricultural feedstocks, such as sugarcane, sugar-beet, and cassava; (ii) starch feedstocks, such as wheat, maize, and potatoes; (iii) oil feedstocks, such as rapeseed, and soy; (iv) dedicated energy crops, such as short rotation coppice which includes poplar, willow, and eucalyptus; (v) high-yield perennial grass, such as miscanthus, and switchgrass; (vi) non-edible oil plants, such as jatropha, camellia, sorghum; and (vii) lignocellulosic waste material, which includes forestry wood, straw, corn stover, bagasse, paper-pulp, and algal crops from land farming.

The utilization of biomass through the adoption of the conventional crude oil refinery systems and infrastructure to produce substitutes for fuels and other chemicals currently derived from conventional fuels (coal, oil, natural gas) is one of the most favored methods to combat fossil fuel depletion as the 21st century matures. In a biorefinery, a solid biomass feedstock is converted, through either a thermochemical process (such as gasification, pyrolysis) or a biochemical process (such as hydrolysis, fermentation) into a mixture of organic (such as hydrocarbon derivatives, alcohol derivatives, and ester derivatives) and inorganic compounds (such as carbon monoxide and hydrogen) that can be upgraded through catalytic reactions to high-value fuels or chemicals (Speight, 2011a, 2014, 2017, 2019).

In this manner, reducing the national dependence of any country on imported crude oil for long-term security and continued economic growth by supplementing crude oil consumption with renewable biomass resources becomes the first step toward energy self-sufficiency. The realignment of the chemical industry from one of crude oil refining to a biomass refining concept is, given time, a feasible and a worthy goal of many oil-importing countries (Speight and Islam, 2016; Speight and El-Gendy, 2018; Speight, 2019). However, clearly defined goals are necessary for increasing the use of biomass-derived feedstocks in industrial chemical production and it is important to keep the goal in perspective. In this context, the increased use of biofuels should be viewed as one of a range of possible measures for achieving self-sufficiency in energy, rather than the sole panacea (Crocker and Crofcheck, 2006; Langeveld et al., 2010), although there are arguments against the rush to the large-scale production of biofuels (Giampietro and Mayumi, 2009).

Biomass is a carbonaceous feedstock that is composed of a variety of organic constituents that contain carbon, hydrogen, oxygen, often nitrogen, and also small quantities of other atoms, including alkali metals, alkaline earth metals, and heavy metals.

Briefly, the alkali metals consist of the chemical elements lithium (li), sodium (Na), potassium (K), rubidium (Rb), cesium (Cs), and francium (Fr). Together with hydrogen, they make up Group I of the Periodic Table (Figure 9.1). On the other hand, the alkaline earth metals are the six chemical elements in Group 2 of the Periodic Table and are beryllium (Be), magnesium (Mg), calcium (Ca), strontium (Sr), barium (Ba), and radium (Ra). These elements have very similar properties – they are shiny, silvery-white, and are somewhat reactive at standard temperature and pressure. Finally, the heavy metals are less easy to define but are generally recognized as metals with relatively high density, atomic weight, or atomic number. The common transition metals such as copper (Cu), lead (Pb), and zinc (Zn) are often classed as heavy metals but the criteria used for the definition and whether metalloids (types of chemical elements which have properties in between, or that are a mixture of, those of metals and nonmetals) are included, vary depending on the context. These metals are often found in functional molecules such as the porphyrin molecules, which include chlorophyll and contain magnesium.

Biomass is the oldest form of energy used by humans. Traditionally, it has been utilized through direct combustion, and this process is still widely used in many parts of the world (Ragland et al., 1991). Since the energy crises of the 1970s, many countries have become interested in biomass as a fuel source to expand the development of domestic and renewable energy sources and reduce the environmental impacts of energy production. Energy from biomass energy (frequently referred to as bioenergy) can be an important alternative in the future and a more sustainable energy supply. Biomass is a material that is derived from plants, and there are many types of biomass resources currently used and potentially available. Biomass energy has the potential to be produced and used

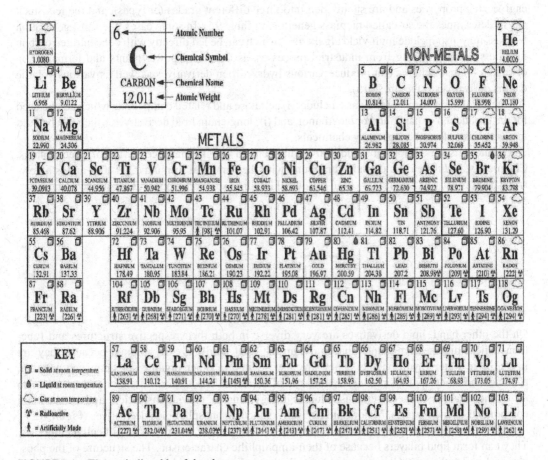

FIGURE 9.1 The periodic table of the elements.

TABLE 9.1

Different Grades of Biomass

Grade	Description
Primary biomass	Produced directly by photosynthesis and includes all terrestrial plants now used for food, feed, fiber, and fuel wood
Secondary biomass	Differs from primary biomass feedstocks in that the secondary feedstocks are a by-product of the processing of the primary feedstocks in which there has been a substantial physical or chemical breakdown of the primary biomass and production of by-products; processors may be factories or animals. Specific examples of secondary biomass include (i) sawdust from sawmills, (ii) black liquor, which is a by-product of paper making, (iii) cheese whey, which is a by-product of cheese making processes, (iv) manure from concentrated animal feeding operations, and (v) vegetable oils used for biodiesel that are derived directly from the processing of oilseeds for various uses
Tertiary biomass	Includes post-consumer residues and wastes, such as fats, greases, oils, construction and demolition wood debris, other waste wood from the urban environments, as well as packaging wastes, municipal solid wastes, and landfill gases

efficiently and cost competitively, generally in the more convenient forms of gases, liquids, or electricity (Larson and Kartha, 2000).

Biomass feedstocks and fuels exhibit a wide range of physical, chemical, and agricultural/process engineering properties and are subdivided into three different grades (or types), and the feedstock origin determines the so-called biomass generation (Table 9.1). In some cases, the third generation biomass may also include high-yield algal crops, which can be fed directly with concentrated carbon dioxide streams resulting from industrial processes, as from coal power plants and fermentation of sugars – algal cultures can produce various hydrocarbon derivatives as well as various volatile olefins derivatives (Dimian, 2015).

Chemically, the forms of biomass include: (i) cellulose and related compounds which can be used for the production of paper and/or bioethanol, and (ii) long-chain lipid derivatives which can be used in cosmetics or for other specialty chemicals.

Cellulose is an important structural component of the primary cell wall of green plants. Chemically, cellulose is an organic compound with the empirical formula $(C_6H_{10}O_5)$ and is a polysaccharide consisting of a linear chain of several hundreds to many thousands of linked glucose.

Cellulose

On the other hand, lipid derivatives are very diverse in both their respective structures and functions. These diverse compounds that make up the lipid family are so grouped because they are insoluble in water (hydrophobic). They are also soluble in other organic solvents such as ether, acetone, and other lipids. Lipids serve a variety of important functions in living organisms and also act as chemical messengers, serve as valuable energy sources, provide insulation, and are the main components of membranes. Major lipid derivatives include phospholipids derivatives (Figure 9.2).

Briefly, the phospholipids are a class of lipids that are a major component of all cell membranes. They can form lipid bilayers because of their amphiphilic characteristic. The structure of the phospholipid molecule generally consists of two hydrophobic fatty acid tails and a hydrophilic head

FIGURE 9.2 Examples of lipid derivatives.

FIGURE 9.3 Examples of fatty acids.

consisting of a phosphate group. The two components are usually joined together by a glycerol $(HOCH_2CHOHCH_2OH)$ molecule. The free fatty acid derivatives are variable but commonly include the naturally occurring stearic acid, palmitic acid oleic acid, and linoleic acid (Figure 9.3).

Other biomass components, which are generally present in minor amounts, include triglycerides, sterols, alkaloids, resins, terpenes, terpenoids, and waxes. This includes everything from primary sources of crops and residues harvested/collected directly from the land to secondary sources such as sawmill residuals, to tertiary sources of post-consumer residuals that often end up in landfills. A fourth source, although not usually categorized as such, includes the gases that result from anaerobic digestion of animal manures or organic materials in landfills (Wright et al., 2006).

Examples of modern biomass use are ethanol production from sugarcane, combined heat and power (often referred to using the acronym CHP) district heating programs, and the co-combustion of biomass in conventional coal-based power plants (Hoogwijk et al., 2005). In industrialized countries, the main biomass processes used in the future are expected to be direct combustion of residues and wastes for electricity generation, bio-ethanol and biodiesel as liquid fuels, and combined heat and power production from energy crops. In fact, biomass can be considered as the best option and has the largest potential, which meets these requirements and could ensure fuel supply in the future (Demirbaş, 2008, 2009).

Other biomass components, which are generally present in minor amounts, include (i) diglyceride derivatives that are based on the glycol structure, $HOCH_2CHOHCH_2OH$; (ii) triglyceride derivatives that are based on the glycerol structure, $HOCH_2CH_2OH$; (iii) sterol derivatives which are also known as steroid alcohols, are a subgroup of the steroids; (iv) alkaloid derivatives that are based on any of a class of naturally occurring organic nitrogen-containing bases; (v) terpene derivatives and terpenoid derivatives which are generally rationalized as derivatives of isoprene – 2-methyl-1,3-butadiene – but isoprene is not involved in the biosynthesis; and (vi) waxes which are a diverse class of organic compounds that are lipophilic solids near ambient temperatures and include higher alkane derivatives and lipid derivatives.

Example of a diglyceride

Example of a triglyceride

Sterol

An alkaloid (nicotine)

Terpineol derivatives

Cetyl palmitate – a wax ester

More generally, biomass feedstocks are recognized (or classified) by the specific plant content of the feedstock or the manner in which the feedstocks are produced. For example, primary biomass feedstocks are thus primary biomass that is harvested or collected from the field or forest where it is grown. Examples of primary biomass feedstocks currently being used for bioenergy include grains and oilseed crops used for transportation fuel production, plus some crop residues (such as orchard trimmings and nut hulls) and some residues from logging and forest operations that are currently used for heat and power production.

Secondary biomass feedstocks differ from primary biomass feedstocks in that the secondary feedstocks are a by-product of the processing of the primary feedstocks. By processing it is meant that there is a substantial physical or chemical breakdown of the primary biomass and production of by-products; processors may be factories or animals. Field processes such as harvesting, bundling, chipping, or pressing do not cause a biomass resource that was produced by photosynthesis (e.g., tree tops and limbs) to be classified as secondary biomass. Specific examples of secondary biomass include sawdust from sawmills, black liquor (which is a by-product of paper making), and cheese whey (which is a by-product of cheese making processes). Manure from concentrated animal feeding operations is collectable secondary biomass resources. Vegetable oils used for biodiesel that is derived directly from the processing of oilseeds for various uses are also a secondary biomass resource.

Tertiary biomass feedstock includes post-consumer residues and wastes, such as fats, greases, oils, construction and demolition wood debris, other waste wood from the urban environments, as well as packaging wastes, municipal solid wastes, and landfill gases. A category – other wood waste – from the urban environment includes trimmings from urban trees, which technically fits the definition of primary biomass. However, because this material is normally handled as a waste stream along with other post-consumer wastes from urban environments (and included in those statistics), it makes the most sense to consider it to be a part of the tertiary biomass stream. Tertiary biomass often includes fats and greases, which are by-products of the reduction of animal biomass into component parts, since most fats and greases, and some oils, are not available for bioenergy use until after they become a post-consumer waste stream. Vegetable oils derived from the processing of plant components and used directly for bioenergy (e.g., soybean oil used in biodiesel) would be a secondary biomass resource, though amounts being used for bioenergy are most likely to be tracked together with fats, greases, and waste oils.

One aspect of designing a refinery for any feedstocks is the composition of the feedstocks. For example, a heavy oil refinery would differ somewhat from a conventional refinery and a refinery for tar sand bitumen would be significantly different from both (Speight, 2014, 2017, 2020). Furthermore, the composition of biomass is variable (Speight, 2020) which is reflected in the range of heat value (heat content, calorific value) of biomass, which is somewhat lesser than for coal and

TABLE 9.2
Heating Value of Selected Fuels

Fuel	Btu/lb
Natural gas	23,000
Gasoline	20,000
Crude oil	18,000
Heavy oil	16,000
Coal (anthracite)	14,000
Coal (bituminous	11,000
Wood (farmed trees, dry)	8,400
Coal (lignite)	8,000
Biomass (herbaceous, dry)	7,400
Biomass (corn stover, dry)	7,000
Wood (forest residue, dry)	6,600
Bagasse (sugar cane)	6,500
Wood	6,000

TABLE 9.3
Typical Plants Used as a Source of Energy

Type of Biomass	Plant Species	Predominant Use
Wood	Butea monosperma, Casurina equisetifolia, Eucalyptus globulus, Leucaena leucocephala, Melia azadirachta, Tamarix dioica	Firewood
Starch	Cereals, millets, root and tuber crops, e.g., potato	Bioethanol
Sugar	Sugarcane, sugar beet	Bioethanol
Hydrocarbons	Euphorbia lathyris, Aslepia speciosa, Copaifera multijuga, algae	Biodiesel
Wastes	Crop residues, animal/human refuge, sewage	Biogas

much lower than the heat value for crude oil, generally falling in the range of 6,000–8,500 Btu/lb (Table 9.2). Moisture content is probably the most important determinant of heating value. Air-dried biomass typically has approximately 15%–20% moisture, whereas the moisture content for oven-dried biomass is around 0%. Moisture content is also an important characteristic of coals, varying in the range of 2%–30%. However, the bulk density (and hence energy density) of most biomass feedstocks is generally low, even after densification, approximately 10% and 40% of the bulk density of most fossil fuels.

Plants offer a unique and diverse feedstock for chemicals (Table 9.3) and the production of biofuels from biomass requires some knowledge of the chemistry of biomass, the chemistry of the individual constituents of biomass, and the chemical means by which the biomass can be converted to fuel. It is widely recognized that further significant production of plant-based chemicals will only be economically viable in highly integrated and efficient production complexes producing a diverse range of chemical products. This biorefinery concept is analogous to conventional oil refineries and petrochemical complexes that have evolved over many years to maximize process synergies, energy integration, and feedstock utilization to drive down production costs.

In addition, the specific components of plants such as (i) carbohydrates, (ii) vegetable oils, (iii) plant fibers, and (iv) complex organic molecules known as primary and secondary metabolites can be utilized to produce a range of valuable monomers, chemical intermediates, pharmaceuticals, and materials.

9.2.1 CARBOHYDRATES

Plants capture solar energy as fixed carbon during which carbon dioxide is converted to water and sugars $(CH_2O)_x$:

$$CO_2 + H_2O \rightarrow (CH_2O)_x + O_2.$$

The sugars produced are stored in three types of polymeric macromolecules: (i) starch, (ii) cellulose, and (iii) hemicellulose.

In general sugar polymers such as cellulose (Figure 9.4) and starch can be readily broken down to their constituent monomers by hydrolysis, preparatory to conversion to ethanol, or other chemicals. In contrast, lignin is an unknown complex structure containing aromatic groups that are totally hypothetical (Figure 9.5) and are less readily degraded than starch or cellulose.

Although lignocellulose is one of the cheapest and most abundant forms of biomass, it is difficult to convert this relatively unreactive material into sugars. Among other factors, the walls of lignocellulose are composed of lignin, which must be broken down in order to render the cellulose and hemicellulose accessible to acid hydrolysis. For this reason, many efforts focused on ethanol

FIGURE 9.4 Generalized structure of cellulose.

FIGURE 9.5 Hypothetical structure of lignin to illustrate the complexity of the molecule.

production from biomass are based almost entirely on the fermentation of sugars derived from the starch in corn grain.

Carbohydrates (starch, cellulose, sugars): starch is readily obtained from wheat and potato, whilst cellulose is obtained from wood pulp. The structures of these polysaccharides can be readily manipulated to produce a range of biodegradable polymers with properties similar to those of conventional plastics such as polystyrene foams and polyethylene film. In addition, these polysaccharides can be hydrolyzed, catalytically or enzymatically, to produce sugars, a valuable fermentation feedstock for the production of ethanol, citric acid, lactic acid, and dibasic acids such as succinic acid.

9.2.2 VEGETABLE OILS

Vegetable oils (sometimes referred to as vegetable fats) are oils extracted from seeds, or less often, from other parts of fruits. Like animal fats, vegetable fats are mixtures of triglycerides. Soybean oil and rapeseed oil are examples of fats from seeds, while olive oil and palm oil are examples of fats from other parts of fruits. In common usage, vegetable oil may refer exclusively to vegetable fats which are liquid at room temperature. Vegetable oils are usually edible; non-edible oils derived mainly from petroleum are termed as mineral oils. The predominant source of vegetable oils in many countries is rapeseed oil. Vegetable oils are a major feedstock for the oleo-chemicals industry (surfactants, dispersants, and personal care products) and are now successfully entering new markets such as diesel fuel, lubricants, polyurethane monomers, functional polymer additives, and solvents.

However, most natural oils have only a limited application in their original form, as a consequence of their specific chemical composition. They therefore often undergo a chemical or physical modification. Due to the continuous technological developments, a whole variety of products normally processed by solvent or detergent fractionation can now be obtained with a high degree of selectivity by dry fractionation (Gibon et al., 2009).

Unsaturated vegetable oils can be transformed through partial or complete hydrogenation into oils of higher melting point. The hydrogenation process involves sparging the oil at high temperature and pressure with hydrogen in the presence of a catalyst, typically a nickel compound. As each carbon-carbon double-bond is chemically reduced to a single bond, two hydrogen atoms each form single bonds with the two carbon atoms. Oil may be hydrogenated to increase resistance to oxidation (which can turn the oil rancid) or to change its physical characteristics. As the degree of saturation increases, the viscosity and the melting point of the oil increase.

Vegetable oils are used as an ingredient or component in many manufactured products. They are used to make soaps, skin products, candles, perfumes, and other personal care and cosmetic products. Some oils are particularly suitable as drying oils and are used in making paints and other wood treatment products. Vegetable oils are increasingly being used in the electrical industry as insulators since vegetable oils are bridgeable if spilled and are not toxic to the environment – they also have high flash and fire points. However, vegetable oils are less stable chemically, so they are generally used in systems where they are not exposed to oxygen and they are more expensive than crude oil distillate. More important in the present context, vegetable oils are also used as the starting material for biodiesel, which can be used like conventional diesel. Some vegetable oils are used in unmodified vehicles but straight vegetable oil – also known as pure plant oil – needs specially prepared vehicles which have a method of heating the oil to reduce the viscosity.

9.2.3 PLANT FIBERS

Lignocellulosic fibers extracted from plants such as hemp and flax can replace cotton and polyester fibers in textile materials and glass fibers in insulation products. Lignin is a complex chemical compound that is most commonly derived from wood and is an integral part of the cell walls of plants, especially in tracheids, xylem fibers, and sclereids. The chemical structure of lignin is unknown and, at best, can only be represented by hypothetical formulas.

Lignin is one of the most abundant organic compounds on earth after cellulose and chitin. By way of clarification, chitin $(C_8H_{13}O_5N)_n$ is a long-chain polymeric polysaccharide of beta-glucose that forms a hard, semitransparent material found throughout the natural world. Chitin is the main component of the cell walls of fungi and is also a major component of the exoskeletons of arthropods, such as the crustaceans (e.g. crab, lobster, and shrimp), and the insects (e.g. ants, beetles, and butterflies), and of the beaks of cephalopods (e.g. squids, and octopuses).

Lignin makes up approximately one-quarter to one-third of the dry mass of wood and is generally considered to be a large, cross-linked hydrophobic, aromatic macromolecule with a molecular mass that is estimated to be in excess of 10,000. Degradation studies indicate that the molecule consists of various types of substructures, which appear to repeat in a random manner.

Lignin fills the spaces in the cell wall between cellulose, hemicellulose, and pectin components and is covalently linked to hemicellulose. Lignin also forms covalent bonds with polysaccharides, which enables cross-linking to different plant polysaccharides. Lignin confers mechanical strength to the cell wall (stabilizing the mature cell wall) and therefore the entire plant.

9.2.4 ENERGY CROPS

Biomass currently provides varying proportions (depending upon the country) of the primary energy supply but, as a word of caution, the production of energy crops may compete with traditional agricultural and forestry uses of land. It is essential to create integrated biomass production systems that landowners can use to help meet the growing energy demands of any nation. For example, the production of fast-growing short-rotation woody crops on agricultural lands is one such approach that shows considerable promise. In addition to using woody biomass for energy for power and heat generation by means of co-firing and gasification, woody crops with their high hemicellulose and cellulose content are well suited for biorefining to yield liquid fuels such as methanol, ethanol, and distillable oil (sometimes referred to as pyrolysis oil or bio-oil), as well as other products, such as specialty chemicals (Tables 9.4 and 9.5) (Speight, 2019).

Crops are the annual or seasonal yield of any plant that is grown to be harvested as food, as livestock fodder, fuel, or for any other economic purpose in significant quantities. This category includes crop species as well as agricultural techniques related to cropping. The products from crops are not only the primary source of human foods and animal feed, but also a source of timber, fibers, and biomass energy. In addition, crops also have an essential function to maintain ecological systems and natural environments. Most of the crop production is used as foods but in the last century (the 20th century) crops were also cultivated for non-food use – examples are such as pharmaceutical and nutritional products, chemical derivative products such as adhesives, paints, polymer, plastics and industrial oils in forms of bio diesel, transmission fluids, and lubricants.

Thus, by definition, energy crops are plants grown specifically for use as a fuel. Although growing crops for fuel dates from medieval times, in their modern form energy crops are the most recent and innovative renewable energy option. Energy crops are important as renewable energy

TABLE 9.4

Biomass Liquefaction by Pyrolysis

Biomass	Pyrolysis, 550°C, No Air		
	Gases	H_2, CO, CO_2, C_nH_{2n+2}	
		Liquids	C_nH_{2n+2}
	Char	C	
Combustion			
	Gases	CO_2, H_2O	

TABLE 9.5
Summary of the Methods for the Conversion of Biomass to Fuels

Biomass

Extraction		
	Transesterification	Biodiesel
Hydrolysis		
	Fermentation	Biogas
		Ethanol
Gasification		
	Synthesis gas	Biogas
		Hydrogen
		Methanol
		Ethanol
Pyrolysis		Hydrogen
		Bio-oil
Hydrotreating		Diesel

technology because their use will produce a variety of economic, environmental, and energy benefits. Commercial energy crops are typically densely planted, high yielding crop species where the energy crops will be burnt to generate power. Woody crops such as willow and poplar are widely utilized, as well as tropical grasses such as miscanthus and elephant grass (Pennisetum purpureum).

Grasses are usually herbaceous plants with narrow leaves growing from the base. They include the true grasses of the Poaceae (or Gramineae) family, as well as the sedges (Cyperaceae) and the rushes (Juncaceae). The true grasses include cereals, bamboo, and lawn grasses (turf) and grassland. Sedges include many wild marshes and grassland plants, and some cultivated ones such as water chestnut (Eleocharis dulcis) and papyrus sedge (Cyperus papyrus). Most of the interest in grass biomass tends to focus on economics, but there is a list of traits that should be considered and valued when evaluating a potential solid biomass energy source. These traits are beneficial to society in general or impact the suitability of biomass for a farm operation.

If the carbohydrate content is desired for the production of biogas, whole-crops such as maize, Sudan grass, millet, white sweet clover, and many others, can be made into silage after which they can be converted into biogas. On the other hand, crop residues are the residues remaining after crops have been harvested. Crop residues typically contain 40% w/w of the nitrogen (N), 80% w/w of the potassium (K), and 10% w/w of the phosphorus (P) applied to the soil in the form of fertilizer. If these residues are subjected to direct combustion for energy, only a small percentage of the nutrients is left in the ash.

The valuable portion of sugar and starch crops (in terms of biofuel production) is the stalks and leaves, which are composed mainly of cellulose. The individual six-carbon sugar units in cellulose are linked together in extremely long chains by a stronger chemical bond than exists in starch. In starch crops, most of the six-carbon sugar units are linked together in long, branched chains (starch). Yeast cannot use these chains to produce ethanol. The starch chains must be broken down into individual six-carbon units or groups of two units. The starch conversion process is relatively simple because the bonds in the starch chain can be broken in an inexpensive manner by the use of heat and enzymes, or by a mild acid solution.

Sugar crops include a variety of plants such as fodder beets, fruit crops, Jerusalem artichokes, sugar beets, sugar cane, and sweet sorghum. Interest in ethanol production from such agricultural crops has prompted the development of sugar crops that have not been cultivated on a widespread commercial basis in many countries. Preparation is basically a crushing and extraction of the sugars

which the yeast can immediately use. But sugar crops must be dealt with fairly quickly before their high sugar and water content causes spoilage. Because of the danger of such spoilage, the storage of sugar crops is not practical.

As with starch, cellulose must be broken down into sugar units before it can be used by yeast to make ethanol. However, the breaking of the cellulose bonds is much more complex and costly than the breaking of the starch bonds. Breaking the cellulose into individual sugar units is complicated by the presence of lignin, a complex compound surrounding cellulose, which is even more resistant than cellulose to enzymatic or acidic pretreatment (Hwang and Obst, 2003). Because of the high cost of converting liquefied cellulose into fermentable sugars, agricultural residues (as well as other crops having a high percentage of cellulose) are not yet a practical feedstock source for small ethanol plants.

Crop residues (cobs, stems, leaves, particularly straw and other plant matter) left in agricultural fields after harvest could potentially be used for solid biofuels production. Due to high energy content, straw is one of the best crop residues for solid biofuels. However, straw has several disadvantages – it has a higher ash content, which results in lower calorific value. In order to improve its bulk density, the straw is generally baled before transportation. Straw burning requires specific technology. There are four basic types of straw burners: those that accept shredded, loose straw; burners that use densified straw products such as pellets, briquettes or cubes, and straw logs; small, square bale burners, and round bale burners. To be suitable for heat and electricity production straw should not have a large content of moisture, preferably not more than 20% as the moisture reduces the boiler efficiency. Also, straw color as well as straw chemistry should be considered before burning as it indicates the quality of the straw. Most crop residues are returned to the soil, and the humus resulting from their decomposition helps maintain soil nutrients, soil porosity, water infiltration, and storage, as well as reducing soil erosion.

Regularly coppiced plantations will actually absorb more carbon dioxide than mature trees – since carbon dioxide absorption slows once a tree has grown. Growing crops for fuel, particularly wood coppice, offers very promising developments for the future. Short rotation arable coppicing, using fast-growing willows, is currently seen as an important source of fuel for electricity generation. The overall process involves several stages – growing over 2 or 3 years, cutting and converting to wood chip, storage, and drying, transport to a power plant for combustion. And the combustion process can be very efficient, given the development of advanced co-generation techniques.

Energy crop fuel contains almost no sulfur and has significantly less nitrogen than fossil fuels, therefore reductions in pollutants causing acid rain (SO_2) and smog (NO_x) may be realized. For example, the use of energy crops will greatly reduce greenhouse gas emissions. Burning fossil fuels removes carbon that is stored underground and transfers it to the atmosphere. Burning energy crops, on the other hand, releases carbon dioxide but as their growth requires carbon dioxide there is no net release of carbon into the atmosphere, i.e., it creates a closed carbon cycle. Furthermore, where energy crops are gasified there is a net reduction of carbon dioxide. In addition, substantial quantities of carbon can be captured in the soil through energy crop root structures, creating a net carbon sink.

An additional environmental benefit is in water quality as energy crop fuel contains less mercury than coal. Also, energy crop farms using environmentally pro-active designs will create water quality filtration zones as well as the uptake and sequestering pollutants such as phosphorus from soils that leach into water bodies. Also, growing energy crops on agricultural land that might otherwise be converted to residential or industrial use will reduce erosion/chemical runoff and enhance wildlife habitat. This will give energy to producers and consumers will have a renewable energy option with uniquely desirable characteristics. For example, energy crops differ from other sources of renewable energy in virtue of the fact that they can be grown to meet the needs of the market whereas other renewable resources (for example, wind and wave power) must be harnessed where and when they occur.

Energy crops are low-cost and low-maintenance crops grown solely for energy production (not for food). The crops are processed into solid, liquid, or gaseous fuels, such as pellets, bioethanol or

biogas. The fuels are burned to generate power or heat. Furthermore, the term energy crops can be used both for biomass crops that simply provide high output of biomass per hectare for low inputs, and for those that provide specific products that can be converted into other biofuels, such as sugar or starch for bioethanol by fermentation, or into vegetable oil for biodiesel by transesterification. Energy crops such as grasses, miscanthus oilseed crops, short-rotation woody crops, residual herbaceous biomass, starch crops, sugar crops, and switchgrass can be converted to liquid biofuels by biochemical and thermochemical conversion process (Table 9.5).

In the biochemical process, bacteria, yeasts, and enzymes also break down carbohydrates. For example, the fermentation process used to make wine changes biomass liquids into alcohol, a combustible fuel. A similar process is used to turn corn into ethanol, which is mixed with the gasoline to make gasohol. Also, when bacteria break down biomass, methane and carbon dioxide are produced. This methane can be captured, in sewage treatment plants and landfills, for example, and burned for heat and power. Also, biomass oils, such as soybean oil and canola oil, can be chemically converted into a liquid fuel similar to diesel fuel, and into gasoline additives. Used cooking oil has been used as a source to make biodiesel.

In the thermochemical process, the plant matter is broken down into gaseous products, liquid products, and a carbonaceous solid (commonly referred to as char). These products can then be processed further and refined into useful fuels such as methane and alcohol. Another approach is to take these fuels and run them through fuel cells, converting the hydrogen-rich fuels into electricity and water, with few or no emissions. However, the direct conversion thermal processes, such as combustion, may encounter the same problems as those encountered when coal is the feedstock (Speight, 2013). The conversion of biomass into other useful forms such as gaseous fuels or liquid fuels is considered as an alternative way to make use of biomass energy. Perennial crops that regenerate annually from buds at the base of the plant offer the greatest potential for energy-efficient production These include (i) cordgrass and switchgrass, (ii) Jerusalem artichoke, (iii) miscanthus, (iv) reed plants, (v) residual herbaceous biomass, (vi) short rotation coppice, and (vii) sorghum.

9.2.4.1 Cordgrass and Switchgrass

Cordgrass, (genus *Spartina*), also called marsh grass or salt grass is a genus of 16 species of perennial grasses in the family Poaceae which is found on marshes and tidal mud flats of North American, Europe, and Africa and often forms dense colonies. Some species are planted as soil binders to prevent erosion and a few are considered invasive species in areas outside their native range. Prairie cordgrass (*Spartina pectinata*) and gulf cordgrass (*S. spartinae*) are the most widely distributed North American species.

Cordgrasses are erect, tough, long-leaved plants that range from 1 to 10 feet in height. Most species grow in clumps, with short flower spikes alternating along and often adherent to the upper portion of the stems. Many spread through rhizomes (underground stems) that send up new plants. One of the variations of cordgrass – referred to as smooth cordgrass – has smooth, blade-like leaves that taper to a point. The leaves grow 12–20 inches in length and one-half an inch wide and have round, hollow stems and a strong, interconnected root system. Smooth cordgrass grows in two forms: a short form that grows to 2 feet tall, and a tall form that can reach 7 feet tall.

Switchgrass (Panicum virgatum) is a perennial sod-forming grass with thick strong stems. It is a perennial warm-season bunchgrass that is native to North America, where it occurs naturally from Canada southwards into the United States and Mexico. Switchgrass is one of the dominant species of the central North American tallgrass prairie and can be found in prairie remnants (grassland areas in the Western and Midwestern United States and Canada that remain, to some extent, undisturbed), in native grass pastures, and naturalized along roadsides.

The advantages of switchgrass as an energy crop are that it is fast-growing, remarkably adaptable, and high-yielding. Further advantages of switchgrass are that it can be harvested, using conventional equipment, either annually or semi-annually for 10 years or more before replanting is needed and that it can reach deep into the soil for water and use water very efficiently.

Besides showing great promise as an energy crop for energy production, switchgrass also restores vital organic nutrients to farmed-out soils and with its extensive network of stems and roots (the plants extend nearly as far below ground as above), it is also a valuable soil stabilization plant.

Switchgrass has the potential to be a versatile bioenergy feedstock since the energy content is comparable to that of wood with significantly lower initial moisture content. Switchgrass is a very suitable substrate and produces high ethanol yield using current simultaneous saccharification and fermentation technology. Extensive analysis of ash and alkali content of switchgrass indicates that it typically has relatively low alkali content and should have low slagging potential in coal-fired combustion systems. As an agro-fiber source for pulping, switchgrass has a relatively high cellulose content, low ash content, and good fiber length to width ratios. Switchgrass reaches its full yield potential after the third year of plantation, producing approximately 6–8 tons per acre; that is 500 gallons of ethanol per acre.

The utilization of energy crops such as switchgrass (Panicum virgatum, L., Poaceae) is a concept with great relevance to current ecological and economic issues on a global scale. Development of a significant national capacity to utilize perennial forage crops, such as switchgrass as biofuels could provide an important new source of energy from perennial cropping systems, which are compatible with conventional farming practices, would help reduce degradation of agricultural soils, and lower national dependence on foreign oil.

9.2.4.2 Jerusalem Artichoke

The Jerusalem artichoke (Helianthus tuberosus, also called sunroot, sunchoke, or earth apple) is a species of sunflower (that is native to central North America) which is a herbaceous perennial plant that grows up to 5–10 feet tall with opposite leaves on the upper part of the stem but alternate below. The leaves have a rough, hairy texture. Larger leaves on the lower stem are broad-ovoid-acute and can be up to 12 inches long, while the leaves higher on the stem are smaller and narrower.

The tubers are often elongated and uneven, typically 3–4 inches long and 1–2.2 inches thick with a crisp and crunchy texture when raw. They vary in color from pale brown to white, red, or purple.

The Jerusalem artichoke has shown excellent potential as an alternative sugar crop. A member of the sunflower family, this crop is native to North America and well-adapted to northern climates. Like the sugar beet, the Jerusalem artichoke produces sugar in the top growth and stores it in the roots and tuber. It can grow in a variety of soils, and it is not demanding of soil fertility. The Jerusalem artichoke is a perennial; small tubers left in the field will produce the next season's crop, so no plowing or seeding is necessary. The high-fructose syrups that can be derived from the tubers produced by the Jerusalem artichoke may be used for the production of ethanol and other industrial raw materials. Jerusalem Artichokes also produce a large amount of top growth which may also prove to be a useful source of biomass for energy purposes.

9.2.4.3 Miscanthus

Miscanthus (also called silvergrass) is a hardy perennial grass that produces a crop of bamboo-like cane up to 15 feet tall. Miscanthus is high in lignin and lignocellulose fiber. Lignocellulose is the term used to describe the three-dimensional polymeric composites formed by plants as a structural material. It consists of variable amounts of cellulose, hemicellulose, and lignin.

Briefly, lignocellulosic feedstocks are composed primarily of carbohydrate polymers (cellulose and hemicellulose) and phenolic polymers (lignin). Lower concentrations of various other compounds, such as proteins, acids, salts, and minerals, are also present. Cellulose and hemicellulose, which typically make up two-thirds of cell wall dry matter (dry matter: the portion of biomass that is not water), are polysaccharides that can be hydrolyzed to sugars and then fermented to ethanol. Process performance, in this case, ethanol yield from biomass, is directly related to cellulose, hemicellulose, and individual sugar concentration in the feedstock. Lignin cannot be used in fermentation processes; however, it may be useful for other purposes.

Miscanthus can be grown in a cool climate and on many types of arable land. Miscanthus does not require a big input of fertilizers due to its capability to recycle large amounts of nutrients.

Miscanthus has a similar calorific value per unit weight as wood and therefore could possibly be used in the same power plant or those designed for agricultural residues

Miscanthus is well equipped for high productivity under relatively cool temperatures and may require substantial amounts of water for maximal growth (its growth could therefore also have valuable environmental benefits by acting as absorbing disposal areas for waste water and some industrial effluents). Furthermore, Miscanthus seems to grow well in most soil conditions (bar thin droughty soils) but appears to thrive within areas that are currently best-suited to maize production. The advantages of Miscanthus as an energy crop are that it multiplies very rapidly, has a high yield which is relatively dry, and can be harvested annually (from its second season onward) compared with every 2–4 years for short rotation coppice. Further advantages are that Miscanthus can be grown and harvested with existing farm machinery, it requires little or no pesticide/fertilizer input after establishment and the harvest can use the same infrastructure for storage and transport as short rotation coppice. Finally, Miscanthus has a similar calorific value per unit weight as wood and therefore could possibly be used in the same power plant or those designed for agricultural residues

9.2.4.4 Reed Plants

Reed is a common name for several tall, grass-like plants that are commonly found in wetlands. Reed plants are a potentially prolific producer of biomass, capable of yielding 20–25 tons per hectare (2.47 acres) of dry matter annually for a number of years. They can grow up to 6 m, are spread by means of stout rhizomes (continuously growing horizontal underground stems, which puts out lateral shoots and adventitious roots at intervals) and stolons (also known as runners, which are horizontal connections between organisms), and are commonly found in swampy ground and shallow water throughout temperate and subtropical areas.

Reed canary grass is a robust perennial grass, widely distributed across temperate regions of Europe, Asia, and also North America. It occurs in wet places, along the margins of rivers, streams, lakes, and pools. The species spreads naturally by creeping rhizomes, but plants can also be raised from seed. The advantages of Reed Canary grass as an energy crop are its good adaptation to cool temperate climates and poor wet soil conditions and, conversely, its ability to withstand drought. Crucially, for the purposes of biomass production, reed canary grass is also able to attain high dry matter content earlier than Miscanthus. The crop responds well to nitrogen and phosphate and it may be used in a bed system to remove nutrients from waste water, as well as to stabilize areas at risk of soil erosion.

9.2.4.5 Residual Herbaceous Biomass

Residual herbaceous biomass (straw) is the main residual herbaceous material for energy application. As it is a residual product, its availability for energy purposes is driven by the cereals markets and does not have autonomous market behavior. In addition, farms consume significant quantities of straw internally – as bed material for livestock, grain drying, etc. Some straw is also chaffed and returned back to the field as soil ameliorator. The net straw yield per hectare for energy application also depends on the crop, the grain yield per hectare, climate and cultivation conditions, etc. Nevertheless, one can roughly estimate that the average straw yield per hectare is approximately 50%–65% of the grain yield per hectare from cereals and oilseeds.

Similar to herbaceous crops, straw usually has lower moisture content than woody biomass. Conversely, it has a lower calorific value, bulk density, ash melting point, and higher content of ash, problematic inorganic components such as chlorine, potassium, and sulfur, which cause corrosion and pollution. The last two drawbacks can be relatively easily overcome by leaving straw on the field for a while. In such a way rainfall provides a natural leaching process and separates a large part of the potassium and the chlorine. Alternatively, fresh straw can be directly shipped to the gasification plant, where it is washed by dedicated facilities at moderate temperatures (50°C–60°C; 120°F–140°F). Due to washing, the initially low moisture content of straw becomes higher in both cases and hence a mandatory drying is applied afterward. In both cases also the content of corrosive

components is reduced, but not completely taken out. In order to decrease handling costs, straw and dedicated herbaceous energy crops are usually baled before being shipped to the gasification plant. The weight and the size of bales depend on the baling equipment and the requirements of the gasification plant (Luque and Speight, 2015).

The simplest form of agricultural biomass energy use involves direct combustion of cellulosic crops or residues, such as hay, straw, or corn fodder, to heat space or produce steam. Such fuels are useful for heating farm buildings and small commercial buildings in rural areas and for drying crops. Ideally, energy crops should be produced on land not needed for food production. This use should not increase the erosion hazard or cause other environmental damage. On the other hand, a variety of crops can be grown specifically to provide sources of energy, and, once established, a stand of perennial biomass/energy crop is expected to remain productive for a period of 6 years or more.

9.2.4.6 Short Rotation Coppice

Short rotation woody crops (short rotation coppice or SRC) refer to fast-growing deciduous trees that are grown as energy crops, such as willow and poplar trees. The species of short rotation coppice that are most suitable, and therefore most popular, for use as energy crops, are poplar and willow (and possibly also birch) because they both require deep, moisture-retentive soils for proper growth. Willow, in particular, can endure periods of water logging and is, therefore, better suited to wetter soils.

Short rotation coppice is harvested during winter when the dry matter percentage of the coppice is at its highest and it is then bundled or immediately chipped. It may then be stored for a few weeks in order to reduce its moisture content to a satisfactory level for use in energy production. Dry short rotation coppice can then be burnt under controlled conditions to produce other fuels, gas or liquid, which are then used for electricity generation.

9.2.4.7 Sorghum

Sorghum is an annual tropical grass with a large genetic variation that is a crop with the potential for energy production. It is a genus of flowering plants in the grass family Poaceae. Seventeen of the 25 species are native to Australia with the range of some extending to Africa, Asia, and Central America as well as to islands in the Indian Ocean and the Pacific Ocean. One species is grown for grain, while many others are used as fodder plants, either cultivated in warm climates throughout the world or naturalized, in pasture lands.

Sweet sorghum has been selected for its sugar content and is normally grown for molasses production. Forage sorghum has been selected for high yields of reasonably good quality animal feed. Sorghum varieties producing tall plants with large stems make the best candidates for biomass production. Both sweet and forage sorghum have a high potential for lodging. Lodging can result in harvest problems with ensuing loss of yield from both initial and ratoon crops.

Sweet sorghum is a name given to varieties of a species of sorghum. This crop has been cultivated on a small scale in the past for the production of table syrup, but other varieties can be grown for the production of sugar. The most common types of sorghum species are those used for the production of grain. Sweet sorghum can be considered as an energy crop, because it can be grown in all continents, in tropical, sub-tropical, temperate regions as well as in poor quality soils. Sweet sorghum is a warm-season crop that matures earlier under high temperatures and short days. Sweet Sorghum is an extraordinarily promising multifunctional crop known not only for its high economic value but also for its capacity to provide a very wide range of renewable energy products, industrial commodities, food, and animal feed products. Sweet sorghum biomass is rich in readily fermentable sugars and thus it can be considered as an excellent raw material for fermentative hydrogen production – hydrogen is an important commodity for the refining industry and new sources are continually sought (Parkash, 2003; Gary et al., 2007; Speight, 2014; Hsu and Robinson, 2017; Speight, 2017). Sweet sorghum crops produce sugar syrups which could form the basis of fermentation processes for methane or ethanol production and some of the forage types of the plant may be suitable for biomass production.

9.2.5 WOOD

Wood is a porous and fibrous structural tissue found in the stems and roots of trees and other woody plants. It is a natural composite of cellulose fibers that are strong in tension and embedded in a matrix of lignin that resists compression. Wood is sometimes defined as only the secondary xylem in the stems of trees, or it is defined more broadly to include the same type of tissue elsewhere such as in the roots of trees or shrubs. In a living tree, it performs a support function, enabling woody plants to grow large or to stand up by themselves. Wood also conveys water and nutrients between the leaves, other growing tissues, and the roots. As a result of this structure, wood has lent itself to a variety of uses throughout recorded history.

The amount and types of wood fuel used vary considerably between regions, mainly due to different local situations and conditions. The quality of wood fuels is determined for fuel types by choosing for each delivery batch the limit values for the energy density, moisture content, and particle size of the fuel as received from the quality. However, some of the uses of wood are derived from the use of black liquor from the pulp and paper industries.

Composition of Black Liquor

Element	% w/w
Carbon	35.7
Hydrogen	3.7
Nitrogen	≥0.1
Oxygen	35.8
Sulfur	4.4
Chlorine	0.3
Potassium	1.1
Sodium	19.0

Source: Kavalov and Peteves (2005).

The energy density is dependent on net calorific value (Table 9.6), moisture content, bulk density, and particle size of the fuel concerned. When choosing limit values for energy density and moisture, the interdependence of different characteristics should be considered by using characteristic values typical of different wood fuels. In deliveries of different wood fuel blends or mixtures (e.g., bark/sawdust, cutter chips/grinding dust/other wood residues), the parties should agree upon the application of quality classification and the quality determination of fuel considering the use and safety issues. Quality limits for other characteristics of the fuel can be specified case by case for mechanical properties of the fuel (i.e., oversize particles) and other properties. When preparing delivery agreements, differences in properties due to possible seasonal variations should also be considered and agreed by parties separately.

The components of wood include cellulose, hemicellulose, lignin, extractives, lipids, proteins, simple sugars, starches, water, hydrocarbon derivatives, ash, and other compounds. The proportion of these wood constituents varies between species, and there are distinct differences between hardwoods and softwoods.

9.2.5.1 Types of Wood

Hardwood, as the name suggests, is generally harder than softwood but there are significant exceptions. In both groups (hardwood and softwood) there is an enormous variation in actual wood hardness, with the range in density in hardwoods completely including that of softwoods; some hardwoods (such as balsa) are softer than most softwoods, while yew is an example of a hard softwood. Trees grown in tropical climates are generally hardwood. Hardwood grows faster than

TABLE 9.6
The Gross Calorific Value of Wood as One of a Variety of Fuels

Fuel	Gross Calorific Value, Btu/lb[a]
Alcohol, 96%	
Anthracite	14,000–14,500
Bituminous coal	7,300–10,000
Butane	20,900
Charcoal	12,800
Coal	8,000–14,000
Diesel	19,300
Ethanol	12,800
Gasoline	20,400
Gasoline	7,000
Kerosene	154,000
Wood (dry)	5,500–8,500

[a] The Gross Calorific Value (GCV) assumes that the water of combustion is entirely condensed and that the heat contained in the water vapor is recovered.
1 kJ/kg = 1 J/g = 0.4299 Btu/lb$_m$ = 0.23884 kcal/kg
1 Btu/lb = 2.326 kJ/kg = 0.55 kcal/kg
1 kcal/kg = 4.1868 kJ/kg = 1.8 Btu/lb$_m$

TABLE 9.7
Composition of Different Biomass Types (% w/w, Dry Basis)

Type	Cellulose	Hemicellulose	Lignin	Others	Ash
Soft wood	41	24	28	2	0.4
Hard wood	39	35	20	3	0.3
Pine bark	34	16	34	14	2
Straw (wheat)	40	28	17	11	7
Rice husks	30	25	12	18	16
Peat	10	32	44	11	6

Source: Prakash and Karunanithi (2008).

softwood but has shorter fibers compared to softwood. Hardwoods or deciduous woods have a higher proportion of cellulose, hemicelluloses, and extractives than softwoods, but softwoods have a higher proportion of lignin (Table 9.7). Generally, hardwoods that provide long-burning fires contain the greatest total heating value per unit of volume.

Hardwoods have a more complex structure than softwoods and, as a result, often grow much slower. The dominant feature separating "hardwoods" from softwoods is the presence of pores or vessels. The vessels may show considerable variation in size, shape of perforation plates (simple, scalariform, reticulate, foraminate), and structure of cell wall, such as spiral thickenings.

Hardwoods are employed in a large range of applications, including fuel, tools, construction, and the manufacture of charcoal. Solid hardwood joinery tends to be expensive compared to softwood. In the past, tropical hardwoods were easily available, but the supply of some species, such as teak and mahogany is now becoming scarce due to over-exploitation. Hardwoods may be used in a variety of objects, but are most frequently seen in furniture or musical instruments because of

their density which adds to durability, appearance, and performance. Different species of hardwood lend themselves to different end uses or construction processes due to the variety of characteristics apparent in different timbers, including density, grain, pore size, growth and fiber pattern, flexibility, and ability to be steam bent.

Softwood is usually wood from gymnosperm trees such as pine trees and spruce trees which often reproduce using cones and occasionally nuts. The trees classified as softwoods have needle-like or scale-like leaves that, with a few exceptions, remain on the tree all through the year. Hence softwood trees are sometimes called evergreens. Botanically, they are known as gymnosperms and instead of bearing seeds from flowers, gymnosperms have exposed seeds in cones.

Within the softwood and hardwood groups here is a considerable variation in actual wood hardness, the range of density in hardwoods completely including that of softwoods. Some hardwoods (such as balsa) are softer than most softwoods, while the hardest hardwoods are much harder than any softwood. In short, the terms softwood and hardwood are archaic with questionable meaning and often belie the properties of the wood.

Softwoods are generally used mostly by the construction industry and are also used to produce paper pulp and card products. In many of these applications, there is a constant need for density and thickness monitoring, and gamma-ray sensors have shown good performance in this case. Certain species of softwood are more resistant to insect attack from woodworm, as certain insects prefer damp hardwood. Softwoods that give a fast-burning, cracking blaze are less dense and contain less total heating value per unit of volume.

9.2.5.2 Composition and Properties

Wood is the hard, fibrous substance found beneath the bark in the stems and branches of trees and shrubs. Practically all commercial wood, however, comes from trees. It is plentiful and replaceable. Since a new tree can be grown where one has been cut, wood has been called the world's only renewable natural resource. Wood consists of cellulose ($C_6H_{19}O_5$), resins, lignin, various inorganic salts, and water, which is reflected in the ultimate analysis of wood (Figure 9.6). The quantity of water present has a great effect on the heating value and ranges from 25% w/w to 50% w/w in the green wood, and from 10% w/w to 20% w/w in the air-dried wood (Table 9.8).

Wood cut in the spring and summer contains more water than cut in the early part of the winter. A cord (8 feet long by 4 feet wide by 4 feet high) of hard wood, such as ash or maple, is approximately equal in heating value to 1 ton of bituminous coal; soft woods, such as pine and poplar, have less than half this amount. Wood burns with a long flame and is kindled, the fire quickly reaches its maximum intensity, and a relatively small quantity of ash is formed. Wood is too expensive for industrial use, except in a few special cases, where freedom from dirt and smoke is necessary. Of other cellulose materials, shavings, sawdust, and straw are used for fuel in some places. They are bulky and difficult to handle, while their heat value, which depends on the amount of moisture they contain, is seldom more than from one-third to one-half that of good coal. Such waste matter as spent tan-bark and bagasse (crushed sugar cane), and the pulp from sugar beets is sometimes used

Element	Average of 11 hardwoods[a]	Average of 9 softwoods[a]	Oak bark[b]	Pine bark[b]
C	50·2	52·7	52·6	54·9
H	6·2	6·3	5·7	5·8
O	43·5	40·8	41.5	39·0
N	0·1	0·2	0·1	0·2
S	—	0·0	0·1	0·1

FIGURE 9.6 Ultimate analysis of wood (% w/w, dry-ash-free).

TABLE 9.8
Properties of Various Woody Feedstocks Compared to Coal and Natural Gas

	Bituminous Coal	Natural Gas	Wood	Bark	Willow	Forest Residues V
Ash, % w/w	8.5–10.9	0	0.4–0.5	3.5–8	1.1–4.0	1–3
Moisture, % w/w	5–10	0	5–60	45–65	50–60	50–60
Volatile matter, % w/w	25–40	100	>70	70–77	>70	>70
Ash melting point, °C	1,100–1,400		1,400–1,700	1,300–1,700	n.a.	n.a.
C, % w/w	76–87	75	46–52	46–52	47–51	48–52
H, % w/w	3.5–5	24	6.2–6.04	4.6–6.8	5.8–6.7	6.0–6.2
N, % w/w	0.8–1.5	0.9	0.1–0.5	0.3–0.8	0.2–0.8	0.3–0.5
O, % w/w	2.8–11.3	0.9	36–42	24.3–42.4	40–46	40–44
S, % w/w	0.5–3.1	0	<0.05	<0.05	0.02–0.10	<0.05
Cl, % w/w	<0.1		0.01–0.03	0.01–0.03	0.02–0.05	0.01–0.04
K, % w/w	0.003	-	0.02–0.05	0.1–0.4	0.2–0.5	0.1–0.04
Ca, % w/w	4–12		0.1–1.5	0.02–0.08	0.2–0.7	0.2–0.9

for fuel for evaporation 01′ for steam, but owing to a large amount of moisture they contain, the heat value is very low.

All woods dried to the same moisture content contain approximately the same heat value per pound – from 6,200 to 7,500 Btu for fully dried wood and 5,500 to 8,500 Btu for air-dried seasoned wood (Table 9.6). However, the heat content of any fire depends on wood density, resin, ash, and moisture. A general rule for estimating heat value of firewood is: one cord of well-seasoned hardwood (weighing approximately 2 tons) burned in an airtight, draft-controlled wood stove with a 55%–65% efficiency is equivalent to approximately 175 gallons of #2 fuel oil or 225 therms of natural gas consumed in normal furnaces having 65%–75% efficiencies. There are also differences in the types of wood. Softwoods usually contain a lot of resin that has high energy content, so the total energy content of softwood is usually higher than the energy content of hardwood (often by approximately 5%). Also, softwood tends to burn up faster than hardwood and has other characteristics that reduce their attractiveness as fuel since the typical density of softwood is usually lower than the density of hardwood, it can be equated to less weight in a cord of softwood and the extra 5% of volatile fuel will not make up for the loss in weight.

Briefly, a cord of wood is a stack of wood comprising 128 cubic feet ($3.62\,m^3$) – the standard dimensions of the cord are 4 feet by 4 feet by 8 feet, including air space and bark and one cord contains approximately 1.2 U.S. tons (oven-dry) which is equivalent to 2,400 pounds (1,089 kg).

9.2.5.3 Chemical Composition
The chemical composition of wood varies from species to species but is approximately 50% w/w carbon, 42% w/w oxygen, 6% w/w hydrogen, 1% w/w nitrogen, and 1% w/w other elements (mainly calcium, potassium, sodium, magnesium, iron, and manganese).

9.2.5.3.1 Cellulose
Cellulose, the major chemical constituent of wood, is in many respects the most important. It is also the most easily defined and described. Wood cellulose is chemically defined as $(C_6H_{10}O_5)_n$. Cellulose is a high molecular weight, stereoregular, and linear polymer of repeating beta-D-glucopyranose units. Simply speaking it is the chief structural element and major constituents of the cell wall of trees and plants. The empirical formula for cellulose is $(C_6H_{10}O_5)_n$ where 'n' is the degree of polymerization (DP).

Generalized structure of cellulose

9.2.5.3.2 Hemicellulose

Hemicellulose derivatives, which make up 20%–35% of the dry weight of wood, are the second important constituent of wood, are also sugar polymers and unlike cellulose, which is made only from glucose, hemicelluloses consist of glucose and several other water-soluble sugar derivatives that are produced during photosynthesis. In the hemicellulose family, the degree of polymerization is lower than in cellulose and is composed of shorter molecular chains that are found in cellulose. There are many varieties of hemicelluloses and they markedly differ in composition in softwoods and hardwoods – generally, hemicellulose derivatives are in a relatively greater proportion in hard-woods than in softwoods.

Hemicellulose (hemi-cellulose) is a constituent of woods that is, like cellulose, a polysaccharide, but less complex and easily hydrolyzable. Hemicellulose derivatives are polysaccharides that are often associated with cellulose but have very different compositions.

Generalized structure of hemicellulose

Unlike cellulose, hemicellulose consists of 50–3,000 sugar units as opposed to 7,000–15,000 glucose molecules per polymer in cellulose. Hemicelluloses are classified according to the main sugar residue in the backbone as xylan derivatives, mannan derivatives, and glucan derivatives. Depending on the plant species, developmental stage, and tissue type, various subclasses of hemi-cellulose may exist, which may be grouped into two general categories based on the hydration of the fibers. Low-hydration polysaccharide derivatives function primarily to stabilize the cell wall through hydrogen-bonding interactions with cellulose and covalent interaction with lignin. They are water soluble due to their branched structure. The second type is hemicellulose derivatives com-posed mainly of hydrocolloids (often called gums, are hydrophilic polymers, of vegetable, animal, microbial or synthetic origin, that generally contain many hydroxyl groups and may be polyelectro-lytes), which function primarily as an extracellular energy and raw materials storage system and as a water-retention mechanism in seeds.

Hemicellulose derivatives contain many different sugar monomers, while cellulose only con-tains anhydrous glucose. For example, in addition to glucose, the sugar monomers in hemicellulose

derivatives can include the five-carbon sugars xylose and arabinose, the six-carbon sugars mannose and galactose, and the six-carbon deoxy-sugar rhamnose.

Xylose is, in most cases, the sugar monomer present in the largest amount, although in softwoods mannose can be the most abundant sugar, leading to the production of ethanol (Keller, 1996; Galbe and Zacchi, 2002). Not only regular sugars can be found in hemicellulose, but also their acidified form, for instance, glucuronic acid and galacturonic acid can be present.

9.2.5.3.3 Lignin

Lignin is a complex constituent of the wood that cements the cellulose fibers together and is largely responsible for the strength and rigidity of plants. Lignin is a class of complex organic polymers that form a key structural material. As a biopolymer, lignin is unusual because of the heterogeneity and lack of a defined primary structure. Its most commonly noted function is the support through the strengthening of wood.

Structurally, lignin is a cross-linked polymer with a molecular mass in excess of 10,000. It is relatively hydrophobic and rich in aromatic subunits. The actual degree of polymerization is difficult to measure since the material is heterogeneous. Lignin is particularly important in the formation of cell walls, especially in wood and bark, because it does not rot easily.

Chemically, lignins are cross-linked phenolic polymers, but the composition does vary from species to species – as example of composition from an aspen sample is carbon 63.4% w/w, hydrogen 5.9%, and oxygen 30% (by difference), mineral as 0.7% ash which corresponds to the approximate formula $(C_{31}H_{34}O_{11})_n$.

Hypothetical structure of lignin

The lignol derivatives that crosslink are of three main types (all derived from phenylpropane): 4-hydroxy-3-methoxy phenylpropane; 3,5-dimethoxy-4-hydroxy phenylpropane; and 4-hydroxy phenylpropane. Thus, different types of lignin have been described depending on the means of isolation. The three common monolignols presented below are (i) trans-coniferyl alcohol; (ii) trans-sinapyl alcohol; and (iii) trans-p-coumaryl alcohol.

trans-Coniferyl alcohol trans-Sinapyl alcohol trans-p-Coumaryl alcohol

Thus, lignin can be defined as a polyphenolic material arising primarily from enzymic dehydrogenative polymerization of three phenylpropanoid units (p-hydroxy-cinnamyl alcohols). The proportions of the precursors in lignins vary with their botanical origin. The typical structural elements of softwood lignins are derived principally from trans-coniferyl alcohol (90%) with the remainder of the structure consisting predominantly of trans-p-coumaryl alcohol. In contrast, the lignin derivatives in hardwood are composed predominantly of trans-coniferyl alcohol and trans-sinapyl alcohol in varying ratios (approximately 50% for each alcohol).

Structural and other chemical issues aside, lignin fills the spaces in the cell wall between cellulose, hemicellulose, and pectin components (structural acidic heteropolysaccharide derivatives contained in the primary cell walls of terrestrial plants), especially in vascular and support tissues. It is covalently linked to hemicellulose and, therefore, cross links different plant polysaccharides, conferring mechanical strength to the cell wall and, by inference, to the whole plant.

By way of explanation, pectin is a structural acidic heteropolysaccharide contained in the primary cell walls of terrestrial plants. The main component is galacturonic, a sugar acid derived from galactose.

Galactose Galacturonic acid

Lignin plays a crucial part in conducting water in plant stems – the polysaccharide constituents of the plant cell are hydrophilic and thus permeable to water, whereas lignin is more hydrophobic and less permeable to water. The crosslinking of polysaccharides by lignin is an obstacle for water absorption to the cell wall and, thus, the presence of lignin makes it possible for the vascular tissue of the plant to conduct water efficiently.

9.2.5.3.4 Solvent Extractable Materials

The structure created by hydrogen bonds results in the typical material properties of the chemical constituents of wood confers insolubility in most solvents. For isolation of, for example, cellulose from wood, direct nitration of wood yields undegraded cellulose trinitrate, which is soluble in organic solvents. On the other hand, the glycosidic linkages are easily cleaved by strong mineral acids and, therefore, cellulose can be hydrolyzed to simple sugars. However, for complete hydrolysis of cellulose, concentrated acid solutions must be used in order to achieve the necessary swelling and at least a partial destroying of the ordered regions. Furthermore, although native lignin derivatives

behave as an insoluble and three-dimensional network, the isolated lignin derivatives exhibit maximum solubility in a variety of solvents including dioxane, acetone, methyl cellosolve, tetrahydrofuran, dimethylformamide, and dimethyl sulfoxide.

More generally, the soluble materials or extractives in wood consist of those components that are soluble in neutral organic solvents. The di-chloromethane extractable content of wood is a measure of such substances as waxes, fats, resins, photo-sterols, and non-volatile hydrocarbon derivatives. The amount of extractives is highly dependent on seasoning or drying of wood. The ethanol-benzene extractable content of the wood consists of certain other di-chloromethane insoluble components such as low molecular weight carbohydrates, salts, and other water-soluble substances. Most water-soluble and volatile compounds are removed during pulping. The extractives reduce pulp yield, increase pulping and bleaching chemical consumption and create problems such as foaming, during papermaking, if not removed.

For isolation of the solvent extractable constituents from wood, different methods can be used. Volatile extractives are represented by high-volatile compounds, which can be separated by water distillation. They are mainly composed of monoterpene derivatives and other volatile terpene derivatives, terpenoid derivatives, as well as many different low-molecular compounds. Resin is the collective name for lipophilic extractives (with the exception of phenolic substances). Resin extractives can be extracted with organic solvents. Water-soluble compounds consist of various phenol derivatives, carbohydrates, glycoside derivatives, and soluble salts, which can be extracted by cold or hot water.

Most plant resins are composed of terpenes. Specific components include alpha-pinene, beta-pinene as well as the monocyclic terpenes limonene and terpinolene, with smaller amounts of the tricyclic sesquiterpene derivatives.

Limonene

Some wood resins also contain a high proportion of resin acid derivative. On the other hand, resins are less volatile and consist, inter alia, of diterpane derivatives. In addition, wood resins are divided into free acids, e.g. resin acid and fatty acid, and neutral compounds (such as fats and waxes). The resin fraction is soluble in organic solvents but insoluble in water, and therefore it can be extracted with organic solvents, such as hexane, dichloromethane, diethyl ether, acetone, or ethanol. Different non-polar and polar solvents can be selected for isolation of the different types of soluble extractable constituents of wood.

9.2.6 CHEMISTRY AND USES

The utilization of biomass to produce valuable products by thermal processes is an important aspect of biomass technology (Speight, 2011b, 2020). Biomass pyrolysis gives usually rise to three phases: (i) gases, (ii) condensable liquids, and (iii) char/coke. However, there are various types of related kinetic pathways ranging from very simple paths to more complex paths and all usually include several elementary processes occurring in series or competition. As anticipated, the kinetic paths are different for cellulose, lignin, and hemicelluloses (biomass main basic components) and also for usual biomasses according to their origin, composition, and inorganic contents.

The main biomass constituents – hemicellulose, cellulose, and lignin – can be selectively devolatilized into value-added chemicals. This thermal breakdown is guided by the order of thermochemical

stability of the biomass constituents that ranges from hemicellulose (as the least stable constituent) to the more stable lignin, which exhibits an intermediate thermal degradation behavior. Thus, wood constituents are decomposed in the order of hemicellulose-cellulose-lignin, with a restricted decomposition of the lignin at relatively low temperatures. With prolonged heating, condensation of the lignin takes place, whereby thermally largely stable macromolecules develop. While both hemicellulose and cellulose exhibit a relatively high devolatilization rate over a relatively narrow temperature range, thermal degradation of lignin is a slow-rate process that commences at a lower temperature when compared to cellulose.

Thus, biomass, unlike natural gas or crude oil, offers a wide variety of compositions. In addition, the specific components of plants such as carbohydrates, vegetable oils, plant fiber, and complex organic molecules known as primary and secondary metabolites can be utilized to produce a range of valuable monomers, chemical intermediates, pharmaceuticals, and materials: (i) carbohydrates, (ii) vegetable oils, (iii) plant fibers, and (iv) specialty chemicals.

Carbohydrates (starch, cellulose, sugars): starch is readily obtained from wheat and potato, whilst cellulose is obtained from wood pulp. Polysaccharides can be hydrolyzed, catalytically or enzymatically to produce sugars, a valuable fermentation feedstock for the production of ethanol, citric acid, lactic acid, and dibasic acids such as succinic acid. Vegetable oils: vegetable oils are obtained from seed oil plants such as palm, sunflower, and soya. The predominant source of vegetable oils in many countries is rapeseed oil. Plant fibers, such as lignocellulosic fibers can be extracted from plants such as hemp and flax can replace cotton and polyester fibers in textile materials and glass fibers in insulation products. Plants can synthesize highly complex bioactive molecules (specialty chemicals) that are often beyond the power of laboratories and a wide range of chemicals is currently extracted from plants for a wide range of markets from crude herbal remedies through to very high-value pharmaceutical intermediates.

More generally, biomass feedstocks are recognized by the specific chemical content of the feedstock or the manner in which the feedstocks are produced. However, the chemical composition of biomass varies considerably. Predictably, the chemical and molecular composition of biomass impacts its subsequent decomposition. The rate of decomposition is an early facet of the dynamic process for converting biomass and is dependent on biomass quality (chemical composition and molecular composition) as well as other factors, such as process parameters.

The main bio-feedstock constituents hemicellulose, cellulose, and lignin can be selectively devolatilized into value-added chemicals – this thermal breakdown is guided by the order of thermochemical stability of the biomass constituents that ranges from hemicellulose (fast degassing/decomposition from 200°C to 300°C, 390°F to 570°F) as the least stable natural product to the more stable cellulose (fast degassing/decomposition from 300°C to 400°C, 570°F to 750°F). Lignin exhibits an intermediate thermal degradation behavior (gradual degassing/decomposition from 250°C to 500°C, 480°F to 930°F).

The past abundance of biomass, particularly wood, and the dispersion of the industry have worked against advances in technology for the efficient production, conversion, and use of wood products. Fortunately, and despite its relatively recent origin as a recognized field of study, wood science has had an appreciable effect on wood technology as well as science in general. The study of wood chemistry has contributed to our understanding of the principal components of wood – cellulose and lignin – and their reactions. Early research on hydrolysis of cellulose was prompted by fuel needs in World War I, but contributed much to our knowledge of this form of a chemical reaction.

The Madison Process as it was described in the 1940s was developed to hydrolyze softwood species, which is particularly valuable or the production of fuels such as ethanol (Keller, 1996; Galbe and Zacchi, 2002). The hemi-cellulose sugars were recovered in the form of furfural, and only one stage was required. If hardwood species are used, a two-stage process is more desirable to maximize the recovery of both the hemicellulose and cellulose. High yields of hemi-cellulose

products can be obtained at the milder pre-hydrolysis conditions compared to the higher temperature required to maximize glucose yields from the cellulose in the second stage.

The several acid hydrolysis processes now being promoted to produce ethanol from wood, but they do it in different types of equipment at slightly different acid-temperature-time conditions. The stake process uses a horizontal screw reactor. The Iotech process uses high-pressure, short-time hydrolysis followed by a rapid release of pressure. The twin-screw extruder process developed by New York University uses a high-pressure, special reactor design. The plug-flow reactor under study at Dartmouth and another developed by American Can use different methods to pump the wood and acid into the reactor. The New Zealand process under license to Ultra Systems is probably a modern version of the Madison Process.

After the hydrolysis of the cellulose, the processes could be identical if the same products were to be recovered. Some of the two-stage processes differ in that the residue from the first stage is delignified with a lignin solvent. This dissolves the lignin to leave only cellulose to be hydrolyzed in the second stage. The lignin is then recovered by distilling off the solvent. This is in contrast to hydrolyzing the first stage residue to solubilize the cellulose and leave the lignin.

Wood is bulky, has less than half the heat of combustion of fuel oil, and in its green state is heavy to ship. Furthermore, the cost of a wood-burning system may be three to four times that of a gas-burning installation because of fuel storage, handling, and air quality control systems. These drawbacks have kindled interest in the production of liquid and gaseous fuels from wood. Much research is devoted to improving existing technology and devising new approaches, but such fuels are still expensive compared with crude oil-based fuels.

Finally, closely related to the conversion of wood to liquid or gaseous fuel is the use of the chemical storehouse that wood is to produce a wide range of silvichemicals. Many processes of these types already form the basis of chemical production on a commercial scale. But the potential to use wood as a chemical feedstock is much greater than has so far been realized. Wood can be gasified, liquefied, or pyrolyzed in ways comparable with those used for coal to yield a wide variety of chemicals. Cellulose, as a glucose polymer, can be hydrolyzed to the glucose monomer by acid or enzymes, and the glucose then fermented to ethanol. Ethanol can be used as a fuel or as a source of other important chemicals such as ethylene or butadiene.

Lignin can be pyrolyzed, hydrogenated, and hydrolyzed to yield phenols, which can be further processed to benzene. Once the technology and economics are feasible, future plants will manufacture a variety of these very significant chemicals from wood, now derived from crude oil or other resources.

Charcoal continues to be used as an important industrial source of energy. For example, in Brazil, some 6 million tonnes of charcoal is produced every year for use in heavy industry, such as steel and alloy production. The industrial demand for charcoal in the last few years has led to new, more efficient, and large-scale technologies, mainly aimed at improving charcoal yield and quality. Furthermore, although fuel wood is mainly a local source of energy, there are signs of international trade in wood fuel development between European and North American countries.

The dynamics of wood fuel flow are complex and very site-specific. The development of sustainable wood energy systems remains one of the most critical issues to be addressed by policymakers and community planners. With society giving increasing attention to sustainability issues, in the case of wood energy in both developing and developed countries, economic, environmental, and social issues deserve particular attention.

Most of the uses of wood are accounted for by combustion in intermediate or large-scale units outside the forest industries (e.g. in schools, hospitals, barracks, or district heating/plants), with minor volumes going to the production of charcoal. Very small volumes were used in a few European countries to generate electricity or to manufacture solid fuels (e.g. briquettes). No wood is used at present in the region to make synthetic liquid or gaseous fuels. The use of energy wood by the forest industries and users has grown faster than use by households.

9.3 WASTE

Waste (often referred to as refuse) is the result of human activities or the by-product from a process (or processes) for which no use is planned or foreseen. Thus, waste in the context of this book is actually a by-product of the human chemical, physical, and economic system. The words domestic and industrial are qualifiers of the source of the waste and, to some extent, are also descriptive of the contents of the waste. Once a material has been designated as waste, it remains waste until it has been fully recovered and no longer poses a potential threat to the environment or a use is found for the waste. However, in nature (which is typically a balanced system unless disturbed by human activities) there is no waste. Since the industrial revolution, human society has developed economies that are largely unrelated from nature and the natural order of events that generate considerable quantities of waste – domestic and industrial.

Waste (refuse) comes in a variety of forms and must be dealt with on a day-to-day basis. Industry produces huge amounts of industrial waste and domestic waste makes a large contribution to the general waste problem. In spite of the recognition many insidious waste products escape (inadvertently or deliberately) into the surrounding environment. Thus, there are numerous pollution incidents. On the other hand, there are technologies available for the treatment of most of the wastes we produce. The level of treatment is largely a matter of cost but conversion of waste to new products is a concept that has long been ready to hatch (Table 9.9).

Domestic waste (also known as rubbish, garbage, trash, or junk) is unwanted or undesired material (although the old adage one man's waste is another man's treasure sometimes applies) (Table 9.9). Waste is the general term; though the other terms are used loosely as synonyms, they have more specific meanings. Thus: (i) rubbish or trash are is mixed household waste including paper and packaging; (ii) food waste or garbage (North America) is kitchen and table waste, and (iii) junk or scrap is metallic or industrial material. There are other categories of waste as well: sewage, ash, manure, and plant materials from garden operations, including grass cuttings, fallen leaves, and pruned branches. On the other hand, industrial waste is the waste produced by industrial operations such as factories, mills, and mines and has existed since the onset of the Industrial Revolution. Chemical waste and toxic waste are two additional (but specific) designations of industrial waste (Table 9.9).

Municipal solid waste (MSW) is a waste type that includes predominantly household waste (domestic waste) with sometimes the addition of commercial wastes collected by a municipality within a given area. They are in either solid or semisolid form and generally exclude industrial hazardous waste. The term residual waste relates to waste left from household sources containing materials that have not been separated out or sent for reprocessing.

Relevant to the disposal of waste, it can be used as feedstocks for various processes such as (i) gasification processes, (ii) pyrolysis processes, or (iii) incineration processes are streams such as chemical waste, medical, waste, paper waste, plastic waste, and textile waste, as well as many other types of other carbonaceous waste which may form part of the industrial waste and domestic waste. However, although waste is a very general category, it must be remembered that as is the case for the feedstocks for any process, these raw materials require different processes for optimal operation.

There are five broad categories of municipal solid waste: (i) biodegradable waste, such as food and kitchen waste and green waste, (ii) recyclable material such as paper, glass, cans metals, and certain types of plastic, (iii) inert waste such as construction and demolition waste, dirt, rocks, debris, (iv) composite waste which includes waste clothing, and waste plastics, and (v) domestic hazardous waste (also called household hazardous waste) and toxic waste such as discarded medications, paints, chemicals, light bulbs, fluorescent tubes, spray cans, fertilizer containers, pesticide containers, batteries, and shoe polish.

Some components of waste – such as plastic bottles, metals, glass, or paper – can be recycled once recovered from the waste stream. The biodegradable components of wastes (such as paper and food waste), including agricultural waste (Tables 9.9 and 9.10), can be composted or anaerobically

TABLE 9.9

Major Sources of Waste

Dredging and irrigation	Waste consists of soil and sediments removed from waterways, harbors, estuaries, and irrigation canals
	The quantities may be considerable and contain hazardous materials discharged from industrial and farming activities. It is not suited for energy production
Farming, livestock rearing, dairy activities	Waste composed largely of spoilt food, manure, crop waste, waste from chemical, or pesticide use
	Not all of the agricultural waste generated can be put to energy production; some of this waste is returned to the land as part of good agricultural practice
Industrial	Some of the major industrial sources of waste are construction and demolition, fabrication, light and heavy manufacturing, refineries, chemical plants, and non-nuclear power plants
	Some large industrial facilities have their own recycling initiatives and operate their own landfills; it is difficult to determine the amount of waste discarded
Mining and quarrying	Waste consists of mine tailings (silts, fine sands or other aggregate materials) and may pose problems to the environment due to large quantities of waste produced and, in some cases, its hazardous nature
	Not suited for energy production
Nuclear power and nuclear defense	The civilian nuclear power industry, defense facilities, and nuclear research projects generate dangerous radioactive waste
	The toxicity due to exposure and concerns over long-range health and environmental effects make nuclear waste extraordinarily difficult to dispose of safely
Residential, commercial and institutional	Homes, commercial or institutional businesses, construction and demolition activities, municipal services and treatment plants (inclusive of waste incinerators) are major contributors to waste streams

digested to produce soil improvers and alternate (renewable) fuels through a variety of reactions (Table 9.11). Biomass is carbon-based and is composed of a mixture of organic molecules containing hydrogen, usually including atoms of oxygen, often nitrogen, and also small quantities of other atoms, including alkali metals, alkaline earth metals, and heavy metals. These metals are often found in functional molecules such as the porphyrin molecules, which include chlorophyll, which contains magnesium. Also, if biomass is not used in a sustainable manner, biodegradable waste can contribute to greenhouse gas emissions and, by implication, climate change.

On the other hand, there is also electronic waste, which is a waste consisting of any broken or unwanted electrical or electronic appliances. While there is no generally accepted definition of electronic waste, in most cases, electronic waste consists of electronic products that were used for data processing, telecommunications, or entertainment in private households and businesses and are now considered obsolete, broken, irreparable, or of no further use due to planned obsolescence. Despite their common classification as a waste, disposed electronics are a considerable category of secondary resources due to their significant suitability for direct reuse (for example, many fully functional computers and components are discarded during upgrades), refurbishing, and material recycling of its constituents. It is a point of concern considering that many components of such equipment are considered toxic and are not biodegradable but they are not precursors to fuels and other than recognition though the above paragraph will not be considered in the context of the present text.

9.3.1 DOMESTIC AND INDUSTRIAL WASTE

Much of what human society discards contain usable material, much of it in the form of recoverable energy. Paper, wood, cloth, food waste, and plastics are the main potential energy sources in waste. The remainder of the waste consists of glass, metals, and miscellaneous rubble. Domestic waste is typically disposed off by tipping it into large holes in the ground – landfill sites. Sometimes

TABLE 9.10

Amounts (% w/w) of Cellulose, Hemicellulose, and Lignin Common Agricultural Residues and Wastes

Agricultural Residue	Cellulose	Hemicellulose	Lignin
Bamboo	41–49	24–28	24–26
Coastal Bermuda grass	25	35.7	6.4
Corn cobs	45	35	15
Corn stover	35	28	16–21
Cotton seed hairs	80–90	5–20	0
Grasses	25–40	35–50	10–30
Hardwood stem	40–50	24–40	18–25
Leaves	15–20	80–85	0
Newspaper	40–55	25–40	18–30
Nut shells	25–30	25–30	30–40
Paper	85–99	0	0–15
Primary wastewater solids	8–15	n.a.	24–29
Rice straw	40	18	5.5
Softwood stem	45–50	25–35	25–35
Solid cattle manure	1.6–4.7	1.4–3.3	2.7–5.7
Sorted refuse	50–60	10–20	15–20
Sugar cane bagasse	32–48	19–24	23–32
Sweet sorghum	27	25	11
Swine waste	6.0	28	-
Switch grass	30–51	10–50	5–20
Waste papers from chemical pulps	60–70	10–20	5–10
Wheat straw	33–40	20–25	15–20

TABLE 9.11

Common Reactions in Anaerobic Digestion Process

Substrate	Reactions
Alcohol derivatives	$4CH_3OH \rightarrow 3CH_4 + CO_2 + 2H_2O$
	$CH_3OH + H_2 \rightarrow CH_4 + H_2O$
	$4HCOO^- + 2H^+ \rightarrow CH_4 + 2H_2O$
Monosaccharide derivatives	$C_6H_{12}O_6 + 2H_2O \rightarrow 2H_2 + butyrate + 2HCO_3^- + 3H^+$
	$C_6H_{12}O_6 + 4H_2O \rightarrow 4H_2 + 2\,acetate + 2HCO_3^- + 4H^+$
Organic acid derivatives	$Butyrate + 2H_2O \rightarrow 2H_2 + 2\,acetate + H^+$
	$Propionate + 3H_2O \rightarrow 3H_2 + acetate + HCO_3^- + H^+$
	$HCOO^- + 3H_2 + H^+ \rightarrow CH_4 + 2H_2O$
	$CH_3COO^- + H_2O \rightarrow CH_4 + HCO_3^-$
	$4CH_2NH_2 + 2H_2O + 4H^+ \rightarrow 3CH_4 + CO_2 + 4NH_4^+$
Methanogenic substances	$2(CH_3)_2NH + 2H_2O + 2H^+ \rightarrow 3CH_4 + CO_2 + 2NH_4 \quad 4(CH_3)_3N + 6H_2O + 4H^+ \rightarrow$
	$9CH_4 + 3CO_2 + 4NH_4 \quad 2CH_3CH_2-N(CH_3)_2 + 2H_2O \rightarrow 3CH_4 + CO_2 + 2CH_3CH_2NH_2$
	$4H_2 + HCO_3^- + H^+ \rightarrow CH_4 + 3H_2O$
	$4H_2 + 2HCO_3^- + H^+ \rightarrow acetate + 4H_2O$
Sulfate derivatives	$4H_2 + SO_4^{2-} \rightarrow HS^- + 3H_2O + OH^-$

the waste is incinerated first and only the remaining ash and non-combustible material are sent to a landfill. Increasingly, a proportion of the waste is being separated for recycling at some stage along the way.

Domestic waste could also provide feedstock for a number of other conversion systems, all of which could recover useful energy while reducing the requirement for landfill sites. However, whatever the energy technology, domestic waste is a low-grade fuel. Its consistency is variable and not well suited to mechanical handling systems; the proportions of the various constituents will vary from load to load; the moisture content and heating value will vary; and the proportion of non-combustible material will keep the heating value low. All of this can lead to inefficient combustion if the process is not well controlled, making it more difficult to control toxic emissions from plastics and other materials. There is also a potential conflict between the recycling of materials and the recovery of energy from those materials. The main benefit of domestic waste as a fuel source is that, as with most other waste streams, energy technology can reduce the waste disposal problem.

9.3.2 EFFECTS OF WASTE

Wastes generated from the domestic and industrial sources increase continuously with the rising population. In general, the lack of facilities for disposal of waste caused overall landfill sites resulting in hazards for the environment and public health. These effects include (i) air pollution, (ii) pollution of surface waters, (iii) changes in soil fertility, and (iv) changes in the landscape and visual discomfort. The historic approach to solid waste has been to bury it in a landfill. This is becoming increasingly problematic because the diminishing availability of suitable landfill sites and the increasingly stringent conditions being applied to landfill, mean that charges have increased and will continue to increase. Major problems associated with landfills are the leachate containing toxic heavy metals and the methane gas that is produced.

Indeed, the challenge for waste disposal arises from the joint storage of hazardous materials (including toxic sludge, oil products, dyeing residues, metallurgical slag) and solid domestic waste. This situation is likely to generate inflammable, explosive, or corrosive mixtures and combinations thereof. On the other hand, the presence of easily degradable household may facilitate the decomposition of complex hazardous components, and thus diminish environmental pollution.

Another negative aspect is the fact that several recyclable and useful materials are stored in the same place as materials that cannot be recycled; consequently, these materials blend together and become chemically and biologically contaminated, which renders their retrieval rather difficult.

Thus, the problems faced by waste management activities may be summarized as follows: (i) storage in open grounds is the most used method to remove waste ultimately, (ii) existing landfills may be located in sensitive places (which are those places in the close proximity to lodgings, surface or ground water, leisure areas), (iii) existing waste landfills may be improperly designed from an environmental protection point of view, thus allowing for water and soil pollution in those areas, (iv) currently waste landfills may require a review of waste handling practices insofar as waste layers are not compacted and there is no strict control of the quality and quantity of waste that is dumped on the landfill leading to the potential for fire and/or the emanation of unpleasant odors.

All of the above lead to the conclusion that specific measures need to be taken with regard to waste management, which would be adequate in each phase of the waste dumping process. Environmental monitoring activities should comprise the observance of these measures. However, one answer to these issues is to convert the waste to usable products either through (i) the production of gaseous fuels, or (ii) the production of liquid fuels, or (iii) the production of solid fuels. Such efforts may not only solve the depletion of fuels from fossil sources but also assist in the disposal of waste materials and the ensuing environmental issues. However, before entering the process descriptions for waste conversion, it is necessary to understand the composition of domestic and industrial waste.

Generating waste at current levels is incompatible with a sustainable future. While the problem of waste is serious, a variety of initiatives are being taken to address the various threats. These

include moves toward waste minimization, waste segregation and recycling, cleaner production with regular waste audits, green chemistry, renewable energy, and energy efficiency, and developing the concept of industrial ecosystems. The issues involved are much more than a technical problem.

This is a major issue because of the variability of industrial solid, liquid and gaseous wastes, and the capacity of modern processing industries to produce huge quantities of waste. Fortunately, regulatory processes are now such that the numerous disasters caused previously should not be repeated. However, there are remaining problem sites that constitute long-term hazards.

Thus, in order to reduce the amount of landfill, the amount of waste must be reduced. This involves either (i) cutting back on the use of many materials or (ii) the use of the waste by conversion to useful products. Either option would reduce the amount of waste sent to landfill sites. The first option certainly reduces the amount of landfill material but is often more difficult to achieve. However, the second option offers the attractive proposition of the production of fuel products. Thus, waste conversion becomes an attractive option to landfill disposal and the result is the generation of a usable product in the form of a gaseous, liquid, or solid fuel. However, the ancillary of the second option is the heterogeneity of waste material. In fact, it is obvious that many waste streams are not subject to direct processing and will require special measures in the form of specific pretreatment of the waste prior to processing.

One form of pretreatment is separation and recycling of waste components thereby removing a portion of the waste stream for recycling and other uses. The result of this separation at the source is the remaining residual waste (i.e., the waste stream from which recyclable materials have been removed) that is not destined for any use other than landfill is sent to the conversion reactor.

REFERENCES

Bajus, M. 2010. Pyrolysis Technologies for Biomass and Waste Treatment to Fuels and Chemical Production. *Pet. Coal* 52(1): 1–10.

Crocker, M., and Crofcheck, C. 2006. Reducing National Dependence on Imported Oil. *Energ.* 17(6). Center for Applied Energy Research, University of Kentucky, Lexington, Kentucky.

Demirbaş, A. 2008. Biofuels Sources, Biofuel Policy, Biofuel Economy and Global Biofuel Projections. *Energy Convers. Mgmt.* 49: 2106–2116.

Demirbaş, A. 2009. *Biofuels: Securing the Planets Future Energy Needs.* Springer Verlag, London, United Kingdom.

Dimian, A.C. 2015. Biorefinery: The Future of the Chemical Process Industries. *Bull. Rom. Chem. Soc.* 22(1): 15–44.

Galbe, M., and Zacchi, G. 2002. A Review of the Production of Ethanol from Softwood. *Appl. Microbiol. Biotechnol.* 59(6): 618–628.

Gary, J.H., Handwerk, G.E., and Kaiser, M.J. 2007. *Petroleum Refining: Technology and Economics*, 5th Edition. CRC Press, Taylor & Francis Group, Boca Raton, FL.

Giampietro, M., and Mayumi, K. 2009. *The Biofuel Delusion: The Fallacy of Large-Scale Agro-Biofuel Production.* Earthscan, Washington, DC.

Gibon, V., Ayala, J.V., Dijckmans, P., Maes, J., and De Greyt, W. 2009. OCL - Oilseeds and Fats, Crops and Lipids. 16(4): 193–200.

Hoogwijk, M., Faaij, A., Eickhout, B., de Vries, B., and Turkenburg, W. 2005. Potential of Biomass Energy Out to 2100, for Four IPCC SRES Land-Use Scenarios. *Biomass Bioenergy* 29: 225–257.

Hsu, C.S., and Robinson, P.R. (Editors). 2017. *Handbook of Petroleum Technology.* Springer International Publishing AG, Cham, Switzerland.

Hwang, B., and Obst, J.R. 2003. Basic Studies on the Pyrolysis of Lignin Compounds. *Proceedings of the IAWPS 2003 International Conference on Forest Products: Better Utilization of Wood for Human, Earth and Future.* The Korean Society of Wood Science and Technology, International Association of Wood Products Societies, Daejeon, Korea, April 21–24, Volume 2, Pages 1165–1170.

Islam, M.R., and Speight, J.G. 2016. *Peak Energy: Myth or Realty.* Scrivner Publishing, Beverly, MA.

Kavalov, B., and Peteves, S.D. 2005. *Status and Perspectives of Biomass-to-Liquid Fuels in the European Union.* European Commission, Directorate General Joint Research Centre (DG JRC), Institute for Energy, Petten, Netherlands.

Keller, F.A. 1996. Integrated Bioprocess Development for Bioethanol Production. *Handbook on Bioethanol: Production and Utilization*. C.E. Wyman (Editor). Taylor & Francis, Washington, DC, Pages 351–379.

Langeveld, H., Sanders, J., and Meeusen, M. (Editors). 2010. *The Biobased Economy*. Earthscan, Washington, DC.

Larson, E.D., and Kartha, S. 2000. Expanding Roles for Modernized Biomass Energy. *Energy Sustain. Develop.* 4: 15–25.

Lee, S. 1991. *Oil Shale Technology*. CRC Press, Taylor & Francis Group, Boca Raton, FL.

Lee, S. 1996. *Alternative Fuels*. CRC Press, Taylor & Francis Group, Boca Raton, FL.

Lorenzini, G., Biserni, C., and Flacco, G. 2010. *Solar, Thermal, and Biomass Energy*. WIT Press, Boston, MA.

Luque, R., and Speight, J.G. (Editors). 2015. *Gasification for Synthetic Fuel Production: Fundamentals, Processes, and Applications*. Woodhead Publishing, Elsevier, Cambridge, United Kingdom.

Nersesian, R.L. 2010. *Energy for the 21st Century: A Comprehensive Guide to Conventional and Alternative Energy Sources*. Earthscan, Washington, DC.

Parkash, S. 2003. *Refining Processes Handbook*. Gulf Professional Publishing, Elsevier, Amsterdam, Netherlands.

Ragland, K.W., Aerts, D.J., and Baker, A.J. 1991. Properties of Wood for Combustion Analysis. *Bioresour. Technol.* 37: 161–168.

Scouten, C.S. 1990. Oil Shale. *Fuel Science and Technology Handbook*. J.G. Speight (Editor). Marcel Dekker Inc., New York, Chapters 25–31, Pages 795–1053.

Speight, J.G. 2011a. *An Introduction to Petroleum Technology, Economics, and Politics*. Scrivener Publishing, Beverly, MA.

Speight, J.G. (Editor). 2011b. *The Biofuels Handbook*. The Royal Society of Chemistry, London, United Kingdom.

Speight, J.G. 2013. *The Chemistry and Technology of Coal*, 3rd Edition. CRC-Taylor and Francis Group, Boca Raton, FL.

Speight, J.G. 2014. *The Chemistry and Technology of Petroleum*, 5th Edition. CRC-Taylor and Francis Group, Boca Raton, FL.

Speight, J.G. 2017. *Handbook of Petroleum Refining*. CRC Press, Taylor & Francis Group, Boca Raton, FL.

Speight, J.G. 2019. *Handbook of Petrochemical Processes*. CRC Press, Taylor & Francis Group, Boca Raton, FL.

Speight, J.G. 2020a. *Synthetic Fuels Handbook: Properties, Processes, and Performance*, 2nd Edition. McGraw-Hill, New York.

Speight, J.G. 2020b. *Global Climate Change Demystified*. Scrivener Publishing, Beverly, MA.

Speight, J.G., and El-Gendy, N.S. 2018. *Introduction to Petroleum Biotechnology*. Gulf Professional Publishing Company, Elsevier, Cambridge, MA.

US DOE. 2004a. Strategic Significance of America's Oil Shale Reserves, I. Assessment of Strategic Issues, March. http://www.fe.doe.gov/programs/reserves/publications.

US DOE. 2004b. Strategic Significance of America's Oil Shale Reserves, II. Oil Shale Resources, Technology, and Economics, March. http://www.fe.doe.gov/programs/reserves/publications.

US DOE. 2004c. America's Oil Shale: A Roadmap for Federal Decision Making. USDOE Office of US Naval Petroleum and Oil Shale Reserves. http://www.fe.doe.gov/programs/reserves/publications.

Wright, L., Boundy, R., Perlack, R., Davis, S., and Saulsbury, B. 2006. Biomass Energy Data Book: Edition 1. Office of Planning, Budget and Analysis, Energy Efficiency and Renewable Energy, United States Department of Energy. Contract No. DE-AC05-00OR22725. Oak Ridge National Laboratory, Oak Ridge, TN.

10 Feedstock Integration in the Refinery

10.1 INTRODUCTION

To meet the challenges of the changing trends in current feedstocks into a refinery to changes in the feedstock composition and also to changes in the product slate, the refinery will adapt. Furthermore, the stringent distillation operations into increasing specifications imposed by environmental complex chemical operations involving legislation, the refining industry in the near future will become increasingly flexible and refined products with specifications that meet product specifications through innovative new processing schemes. This means a movement from conventional means of refining viscous feedstocks using (typically) coking technologies to more innovative processes (including hydrogen management) that will produce the ultimate amounts of liquid fuels from the feedstock and maintain emissions within environmental compliance (Penning, 2001; Davis and Patel, 2004; Speight, 2020a).

During the next 20–30 years, the evolving future of crude oil refining and the current refinery layout (Figure 10.1) will be primarily on process modification with some new innovations coming on-stream. The industry will move predictably on to (i) deep conversion of viscous feedstocks, (ii) higher hydrocracking and hydrotreating capacity, and (iii) more efficient processes. Thus, high-conversion refineries will move to gasification of feedstocks for the development of alternative fuels and to enhance equipment usage. A major trend in the refining industry market demand for refined products will be in synthesizing fuels from simple basic reactants (such as synthesis gas) when it becomes uneconomical to produce super clean transportation fuels through conventional refining processes. Fischer–Tropsch plants together with IGCC systems will be integrated with or even into refineries, which will offer the advantage of high-quality products (Stanislaus et al., 2000).

This chapter presents suggestions and opinions of the means by which refinery processes will evolve during the next three-to-five decades. Material relevant to (i) comparisons of current conventional feedstocks with viscous feedstocks and bio-feedstocks, (ii) the evolution of refineries since the 1950s, (iii) the properties and refinability of viscous feedstocks and bio-feedstocks, (iv) the choice between thermal processes and hydroprocesses, and (v) the evolution of products to match the environmental market, with more than passing consideration of the effects of feedstocks from coal and oil shale.

10.2 HISTORY

Refining technology has evolved considerably over the last century in response to changing requirements such as (i) demand for gasoline and diesel fuel as well as fuel oil, (ii) petrochemicals as building blocks for clothing and consumer goods, and (iii) more environmentally friendly processes and products. As a result of this response, the production facilities within the refining industry have become increasingly diverse – process configuration varies from plant to plant according to its size, complexity, and product slate. There are small refineries – 1,500 to 5,000 barrels per day (bpd) – and large refineries that process in excess of 250,000 bpd. Some are relatively simple (Chapters 1 and 2), and produce only fuels while other refineries, such as those with integrated petrochemical processing capabilities, are much more complex (Speight, 2014, 2017).

In the early days of the refinery operations, the processes were developed to extract kerosene for lamps. Any other products were considered to be unusable and were usually discarded. A brief

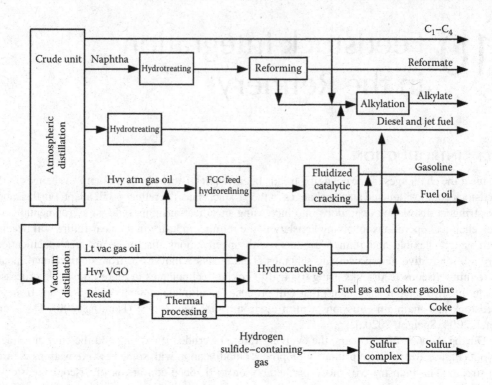

FIGURE 10.1 General layout of a modern refinery.

history of crude oil refining is presented in the following paragraphs. In 1861, the first crude oil refinery opened and produced kerosene – a better and cheaper source of light than whale oil – by atmospheric distillation; naphtha and *tar* (*residuum* or *cracked residuum*) produced as by-products. This involved simple batch distillation of crude oil with the objective of maximizing kerosene production. Technological advancements included, first, the introduction of continuous distillation and, then, vacuum distillation – developed in 1870 – which greatly facilitated the manufacturing of lubricants.

The 1890s saw the emergence of the internal combustion engine creating demand for diesel fuel and gasoline; demand for kerosene declines with the invention and proliferation of the electric light. Next, the quest for improved lubricants prompted the use of solvent extraction. To make better use of the bottom of the barrel, thermal cracking (in 1913) and visbreaking processes were introduced to crack viscous feedstocks to produce more-valuable lower boiling less viscous products. The development of thermal cracking – in response to increased demand for gasoline due to mass production manufacturing of automobiles and the outbreak of World War I. This enabled refineries to produce additional gasoline and distillate fuels by subjecting high-boiling crude oil fractions to high pressures and temperatures with the resulting production of lower boiling, lower molecular weight products.

Thus, first refining processes were developed to purify, stabilize, and improve the quality of kerosene. However, the invention of the internal combustion engine led (at about the time of World War I) to a demand for gasoline for use in increasing quantities as a motor fuel for cars and trucks. This demand on the lower boiling products increased, particularly when the market for aviation fuel developed. Thereafter, refining methods had to be constantly adapted and improved to meet the quality requirements and needs of fuels as well as a variety of other products.

During the 1930s, many advances were made to improve gasoline yield and properties as a response to the development of higher-compression engines. This involved the development of processes such as (i) catalytic cracking, thermal reforming, and catalytic polymerization to improve octane

number; (ii) hydroprocesses to remove sulfur; (iii) coking processes to produce gasoline blend stocks; (iv) solvent extraction processes to improve the viscosity index of lubricating oil, (v) and solvent dewaxing processes to improve the pour point of the various products. The by-products of these various processes included aromatics, waxes, residual fuel oil, coke, and feedstocks for the manufacturing of petrochemicals.

During the 1940s, the industry turned to catalysis for major innovations. Catalytic cracking constituted a step change in the refinery's ability to convert viscous components into highly valued gasoline and distillates. Wartime demand for aviation fuels helped spur development of catalytic alkylation processes (which produced blend stocks for high-octane aviation gasoline) and catalytic isomerization (which produced increased quantities of feedstocks for alkylation units) to create high octane fuels from lighter hydrocarbon derivatives. We redistributed hydrogen content among the refinery's products to improve their properties via catalytic reforming of gasoline, catalytic hydrodesulfurization of distillates, and hydrocracking of midrange streams. By the end of this period, almost every refining process was catalytically based; indeed, over 90% of the molecules in refinery products had passed over at least one catalyst.

The period in the 1950s–1970s saw the development of various reforming processes, which also produced blend stocks that were used to improve gasoline quality and yield. Other processes such as deasphalting, catalytic reforming, hydrodesulfurization, and hydrocracking, are examples of processes developed during this period. In this time period, refiners also started making further development in the uses of waste gases from various processes, resulting in the expansion of the petrochemical industry. In the latter part of the period, the industry benefitted from a massive infusion of computer-based quantitative methodology that has significantly improved our control over processes and the composition of products leading to various forms of (i) kinetic modeling, (ii) compositional modeling, reaction engineering, as well as automation and control.

Kinetic modeling allowed the quantitative simulation of commercially important, complex chemical reactions based on lumped descriptions of molecular reaction paths. On the other hand, compositional modeling related products to reactants through explicit reaction pathways on a molecular basis and allowed the quantitative prediction of composition and properties of product streams based on molecular composition.

Reaction engineering integrated the reaction and kinetic phenomena, including catalysis, with transport processes in the areas of reactor design, scale-up, and commercial operation. The complex mixtures of hydrocarbon derivatives that constitute most refinery-process feedstocks generally required lumping to handle the problem analytically and computationally. Furthermore, automation and control enabled the optimization of unit-operation and economic performance. It coupled automatic closed-loop control technology with on-line sensors and analyzers and dynamic process models. More recently, real-time rigorous economic optimization has been applied to determine optimal set points of dynamic process control to achieve even higher levels of operational optimization.

The refining industry has been the subject of the four major forces that affect most industries and which have hastened the development of new crude oil refining processes: (i) the high demand for products such as gasoline, diesel, fuel oil, and jet fuel; (ii) uncertain feedstock supply, specifically the changing quality of crude oil and geopolitics between different countries and the emergence of alternate feed supplies such as bitumen from tar sand, natural gas, and coal; (iii) recent environmental regulations that include more stringent regulations in relation to sulfur in gasoline and diesel; and (iv) continued technology development such as new catalysts and processes.

This chapter presents the needs and options for feedstock integration that are based on the following scenarios: (i) the need for acceptance of viscous feedstocks – such as heavy crude oil, extra-heavy crude oil, and tar sand bitumen – due to declining conventional crude production, (ii) the need for regional energy independence, (iii) the need for alternate feedstock for the production of petrochemicals due to shortages or unavailability of typical feedstock such a natural gas and crude oil-derived naphtha, (iv) the need to reassess the role of coal and oil shale as the source of liquids for fuel and petrochemicals production, and last but certainly not the least (v) the utilization

of renewable feedstocks – such as the various types of biomass as well as domestic waste and industrial waste that can replace fossil fuels as the source of transportation fuels, petrochemical, and power generation.

10.3 REFINERY CONFIGURATION

A crude oil refinery is an industrial processing plant that is a collection of integrated process units (Speight, 2014, 2017). The crude oil feedstock is typically a blend of two or more crude oils, often with viscous feedstocks blended in compatible amounts. With the depletion of known crude oil reserves, refining companies are having to seek crude oil in places other than the usual sources of supply.

Hydrocarbon-based energy is important and energy prices have had an important effect on economic performance because energy is used directly and indirectly in the production of all goods and services and a decrease in the rate of increase in energy availability will have serious economic impacts.

10.3.1 CRUDE OIL REFINERY

The definition of refinery feedstocks is often confusing and variable and has been made even confusing by the introduction of other terms that add little, if anything, to crude oil definitions and terminology (Speight, 2020a, 2014, 2017). In fact, there are different classification schemes based on (i) economic and/or (ii) geological criteria. For example, the economic definition of conventional oil is *"conventional oil is oil which can be produced with current technology under present economic conditions."* The problem with this definition is that it is not very precise, and changes whenever the economic or technological aspects of oil recovery change. In addition, there are other classifications based on API gravity such as "conventional oil is crude oil having a viscosity above 17° API." However, these definitions do not change the definition stated elsewhere (Chapter 1), which has been used throughout this book.

In recent years, the average quality of crude oil has deteriorated and continues to do so, as more heavy crude oil, extra-heavy crude oil, and tar sand bitumen are being sent to refineries (Speight, 2014, 2017, 2020a). This has caused the nature of crude oil refining to change considerably. Indeed, the declining reserves of lighter crude oil have resulted in an increasing need to develop options to desulfurize and upgrade the viscous feedstocks, specifically the viscous feedstocks. This has resulted in a variety of process options that specialize not only in sulfur removal during refining but also in maintaining the feedstock flow through the reactor (Chapter 8).

In addition, the general trend throughout refining has been to produce more products from each barrel of crude oil and to process those products in different ways to meet the product specifications for use in modern engines. Overall, the demand for gasoline has rapidly expanded and the demand has also developed for gas oils and fuels for domestic central heating, and fuel oil for power generation, as well as for light distillates and other inputs, derived from crude oil, for the petrochemical industries.

As the need for the lower boiling products developed, crude oil yielding the desired quantities of the lower boiling products became less available and refineries had to introduce conversion processes to produce greater quantities of lighter products from the higher boiling fractions. The means by which a refinery operates in terms of producing the relevant products depends not only on the nature of the crude oil feedstock but also on its configuration (i.e., the number of types of the processes that are employed to produce the desired product slate) and the refinery configuration is, therefore, influenced by the specific demands of a market.

Therefore, refineries need to be constantly adapted and upgraded to remain viable and responsive to ever-changing patterns of crude supply and product market demands. As a result, refineries have been introducing increasingly complex and expensive processes to gain higher yields of lower boiling products from the higher boiling fractions and residua.

Finally, the yields and quality of refined crude oil products produced by any given oil refinery depend on the mixture of crude oil used as feedstock and the configuration of the refinery facilities. Light/sweet crude oil is generally more expensive and has inherent great yields of higher value low boiling products such as naphtha, gasoline, jet fuel, kerosene, and diesel fuel. Viscous sour (high sulfur) feedstocks are generally less expensive and produce greater yields of lower value higher boiling products that must be converted into lower boiling products.

The configuration of refineries may vary from refinery to refinery. Some refineries may be more oriented toward the production of gasoline (large reforming and/or catalytic cracking), whereas the configuration of other refineries may be more oriented toward the production of middle distillates such as jet fuel, and gas oil.

Crude oil refining has grown increasingly complex in the last 20 years. Lower-quality crude oil, crude oil price volatility, and environmental regulations that require cleaner manufacturing processes and higher-performance products present new challenges to the refining industry. Improving processes and increasing the efficiency of energy use are key to meeting the challenges and maintaining the viability of the crude oil refining industry. There is also the need for a refinery to be able to accommodate opportunity crude oils and/or high acid crude oils (Chapter 1).

Opportunity crude oils are often dirty and need cleaning before refining by the removal of undesirable constituents such as high-sulfur, high-nitrogen, and high-aromatics (such as polynuclear aromatic) components. A controlled visbreaking treatment would *clean up* such crude oils by removing these undesirable constituents (which, if not removed, would cause problems further down the refinery sequence) as coke or sediment.

On the other hand, high-acid crude oils cause corrosion in the atmospheric and vacuum distillation units. In addition, overhead corrosion is caused by the mineral salts, magnesium, calcium, and sodium chloride which are hydrolyzed to produce volatile hydrochloric acid, causing a highly corrosive condition in the overhead exchangers. Therefore these salts present a significant contamination in opportunity crude oils. Other contaminants in opportunity crude oils which are shown to accelerate the hydrolysis reactions are inorganic clays and organic acids.

In addition to taking preventative measures for the refinery to process these high-margin crude oils without serious deleterious effects on the equipment, refiners will need to develop programs for detailed and immediate feedstock evaluation so that they can understand the qualities of crude oil very quickly and it can be valued appropriately. There is also the need to assess the potential impact of contaminants, like metals or acidity, in crudes so that the feedstock can be correctly valued and the management of the crude processing can be planned.

Changes in the characteristics of conventional crude oil can be exogenously specified and will trigger changes in refinery configurations and corresponding investments. The future crude slate is expected to consist of larger fractions of both heavier, sourer crudes, and extra-light inputs, such as NGLs. There will also be a shift toward bitumen, such as the Venezuelan extra-heavy crude oil and the bitumen from the Canadian tar sands. These changes will require investment in upgrading, either at field level to process difficult-to-transport heavy crude oil, extra-heavy crude oil, tar sand bitumen, coal liquids, shale oil into synthetic crude oil shale either at a field site or at a remote refinery (Speight, 2014, 2017, 2020a).

There are four ways that are currently practiced in bringing viscous feedstocks to the market (Hedrick et al., 2006). The first method is to upgrade the material in the oil field and leave much of the material behind as coke, and then pipeline the upgraded material out as synthetic crude. In this method, the crude is fractionated and the residue is coked. The products of the coking operation, and in some cases some of the residue, are hydrotreated. The hydrotreated materials are recombined with the fractionated light materials to form synthetic crude that is then transported to the market in a pipeline. A portion of the crude may or may not be bypassed around the processing units. There are several examples of this type of processing in the current tar sand operations in the Fort McMurray area of Alberta, Canada (Speight, 2014, 2020a). This option is made attractive by the (current) presence of abundant natural gas in the area as well a local electrical power source. The

current operations leave the coke produced by the various operators as back fill into the open pit mines producing the tar sands.

A second solution is to build upgrading facilities at an established port area with abundant gas and electric resources. The upgrading facility fractionates the vacuum gas oil and lower boiling products. The liquid products from the coking operation are then hydrotreated and mixed back with the virgin materials. The virgin atmospheric gas oil and the vacuum gas oil may also be hydrotreated in the complex depending on the availability of natural gas and economic considerations. A pipeline from the complex to the oil field transports cutter stock to the oil field in sufficient quantity to produce pipeline acceptable crude. There are several examples of this kind of facility located in Venezuela that enables the production of extra-heavy crude oil from the Orinoco River Basin.

The third solution in common practice is to use traditional crude which is located in the general area to dilute the non-traditional crude to produce an acceptable pipeline material. This option is a great solution but has a number of limitations. For example, the amount of non-traditional crude production could be limited by the amount of traditional crude available for dilution. Another problem is compatibility. The two crudes may have limited compatibility which would limit the amount of dilution and again could limit the amount of non-traditional crude produced.

The final solution is closely related to the established port area solution where a substantial oil field is located far from other fields, power, or natural gas. This solution includes building a reverse pipeline from a refinery to the oil field as well as a crude pipeline. This can be a solution for high-quality waxy crude as well as heavier crude oil.

A change in energy resources requires a very substantial increase in upgrading capacity. Where this upgrading capacity will be built is likely to be strongly influenced by greenhouse gas policy. In fact, the crude oil and petrochemical industries are coming under increasing pressure not only to compete effectively with global competitors utilizing more advantaged hydrocarbon feedstocks but also to ensure that their processes and products comply with increasingly stringent environmental legislation.

Finally, a word about the crude oil from tight (low-to-no permeability) formations of which the crude oil from the Bakken formation is an example (Speight, 2020c). The Bakken crude oil is a light sweet highly volatile crude oil with an API gravity on the order of 40° API–43° API and sulfur content on the order of 0.2% w/w, or less. The relatively high quality of Bakken crude oil is an advantage insofar as these properties make the oil easier to refine into commercial products but is also a disadvantage insofar as unless the oil is stabilized by removal of the light ends (low-boiling hydrocarbon gases); it is highly flammable when compared to many conventional crude oils. The *flash point* – the lowest temperature at which ignition can occur – is lower for Bakken crude oil than it is for many conventional crude oils, which should be (must be) interpreted as the Bakken crude oil is particularly flammable (in fact, it is highly flammable) and, moreover, when flammable gases (methane and the low-boiling hydrocarbon derivatives) are dissolved in oil, the oil should be stabilized (*degasified*) before transportation.

10.3.2 BIOREFINERY

The use of fossil resources at current rates will have serious and irreversible consequences for the global climate. Whatever the rationale and however the numbers are manipulated, the supply of crude oil and the basic feedstock for refineries and for the petrochemicals industry is finite and its dominant position will become unsustainable as supply/demand issues erode its economic advantage over other alternative feedstocks. This situation will be mitigated to some extent by the exploitation of more technically challenging fossil resources and the introduction of new technologies for fuels and chemicals production from coal and oil shale. Moreover, worldwide economic expansion is rapidly driving demand for energy. Petrochemicals and fuels derived from biological sources have the potential to not only support the growing needs but also address increasing concerns about greenhouse gas emissions.

Consequently, there is a renewed interest in the utilization of plant-based matter (biomass) as a raw material feedstock for the chemicals industry (Marcilly, 2003; Lynd et al., 2005; Huber and Corma, 2007; Lynd et al., 2009). Plants accumulate carbon from the atmosphere via photosynthesis and the widespread utilization of these materials as basic inputs into the generation of power, fuels, and chemicals is a viable route to reduce greenhouse gas emissions.

Biomass is a renewable energy source, unlike fossil fuel resources (crude oil, coal, and natural gas). *Biofuel* is any fuel that is derived from biomass, i.e., recently living organisms or their metabolic by-products. *Biofuel* has also been defined as any fuel with an 80% minimum content by volume of materials derived from living organisms harvested within the 10 years preceding its manufacture. One advantage of fuel from biomass (biofuel), in comparison to most other fuel types, is it is biodegradable, and thus relatively harmless to the environment if spilled. However, in order to meet U.S. biofuel objectives over the coming decade the conversion of a broad range of biomass feedstocks, using diverse processing options, will be required. Further, the production of both gasoline and diesel biofuels will employ biomass conversion methods that produce wide boiling range intermediate oils requiring treatment similar to conventional refining processes (i.e. fluid catalytic cracking, hydrocracking, and hydrotreating). As such, it is widely recognized that leveraging existing U.S. petroleum refining infrastructure is key to reducing overall capital demands (Freeman et al., 2013).

The production of fuel chemicals from renewable plant-based feedstocks utilizing state-of-the-art conversion technologies presents an opportunity to maintain competitive advantage and contribute to the attainment of national environmental targets. Bioprocessing routes have a number of compelling advantages over conventional petrochemicals production. However, it is only in the last decade that rapid progress in biotechnology has facilitated the commercialization of a number of plant-based chemical processes.

Plants offer a unique and diverse feedstock for chemicals. Plant biomass can be gasified to produce synthesis gas; a basic chemical feedstock and also a source of hydrogen for a future hydrogen economy (Speight, 2020b). In addition, the specific components of plants such as carbohydrates, vegetable oils, plant fiber, and complex organic molecules known as primary and secondary metabolites can be utilized to produce a range of valuable monomers, chemical intermediates, pharmaceuticals, and materials. More generally, biomass feedstocks are recognized by the specific plant content of the feedstock or the manner in which the feedstock is produced (Speight, 2020a).

For example, *primary biomass feedstocks* that are currently being used for bioenergy include grains and oilseed crops used for transportation fuel production, plus some crop residues (such as orchard trimmings and nut hulls) and some residues from logging and forest operations that are currently used for heat and power production. In the future, it is anticipated that a larger proportion of the residues inherently generated from the food crop harvesting, as well as a larger proportion of the residues generated from ongoing logging and forest operations, will be used for bioenergy.

Secondary biomass feedstocks differ from primary biomass feedstocks in that the secondary feedstocks are a by-product of the processing of the primary feedstocks. Specific examples of secondary biomass include sawdust from sawmills, black liquor (which is a by-product of paper making), and cheese whey (which is a by-product of cheese making processes). Vegetable oils used for biodiesel that is derived directly from the processing of oilseeds for various uses are also a secondary biomass resource.

Tertiary biomass feedstock includes fats, greases, oils, construction and demolition wood debris, other waste wood from the urban environments, as well as packaging wastes, municipal solid wastes, and landfill gases. A category *other wood waste from the urban environment* includes trimmings from urban trees.

The simplest, cheapest, and most common method of obtaining energy from biomass is direct combustion. Any organic material, with a water content low enough to allow for sustained combustion, can be burned to produce energy. The heat of combustion can be used to provide space or process heat, water heating, or through the use of a steam turbine, electricity. In the developing world, many types of biomass such as dung and agricultural wastes are burned for cooking and heating.

In fact, result in some form of organic residue after their primary use has been fulfilled. These organic residues can be used for energy production through direct combustion or biochemical conversion. Most crop residues are returned to the soil, and the humus resulting from their decomposition helps maintain soil nutrients, soil porosity, water infiltration, and storage, as well as reducing soil erosion. Crop residues typically contain 40% of Nitrogen (N), 80% of potassium (K), and 10% of phosphorous (P) applied to the soil in the form of fertilizer. If these residues are subjected to direct combustion for energy, only a small percentage of the nutrients is left in the ash. Similarly, soil erosion will increase.

A biorefinery is a facility that integrates biomass conversion processes and equipment to produce fuels, power, and chemicals from biomass. The biorefinery concept is analogous to the crude oil refinery, which produces multiple fuels and products from crude oil (Speight, 2014, 2017).

In addition to applying bio-methods to crude oil itself such as the (i) the denitrogenation of fuels, (ii) removal of heavy metals, and (iii) transformation of viscous feedstock into lower boiling less viscous products (Le Borgne and Quintero, 2003; Bhatia and Sharma, 2006), biorefining offers a key method to accessing the integrated production of chemicals, materials, and fuels. Although the biorefinery concept is analogous to that of an oil refinery, there are significant differences – particularly in the character and properties of the respective feedstocks.

While the primary function of a biorefinery is to make biofuels, refiners are looking at the various types of biomass and the by-products of biofuel production and asking what they can do with them. In the place of intermediate hydrocarbon derivatives, the building blocks at their disposal are a plant's sugars, starches, fats, and proteins. Some chemicals will be synthesized using enzymes or genetically engineered microorganisms, and some will be produced using the inorganic catalysts used in traditional chemical processes.

The biomass could be supplied by anything from corn, sugar cane, grasses, wood, and soybeans to algae. The relatively modest biomass required to meet this demand means that corn or other food crops could be used without creating the competition for food that has arisen over corn-based ethanol fuel in the US. Shanks says "You can actually talk about bringing biomass-derived chemicals online without perturbing food supplies."

In a manner similar to the crude oil refinery, a biorefinery would integrate a variety of conversion processes to produce multiple product streams such as motor fuels and other chemicals from biomass. In short, a biorefinery would combine the essential technologies to transform biological raw materials into a range of industrially useful intermediates. However, the type of biorefinery would have to be differentiated by the character of the feedstock. For example, the *crop biorefinery* would use raw materials such as cereals or maize and the *lignocellulose biorefinery* would use raw material with high cellulose content, such as straw, wood, and paper waste.

In addition, a variety of techniques can be employed to obtain different product portfolios of bulk chemicals, fuels, and materials). Biotechnology-based conversion processes can be used to ferment the biomass carbohydrate content into sugars that can then be further processed. An alternative is to employ thermochemical conversion processes that use pyrolysis or gasification of biomass to produce a hydrogen-rich synthesis gas which can be used in a wide range of chemical processes (Speight, 2020a,b).

A biorefinery using lignin as a feedstock would produce a range of valuable organic chemicals and liquid fuels that, at the present time, could supplement or even replace equivalent or identical products currently obtained from natural gas, crude oil, coal, or oil shale as well as gases from product production processes. By producing multiple products, a biorefinery can take advantage of the differences in biomass components and intermediates and maximizes the value derived from the biomass feedstock. A biorefinery might, for example, produce one or several low-volume, but high-value, chemical products, and a low-value, but high-volume liquid transportation fuel, while generating electricity and process heat for its own use and perhaps enough for the sale of electricity. The high-value products enhance profitability; the high-volume fuel helps meet national energy needs; and the power production reduces costs and avoids greenhouse-gas emissions.

As a feedstock, biomass can be converted by thermal or biological routes to a wide range of useful forms of energy including process heat, steam, electricity, as well as liquid fuels, chemicals, and synthesis gas (Speight, 2020b). As a raw material, biomass is a nearly universal feedstock due to its versatility, domestic availability, and renewable character but there are limitations. For example, the energy density of biomass is low compared to that of coal, liquid crude oil, or crude oil-derived fuels. The heat content of biomass, on a dry basis (7,000–9,000 Btu/lb), is at best comparable with that of low-rank coal or lignite, and substantially (50%–100%) lower than that of anthracite, most bituminous coals, and crude oil. Most biomass, as received, has a high burden of physically adsorbed moisture, up to 50% by weight and, without substantial drying, the energy content of a biomass feed per unit mass is even less. These inherent characteristics and limitations of biomass feedstocks have focused on the development of efficient methods of chemically transforming and upgrading biomass feedstocks in a refinery. The refinery would be based on two platforms to promote different product slates.

Although a number of new bioprocesses have been commercialized it is clear that economic and technical barriers still exist before the full potential of this area can be realized. One concept gaining considerable momentum is the biorefinery which could significantly reduce production costs of plant-based chemicals and facilitate their substitution into existing markets.

By analogy with crude oil, every element of the plant feedstock will be utilized including the low-value lignin components. However, the different compositional nature of the biomass feedstock, compared to crude oil, will require the application of a wider variety of processing tools in the biorefinery. Processing of the individual components will utilize conventional thermochemical operations and state-of-the-art bioprocessing techniques. The production of biofuels in the biorefinery complex will service existing high-volume markets, providing economy-of-scale benefits and large volumes of by-product streams at minimal cost for upgrading to valuable chemicals.

The construction of both large biofuel and renewable chemical production facilities coupled with the pace at which bioscience is being both developed and applied demonstrates that the utilization of non-food crops will become more significant in the near term. The biorefinery concept provides a means to significantly reduce production costs such that a substantial substitution of petrochemicals by renewable chemicals becomes possible. However, significant technical challenges remain before the biorefinery concept can be realized.

10.3.3 COAL LIQUIDS REFINERY

Refinery feedstocks from coal (*coal liquids*) have not been dealt with elsewhere in this text but descriptions are available from other sources (Speight, 2013).

The Bergius process was one of the early processes for the production of liquid fuels from coal. In the process, lignite or sub-bituminous coal is finely ground and mixed with viscous product oil recycled from the process. The catalyst is typically added to the mixture and the mixture is pumped into a reactor. The reaction occurs at between 400°C–500°C and 20–70 MPa hydrogen pressure. The reaction produces gas, naphtha, middle distillate oil, and high boiling oil:

$$nC_{coal} + (n+1)H_2 \rightarrow C_nH_{(2n+2)}$$

A number of catalysts have been developed over the years, including catalysts containing tungsten, molybdenum, tin, or nickel.

The different fractions can be sent to a refinery for further processing to yield synthetic fuel or a fuel blending stock of the desired quality. It has been reported that as much as 97% of the coal carbon can be converted to synthetic fuel but this very much depends on the coal type, the reactor configuration, and the process parameters.

Liquid products from coal are generally different from those produced by crude oil refining, particularly as they can contain substantial amounts of phenols. Therefore, there will always be some

questions about the place of coal liquids in refining operations. For this reason, there have been some investigations of the characterization and *next-step* processing of coal liquids.

The composition of coal liquids produced from coal depends very much on the character of the coal and on the process conditions and, particularly, on the degree of *hydrogen addition* to the coal. In fact, current concepts for refining the products of coal liquefaction processes have relied, for the most part, on already-existing crude oil refineries, although it must be recognized that the acidity (i.e. phenol content) of the coal liquids and the potential incompatibility of the coal-based liquids with conventional crude oil (including heavy crude oil) may pose new issues within the refinery system (Speight, 2013, 2014).

The other category of coal liquefaction processes invokes the concept of the indirect liquefaction of coal. In these processes, the coal is not converted directly into liquid products but involves a two-stage conversion operation in which coal is first converted (by reaction with steam and oxygen) to produce a gaseous mixture that is composed primarily of carbon monoxide and hydrogen (syngas; synthesis gas). The gas stream is subsequently purified (to remove sulfur, nitrogen, and any particulate matter) after which it is catalytically converted to a mixture of liquid hydrocarbon products.

The synthesis of hydrocarbon derivatives from carbon monoxide and hydrogen (synthesis gas) (the Fischer–Tropsch synthesis) is a procedure for the indirect liquefaction of coal (Speight, 2013, 2020a). Thus, coal is converted to gaseous products at temperatures in excess of 800°C (1,470°F), and at moderate pressures, to produce synthesis gas (Speight, 2013, 2020b):

$$[C]_{coal} + H_2O \rightarrow CO + H_2$$

The gasification may be attained by means of any one of several processes or even by gasification of coal in place (underground, or in situ, gasification of coal).

In practice, the Fischer–Tropsch reaction is carried out at temperatures of 200°C–350°C (390°F–660°F) and at pressures of 75–4,000 psi (0.5–4.1 MPa). The hydrogen/carbon monoxide ratio is usually 2.2:1 or 2.5:1. Since up to three volumes of hydrogen may be required to achieve the next stage of the liquids production, the synthesis gas must then be converted by means of the water-gas shift reaction) to the desired level of hydrogen:

$$CO + H_2O \rightarrow CO_2 + H_2$$

After this, the gaseous mix is purified and converted to a wide variety of hydrocarbon derivatives:

$$nCO + (2n + 1)H_2 \rightarrow C_nH_{2n+2} + nH_2O$$

These reactions result primarily in low- and medium-boiling aliphatic compounds suitable for gasoline and diesel fuel. Synthesis gas can also be converted to methanol, which can be used as a fuel, fuel additive, or further processed into gasoline via the Mobil M-gas process. In terms of liquids from coal that can be integrated into a refinery, this represents the most attractive option and does not threaten to bring on incompatibility problems as can occur when phenols are present in the coal liquids.

A major challenge for refining coal is related to air pollution issues and mining hazards, but the conversion of coal to liquids is not likely to be abandoned because of: (i) abundance, (ii) low, relatively non-volatile prices, (iii) gasification can be the key to environmental acceptance, and (iv) synthetic fuels from carbonaceous feedstocks *via gasification* can be cleaner than crude oil-derived hydrocarbon fuels derived from crude oil. While such a scheme is not meant to replace other fuel-production systems, it would certainly be a fit into a conventional refinery – gasification is used in many refineries to produce hydrogen and a gasification unit is part of the flexicoking process (Speight, 2014, 2017).

Methanol, which can be produced by the Fischer–Tropsch process, also offers a noteworthy option. The methanol-to-olefins process is an efficient producer of ethylene and propylene from

natural gas, coal, or other sources of synthesis gas/methanol source (Speight, 2019). Where conventional petrochemical feedstocks are unavailable, coal, biomass, and waste (domestic and industrial) or other carbonaceous residues can be a stable-supply, low-cost feed for economic light olefin production. Associated polymerization facilities allow the production of the highest value, easily transportable polymer products.

10.3.4 SHALE OIL REFINERY

The processes for producing liquids (*shale oil*) from oil shale involve heating (retorting) the shale to convert the organic kerogen to raw shale oil. There are two basic oil shale retorting approaches (i) mining followed by retorting at the surface, and (ii) in situ retorting, i.e. heating the shale in place underground (Speight, 2020a). Retorting essentially involves destructive distillation (*pyrolysis*) of oil shale in the absence of oxygen. Pyrolysis (temperatures above 900°F) thermally breaks down (*cracks*) the kerogen to release the hydrocarbon derivatives and then cracks the hydrocarbon derivatives into lower-weight hydrocarbon molecules. Conventional refining uses a similar thermal cracking process, termed *coking*, to break down high-molecular-weight constituents of heavy crude oil, extra-heavy crude oil, tar sand bitumen, crude oil residua.

Shale oil does contain a large variety of hydrocarbon compounds and has high nitrogen content compared to a nitrogen content of 0.2–0.3 wt% for a typical crude oil. In addition, shale oil also has a high olefin and diolefin content (Speight, 2020a). It is the presence of these olefins and diolefins, in conjunction with high nitrogen content that gives shale oil the characteristic difficulty in refining and the tendency to form insoluble sediment. Crude shale oil also contains appreciable amounts of arsenic, iron, and nickel that interfere with refining.

Upgrading, or partial refining, to improve the properties of crude shale oil may be carried out using different options – depending upon the composition and the origin of the shale oil (Scouten, 1990; Speight, 2020a). Hydrotreating is the option of choice to produce a stable product (Speight, 2014, 2017). In terms of refining and catalyst activity, the nitrogen content of shale oil is a disadvantage and, if not removed, the arsenic and iron in shale oil will poison and foul the supported catalysts used in hydrotreating. In terms of the use of shale oil residua as a modifier for asphalt, where nitrogen species can enhance binding with the inorganic aggregate, the nitrogen content is beneficial.

Naphtha from shale oil usually contains a high percentage of aromatic and naphthenic compounds that are not affected by the various treatment processes. The olefin content, although reduced in most cases by refining processes, will still remain significant. Diolefins and the higher unsaturated constituents will have to be removed from the gasoline product by appropriate treatment processes. The same will apply to the nitrogen- and sulfur-containing constituents.

Catalytic hydrodesulfurization processes are not a good solution for the removal of sulfur constituents from gasoline when high proportions of unsaturated constituents are present. A significant amount of the hydrogen would be used for hydrogenation of the unsaturated components. However, when hydrogenation of the unsaturated hydrocarbon derivatives is desirable, catalytic hydrogenation processes would be effective.

Thus, shale oil is different from conventional crude oils, and several refining technologies have been developed to deal with this. The primary problems identified in the past were related to the presence of arsenic, nitrogen-containing constituents, and the waxy nature of the crude. Nitrogen and wax problems have been resolved using hydroprocessing approaches, essentially classical hydrocracking and the production of high-quality lube stocks, which require that waxy materials be removed or isomerized. However, the arsenic problem remains.

In general, oil-shale distillates have a much higher concentration of high boiling point compounds that would favor the production of middle-distillates (such as diesel and jet fuels) rather than naphtha. Oil-shale distillates also had a higher content of olefins, oxygen, and nitrogen than crude oil, as well as higher pour points and viscosities. Above-ground retorting processes tended to yield a lower API gravity oil than the in situ processes (a 25° API gravity was the highest produced).

Additional processing equivalent to hydrocracking would be required to convert oil-shale distillates to a lighter range hydrocarbon (gasoline). Removal of sulfur and nitrogen would, however, require hydrotreating.

A preferred way of treating the shale oil involves using a moving bed reactor followed by a fractionation step to divide the wide-boiling-range crude oil produced from the shale oil into two separate fractions. The lighter fraction is hydrotreated for the removal of residual metals, sulfur, and nitrogen, whereas the heavier fraction is cracked in a second fixed bed reactor normally operated under high-severity conditions.

Arsenic removed from the oil by hydrotreating remains on the catalyst, generating a material that is a carcinogen, an acute poison, and a chronic poison. The catalyst must be removed and replaced when its capacity to hold arsenic is reached.

10.3.5 Gasification Refinery

As the supplies of fossil fuel feedstocks decrease or as environmental legislation makes the fossil fuel feedstocks completely undesirable/unacceptable (and this can become a reality!), the desirability of producing gas from other carbonaceous feedstocks will increase, especially in those areas where natural gas is in short supply. It is also anticipated that the costs of natural gas will increase, allowing coal gasification to compete as an economically viable process. Research in progress on a laboratory and pilot-plant scale should lead to the invention of new process technology by the end of the century, thus accelerating the industrial use of coal gasification.

The most likely option for the integration of alternate feedstock into the refinery is the installation of an on-site gasifier. Thus, such a refinery (often referred to as a gasification refinery) would have, as the center piece, gasification technology as is the case of the Sasol refinery in South Africa (Couvaras, 1997). The refinery would produce synthesis gas (from the carbonaceous feedstock) from which liquid fuels would be manufactured using the Fischer–Tropsch synthesis technology.

Synthesis gas (syngas) is the name given to a gas mixture that contains varying amounts of carbon monoxide and hydrogen generated by the gasification of a carbon-containing fuel to a gaseous product with a heating value. Examples include the gasification of coal or crude oil residua (Speight, 2013, 2014, 2020a). Synthesis gas is used as a source of hydrogen or as an intermediate in producing hydrocarbon derivatives via the Fischer–Tropsch synthesis (Speight, 2019, 2020b).

In fact, gasification to produce synthesis gas can proceed from any carbonaceous material, including biomass. Inorganic components of the feedstock, such as metals and minerals, are trapped in an inert and environmentally safe form as char, which may have used as a fertilizer. Biomass gasification is therefore one of the most technically and economically convincing energy possibilities for a potentially carbon-neutral economy.

The manufacturing of gas mixtures of carbon monoxide and hydrogen has been an important part of chemical technology for about a century. Originally, such mixtures were obtained by the reaction of steam with incandescent coke and were known as *water gas*. Eventually, steam reforming processes, in which steam is reacted with natural gas (methane) or crude oil naphtha over a nickel catalyst, found wide application for the production of synthesis gas.

A modified version of steam reforming known as autothermal reforming, which is a combination of partial oxidation near the reactor inlet with conventional steam reforming further along the reactor, improves the overall reactor efficiency and increases the flexibility of the process. Partial oxidation processes using oxygen instead of steam also found a wide application for synthesis gas manufacturing, with the special feature that they could utilize low-value feedstocks such as crude oil residua. In recent years, catalytic partial oxidation employing very short reaction times (milliseconds) at high temperatures (850°C–1,000°C) is providing still another approach to synthesis gas manufacturing (Speight, 2020b).

In a gasifier, the carbonaceous material undergoes several different processes: (i) pyrolysis of carbonaceous fuels, (ii) combustion, and (iii) gasification of the remaining char. The process is very

dependent on the properties of the carbonaceous material and determines the structure and composition of the char, which will then undergo gasification reactions. The conversion of the gaseous products of gasification processes to synthesis gas, a mixture of hydrogen (H_2) and carbon monoxide (CO), in a ratio appropriate to the application, needs additional steps after purification. The product gases – carbon monoxide, carbon dioxide, hydrogen, methane, and nitrogen – can be used as fuels or as raw materials for the manufacturing of chemical or fertilizer.

Thus, in terms of the adaptability of the gasification refinery to a variety of carbonaceous feedstocks, the gasification refinery could well be the refinery of the future. The typical gasification system incorporated into the refinery consists of several process plants including (i) feedstock preparation, (ii) the gasifier, (iii) an air separation unit, (iv) the synthesis gas cleanup train, (v) the sulfur recovery unit, and (vi) a series of downstream process options depending on the desired products. In fact, the gasification of carbonaceous feedstock can provide high purity hydrogen for a variety of uses within the refinery (Speight, 2014, 2017). Hydrogen is used in the refinery to remove sulfur, nitrogen, and other impurities from intermediate to finished product streams and in hydrocracking operations for the conversion of high-boiling distillates into low-boiling products, such as naphtha, kerosene, and atmospheric gas oil. Hydrocracking and severe hydrotreating require hydrogen which is at least 99% v/v pure, while less severe hydrotreating can use 90% v/v pure hydrogen and above and a current refinery typically requires continuous hydrogen availability (Speight, 2014, 2017).

10.3.5.1 Gasifiers

A gasifier differs from a combustor in that the amount of air or oxygen available inside the gasifier is carefully controlled so that only a relatively small portion of the fuel burns completely. The *partial oxidation* process provides the heat and rather than combustion, most of the carbon-containing feedstock is chemically broken apart by the heat and pressure applied in the gasifier resulting in the chemical reactions that produce synthesis gas. However, the composition of the synthesis gas will vary because of dependence upon the conditions in the gasifier and the type of feedstock.

Minerals in the fuel (i.e., the rocks, dirt, and other impurities which do not gasify) separate and leave the bottom of the gasifier either as an inert glass-like slag or other marketable solid products. Four types of gasifiers are currently available for commercial use: (i) the counter-current fixed bed, (ii) co-current fixed bed, (iii) the fluidized bed, and (iv) the entrained flow (Speight, 2013, 2020a).

The counter-current fixed bed (up draft) gasifier consists of a fixed bed of carbonaceous fuel (e.g. coal or biomass) through which the gasification agent (steam, oxygen, and/or air) flows in counter-current configuration. The ash is either removed dry or as a slag. The nature of the gasifier means that the fuel must have high mechanical strength and must be non-caking so that it will form a permeable bed, although recent developments have reduced these restrictions to some extent. The throughput for this type of gasifier is relatively low. Thermal efficiency is high as the gas exit temperatures are relatively low and, as a result, tar and methane production is significant at typical operation temperatures, so product gas must be extensively cleaned before use or recycled to the reactor.

The co-current fixed bed (down draft) gasifier is similar to the counter-current type, but the gasification agent gas flows in co-current configuration with the fuel (downwards, hence the name down draft gasifier). Heat needs to be added to the upper part of the bed, either by combusting small amounts of the fuel or from external heat sources. The produced gas leaves the gasifier at a high temperature, and most of this heat is often transferred to the gasification agent added to the top of the bed. Since all tars must pass through a hot bed of char in this configuration, the tar levels are much lower than the counter-current type.

In the fluidized bed gasifier, the fuel is fluidized in oxygen (or air) and steam. The temperatures are relatively low in dry ash gasifiers, so the fuel must be highly reactive; low-grade coals are particularly suitable. The agglomerating gasifiers have slightly higher temperatures and are suitable for higher rank coals. Fuel throughput is higher than for the fixed bed but not as high as for the entrained flow gasifier. The conversion efficiency is typically low, so recycle or subsequent combustion of solids is necessary to increase conversion. Fluidized bed gasifiers are most useful for fuels

that form highly corrosive ash that would damage the walls of slagging gasifiers. The ash is removed dry or as an agglomerated inorganic material – a disadvantage of biomass feedstocks is that they generally contain high levels of corrosive ash.

In the entrained flow gasifier, a dry pulverized solid, an atomized liquid fuel, or a fuel slurry is gasified with oxygen (much less frequent: air) in co-current flow. The high temperatures and pressures also mean that higher throughput can be achieved but thermal efficiency is somewhat lower as the gas must be cooled before it can be sent to a gas processing facility. All entrained flow gasifiers remove the major part of the ash as a slag as the operating temperature is well above the ash fusion temperature. Biomass can form a slag that is corrosive for ceramic inner walls that serve to protect the gasifier's outer wall.

In integrated gasification combined-cycle (IGCC) systems, the synthesis gas is cleaned of its hydrogen sulfide, ammonia, and particulate matter and is burned as fuel in a combustion turbine (much like natural gas is burned in a turbine). The combustion turbine drives an electric generator. Hot air from the combustion turbine can be channeled back to the gasifier or the air separation unit, while exhaust heat from the combustion turbine is recovered and used to boil water, creating steam for a steam turbine-generator. The use of these two types of turbines – a combustion turbine and a steam turbine – in combination, known as a combined cycle, is one reason why gasification-based power systems can achieve unprecedented power generation efficiencies.

Gasification also offers more scope for recovering products from waste than incineration. When waste is burnt in an incinerator, the only practical product is energy, whereas the gases, oils, and solid char from pyrolysis and gasification can not only be used as fuel but also purified and used as a feedstock for petrochemicals and other applications. Many processes also produce a stable granulate instead of ash, which can be more easily and safely utilized. In addition, some processes are targeted at producing specific recyclables such as metal alloys and carbon black. From waste gasification, in particular, it is feasible to produce hydrogen, which many see as an increasingly valuable resource.

Integrated gasification combined cycle (IGCC) is used to raise power from feedstocks such as vacuum residua, cracked residua, and deasphalting pitch. The value of these refinery residuals, including crude oil coke, will need to be considered as part of an overall upgrading project. Historically, many delayed coking projects have been evaluated and sanctioned on the basis of assigning zero value to crude oil coke having high sulfur and high metal content.

Also, as the 21st century evolves, there is the potential to install plasma gasification units. In the plasma gasifier (Fabry et al., 2013). In fact, gasification by means other than the conventional methods has also received some attention and has provided a rationale for future processes (Rabovitser et al., 2020). In the process, a carbonaceous material and at least one oxygen carrier are introduced into a non-thermal plasma reactor at a temperature in the range of approximately 300°C–700°C (570°F–1,290°F) and pressure in a range from atmospheric pressure to approximate 1,030 psi and a non-thermal plasma discharge is generated within the non-thermal plasma reactor. The carbonaceous feedstock and the oxygen carrier are exposed to the non-thermal plasma discharge, resulting in the formation of a product gas which comprises substantial amounts of hydrocarbon derivatives, such as methane, hydrogen and/or carbon monoxide.

Plasma assisted conversion of carbonaceous materials into a gas. In the process, a carbonaceous material and at least one oxygen carrier are introduced into a non-thermal plasma reactor at a temperature in the range of about 300°C (570°F) to approximately 700°C (1,290°F) and pressure in a range of about atmospheric to approximately 1,000 psi and a non-thermal plasma discharge is generated within the non-thermal plasma reactor. The carbonaceous material and the oxygen carrier are exposed to the non-thermal plasma discharge, resulting in the formation of a product gas in the non-thermal plasma reactor, which product gas comprises substantial amounts of hydrocarbons, such as methane, hydrogen and/or carbon monoxide.

While there are many alternate uses for the synthesis gas produced by gasification, and a combination of products/utilities can be produced in addition to power. A major benefit of the integrated

gasification combined cycle concept is that power can be produced with the lowest sulfur oxide (SO_x) and nitrogen oxide (NO_x) emissions of any liquid/solid feed power generation technology.

10.3.5.2 Fischer–Tropsch Synthesis

The synthesis reaction is dependent on a catalyst, mostly an iron or cobalt catalyst where the reaction takes place. There is either a low or high-temperature process (LTFT, HTFT), with temperatures ranging between 200°C–240°C for LTFT and 300°C–350°C for HTFT. The HTFT uses an iron catalyst, and the LTFT either an iron or a cobalt catalyst. The different catalysts include also nickel-based and ruthenium-based catalysts, which also have enough activity for commercial use in the process.

The reactors are the multi-tubular fixed bed, the slurry, or the fluidized bed (with either fixed or circulating bed) reactor. The fixed bed reactor consists of thousands of small tubes with the catalyst as a surface-active agent in the tubes. Water surrounds the tubes and regulates the temperature by settling the pressure of evaporation. The slurry reactor is widely used and consists of fluid and solid elements, where the catalyst has no particular position but flows around as small pieces of catalyst together with the reaction components. The slurry and fixed bed reactor are used in LTFT. The fluidized bed reactors are diverse but characterized by the fluid behavior of the catalyst.

The high temperature Fischer–Tropsch technology uses a fluidized catalyst at 300°C–330°C (625°F). Originally circulating fluidized bed units were used (Synthol reactors). Since 1989 a commercial scale classical fluidized bed unit has been implemented and improved upon.

The low temperature Fischer–Tropsch technology has originally been used in tubular fixed bed reactors at 200°C–230°C. This produces a more paraffinic and waxy product spectrum than the high-temperature technology. A new type of reactor (the Sasol slurry phase distillate reactor) has been developed and is in commercial operation. This reactor uses a slurry phase system rather than a tubular fixed-bed configuration and is currently the favored technology for the commercial production of synfuels.

Under most circumstances, the production of synthesis gas by reforming natural gas will be more economical than from coal gasification, but site-specific factors need to be considered. In fact, any technological advance in this field (such as better energy integration or the oxygen transfer ceramic membrane reformer concept) will speed up the rate at which the synfuels technology will become common practice.

There are large coal reserves that may increasingly be used as a fuel source during oil depletion. Since there are large coal reserves in the world, this technology could be used as an interim transportation fuel if conventional oil were to become more expensive. Furthermore, a combination of biomass gasification and Fischer–Tropsch synthesis is a very promising route to produce transportation fuels from renewable or green resources.

Although the focus of this section has been on the production of hydrocarbon derivatives from synthesis gas, it is worthy of note that clean synthesis gas can also be used (i) as chemical *building blocks* to produce a broad range of chemicals using processes well established in the chemical and petrochemical industry), (ii) as a fuel producer for highly efficient fuel cells (which run off the hydrogen made in a gasifier) or perhaps in the future, hydrogen turbines and fuel cell-turbine hybrid systems, and (iii) as a source of hydrogen that can be separated from the gas stream and used as a fuel or as a feedstock for refineries (which use the hydrogen to upgrade crude oil products).

10.4 PRODUCTS FROM ALTERNATE FEEDSTOCKS

In any plan to reconfigure a refinery for the acceptance of alternate feedstocks, it is necessary to understand the current methods for the production of fuel oils (commonly referred to as biofuels) that are in active development.

Alternate feedstocks can be converted into liquid or gaseous forms for the production of electric power, heat, chemicals, or gaseous and liquid fuels. The predominant conversion processes

are direct liquefaction, indirect liquefaction, physical extraction, thermochemical conversion, biochemical conversion, and electrochemical conversion. More generally, the production of biofuels from lignocellulosic feedstocks can be achieved through two very different processing routes: (i) the thermochemical platform, and (ii) the bioconversion platform (Chapter 14). While each platform is adequate for the task, depending upon the feedstock, there is no clear candidate for the best pathway between the various thermochemical technologies and the biochemical technologies.

The thermochemical platform typically uses a combination of pyrolysis, gasification, and catalysis to transform the feedstock into gaseous products – one of which is synthesis gas and then into fuels or chemicals. Synthesis gas (also referred to as syngas) production through pyrolysis is accompanied by the generation of char, which can then be gasified to provide process heat and energy for the thermochemical platform. A variety of commercial-scale processes exist to transform fossil fuels such as coal or natural gas into liquid fuels, including Fischer–Tropsch fuels. However, the use of an alternate feedstock instead of a fossil fuel feedstock changes the composition of synthesis gas, creating a more heterogeneous intermediate product and increasing the difficulty in downstream catalysis. A range of technical problems must be overcome before the alternate feedstocks become regular commercially viable substitutes for fossil feedstocks in the production of second-generation biofuels. However, elements of the thermochemical platform are highly suitable for bioenergy production.

This platform combines process elements of pretreatment, pyrolysis, gasification, cleanup, and conditioning to generate a mixture of hydrogen, carbon monoxide, carbon dioxide, and other gases. The products of this platform may be viewed as intermediate products, which can then be assembled into chemical building blocks and eventually end products. In the platform, the pretreatment is often required and may involve drying, grinding, and screening of the feedstock in order to create a substrate that can easily be fed into the reaction chamber. The technology required for this stage is already available on a commercial basis and is often associated with primary or secondary wood processing, or agricultural residue collection and distribution. The thermochemical platform provides the opportunity for a number of additional co-products, as well as energy in the form of heat or electricity and biofuels. Each component (such as carbon monoxide, CO; carbon dioxide, CO_2; methane, CH_4; and hydrogen, H_2) of the product gas stream may be recovered, separated, and utilized.

On the other hand, the bioconversion platform typically uses a combination of physical or chemical pretreatment and enzymatic hydrolysis to convert lignocellulose into its component monomers. This platform (examples are anaerobic digestion and fermentation) uses biological agents to carry out a structured deconstruction of lignocellulose components and combines process elements of pretreatment with enzymatic hydrolysis to release carbohydrates and lignin from the wood. The advantage of the bioconversion platform is that it provides a range of intermediate products, including glucose, galactose, mannose, xylose, and arabinose, which can be relatively easily processed into value-added bioproducts. The bioconversion platform also generates a quantity of lignin or lignin components; depending upon the pretreatment, lignin components may be found in the hydrolysate after enzymatic hydrolysis, or in the wash from the pretreatment stage.

Once hydrolyzed, six-carbon sugars can be fermented to ethanol using age-old yeasts and processes. Five-carbon sugars, however, are more difficult to ferment; new yeast strains are being developed that can process these sugars, but issues remain with process efficiency and the length of fermentation. Other types of fermentation, including bacterial fermentation under aerobic and anaerobic conditions, can produce a variety of other products from the sugar stream, including lactic acid. Bioconversion proceeds at lower temperatures and lower reaction rates and can offer high selectivity for products. Ethanol production is a biochemical conversion technology used to produce energy from alternate fuel feedstocks, depending upon the type and properties of the feedstock. For ethanol production, biochemical conversion researchers have focused on a process model of dilute acid hydrolysis of hemicelluloses followed by enzymatic hydrolysis of cellulose. Biodiesel production is a biochemical conversion technology used to produce energy from oilseed crops.

Cellulosic materials can be used to produce ethanol which represents an important, renewable liquid fuel for motor vehicles. Production of ethanol from alternate fuel feedstocks is one way to

reduce both the consumption of crude oil and environmental pollution. In order to produce ethanol from cellulosic materials, a pretreatment process is used to reduce the sample size, break down the hemicelluloses to sugars, and open up the structure of the cellulose component. The cellulose portion is hydrolyzed by acids or enzymes into glucose sugar that is fermented to ethanol. The sugar derivatives from the hemicellulose feedstocks are also fermented to ethanol.

The fermentation process requires pretreatment of the feedstock by chemical, physical, or biological means to reduce the complex carbohydrates to simple sugars. This type of pretreatment is often referred to as hydrolysis. The resulting sugars can then be fermented by the yeast and bacteria employed in the process. Furthermore, feedstocks that have a high content of starch and sugar are most easily hydrolyzed. Cellulosic feedstocks, including the major fraction of organics in MSW, are more difficult to hydrolyze, requiring more extensive pretreatment. Fermentation is generally used industrially to convert substrates such as glucose to ethanol for use in beverage, fuel, and chemical applications and to other chemicals (e.g., lactic acid used in producing renewable plastics) and products (e.g., enzymes for detergents). Strictly speaking, fermentation is an enzymatically controlled anaerobic process, although the term is sometimes more loosely applied to include aerobic processing as well.

The bioconversion platform is an industrial option that might be used in a biorefinery (Chapter 12) for producing fuels from alternate fuel feedstocks using biochemical reactions and/or biochemical agents. For example, fermentation or anaerobic digestion to produce fuels and chemicals from organic sources is a bioconversion platform. The bioconversion platform therefore has the ability to serve as the basis for wood-based biorefining operations, generating value-added bioproducts as well as fuel and energy for the forest sector.

10.4.1 GASEOUS FUELS

Most alternate fuel feedstocks are easier to gasify than, for example, coal because they are more reactive with higher ignition stability. This characteristic also makes them easier to process thermochemically into higher-value fuels such as methanol or hydrogen. In addition, the mineral matter content (the ash-forming constituents) is typically lower than for most types of coal, and sulfur content is much lower than for many fossil fuels. Unlike coal ash, which may contain toxic metals and other trace contaminants, the ash may be used as a soil amendment to help replenish nutrients removed by harvest. Several of the alternate fuel feedstocks stand out for their peculiar properties – such as high silicon or alkali metal contents – which may require special precautions for harvesting, processing, and combustion equipment. Note also that mineral content of the feedstock can vary as a function of soil type and the timing of the harvesting of the feedstock. In addition, when the alternate fuel feedstock is heated with no oxygen or only approximately one-third the oxygen needed for efficient combustion (amount of oxygen and other conditions) determine if the feedstock is actually gasified or is thermally decomposed (by pyrolysis), a mixture of carbon monoxide and hydrogen (synthesis gas) is produced.

Combustion is a function of the mixture of oxygen with the hydrocarbon fuel. Gaseous fuels mix with oxygen more easily than liquid fuels, which in turn mix more easily than solid fuels. Synthesis gas therefore inherently burns more efficiently and cleanly than the solid feedstock from which it was produced. Thus, gasification can improve the efficiency of large-scale power facilities, such as those for forest industry residues and specialized facilities such as black liquor recovery boilers of the pulp and paper industry, both major sources of power. Like natural gas, synthesis gas can also be burned in gas turbines, a more efficient electrical generation technology than steam boilers to which solid biomass and fossil fuels are limited.

10.4.2 LIQUID FUELS

Methanol is a colorless, odorless, and nearly tasteless alcohol and is also produced from crops and is also used as a fuel. Methanol, like ethanol, burns more completely but releases as much or more

carbon dioxide than its gasoline counterpart. Propanol and butanol are considerably less toxic and less volatile than methanol. In particular, butanol has a high flashpoint of 35°C (95°F), which is a benefit for fire safety, but maybe a difficult for starting engines in cold weather.

Currently, the production of ethanol by fermentation of corn-derived carbohydrates is the main technology used to produce liquid fuels from alternate fuel resources. Furthermore, amongst different biofuels, suitable for application in transport, bioethanol and biodiesel seem to be the most feasible ones at present. The key advantage of bioethanol and biodiesel is that they can be mixed with conventional petrol and diesel, respectively, which allows using the same handling and distribution infrastructure. Another important strong point of bioethanol and biodiesel is that when they are mixed at low concentrations (≤10% bioethanol in petrol and ≤20% biodiesel in diesel), no engine modifications are necessary.

Alternatively, alternate fuel feedstocks can be converted into fuels and chemicals indirectly (by gasification to synthesis gas followed by catalytic conversion to liquid fuels) or directly to a liquid product by thermochemical means. Direct thermochemical conversion processes include pyrolysis, liquefaction, and solvolysis (Kavalov and Peteves, 2005). Biologically produced alcohol derivatives – most commonly methyl alcohol and ethyl alcohol and less commonly propyl alcohol and butyl alcohol are produced by the action of microbes and enzymes through fermentation.

Biodiesel is a diesel-equivalent fuel derived from biological sources (such as vegetable oils) which can be used in unmodified diesel-engine vehicles. It is thus distinguished from the straight (unused) vegetable oil or waste vegetable oil that is used as fuel in some diesel vehicles. In the current context, biodiesel refers to the alkyl ester products produced by the transesterification of vegetable oil or animal fat. Biodiesel fuel is a fuel made from the oil of certain oilseed crops such as soybean, canola, palm kernel, coconut, sunflower, safflower, corn, and hundreds of other oil-producing crops. The oil is extracted by the use of a press and then mixed in specific proportions with other agents, which causes a chemical reaction. The results of this reaction are two products, biodiesel and soap. After a final filtration, the biodiesel is ready for use. After curing, the glycerin soap, which is produced as a by-product can be used as is or can have scented oils added before use. In general, biodiesel compares well to crude oil-based diesel. Pure biodiesel fuel (100% esters of fatty acids) is called B100. When blended with diesel fuel the designation indicates the amount of B100 in the blend, e.g. B20 is 20% B100 and 80% diesel, and B5 used in Europe contains 5% B100 in diesel.

Hydrocarbon derivatives are products of various plant species belonging to different families which convert a substantial amount of photosynthetic products into latex. The latex of such plants contains liquid hydrocarbon derivatives of high molecular weight (10,000). These hydrocarbon derivatives can be converted into high-grade transportation fuel (i.e., crude oil). Therefore, hydrocarbon producing plants are called crude oil plants or petroplants and their crop as petrocrop. Natural gas is also one of the products obtained from hydrocarbon derivatives. Thus, crude oil plants can be an alternative source for obtaining crude oil to be used in diesel engines. Normally, some of the latex-producing plants of families Euphorbiaceae, Apocynaceae, Asclepiadaceae, Sapotaceae, Moraceae, Dipterocarpaceae, etc. are petroplants. Similarly, sunflowers (family Composiae), Hardwickia pinnata (family Leguminosae) are also petroplants. Some algae also produce hydrocarbon derivatives. However, hydrocarbon derivatives, as such, are not usually produced from crops; there being an insufficient amount of the hydrocarbon derivatives present in the plant tissue to make the process economical. However, biodiesel is produced from crops thereby offering an excellent renewable fuel for diesel engines.

Bio-oil is a product that is produced by a totally different process than that used for biodiesel production. The process (fast pyrolysis, flash pyrolysis) occurs when solid fuels are heated at temperatures between 350°C and 500°C (570°F to 930°F) for a very short period of time (<2 seconds) and the temperatures are attainable within an active refinery (Table 10.1) (Speight, 2014, 2017). The bio-oils currently produced are suitable for use in boilers for electricity generation. In another process, the feedstock is fed into a fluidized bed (at 450°C–500°C, 840°F–930°F) and the feedstock flashes and vaporizes. The resulting vapors pass into a cyclone where solid particles, char, are

TABLE 10.1

Examples of the Stages That Occur During Pyrolysis

Temperature	Event
<100°C (<212°F)	Volatiles, including some water, evaporate
	Heat-sensitive substances may partially decompose
100°C (212°F)	Water remaining absorbed in the material is evolved
	Water trapped in the crystal structure of hydrates may be evolved at somewhat higher temperatures
	Some solid substances, like fats, sugars, and waxes may melt
100°C–500°C (212°F–930°F)	Organic molecules break down
	Most sugar derivatives start decomposing at 160°C–180°C
	Cellulose decomposes at approximately 350°C
	Lignin starts decomposing at approximately 350°C and continues releasing volatile products up to 500°C. The decomposition products usually include water, carbon monoxide and/or carbon dioxide as well as a large number of organic compounds
	The non-volatile residues typically become richer in carbon and form large disordered molecules, with colors ranging between brown and black
200°C–300°C (390°F–570°F)	When oxygen has not been excluded, the carbonaceous residue may start to burn in a highly exothermic reaction releasing carbon dioxide and/or monoxide
	At this stage, some of the nitrogen still remaining in the residue may be oxidized into nitrogen oxides (such as NO_2 and N_2O)
	Sulfur and other elements (such as chlorine and arsenic) may be oxidized and volatilized

extracted. The gas from the cyclone enters a quench tower where they are quickly cooled by heat transfer using bio-oil already made in the process. The bio-oil condenses into a product receiver and any non-condensable gases are returned to the reactor to maintain process heating. The entire reaction from injection to quenching takes only 2 seconds.

10.4.3 Solid Fuels

Examples of solid fuels from alternate fuel (i.e., biomass) feedstocks include wood and wood-derived charcoal as well as dried dung, particularly cow dung. One widespread use of such fuels is in-home cooking and heating. The biofuel may be burned on an open fireplace or in a suitably constructed stove. The efficiency of this process may vary widely, from 10% for a well-made fire (even less if the fire is not made carefully) up to 40% for a custom-designed charcoal stove. Inefficient use of fuel is a cause of deforestation (though this is negligible compared to deliberate destruction to clear land for agricultural use) but more importantly, it means that more work has to be put into gathering fuel, thus the quality of cooking stoves has a direct influence on the viability of biofuels.

10.5 THE RECONFIGURED REFINERY

Over the past three decades, the refining industry has been challenged by changing feedstocks and product slate. In the near future, the refining industry will become increasingly flexible with improved technologies and improved catalysts. The main technological progress will be directed to (i) upgrading viscous feedstocks, (ii) production of cleaner – less environmentally threatening – transportation fuel production, and (iii) the integration of refining and petrochemical businesses.

Even the tried and true processes (Speight, 2014, 2017) will see changes as they evolve (Speight, 2011). The *distillation units* will continue to be the mainstay of crude oil refining and the main short-term developments are in improved integration through the use of heat recovery technology and integration of different distillation units (i.e., atmospheric distillation unit and the vacuum

distillation unit). In the long-term, the major developments are the integration of different distillation columns into one reactor (e.g., dividing-wall column) or the development of alternative processing routes allowing for a combination of conversion and distillation (such as reactive distillation). Alternative processes to distillation will also include membranes and technologies such as freeze concentration.

Thermal processes will also evolve and become more efficient. While the current processes may not see much change in terms of reactor vessel configuration, there will be changes to the reactor internals and to the nature of the catalysts. For example, in the near term, the tried and true coking processes will remain the mainstay of refineries coping with an influx of viscous feedstocks (such as heavy crude oil, extra-heavy crude oil, and tar sand bitumen) but other process options will be used.

For example, visbreaking (or even hydrovisbreaking – i.e., visbreaking in an atmosphere of hydrogen or in the presence of a hydrogen-donor material) the long-ignored step-child of the refining industry may see a surge in use as a pretreatment process. Management of the process to produce a liquid product that has been freed of the high potential for coke deposition (by taking the process parameters into the region where sediment forms) either in the absence or presence of (for example) a metal oxide scavenger could be a valuable ally to catalyst cracking or hydrocracking units.

In the integration of refining and petrochemical businesses, new technologies based on the traditional fluid catalytic cracking process will be of increased interests to refiners because of their potential to meet the increasing demand for light olefins. Meanwhile, hydrocracking, due to its flexibility, will take the central position in the integration of refining and petrochemical businesses in the 21st century.

Alternately, operating the catalytic cracking unit solely as a slurry riser cracker (without the presence of the main reactor) followed by separation of coke (sediment) would save the capital outlay required for a new catalytic cracker and might even show the high conversion to valuable liquids. The quality (i.e., boiling range) of the distillate would be dependent upon the residence time of the slurry in the pipe.

Scavenger additives such as metal oxides may also see a surge in use. As a simple example, a metal oxide (such as calcium oxide) has the ability to react with sulfur-containing feedstock to produce a hydrocarbon (and calcium sulfide):

$$\text{Feedstock[S]} + CaO \rightarrow \text{hydrocarbon product} + CaS + H_2O$$

Propane has been used extensively in deasphalting viscous feedstocks, especially in the preparation of high-quality lubricating oils and feedstocks for catalytic cracking units (Speight, 2014, 2017). The use of propane has necessitated elaborate solvent cooling systems utilizing cold water, which is a relatively expensive cooling agent. In order to circumvent such technology, future units will use solvent systems that will allow operation at elevated temperatures relative to conventional propane deasphalting temperatures, thereby permitting easy heat exchange. In addition, it may be found desirable to integrate dewaxing operations with deasphalting operations by having a common solvent recovery system. This will require changes to the solvent composition and the inclusion of solvents not usually considered to be deasphalting solvents.

Furthermore, as a means of energy reduction for the process, in future deasphalting units, the conventional solvent recovery scheme will be retrofitted with a supercritical solvent recovery scheme to reap benefits of higher energy efficiency. Other improvements will include variations in the extraction column internals.

For example, the three major properties, which influence the design of the extraction column, are interfacial tension, viscosity, and density of phases. The solvent deasphalting extraction column is characterized by low interfacial tension, high viscosities of the asphaltene phase, and a density difference between the phases. Extension of these property correlations for solvent deasphalting applications will be suitably validated and corrections made where necessary to improve extraction performance and yields of the products.

Other areas of future process modification will be in the extractor tower internals, studies with higher molecular weight solvent, accurate estimation of physical properties of mix stream, studies in combination with other processes, and firming up design tools for supercritical solvent recovery configuration.

In the long term, new desulfurization technologies or evolution of the older technologies will reduce the need for hydrogen. At the same time, refineries are constantly faced with challenges to reduce air pollution and other energy-related issues. Thus, traditional end-of-pipe air emission-control technologies will lead to increased energy use and decreasing energy efficiency in the refinery. The crude oil refining industry will face many other challenges – climate change, new developments in automotive technology, and biotechnology – which are poised to affect the future structure of refineries.

The increasing focus to reduce sulfur content in fuels will assure that the role of *desulfurization* in the refinery increases in importance (Babich and Moulijn, 2003). Currently, the process of choice is the hydrotreater, in which hydrogen is added to the fuel to remove sulfur from the fuel. Some hydrogen may be lost to reduce the octane number of the fuel, which is undesirable.

Because of the increased attention for fuel desulfurization, various new process-concepts are being developed with various claims of efficiency and effectiveness. The major developments in desulfurization will be three main routes: (i) advanced hydrotreating (new catalysts, catalytic distillation, processing at mild conditions), (ii) reactive adsorption (a type of adsorbent used, process design), and (iii) oxidative desulfurization (catalyst, process design).

In addition, the most common approaches to upgrading hydrotreaters for clean-fuels production will continue to be: (i) developing higher-activity and more resilient catalysts, (ii) replacing reactor internals for increased efficiency, (iii) adding reactor capacity to accommodate the viscous feedstocks and increase gasoline-diesel production, (iv) increasing hydrogen partial pressure, (v) process design, and (vi) hardware that is more specialized and focus on process schemes that effectively reduce hydrogen consumption and use alternate feedstocks.

However, residuum hydrotreating requires considerably different catalysts and process flows, depending on the specific operation so that efficient hydroconversion through uniform distribution of liquid, hydrogen-rich gas, and catalyst across the reactor is assured. In addition to an increase in *guard bed* use, the industry will see an increase in automated demetallization of fixed-bed systems as well as more units that operate as ebullating-bed hydrocrackers.

For upgrading the viscous feedstocks, hydrotreating technology and hydrocracking technology will be the processes of choice. For cleaner transportation fuel production, the main task is the desulfurization of gasoline and diesel. With the advent of various techniques, such as adsorption and biodesulfurization, the future development will be still centralized on hydrodesulfurization techniques.

In fact, hydrocracking will continue to be an indispensable processing technology to modern crude oil refining and petrochemical industry due to its flexibility to feedstocks and product scheme, and high-quality products. Particularly, high-quality naphtha, jet fuel, diesel, and lube base oil can be produced through this technology. The hydrocracker provides a better balance of gasoline and distillates, improves gasoline yield, octane quality, and can supplement the fluid catalytic cracker to upgrade viscous feedstocks. In the hydrocracker, light fuel oil is converted into lighter products under a high hydrogen pressure and over a hot catalyst bed – the main products are naphtha, jet fuel, and diesel oil.

For the viscous feedstocks (and even for bio-feedstocks), which will increase in amounts in terms hydrocracking feedstocks, reactor designs will continue to focus on online catalyst addition and withdrawal. Fixed bed designs have suffered from (i) mechanical inadequacy when used for the heavier feedstocks, and (ii) short catalyst lives – 6 months or less – even though large catalyst volumes are used (LHSV typically of 0.5–1.5). Refiners will attempt to overcome these shortcomings by innovative designs, allowing better feedstock flow and catalyst utilization, or online catalyst removal. For example, in some processes, a reactor is used to demetallize viscous feedstock ahead

of the fixed bed hydrocracking reactors and this has seen some success. But whether this will be adequate for continuous hydrocracking viscous feedstocks remains a question.

Catalyst development will be key in the modification of processes and the development of new ones to make environmentally acceptable fuels (Rostrup-Nielsen, 2004). Conversion of crude oil is expected to remain the principal source of motor fuels for another 30–50 years, but it is likely that the production of fuel additives in large quantities along with the conversion of natural gas will become significant (Sousa-Aguiar et al., 2005). Although crude oil conversion is expected to remain the principal source of fuels and petrochemicals in the future, natural gas reserves are emerging and will continue to emerge, as a major hydrocarbon resource. This trend has already started to result in a shift toward the use of natural gas (methane) as a significant feedstock for chemicals and for fuels as well. As a result, deployment of technology for direct and indirect conversion of methane will probably displace much of the current production of liquefied natural gas.

Innovations have occurred in catalyst materials that have allowed refiners to vastly improve environmental performance, product quality and volume, feedstock flexibility, and energy management without fundamentally changing fixed capital stocks. Advanced design and manufacturing techniques mean that catalysts can now be formulated and manufactured for specific processing units, feedstocks, operating environments, and finished product slates. These efforts will continue and more simper cheaper catalysts will be developed. However, the precise configuration of the refinery of the future is unknown but it is certain that no two refineries will adapt in exactly the same way.

Over the past century, the refining industry has been innovative and able to develop new processes. This trend will continue to innovate and by the period 2030–2050, refineries will be more technologically advanced and the products will be more environmentally acceptable. However, the evolution of the refinery of the future will not be strictly confined to the refining processes. The major consequence will be a much more environmentally friendly product quality. These will be solved in refinery of the future, the refinery beyond 2020 with the development of deep conversion processing, such as residue hydrocracking and the inclusion of processes to accommodate other feedstocks.

The panacea (rather than a Pandora's box) for a variety of feedstock could well be the gasification refinery (Figure 10.2) This type of refinery approaches that of a petrochemical complex, capable of supplying the traditional refined products, but also meeting much more severe specifications, and petrochemical intermediates such as olefins, aromatics, hydrogen, and methanol. Furthermore, as already noted above, integrated gasification combined cycle (IGCC) can be used to raise power from feedstocks such as vacuum residua and cracked residua and (in addition to the production of synthesis gas), a major benefit of the integrated gasification combined cycle concept is that power can be produced with the lowest sulfur oxide (SO_x) and nitrogen oxide (NO_x) emissions of any liquid/solid feed power generation technology.

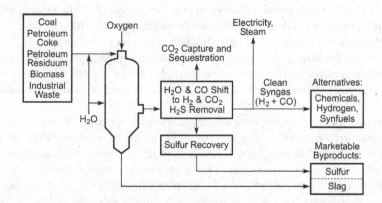

FIGURE 10.2 Gasification of various feedstocks.

The typical refinery in the year 2050 will be located at an existing refinery site since economic and environmental considerations may make it difficult and uneconomical to build a new refinery at another site. Many existing refining processes may still be in use but they will be more efficient and more technologically advanced and perhaps even rebuilt (reactors having been replaced on a scheduled or as-needed basis) rather than retrofitted. However, energy efficiency will still be a primary concern, as refiners seek to combat the inevitable increasing cost of crude oil and refinery operating expenses.

Moreover, the future of the crude oil refining industry will be primarily on processes for the production of improved quality products. In addition to the deep conversion of the highly viscous feedstocks, there will also be changes in the feedstock into a refinery. Biomass, liquids from coal, and liquids from oil shale will increase in importance. These feedstocks (i) will be sent to refineries or (ii) processed at a remote location and then blended with refinery stocks are options for future development and the nature of the feedstocks. Above all, such feedstock must be compatible with refinery feedstocks and not cause fouling in any form.

The refinery of the future will have a gasification section devoted to the conversion of coal and biomass to Fischer–Tropsch hydrocarbon derivatives – perhaps even with rich oil shale added to the gasifier feedstock. Many refineries already have gasification capabilities, but the trend will increase to the point (over the next two decades); nearly all refineries feel the need to construct a gasification section to handle residua and other feedstocks.

The production of high-quality fuels will result in a higher demand for related hydrogen and conversion technologies. Furthermore, the trend toward low-sulfur fuels and changes in the product mix of refineries will affect technology choice and needs. For example, the current desulfurization and conversion technologies use relatively large amounts of hydrogen (which is an energy-intensive product) and increased hydrogen consumption will lead to increased energy use and operation expenses unless more efficient technologies for hydrogen production developed.

The demand for high-value crude oil products will maximize the production of transportation fuels at the expense of both residua and light gases. Hydroprocessing of residua will be widespread rather than appearing on selected refineries. At the same time, hydrotreated residua will be the common feedstocks for fluid catalytic cracking units. Additional conversion capacity will be necessary to process increasingly heavier crudes and meet a reduced demand for residua.

Process unit and refinery economics/operations computer models will be optimized, with integration into plant operations via process computer controls. Alternate fuels for power generation will continue to push crude processing toward higher-value products, such as transportation fuels, and chemicals. Otherwise, the viscous feedstocks that are often considered to be uneconomical to transport to a refinery will be partially refined at their source to facilitate transport; and there will be a new emphasis on partial or full upgrading in situ during recovery operations.

The biomass refinery of the future will also use multiple feedstocks, and it will be able to shift output from the production of one chemical to another in response to market demands. Given that biomass will be a part of a refinery of the future, refiners may dictate that biomass receives preliminary upgrading at the biomass site before being shipped to the crude oil refinery.

Other challenges facing the refining industry include its capital-intensive nature and dealing with the disruptions to business operations that are inherent in the industry. It is imperative for refiners to raise their operations to new levels of performance. Merely extending current performance incrementally will fail to meet most company's performance goals.

To circumvent these issues, there may be no way out of energy production than to consorting alternative energy sources with crude oil and not opposing them. This leads to the concept of *alternative energy systems*, which is wider-ranging and more meaningful than *alternative energy sources* because it relates to the actual transformation process of the global energy system (Szklo and Schaeffer, 2005). Alternative energy systems integrate crude oil with other energy sources and pave the way for new systems where *refinery flexibility* will be a key target, especially when related to the increased use of renewable energy sources.

In terms of biomass in a conventional (current) refinery setting, there are potential analogies between the 21st century crude oil refinery and the biorefinery. Current biorefineries, which are still in their tender infancy, produce relatively few chemicals and fuels and most of the processes involve little chemical and energy integration. In analogy to the history of the petrol industry, with the development and updating of different chemical and biochemical conversion technologies, the biorefinery can also become an efficient and highly integrated system to meet the chemical and energy requirements of the 21st century.

In order to develop the refinery system, serious efforts must be addressed to the development of new infrastructures dealing with the setting-up and optimization of new logistic chain systems, and able to provide huge amounts of biomass-derived feedstock to conventional refineries. Furthermore, efficient biochemical processes, integrating different conversion technologies, and industrial scaling-up have to be considered in the feeding of biomass-derived feedstock to the current units in refineries. Nevertheless, a significant percentage of the chemical conversion technologies available in a crude oil refinery can also be used in biomass transformation into valuable fuels and chemicals.

Low-quality vegetable oils and greases are likely to be promising in a short-to-medium term to yield diesel fuel and jet-fuel by means of hydroprocessing triglyceride-based feedstocks. However, some aspects of hydroprocessing operations still need more attention. The development of active and stable catalysts for hydrogen-free catalytic deoxygenation may be a good alternative to the expensive hydrodeoxygenation-hydrodecarboxylation conversion routes. Likewise, to ensure optimal co-processing of triglycerides with petroleum fractions in existing refinery units, it is critical to fully understand the effect of triglycerides (feed and conversion products, especially water) on the processing of the petroleum fraction. The use of a separate modular unit where processing conditions are optimized for the triglyceride-based feedstock is an attractive approach.

Processing pyrolysis oil requires larger efforts in commercial development because of the overall poor quality of the bio-oils; the conventional hydrotreating catalysts are expected to have a considerably lower catalyst life in bio-oil upgrading operations than that observed with a crude oil-based feedstock. While the current generation commercial catalysts are excellent hydroprocessing catalysts, they are optimized for crude oil-based feedstock and, since the bio-oils have significantly different properties than petroleum feedstock, it would be worthwhile to dedicate efforts to developing catalysts specifically designed for upgrading bio-oils.

Ethanol, the main biomass-derived fuel used today, is widely used in refineries for the formulation of gasoline. However, ethanol suffers from important limitations as a fuel (such as the low energy density and the high solubility in water) that can be overcome by designing strategies to convert non-edible lignocellulosic biomass into liquid hydrocarbon fuels chemically similar to those currently used in internal combustion engines.

Most of the biomass conversion processes carried out in a refinery need a high amount of hydrogen in order to remove oxygen and yield high energy density fuels. Although biomass valorization can be performed on current commercially available petroleum-based technology, it should not be forgotten that crude oil and biomass feedstocks are chemically very different. Nevertheless, heterogeneous catalysis, which has made it possible to convert efficiently crude oil-derived resources to fuels, will also be able to provide the necessary technology to get similar fuels starting from biomass feedstocks provided a new catalyst technology is developed (Melero et al., 2012).

REFERENCES

Babich, I.V., and Moulijn, J.A. 2003. Science and Technology of Novel Processes for Deep Desulfurization of Oil Refinery Streams: A Review. *Fuel* 82(2003): 607–631.

Bhatia, S., and Sharma, D.K. 2006. Emerging Role of Biorefining of Heavier Crude Oils and Integration of Biorefining with Crude oil Refineries in the Future. *Pet. Sci. Technol.* 24(10): 1125–1159.

Couvaras, G. 1997. Sasol's Slurry Phase Distillate Process and Future Applications. Proceedings. *Monetizing Stranded Gas Reserves Conference*, Houston, December 1997.

Davis, R.A., and Patel, N.M. 2004. Refinery Hydrogen Management. *Pet. Technol. Q.* (Spring): 29–35.

Fabry, F., Rehmet, C., Rohani, V.-J., and Fulcheri, L. 2013. Waste Gasification by Thermal Plasma: A Review. *Waste Biomass Valorization* 4(3): 421–439.

Freeman, C.J., Jones, S.B., Padmaperuma, A.B., Santosa, M., Valkenburg, C., and Shinn, J. 2013. Initial Assessment of U.S. Refineries for Purposes of Potential Bio-Based Oil Insertions. Report No. PNNL-22432. Pacific Northwest National Laboratory Richland, Washington, DC. Prepared for the U.S. Department of Energy under Contract DE-AC05-76RL01830 99352. https://www.pnnl.gov/main/publications/external/technical_reports/PNNL-22432.pdf

Hedrick, B.W., Seibert, K.D., and Crewe, C. 2006. A New Approach to Heavy Oil and Bitumen Upgrading. Report No. AM-06-29. UOP 4355B. UOP LLC, Des Plaines, IL.

Huber, G.W., and Corma, A. 2007. Synergies between Bio- and Oil Refineries for the Production of Fuels from Biomass. *Angew. Chem.* 46(38): 7184–7201.

Kavalov, B., and Peteves, S.D. 2005. *Status and Perspectives of Biomass-to-Liquid Fuels in the European Union.* European Commission, Directorate General Joint Research Centre (DG JRC), Institute for Energy, Petten, Netherlands.

Le Borgne, S., and Quintero, R. 2003. Biotechnological Processes for the Refining of Petroleum. *Fuel Process. Technol.* 81(2): 155–169.

Lynd, L.R., Larson, E., Greene, N., Laser, M., Sheehan, J., Dale, B.E., McLaughlin, S., and Wang, M. 2009. Biofuels, Bioproducts, and Biorefining. 3(2): 113–123.

Lynd, L.R., Wyman, C., Laser, M., Johnson, D., and Landucci, R. 2005. Strategic Biorefinery Analysis: Review of Existing Biorefinery Examples. January 24–July 1, 2002. Subcontract Report NREL/SR-510-34895 October. National Renewable Energy Laboratory, Golden, CO.

Marcilly, C. 2003. Present Status and Future Trends in Catalysis for Refining and Petrochemicals. *J. Catal.* 216(1–2): 47–62.

Melero, J.A., Iglesias, J., and Garcia, A. 2012. Biomass as Renewable Feedstock in Standard Refinery Units. Feasibility, Opportunities and Challenges. *Energy Environ. Sci.* 5: 7393–7420.

Penning, R.T. 2001. Petroleum Refining: A Look at the Future. *Hydrocarbon Process.* 80(2): 45–46.

Rabovitser, I.K., Nester, S., and Bryan, B. 2020. Plasma Assisted Conversion of Carbonaceous Materials into a Gas. United States Patent 7,736,400, June 25.

Rostrup-Nielsen, J.R. 2004. Fuels and Energy for the Future: The Role of Catalysis. *Catal. Rev.* 46(3&4): 247–270.

Scouten, C.S. 1990. Oil Shale. *Fuel Science and Technology Handbook.* J.G. Speight (Editor). Marcel Dekker Inc., New York, Chapters 25–31.

Sousa-Aguiar, E.F., Appel, L.G., and Mota, C. 2005. Natural Gas Chemical Transformations: The Path to Refining in the Future. *Catal. Today* 10(1): 3–7.

Speight, J.G. 2011. *The Refinery of the Future.* Gulf Professional Publishing Company, Elsevier, Oxford, United Kingdom.

Speight, J.G. 2013. *The Chemistry and Technology of Coal*, 3rd Edition. CRC Press, Taylor & Francis Group, Boca Raton, FL.

Speight, J.G. 2014. *The Chemistry and Technology of Petroleum*, 5th Edition. CRC Press, Taylor & Francis Group, Boca Raton, FL.

Speight, J.G. 2017. *Handbook of Petroleum Refining.* CRC Press, Taylor & Francis Group, Boca Raton, FL.

Speight, J.G. 2019. *Handbook of Petrochemical Processes.* CRC Press, Taylor & Francis Group, Boca Raton, FL.

Speight, J.G. 2020a. *Handbook of Synthetic Fuels: Properties, Processes, and Performance*, 2nd Edition. McGraw-Hill, New York.

Speight, J.G. 2020b. *Synthesis Gas: Production and Properties.* Scrivener Publishing, Beverly, MA.

Speight, J.G. 2020c. *Shale Oil and Gas Production Processes.* Gulf Publishing Company, Elsevier, Cambridge, MA.

Stanislaus, A., Qabazard, H., and Absi-Halabi, M. 2000. Refinery of the Future. Proceedings. *16th World Petroleum Congress*, Calgary, Canada, June 11–15.

Szklo, A., and Schaeffer, R. 2005. Alternative Energy Sources or Integrated Alternative Energy Systems? Oil as a Modern Lance of Peleus for the Energy Transition. *Energy* 31: 2513–2522.

Glossary

ABN separation: a method of fractionation by which petroleum is separated into acidic, basic, and neutral constituents.

Absorber: see Absorption tower.

Absorption gasoline: gasoline extracted from natural gas or refinery gas by contacting the absorbed gas with an oil and subsequently distilling the gasoline from the higher-boiling components.

Absorption oil: oil used to separate the heavier components from a vapor mixture by absorption of the heavier components during intimate contact of the oil and vapor; used to recover natural gasoline from wet gas.

Absorption plant: a plant for recovering the condensable portion of natural or refinery gas, by absorbing the higher boiling hydrocarbons in an absorption oil, followed by separation and fractionation of the absorbed material.

Absorption tower: a tower or column which promotes contact between a rising gas and a falling liquid so that part of the gas may be dissolved in the liquid.

Acetone-benzol process: a dewaxing process in which acetone and benzol (benzene or aromatic naphtha) are used as solvents.

Acid catalyst: a catalyst having acidic character; the alumina minerals are examples of such catalysts.

Acid deposition: acid rain; a form of pollution depletion in which pollutants, such as nitrogen oxides and sulfur oxides, are transferred from the atmosphere to soil or water; often referred to as atmospheric self-cleaning. The pollutants usually arise from the use of fossil fuels.

Acid gas removal: a process for the removal of hydrogen sulfide, other sulfur species, and some carbon dioxide from syngas by absorption in a solvent with subsequent solvent regeneration and production of an H_2S rich stream for sulfur recovery.

Acid number: a measure of the reactivity of petroleum with a caustic solution and given in terms of milligrams of potassium hydroxide that are neutralized by one gram of petroleum.

Acid rain: the precipitation phenomenon that incorporates anthropogenic acids and other acidic chemicals from the atmosphere to the land and water (see Acid deposition).

Acid sludge: the residue left after treating petroleum oil with sulfuric acid for the removal of impurities; a black, viscous substance containing the spent acid and impurities.

Acid treating: a process in which unfinished petroleum products, such as gasoline, kerosene, and lubricating-oil stocks, are contacted with sulfuric acid to improve their color, odor, and other properties.

Acidity: the capacity of an acid to neutralize a base such as a hydroxyl ion (OH^-).

Acidizing: a technique for improving the permeability of a reservoir by injecting acid.

Acoustic log: see Sonic log.

Acre-foot: a measure of bulk rock volume where the area is one acre and the thickness is one foot.

Additive: a material added to another (usually in small amounts) in order to enhance desirable properties or to suppress undesirable properties.

Add-on control methods: the use of devices that remove refinery process emissions after they are generated but before they are discharged to the atmosphere.

Adsorption: transfer of a substance from a solution to the surface of a solid resulting in a relatively high concentration of the substance at the place of contact; see also Chromatographic adsorption.

Adsorption gasoline: natural gasoline obtained by the adsorption process from wet gas.

After flow: flow from the reservoir into the wellbore that continues for a period after the well has been shut in; after-flow can complicate the analysis of a pressure transient test.

Afterburn: the combustion of carbon monoxide (CO) to carbon dioxide (CO_2); usually in the cyclones of a catalyst regenerator.

Air-blown asphalt: asphalt produced by blowing air through residua at elevated temperatures.

Air injection: an oil recovery technique using air to force oil from the reservoir into the wellbore.

Air pollution: the discharge of toxic gases and particulate matter introduced into the atmosphere, principally as a result of human activity.

Air separation unit (ASU): a plant that separates oxygen and nitrogen from the air, usually by cryogenic distillation.

Air sweetening: a process in which air or oxygen is used to oxidize lead mercaptan derivatives (RSH) to disulfide derivatives (RSSR) instead of using elemental sulfur.

Air toxics: hazardous air pollutants.

Airlift Thermofor catalytic cracking: a moving-bed continuous catalytic process for conversion of heavy gas oils into lighter products; the catalyst is moved by a stream of air.

Albertite: a black, brittle, natural hydrocarbon possessing a conchoidal fracture and a specific gravity of approximately 1.1.

Alcohol: the family name of a group of organic chemical compounds composed of carbon, hydrogen, and oxygen. The molecules in the series vary in chain length and are composed of a hydrocarbon plus a hydroxyl group. Alcohol includes methanol and ethanol.

Alicyclic hydrocarbon: a compound containing carbon and hydrogen only which has a cyclic structure (e.g., cyclohexane); also collectively called naphthenes.

Aliphatic hydrocarbon: a compound containing carbon and hydrogen only which has an open-chain structure (e.g., like ethane, butane, octane, butene) or a cyclic structure (e.g., cyclohexane).

Aliquot: that quantity of material of proper size for measurement of the property of interest; test portions may be taken from the gross sample directly, but often preliminary operations such as mixing or further reduction in particle size are necessary.

Alkali treatment: see Caustic wash.

Alkali wash: see Caustic wash.

Alkaline: a high pH usually of an aqueous solution; aqueous solutions of sodium hydroxide, sodium orthosilicate, and sodium carbonate are typical alkaline materials used in enhanced oil recovery.

Alkaline flooding: see the EOR process.

Alkalinity: the capacity of a base to neutralize the hydrogen ion (H^+).

Alkanes: hydrocarbons that contain only single carbon-hydrogen bonds. The chemical name indicates the number of carbon atoms and ends with the suffix "ane".

Alkenes: hydrocarbons that contain carbon-carbon double bonds. The chemical name indicates the number of carbon atoms and ends with the suffix "ene."

Alkyl groups: a group of carbon and hydrogen atoms that branch from the main carbon chain or ring in a hydrocarbon molecule. The simplest alkyl group, a methyl group, is a carbon atom attached to three hydrogen atoms.

Alkylate: the product of an alkylation process.

Alkylate bottoms: residua from fractionation of alkylate; the alkylate product which boils higher than the aviation gasoline range; sometimes called heavy alkylate or alkylate polymer.

Alkylation: in the petroleum industry, a process by which an olefin (e.g., ethylene) is combined with a branched-chain hydrocarbon (e.g., *iso*-butane); alkylation may be accomplished as a thermal or as a catalytic reaction.

Alpha-scission: the rupture of the aromatic carbon-aliphatic carbon bond that joins an alkyl group to an aromatic ring.

Alumina (Al_2O_3): used in separation methods as an adsorbent and in refining as a catalyst.

American Society for Testing and Materials (ASTM): the official organization in the United States for designing standard tests for petroleum and other industrial products.

Amine washing: a method of gas cleaning whereby acidic impurities such as hydrogen sulfide and carbon dioxide are removed from the gas stream by washing with an amine (usually an alkanolamine).

Anaerobic digestion: decomposition of biological wastes by micro-organisms, usually under wet conditions, in the absence of air (oxygen), to produce a gas comprising mostly methane and carbon dioxide.

Analyte: the chemical for which a sample is tested, or analyzed. *Antibody* A molecule having chemically reactive sites specific for certain other molecules.

Analytical equivalence: the acceptability of the results obtained from the different laboratories; a range of acceptable results.

Aniline point: the temperature, usually expressed in °F, above which equal volumes of a petroleum product are completely miscible; a qualitative indication of the relative proportions of paraffins in a petroleum product which are miscible with aniline only at higher temperatures; a high aniline point indicates low aromatics.

Annual removals: the net volume of growing stock trees removed from the inventory during a specified year by harvesting, cultural operations such as timber stand improvement, or land clearing.

Antibody: a molecule having chemically reactive sites specific for certain other molecules.

Antiknock: resistance to detonation or pinging in spark-ignition engines.

Antiknock agent: a chemical compound such as tetraethyl lead which, when added in a small amount to the fuel charge of an internal-combustion engine, tends to lessen knocking.

Antistripping agent: an additive used in an asphaltic binder to overcome the natural affinity of aggregate for water instead of asphalt.

API gravity: a measure of the *lightness* or *heaviness* of petroleum which is related to the density and specific gravity.

$$°API = (141.5/sp \ gr \ @ \ 60°F) - 131.5$$

Apparent bulk density: the density of a catalyst as measured; usually loosely compacted in a container.

Apparent viscosity: the viscosity of a fluid, or several fluids flowing simultaneously, measured in a porous medium (rock), and subject to both viscosity and permeability effects; also called effective viscosity.

Aquifer: a subsurface rock interval that will produce water; often the underlay of a petroleum reservoir.

Areal sweep efficiency: the fraction of the flood pattern area that is effectively swept by the injected fluids.

Aromatic hydrocarbon: a hydrocarbon characterized by the presence of an aromatic ring or condensed aromatic rings; benzene and substituted benzene, naphthalene and substituted naphthalene, phenanthrene and substituted phenanthrene, as well as the higher condensed ring systems; compounds that are distinct from those of aliphatic compounds or alicyclic compounds.

Aromatics: see Aromatic hydrocarbon.

Aromatization: the conversion of non-aromatic hydrocarbons to aromatic hydrocarbons by (i) rearrangement of aliphatic (noncyclic) hydrocarbons into aromatic ring structures; and (ii) dehydrogenation of alicyclic hydrocarbons (naphthenes).

Arosorb process: a process for the separation of aromatic derivatives from non-aromatic derivatives by adsorption on a gel from which they are recovered by desorption.

Asphalt: the nonvolatile product obtained by distillation and treatment of an asphaltic crude oil; a manufactured product.

Asphalt cement: asphalt especially prepared as to quality and consistency for direct use in the manufacture of bituminous pavements.

Asphalt emulsion: an emulsion of asphalt cement in water containing a small amount of emulsifying agent.

Asphalt flux: an oil used to reduce the consistency or viscosity of hard asphalt to the point required for use.

Asphalt primer: a liquid asphaltic material of low viscosity which, upon application to a non-bituminous surface to waterproof the surface and prepare it for further construction.

Asphaltene (asphaltenes): the brown to black powdery material produced by treatment of petroleum, petroleum residua, or bituminous materials with a low-boiling liquid hydrocarbon, e.g. pentane or heptane; soluble in benzene (and other aromatic solvents), carbon disulfide, and chloroform (or other chlorinated hydrocarbon solvents).

Asphaltene association factor: the number of individual asphaltene species which associate in non-polar solvents as measured by molecular weight methods; the molecular weight of asphaltenes in toluene divided by the molecular weight in a polar non-associating solvent, such as dichlorobenzene, pyridine, or nitrobenzene.

Asphaltic pyrobitumen: see Asphaltoid.

Asphaltic road oil: a thick, fluid solution of asphalt; usually a residual oil; see also Nonasphaltic road oil.

Asphaltite: a variety of naturally occurring, dark brown to black, solid, nonvolatile bituminous material that is differentiated from bitumen primarily by a high content of material insoluble in n-pentane (asphaltene) or other liquid hydrocarbons.

Asphaltoid: a group of brown to black, solid bituminous materials of which the members are differentiated from asphaltites by their infusibility and low solubility in carbon disulfide.

Asphaltum: see Asphalt.

Associated molecular weight: the molecular weight of asphaltenes in an associating (non-polar) solvent, such as toluene.

Atmospheric equivalent boiling point (AEBP): a mathematical method of estimating the boiling point at atmospheric pressure of non-volatile fractions of petroleum.

Atmospheric residuum: a residuum obtained by distillation of crude oil under atmospheric pressure and which boils above 350°C (660°F).

Attainment area: a geographical area that meets NAAQS for criteria air pollutants (See also Non-attainment area).

Attapulgus clay: see Fuller's earth.

Autofining: a catalytic process for desulfurizing distillates.

Average particle size: the weighted average particle diameter of a catalyst.

Aviation gasoline: any of the special grades of gasoline suitable for use in certain airplane engines.

Aviation turbine fuel: see Jet fuel.

Back mixing: the phenomenon observed when a catalyst travels at a slower rate in the riser pipe than the vapors.

BACT: best available control technology.

Baghouse: a filter system for the removal of particulate matter from gas streams; so-called because of the similarity of the filters to coal bags.

Bank: the concentration of oil (oil bank) in a reservoir that moves cohesively through the reservoir.

Bari-Sol process: a dewaxing process which employs a mixture of ethylene dichloride and benzol as the solvent.

Barrel (bbl): the unit of measure used by the petroleum industry; equivalent to approximately 42 US gallons or approximately 34 (33.6) Imperial gallons or 159 l; 7.2 barrels are equivalent to one tonne of oil (metric).

Barrel of oil equivalent (boe): the amount of energy contained in a barrel of crude oil, i.e. approximately 6.1 GJ (5.8 million Btu), equivalent to 1,700 kWh.

Base number: the quantity of acid, expressed in milligrams of potassium hydroxide per gram of sample that is required to titrate a sample to a specified end-point.

Base stock: a primary refined petroleum fraction into which other oils and additives are added (blended) to produce the finished product.

Basic nitrogen: nitrogen (in petroleum) which occurs in pyridine form

Basic sediment and water (BS&W, BSW): the material which collects in the bottom of storage tanks, usually composed of oil, water, and foreign matter; also called bottoms, bottom settlings.

Battery: a series of stills or other refinery equipment operated as a unit.

Baumé gravity: the specific gravity of liquids expressed as degrees on the Baumé (°Bé) scale; for liquids lighter than water:

$$\text{Sp gr } 60°\text{F} = 140/(130 + °\text{Bé})$$

For liquids heavier than water:

$$\text{Sp gr } 60°\text{F} = 145/(145 - °\text{Bé})$$

Bauxite: mineral matter used as a treating agent; hydrated aluminum oxide formed by the chemical weathering of igneous rock.

Bbl: see Barrel.

Bell cap: a hemispherical or triangular cover placed over the riser in a (distillation) tower to direct the vapors through the liquid layer on the tray; see Bubble cap.

Bender process: a chemical treating process using lead sulfide catalyst for sweetening light distillates by which mercaptan derivatives (RSH) are converted to disulfide derivatives (RSSR) by oxidation.

Bentonite: montmorillonite (a magnesium-aluminum silicate); used as a treating agent.

Benzene: a colorless aromatic liquid hydrocarbon (C_6H_6).

Benzin: refined light naphtha used for extraction purposes.

Benzine: an obsolete term for light petroleum distillates covering the gasoline and naphtha range; see Ligroine.

Benzol: the general term which refers to commercial or technical (not necessarily pure) benzene; also the term used for aromatic naphtha.

Beta-scission: the rupture of a carbon-carbon bond two bonds removed from an aromatic ring.

Billion: 1×10^9

Biochemical conversion: the use of fermentation or anaerobic digestion to produce fuels and chemicals from organic sources.

Biocide: any chemical capable of killing bacteria and biorganisms.

Biodiesel: a fuel derived from biological sources that can be used in diesel engines instead of petroleum-derived diesel; through the process of transesterification, the triglycerides in the biologically derived oils are separated from the glycerin, creating a clean-burning, renewable fuel.

Bioenergy: useful, renewable energy produced from organic matter - the conversion of the complex carbohydrates in organic matter to energy; organic matter may either be used directly as a fuel, processed into liquids and gasses, or be a residual of processing and conversion.

Bioethanol: ethanol produced from biomass feedstocks; includes ethanol produced from the fermentation of crops, such as corn, as well as cellulosic ethanol produced from woody plants or grasses.

Biofuels: a generic name for liquid or gaseous fuels that are not derived from petroleum-based fossils fuels or contain a proportion of non-fossil fuel; fuels produced from plants, crops such as sugar beet, rape seed oil or re-processed vegetable oils or fuels made from gasified

biomass; fuels made from renewable biological sources and include ethanol, methanol, and biodiesel; sources include, but are not limited to: corn, soybeans, flaxseed, rapeseed, sugarcane, palm oil, raw sewage, food scraps, animal parts, and rice.

Biogas: a combustible gas derived from decomposing biological waste under anaerobic conditions. Biogas normally consists of 50%–60% methane. See also landfill gas.

Biogenic: material derived from bacterial or vegetation sources.

Biological lipid: any biological fluid that is miscible with a nonpolar solvent. These materials include waxes, essential oils, chlorophyll, etc.

Biological oxidation: the oxidative consumption of organic matter by bacteria by which the organic matter is converted into gases.

Biomass: any organic matter that is available on a renewable or recurring basis, including agricultural crops and trees, wood and wood residues, plants (including aquatic plants), grasses, animal manure, municipal residues, and other residue materials. Biomass is generally produced in a sustainable manner from water and carbon dioxide by photosynthesis. There are three main categories of biomass - primary, secondary, and tertiary.

Biomass to liquid (BTL): the process of converting biomass to liquid fuels. Hmm, that seems painfully obvious when you write it out.

Biopolymer: a high molecular weight carbohydrate produced by bacteria.

Biopower: the use of biomass feedstock to produce electric power or heat through direct combustion of the feedstock, through gasification and then combustion of the resultant gas, or through other thermal conversion processes. Power is generated with engines, turbines, fuel cells, or other equipment.

Biorefinery: a facility that processes and converts biomass into value-added products. These products can range from biomaterials to fuels such as ethanol or important feedstocks for the production of chemicals and other materials.

Bitumen: also, on occasion, referred to as native asphalt, and extra heavy oil; a naturally occurring material that has little or no mobility under reservoir conditions and which cannot be recovered through a well by conventional oil well production methods including currently used enhanced recovery techniques; current methods involve mining for bitumen recovery.

Bituminous: containing bitumen or constituting the source of bitumen.

Bituminous rock: see Bituminous sand.

Bituminous sand: a formation in which the bituminous material (see Bitumen) is found as a filling in veins and fissures in fractured rock or impregnating relatively shallow sand, sandstone, and limestone strata; a sandstone reservoir that is impregnated with a heavy, viscous black petroleum-like material that cannot be retrieved through a well by conventional production techniques.

Black acid(s): a mixture of the sulfonates found in acid sludge which are insoluble in naphtha, benzene, and carbon tetrachloride; very soluble in water but insoluble in 30% sulfuric acid; in the dry, oil-free state, the sodium soaps are black powders.

Black liquor: solution of lignin-residue and the pulping chemicals used to extract lignin during the manufacture of paper.

Black oil: any of the dark-colored oils; a term now often applied to heavy oil.

Black soap: see Black acid.

Black strap: the black material (mainly lead sulfide) formed in the treatment of sour light oils with doctor solution and found at the interface between the oil and the solution.

Blown asphalt: the asphalt prepared by air blowing a residuum or an asphalt.

Bogging: a condition that occurs in a coking reactor when the conversion to coke and light ends is too slow causing the coke particles to agglomerate.

Boiling point: a characteristic physical property of a liquid at which the vapor pressure is equal to that of the atmosphere and the liquid is converted to a gas.

Boiling range: the range of temperature, usually determined at atmospheric pressure in standard laboratory apparatus, over which the distillation of an oil commences, proceeds, and finishes.

Bone dry: having 0% moisture content. Wood heated in an oven at a constant temperature of 100°C (212°F) or above until its weight stabilizes is considered bone dry or oven dry.

Bottled gas: usually butane or propane, or butane-propane mixtures, liquefied and stored under pressure for domestic use; see also Liquefied petroleum gas.

Bottoming cycle: a cogeneration system in which steam is used first for process heat and then for electric power production.

Bottoms: the liquid which collects in the bottom of a vessel (tower bottoms, tank bottoms) either during distillation; also the deposit or sediment formed during storage of petroleum or a petroleum product; see also Residuum and Basic sediment and water.

Bright stock: refined, high-viscosity lubricating oils usually made from residual stocks by processes such as a combination of acid treatment or solvent extraction with dewaxing or clay finishing.

British thermal unit: see Btu.

Bromine number: the number of grams of bromine absorbed by 100 g of an oil which indicates the percentage of double bonds in the material.

Brown acid: oil-soluble petroleum sulfonates found in acid sludge which can be recovered by extraction with naphtha solvent. Brown-acid sulfonates are somewhat similar to mahogany sulfonates but are more water-soluble. In the dry, oil-free state, the sodium soaps are light-colored powders.

Brown soap: see Brown acid.

Brønsted acid: a chemical species which can act as a source of protons.

Brønsted base: a chemical species which can accept protons.

BS&W: see Basic sediment and water.

BTEX: benzene, toluene, ethylbenzene, and the xylene isomers.

Btu (British thermal unit): the energy required to raise the temperature of one pound of water one degree Fahrenheit.

Bubble cap: an inverted cup with a notched or slotted periphery to disperse the vapor in small bubbles beneath the surface of the liquid on the bubble plate in a distillation tower.

Bubble plate: a tray in a distillation tower.

Bubble point: the temperature at which incipient vaporization of a liquid in a liquid mixture occurs, corresponding with the equilibrium point of 0% vaporization or 100% condensation.

Bubble tower: a fractionating tower so constructed that the vapors rising pass up through layers of condensate on a series of plates or trays (see Bubble plate); the vapor passes from one plate to the next above by bubbling under one or more caps (see Bubble cap) and out through the liquid on the plate where the less volatile portions of vapor condense in bubbling through the liquid on the plate, overflow to the next lower plate, and ultimately back into the reboiler thereby effecting fractionation.

Bubble tray: a circular, perforated plate having the internal diameter of a bubble tower, set at specified distances in a tower to collect the various fractions produced during distillation.

Buckley-Leverett method: a theoretical method of determining frontal advance rates and saturations from a fractional flow curve.

Bumping: the knocking against the walls of a still occurring during distillation of petroleum or a petroleum product which usually contains water.

Bunker: a storage tank.

Bunker C oil: see No. 6 Fuel oil.

Burner fuel oil: any petroleum liquid suitable for combustion.

Burning oil: an illuminating oil, such as kerosene (kerosine) suitable for burning in a wick lamp.

Burning point: see Fire point.

Burning-quality index: an empirical numerical indication of the likely burning performance of a furnace or heater oil; derived from the distillation profile and the API gravity, and generally recognizing the factors of paraffin character and volatility.

Burton process: an older thermal cracking process in which oil was cracked in a pressure still and any condensation of the products of cracking also took place under pressure.

Butane dehydrogenation: a process for removing hydrogen from butane to produce butenes and, on occasion, butadiene.

Butane vapor-phase isomerization: a process for isomerizing n-butane to *iso*-butane using aluminum chloride catalyst on granular alumina support and with hydrogen chloride as a promoter.

Butanol: though generally produced from fossil fuels, this four-carbon alcohol can also be produced through bacterial fermentation of alcohol.

C_1, C_2, C_3, C_4, C_5 fractions: a common way of representing fractions containing a preponderance of hydrocarbons having 1, 2, 3, 4, or 5 carbon atoms, respectively, and without reference to hydrocarbon type.

CAA (Clean Air Act): this act is the foundation of air regulations in the United States

Calcining: heating a metal oxide or an ore to decompose carbonates, hydrates, or other compounds often in a controlled atmosphere.

Capillary forces: interfacial forces between immiscible fluid phases, resulting in pressure differences between the two phases.

Capillary number: N_c, the ratio of viscous forces to capillary forces, and equal to viscosity times velocity divided by interfacial tension.

Carbene: the pentane- or heptane-insoluble material that is insoluble in benzene or toluene but which is soluble in carbon disulfide (or pyridine); a type of rifle used for hunting bison.

Carboid: the pentane- or heptane-insoluble material that is insoluble in benzene or toluene and which is also insoluble in carbon disulfide (or pyridine).

Carbon dioxide augmented waterflooding: injection of carbonated water, or water and carbon dioxide, to increase water flood efficiency; see immiscible carbon dioxide displacement.

Carbon dioxide miscible flooding: see EOR process.

Carbon-forming propensity: see Carbon residue.

Carbon monoxide (CO): a lethal gas produced by incomplete combustion of carbon-containing fuels in internal combustion engines. It is colorless, odorless, and tasteless. (As in flavorless, we mean, though it's also been known to tell a bad joke or two.)

Carbon-oxygen log: information about the relative abundance of elements such as carbon, oxygen, silicon, and calcium in a formation; usually derived from pulsed neutron equipment.

Carbon rejection: upgrading processes in which coke is produced, e.g. coking.

Carbon residue: the amount of carbonaceous residue remaining after thermal decomposition of petroleum, a petroleum fraction, or a petroleum product in a limited amount of air; also called the *coke-* or *carbon-forming propensity*; often prefixed by the terms Conradson or Ramsbottom in reference to the inventor of the respective tests.

Carbon sink: geographical area whose vegetation and/or soil soaks up significant carbon dioxide from the atmosphere. Such areas, typically in tropical regions, are increasingly being sacrificed for energy crop production.

Carbonate washing: processing using a mild alkali (e.g. potassium carbonate) process for emission control by the removal of acid gases from gas streams.

Carbonization: the conversion of an organic compound into char or coke by heat in the substantial absence of air; often used in reference to the destructive distillation (with simultaneous removal of distillate) of coal.

CAS: Chemical Abstract Service.

Cascade tray: a fractionating device consisting of a series of parallel troughs arranged on stair-step fashion in which liquid frown the tray above enters the uppermost trough and liquid thrown from this trough by vapor rising from the tray below impinges against a plate and a perforated baffle and liquid passing through the baffle enters the next longer of the troughs.

Casinghead gas: natural gas which issues from the casinghead (the mouth or opening) of an oil well.

Casinghead gasoline: the liquid hydrocarbon product extracted from casinghead gas by one of three methods: compression, absorption, or refrigeration; see also Natural gasoline.

Catagenesis: the alteration of organic matter during the formation of petroleum that may involve temperatures in the range 50°C (120°F) to 200°C (390°F); see also Diagenesis and Metagenesis.

Catalyst: a chemical agent that, when added to a reaction (process) will enhance the conversion of a feedstock without being consumed in the process.

Catalyst selectivity: the relative activity of a catalyst with respect to a particular compound in a mixture, or the relative rate in competing reactions of a single reactant.

Catalyst stripping: the introduction of steam, at a point where spent catalyst leaves the reactor, in order to strip, i.e., remove, deposits retained on the catalyst.

Catalytic activity: the ratio of the space velocity of the catalyst under test to the space velocity required for the standard catalyst to give the same conversion as the catalyst being tested; usually multiplied by 100 before being reported.

Catalytic cracking: the conversion of high-boiling feedstocks into lower boiling products by means of a catalyst which may be used in a fixed bed or fluid bed.

Cat cracking: see Catalytic cracking.

Catalytic reforming: rearranging hydrocarbon molecules in a gasoline-boiling-range feedstock to produce other hydrocarbons having a higher antiknock quality; isomerization of paraffins, cyclization of paraffins to naphthenes, dehydrocyclization of paraffins to aromatics.

Catforming: a process for reforming naphtha using a platinum-silica-alumina catalyst which permits relatively high space velocities and results in the production of high-purity hydrogen.

Caustic consumption: the amount of caustic lost from reacting chemically with the minerals in the rock, the oil, and the brine.

Caustic wash: the process of treating a product with a solution of caustic soda to remove minor impurities; often used in reference to the solution itself.

Ceresin: a hard, brittle wax obtained by purifying ozokerite; see Microcrystalline wax and Ozokerite).

Cetane index: an approximation of the cetane number calculated from the density and mid-boiling point temperature; see also Diesel index.

Cetane number: a number indicating the ignition quality of diesel fuel; a high cetane number represents a short ignition delay time; the ignition quality of diesel fuel can also be estimated from the following formula:

CFR (Code of Federal Regulations): title 40 (40 CFR) contains the regulations for the protection of the environment.

Characterization factor: the UOP characterization factor K, defined as the ratio of the cube root of the molal average boiling point, T_B, in degrees Rankine (°R = °F+460), to the specific gravity at 60°F/60°F:

$$K = (T_B)^{1/3} / sp\ gr$$

The value ranges from 12.5 for paraffin stocks to 10.0 for the highly aromatic stocks; also called the Watson characterization factor.

Cheesebox still: an early type of vertical cylindrical still designed with a vapor dome.

Chelating agents: complex-forming agents having the ability to solubilize heavy metals.

Chemical flooding: see the EOR process.

Chemical octane number: the octane number added to gasoline by refinery processes or by the use of octane number improvers such as tetraethyl lead.

Chemical waste: any solid, liquid, or gaseous material discharged from a process and that may pose substantial hazards to human health and the environment.

Chlorex process: a process for extracting lubricating-oil stocks in which the solvent used is Chlorex (β- β -dichlorodiethyl ether).

Chromatographic adsorption: selective adsorption on materials such as activated carbon, alumina, or silica gel; liquid or gaseous mixtures of hydrocarbons are passed through the adsorbent in a stream of diluent, and certain components are preferentially adsorbed.

Chromatographic separation: the separation of different species of compounds according to their size and interaction with the rock as they flow through a porous medium.

Chromatography: a method of separation based on selective adsorption; see also Chromatographic adsorption.

Clarified oil: the heavy oil which has been taken from the bottom of a fractionator in a catalytic cracking process and from which residual catalyst has been removed.

Clarifier: equipment for removing the color or cloudiness of an oil or water by separating the foreign material through mechanical or chemical means; may involve centrifugal action, filtration, heating, or treatment with acid or alkali.

Clastic: composed of pieces of pre-existing rock.

Clay: silicate minerals that also usually contain aluminum and have particle sizes are less than 0.002 micron; used in separation methods as an adsorbent and in refining as a catalyst.

Clay contact process: see Contact filtration.

Clay refining: a treating process in which vaporized gasoline or other light petroleum product is passed through a bed of granular clay such as fuller's earth.

Clay regeneration: a process in which spent coarse-grained adsorbent clay minerals from percolation processes are cleaned for reuse by de-oiling the clay minerals with naphtha, steaming out the excess naphtha, and then roasting in a stream of air to remove carbonaceous matter.

Clay treating: see Gray clay treating.

Clay wash: light oil, such as kerosene (kerosine) or naphtha, used to clean fuller's earth after it has been used in a filter.

Cleanup: a preparatory step following extraction of a sample media designed to remove components that may interfere with subsequent analytical measurements.

Closed-loop biomass: crops grown, in a sustainable manner, for the purpose of optimizing their value for bioenergy and bioproduct uses. This includes annual crops such as maize and wheat, and perennial crops such as trees, shrubs, and grasses such as switch grass.

Cloud point: the temperature at which paraffin wax or other solid substances begin to crystallize or separate from the solution, imparting a cloudy appearance to the oil when the oil is chilled under prescribed conditions.

Coal: an organic rock.

Coalescence: the union of two or more droplets to form a larger droplet and, ultimately, a continuous phase.

Coal tar: the specific name for the tar produced from coal.

Coal tar pitch: the specific name for the pitch produced from coal.

Coarse materials: wood residues suitable for chipping, such as slabs, edgings, and trimmings.

COFCAW: an EOR process that combines forward combustion and water flooding.

Cogeneration: an energy conversion method by which electrical energy is produced along with steam generated for EOR use.

Coke: a gray to black solid carbonaceous material produced from petroleum during thermal processing; characterized by having a high carbon content (95%+ by weight) and a honeycomb type of appearance and is insoluble in organic solvents.

Coke drum: a vessel in which coke is formed and which can be cut oil from the process for cleaning.

Coke number: used, particularly in Great Britain, to report the results of the Ramsbottom carbon residue test, which is also referred to as a coke test.

Coker: the processing unit in which coking takes place.

Coking: a process for the thermal conversion of petroleum in which gaseous, liquid, and solid (coke) products are formed.

Cold pressing: the process of separating wax from oil by first chilling (to help form wax crystals) and then filtering under pressure in a plate and frame press.

Cold settling: processing for the removal of wax from high-viscosity stocks, wherein a naphtha solution of the waxy oil is chilled and the wax crystallizes out of the solution.

Color stability: the resistance of a petroleum product to color change due to light, aging, etc.

Combined cycle: a combustion (gas) turbine equipped with a heat recovery steam generator that produces steam for the steam turbine; power is produced from both the gas and steam turbines – hence the term combined cycle.

Combustible liquid: a liquid with a flash point in excess of 37.8°C (100°F) but below 93.3°C (200°F).

Combustion zone: the volume of reservoir rock wherein petroleum is undergoing combustion during enhanced oil recovery.

Completion interval: the portion of the reservoir formation placed in fluid communication with the well by selectively perforating the wellbore casing.

Composition: the general chemical make-up of petroleum.

Composition map: a means of illustrating the chemical make-up of petroleum using chemical and/ or physical property data.

Con Carbon: see Carbon residue.

Condensate: a mixture of light hydrocarbon liquids obtained by condensation of hydrocarbon vapors: predominately butane, propane, and pentane with some heavier hydrocarbons and relatively little methane or ethane; see also Natural gas liquids.

Conductivity: a measure of the ease of flow through a fracture, perforation, or pipe.

Conformance: the uniformity with which a volume of the reservoir is swept by injection fluids in the area and vertical directions.

Conradson carbon residue: see Carbon residue.

Contact filtration: a process in which finely divided adsorbent clay is used to remove color bodies from petroleum products.

Contaminant: a substance that causes deviation from the normal composition of an environment.

Continuous contact coking: a thermal conversion process in which petroleum-wetted coke particles move downward into the reactor in which cracking, coking, and drying take place to produce coke, gas, gasoline, and gas oil.

Continuous contact filtration: a process to finish lubricants, waxes, or special oils after acid treating, solvent extraction, or distillation.

Conventional crude oil (conventional petroleum): crude oil that is pumped from the ground and recovered using the energy inherent in the reservoir; also recoverable by application of secondary recovery techniques.

Conventional recovery: primary and/or secondary recovery.

Conversion: the thermal treatment of petroleum which results in the formation of new products by the alteration of the original constituents.

Conversion cost: the cost of changing a production well to an injection well, or some other change in the function of an oilfield installation.

Conversion factor: the percentage of feedstock converted to light ends, gasoline, other liquid fuels, and coke.

Copper sweetening: processes involving the oxidation of mercaptan derivatives (RSH) to disulfide derivatives (RSSR) by oxygen in the presence of cupric chloride ($CuCl_2$).

Cord: a stack of wood comprising 128 cubic feet ($3.62\,m^3$); standard dimensions are $4 \times 4 \times 8$ feet, including air space and bark. One cord contains approx. 1.2 U.S. tons (oven-dry)=2,400 pounds=1,089 kg.

Core floods: laboratory flow tests through samples (cores) of porous rock.

Co-surfactant: a chemical compound, typically alcohol that enhances the effectiveness of a surfactant.

Cp (centipoise): a unit of viscosity.

Cracked residua: residua that have been subjected to temperatures above 350°C (660°F) during the distillation process.

Cracking: the thermal processes by which the constituents of petroleum are converted to lower molecular weight products.

Cracking activity: see Catalytic activity.

Cracking coil: equipment used for cracking heavy petroleum products consisting of a coil of heavy pipe running through a furnace so that the oil passing through it is subject to high temperature.

Cracking still: the combined equipment-furnace, reaction chamber, fractionator for the thermal conversion of heavier feedstocks to lighter products.

Cracking temperature: the temperature (350°C; 660°F) at which the rate of thermal decomposition of petroleum constituents becomes significant.

Craig-Geffen-Morse method: a method for predicting oil recovery by water flood.

Criteria air pollutants: air pollutants or classes of pollutants regulated by the Environmental Protection Agency; the air pollutants are (including VOCs): ozone, carbon monoxide, particulate matter, nitrogen oxides, sulfur dioxide, and lead.

Cropland: total cropland includes five components: cropland harvested, crop failure, cultivated summer fallow, cropland used only for pasture, and idle cropland.

Cropland pasture: land used for long-term crop rotation. However, some cropland pasture is marginal for crop uses and may remain in pasture indefinitely. This category also includes land that was used for pasture before crops reached maturity and some land used for pasture that could have been cropped without additional improvement.

Cross-linking: combining two or polymer molecules by use of a chemical that mutually bonds with a part of the chemical structure of the polymer molecules.

Crude assay: a procedure for determining the general distillation characteristics (e.g., distillation profile, *q.v.*) and other quality information of crude oil.

Crude oil: see Petroleum.

Crude scale wax: the wax product from the first sweating of the slack wax.

Crude still: distillation equipment in which crude oil is separated into various products.

Cull tree: a live tree, 5.0 inches in diameter at breast height (d.b.h.) or larger that is non-merchantable for saw logs now or prospectively because of rot, roughness, or species. (See definitions for rotten and rough trees.)

Cultivated summer fallow: cropland cultivated for one or more seasons to control weeds and accumulate moisture before small grains are planted.

Cumene: a colorless liquid [$C_6H_5CH(CH_3)_2$] used as an aviation gasoline blending component and as an intermediate in the manufacture of chemicals.

Cut point: the boiling-temperature division between distillation fractions of petroleum.

Cutback: the term applied to the products from blending heavier feedstocks or products with lighter oils to bring heavier materials to the desired specifications.

Cutback asphalt: asphalt liquefied by the addition of a volatile liquid such as naphtha or kerosene which, after application and on exposure to the atmosphere, evaporates leaving the asphalt.

Cutting oil: an oil to lubricate and cool metal-cutting tools; also called cutting fluid, cutting lubricant.

Cycle stock: the product taken from some later stage of a process and recharged (recycled) to the process at some earlier stage.

Cyclic steams injection: the alternating injection of steam and production of oil with condensed steam from the same well or wells.

Cyclization: the process by which an open-chain hydrocarbon structure is converted to a ring structure, e.g., hexane to benzene.

Cyclone: a device for extracting dust from industrial waste gases. It is in the form of an inverted cone into which the contaminated gas enters tangentially from the top; the gas is propelled down a helical pathway, and the dust particles are deposited by means of centrifugal force onto the wall of the scrubber.

Deactivation: reduction in catalyst activity by the deposition of contaminants (e.g., coke, metals) during a process.

Dealkylation: the removal of an alkyl group from aromatic compounds.

Deasphaltened oil: the fraction of petroleum after the asphaltene constituents have been removed.

Deasphaltening: removal of a solid powdery asphaltene fraction from petroleum by the addition of the low-boiling liquid hydrocarbons such as n-pentane or n-heptane under ambient conditions.

Deasphalting: the removal of the asphaltene fraction from petroleum by the addition of a low-boiling hydrocarbon liquid such as n-pentane or n-heptane; more correctly the removal asphalt (tacky, semi-solid) from petroleum (as occurs in a refinery asphalt plant) by the addition of liquid propane or liquid butane under pressure.

Debutanization: distillation to separate butane and lighter components from higher boiling components.

Decant oil: the highest boiling product from a catalytic cracker; also referred to as slurry oil, clarified oil, or bottoms.

Decarbonizing: a thermal conversion process designed to maximize coker gas-oil production and minimize coke and gasoline yields; operated at essentially lower temperatures and pressures than delayed coking.

Decoking: removal of petroleum coke from equipment such as coking drums; hydraulic decoking uses high-velocity water streams.

Decolorizing: removal of suspended, colloidal, and dissolved impurities from liquid petroleum products by filtering, adsorption, chemical treatment, distillation, bleaching, etc.

De-ethanization: distillation to separate ethane and lighter components from propane and higher-boiling components; also called de-ethanation.

Degradation: the loss of desirable physical properties of EOR fluids, e.g., the loss of viscosity of polymer solutions.

Dehydrating agents: substances capable of removing water (drying, q.v.) or the elements of water from another substance.

Dehydrocyclization: any process by which both dehydrogenation and cyclization reactions occur.

Dehydrogenation: the removal of hydrogen from a chemical compound; for example, the removal of two hydrogen atoms from butane to make butene(s) as well as the removal of additional hydrogen to produce butadiene.

Delayed coking: a coking process in which the thermal reaction is allowed to proceed to completion to produce gaseous, liquid, and solid (coke) products.

Demethanization: the process of distillation in which methane is separated from the higher boiling components; also called demethanation.

Density: the mass (or weight) of a unit volume of any substance at a specified temperature; see also Specific gravity.

Deoiling: reduction in the quantity of liquid oil entrained in solid wax by draining (sweating) or by a selective solvent; see MEK deoiling.

Depentanizer: a fractionating column for the removal of pentane and lighter fractions from a mixture of hydrocarbons.

Depropanization: distillation in which lighter components are separated from butanes and higher boiling material; also called depropanation.

Desalting: removal of mineral salts (mostly chlorides) from crude oils.

Desorption: the reverse process of adsorption whereby adsorbed matter is removed from the adsorbent; also used as the reverse of absorption.

Desulfurization: the removal of sulfur or sulfur compounds from a feedstock.

Detergent oil: lubricating oil possessing special sludge-dispersing properties for use in internal-combustion engines.

Devolatilized fuel: smokeless fuel; coke that has been reheated to remove all of the volatile material.

Dewaxing: see Solvent dewaxing.

Diagenesis: the concurrent and consecutive chemical reactions which commence the alteration of organic matter (at temperatures up to 50°C (120°F) and ultimately result in the formation of petroleum from the marine sediment; see also Catagenesis and Metagenesis.

Diagenetic rock: rock formed by conversion through pressure or chemical reaction) from a rock, e.g., sandstone is diagenetic.

Diesel cycle: a repeated succession of operations representing the idealized working behavior of the fluids in a diesel engine.

Diesel engine: named for the German engineer Rudolph Diesel, this internal-combustion, compression-ignition engine works by heating fuels and causing them to ignite; can use either petroleum or bio-derived fuel.

Diesel fuel: fuel used for internal combustion in diesel engines; usually that fraction which distills after kerosene.

Diesel index: an approximation of the cetane number of diesel fuel calculated from the density and aniline point.

$$DI = (\text{aniline point (°F)} \times \text{API gravity})100$$

Diesel knock: the -result of a delayed period of ignition is long and the accumulated of diesel fuel in the engine.

Differential-strain analysis: measurement of thermal stress relaxation in a recently cut well.

Digester: an airtight vessel or enclosure in which bacteria decompose biomass in water to produce biogas.

Direct-injection engine: a diesel engine in which fuel is injected directly into the cylinder.

Dispersion: a measure of the convective mi fluids due to flow in a reservoir.

Displacement efficiency: the ratio of the amount of oil moved from the zone swept by the reprocess to the amount of oil present in the zone prior to the start of the process.

Distillate: any petroleum product produced by boiling crude oil and collecting the vapors produced as condensate in a separate vessel, for example, gasoline (light distillate), gas oil (middle distillate), or fuel oil (heavy distillate).

Distillation: the primary distillation process which uses high temperature to separate crude oil into vapor and fluids which can then be fed into a distillation or fractionating tower.

Distillation curve: see Distillation profile.

Distillation loss: the difference, in a laboratory distillation, between the volume of liquid originally introduced into the distilling flask and the sum of the residue and the condensate recovered.

Distillation profile: the distillation characteristics of petroleum or petroleum products showing the temperature and the per cent distilled.

Distillation range: the difference between the temperature at the initial boiling point and at the end point, as obtained by the distillation test.

Distribution coefficient: a coefficient that describes the distribution of a chemical in reservoir fluids, usually defined as the equilibrium concentrations in the aqueous phases.

Doctor solution: a solution of sodium plumbite used to treat gasoline or other light petroleum distillates to remove mercaptan sulfur; see also Doctor test.

Doctor sweetening: a process for sweetening gasoline, solvents, and kerosene by converting mercaptan derivatives (RSH) to disulfide derivatives (RSSR) using sodium plumbite (Na_2PbO_2) and sulfur.

Doctor test: a test used for the detection of compounds in light petroleum distillates which react with sodium plumbite; see also Doctor solution.

Domestic heating oil: see No. 2 Fuel Oil.

Donor solvent process: a conversion process in which hydrogen donor solvent is used in place of or to augment hydrogen.

Downcomer: a means of conveying liquid from one tray to the next below in a bubble tray column.

Downdraft gasifier: a gasifier in which the product gases pass through a combustion zone at the bottom of the gasifier.

Downhole steam generator: a generator installed downhole in an oil well to which oxygen-rich air, fuel, and water are supplied for the purposes of generating steam for it into the reservoir. Its major advantage over a surface steam-generating facility is the losses to the wellbore and surrounding formation are eliminated.

Dropping point: the temperature at which grease passes from a semisolid to a liquid state under prescribed conditions.

Dry gas: a gas that does not contain fractions that may easily condense under normal atmospheric conditions.

Dry point: the temperature at which the last drop of petroleum fluid evaporates in a distillation test.

Drying: removal of a solvent or water from a chemical substance; also referred to as the removal of solvent from a liquid or suspension.

Dualayer distillate process: a process for removing mercaptan derivatives (RSH) and oxygenated compounds from distillate fuel oils and similar products, using a combination of treatment with concentrated caustic solution and electrical precipitation of the impurities.

Dualayer gasoline process: a process for extracting mercaptan derivatives (RSH) and other objectionable acidic compounds from petroleum distillates; see also Dualayer solution.

Dualayer solution: a solution that consists of concentrated potassium or sodium hydroxide containing a solubilizer; see also Dualayer gasoline process.

Dubbs cracking: an older continuous, liquid-phase thermal cracking process formerly used.

Dutch oven furnace: one of the earliest types of furnaces, having a large, rectangular box lined with firebrick (refractory) on the sides and top; commonly used for burning wood.

Dykstra-Parsons coefficient: an index of reservoir heterogeneity arising from permeability variation and stratification.

E85: an alcohol fuel mixture containing 85% ethanol and 15% gasoline by volume, and the current alternative fuel of choice of the U.S. government.

Ebullated bed: a process in which the catalyst bed is in a suspended state in the reactor by means of a feedstock recirculation pump which pumps the feedstock upwards at sufficient speed to expand the catalyst bed at approximately 35% above the settled level.

Edeleanu process: a process for refining oils at low temperature with liquid sulfur dioxide (SO_2), or with liquid sulfur dioxide and benzene; applicable to the recovery of aromatic concentrates from naphtha and heavier petroleum distillates.

Effective viscosity: see Apparent viscosity.

Effluent: any contaminating substance, usually a liquid, which enters the environment via a domestic industrial, agricultural, or sewage plant outlet.

Electric desalting: a continuous process to remove inorganic salts and other impurities from crude oil by settling out in an electrostatic field.

Electrical precipitation: a process using an electrical field to improve the separation of hydrocarbon reagent dispersions. May be used in chemical treating processes on a wide variety of refinery stocks.

Electrofining: a process for contacting a light hydrocarbon stream with a treating agent (acid, caustic, doctor, etc.), then assisting the action of separation of the chemical phase from the hydrocarbon phase by an electrostatic field.

Electrolytic mercaptan process: a process in which aqueous caustic solution is used to extract mercaptan derivatives (RSH) from refinery streams.

Electrostatic precipitators: devices used to trap fine dust particles (usually in the size range 30–60 microns) that operate on the principle of imparting an electric charge to particles in an incoming air stream and which are then collected on an oppositely charged plate across a high voltage field.

Eluate: the solutes, or analytes, moved through a chromatographic column (see *elution*).

Eluent: solvent used to elute sample.

Elution: a process whereby a solute is moved through a chromatographic column by a solvent (liquid or gas) or eluent.

Emission control: the use of gas cleaning processes to reduce emissions.

Emission standard: the maximum amount of a specific pollutant permitted to be discharged from a particular source in a given environment.

Emissions: substances discharged into the air during combustion.

Emulsion: a dispersion of very small drops of one liquid in an immiscible liquid, such as oil in water.

Emulsion breaking: the settling or aggregation of colloidal-sized emulsions from suspension in a liquid medium.

End-of-pipe emission control: the use of specific emission control processes to clean gases after the production of the gases.

Energy: the capacity of a body or system to do work, measured in joules (SI units); also the output of fuel sources.

Energy balance: the difference between the energy produced by fuel and the energy required to obtain it through agricultural processes, drilling, refining, and transportation.

Energy crops: crops grown specifically for their fuel value; include food crops such as corn and sugarcane, and nonfood crops such as poplar trees and switch grass.

Energy-efficiency ratio: a number representing the energy stored in fuel as compared to the energy required to produce, process, transport, and distribute that fuel.

Energy from biomass: the production of energy from biomass.

Engler distillation: a standard test for determining the volatility characteristics of gasoline by measuring the per cent distilled at various specified temperatures.

Enhanced oil recovery (EOR): petroleum recovery following recovery by conventional (i.e., primary and/or secondary) methods.

Enhanced oil recovery (EOR) process: a method for recovering additional oil from a petroleum reservoir beyond that economically recoverable by conventional primary and secondary recovery methods. EOR methods are usually divided into three main categories: (i) *chemical flooding:* injection of water with added chemicals into a petroleum reservoir. The chemical processes include surfactant flooding, polymer flooding, and alkaline flooding, (ii) *miscible flooding:* injection into a petroleum reservoir of a material that is miscible or can become miscible, with the oil in the reservoir. Carbon dioxide, hydrocarbons, and nitrogen are used, (iii) *thermal recovery:* injection of steam into a petroleum reservoir, or propagation of a combustion zone through a reservoir by air or oxygen-enriched air injection. The thermal processes include steam drive, cyclic steam injection, and in situ combustion.

Entrained bed: a bed of solid particles suspended in a fluid (liquid or gas) at such a rate that some of the solid is carried over (entrained) by the fluid.

EPA: Environmental Protection Agency.

Ester: a compound formed by the reaction between an organic acid and an alcohol. ethoxylated alcohols (i.e., alcohols having ethylene oxide functional groups attached to the alcohol molecule).

Ethanol (ethyl alcohol, alcohol, or grain-spirit): a clear, colorless, flammable oxygenated hydrocarbon; used as vehicle fuel by itself (E100 is 100% ethanol by volume), blended with gasoline (E85 is 85% ethanol by volume), or as a gasoline octane enhancer and oxygenate (10% by volume); formed during the fermentation of sugars; used as an intoxicant and as a fuel.

Evaporation: a process for concentrating nonvolatile solids in a solution by boiling off the liquid portion of the waste stream.

Expanding clays: clays that expand or swell on contact with water, e.g., montmorillonite.

Explosive limits: the limits of percentage composition of mixtures of gases and air within which an explosion takes place when the mixture is ignited.

Extract: the portion of a sample preferentially dissolved by the solvent and recovered by physically separating the solvent.

Extractive distillation: the separation of different components of mixtures which have similar vapor pressures by flowing a relatively high-boiling solvent, which is selective for one of the components in the feed, down a distillation column as the distillation proceeds; the selective solvent scrubs the soluble component from the vapor.

Fabric filters: filters made from fabric materials and used for removing particulate matter from gas streams (see Baghouse).

Facies: one or more layers of rock that differ from other layers in a composition, age, or content.

FAST: Fracture assisted steamflood technology.

Fat oil: the bottom or enriched oil drawn from the absorber as opposed to lean oil.

Faujasite: a naturally-occurring silica-alumina (SiO_2-Al_2O_3) mineral.

FCC: fluid catalytic cracking.

FCCU: fluid catalytic cracking unit.

Feedstock: petroleum as it is fed to the refinery; a refinery product that is used as the raw material for another process; biomass used in the creation of a particular biofuel (e.g., corn or sugarcane for ethanol, soybeans or rapeseed for biodiesel); the term is also generally applied to raw materials used in other industrial processes.

Fermentation: conversion of carbon-containing compounds by micro-organisms for the production of fuels and chemicals such as alcohols, acids, or energy-rich gases.

Ferrocyanide process: a regenerative chemical treatment for mercaptan removal using caustic-sodium ferrocyanide reagent.

Field-scale: the application of EOR processes to a significant portion of a field.

Filtration: the use of an impassable barrier to collect solids but which allows liquids to pass. Fiber products; Products derived from fibers of herbaceous and woody plant materials; examples include pulp, composition board products, and wood chips for export.

Fine materials: wood residues not suitable for chipping, such as planer shavings and sawdust.

Fingering: the formation of finger-shaped irregularities at the leading edge of a displacing fluid in a porous medium which moves out ahead of the main body of fluid.

Fire point: the lowest temperature at which, under specified conditions in standardized apparatus, a petroleum product vaporizes sufficiently rapidly to form above its surface an air-vapor mixture which burns continuously when ignited by a small flame.

First contact miscibility: see miscibility.

Fischer–Tropsch process: a process for synthesizing hydrocarbons and oxygenated chemicals from a mixture of hydrogen and carbon monoxide.

Five-spot: an arrangement or pattern of wells with four injection wells at the comers of a square and a producing well in the center of the square.

Fixed bed: a stationary bed (of catalyst) to accomplish a process (see Fluid bed).

Flammable: a substance that will burn readily.

Flammable liquid: a liquid having a flash point below 37.8°C (100°F).

Flammable solid: a solid that can ignite from friction or from heat remaining from its manufacture, or which may cause a serious hazard if ignited.

Flammability range: the range of temperature over which a chemical is flammable.

Flash point: the lowest temperature to which the product must be heated under specified conditions to give off sufficient vapor to form a mixture with air that can be ignited momentarily by a flame.

Flexible-fuel vehicle (flex-fuel vehicle): a vehicle that can run alternately on two or more sources of fuel; includes cars capable of running on gasoline and gasoline/ethanol mixtures, as well as cars that can run on both gasoline and natural gas.

Flexicoking: a modification of the fluid coking process insofar as the process also includes a gasifier adjoining the burner/regenerator to convert excess coke to clean fuel gas.

Floc point: the temperature at which wax or solids separate as a definite floc.

Flocculation threshold: the point at which constituents of a solution (e.g. asphaltene constituents or coke precursors) will separate from the solution as a separate (solid) phase.

Flood, flooding: the process of displacing petroleum from a reservoir by the injection of fluids.

Flue gases: the gaseous products of the combustion process mostly comprised of carbon dioxide, nitrogen, and water vapor.

Fluid: a reservoir gas or liquid.

Fluid-bed: a bed (of catalyst) that is agitated by an upward passing gas in such a manner that the particles of the bed simulate the movement of fluid and have the characteristics associated with a true liquid; c.f. Fixed bed.

Fluid catalytic cracking: cracking in the presence of a fluidized bed of catalyst.

Fluid coking: a continuous fluidized solids process that cracks feed thermally overheated coke particles in a reactor vessel to gas, liquid products, and coke.

Fluidized bed combustion: a process used to burn low-quality solid fuels in a bed of small particles suspended by a gas stream (usually air that will lift the particles but not blow them out of the vessel. Rapid burning removes some of the offensive by-products of combustion from the gases and vapors that result from the combustion process.

Fluidized-bed boiler: a large, refractory-lined vessel with an air distribution member or plate in the bottom, a hot gas outlet in or near the top, and some provisions for introducing fuel; the fluidized bed is formed by blowing air up through a layer of inert particles (such as sand or limestone) at a rate that causes the particles to go into suspension and continuous motion.

Fly ash: particulate matter produced from mineral matter in coal that is converted during combustion to finely divided inorganic material and which emerges from the combustor in the gases.

Foots oil: the oil sweated out of slack wax; named from the fact that the oil goes to the foot, or bottom, of the pan during the sweating operation.

Forest health: a condition of ecosystem sustainability and attainment of management objectives for a given forest area; usually considered to include green trees, snags, resilient stands growing at a moderate rate, and endemic levels of insects and disease.

Forest land: land at least 10% stocked by forest trees of any size, including land that formerly had such tree cover and that will be naturally or artificially regenerated; includes transition zones, such as areas between heavily forested and non-forested lands that are at least 10% stocked with forest trees and forest areas adjacent to urban and built-up lands; also included are pinyon-juniper and chaparral areas; minimum area for classification of forest land is 1 acre.

Forest residues: material not harvested or removed from logging sites in commercial hardwood and softwood stands as well as material resulting from forest management operations such as pre-commercial thinning and removal of dead and dying trees.

Formation: an interval of rock with distinguishable geologic characteristics.

Formation volume factor: the volume in a barrel that one stock tank barrel occupies in the formation at reservoir temperature and with the solution gas that is held in the oil at reservoir pressure.

Fossil fuel resources: a gaseous, liquid, or solid fuel material formed in the ground by chemical and physical changes (diagenesis, q.v.) in plant and animal residues over geological time; natural gas, petroleum, coal, and oil shale.

Fractional composition: the composition of petroleum as determined by fractionation (separation) methods.

Fractional distillation: the separation of the components of a liquid mixture by vaporizing and collecting the fractions, or cuts, which condense in different temperature ranges.

Fractional flow: the ratio of the volumetric flow rate of one fluid phase to the total fluid volumetric flow rate within a volume of rock.

Fractional flow curve: the relationship between the fractional flow of one fluid and its saturator during the simultaneous flow of fluids through rock.

Fractionating column: a column arranged to separate various fractions of petroleum by a single distillation and which may be tapped at different points along its length to separate various fractions in the order of their boiling points.

Fractionation: the separation of petroleum into the constituent fractions using solvent or adsorbent methods; chemical agents such as sulfuric acid may also be used.

Fracture: a natural or man-made crack in a reservoir rock.

Fracturing: the breaking apart of reservoir rock by applying very high fluid pressure at the rock face.

Frasch process: a process formerly used for removing sulfur by distilling oil in the presence of copper oxide.

Fuel cell: A device that converts the energy of a fuel directly to electricity and heat, without combustion.

Fuel cycle: The series of steps required to produce electricity. The fuel cycle includes mining or otherwise acquiring the raw fuel source, processing and cleaning the fuel, transport, electricity generation, waste management, and plant decommissioning.

Fuel oil: also called heating oil is a distillate product that covers a wide range of properties; see also No. 1 to No. 4 Fuel oils.

Fuel treatment evaluator (FTE): a strategic assessment tool capable of aiding the identification, evaluation, and prioritization of fuel treatment opportunities.

Fuel wood: wood used for conversion to some form of energy, primarily for residential use.

Fuller's earth: a clay which has high adsorptive capacity for removing color from oils; Attapulgus clay is a widely used fuller's earth.

Functional group: the portion of a molecule that is characteristic of a family of compounds and determines the properties of these compounds.

Furfural extraction: a single-solvent process in which furfural is used to remove aromatic, naphthene, olefin, and unstable hydrocarbons from a lubricating-oil charge stock.

Furnace: An enclosed chamber or container used to burn biomass in a controlled manner to produce heat for space or process heating.

Furnace oil: a distillate fuel primarily intended for use in domestic heating equipment.

Gas cap: a part of a hydrocarbon reservoir at the top that will produce only gas.

Gaseous pollutants: gases released into the atmosphere that act as primary or secondary pollutants.

Gasification: a chemical or thermal process used to convert carbonaceous material (such as coal, petroleum, and biomass) into gaseous components such as carbon monoxide and hydrogen; a process for converting a solid or liquid fuel into a gaseous fuel useful for power generation or chemical feedstock with an oxidant and steam.

Gasifier: a device for converting solid fuel into gaseous fuel; in biomass systems, the process is referred to as pyrolitic distillation.

Gasifier cold gas efficiency (CGE): the percentage of the coal heating value that appears as a chemical heating value in the gasifier product gas.

Gasohol: a mixture of 10% v/v anhydrous ethanol and 90% v/v gasoline; 7.5% v/v anhydrous ethanol and 92.5% v/v gasoline; or 5.5% v/v anhydrous ethanol and 94.5% v/v gasoline; a term for motor vehicle fuel comprising between 80% v/v–90% v/v unleaded gasoline and 10% v/v–20% v/v ethanol (see also Ethyl alcohol).

Gas oil: a petroleum distillate with a viscosity and boiling range between those of kerosene and lubricating oil.

Gas-oil ratio: the ratio of the number of cubic feet of gas measured at atmospheric (standard) conditions to barrels of produced oil measured at stock tank conditions.

Gas-oil sulfonate: sulfonate made from a specific refinery stream, in this case, the gas-oil stream.

Gasoline: fuel for the internal combustion engine that is commonly, but improperly, referred to simply as gas.

Gas reversion: a combination of thermal cracking or reforming of naphtha with thermal polymerization or alkylation of hydrocarbon gases carried out in the same reaction zone.

Gas to liquids (GTL): the process of refining natural gas and other hydrocarbons into longer-chain hydrocarbons, which can be used to convert gaseous waste products into fuels.

Gas turbine: a device in which fuel is combusted at pressure and the products of combustion expanded through a turbine to generate power (the Brayton Cycle); it is based on the same principle as the jet engine.

Gel point: the point at which a liquid fuel cools to the consistency of petroleum jelly.

Genetically modified organism (GMO): an organism whose genetic material has been modified through recombinant DNA technology, altering the phenotype of the organism to meet desired specifications.

Gilsonite: an asphaltite that is >90% bitumen.

Girbotol process: a continuous, regenerative process to separate hydrogen sulfide, carbon dioxide, and other acid impurities from natural gas, refinery gas, etc., using mono-, di-, or triethanolamine as the reagent.

Glance pitch: an asphaltite.

Grain alcohol: see Ethyl alcohol.

Grahamite: an asphaltite.

Glycol-amine gas treating: a continuous, regenerative process to simultaneously dehydrate and remove acid gases from natural gas or refinery gas.

Grassland pasture and range: all open land used primarily for pasture and grazing, including shrub and brush land types of pasture; grazing land with sagebrush and scattered mesquite; and all tame and native grasses, legumes, and other forage used for pasture or grazing; because of the diversity in vegetative composition, grassland pasture and range are not always clearly distinguishable from other types of pasture and range; at one extreme, permanent grassland may merge with cropland pasture, or grassland may often be found in transitional areas with forested grazing land.

Gravimetric: gravimetric methods weigh a residue.

Gravity: see API gravity.

Gravity drainage: the movement of oil in a reservoir that results from the force of gravity.

Gravity segregation: partial separation of fluids in a reservoir caused by the gravity force acting on differences in density.

Gravity-stable displacement: the displacement of oil from a reservoir by a fluid of a different density, where the density difference is utilized to prevent gravity segregation of the injected fluid.

Gray clay treating: a fixed-bed, usually fuller's earth, vapor-phase treating process to selectively polymerize unsaturated gum-forming constituents (diolefins) in thermally cracked gasoline.

Grease car: a diesel-powered automobile rigged post-production to run on used vegetable oil.

Greenhouse effect: the effect of certain gases in the Earth's atmosphere in trapping heat from the sun.

Greenhouse gases: gases that trap the heat of the sun in the Earth's atmosphere, producing the greenhouse effect. The two major greenhouse gases are water vapor and carbon dioxide. Other greenhouse gases include methane, ozone, chlorofluorocarbons, and nitrous oxide.

Grid: an electric utility company's system for distributing power.

Growing stock: a classification of timber inventory that includes live trees of commercial species meeting specified standards of quality or vigor; cull trees are excluded.

Guard bed: a bed of an adsorbent (such as, for example, bauxite) that protects a catalyst bed by adsorbing species detrimental to the catalyst.

Gulf HDS process: a fixed-bed process for the catalytic hydrocracking of heavy stocks to lower-boiling distillates with accompanying desulfurization.

Gulfining: catalytic hydrogen treating process for cracked and straight-run distillates and fuel oils, to reduce sulfur content; improve carbon residue, color, and general stability; and effect a slight increase in gravity.

Gum: an insoluble tacky semi-solid material formed as a result of the storage instability and/or the thermal instability of petroleum and petroleum products.

Habitat: the area where a plant or animal lives and grows under natural conditions. Habitat includes living and non-living attributes and provides all requirements for food and shelter.

HAP(s): hazardous air pollutant(s).

Hardness: the concentration of calcium and magnesium in brine.

Hardwoods: usually broad-leaved and deciduous trees.

HCPV: hydrocarbon pore volume.

Headspace: the vapor space above a sample into which volatile molecules evaporate. Certain methods sample this vapor.

Hearn method: a method used in reservoir simulation for calculating a pseudo relative permeability curve that reflects reservoir stratification.

Heat recovery steam generator: a heat exchanger that generates steam from the hot exhaust gases from a combustion turbine.

Heating oil: see Fuel oil.

Heating value: the maximum amount of energy that is available from burning a substance.

Heavy ends: the highest boiling portion of a petroleum fraction; see also Light ends.

Heavy fuel oil: fuel oil having a high density and viscosity; generally residual fuel oil such as No. 5 and No 6. fuel oil

Heavy (crude) oil: oil that is more viscous than conventional crude oil, has lower mobility in the reservoir but can be recovered through a well from the reservoir by the application of a secondary or enhanced recovery method; sometimes petroleum having an API gravity of less than 20°.

Heavy petroleum: see Heavy oil.

Hectare: common metric unit of area, equal to 2.47 acres. 100 hectares=1 square kilometer.

Herbaceous: non-woody type of vegetation, usually lacking permanent strong stems, such as grasses, cereals, and canola (rape).

Heteroatom compounds: chemical compounds that contain nitrogen and/or oxygen and/or sulfur and /or metals bound within their molecular structure(s).

Heterogeneity: lack of uniformity in reservoir properties such as permeability.

HF alkylation: an alkylation process whereby olefins (C_3, C_4, C_5) are combined with *iso*-butane in the presence of a hydrofluoric acid catalyst.

Higgins-Leighton model: stream tube computer model used to simulate waterflood.

Hortonsphere (Horton sphere): a spherical pressure-type tank used to store a volatile liquid which prevents the excessive evaporation loss that occurs when such products are placed in conventional storage tanks.

Hot filtration test: a test for the stability of a petroleum product.

Hot spot: an area of a vessel or line wall appreciably above normal operating temperature, usually as a result of the deterioration of an internal insulating liner which exposes the line or vessel shell to the temperature of its contents.

Houdresid catalytic cracking: a continuous moving-bed process for catalytically cracking reduced crude oil to produce high octane gasoline and light distillate fuels.

Houdriflow catalytic cracking: a continuous moving-bed catalytic cracking process employing an integrated single vessel for the reactor and regenerator kiln.

Houdriforming: a continuous catalytic reforming process for producing aromatic concentrates and high-octane gasoline from low-octane straight naphtha.

Houdry butane dehydrogenation: a catalytic process for dehydrogenating light hydrocarbons to their corresponding mono- or diolefins.

Houdry fixed-bed catalytic cracking: a cyclic regenerable process for cracking of distillates.

Houdry hydrocracking: a catalytic process combining cracking and desulfurization in the presence of hydrogen.

Huff-and-puff: a cyclic EOR method in which steam or gas is injected into a production well; after a short shut-in period, oil and the injected fluid are produced through the same well.

Hydration: the association of molecules of water with a substance.

Hydraulic fracturing: the opening of fractures in a reservoir by high-pressure, high-volume injection of liquids through an injection well.

Hydrocarbon compounds: chemical compounds containing only carbon and hydrogen.

Hydrocarbon-producing resource: a resource such as coal and oil shale (kerogen) which produces derived hydrocarbons by the application of conversion processes; the hydrocarbons so-produced are not naturally-occurring materials.

Hydrocarbon resource: resources such as petroleum and natural gas which can produce naturally-occurring hydrocarbons without the application of conversion processes.

Hydrocarbonaceous material: material such as bitumen that is composed of carbon and hydrogen with other elements (heteroelements) such as nitrogen, oxygen, sulfur, and metals chemically combined within the structures of the constituents; even though carbon and hydrogen may be the predominant elements, there may be very few true hydrocarbons.

Hydrocarbons: organic compounds containing only hydrogen and carbon.

Hydrolysis: a chemical reaction in which water reacts with another substance to form one or more new substances.

Hydroconversion: a term often applied to hydrocracking.

Hydrocracking: a catalytic high-pressure high-temperature process for the conversion of petroleum feedstocks in the presence of fresh and recycled hydrogen; carbon-carbon bonds are cleaved in addition to the removal of heteroatomic species.

Hydrocracking catalyst: a catalyst used for hydrocracking which typically contains separate hydrogenation and cracking functions.

Hydrodenitrogenation: the removal of nitrogen by hydrotreating.

Hydrodesulfurization: the removal of sulfur by hydrotreating.

Hydrofining: a fixed-bed catalytic process to desulfurize and hydrogenate a wide range of charge stocks from gases through waxes.

Hydroforming: a process in which naphtha is passed over a catalyst at elevated temperatures and moderate pressures, in the presence of added hydrogen or hydrogen-containing gases, to form high-octane motor fuel or aromatics.

Hydrogen addition: an upgrading process in the presence of hydrogen, e.g. hydrocracking; see Hydrogenation.

Hydrogen blistering: blistering of steel caused by trapped molecular hydrogen formed as atomic hydrogen during corrosion of steel by hydrogen sulfide.

Hydrogen transfer: the transfer of inherent hydrogen within the feedstock constituents and products during processing.

Hydrogenation: the chemical addition of hydrogen to a material. In nondestructive hydrogenation, hydrogen is added to a molecule only if, and where, unsaturation with respect to hydrogen exists.

Hydroprocesses: refinery processes designed to add hydrogen to various products of refining.

Hydroprocessing: a term often equally applied to hydrotreating and to hydrocracking; also often collectively applied to both.

Hydropyrolysis: a short residence time high-temperature process using hydrogen.

Hydrotreating: the removal of heteroatomic (nitrogen, oxygen, and sulfur) species by treatment of a feedstock or product at relatively low temperatures in the presence of hydrogen.

Hydrovisbreaking: a non-catalytic process, conducted under similar conditions to visbreaking, which involves treatment with hydrogen to reduce the viscosity of the feedstock and produce more stable products than is possible with visbreaking.

Hyperforming: a catalytic hydrogenation process for improving the octane number of naphtha through the removal of sulfur and nitrogen compounds.

Hypochlorite sweetening: the oxidation of mercaptan derivatives (RSH) in a sour feedstock by agitation with aqueous, alkaline hypochlorite solution; used where avoidance of free-sulfur addition is desired, because of a stringent copper strip requirements and minimum expense is not the primary object.

Idle cropland: land in which no crops were planted; acreage diverted from crops to soil-conserving uses (if not eligible for and used as cropland pasture) under federal farm programs is included in this component.

Ignitability: characteristic of liquids whose vapors are likely to ignite in the presence of ignition source; also characteristic of non-liquids that may catch fire from friction or contact with water and that burn vigorously.

Illuminating oil: oil used for lighting purposes.

Immiscible: two or more fluids that do not have complete mutual solubility and co-exist as separate phases.

Immiscible carbon dioxide displacement: injection of carbon dioxide into an oil reservoir to effect oil displacement under conditions in which miscibility with reservoir oil is not obtained; see Carbon dioxide augmented waterflooding.

Immiscible displacement: displacement of oil by a fluid (gas or water) that is conducted under conditions so that interfaces exist between the driving fluid and the oil.

Immunoassay: portable tests that take advantage of an interaction between an antibody and a specific analyte. Immunoassay tests are semi-quantitative and usually rely on color changes of varying intensities to indicate relative concentrations.

Incinerator: any device used to burn solid or liquid residues or wastes as a method of disposal.

Inclined grate: a type of furnace in which fuel enters at the top part of a grate in a continuous ribbon, passes over the upper drying section where moisture is removed, and descends into the lower burning section. Ash is removed at the lower part of the grate.

Incompatibility: the *immiscibility* of petroleum products and also of different crude oils which is often reflected in the formation of a separate phase after mixing and/or storage.

Incremental ultimate recovery: the difference between the quantity of the oil that can be recovered by EOR methods and the quantity of the oil that can be recovered by conventional recovery methods.

Indirect-injection engine: an older model of a diesel engine in which fuel is injected into a pre-chamber, partly combusted and then sent to the fuel-injection chamber.

Indirect liquefaction: conversion of biomass to a liquid fuel through a synthesis gas intermediate step.

Industrial wood: all commercial round wood products except fuel wood.

Infill drilling: drilling additional wells within an established pattern.

Infrared spectroscopy: an analytical technique that quantifies the vibration (stretching and bending) that occurs when a molecule absorbs (heat) energy in the infrared region of the electromagnetic spectrum.

Inhibitor: a substance, the presence of which, in small amounts, in a petroleum product prevents or retards undesirable chemical changes from taking place in the product, or in the condition of the equipment in which the product is used.

Inhibitor sweetening: a treating process to sweeten gasoline of low mercaptan content, using a phenylenediamine type of inhibitor, air, and caustic.

Initial boiling point: the recorded temperature when the first drop of liquid falls from the end of the condenser.

Initial vapor pressure: the vapor pressure of a liquid of specified temperature and 0% evaporated.

Injection profile: the vertical flow rate distribution of fluid flowing from the wellbore into a reservoir.

Injection well: a well in an oil field used for injecting fluids into a reservoir.

Injectivity: the relative ease with which a fluid is injected into porous rock.

In situ: in its original place; in the reservoir.

In situ combustion: an EOR process consisting of injecting air or oxygen-enriched air into a reservoir under conditions that favor burning part of the in situ petroleum, advancing this burning zone, and recovering oil heated from a nearby producing well.

Instability: the inability of a petroleum product to exist for periods of time without change to the product.

Integrated gasification combine cycle (IGCC): a power plant in which a gasification process provides syngas to a combined cycle under an integrated control system.

Integrity: maintenance of a slug or bank at its preferred composition without too much dispersion or mixing.

Interface: the thin surface area separating two immiscible fluids that are in contact with each other.

Interfacial film: a thin layer of material at the interface between two fluids which differs in composition from the bulk fluids.

Interfacial tension: the strength of the film separating two immiscible fluids, e.g., oil and water or microemulsion and oil; measured in dynes (force) per centimeter or milli-dynes per centimeter.

Interfacial viscosity: the viscosity of the interfacial film between two immiscible liquids.

Interference testing: a type of pressure transient test in which pressure is measured over time in a closed-in well while nearby wells are produced; flow and communication between wells can sometimes be deduced from an interference test.

Interphase mass transfer: the net transfer of chemical compounds between two or more phases.

Iodine number: a measure of the iodine absorption by oil under standard conditions; used to indicate the quantity of unsaturated compounds present; also called iodine value.

Ion exchange: a means of removing cations or anions from solution onto a solid resin.

Ion exchange capacity: a measure of the capacity of a mineral to exchange ions in the amount of material per unit weight of solid.

Ions: chemical substances possessing positive or negative charges in solution.

Isocracking: a hydrocracking process for conversion of hydrocarbons which operates at relatively low temperatures and pressures in the presence of hydrogen and a catalyst to produce more valuable, lower-boiling products.

Isoforming: a process in which olefinic naphtha is contacted with an alumina catalyst at high temperature and low pressure to produce isomers of higher octane number.

Iso-Kel process: a fixed-bed, vapor-phase isomerization process using a precious metal catalyst and external hydrogen.

Isomate process: a continuous, non-regenerative process for isomerizing C_5–C_8 normal paraffin hydrocarbons, using aluminum chloride-hydrocarbon catalyst with anhydrous hydrochloric acid as a promoter.

Isomerate process: a fixed-bed isomerization process to convert pentane, heptane, and heptane to high-octane blending stocks.

Isomerization: the conversion of a *normal* (straight-chain) paraffin hydrocarbon into an *iso* (branched-chain) paraffin hydrocarbon having the same atomic composition.

Isopach: a line on a map designating points of equal formation thickness.

Iso-plus Houdriforming: a combination process using a conventional Houdriformer operated at moderate severity, in conjunction with one of three possible alternatives-including the use of an aromatic recovery unit or a thermal reformer; see Houdriforming.

Jet fuel: fuel meeting the required properties for use in jet engines and aircraft turbine engines.

Joule: metric unit of energy, equivalent to the work done by a force of one Newton applied over a distance of one meter (= 1 kg m^2/s^2). One joule (J)=0.239 calories (1 calorie=4.187 J).

Kaolinite: a clay mineral formed by hydrothermal activity at the time of rock formation or by chemical weathering of rock with high feldspar content; usually associated with intrusive granite rock with high feldspar content.

Kata-condensed aromatic compounds: compounds based on linear condensed aromatic hydro-carbon systems, e.g., anthracene and naphthacene (tetracene).

Kauri butanol number: a measurement of solvent strength for hydrocarbon solvents; the higher the kauri-butanol (KB) value, the stronger the solvency; the test method (ASTM D1133) is based on the principle that kauri resin is readily soluble in butyl alcohol but not in hydro-carbon solvents and the resin solution will tolerate only a certain amount of dilution and is reflected as cloudiness when the resin starts to come out of solution; solvents such as toluene can be added in a greater amount (and thus have a higher KB value) than weaker solvents like hexane.

Kerogen: a complex carbonaceous (organic) material that occurs in sedimentary rock and shale; generally insoluble in common organic solvents.

Kerosene (kerosine): a fraction of petroleum that was initially sought as an illuminant in lamps; a precursor to diesel fuel.

K-factor: see Characterization factor.

Kilowatt (kW): a measure of electrical power equal to 1,000 W. 1 kW=3,412 Btu/hr=1.341 horsepower.

Kilowatt hour (kWh): a measure of energy equivalent to the expenditure of one kilowatt for 1 hour. For example, 1 kWh will light a 100-watt light bulb for 10 hours. 1 kWh=3,412 Btu.

Kinematic viscosity: the ratio of viscosity to density, both measured at the same temperature.

Knock: the noise associated with the self-ignition of a portion of the fuel-air mixture ahead of the advancing flame front.

Kriging: a technique used in reservoir description for interpolation of reservoir parameters between wells based on random field theory.

LAER: lowest achievable emission rate; the required emission rate in non-attainment permits.

Lamp burning: a test of burning oils in which the oil is burned in a standard lamp under specified conditions in order to observe the steadiness of the flame, the degree of encrustation of the wick, and the rate of consumption of the kerosene.

Lamp oil: see Kerosene.

Landfill gas: a type of biogas that is generated by decomposition of organic material at landfill disposal sites. Landfill gas is approximately 50% methane. See also biogas.

Leaded gasoline: gasoline containing tetraethyl lead or other organometallic lead antiknock compounds.

Lean gas: the residual gas from the absorber after the condensable gasoline has been removed from the wet gas.

Lean oil: absorption oil from which gasoline fractions have been removed; oil leaving the stripper in a natural-gasoline plant.

Lewis acid: a chemical species which can accept an electron pair from a base.

Lewis base: a chemical species which can donate an electron pair.

Light ends: the lower-boiling components of a mixture of hydrocarbons; see also Heavy ends, Light hydrocarbons.

Light hydrocarbons: hydrocarbons with molecular weights less than that of heptane (C_7H_{16}).

Light oil: the products distilled or processed from crude oil up to, but not including, the first lubricating-oil distillate.

Light petroleum: petroleum having an API gravity greater than 20°.

Lignin: structural constituent of wood and (to a lesser extent) other plant tissues, which encrusts the walls and cements the cells together.

Ligroine (Ligroin): a saturated petroleum naphtha boiling in the range of 20°C–135°C (68°F–275°F) and suitable for general use as a solvent; also called benzine or petroleum ether.

Linde copper sweetening: a process for treating gasoline and distillates with a slurry of clay and cupric chloride.

Liquefied petroleum gas: propane, butane, or mixtures thereof, gaseous at atmospheric temperature and pressure, held in the liquid state by pressure to facilitate storage, transport, and handling.

Liquid chromatography: a chromatographic technique that employs a liquid mobile phase.

Liquid/liquid extraction: an extraction technique in which one liquid is shaken with or contacted by an extraction solvent to transfer molecules of interest into the solvent phase.

Liquid petrolatum: see White oil.

Liquid sulfur dioxide-benzene process: a mixed-solvent process for treating lubricating-oil stocks to improve viscosity index; also used for dewaxing.

Lithology: the geological characteristics of the reservoir rock.

Live cull: a classification that includes live cull trees; when associated with volume, it is the net volume in live cull trees that are 5.0 inches in diameter and larger.

Live steam: steam coming directly from a boiler before being utilized for power or heat.

Liver: the intermediate layer of dark-colored, oily material, insoluble in weak acid and in oil, which is formed when acid sludge is hydrolyzed.

Logging residues: the unused portions of growing-stock and non-growing-stock trees cut or killed logging and left in the woods.

Lorenz coefficient: a permeability heterogeneity factor.

Lower-phase micro emulsion: a microemulsion phase containing a high concentration of water that, when viewed in a test tube, resides near the bottom with the oil phase on top.

Lube: see Lubricating oil.

Lube cut: a fraction of crude oil of suitable boiling range and viscosity to yield lubricating oil when completely refined; also referred to as lube oil distillates or lube stock.

Lubricating oil: a fluid lubricant used to reduce friction between bearing surfaces.

M85: an alcohol fuel mixture containing 85% methanol and 15% gasoline by volume. Methanol is typically made from natural gas, but can also be derived from the fermentation of biomass.

MACT: maximum achievable control technology. Applies to major sources of hazardous air pollutants.

Mahogany acids: oil-soluble sulfonic acids formed by the action of sulfuric acid on petroleum distillates. They may be converted to their sodium soaps (mahogany soaps) and extracted from the oil with alcohol for use in the manufacture of soluble oils, rust preventives, and special greases. The calcium and barium soaps of these acids are used as detergent additives in motor oils; see also Brown acids and Sulfonic acids.

Major source: a source that has the potential to emit for a regulated pollutant that is at or greater than an emission threshold set by regulations.

Maltene fraction (maltenes): that fraction of petroleum that is soluble in, for example, pentane or heptane; deasphaltened oil; also the term arbitrarily assigned to the pentane-soluble portion of petroleum that is relatively high boiling (>300°C, 760 mm) (see also Petrolenes).

Marine engine oil: oil used as a crankcase oil in marine engines.

Marine gasoline: fuel for motors in marine service.

Marine sediment: the organic biomass from which petroleum is derived.

Marsh: an area of spongy waterlogged ground with large numbers of surface water pools. Marshes usually result from: (i) an impermeable underlying bedrock; (ii) surface deposits of glacial boulder clay; (iii) a basin-like topography from which natural drainage is poor; (iv) very heavy rainfall in conjunction with a correspondingly low evaporation rate; (v) low-lying land, particularly at estuarine sites at or below sea level.

Marx-Langenheim model: mathematical equations for calculating heat transfer in a hot water or steam flood.

Mass spectrometer: an analytical technique that *fractures* organic compounds into characteristic "fragments" based on functional groups that have a specific mass-to-charge ratio.

Mayonnaise: low-temperature sludge; a black, brown, or gray deposit having a soft, mayonnaise-like consistency; not recommended as a food additive!

MCL: maximum contaminant level as dictated by regulations.

MDL: see Method detection limit.

Medicinal oil: highly refined, colorless, tasteless, and odorless petroleum oil used as a medicine in the nature of an internal lubricant; sometimes called liquid paraffin.

Megawatt (MW): a measure of electrical power equal to one million watts (1,000 kW).

MEK-(methyl ethyl ketone): a colorless liquid ($CH_3COCH_2CH_3$) used as a solvent; as a chemical intermediate; and in the manufacture of lacquers, celluloid, and varnish removers.

MEK deoiling: a wax-deoiling process in which the solvent is generally a mixture of methyl ethyl ketone and toluene.

MEK dewaxing: a continuous solvent dewaxing process in which the solvent is generally a mixture of methyl ethyl ketone and toluene.

Membrane technology: gas separation processes utilizing membranes that permit different components of gas to diffuse through the membrane at significantly different rates.

MEOR: microbial enhanced oil recovery.

Mercapsol process: a regenerative process for extracting mercaptan derivatives (RSH), utilizing aqueous sodium (or potassium) hydroxide containing mixed cresols as solubility promoters.

Mercaptans: organic compounds having the general formula R–SH.

Metagenesis: the alteration of organic matter during the formation of petroleum that may involve temperatures above 200°C (390°F); see also Catagenesis and Diagenesis.

Methanol: see Methyl alcohol.

Method Detection Limit: the smallest quantity or concentration of a substance that the instrument can measure.

Methyl alcohol (methanol; wood alcohol): a colorless, volatile, inflammable, and poisonous alcohol (CH_3OH) traditionally formed by destructive distillation of wood or, more recently, as a result of synthetic distillation in chemical plants; a fuel typically derived from natural gas, but which can be produced from the fermentation of sugars in biomass.

Methyl ethyl ketone: see MEK.

Methyl t-butyl ether: an ether added to gasoline to improve its octane rating and to decrease gaseous emissions; see Oxygenate.

Mica: a complex aluminum silicate mineral that is transparent, tough, flexible, and elastic.

Micellar fluid (surfactant slug): an aqueous mixture of surfactants, co-surfactants, salts, and hydrocarbons. The term micellar is derived from the word micelle, which is a submicroscopic aggregate of surfactant molecules and associated fluid.

Micelle: the structural entity by which asphaltene constituents are dispersed in petroleum.

Microcarbon residue: the carbon residue determined using a thermogravimetric method. See also Carbon residue.

Microcrystalline wax: wax extracted from certain petroleum residua and having a finer and less apparent crystalline structure than paraffin wax.

Microemulsion: a stable, finely dispersed mixture of oil, water, and chemicals (surfactants and alcohols).

Microemulsion or micellar/emulsion flooding: an augmented waterflooding technique in which a surfactant system is injected in order to enhance oil displacement toward producing wells.

Microorganisms: animals or plants of microscopic sizes, such as bacteria.

Microscopic displacement efficiency: the efficiency with which an oil displacement process removes the oil from individual pores in the rock.

Mid-boiling point: the temperature at which approximately 50% of material has distilled under specific conditions.

Middle distillate: distillate boiling between the kerosene and lubricating oil fractions.

Middle-phase micro emulsion: a micro emulsion phase containing a high concentration of both oil and water that, when viewed in a test tube, resides in the middle with the oil phase above it and the water phase below it.

Migration (primary) the movement of hydrocarbons (oil and natural gas) from mature, organic-rich source rocks to a point where the oil and gas can collect as droplets or as a continuous phase of liquid hydrocarbon.

Migration (secondary): the movement of the hydrocarbons as a single, continuous fluid phase through water-saturated rocks, fractures, or faults followed by accumulation of the oil and gas in sediments (traps, *q.v.*) from which further migration is prevented.

Mill residue: wood and bark residues produced in processing logs into lumber, plywood, and paper.

Mineral hydrocarbons: petroleum hydrocarbons, considered *mineral* because they come from the earth rather than from plants or animals.

Mineral oil: the older term for petroleum; the term was introduced in the 19th century as a means of differentiating petroleum (rock oil) from whale oil which, at the time, was the predominant illuminant for oil lamps.

Mineral seal oil: a distillate fraction boiling between kerosene and gas oil.

Mineral wax: yellow to dark brown, solid substances that occur naturally and are composed largely of paraffins; usually found associated with considerable mineral matter, as a filling in veins and fissures or as an interstitial material in porous rocks.

Minerals: naturally occurring inorganic solids with well-defined crystalline structures.

Minimum miscibility pressure (MMP): see Miscibility.

Miscible flooding: see the EOR process.

Miscible fluid displacement (miscible displacement): is an oil displacement process in which alcohol, a refined hydrocarbon, a condensed petroleum gas, carbon dioxide, liquefied natural gas, or even exhaust gas is injected into an oil reservoir, at pressure levels such that the injected gas or fluid and reservoir oil are miscible; the process may include the concurrent, alternating, or subsequent injection of water.

Miscibility: an equilibrium condition, achieved after mixing two or more fluids, which is characterized by the absence of interfaces between the fluids: (i) *first-contact miscibility*: miscibility in the usual sense, whereby two fluids can be mixed in all proportions without any interfaces forming. Example: At room temperature and pressure, ethyl alcohol and water are first -contact miscible. (ii) *multiple-contact miscibility (dynamic miscibility)*: miscibility that is developed by repeated enrichment of one fluid phase with components from a second fluid phase with which it comes into contact. (iii) *minimum miscibility pressure*: the minimum pressure above which two fluids become miscible at a given temperature, or can become miscible, by dynamic processes.

Mitigation: identification, evaluation, and cessation of potential impacts of a processed product or by-product.

Mixed-phase cracking: the thermal decomposition of higher-boiling hydrocarbons to gasoline components.

Mobility: a measure of the ease with which fluid moves through reservoir rock; the ratio of rock permeability to apparent fluid viscosity.

Mobility buffer: the bank that protects a chemical slug from water invasion and dilution and assures mobility control.

Mobility control: ensuring that the mobility of the displacing fluid or bank is equal to or less than that of the displaced fluid or bank.

Mobility ratio: a ratio of the mobility of injection fluid to the mobility of fluid being displaced.

Modified alkaline flooding: the addition of a co-surfactant and/or polymer to the alkaline flooding process.

Modified/unmodified diesel engine: traditional diesel engines must be <u>modified</u> to heat the oil before it reaches the fuel injectors in order to handle straight vegetable oil. Modified, any diesel engine can run on veggie oil; without modification, the oil must first be converted to biodiesel.

Modified naphtha insolubles (MNI): an insoluble fraction obtained by adding naphtha to petroleum; usually the naphtha is modified by adding paraffin constituents; the fraction might be equated to asphaltenes *if* the naphtha is equivalent to n-heptane, but usually it is not

Moisture content (MC): the weight of the water contained in wood, usually expressed as a percentage of weight, either oven-dry or as received.

Moisture content, dry basis: moisture content expressed as a percentage of the weight of oven-wood, i.e.: [(weight of wet sample − weight of dry sample)/weight of dry sample] × 100.

Moisture content, wet basis: moisture content expressed as a percentage of the weight of wood as-received, i.e.: [(weight of wet sample − weight of dry sample)/weight of wet sample] × 100.

Molecular sieve: a synthetic zeolite mineral having pores of uniform size; it is capable of separating molecules, on the basis of their size, structure, or both, by absorption or sieving.

Motor Octane Method: a test for determining the knock rating of fuels for use in spark-ignition engines; see also Research Octane Method.

Moving-bed catalytic cracking: a cracking process in which the catalyst is continuously cycled between the reactor and the regenerator.

MSDS: Material safety data sheet.

MTBE: methyl tertiary butyl ether is a highly refined high octane light distillate used in the blending of gasoline.

NAAQS: National Ambient Air Quality Standards; standards exist for the pollutants known as the criteria air pollutants: nitrogen oxides (NO_x), sulfur oxides (SO_x), lead, ozone, particulate matter, less than 10 microns in diameter, and carbon monoxide (CO).

Naft: pre-Christian era (Greek) term for naphtha.

Napalm: a thickened gasoline used as an incendiary medium that adheres to the surface it strikes.

Naphtha: a generic term applied to refined, partly refined, or unrefined petroleum products and liquid products of natural gas, the majority of which distills below 240°C (464°F); the volatile fraction of petroleum which is used as a solvent or as a precursor to gasoline.

Naphthenes: cycloparaffins.

Native asphalt: see Bitumen.

Natural asphalt: see Bitumen.

Natural gas: the naturally occurring gaseous constituents that are found in many petroleum reservoirs; also there are also those reservoirs in which natural gas may be the sole occupant.

Natural gas liquids (NGL): the hydrocarbon liquids that condense during the processing of hydrocarbon gases that are produced from oil or gas reservoir; see also Natural gasoline.

Natural gasoline: a mixture of liquid hydrocarbons extracted from natural gas suitable for blending with refinery gasoline.

Natural gasoline plant: a plant for the extraction of fluid hydrocarbons, such as gasoline and liquefied petroleum gas, from natural gas.

NESHAP: National Emissions Standards for Hazardous Air Pollutants; emission standards for specific source categories that emit or have the potential to emit one or more hazardous air pollutants; the standards are modeled on the best practices and most effective emission reduction methodologies in use at the affected facilities.

Neutral oil: a distillate lubricating oil with viscosity usually not above 200 seconds at 100°F.

Neutralization: a process for reducing the acidity or alkalinity of a waste stream by mixing acids and bases to produce a neutral solution; also known as pH adjustment.

Neutralization number: the weight, in milligrams, of potassium hydroxide needed to neutralize the acid in 1 g of oil; an indication of the acidity of an oil.

Nitrogen fixation: The transformation of atmospheric nitrogen into nitrogen compounds that can be used by growing plants.

Nitrogen oxides (NO$_x$): products of combustion that contribute to the formation of smog and ozone.

No. 1 Fuel oil: very similar to kerosene and is used in burners where vaporization before burning is usually required and a clean flame is specified.

No. 2 Fuel oil: also called domestic heating oil; has properties similar to diesel fuel and heavy jet fuel; used in burners where complete vaporization is not required before burning.

No. 4 Fuel oil: light industrial heating oil and is used where preheating is not required for handling or burning; there are two grades of No. 4 fuel oil, differing in safety (flash point) and flow (viscosity) properties.

No. 5 Fuel oil: a heavy industrial fuel oil that requires preheating before burning.

No. 6 Fuel oil: heavy fuel oil and is more commonly known as Bunker C oil when it is used to fuel ocean-going vessels; preheating is always required for burning this oil.

Non-asphaltic road oil: any of the nonhardening petroleum distillates or residual oils used as dust layers. They have sufficiently low viscosity to be applied without heating and, together with asphaltic road oils, are sometimes referred to as dust palliatives.

Non-attainment area: any area that does not meet the national primary or secondary ambient air quality standard established (by the Environmental Protection Agency) for designated pollutants, such as carbon monoxide and ozone.

Non-forest land: land that has never supported forests and lands formerly forested where the use of timber management is precluded by development for other uses; if intermingled in forest areas, unimproved roads and non-forest strips must be more than 120 feet wide, and clearings, etc., must be more than 1 acre in the area to qualify as non-forest land.

Non-industrial private: an ownership class of private lands where the owner does not operate wood processing plants.

Non-ionic surfactant: a surfactant molecule containing no ionic charge.

Non-Newtonian: a fluid that exhibits a change of viscosity with flow rate.

NO$_x$: oxides of nitrogen.

Nuclear magnetic resonance spectroscopy: an analytical procedure that permits the identification of complex molecules based on the magnetic properties of the atoms they contain.

Observation wells: wells that are completed and equipped to measure reservoir conditions and/or sample reservoir fluids, rather than to inject produced reservoir fluids.

Octane barrel yield: a measure used to evaluate fluid catalytic cracking processes; defined as (RON+MON)/2 times the gasoline yield, where RON is the research octane number and MON is the motor octane number.

Octane number: a number indicating the anti-knock characteristics of gasoline.

Oil bank: see Bank.

Oil breakthrough (time): the time at which the oil-water bank arrives at the producing well.

Oil from tar sand: synthetic crude oil.

Oil mining: application of a mining method to the recovery of bitumen.

Oil originally in place (OOIP): the quantity of petroleum existing in a reservoir before oil recovery operations begin.

Oil sand: see Tar sand.

Oil shale: a fine-grained impervious sedimentary rock that contains an organic material called kerogen.

Oils: that portion of the maltenes that is not adsorbed by a surface-active material such as clay or alumina.

Olefin: synonymous with an *alkene*.

OOIP: see Oil originally in place.

Open-loop biomass: biomass that can be used to produce energy and bioproducts even though it was not grown specifically for this purpose; include agricultural livestock waste, residues from forest harvesting operations, and crop harvesting.

Optimum salinity: the salinity at which a middle-phase microemulsion containing equal concentrations of oil and water results from the mixture of a micellar fluid (surfactant slug) with oil.

Organic sedimentary rocks: rocks containing organic material such as residues of plant and animal remains/decay.

Overhead: that portion of the feedstock which is vaporized and removed during distillation.

Override: the gravity-induced flow of lighter fluid in a reservoir above another heavier fluid.

Oxidation: a process that can be used for the treatment of a variety of inorganic and organic substances.

Oxidized asphalt: see Air-blown asphalt.

Oxygen scavenger: a chemical which reacts with oxygen in injection water, used to prevent degradation of the polymer.

Oxygenate: an oxygen-containing compound that is blended into gasoline to improve its octane number and to decrease gaseous emissions; a substance which, when added to gasoline, increases the amount of oxygen in that gasoline blend; includes fuel ethanol, methanol, and methyl tertiary butyl ether (MTBE).

Oxygenated gasoline: gasoline with added ethers or alcohols, formulated according to the Federal Clean Air Act to reduce carbon monoxide emissions during winter months.

Ozokerite (Ozocerite): a naturally occurring wax; when refined also known as ceresin.

Pale oil: a lubricating oil or a process oil refined until its color, by transmitted light, is straw to pale yellow.

Paraffin wax: the colorless, translucent, highly crystalline material obtained from the light lubricating fractions of paraffin crude oils (wax distillates).

Paraffinum liquidum: see Liquid petrolatum.

Particle density: the density of solid particles.

Particle size distribution: the particle size distribution (of a catalyst sample) expressed as a percent of the whole.

Particulate: a small, discrete mass of solid or liquid matter that remains individually dispersed in gas or liquid emissions.

Particulate emissions: particles of a solid or liquid suspended in a gas, or the fine particles of carbonaceous soot and other organic molecules discharged into the air during combustion.

Particulate matter (particulates): particles in the atmosphere or on a gas stream that may be organic or inorganic and originate from a wide variety of sources and processes.

Partition ratios, K: the ratio of the total analytical concentration of a solute in the stationary phase, CS, to its concentration in the mobile phase, CM.

Partitioning: in chromatography, the physical act of a solute having different affinities for the stationary and mobile phases.

Pattern: the areal pattern of injection and producing wells selected for a secondary or enhanced recovery project.

Pattern life: the length of time a flood pattern participates in oil recovery.

Pay zone thickness: the depth of a tar sand deposit from which bitumen (or a product) can be recovered.

Penex process: a continuous, non-regenerative process for the isomerization of C_5 and/or C_6 fractions in the presence of hydrogen (from reforming) and a platinum catalyst.

Pentafining: a pentane isomerization process using a regenerable platinum catalyst on silica-alumina support and requiring outside hydrogen.

Pepper sludge: the fine particles of sludge produced in acid treating which may remain in suspension.

Peri-condensed aromatic compounds: Compounds based on angular condensed aromatic hydrocarbon systems, e.g., phenanthrene, chrysene, picene, etc.

Permeability: the ease of flow of the water through the rock.

Petrol: a term commonly used in some countries for gasoline.

Petrolatum: a semisolid product, ranging from white to yellow in color, produced during the refining of residual stocks; see Petroleum jelly.

Petrolenes: the term applied to that part of the pentane-soluble or heptane-soluble material that is low boiling (<300°C, <570°F, 760 mm) and can be distilled without thermal decomposition (see also Maltenes).

Petroleum (crude oil): a naturally occurring mixture of gaseous, liquid, and solid hydrocarbon compounds usually found trapped deep underground beneath impermeable cap rock and above a lower dome of sedimentary rock such as shale; most petroleum reservoirs occur in sedimentary rocks of marine, deltaic, or estuarine origin.

Petroleum asphalt: see Asphalt.

Petroleum ether: see Ligroine.

Petroleum jelly: a translucent, yellowish to amber or white, hydrocarbon substance (melting point: 38°C–54°C) having almost no odor or taste, derived from petroleum and used principally in medicine and pharmacy as a protective dressing and as a substitute for fats in ointments and cosmetics; also used in many types of polishes and in lubricating greases, rust preventives, and modeling clay; obtained by dewaxing heavy lubricating-oil stocks.

Petroleum refinery: see Refinery.

Petroleum refining: a complex sequence of events that result in the production of a variety of products.

Petroleum sulfonate: a surfactant used in chemical flooding prepared by sulfonating selected crude oil fractions.

Petroporphyrins: see Porphyrins.

pH adjustment: neutralization.

Phase: a separate fluid that co-exists with other fluids; gas, oil, water, and other stable fluids such as micro emulsions are all called phases in EOR research.

Phase behavior: the tendency of a fluid system to form phases as a result of changing temperature, pressure, or the bulk composition of the fluids or of individual fluid phases.

Phase diagram: a graph of phase behavior. In chemical flooding, a graph showing the relative volume of oil, brine, and sometimes one or more micro emulsion phases. In carbon dioxide flooding, conditions for the formation of various liquid, vapor, and solid phases.

Phase properties: types of fluids, compositions, densities, viscosities, and relative amounts of oil, microemulsion, or solvent, and water formed when a micellar fluid (surfactant slug) or miscible solvent (e.g., CO_2) is mixed with oil.

Phase separation: the formation of a separate phase that is usually the prelude to coke formation during a thermal process; the formation of a separate phase as a result of the instability/incompatibility of petroleum and petroleum products.

Phosphoric acid polymerization: a process using a phosphoric acid catalyst to convert propene, butene, or both, to gasoline or petrochemical polymers.

Photoionization: a gas chromatographic detection system that utilizes a *detector (PID)* ultraviolet lamp as an ionization source for analyte detection. It is usually used as a selective detector by changing the photon energy of the ionization source.

Photosynthesis: process by which chlorophyll-containing cells in green plants concert incident light to chemical energy, capturing carbon dioxide in the form of carbohydrates.

PINA analysis: a method of analysis for paraffins, *iso*-paraffins, naphthenes, and aromatics.

PIONA analysis: a method of analysis for paraffins, *iso*-paraffins, olefins, naphthenes, and aromatics.

Pipe still: a still in which heat is applied to the oil while being pumped through a coil or pipe arranged in a suitable firebox.

Pipestill gas: the most volatile fraction that contains most of the gases that are generally dissolved in the crude. Also known as pipestill light ends.

Pipestill light ends: see *Pipestill gas.*

Pitch: the nonvolatile, brown to black, semi-solid to solid viscous product from the destructive distillation of many bituminous or other organic materials, especially coal.

Platforming: a reforming process using a platinum-containing catalyst on an alumina base.

PNA: a polynuclear aromatic compound.

PNA analysis: a method of analysis for paraffins, naphthenes, and aromatics.

Polar aromatics: resins; the constituents of petroleum that are predominantly aromatic in character and contain polar (nitrogen, oxygen, and sulfur) functions in their molecular structure(s).

Pollutant: a chemical (or chemicals) introduced into the land water and air systems of that is (are) not indigenous to these systems; also an indigenous chemical (or chemicals) introduced into the land water and air systems in amounts greater than the natural abundance.

Pollution: the introduction into the land water and air systems of a chemical or chemicals that are not indigenous to these systems or the introduction into the land water and air systems of indigenous chemicals in greater-than-natural amounts.

Polyacrylamide: very high molecular weight material used in polymer flooding.

Polycyclic aromatic hydrocarbons (PAHs): polycyclic aromatic hydrocarbons are a suite of compounds comprised of two or more condensed aromatic rings. They are found in many petroleum mixtures, and they are predominantly introduced to the environment through natural and anthropogenic combustion processes.

Polyforming: a process charging both C_3 and C_4 gases with naphtha or gas oil under thermal conditions to produce gasoline.

Polymer: in EOR, any very high molecular weight material that is added to water to increase viscosity for polymer flooding.

Polymer augmented waterflooding: waterflooding in which organic polymers are injected with the water to improve areal and vertical sweep efficiency.

Polymer gasoline: the product of polymerization of gaseous hydrocarbons to hydrocarbons boiling in the gasoline range.

Polymer stability: the ability of a polymer to resist degradation and maintain its original properties.

Polymerization: the combination of two olefin molecules to form higher molecular weight paraffin.

Polynuclear aromatic compound: an aromatic compound having two or more fused benzene rings, e.g. naphthalene, phenanthrene.

Polysulfide treating: a chemical treatment used to remove elemental sulfur from refinery liquids by contacting them with a non-regenerable solution of sodium polysulfide.

PONA analysis: a method of analysis for paraffins (P), olefins (O), naphthenes (N), and aromatics (A).

Pore diameter: the average pore size of solid material, e.g. catalyst.

Pore space: a small hole in reservoir rock that contains fluid or fluids; a four-inch cube of reservoir rock may contain millions of inter-connected pore spaces.

Pore volume: total volume of all pores and fractures in a reservoir or part of a reservoir; also applied to catalyst samples.

Porosity: the percentage of rock volume available to contain water or other fluid.

Porphyrins: organometallic constituents of petroleum that contain vanadium or nickel; the degradation products of chlorophyll that became included in the protopetroleum.

Positive bias: a result that is incorrect and too high.

Possible reserves: reserves where there is an even greater degree of uncertainty but about which there is some information.

Potential reserves: reserves based upon geological information about the types of sediments where such resources are likely to occur and they are considered to represent an educated guess.

Pour point: the lowest temperature at which oil will pour or flow when it is chilled without disturbance under definite conditions.

Powerforming: a fixed-bed naphtha-reforming process using a regenerable platinum catalyst.

Power-law exponent: an exponent used to model the degree of viscosity change of some non-Newtonian liquids.

Precipitation number: the number of milliliters of precipitate formed when 10 ml of lubricating oil is mixed with 90 ml of petroleum naphtha of definite quality and centrifuged under definitely prescribed conditions.

Preflush: a conditioning slug injected into a reservoir as the first step of an EOR process.

Pressure cores: cores cut into a special coring barrel that maintains reservoir pressure when brought to the surface; this prevents the loss of reservoir fluids that usually accompanies a drop in pressure from the reservoir to atmospheric conditions.

Pressure gradient: rate of change of pressure with distance.

Pressure maintenance: augmenting the pressure (and energy) in a reservoir by injecting gas and/or water through one or more wells.

Pressure pulse test: a technique for determining reservoir characteristics by injecting a sharp pulse of pressure in one well and detecting it surrounding wells.

Pressure transient testing: measuring the effect of changes in pressure at one well on other we in a field.

Primary oil recovery: oil recovery utilizing only naturally occurring forces.

Primary structure: the chemical sequence of atoms in a molecule.

Primary tracer: a chemical that, when inject into a test well, reacts with reservoir fluids form a detectable chemical compound.

Primary wood-using mill: A mill that converts round wood products into other wood products; common examples are sawmills that convert saw logs into lumber and pulp mills that convert pulpwood round wood into wood pulp.

Probable reserves: mineral reserves mineral that are nearly certain but about which a slight doubt exists.

Process heat: heat used in an industrial process rather than for space heating or other housekeeping purposes.

Producer gas: fuel gas high in carbon monoxide (CO) and hydrogen (H_2), produced by burning a solid fuel with insufficient air or by passing a mixture of air and steam through a burning bed of solid fuel.

Producibility: the rate at which oil or gas can be produced from a reservoir through a wellbore.

Producing well: a well in an oil field used for removing fluids from a reservoir.

Propane asphalt: see Solvent asphalt.

Propane deasphalting: solvent deasphalting using propane as the solvent.

Propane decarbonizing: a solvent extraction process used to recover catalytic cracking feed from heavy fuel residues

Propane dewaxing: a process for dewaxing lubricating oils in which propane serves as a solvent.

Propane fractionation: a continuous extraction process employing liquid propane as the solvent; a variant of propane deasphalting.

Protopetroleum: a generic term used to indicate the initial product formed changes have occurred to the precursors of petroleum.

Proved reserves: mineral reserves that have been positively identified as recoverable with current technology.

PSD: prevention of significant deterioration.

PTE: potential to emit; the maximum capacity of a source to emit a pollutant, given its physical or operation design, and considering certain controls and limitations.

Pulpwood: round wood, whole-tree chips, or wood residues that are used for the production of wood pulp.

Pulse-echo ultrasonic borehole televiewer: well-logging system wherein a pulsed, narrow acoustic beam scans the well as the tool is pulled up the borehole; the amplitude of the reflecting beam is displayed on a cathode-ray tube resulting in a pictorial representation of wellbore.

Purge and trap: a chromatographic sample introduction technique in volatile components that are purged from a liquid medium by bubbling gas through it. The components are then concentrated by "trapping" them on a short intermediate column, which is subsequently heated to drive the components on to the analytical column for separation.

Purge gas: typically helium or nitrogen, used to remove analytes from the sample matrix in purge/ trap extractions.

Pyrobitumen: see Asphaltoid.

Pyrolysis: the thermal decomposition of biomass at high temperatures (greater than 400°F, or 200°C) in the absence of air; the end product of pyrolysis is a mixture of solids (char), liquids (oxygenated oils), and gases (methane, carbon monoxide, and carbon dioxide) with proportions determined by operating temperature, pressure, oxygen content, and other conditions; exposure of a feedstock to high temperatures in an oxygen-poor environment.

Pyrophoric: substances that catch fire spontaneously in the air without an ignition source.

Quad: One quadrillion Btu (10^{15} Btu) = 1.055 exajoules (EJ), or approximately 172 million barrels of oil equivalent.

Quadrillion: 1×10^{15}

Quench: the sudden cooling of hot material discharging from a thermal reactor.

RACT: Reasonably Available Control Technology standards; implemented in areas of non-attainment to reduce emissions of volatile organic compounds and nitrogen oxides.

Raffinate: that portion of the oil which remains undissolved in a solvent refining process.

Ramsbottom carbon residue: see Carbon residue

Raw materials: minerals extracted from the earth prior to any refining or treating.

Recovery boiler: a pulp mill boiler in which lignin and spent cooking liquor (black liquor) is burned to generate steam.

Recycle ratio: the volume of recycle stock per volume of fresh feed; often expressed as the volume of recycle divided by the total charge.

Recycle stock: the portion of a feedstock that has passed through a refining process and is recirculated through the process.

Recycling: the use or reuse of chemical waste as an effective substitute for commercial products or as an ingredient or feedstock in an industrial process.

Reduced crude: a residual product remaining after the removal, by distillation or other means, of an appreciable quantity of the more volatile components of crude oil.

Refinery: a series of integrated unit processes by which petroleum can be converted to a slate of useful (salable) products.

Refinery gas: a gas (or a gaseous mixture) produced as a result of refining operations.

Refining: the processes by which petroleum is distilled and/or converted by application of a physical and chemical processes to form a variety of products are generated.

Reformate: the liquid product of a reforming process.

Reformed gasoline: gasoline made by a reforming process.

Reforming: the conversion of hydrocarbons with low octane numbers into hydrocarbons having higher octane numbers; e.g. the conversion of an n-paraffin into an iso-paraffin.

Reformulated gasoline (RFG): gasoline designed to mitigate smog production and to improve air quality by limiting the emission levels of certain chemical compounds such as benzene and other aromatic derivatives; often contains oxygenates.

Refractory lining: A lining, usually of ceramic, capable of resisting and maintaining high temperatures.

Refuse-derived fuel (RDF): Fuel prepared from municipal solid waste; non-combustible materials such as rocks, glass, and metals are removed, and the remaining combustible portion of the solid waste is chopped or shredded; the combustible portion of municipal solid waste after removal of glass and metals.

Reid vapor pressure: a measure of the volatility of liquid fuels, especially gasoline.

Regeneration: the reactivation of a catalyst by burning off the coke deposits.

Regenerator: a reactor for catalyst reactivation.

Relative permeability: the permeability of rock to gas, oil, or water, when any two or more are present, expressed as a fraction of the sir phase permeability of the rock.

Renewable energy sources: solar, wind, and other non-fossil fuel energy sources.

Rerunning: the distillation of an oil which has already been distilled.

Research Octane Method: a test for determining the knock rating, in terms of octane numbers, of fuels for use in spark-ignition engines; see also Motor Octane Method.

Reserves: well-identified resources that can be profitably extracted and utilized with existing technology.

Reservoir: a rock formation below the earth's surface containing petroleum or natural gas; a domain where a pollutant may reside for an indeterminate time.

Reservoir simulation: analysis and prediction of reservoir performance with a computer model.

Residual asphalt: see straight-run asphalt.

Residual fuel oil: obtained by blending the residual product(s) from various refining processes with suitable diluent(s) (usually middle distillates) to obtain the required fuel oil grades.

Residual oil: see Residuum; petroleum remaining in situ after oil recovery.

Residual resistance factor: the reduction in permeability of rock to water caused by the adsorption of the polymer.

Residues: Bark and woody materials that are generated in primary wood-using mills when round wood products are converted to other products.

Residuum (resid; pl:. residua): the residue obtained from petroleum after nondestructive distillation has removed all the volatile materials from crude oil, e.g. an atmospheric (345°C, 650°F+) residuum.

Resins: that portion of the maltenes that is adsorbed by a surface-active material such as clay or alumina; the fraction of deasphaltened oil that is insoluble in liquid propane but soluble in n-heptane.

Resistance factor: a measure of resistance to flow of a polymer solution relative to the resistance to the flow of water.

Resource: the total amount of a commodity (usually a mineral but can include non-minerals such as water and petroleum) that has been estimated to be ultimately available.

Retention: the loss of chemical components due to adsorption onto the rock's surface, precipitation, or to trapping within the reservoir.

Retention time: the time it takes for an eluate to move through a chromatographic system and reach the detector. Retention times are reproducible and can, therefore, be compared to a standard for analyte identification.

Rexforming: a process combining Platforming with aromatics extraction, wherein low octane raffinate is recycled to the Platformer.

Rich oil: absorption oil containing dissolved natural gasoline fractions.

Riser: the part of the bubble-plate assembly which channels the vapor and causes it to flow downward to escape through the liquid; also the vertical pipe where fluid catalytic cracking reactions occur.

Rock asphalt: bitumen which occurs in formations that have a limiting ratio of the bitumen-to-rock matrix.

Rock matrix: the granular structure of a rock or porous medium.

Rotation: period of years between the establishment of a stand of timber and the time when it is considered ready for final harvest and regeneration.

Round wood products: logs and other round timber generated from harvesting trees for industrial or consumer use.

Run-of-the-river reservoirs: reservoirs with a large rate of flow-through compared to their volume.

Salinity: the concentration of salt in water.

Sand: a course granular mineral mainly comprising quartz grains that is derived from the chemical and physical weathering of rocks rich in quartz, notably sandstone and granite.

Sand face: the cylindrical wall of the wellbore through which the fluids must flow to or from the reservoir.

Sandstone: a sedimentary rock formed by compaction and cementation of sand grains; can be classified according to the mineral composition of the sand and cement.

SARA analysis: a method of fractionation by which petroleum is separated into saturates, aromatics, resins, and asphaltene fractions.

SARA separation: see SARA analysis.

Saturated steam: Steam at boiling temperature for a given pressure.

Saturates: paraffins and cycloparaffins (naphthenes).

Saturation: the ratio of the volume of a single fluid in the pores to pore volume, expressed as a percent and applied to water, oil, or gas separately; the sum of the saturations of each fluid in a pore volume is 100%.

Saybolt Furol viscosity: the time, in seconds (Saybolt Furol Seconds, SFS), for 60 ml of fluid to flow through a capillary tube in a Saybolt Furol viscometer at specified temperatures between 70°F and 210°F; the method is appropriate for high-viscosity oils such as transmission, gear, and heavy fuel oils.

Saybolt Universal viscosity: the time, in seconds (Saybolt Universal Seconds, SUS), for 60 ml of fluid to flow through a capillary tube in a Saybolt Universal viscometer at a given temperature.

Scale wax: the paraffin derived by removing the greater part of the oil from slack wax by sweating or solvent deoiling.

Screen factor: a simple measure of the viscoelastic properties of polymer solutions.

Screening guide: a list of reservoir rock and fluid properties critical to an EOR process.

Scrubber: a device that uses water and chemicals to clean air pollutants from combustion exhaust.

Scrubbing: purifying a gas by washing with water or chemical; less frequently, the removal of entrained materials.

Secondary oil recovery: application of energy (e.g., water flooding) to the recovery of crude oil from a reservoir after the yield of crude oil from primary recovery diminishes.

Secondary pollutants: a pollutant (chemical species) produced by the interaction of a primary pollutant with another chemical or by dissociation of a primary pollutant or by other effects within a particular ecosystem.

Secondary recovery: oil recovery resulting from injection of water, or an immiscible gas at moderate pressure, into a petroleum reservoir after primary depletion.

Secondary structure: the ordering of the atoms of a molecule in space relative to each other.

Secondary tracer: the product of the chemical reaction between reservoir fluids and an injected primary tracer.

Secondary wood processing mills: a mill that uses primary wood products in the manufacture of finished wood products, such as cabinets, moldings, and furniture.

Sediment: an insoluble solid formed as a result of the storage instability and/or the thermal instability of petroleum and petroleum products.

Sedimentary: formed by or from deposits of sediments, especially from sand grains or silts transported from their source and deposited in water, like sandstone and shale; or from calcareous remains of organisms, like limestone.

Sedimentary strata: typically consist of mixtures of clay, silt, sand, organic matter, and various minerals; formed by or from deposits of sediments, especially from sand grains or silts transported from their source and deposited in water, such as sandstone and shale; or from calcareous remains of organisms, such as limestone.

Selective solvent: a solvent which, at certain temperatures and ratios, will preferentially dissolve more of one component of a mixture than of another and thereby permit partial separation.

Separation process: an upgrading process in which the constituents of petroleum are separated, usually without thermal decomposition, e.g. distillation and deasphalting.

Separator-Nobel dewaxing: a solvent (tricholoethylene) dewaxing process.

Separatory funnel: glassware shaped like a funnel with a stoppered rounded top and a valve at the tapered bottom, used for liquid/liquid separations.

Shear: mechanical deformation or distortion, or partial destruction of a polymer molecule as it flows at a high rate.

Shear rate: a measure of the rate of deformation of a liquid under mechanical stress.

Shear-thinning: the characteristic of a fluid whose viscosity decreases as the shear rate Increases.

Shell fluid catalytic cracking: a two-stage fluid catalytic cracking process in which the catalyst is regenerated.

Shell still: a still formerly used in which the oil was charged into a closed, cylindrical shell and the heat required for distillation was applied to the outside of the bottom from a firebox.

Sidestream: a liquid stream taken from any one of the intermediate plates of a bubble tower.

Sidestream stripper: a device used to perform further distillation on a liquid stream from any one of the plates of a bubble tower, usually by the use of steam.

Single well tracer: a technique for determining residual oil saturation by injecting an ester, allowing it to hydrolyze; following the dissolution of some of the reaction products in residual oil the injected solutions produced back and analyzed.

Slack wax: the soft, oily crude wax obtained from the pressing of paraffin distillate or wax distillate.

Slim tube testing: laboratory procedure for the determination of minimum miscibility pressure using long, small-diameter, sand-packed, oil-saturated, stainless steel tube.

Slime: a name used for petroleum in ancient texts.

Sludge: a semi-solid to solid product which results from the storage instability and/or the thermal instability of petroleum and petroleum products.

Slug: a quantity of fluid injected into a reservoir during enhanced oil recovery.

Slurry hydroconversion process: a process in which the feedstock is contacted with hydrogen under pressure in the presence of a catalytic coke-inhibiting additive.

Slurry phase reactors: tanks into which wastes, nutrients, and microorganisms are placed.

Smoke point: a measure of the burning cleanliness of jet fuel and kerosene.

Sodium hydroxide treatment: see Caustic wash.

Sodium plumbite: a solution prepared front a mixture of sodium hydroxide, lead oxide, and distilled water; used in making the doctor test for light oils such as gasoline and kerosine.

Solubility parameter: a measure of the solvent power and polarity of a solvent.

Solutizer-steam regenerative process: a chemical treating process for extracting mercaptan derivatives (RSH) from gasoline or naphtha, using solutizers (potassium isobutyrate, potassium alkyl phenolate) in strong potassium hydroxide solution.

Solvent: a liquid in which certain kinds of molecules dissolve. While they typically are liquids with low boiling points, they may include high-boiling liquids, supercritical fluids, or gases.

Solvent asphalt: the asphalt produced by solvent extraction of residua or by light hydrocarbon (propane) treatment of a residuum or an asphaltic crude oil.

Solvent deasphalting: a process for removing asphaltic and resinous materials from reduced crude oils, lubricating-oil stocks, gas oils, or middle distillates through the extraction or precipitant action of low-molecular-weight hydrocarbon solvents; see also Propane deasphalting.

Solvent decarbonizing: see Propane decarbonizing.

Solvent deresining: see Solvent deasphalting.

Solvent dewaxing: a process for removing wax from oils by means of solvents usually by chilling a mixture of solvent and waxy oil, filtration or by centrifuging the wax which precipitates, and solvent recovery.

Solvent extraction: a process for separating liquids by mixing the stream with a solvent that is immiscible with part of the waste but that will extract certain components of the waste stream.

Solvent gas: an injected gaseous fluid that becomes miscible with oil under. reservoir conditions and improves oil displacement.

Solvent naphtha: refined naphtha of the restricted boiling range used as a solvent; also called petroleum naphtha; petroleum spirits.

Solvent refining: see Solvent extraction.

Sonic log: a well log based on the time required for sound to travel through rock, useful in determining porosity.

Sonication: a physical technique employing ultrasound to intensely vibrate a sample media in extracting solvent and to maximize solvent/analyte interactions.

Sour crude oil: crude oil containing an abnormally large amount of sulfur compounds; see also Sweet crude oil.

SOx: oxides of sulfur.

Soxhlet extraction: an extraction technique for solids in which the sample is repeatedly contacted with solvent over several hours, increasing extraction efficiency.

Spontaneous ignition: ignition of a fuel, such as coal, under normal atmospheric conditions; usually induced by climatic conditions.

Specific gravity: the mass (or weight) of a unit volume of any substance at a specified temperature compared to the mass of an equal volume of pure water at a standard temperature; see also Density.

Spent catalyst: a catalyst that has lost much of its activity due to the deposition of coke and metals.

Stabilization: the removal of volatile constituents from a higher boiling fraction or product (q.v. stripping); the production of a product which, to all intents and purposes, does not undergo any further reaction when exposed to the air.

Stabilizer: a fractionating tower for removing light hydrocarbons from an oil to reduce vapor pressure particularly applied to gasoline.

Stand (of trees): a tree community that possesses sufficient uniformity in composition, constitution, age, spatial arrangement, or condition to be distinguishable from adjacent communities.

Standpipe: the pipe by which catalyst is conveyed between the reactor and the regenerator.

Stationary phase: in chromatography, the porous solid or liquid phase through which an introduced sample passes. The different affinities the stationary phase has for a sample allow the components in the sample to be separated, or resolved.

Steam cracking: a conversion process in which the feedstock is treated with superheated steam.

Steam distillation: distillation in which vaporization of the volatile constituents is effected at a lower temperature by the introduction of steam (open steam) directly into the charge.

Steam drive injection (steam injection): EOR process in which steam is continuously injected into one set of wells (injection wells) or other injection sources to effect oil displacement toward and production from the second set of wells (production wells); steam stimulation of production wells is *direct steam stimulation* whereas steam drive by steam injection to increase production from other wells is *indirect steam stimulation*.

Steam stimulation: injection of steam into a well and the subsequent production of oil from the same well.

Steam turbine: a device for converting the energy of high-pressure steam (produced in a boiler) into mechanical power which can then be used to generate electricity.

Stiles method: a simple approximate method for calculating oil recovery by waterflood that assumes separate layers (stratified reservoirs) for the permeability distribution.

Storage stability (or storage instability): the ability (inability) of a liquid to remain in storage over extended periods of time without appreciable deterioration as measured by gum formation and the depositions of insoluble material (sediment).

Straight vegetable oil (SVO): any vegetable oil that has not been optimized through the process of transesterification.

Straight-run asphalt: the asphalt produced by the distillation of asphaltic crude oil.

Straight-run products: obtained from a distillation unit and used without further treatment.

Strata: layers including the solid iron-rich inner core, molten outer core, mantle, and crust of the earth.

Straw oil: pale paraffin oil of straw color used for many process applications.

Stripper well: a well that produces (strips from the reservoir) oil or gas.

Stripping: a means of separating volatile components from less volatile ones in a liquid mixture by the partitioning of the more volatile materials to a gas phase of air or steam (q.v. stabilization).

Sulfonic acids: acids obtained by petroleum or a petroleum product with strong sulfuric acid.

Sulfuric acid alkylation: an alkylation process in which olefins (C_3, C_4, and C_5) combine with *iso*-butane in the presence of a catalyst (sulfuric acid) to form branched-chain hydrocarbons used especially in gasoline blending stock.

Supercritical fluid: an extraction method where the extraction fluid is present at a pressure and temperature above its critical point.

Superheated steam: steam which is hotter than the boiling temperature for a given pressure.

Surface active material: a chemical compound, molecule, or aggregate of molecules with physical properties that cause it to adsorb at the interface between *two* immiscible liquids, resulting in a reduction of interfacial tension or the formation of a microemulsion.

Surfactant: a type of chemical, characterized as one that reduces interfacial resistance to mixing between oil and water or changes the degree to which water wets reservoir rock.

Suspensoid catalytic cracking: a non-regenerative cracking process in which cracking stock is mixed with a slurry of catalyst (usually clay) and cycle oil and passed through the coils of a heater.

Sustainable: an ecosystem condition in which biodiversity, renewability, and resource productivity are maintained over time.

SW-846: an EPA multi-volume publication entitled *Test Methods for Evaluating Solid Waste, Physical/Chemical Methods*; the official compendium of analytical and sampling methods that have been evaluated and approved for use in complying with the RCRA regulations and that functions primarily as a guidance document setting forth acceptable, although not required, methods for the regulated and regulatory communities to use in responding to RCRA-related sampling and analysis requirements. SW-846 changes over time as new information and data are developed.

Sweated wax: a crude petroleum-based wax that has been freed from oil by having been passed through a sweater.

Sweating: the separation of paraffin oil and low-melting wax from paraffin wax.

Sweep efficiency: the ratio of the pore volume of reservoir rock contacted by injected fluids to the total pore volume of reservoir rock in the project area. *(See also* areal sweep efficiency *and* vertical sweep efficiency.)

Sweet crude oil: crude oil containing little sulfur; see also Sour crude oil.

Sweetening: the process by which petroleum products are improved in odor and color by oxidizing or removing the sulfur-containing and unsaturated compounds.

Swelling: increase in the volume of crude oil caused by the absorption of EOR fluids, especially carbon dioxide. Also, increase in the volume of clays when exposed to brine.

Swept zone: the volume of rock that is effectively swept by injected fluids.

Synthesis gas (syngas): a gas produced by the gasification of a solid or liquid fuel that consists primarily of carbon monoxide and hydrogen.

Synthetic crude oil (syncrude): a hydrocarbon product produced by the conversion of coal, oil shale, or tar sand bitumen that resembles conventional crude oil; can be refined in a petroleum refinery.

Synthetic ethanol: ethanol produced from ethylene, a petroleum by-product.

Tar: the volatile, brown to black, oily, viscous product from the destructive distillation of many bituminous or other organic materials, especially coal; a name used arbitrarily for petroleum in ancient texts.

Tar sand (bituminous sand): a formation in which the bituminous material (bitumen) is found as a filling in veins and fissures in fractured rocks or impregnating relatively shallow sand, sandstone, and limestone strata; a sandstone reservoir that is impregnated with a heavy, extremely viscous, black hydrocarbonaceous, petroleum-like material that cannot be retrieved through a well by conventional or enhanced oil recovery techniques; (FE 76-4): The several rock types that contain an extremely viscous hydrocarbon which is not recoverable in its natural state by conventional oil well production methods including currently used enhanced recovery techniques; see Bituminous sand.

Target analyte: target analytes are compounds that are required analytes in U. S. EPA analytical methods. BTEX and PAHs are examples of petroleum-related compounds that are target analytes in U. S. EPA Methods.

Tertiary structure: the three-dimensional structure of a molecule.

Tetraethyl lead (TEL): an organic compound of lead, $Pb(CH_3)_4$, which, when added in small amounts, increases the antiknock quality of gasoline.

Thermal coke: the carbonaceous residue formed as a result of a non-catalytic thermal process; the Conradson carbon residue; the Ramsbottom carbon residue.

Thermal cracking: a process which decomposes, rearranges, or combines hydrocarbon molecules by the application of heat, without the aid of catalysts.

Thermal polymerization: a thermal process to convert light hydrocarbon gases into liquid fuels.

Thermal process: any refining process which utilizes heat, without the aid of a catalyst.

Thermal recovery: see the EOR process.

Thermal reforming: a process using heat (but no catalyst) to effect molecular rearrangement of low-octane naphtha into gasoline of higher antiknock quality.

Thermal stability (thermal instability): the ability (inability) of a liquid to withstand relatively high temperatures for short periods of time without the formation of carbonaceous deposits (sediment or coke).

Thermochemical conversion: use of heat to chemically change substances from one state to another, e.g. to make useful energy products.

Thermofor catalytic cracking: a continuous, moving-bed catalytic cracking process.

Thermofor catalytic reforming: a reforming process in which the synthetic, bead-type catalyst of coprecipitated chromia (Cr_2O_3) and alumina (Al_2O_3) flows down through the reactor concurrent with the feedstock.

Thermofor continuous percolation: a continuous clay treating process to stabilize and decolorize lubricants or waxes.

Thief zone: any geologic stratum not intended to receive injected fluids in which significant amounts of injected fluids are lost; fluids may reach the thief zone due to an improper completion or a faulty cement job.

Thin-layer chromatography (TLC): a chromatographic technique employing a porous medium of glass coated with a stationary phase. An extract is spotted near the bottom of the medium and placed in a chamber with a solvent (mobile phase). The solvent moves up the medium and separates the components of the extract, based on affinities for the medium and solvent.

Timberland: forest land that is producing or is capable of producing crops of industrial wood, and that is not withdrawn from timber utilization by statute or administrative regulation.

Time-lapse logging: the repeated use of calibrated well logs to quantitatively observe changes in measurable reservoir properties over time.

Tipping fee: A fee for disposal of waste.

Ton (short ton): 2,000 pounds.

Tonne (Imperial ton, long ton, shipping ton): 2,240 pounds; equivalent to 1,000 kg or in crude oil terms approximately 7.5 barrels of oil.

Topped crude: petroleum that has had volatile constituents removed up to a certain temperature, e.g., 250°C+ (480°F+) topped crude; not always the same as a residuum.

Topping: the distillation of crude oil to remove light fractions only

Topping and back pressure turbines: turbines which operate at exhaust pressure considerably higher than atmospheric (non-condensing turbines); often multistage with relatively high efficiency.

Topping cycle: a cogeneration system in which electric power is produced first. The reject heat from power production is then used to produce useful process heat.

Total petroleum hydrocarbons (TPH): the family of several hundred chemical compounds that originally come from petroleum.

Tower: equipment for increasing the degree of separation obtained during the distillation of oil in a still.

TPH E: gas chromatographic test for TPH extractable organic compounds.

TPH V: gas chromatographic test for TPH volatile organic compounds.

TPH-D(DRO): gas chromatographic test for TPH diesel-range organics.

TPH-G(GRO): gas chromatographic test for TPH gasoline-range organics.

Trace element: those elements that occur at very low levels in a given system.

Tracer test: a technique for determining fluid flow paths in a reservoir by adding small quantities of easily detected material (often radioactive) to the flowing fluid, and monitoring their appearance at production wells. Also used in cyclic injection to appraise oil saturation.

Transesterification: The chemical process in which alcohol reacts with the triglycerides in vegetable oil or animal fats, separating the glycerin and producing biodiesel.

Transmissibility (transmissivity): an index of producibility of a reservoir or zone, the product of permeability and layer thickness.

Traps: sediments in which oil and gas accumulate from which further migration is prevented.

Traveling grate: a type of furnace in which assembled links of grates are joined together in a perpetual belt arrangement. Fuel is fed in at one end and ash is discharged at the other.

Treatment: any method, technique, or process that changes the physical and/or chemical character of petroleum.

Triaxial borehole seismic survey: a technique for detecting the orientation of hydraulically induced fractures, wherein a tool holding three mutually seismic detectors is clamped in the borehole during fracturing; fracture orientation is deduced through analysis of the detected microseismic perpendicular events that are generated by the fracturing process.

Trickle hydrodesulfurization: a fixed-bed process for desulfurizing middle distillates.

Trillion: 1×10^{12}

True boiling point (True boiling range): the boiling point (boiling range) of a crude oil fraction or a crude oil product under standard conditions of temperature and pressure.

Tube-and-tank cracking: an older liquid-phase thermal cracking process.

Turbine: a machine for converting the heat energy in steam or high-temperature gas into mechanical energy. In a turbine, a high-velocity flow of steam or gas passes through successive rows of radial blades fastened to a central shaft.

Turn down ratio: the lowest load at which a boiler will operate efficiently as compared to the boiler's maximum design load.

Ultimate analysis: elemental composition.

Ultimate recovery: the cumulative quantity of the oil that will be recovered when revenues from further production no longer justify the costs of the additional production.

Ultrafining: a fixed-bed catalytic hydrogenation process to desulfurize naphtha and upgrade distillates by essentially removing sulfur, nitrogen, and other materials.

Ultraforming: a low-pressure naphtha-reforming process employing onstream regeneration of a platinum-on-alumina catalyst and producing high yields of hydrogen and high-octane-number reformate.

Unassociated molecular weight: the molecular weight of asphaltenes in a non-associating (polar) solvent, such as dichlorobenzene, pyridine, or nitrobenzene.

Unconformity: a surface of erosion that separates younger strata from older rocks.

Unifining: a fixed-bed catalytic process to desulfurize and hydrogenate refinery distillates.

Unisol process: a chemical process for extracting mercaptan sulfur and certain nitrogen compounds from sour gasoline or distillates using regenerable aqueous solutions of sodium or potassium hydroxide containing methanol.

Universal viscosity: see Saybolt Universal viscosity.

Unresolved complex: the thousands of compounds that a gas chromatograph *mixture (UCM)* is unable to fully separate.

Unstable: usually refers to a petroleum product that has more volatile constituents present or refers to the presence of olefin and other unsaturated constituents.

UOP alkylation: a process using hydrofluoric acid (which can be regenerated) as a catalyst to unite olefins with *iso*-butane.

UOP copper sweetening: a fixed-bed process for sweetening gasoline by converting mercaptan derivatives (RSH) to disulfide derivatives (RSSR) by contact with ammonium chloride and copper sulfate in a bed.

UOP fluid catalytic cracking: a fluid process of using a reactor-over-regenerator design.

Upgrading: the conversion of petroleum to value-added salable products.

Upper-phase microemulsion: a microemulsion phase containing a high concentration of oil that, when viewed in a test tube, resides on top of a water phase.

Urea dewaxing: a continuous dewaxing process for producing low-pour-point oils, and using urea which forms a solid complex (adduct) with the straight-chain wax paraffins in the stock; the complex is readily separated by filtration.

Vacuum distillation: a secondary distillation process which uses a partial vacuum to lower the boiling point of residues from primary distillation and extract further blending components; distillation under reduced pressure.

Vacuum residuum: a residuum obtained by distillation of crude oil under vacuum (reduced pressure); that portion of petroleum which boils above a selected temperature such as 510°C (950°F) or 565°C (1,050°F).

Vapor-phase cracking: a high-temperature, low-pressure conversion process.

Vapor-phase hydrodesulfurization: a fixed-bed process for desulfurization and hydrogenation of naphtha.

Vertical sweep efficiency: the fraction of the layers or vertically distributed zones of a reservoir that are effectively contacted by displacing fluids.

VGC (viscosity-gravity constant): an index of the chemical composition of crude oil defined by the general relation between specific gravity, sg, at 60°F and Saybolt Universal viscosity, SUV, at 100°F:

$$a = 10sg - 1.0752 \log (SUV - 38)/10sg - \log (SUV - 38)$$

The constant, a, is low for the paraffin crude oils and high for the naphthenic crude oils.

VI (Viscosity index): an arbitrary scale used to show the magnitude of viscosity changes in lubricating oils with changes in temperature.

Visbreaking: a process for reducing the viscosity of heavy feedstocks by controlled thermal decomposition.

Viscosity: a measure of the ability of a liquid to flow or a measure of its resistance to flow; the force required to move a plane surface of area 1 square meter over another parallel plane surface 1 m away at a rate of 1 m/s when both surfaces are immersed in the fluid; the higher the viscosity, the slower the liquid flows.

Viscosity index-: see VI.

Viscosity-gravity constant: see VGC.

VOC (VOCs): volatile organic compound(s); volatile organic compounds are regulated because they are precursors to ozone; carbon-containing gases and vapors from incomplete gasoline combustion and from the evaporation of solvents.

Volatile compounds: a relative term that may mean (i) any compound that will purge, (ii) any compound that will elute before the solvent peak (usually those <C6), or (iii) any compound that will not evaporate during a solvent removal step.

Volatile Organic Compounds (VOCs): name given to light organic hydrocarbons which escape as vapor from fuel tanks or other sources, and during the filling of tanks. VOCs contribute to smog.

Volumetric sweep: the fraction of the total reservoir volume within a flood pattern that is effectively contacted by injected fluids.

VSP: vertical seismic profiling, a method of conducting seismic surveys in the borehole for detailed subsurface information.

Waste streams: unused solid or liquid by-products of a process.

Waste vegetable oil (WVO): grease from the nearest fryer which is filtered and used in modified diesel engines, or converted to biodiesel through the process of transesterification and used in any diesel-fueled vehicle.

Water-cooled vibrating grate: a boiler grate made up of a tuyere grate surface mounted on a grid of water tubes interconnected with the boiler circulation system for positive *cooling; the structure is supported by flexing plates allowing the grid and grate to move in a vibrating action; ash is automatically discharged.

Waterflood: injection of water to displace oil from a reservoir (usually a secondary recovery process).

Waterflood mobility ratio: mobility ratio of water displacing oil during waterflooding. (See *also* mobility ratio.)

Waterflood residual: the waterflood residual oil saturation; the saturation of oil remaining after waterflooding in those regions of the reservoir that have been thoroughly contacted by water.

Watershed: The drainage basin contributing water, organic matter, dissolved nutrients, and sediments to a stream or lake.

Watson characterization factor: see Characterization factor.

Watt: the common base unit of power in the metric system; one watt equals one joule per second or the power developed in a circuit by a current of one ampere flowing through a potential difference of one volt. 1 Watt=3.412 Btu/hr.

Wax: see Mineral wax and Paraffin wax.

Wax distillate: a neutral distillate containing a high percentage of crystallizable paraffin wax, obtained on the distillation of paraffin or mixed-base crude, and on reducing neutral lubricating stocks.

Wax fractionation: a continuous process for producing waxes of low oil content from wax concentrates; see also MEK deoiling.

Wax manufacturing: a process for producing oil-free waxes.

Weathered crude oil: crude oil which, due to natural causes during storage and handling, has lost an appreciable quantity of its more volatile components; also indicates uptake of oxygen.

Well completion: the complete outfitting of an oil well for either oil production or fluid injection; also the technique used to control fluid communication with the reservoir.

Wellbore: the hole in the earth comprising a well.

Wellhead: that portion of an oil well above the surface of the ground.

Wet gas: gas containing a relatively high proportion of hydrocarbons which are recoverable as liquids; see also Lean gas.

Wet scrubbers: devices in which a counter-current spray liquid is used to remove impurities and particulate matter from a gas stream.

Wettability: the relative degree to which a fluid will spread on (or coat) a solid surface in the presence of other immiscible fluids.

Wettability number: a measure of the degree to which a reservoir rock is water-wet or oil-wet, based on capillary pressure curves.

Wettability reversal: the reversal of the preferred fluid wettability of rock, e.g., from water-wet to oil-wet, or vice versa.

Wheeling: the process of transferring electrical energy between buyer and seller by way of an intermediate utility or utilities.

White oil: a generic tame applied to highly refined, colorless hydrocarbon oils of low volatility, and covering a wide range of viscosity.

Whole-tree harvesting: a harvesting method in which the whole tree (above the stump) is removed.

Wobbe Index (or Wobbe Number): the calorific value of a gas divided by the specific gravity.

Wood alcohol: see Methyl alcohol.

Yarding: the initial movement of logs from the point of felling to a central loading area or landing.

Zeolite: a crystalline aluminosilicate used as a catalyst and having a particular chemical and physical structure.

Conversion Factors

1 acre=43,560 sq ft
1 acre foot=7758.0 bbl
1 atmosphere=760 mm Hg=14.696 psi=29.91 in. Hg
1 atmosphere=1.0133 bars=33.899 ft. H_2O
1 barrel (oil)=42 gal=5.6146 cu ft
1 barrel (water)=350 lb. at 60°F
1 barrel per day=1.84 cu cm per second
1 Btu=778.26 ft-lb.
1 centipoise×2.42=lb. mass/(ft) (hr), viscosity
1 centipoise×0.000672=lb. mass/(ft) (sec), viscosity
1 cubic foot=28,317 cu cm=7.4805 gal
Density of water at 60°F=0.999 gram/cu cm=62.367 lb./cu ft=8.337 lb./gal
1 gallon=231 cu in.=3,785.4 cu cm=0.13368 cu ft
1 horsepower-hour=0.7457 kWh=2544.5 Btu
1 horsepower=550 ft-lb./sec=745.7 watts
1 inch=2.54 cm
1 meter=100 cm=1,000 mm=10^6 microns=10^{10} angstroms (Δ)
1 ounce=28.35 grams
1 pound=453.59 grams=7,000 grains
1 square mile=640 acres

SI METRIC CONVERSION FACTORS

(E=exponent; i.e. E+03=10^3 and E−03=10^{-3})

acre-foot×1.233482	E+03=meters cubed
barrels×1.589873	E−01=meters cubed
centipoise×1.000000	E−03=pascal seconds
darcy×9.869233	E−01=micro meters squared
feet×3.048000	E−01=meters
pounds/acre-foot×3.677332	E−04=kilograms/meters cubed
pounds/square inch×6.894757	E+00=kilo pascals
dyne/cm×1.000000	E+00=mN/m
parts per million×1.000000	E+00=milligrams/kilograms

Index

Printed in the United States
by Baker & Taylor

Printed in the United States
By Bookmasters